Hatumere: ISLAMIC DESIGN IN WEST AFRICA

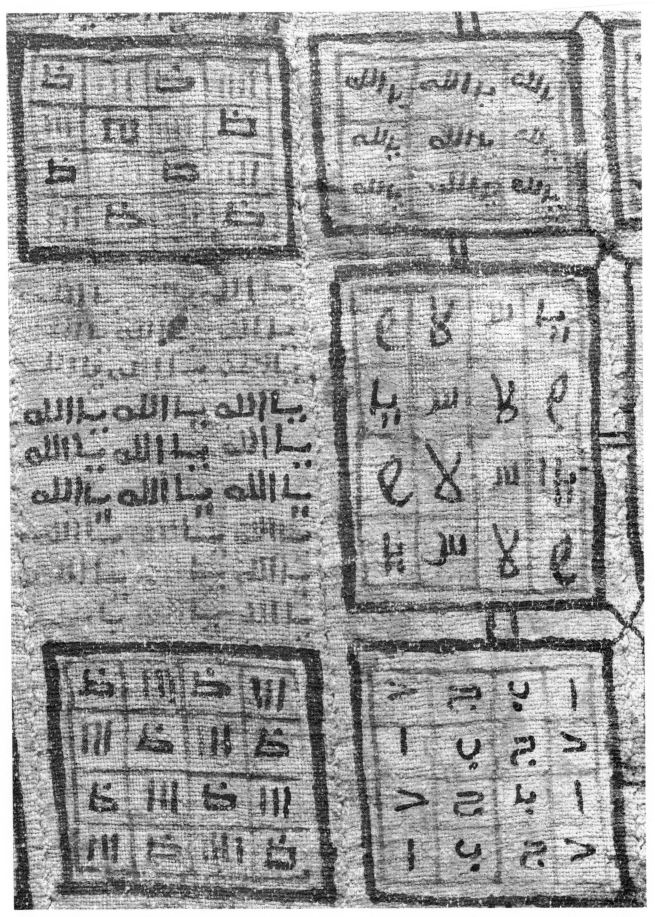

Frontispiece. Hatumere designs on a handspun, handwoven shroud from northern Togoland, ca. 1910.

LABELLE PRUSSIN

Hatumere:
ISLAMIC DESIGN
IN WEST AFRICA

Published with the assistance of the Aga Khan Program for Islamic Architecture (Harvard University and the Massachusetts Institute of Technology)

UNIVERSITY OF CALIFORNIA PRESS　　*Berkeley · Los Angeles · London*

University of California Press
Berkeley and Los Angeles, California
University of California Press, Ltd.
London, England
©1986 by
The Regents of the University of California
Printed in the United States of America
1 2 3 4 5 6 7 8 9

Library of Congress Cataloging in Publication Data

Prussin, Labelle.
 Hatumere: Islamic design in West Africa.

 Bibliography: p.
 Includes index.
 1. Architecture, Islamic—Africa, West. 2. Vernacular
architecture—Africa, West. 3. Art, Islamic—Africa,
West. 4. Art—Africa, West. I. Title.
NA1598.P77 1985 709'.01'10966 75–7202
ISBN 0–520–03004–4

*To the memory of my parents
and the future of my children*

CONTENTS

FIGURES

In those instances where published sources have been used and where such sources are particularly relevant to the textual discussion, an abbreviated documentation has been included with the caption. Full entries may be found in the bibliography. In the case of historical materials, the current political boundaries are given in order to help the reader locate the subject matter in space. The maps at the opening of each chapter are further intended to locate subject matter for readers unfamiliar with their provenance or with African place-names. Where not otherwise noted, line drawings are by Rachel Volberg and photographs are by the author.

Chapter 4

Chapter 5

Chapter 6

Chapter 7

Chapter 8

PLATES

FOREWORD AND ACKNOWLEDGMENTS

Author's prefaces tend to be conventions. In this case, however, since it seems necessary to explain to the reader our intentions and the obstacles in their way, the foreword is a component of the work.

Both a survey and a theoretical study, this book attempts to shed some light on a subject that has been ignored until recently; once recognized, it was viewed with condescension; now acknowledged, it still eludes scrutiny. The work has evolved over a long period of time, during which we have become familiar with areas of knowledge and educated about many disciplines outside our own profession. In the course of this learning process we came to question many of the concepts, canons, and tenets traditionally held by our generation of architects, architectural historians, African scholars, and by orthodox Islamicists. Begun as a simple survey of African architecture, the work evolved into a study of the interface between the arts and architecture of West Africa and has culminated by focusing on the role of Islam in shaping both.

Hatumere, the title of this study, derives from the Arabic term *khatem* or seal, used in reference to the amulets written in the form of squares and applied to a range of behavioral situations and contexts in North Africa. The Fulbe term *hatumere*, equivalent to the Mande term *sebe*, has developed into a generic reference to many aspects of self-conscious design in the West African environment.

Our Western perspective was born in and evolved through experience in an American urban setting, and our biases were conditioned by exposure to European interpretation. Years of living in and orientation to the African milieu have replaced arrogance with humility. We are aware that with the removal of each successive cultural veil, there will always be, like the nets of the Sorko fishermen, another hanging before our eyes.

The contents of this volume are neither comprehensive nor of even emphasis. Rather, they reflect our own research interests and areas of familiarity. Like many other Western observers, we feel greater empathy for the upper reaches of the West African savannah than for the enveloping, less revealing rain forest. The man-built forms that emerge from its landscape are readily recognizable and hence relatively easily integrated into Western aesthetic experience. Shapes and surfaces—as well as the things people do with them—are clearly discernible. From those schooled in a sensitivity to the way light reveals form in the architectonic archetypes of the classical Mediterranean world, it is little wonder that three-dimensional geometric forms evoke a more sympathetic response. It is easier to see and hence to admit to architecture in the savannah than it is in the rain forest or the sahel.

Although the emphases of this study reflect a Western bias and training, they are equally a revolt against that bias. Like many of our colleagues schooled in the twentieth-century tradition of architectural functionalism and the aftermath of the International Style, we judged architecture by the "purity" of its structural expression, by its "honest" use of materials, and by its

xix

ability to "enclose" space economically. Ingenuity of environmental and structural technology governed design judgment. Applied ornament, long considered an aesthetic crime, was never, until recently, acknowledged as a functional component. The questions we attempted to formulate in an earlier book, *Architecture in Northern Ghana* (Berkeley and Los Angeles: University of California Press, 1969), themselves reflected that background.

In the decade following its publication, we, like many of our colleagues, came to realize that while answers to *shelter* might be found in measuring, describing, or analyzing physical reality, an understanding of *architecture* rests at least as heavily on the links and ties that people establish between the concrete and conceptual worlds in which they move. The empirical creative act is enveloped in abstract thought, symbolic existence, and relative judgment.

Another facet of our bias is a concern with the nature of creativity in the man-built environment. Involvement in the architectural design process perforce requires continual questioning. *How* is a building created, and *why* is it architecture? To what extent can the single heroic act of creation be attributed to an individual? To what extent do its beholders and its users imbue it with symbolic meaning and bestow beauty upon it? Do the judgments voiced by our peers reflect a set of universal values, or merely the taste and tenets of time and place? The introspection that creativity requires also serves to sharpen our perceptions of the decisions and judgments made by others similarly involved. The experience of doing intensifies and sensitizes our affective response.

Any attempt to order a broad range of interdisciplinary material must also resolve the problem of communicating to and comprehension by an audience with diverse and divergent interests, backgrounds, and perspectives. Language itself varies in its connotations according to the academic or research setting in which it is being used. An even more relevant problem of communication when dealing with the African reality is that the language of architectural description which the Western world has evolved reflects technical and spatial biases that are often inapplicable to non-Western and less specialized settings. Few terms in our language adequately describe African building technologies, the range and multiplicity of behaviors that take place in space, or the very nature of spatial definition and enclosure in Africa. By the same token, interpretation of the written sources on which much analysis is based is fraught with difficulty. One of the most difficult problems faced by a Western author schooled in other conceptual modes and other building technologies is the absence of a universal lexicon, one fully applicable to

other cultural contexts. Lexical changes over time do, however, follow similar patterns; etymologies do follow similar courses. Just as the analysis of terms such as *watercloset*, *parlor*, or *facade*—all common to the traditional Western lexicon of architecture—provides insights into the historical development of European house forms, so, also, changes in the African lexicon reflect stylistic as well as technological changes in the architectural process. Thus, the analysis presented here emphasizes local lexical terms.

The contents of this study have been divided into two parts, one dealing with space, the other with time. One might object that this format itself reflects the way in which the Western world structures material in order to describe, analyze, and synthesize. Traditional African societies do not segregate their worlds into synchronic and diachronic networks. Nevertheless, since things in space do change over time, we can measure the "shape of time" if we acknowledge that change occurs differentially.

In Part I, we attempt to relate a range of artifactual material to socially functional behavior patterns and to the conceptual imageries that have been generated by them. Depending heavily on the ethnographic literature, Part I is a hypothetically ordered inventory of man's interaction with, and adaptation to, his environment, both physical and conceptual. The assumption of timelessness in the life and mind of Africa is used only for the purpose of analysis.

In Part II, we attempt to trace temporal change in the architectural environment. Hence, Part II depends in greater measure on available historical sources, both written and oral. In a number of instances, artifactual, architectural, and archeological evidence has been used in questioning currently accepted historical explanation.

Readers schooled in the methodologies of the social sciences may take issue with the seeming lack of system and meagerness of the field data that are used to justify what appear to be sweeping generalizations. If we assume, however, that the man-structured, man-built physical environment mirrors society, then material observation provides what is in some ways the most accurate evidence by which patterns of behavior in space and time can be reconstructed. It is on the basis of material evidence, then, both ethnographic and archeological, that explanation is proffered.

The reader schooled in the methodology of art or architectural history may view the possibility of ever writing a history of African art or architecture with skepticism. History has traditionally depended on the written and physical record; it has often consisted merely of arranging names, dates, and places in chronological sequence. In Africa, the minimal written docu-

ments are full of bias, oral traditions are veiled in a fabric of myth and legend, materials and artifacts are mutable and perishable, and the archeological record is still in its infancy. Yet, it is often out of this very challenge that innovative interpretation is born. While it may never be possible to uncover the minutiae of conclusive history which the Western mind finds so essential for its satisfaction, it is possible to paint a panoramic canvas rich in insights not only for Africa but for the world.

Any study that purports to focus on Islam in West Africa must include reference to North Africa. African studies have traditionally followed a format, ostensibly for reasons of geography, cultural discreteness, or Negritude, that segregates North African from sub-Saharan subject matter. The Sahara Desert has always been viewed as a territorial barrier separating two vastly different cultural and environmental milieus. When admitted, trans-Saharan contact has been used to argue the merits of diffusion and to deny indigenous West African creativity and innovation. Hence, our perception, understanding, and interpretation of historical reality have often prevented recognition of the contribution made by sub-Saharan cultures to North Africa. The course of this study, however, has convinced us that the current pattern of delimitation and circumscription is due to historical bias and interpretation rather than to any genuine cultural discreteness.

The interpretations proffered in this study are undoubtedly controversial. These controversies will, we hope, suggest avenues for further research, in the course of which we would be enormously surprised if we were not shown to be in error on some matters. Our aim has been to call attention to the relevance and richness of a subject so long ignored and frequently misrepresented to an audience which, in this age of alienation, desperately seeks answers to its own identity in a world from which it cannot escape.

The ideas and knowledge embodied in this study are a result of many years of sustained interest. Hence, myriad sources and friends deserve acknowledgment. Indeed, there are so many to whom so much is owed that we despair of ever sorting out the nexus from its nodes.

To our friends and colleagues in Ghana, at the Volta River Authority and the University of Science and Technology, who opened our eyes to this other world, we owe an initial debt of gratitude. Some of the framework on which the themes are woven was developed during an appointment as a teaching fellow in the Department of Fine Arts at Indiana University. Support from the Department of the History of Art and the Council on African Studies at Yale University enabled

us to do archival work in Europe and Africa and fieldwork in the Upper Niger Delta. A Rackham Graduate School Faculty Research Grant from the University of Michigan made possible another research trip to Niger, and a grant from the Rackham Graduate School of the University of Michigan contributed to the preparation of the illustrations. More recently, a Fulbright-Hays Research Grant provided the opportunity to continue field research on Islam and the process of Fulani sedentarization in Guinea. We would like to express our gratitude to the staff of the Institut National de Recherche et Documentation de Guinée for their help and cooperation. Concurrently, a planning grant awarded to the Detroit Institute of Arts by the National Endowment for the Humanities for an exhibition and symposium on Islamic Arts and Architecture in West Africa contributed enormously to the crystallization of our thoughts on the nature of Islamic arts and architecture. Further financial help from the Founders Society of the Detroit Institute of Arts and from the Aga Khan Program for Islamic Architecture, and a Faculty Award from the College of Architecture and Urban Planning at the University of Washington allowed us to complete this part of an ongoing study.

Numerous curators of museums in both the United States and Europe gave unstintingly of their time in aiding our search for artifactual materials to illustrate the continuum and interface between the arts and architecture of Islam in West Africa. We would particularly like to acknowledge the help of Mme Francine Ndiaye at the Musée de l'Homme. To Mme Danièle Denis, Conservateur, Section du Magreb at the Musée des Arts Africains et Océaniens, Paris; to Dr. Claude Savary, Musée d'Ethnographie, Geneva; to Drs. Paul Jenkins and Peter Valentin at the Museum der Basler Mission, Basel; to Malcolm McLeod, Keeper at the Museum of Mankind, London; to Kathleen Berrin at the M. H. de Young Museum, San Francisco; to Dr. Sylvia Williams at the Brooklyn Museum; to Dr. Enid Schildkrout at the American Museum of Natural History, New York; to Ms. Caroline Dosker at The University Museum, Philadelphia; to Dr. Susan Vogel at the Metropolitan Museum of Art, New York; and to Pamela McCluskey at the Seattle Art Museum, we also owe a debt of gratitude.

We would also like to thank Linda Haverfield for her help in typing the final draft of this manuscript, Professor Philip Thiel for his helpful comments and suggestions, and Jane-Ellen Long for her editorial corrections.

Much of the architectural photography is by the hand and eye of Marli Shamir, taken on a visit to us in Djenné, Mali. Without her help it would have been impossible to convey the unique quality of the built envi-

ronment in the West African savannah, since words alone can never do justice to its beauty.

Much as we are indebted to all the above, our greatest debt is due to the students and colleagues, too numerous to name, who by their attentive ears, helpful comments, and constructive challenges were instru-mental in the shaping and reshaping of ideas. Finally, the book could never have come to fruition without the very special stimulus and encouragement of Professors Raymond Mauny and Robert Farris Thompson, over the years.

NOTE ON ORTHOGRAPHY

One problem encountered in describing "non-literate" societies, or societies whose phonetic structure differs from English, is the transcription of proper names and vernacular terms. Since transcription systems are numerous and methods for their use diverse, we have chosen simply to render vernacular, indigenous terms as closely as possible according to English pronunciation. Such terms are italicized and are spelled phonetically.

We have used *Webster's Geographical Dictionary* and the *Oxford Atlas* as a guide but, since much of the area discussed here is a part of the French-speaking world, we have honored the French spelling for proper nouns in Francophone West Africa. In some instances where an English spelling has become common outside the French-speaking world, we have rendered the name in English. For Arabic terms, we have used the accepted system of English transcription.

PART I

Space

CHAPTER 1

Introduction

FOR WELL OVER a millennium, West Africa has been in contact with, host to, and influenced by Islam. Rarely acknowledged, until quite recently, by the Western world, by the Near Eastern wellspring of Islamic orthodoxy, or by studies of traditional sub-Saharan cultures, the Islamic presence has nevertheless deeply affected indigenous social, political, and economic organization, beliefs and value systems. Subtly woven into the cultural fabric, Islam finds expression in many facets of the traditional sub-Saharan aesthetic. It has been instrumental in the processes of political centralization, urbanization, and sedentarization. Among some peoples, the carriers of Islam created pluralistic societies. In other areas, the population was converted to orthodox Islam. In yet others, Muslim belief and practices merged with the traditional into a syncretist pattern. Hence, the cultural offerings of Islam were integrated into indigenous societies with varying success and intensity. West Africa has thus been witness to the evolution of a unique Islam, different from Near Eastern and North African models. Rather than a vitiation of the faith, it is an Islam rethought, rephrased, and remolded to the sub-Saharan cultural milieu.[1]

Africanist scholarship in the humanities, the social sciences, religion, and philosophy is gradually becoming more receptive to the role of Islam in structuring West African cultures over space and time. This shift in perspective and emphasis has, however, barely been reflected in the study, interpretation, explanation, or presentation of the arts and architecture in West Africa.

It is not easy to disentangle the substratum from the overlays. It is difficult to delineate what is "traditional," what is "pre-Islamic," and what Islam itself contributed during the millennium of its presence on West African soil.[2] While it may never be possible to unravel the tightly woven threads of traditional and Muslim culture completely, it is essential that acknowledgment be made of the richness of the resultant fabric.

Until quite recently, the Western world accorded no place in its architectural schema to Africa—with the exception of Egypt. Architecture in Africa was, and still is, considered nonexistent by some. To be sure, the existence of "shelter" has been universally admitted—every human being requires some kind of shelter—but the studied neglect or denial of a discrete, viable African architecture by practitioners, theoreticians, and the public can be illustrated ad infinitum. A noted urban historian, E. A. Gutkind, suggested in 1953, in a leading architectural journal, that African architecture lacks "a feeling of space as we understand it" and that "Africans have never made an attempt to use space itself as a building material."[3] The initial reaction of a team sent to Africa in 1968 by a popular American news weekly, to photograph architectural monuments for a feature article on the great epochs of African history, was that all they could find was "a bunch of mud huts." This same attitude, though clothed in scholarly respectability, prevailed until quite recently in the theo-

3

retical literature. Thus, well-known American anthropologists could write in 1960 that art forms other than woodcarving, folklore, music, and dance are relatively unimportant in Africa, and an article published by Julius Glück in 1956 that characterizes African architecture as pre-architecture—an *urarchitektur* devoid of "sacrality"—perpetuated this attitude by being reprinted in several subsequent scholarly anthologies. This reluctance to accord architectural respectability to the African setting was most recently reflected in the title of a distinguished collection of essays, *Shelter in Africa*.[4]

In the same vein, it has been only in recent years that the Islamic community has begun to attend consciously to the nature and quality of its own architecture.[5] While the Muslim world included North Africa within the orthodox tradition, far more has been written in the past by the European scholarly community who, in their explorations of the Roman presence in North Africa, found themselves in the midst of centuries of Islamic productivity and creativity. Finally, only in these last two decades—as a result of national independence and of the attention increasingly accorded to the Muslim world—has the Islamic content of sub-Saharan cultures been recognized. In some measure the explanation lies in the attitude of the orthodox Islamic world itself, which holds that there was a narrowing of the tradition. In the sense of true belief in the unity of god, the West African Muslim was considered to be only a second-class citizen.

Western historians, ignorant of Islam, have tended to dismiss its pervasive and subtle presence and to avoid consideration of the ways in which traditional belief systems and behavior patterns have absorbed and integrated facets of the Muslim heritage. The long-held belief among students of African art (and, indeed, the whole scholarly community) that Islam destroyed traditional indigenous art forms still persists, despite the few scholarly attempts to prove the contrary.[6] Arbitrary boundaries continue to be drawn between the world of "pagan" Africa and "Muslim" Africa, between Black and White Africa.

That such attitudes have severely limited the development of any real understanding of the subject is obvious; even more important, they reflect the deep-seated, historically evolved patterns of theoretical misconception and misinterpretation. Rather than mere oversight, such attitudes are the conceptual legacy of a marriage between ideological fallacy and both Western and Muslim ethno- and egocentrism. A brief review of the historiography is germane to an understanding not only of the reasons for our ignorance and misconceptions but also of the way in which the material in this collection has been ordered.

The Sources

Several recent scholarly surveys have carried admirable reviews of the available historical references on the built environment in Africa.[7] While the richness and diversity of these bibliographic surveys suggest the importance of drawing upon an extensive interdisciplinary range of oral, written, and physical data, they make little mention of the repertoire of Islamic resources. Furthermore, despite the fact that they are drawn from widely disparate points in time and space, many of the cited sources appear to have been taken at their face value. The biases inherent in these sources, dealt with at length by some Africanist historians, have rarely been considered in studies of the arts.

First, some general problems of conditioned observation merit attention. A student embarking on a course in European architecture brings an established set of cognitive expectations, structured by experience, to his subject: when we are faced with a visual replica, or the reality, of St. Peter's in Rome, Notre Dame in Paris, Anne Hathaway's cottage at Stratford-on-Avon, or an American log cabin, what we perceive is already partly familiar. The forms and their surface ornamentation recall the classical facade of the local bank, the spires and windows of the neighborhood church, the trite eclecticisms of suburban tract housing, a trip to Disneyland, or, even more elementally, the imagery of the visual mass media, internalized almost from birth. To the study and understanding of European architecture we therefore bring an empathy for the perception of, and movement in, those forms and spaces conditioned by or born of a temperate environment. We are familiar with the codes of behavior that establish our relationship to them. How many of us have internalized the earthen, curvilinear walls of a West African compound into a "deep structure"? One might argue further that the Renaissance science of perspective drawing (on which the techniques of photography are based) is a function of that historical construct of space peculiar to the Western world.[8] What we observe is preconditioned.

A second general problem in observation, particularly disturbing in the literary sources, stems from terminologies of the art and architectural disciplines. These, too, have evolved from behaviors, building skills, and technologies peculiar to Western culture. Terms referring to architectural detail and building materials derive from the traditional stance that timber, brick, and stone and, more recently, steel, concrete, glass, and plastics are most appropriate to architectural creativity. Both the units of earthen materials and their techniques of assembly are shamefully disregarded. The same is true for vegetal materials other than timber. At

best, one must revert to terms long abandoned in the Western world in order to describe and comprehend building conditions still prevalent in Africa. The point is that we cannot *observe* with precision variations in detail with which we are no longer familiar. Despite the richness of vocabulary in the cultures who use these technologies, in European languages all are subsumed under the blanket term *earth*, *banco*. The lost art of delineation among fledgling architects may well also contribute to the rationalized omission of that intricate ornamental detail which enriched architectural surfaces a century ago. The slick, elongated cube with its barely articulated curtain walls, eulogized as the quintessence of simplicity, is like the language of the near-mute: it requires a minimal vocabulary. The inability to delineate detail impairs our ability to conceptualize detail.

To view less differentiated and less specialized societies through Western eyes also creates problems in our designation of how spaces are used. A unit of space which we call a bedroom implies a specialized behavior for a specified, circumscribed period of time in a daily cycle of life. But, if there is no bed, no enclosed room, nor any pattern of activity similar to that which we associate with the name, how is one to designate architecturally the space concerned? For that matter, what scales and whose units of measure is one to use? Language affects our ability to perceive reality objectively.

Finally, considering the biases of those who have been trained to observe the physical milieu, how much less sensitive and less accurate must be the data of observers neither trained nor skilled in recording what they observe? Few observers of the African scene, early or late, Western or Islamic, had training in or a natural talent for visual observation or graphic representation. Their sensitivity to the detail of the subject-matter they chose to record and translate for a distant audience varied widely. Field sketches capturing only what had filtered through the observer's senses became fertile soil for the European engraver's interpretations. Even the eye of the camera, the so-called objective recorder of reality, is limited, by its very structure, to recording the biases of its user.

The available sources for all aspects of African architecture consist of oral description and history, written description in the ethnographic and historical literature, visual description (traditionally, line drawings; more recently, photographs), and archeology. Oral traditions, now admitted as tools for historical reconstruction, have rarely, if ever, been used for architectural reference.[9] This neglect may result from the obscurity, in the Western mind, of the link between mythologic reference and the physical environment, but oral traditions are a potentially rich source for architectural

reconstruction. It is unfortunate that despite several decades of admirable and intense archeological research south of the Sahara carried out under the auspices of the Institut Fondamental d'Afrique Noir, under the aegis of newly emergent African nations and their agencies, and by various departments of archeology in African, European, and American universities, so little data for a broad diachronic analysis has yet been amassed. The century-old North African archeological enterprise, undertaken on a littoral rich in classical ruins and impermeable materials, highlighted the difficulties of West African archeology. Traditional methodologies also militated against achieving a better understanding of the African historical setting, since permeable, non-monumental architecture and kinetic, transient settlement patterns had no place in their schema. To reconstruct spatial patterns in temporal depth under such conditions is difficult. It is only very recently that innovative methodologies and data analyses capable of generating spatio-temporal frameworks have begun to emerge.[10]

The main sources, then, are still the written and visual records. These sources should be further distinguished, since there are differences in culturally conditioned observation between European and Arabic chronicles, records, and publications. Aside from the Western classical world, the earliest written references to architectural phenomena appear in those North African Arabic chronicles that document the first centuries of Islamic expansion during the formative stages of sedentarization and urbanization in North and West Africa. It seems reasonable to suggest that the Arabic nomadic tradition, initially little concerned with the material artifacts of the fixed environment, would provide few references to, or descriptions of, the man-built setting; rather, it attended to the geographic aspects of space. For example, the eleventh-century Arabic chronicler El-Bekri divided his treatise into chapters which describe routes taken from one point in space to another. The meager descriptions of the cities he visited consist, with few exceptions, of passing references to city walls and gates or singular monumental structures such as a mosque, a palace, or mausolea.[11] The minimal descriptions of the twin cities of the capital of Ghana and of the funerary building rite for the deceased king of Ghana, by contrast with the detailed architectural description of the Great Mosque at Kairouan, can be explained by this preoccupation with geography (see Fig. 1.1).

By the fourteenth century, however, Muslim urbanism had become a way of life. Monumentality in building, importance of place, and the appreciation of building as a function of politics and religion are all clearly evident in the writings of Ibn Battūta and Ibn

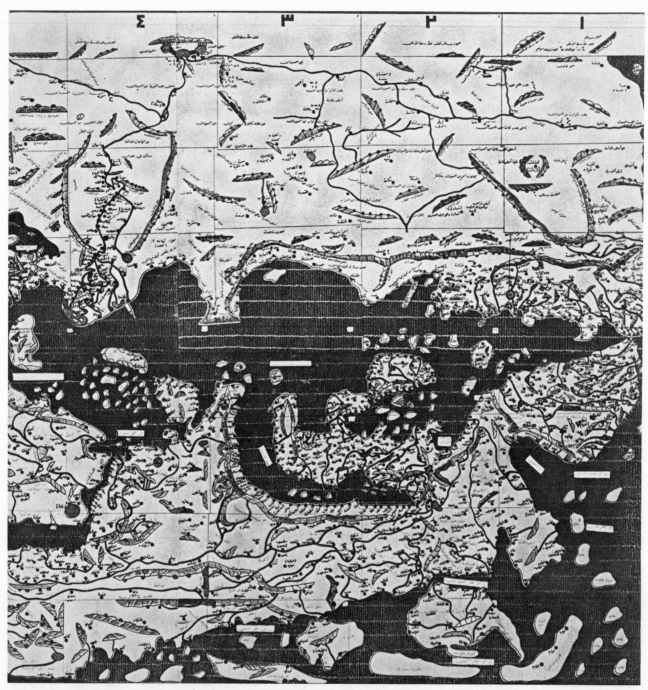

Fig. 1.1 Map of part of the Arab world, al-Idrisi, A.D. 1154. A number of "Islamized" kingdoms are indicated. At that time, it was still believed that the Sénégal and Nile rivers were linked, flowing into each other in the Sahara desert. It has been suggested that all the evidence points to inspiration from El-Bekri's account a century earlier.

Khaldûn, two fourteenth-century Islamic scholars.[12] Both reward us with a flood of detail for the architectural record, encompassing builders, building techniques, and building prescriptions.[13]

Another—negative—aspect of the North African reportage is due to the nature of Islamic architecture itself. The heavy preoccupation with surface decoration, so characteristic of the Muslim artistic heritage, suggests that in the absence of such decoration in West Africa, the architecture itself was effectively invisible to Muslim observers. Moreover, Muslim prescriptions against anthropomorphic representation would have precluded observation of such representations by the Islamic travelers. Thus, while the Arabic chronicles of North Africa remain an incomparably rich source for historical events and personages, description of the built form is, in general, sparse.

A similar subtle distinction emerges when the North African chronicles are compared with those subsequently kept in West Africa by resident observers (see Fig. 1.2).[14] Once again, while rich in chronological detail and biographical anecdote, references to art form and the architectural scene are obscure and confusing. The few there are have all been overworked in a frustrated hope that repetition itself might reveal additional data.

Comparison of the *Tarikh*s is equally revealing. Those passages of Mahmoud Kâti's seventeenth-century *Tarikh el-Fettach* which may in fact be a revision, instigated by the nineteenth-century Fulbe empire builder Sheku Ahmadu, contain far fuller references to builders and building programs than the original manuscript.[15] The revisions themselves therefore appear to reflect increasing concern with the built environment as well as the changing needs of nascent political structures.

As problematic as the Arabic sources are, the European sources, while rich in verbal and visual description, present the greatest hazards for interpretation. They reflect not only the same shifts in historical and cultural concern, but major differences in attitude, conceptualization, and perception. Our familiarity with Western thought and history has inclined us to accept them with little question. They continue to comprise the bulk of our descriptive and analytic resources, even though plagiarism, exoticism, environmental determinism, racism, and differences in national and colonial policy have all been instrumental in coloring their contents.

There is considerable documentation, both in the literary sources and in art, of the extent of the African presence in the classical world. The earliest reference to Ifriqiya, the *pars hostilis* of the classical *imago mundi*, appears in the writings of the fifth-century B.C. Greek

Fig. 1.2 A page of Arabic text, MS No. 6, "Succession des rois 'Markas' de Djenné avant la conquête Songhoy," Missions de Gironcourt en Afrique, 1908–1909, 1911–1912.

geographer Herodotus. From his Cyrenean perspective, however, it is likely that references to Meröe and the Upper Nile are more reliable; there is only supposition regarding the extent of his familiarity with or direct observation of other regions of Africa. The "cave-dwelling" Garamantes in the region of the Fezzan, Libya, to which he refers, or the Ethopian troglodytes and mountain-dwelling savages referred to by Hammo, another classical scholar, may very well reflect the elaboration into pseudo-mythology of an as yet little-known region of the Upper Nile Valley.

The first reliable references to housing beyond the limits of the familiar *patriae* appear in the Roman records. As a result of their imperial expansion across the Mediterranean and beyond the North African coastline, the Roman knowledge was derived from intimacy and interaction with the African milieu. For the first time, firsthand knowledge was available. The earliest of these records are embodied in the second century B.C. Roman mosaics that adorned the walls and floors of North African houses and sepulchres.[16] In these mosaics, along with the representation of the more familiar arcaded and tile-roofed Roman villas, one finds *mapalia* or *nouala*, matframe tents. Variations of these tents, subsequently mentioned by Leo Africanus and Henry Barth, can be seen in North Africa to this day.[17] Interspersed with an abundance of verdant flora, indigenous fauna, and Roman chariots on the move, one can find

an occasional circular palisaded enclosure, its single opening guarded by a ceremonial urn or lamp.

Reportage on sub-Saharan Africa in the centuries following the decline of the Roman empire includes numerous Islamic accounts reflecting the expansion of the Muslim world through trans-Saharan traffic and trade (see Fig. 1.3).[18] While these accounts offer verbal description, obviously they cannot provide graphic evidence of either the architectural environment or the presence of Islam itself. One source within the African milieu that may, with care, yield information to fill this hiatus is the rich collection of frescoes and wall paintings from the Tassili region in the Sahara desert. Although authorship and datelines remain obscure, some of the subject matter suggests a period of execution postdating the introduction of the camel for trans-Saharan transport and the beginnings of sedentariza-

tion (Fig. 1.4). The rendering of various architectural elements also invites speculation. For example, the square enclosure with its triangular wall projections, the entry rug, and the person within with an ablutions kettle are evocative of the plan of an early Sudanese-style or Algerian Mzab-style tomb or mosque.

With the Age of Exploration and Discovery, Africa was once again ushered onto the stage of European concern. Fourteenth- and fifteenth-century European mapmakers were familiar with the existence of the Sahara and the Sudan, but few of their maps record geographic reality or detail. Islamic control of the Mediterranean littoral made direct European penetration well-nigh impossible, and firsthand information from across the Sahara was not readily available to the European world. The early accounts and reports which came through North African channels were gathered through

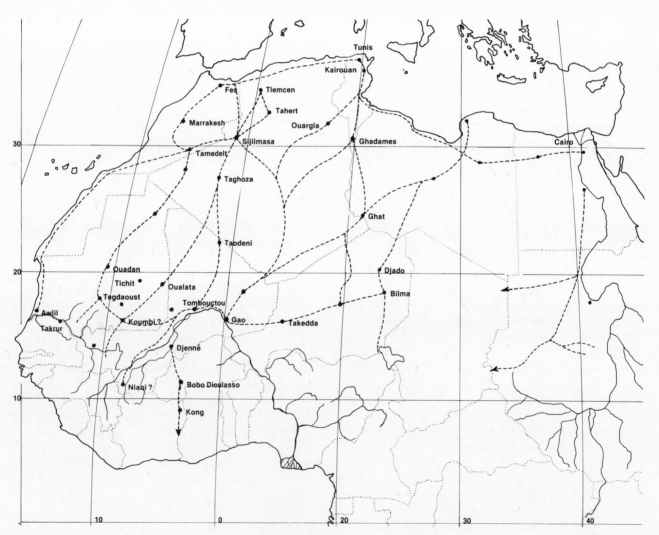

Fig. 1.3 The principal commercial axes across the Sahara desert between the eighth and the sixteenth century, and the avenues of Islamic penetration into the *bilad al-sudan*, or "land of the blacks." Drawing after Cuoq (1975).

Fig. 1.4 Two rock paintings from the Tassili n'Ajjer region at Ouan Bender, northeast of Djanet, near the Algeria-Niger border. It has been suggested that these date from the appearance of the camel and the beginnings of nomadic sedentarization, but it is also tempting to suggest that the square plan of the house itself, with its triangular projections, entry rug and ablutions kettle, might be a record of an early Sudanese-style mosque or an Algerian Mzab-style house or tomb. Drawings after Lajoux (1962).

the intermediary of European merchants and diplomats in contact with the Muslim world of trade.

Fifteenth- and sixteenth-century verbal and visual descriptions of the sub-Saharan African milieu reflected the international egalitarian relationships of those epochs: rendering of the physiognomy or the anatomy was merely a matter of descriptive accuracy. Just as the kings of Portugal and the Congo were considered *inter pares*, so Burgkmaier's rendition of *Gennea* (the generic term for the whole of Africa at that time) differs little from his rendering of other exotic peoples, or even from Dürer's *Adam and Eve* of 1504 (Fig. 1.5). Indeed, if one considers how medieval cartography included nonexistent, mythologic realms on its maps, then Africa, little better known than Terrestrial Paradise, the Garden of Eden, or Purgatory, could well be represented in the same vein as *Adam and Eve*. It is perhaps little wonder that the African continent, as distant from medieval man as the above-mentioned realms, would have been rendered with equal imagination.[19]

The major breakthrough came with the Portuguese exploration of the West African coastline toward the end of the fifteenth century, but their Conspiracy of Silence militated against rapid dissemination of knowledge about West Africa in the decades immediately following. Nevertheless, sixteenth-century Europe witnessed an impressive accumulation of firsthand knowledge. As a result of series of forays, footholds,

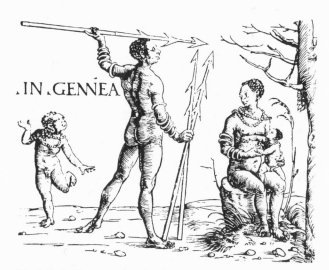

Fig. 1.5 In Gennea, one of a six-page woodcut series on "Exotic Tribes," by Hans Burgkmaier, 1508. A contemporary of Dürer and the founder of Renaissance painting in Augsberg, Burgkmaier produced the series of illustrations for a travelogue by Bertolomaus Springer, a voyager who had sailed to India on behalf of several merchant families of Augsburg and who, in the course of his travels, had also reached Africa. Kunst (1967).

and exploration of river outlets by various competing European representatives, remarkable detail had been acquired about the shoreline configuration and its occupants—as a map of Guineae Nova Descriptio in 1606 indicates (Fig. 1.6). The interior, however, remained a mystery. Thus, while the coastline was articulated in minute detail—testimony to the navigational skills and *portolano*, or sailing chart, orientation of the maritime observer—the inland, Islamized city-states of Gennea, Tombutu, and Gago were vaguely indicated with the symbol of a single monument. The maritime observers had been conditioned to a linear perception of reality by long periods of horizontal scanning. They had difficulty with three-dimensional representation and the laws of perspective.

Careful perusal of the sixteenth-century European literature about the West African coastline yields a rich harvest of references to Islamized Africans, to trade routes linking the coast to the interior, and to hearsay description of the famed inland cities.[20] It also yields much information on various behaviors and technologies which, when reconstructed in the context of vernacular traditions, sheds much light on the arts and architectures of the time. One is tempted to speculate on the possible impact this early presence of Islam on the coast had on the aesthetic heritage of its coastal residents.

Despite the rapid change from egality to slaving in seventeenth-century European-African interaction, Renaissance-style representation continued throughout the century. During this period, the number of European *commerçants* actively involved in exploration and exploitation of various aspects of the African trade—

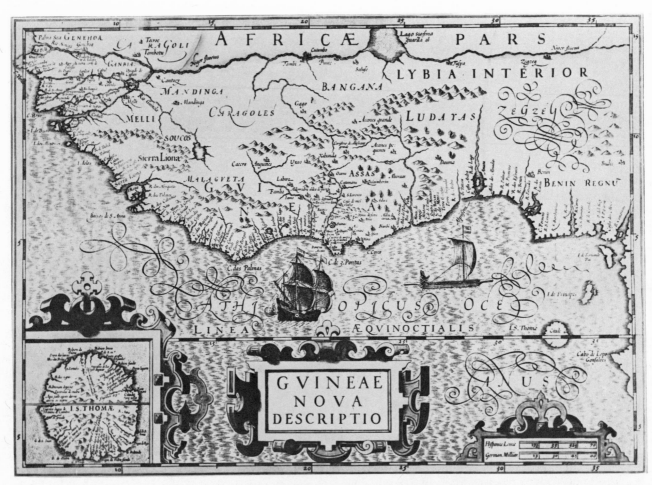

Fig. 1.6 "Guineae Nova Descriptio." Gennea, formerly a generic term for the entire African continent, had evolved into a specific (but nonexistent) place-name for a city-state north of the Sénégal River. In this map, Genehoa is shown as a city on the Rio Senega (Sénégal River), Tombutu (Tombouctou) is shown due east in the region of Caragoli (Sarakolle) at a point where the Rio Senega meets the Niger Fluvius (Niger River), and Gago (Gao) is located much further east, closer to Segzeg (Zaria). Jodocus Hondius' *Mercator's Atlas*, 1606.

not the least of which was slaving—grew rapidly. Unlike their Portuguese predecessors, many came ashore and pushed up the rivers in efforts to establish contact with inland peoples. One such explorer was Jannequin, whose 1643 rendering of a village at the mouth of the Sénégal River, with its reasonably accurate representation of the conical thatch-roofed structures, has become a prototypical image of West African savannah architecture (Fig. 1.7).[21] Two other explorers were the late-seventeenth-century Dutch traders Dapper and Müller.[22] Dapper's view of the city of Benin, so frequently reproduced in volumes on African art and history, is matched by Müller's precise and accurate description of art, architecture, and technologies on the former Gold Coast. A half-century later, more explicit illustrations appeared in the French accounts of the Canary Islands, Cape Verde, Senegal, and the Gambia by Le Maire and Froger (Fig. 1.8).[23] The detail in Le Maire's rendering of semi-nomadic Fulbe matframe tents and Froger's of building palisades are as revealing as their descriptions of the masking traditions that accompanied circumcision rites.

These early illustrations and descriptions mark the onset of another increasingly frequent problem in both the written and visual sources: literary theft. It has been suggested that Dapper's plates had been taken from an account published in 1648, and the illustrations in the oft-cited account of Godefrey Loyer are directly borrowed or slightly modified copies of the earlier Le Maire drawings.[24] What might be excused on the basis of inadequate printing facilities at the turn of the eighteenth century flowered into outright plagiarism—or, more graciously, "economy"—in the nineteenth. A classic example is the rendering of Niantanso,

Fig. 1.8 *Les Maisons des Negres* and *Comment sont faits les lits des Negres.* Although the caption calls attention to "beds," the tendency is to focus on the structure as a whole in the drawing, and the Western viewer loses the critical focal point of the drawing. Le Maire (1695).

Fig. 1.7 *Bourgade de Neigre.* Jannequin (1643).

Mali, which first appeared in an account by Lieutenant Mage of his voyage in the western Sudan between 1863 and 1866 (Fig. 1.9). The identical plate, itself reminiscent of Jannequin's drawing (Fig. 1.7), was used subsequently by on-the-scene observers to illustrate both a Mahi village in northern Dahomey and the Wolof village of Oualija in Senegal.[25]

An even more blatant example of plagiarism in the mass media, albeit justified by environmental similarity, comes from the work of Jules Verne. Henry Barth, the unsurpassed German explorer of sub-Saharan Africa in the mid-nineteenth century, spent much

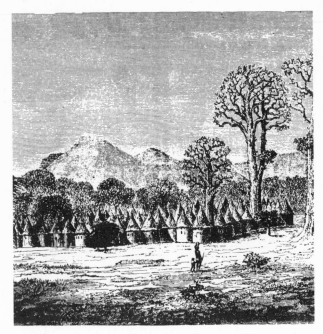

Fig. 1.9 The village of Niantanso. Mage (1868b).

identical. Illustrations accompanying accounts of the coastal, rainforest peoples were reused with equal lack of discrimination.[28]

The contrast between the West African rainforest and the savannah-sahel environments was clearly reflected in the Western world's nineteenth-century perception of its newly acquired colonial holdings. One has only to compare an image of the Niger River from Verne's *Cinq semaines en ballon* with an image of the coastal forest of Konkronsou by the same artist. The soft, serene flow of the river, with its horizontal lines, gentle breezes, and plodding camels, all rendered lightly in subtle line and tone, conveys a sense of "civilization." The somber heaviness and dense, confused foliage of the rainforest, replete with snakes and monkeys, evoke a sense of depression, savagery, and jungle wilderness (Fig. 1.11a, b).[29] The popularization of nineteenth-century visual and verbal imagery flourished on the twin foundation stones of selective plagiarism and perceived environmental differentiation.

time at Kano, Nigeria.[26] A skilled delineator, he included a meticulous drawing in his published, three-volume masterpiece (Fig. 1.10a). Several years later, the first of Jules Verne's sixty Voyages Extraordinaires, *Cinq semaines en ballon*, appeared.[27] The book, which drew heavily on materials from Barth as well as from René Caillié, another French explorer, included a rendering of the balloon passage over Kouka at Lake Chad (Fig. 1.10b). This latter drawing is no more than a slightly modified reverse of the original Barth drawing—despite the fact that Kouka and Kano are some distance from each other and sit in quite different cultural environments. Although serialized in several newly established geographic journals of the time, Barth's account reached a limited audience. Verne's popularized romance, however, reached a vast audience, both juvenile and adult. Popular literature became a vehicle through which environmental imagery was transmitted to the entire Western world.

Environmental imagery reflected another ideological development in European thought, that of environmental determinism. The eighteenth-century commitment to environmentally induced modification, derivative of Locke's doctrine that different experiences produce different products, found fertile soil in the European obsession with geographical exploration. Hence, although locales may have been markedly distant from each other, visual reportage reflected the concept that since all were located in a similar environment, i.e., the savannah, the building product would be

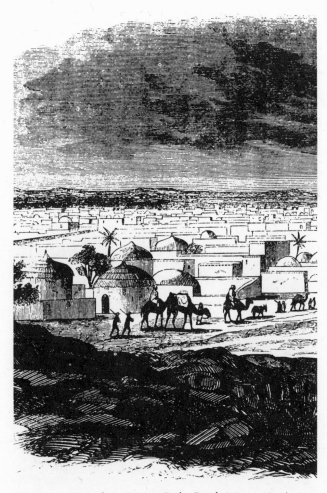

Fig. 1.10a Kano from Mount Dala. Barth (1857–1859), vol. I.

Parallel to the early development of environmentalism was another ideological concept, that of the "noble savage." The environmental contrasts noted above were projected onto the human physiognomy of inhabitants residing in the various environmental belts of West Africa, and the "levels of civilization" stressed by anthropological writings of this period were used to categorize the pagan peoples of the rain forest and the seemingly Islamized peoples of the savannah belt.

William Gray, an English visitor to the rain forest and the savannah in the early nineteenth century, expressed this dichotomy in several ways. The plates accompanying his account vividly illustrate the associations made in the European mind among Islam, civilization, and the savannah, on the one hand, and paganism, primitivism, and the rain forest, on the other. On the first leg of his journey Gray traveled inland along Río Nuñez on the Guinea coast, and despite his delicate, almost calico-like rendition of decorative wall patterns, the thatched roofing and rough posts

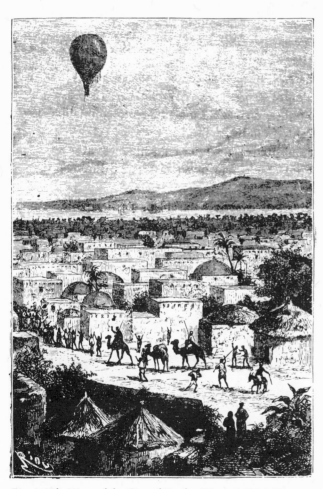

Fig. 1.10b View of the City of Kouka. Verne (1863). Drawing by Riou.

were clearly a record of crude construction (Fig. 1.12a). On the second leg of his journey he traveled up the Sénégal River to Galem, then the site of a French trading post and fort. The drawing of the mosque at Dramanet Galem, with its tapering pinnacles, triangular niches, and ostrich-egg finials (perhaps the first published rendition of a Sudanese Dyula mosque) suggests a more sophisticated technology and the quality of a European parish church (Fig. 1.12b). The renditions of the Muslims seated under the assembly or *bentang* tree and of the pagan resident on Río Nuñez match the environments behind each. The comparison is made more explicit in a second set of drawings which illustrate, side by side, the dancer-participant in the non-Islamic *Kongcorong* masquerade and the "young prince about to undergo the Muslim rite of circumcision" (Fig. 1.13a, b).

The impression conveyed by the French traveler Mollien, a contemporaneous observer of the same setting, argues even more cogently for the distinctions being made between the sophisticated Muslim milieu in the upper savannah reaches and the hostile forest interior (Fig. 1.14a). Diai Boukari, a native Futa marabout from Senegal who was Mollien's interpreter and traveling companion, "was a negro in colour only, for his features resembled those of a white man."[30]

Much of the reportage in these first decades of the nineteenth century reflects France's active involvement in the Senegalese savannah and Britain's penetration of West Africa via the Guinea coastal rain forest. Contrastive environmental experiences further intensified the interpretive lens. Ambiguity and ambivalence in reconciling environmental determinism with concepts of noble savagery are clearly apparent, for example, in Dalzel's account of coastal Dahomey (Republic of Benin).[31] Dahomeyan aristocracy is rendered with savage nobility, whereas the architectural backdrop is represented crudely and primitively. Elegant, flamboyant tents and parasols, and ladies lavishly dressed in flowing robes and feathered coiffures recall the richness of the Eastern potentate's harem. But they appear alongside a text that stresses the cannibalism of the Dahomeyan court and the savagery of its politics.

This ambivalence also tended to obscure the presence of Islam on the coast. Thus, while Bowdich and Dupuis, two English visitors to the Gold Coast (Ghana) during this period, documented the presence of Islam at the court of the Asante kings in Kumasi, the visual images that accompanied their verbal accounts were demeaning caricatures of the innumerable Islamic components in the panoply of Asante culture (Fig. 1.14b).

The Aristotelian stance of Mollien's interpreter was a harbinger of the French exoticism that was to flourish in the decades to follow. The European canvas

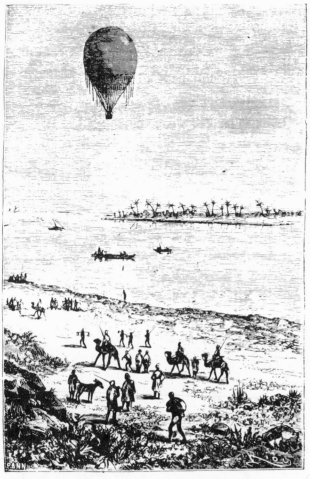

Fig. 1.11a The Niger. Verne (1863). Drawing by Riou.

Fig. 1.11b The forest of Konkronsou, Guinea. Binger (1892), vol. II. Drawing by Riou.

Fig. 1.12a A native hut at Tallabunchia. Gray (1825).

Fig. 1.12b Mosque and place of assembly at Dramanet Galem on the Sénégal River. Dramanet was east of Fort St. Joseph, midway between Bakel and Kayes, in the upper savannah region. Gray (1825).

Fig. 1.13a The *Kongcorong* masquerade recorded in 1820 in eastern Senegal. The costume is reminiscent of an earlier one in Froger's account and also recalls a description of a similar dancing masquerade at the court of Mali in 1374 in Ibn Battūta's account. Gray (1825).

Fig. 1.13b A "young prince about to undergo the Muslim rite of circumcision" at Sanjarra, eastern Senegal. Aside from the obvious contrast between the two drawings, they highlight, in perhaps the sharpest profile, the unique quality of African Islam as an interface between traditional and Islamic ritual. Gray (1825).

of nineteenth-century Africa can hardly be understood without consideration of this French ethos. French colonialism was heavily colored by the writings and artwork of Hugo, Dumas, Delacroix, and Fromentin, noted men of letters and the arts who translated reality into fantasy.[32] The French disenchantment with New World holdings after the loss of Haiti was rapidly forgotten in a new involvement with Islamic North Africa. The less "civilized" Black of West Africa, when clothed in Islamic garb, was now viewed through the North African perspective. Delacroix's *Femmes d'Alger dans leur appartement*, exhibited at the Paris Salon of 1834, differed little in spirit from either Mollien's earlier Boukari or the later line drawings of the languorous Senegalese ladies of St. Louis.

The nineteenth century was not only an age of colonial expansion and environmentalist theory, it was also an age of geographic and technological discovery.[33] Newly founded Geographical Societies sponsored explorations of lands and holdings hitherto known only by hearsay in the Western world, but travel by "infidels" into the inhospitable interior was hazardous.[34] Mungo Park's death on the Niger River has been attributed to the hostility of Islamized tribes, and René Caillié was able to realize his obsession—reaching the fabled city of Tombouctou—only in the guise of a Muslim. His sensitive watercolor rendering of the cityscape, still an invaluable architectural document, had to be made surreptitiously (Fig. 1.15).

The proliferation of geographical and technological journals of exploration and invention peaked by mid-century; their pages abounded in accounts of exploration into the West African interior and its Muslim strongholds.[35] The voluminous account of Henry Barth, still one of the best known and most accurate resources for West African life and politics during this era, was originally published in England in 1854, first by Petermann and then by Longmans, Green. Soon after, two different editions as well as several abridged versions appeared in the United States. Subsequently

Fig. 1.14a Portrait of Diai-Boukari. Mollien (1820a).

Fig. 1.14b A Dagomba *caboceer* at the court of the Asante-hene. Bowdich (1819).

translated into French, Dutch and German, it reached a yet wider international audience.

This European obsession with geography and technology also guaranteed the popularity of Jules Verne's works of marvel and adventure. *Cinq semaines en ballon*, first published in 1864, was not merely the first of his tales of adventure, it was his passport to fame, fortune, and the production of some fifty-nine subsequent Voyages Extraordinaires.[36] This first volume, which drew on the firsthand accounts of Caillié and Barth for its West African setting, also catapulted the career of its illustrator, Edouard Riou, from that of mediocre painter to the most prolific delineator of France's new West African empire. He illustrated a number of the Verne novels and, in time, much of the most important reportage and documentation of the French military effort.[37] As illustrator for the oft-serialized, much-publicized accounts of a host of French military diplomat-explorers who wove a network of routes, forts, and treaties across the savannah and sahel during the late nineteenth century, he was instrumental in shaping France's image of her colonial self and her colonies.

French concern with securing the upper reaches of the savannah through the Senegalese gateway generated a profusion of forts and a preoccupation with indigenous building technologies by a military cadre schooled in the rationalist teachings of the Ecole Polytechnique, the School of Military Engineering, and the School of Bridges and Roads.[38] Securing "place" required extensive cartography. The French military rotational system, which assigned and familiarized officers with stations in similar environments, also encouraged a perception of North and West Africa as a unity. Military conquerors-*cum*-explorers such as Mage, Gallieni, and Binger were caught up in the politics of negotiation as they moved through the territories of Islam, both North and West. Thus, Lt. Mage could faithfully render the house of the daughter of the last king of Ségou at Yamina, Mali, with its Arabic script at the base of the buttressing; Lt. Gallieni could record the French reception at the Fougoumba mosque in Guinea; and Le capitaine Binger found at least five mosques in the city of Kong, northern Ivory Coast, as he pursued the Manding Muslim resistance leader Samori (Fig. 1.16a, b, c).

The conquest of the Western Sudan at the turn of this century brought onto the scene reporters and artists serving the interests of the mass media, just as the earlier nineteenth century had prescribed the presence of men of letters in fledgling embassies and missions to North Africa. Thus, immediately following upon the conquest of Tombouctou in 1895, *Le Figaro* sent Félix Dubois, a seasoned reporter, into the field. His account of Djenné and Tombouctou, appearing first in serial form at the crest of the tidal wave of French colonial expansion, optimism, and hope, was more influential than any other single publication in publicizing the Islamic presence in West Africa. *Tombouctou la Mystèrieuse* became a best-seller overnight. Combining an account of the cities' archeology, architecture, and scholarly repute with the penultimate in French exoticism, it inspired Zola to portray the Upper Niger Delta (where Djenné is located) as the future breadbasket of France.[39] The prevalence of French accounts during this period—indeed, the entire ethos of exoticism, of environmentalism, of France's intense commitment to and concern with Muslim Africa—is eloquently summarized by the geographic boundaries of her African holdings in 1899 (Fig. 1.17).

One of the most fascinating subjects in the architectural history of the Western world is the periodic sponsorship of world's fairs and expositions. Expositions, it has been suggested, were (and are) catalysts of taste and style. They are also competitive, public displays of national self-image. As a presentation of national self, they reveal aspirations as well as reality. The image France presented in the various world's fairs of

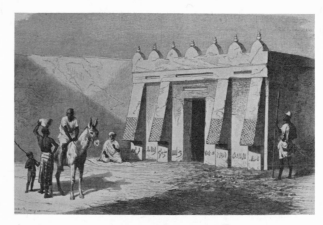

Fig. 1.16a House of the daughter of the last king of Ségou, at Yamina, Mali. Mage (1868a).

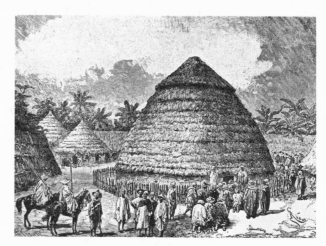

Fig. 1.16b The French reception at Fougoumba, Guinea, 1888. Gallieni (1891). Drawing by Riou.

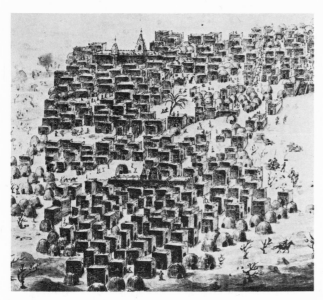

Fig. 1.15 View of part of the city of Tombouctou (1828). Original sketch by René Caillié.

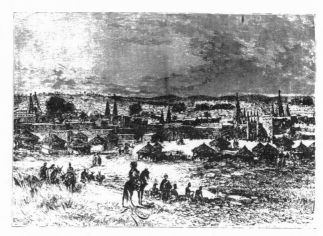

Fig. 1.16c View of Kong, Ivory Coast. Binger (1892), vol. 1. Drawing by Riou.

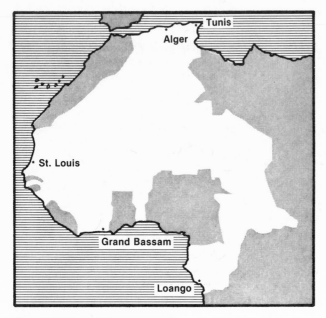

Fig. 1.17 Map of the extent of France's African holdings in 1899. Drawing after Hulot (1900).

this period mirrored her increasing preoccupation with colonial expansion in general and the Islamic content of her African holdings in particular (Fig. 1.18). In contrast to the paucity of her West African display at the Exposition Universelle in 1855, the Centennial Exposition Universelle of 1889 marked France's full emergence as an imperial world power. Included as part of its Exposition Coloniale were a Senegalese village and the house of a Muhamedan from the French Soudan, for contrast with "some huts of the savages of Africa."[40]

By 1900, France possessed more land on the African continent than did any other colonial power, and the largest component of the 1900 Exposition Universelle in Paris was its Exposition Coloniale. Situated in a most prominent position within it was the Sénégal-Soudan Pavilion, and behind, among others, sat the Dahomey Pavilion (Fig. 1.19a, b).

The inspiration for the design of the Sénégal-Soudan Pavilion, wrote the chief architect, was the architecture of Djenné and Tombouctou. The documents he referred to were those brought back by Félix Dubois and others in the course of the preceding decade, and it was claimed that the pavilion was truly original and had no predecessor in any previous Exposition. Thus, France herself perpetuated and to some extent transformed the imagery of Islamic architecture in West Africa.

The graphic reflection of the conceptual dichotomy between Black Equatorial Africa and White Mus-

lim Africa, suggested above, is even more striking when the Sénégal-Soudan Pavilion is compared with the adjacent Dahomey Pavilion. The regularity, balance, and bilateral symmetry of the former stands in stark opposition to the serpent-enveloped pillars, the crudely fashioned balustrade of gnarled timbers, and the thatched roof of the latter, all of which perpetuate the image of "primitive savagery" portrayed decades before by Dalzel and Richard Burton.

The French imagery stressing the Islamic character of her African empire gradually evolved into an architectural symbol in later expositions. The colonial *tata* or citadel of French West Africa at the Marseille Colonial Exposition of 1922, by combining the minaret of the Djingueré Ber mosque at Tombouctou with the traditional Muslim facade of a house at Djenné, Mali, established an architectural prototype for France's entire West African empire. The image, enhanced by the physical presence of *les indigènes soudanaises*, recurred again and again in subsequent expositions (Fig. 1.20).

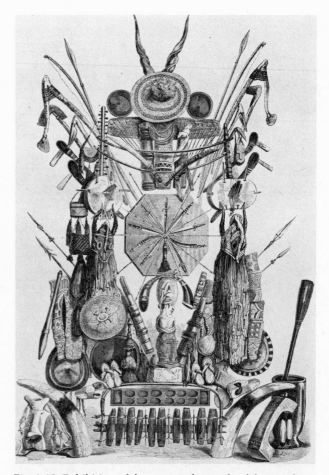

Fig. 1.18 Exhibition of the arms and utensils of the peoples of Senegal, Exposition Universelle, Paris, 1855. "Voyages et expéditions au Sénégal," *Tour du Monde* 3, 1 (1861), p. 27.

The development of divergent schools of anthropological theory and methodology at the turn of this century introduced yet another set of interpretive problems for research into Islamic art and architecture. Ethnographic reportage followed the political boundaries of colonial holdings, and data interpretation reflected colonial interests and policies. The German tendency to generalize across space produced diffusionist theories, the concept of *Kulturkreise*, and a geographic determinism which organized "house form" and "settlement pattern" into an invariant set of typologies using a jargon made up of terms from geometry.[41] At the same time, German precision and order laid the foundation for superb documentation of material culture, unmatched to this day.

Out of the English-speaking tradition of indirect rule came social anthropology that focused on social structure and organization, and the ecologically oriented theory that environmental patterns are determinants of adaptation. Neither, with few exceptions, recorded material conditions other than as tangential to

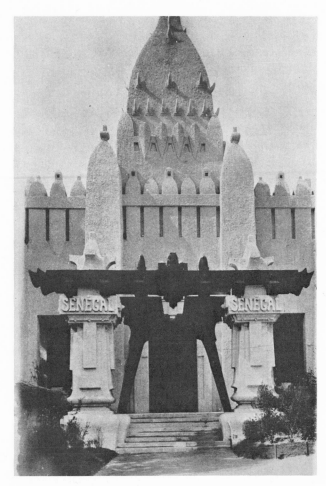

Fig. 1.19a West view of the Pavilion of Sénégal-Soudan, Exposition Universelle, Paris, 1900. *Le Pavillon du Sénégal-Soudan à l'Exposition Universelle de 1900* (1901).

Fig. 1.19b Pavilion of Dahomey at the Exposition Universelle, Paris, 1900. *Paris Exposition Reproduced* (1900).

Fig. 1.20 Le 'tata' colonial de l'A.O.F., Marseille, 1922. *L'Illustration* 160, 21 October 1922, p. 388.

their major concern—administration through Native Authority. Out of the French-speaking tradition of Durkheim, Mauss, and direct rule came a structural anthropology that ignored, in the main, the concrete factors of physical, social, and technological environments in favor of the search for cosmologic, philosophic structures underlying society. It is thus no coincidence that the French literature pays far more attention to the presence of Islam than does the English research literature.

One has only to read the literature to realize that French and English anthropologists, talking about the same people, viewed them from quite different conceptual frameworks.[42] British anthropologists sought to establish interconnections in social relations; their French colleagues endeavored to discover links among indigenous belief systems, concepts, and myths. While neither, unlike the German tradition, provided much material, measurable data on the built environment, both provided a pregnant point of departure for examining the nature of the architectural realm in Islamized West Africa. In some ways, differences in emphasis among the three European traditions match the three components we have chosen to analyze in the built environment: the physical, the behavioral, and the conceptual. Architecture both reflects and affects society; hence the literature on all aspects of society becomes relevant to understanding. When viewed in the appropriate context, it can be a revelation.

Architectural Historiography

The ideologies that molded reportage on Africa over the centuries had their counterparts in the changing tenets and canons of architectural history. Reasons for the studied denial of both—and, by extension, their Islamic expression in Africa—emerge in the context of changing architectural theories. Early attempts to define the workings of society by means of a biological model were paralleled by use of the laws of nature as aesthetic criteria. In time, functional expression came to be seen as a principal criterion of good architectural design. Early environmental models provided the underpinnings for a rationale which saw the measure of beauty in optimum use of the materials of construction.[43] The evolution of technology became a foundation stone for yet other criteria: structural honesty, lightness of structure, fitness of purpose. Functionalism itself rests on the evolutionary model of technological advance and achievement. Hence, the classic Vitruvian model used by the Western world was reinterpreted into a canonical set in which permanence, monumentality, the technological ability to enclose space, and

singular authorship endowed with "intuitive artistic judgment" emerged as the governing criteria for the existence of "architecture." As perceived by the Western mind, none of these were applicable to the West African scene.

Architectural permanence in turn became synonymous with establishment of place. As a consequence, transience and mobility implied non-architecture, and transient structures were barred from the respectable typological plateau that the world of architecture had built for itself. Since temporariness is the antonym of permanence, it too was associated with transience. Nomadic structures, despite the fact that their lifespan is often much longer than that of middle-income suburban tract housing today, are still only reluctantly and recently admitted to architectural membership. Buildings constructed of permeable materials were barred, despite the fact that they have been used, in many cultures, on a scale comparable to many spectacular technological creations in the Western world.

Material permanence became for architectural history what the written word had become for world history at large. The written and the archeological record was the tool-of-the-trade for the architectural historian. Courses in architectural history were, and still are, divided by subject matter into a chronology which began with, and has ultimately become bounded by, the written record.[44] Thus, pre-literate, non-literate, and non-Western societies were until recently not considered respectable citizens on the plateau of civilization built by Western thought. By the same rationale, we continue to think and teach in terms of "key monuments" as physical indicators measuring a level of civilization. Permanence and monumentality become synonymous in the mind of society with public, civil architecture. Public architecture embodied the collective as a symbolic statement of society-at-large, whereas housing was until recently an inconsequential subject, relegated to the realm of the popular or the vernacular. The idea that a house could also be a symbol of both society and self is of recent vintage.

Another architectural principle that emerged out of nineteenth- and twentieth-century pragmatic thought was functionalism. Aesthetic judgment rested on the success with which a *built structure* could accommodate man's behavior in space and provide for his physical comforts. Improvements in function implied improvements in building technology, in building materials, and in those facilities which catered to basic physical human needs. By extension, technological achievement became synonymous with improved function and spatial *enclosure*. It is this logic that led us to seek the origins of architecture in shelter and the conceptualization of internal space.[45]

Increasing specialization of skills, with its concomitant intellectualizing of the arts over these last centuries, created a discrete discipline characterized by an obsessive concern with authorship. The initial negative reaction by architects to an exhibition of architecture without architects reflected this need for Ego-identity. Western technology and individuality, the foundations on which contemporary architecture had come to rest, had been brought into question. Not only did the subject matter of the exhibition disturb the individualism that has come to dominate the Western world, but it implied that collective creativity and a less-than-quintessential use of technology per se constituted valid contributions to the architectural scene. It also threatened what had come to be a tacit, somewhat arrogant assumption that the business of architecture could only be carried on by an elite in possession of special intuitive or culturally acquired qualifications. In a most unceremonious manner, the exhibition also introduced collective and subconscious aspects of the creative act into a realm of thought which had heretofore assigned proprietary rights solely to the intellectual role of the individual in history.

The Western aesthetic tends to categorize artifacts into art and craft, and arts in the Western world have come to be traditionally divided into the fine versus the decorative or "applied" arts. This distinction is reflected in the differentiation between architecture and building, and just as the evolutionary origins of ethnographic arts were sought in their original functional purpose, so the origins of architecture came to be sought in the built shelter. Herbert Read, in his discussion of the origin of form in architecture, suggests an "obvious proposition": that architecture had its origin as an artificial shelter from the elements, and that "primitive architecture can be explained wholly by means of . . . material factors." "Architecture," he continues, "if it is to escape from the primitive, the childish, the archaic, must be inspired by considerations that are intellectual, abstract, spiritual—considerations that modify the strict requirements of utility." For his model of the transformation from shelter to architecture, for the "refinement of a utilitarian structure into a symbol for spiritual values," he used the Greek temple. Read, in counterposing the utilitarian and the spiritual, was merely voicing what had been espoused by almost every aesthetician before him; the danger lay in coupling his model with an evolutionary paradigm that credited the African with minimal intellect. Logically, then, there could be no African architecture—only African shelter.

The categorization into fine and decorative arts led to the further divisions into which the Western world has carved its fine arts: sculpture, drawing, painting, architecture. As a consequence, when the arts of

Africa began to attract attention at the turn of the century and increasing numbers of artifacts and "curios," pilfered and pillaged over the decades of colonial expansion, made their appearance in European museums and bistros, they were divided into this same tetrad. However, since by Western definition drawing and painting were negligible and since by Western criteria architecture was inadmissible, African sculpture received singular recognition. Western preoccupation with African sculpture in turn encouraged a negative approach to the role of Islam in West Africa. Islam, with its supposed proscription against human representation and the graven image, was held responsible for destruction of traditions of African sculpture.

Even if the existence of African architecture had been admitted, elements composed primarily of vegetal and earthen materials were difficult to remove and transport. Since wooden, metal, and terra cotta elements were portable, however, carved wooden columns, metal and wooden plaques, decorative roof finials, doors, doorposts, door frames, lintels, locks, metal and terra cotta furnishings were removed from their contextual surroundings and reclassified into a Western sculptural category. Even the so-called ethnographic arts were subject to a reordering that matched the prevailing Western *Gestalt* of form: symmetry and balance. Not only was African architecture deprived of its meaningful elements but, even more importantly, the elements were perceived completely outside their structural or spatial context. Western predilections, by removing these components to another category, inhibited any conception of the critical role they played in African architectural definition. Our interpretations of the intellectual and iconographic components of African architectural definition were thereby distorted.[46] Thus, since no permanence, monumentality, authorship, materials of construction, building technologies, spatial articulation, or enclosure was visible to the Western eye, the intellectual perspective we had inherited forced us to deny the existence of an African architecture.

The same prevalent theories of Western aesthetics that thwarted any true understanding of the African materials have also kept us from formulating a paradigm that could provide insights into the corpus of non-Western architectural phenomena. The problems inherent in any analysis of non-Western architecture can only be solved by developing an entirely new intellectual perspective by which to view the basic elements on which architectural definition rests.

Recently, the architectural world—and, for that matter, the world at large—faced with the almost insurmountable task of explaining its own existence in an increasingly complex and specialized society, has begun

to reflect on the broader theoretical frame of the man-built environment. In order to insure its continued existence and to justify its definition as a discipline, architecture has extended its parameters to include the total spectrum of man's relationship to his built environment. In so doing it forced a revaluation of prevalent theories and aroused a new and urgent interest in fundamental principles. Until now, we had continued to adhere to the tenet that the starting point of architecture is man's control *over* his environment because, as Edmund Leach has suggested, "our thinking is the product of a culture alienated from nature."[47] To establish an all-inclusive paradigm for the totality of the man-built environment, one must begin prior to the point at which alienation begins, accepting a continuum extending from the situation in which culture is integral with nature, i.e., its environment, through its gradual process of separation via mediation and conciliation into a situation in which a culture ultimately becomes capable of re-creating an environment. To do so, the concept of space rather than shelter offers the most germane all-encompassing, non-restrictive point of departure. Man can neither exist without space nor escape his relationship to it. All human existence, whether considered concretely or conceptually, has a conscious or subconscious spatial referent. Spatial disorientation is a measure of both psychotic and physiologic disorder.

The use of a spatial construct for architectural definition and judgment is, of course, not new. It has been cogently argued by Bruno Zevi and by Siegfried Gideon. Zevi suggests that architecture is composed of the void itself, the enclosed space in which man lives and moves, and that internal space is the protagonist of architecture. Gideon, on the other hand, suggests that internal space was merely a nineteenth-century stage in the development of architectural space conception, and that it is the interplay between interior and exterior space which is currently critical: volumes in space in combination with interior space. Both scholars use the *built form* as their starting point for analysis. Rather than begin with built space, it might prove more fruitful to begin with spatial awareness as manifested on the landscape.

It has been suggested that when history is not related to a stable system of places it becomes meaningless.[48] While it is true that the West assumes stability to be a function of immobile, built structures, key monuments in the image of the city, stability can exist equally well in the untampered-with environment; the image of the city or the built environment may have parallel images in the landscape. What is essential perhaps is not stability but the sense of place, real or imagined. It has been suggested that "an environment without place

names is fearful. The naming of particular places is an essential part of territoriality."[49] Where space is, or was, an unknown, the fertile imagination of man was called upon to render an image of it within the frame of his own mythos, as he did for paradise, purgatory, Africa, and the moon. It is a truism that existence can only be conceived within the frame of space and place.

Returning to a set of spatial referents also permits us to formulate a methodology for architectural history that concerns itself not with chronological but with processual time. Lévi-Strauss defined the characteristic feature of the savage mind as "its timelessness; its object is to grasp the world as both a synchronic and a diachronic totality."[50] Nevertheless, things do change over time, albeit very slowly for the Islamized African societies which concern us here. The approximation to timelessness apparently derives from the absence of conflict between an individual and his society—hence a minimal alienation, separation, or distance. While it appears unlikely that architectural history conforming to a Western paradigm will ever be written for Africa, the spatial frame may itself provide a time frame within which to trace temporal change, since there is some indication that time can be subsumed within space or that space is itself used as a notational device for time.[51] For example, it has been suggested that ritual is an important spatial component bridging the gap between behavior and emotion. Through its repetition over time, ritual provides a constancy that is essential to identity and emotion. Space itself, defined in man's mind by place, also has an invariant quality; constancy in the landscape can serve as a surrogate for ritual behavior in men's minds, since it offers many of the same properties of identity as ritual behavior provides.

The absence of conflict and alienation which may explain the approximation to timelessness accounts for the multivalent, multivocal quality of African arts. Once again, the man-environment space continuum provides a model which may mirror the nature of the African aesthetic dynamic more accurately than do the current Western typologies which rest on discrete categories. If, as has been suggested in another context, "art is essentially one, the symbolic function is the same in every kind of artistic expression . . . and their logic is all of a piece,"[52] then the iconographic and iconologic aspects of art will become manifest in a continuum extending from man himself to his total environment. This spatial continuum accommodates and parallels the extension from self-awareness to the entire culturally constituted behavioral environment referred to by Irving Hallowell.

Our point of departure for considering the African, the Islamic, and perhaps all non-Western architectures, then, ought to be not at the point when man

began to write or when he began to build, but when he either rationally or emotionally became conscious of his environment and set about articulating that awareness. The borrowed use of a cave, involving little if any technological skill, became an architectural act when man acknowledged his existence in it by taking it over, i.e., by painting upon its walls. That establishment of an identity with the cave marked his embarkation into architectural creativity. The act of identity in turn involved some degree of illusion, abstraction, or intellectualization. It is in this broader sense that Read's discussion of origin may be relevant, but perhaps Le Corbusier's concept that "architecture is the first manifestation of man creating his own universe"[53] is a more appropriate keynote for understanding Islam, art, and architecture in West Africa.

CHAPTER 2

The Physical Environment

THE LAND MASS of West Africa lies between the Equator and the Tropic of Cancer. If we were to visually project this area onto the American continents, it would overlap a surface extending from Yucatán, Mexico, in the north to the mouth of the Amazon River in the south, from Baja California in the west to the Panama Canal in the east. Within its range of latitude and longitude, a series of parallel, horizontal environmental belts merge imperceptibly into one another, providing maximum expression for a set of hot and humid tropical conditions yet offering a broad range of sharp geographic contrasts. A longitudinal axis following the Greenwich Meridian from Accra, Ghana, to Tombouctou, Mali, would carry us through an area of perpetually high temperatures strongly modified by varying conditions of humidity: rain forest on the coast, derived woodland savannah grading into grassland savannah, and semi-arid sahel ending in the Sahara Desert (Fig. 2.1).[1]

The history of West Africa in general and of West African Islam in particular is a rich and exciting account of human movement, of the displacement and succession of populations, their interfaces and interstices, but, as a noted African geographer has suggested, "Much of this history is understandable only when set against the character of the land."[2] In West Africa, the course of man's life has been conditioned, in great measure, by his environment. He has been far more subject to its dictates here than elsewhere. The techniques of production, which determine the measure of his control over the natural environment, have been less complex in Africa than those of the Western world; hence the physical environment has been more persistent and more pervasive in structuring economic development. Man has interacted on a more intimate level with the givens of his milieu; his ties to the earth have been more profound, so that he placated it and compromised with it as often as he controlled it. The intimacy that characterized man's relationship to his physical environment has been reflected in his behavioral and his conceptual environment, in his aesthetic and in his cosmogony, imbuing the West African cultural fabric with a unique quality. Architectural history in West Africa is the story of the subtle and intimate relationships among climate, vegetation, earth form, land content, and land use—relationships regulated and modified by human techniques and technologies. The arts and architecture of Islam in West Africa can, by extension, be recounted as a process of modification to this set of givens.

Building technologies, with their limited infrastructures, offer few alternatives in the choice of materials and in their exploitation in the building process. The limited specialization of building skills inhibits diversity of building responses. Few options exist beyond those directly conditioned by the natural properties of the building materials at hand, i.e., timber, vegetal fibers, earth, and stone. The traditional architectural image derives from a level of technology prior to the introduction of such modified natural or man-created materials as dressed stone or milled timber, plywoods

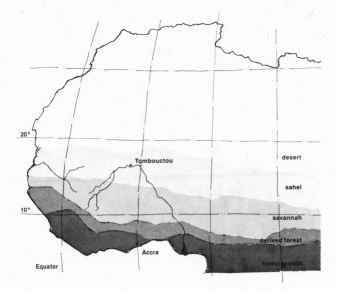

Fig. 2.1 Map of the zones of vegetation and the environmental belts in West Africa.

or plastics, cast iron or steel, polymers or super-alloys.[3] This distinction also proves to be a convenient, appropriate measure for establishing the parameters of "traditional" or vernacular architecture.

When technologies and their accompanying tool kits are minimal, micro-variation in the physical environment becomes especially critical in dictating the built form. Building techniques, details of construction, texture, color, scale, and volume are directly affected by even minimal variation in the available building materials. This is as true for soil content and composition as it is for vegetal resources, so marked variability in the built form may occur within the boundaries of a single cultural heritage that occupies several environmental niches.[4]

The climatic belts in West Africa are all tropical: there is ample heat and light to nourish plant and animal life. Agriculture, livestock herding, and plant growth (and, ultimately, building resources) are largely controlled not, as in the temperate zones, by temperature, but by the amount, the distribution, the reliability, and the effectiveness of rainfall.

Geologic and archeologic records reveal that the Sahara Desert was much wetter and more humid between 6000 and 3000 B.C., as a result of the ending of the Ice Age in Europe. Gradually, climatic changes crossed the threshold of conditions conducive to human occupation, and by the third millennium B.C. a comparatively small decrease in rainfall could effectively initiate the present ecological no-man's-land. The Mediterranean pine, cypress, and juniper gave way to acacia brush.[5]

This period of gradual desiccation was the setting for the protohistorical epochs of the Fulbe-speaking peoples, as the layers of Tassili rock-painting in southern Algeria testify. Hunting and pastoralism replaced incipient agriculture as a way of life, and major population migrations and redistributions were frequent. Agricultural economies at the northern edge of the desert collapsed, giving way to Berber and Arabic nomadic economies until, with the Roman introduction of the camel into the North African *limitanai* during the first centuries A.D., the potential for trans-Saharan communication and trade reemerged.

The desert effectively severed communication between West Africa and the Mediterranean world precisely when the latter was embarking on a course of nascent urbanization. The development pattern of sub-Saharan urbanization was thus in great measure dictated by Muslim-controlled trans-Saharan trade routes and economic interests. These in turn established the locations of medieval West African cities in the sahel and savannah regions.[6] Thus, the creation of the desert was of particular import in structuring West African history in general and the African character of Islam in particular.

Rainfall is largely determined by the seasonal migration of two air masses. As these air masses move across West Africa they modify temperature and conditions of light and moisture. The more widespread of the two air masses is the *harmattan*, which forms over the Sahara Desert. Dry, hot, and dust-laden, it moves southwest between December and February, extending maximally during January to the Guinea coast. The *harmattan* alternates seasonally with a highly contrasting maritime air mass, warm and humid, which forms over the southern Atlantic Ocean and moves inland progressively from January to July, bringing rain to large parts of the region. From July to December, the wet front retreats southward and the north becomes increasingly dry under the *harmattan* blowing in from the northeast. The well-known pattern of rainfall distribution is a direct result of these alternating movements. In the south, rain falls virtually throughout the year, although there is a tendency toward two wet seasons. As one moves north, the rain period concentrates into a single season and the dry season becomes increasingly severe. These seasonal variations, so critical to subsistence agricultural and pastoralist economies, play an equally important role in determining building materials, building processes, and building responses. The availability of water not only influences the quality and quantity of vegetal materials, but water is an essential ingredient in any building endeavor using earth.

The movement of these two air masses also contributes to differential conditions of diurnal tempera-

ture. There is little variation between day and night temperatures in the southern humid belts, but as one moves northward the differential increases, with drier, hot days alternating with increasingly colder nights. Normally, cloudless skies with bright sunshine and intense radiation contrast with clear, cold, starlit nights, so that even the range of shade temperatures may reach 60° F. The contrast doubles on surfaces exposed to the sun. These extremes of temperature are associated with clear atmospheres and dry air; relative humidity may drop to less than 10 percent. In the rain forest, on the contrary, there is little or no seasonal rhythm and no great extremes of diurnal temperature. The thermometer remains around 80° F., rarely rising above 90° F. on the hottest days and barely sinking below 70° F. on the coolest nights. The skies are often overcast. The keynote of the rain forest is a monotonous constancy of humid heat and rainfall. This pattern of contrast between the northern savannah reaches and the coastal regions is of critical import to physical comfort, since air movement is the most important factor in the evaporation of skin moisture—the physiological regulator of the human body.

The humid coastal rain forest with its negligible diurnal and seasonal climatic change calls for an enclosure that permits maximum cross-ventilation, so air can move easily across the skin surface. To achieve this, traditional structures opted for a maximum number of louvered or natural openings in the built form. Openwork screen-type walls were designed to encourage air circulation. Floors were raised on platforms high off the ground, to catch the cooler ocean breezes. Buildings were oriented to minimize air resistance on their surfaces.

In contrast, the inland savannah and sahel, with their extremes in diurnal and seasonal temperatures, call for alleviation of the cold, biting winds while providing respite from the intense radiation of the midday sun. The indigenous response to the problem was to build thick, curvilinear earthen walls whose insulating properties could accumulate and store the heat of the day for evening comfort. The curved circular forms themselves acted to concentrate thermal radiation within the enclosed spaces. The insulative quality of the building material mitigated the temperature differential. Window openings were shunned and ingress was reduced to the smallest possible dimension, in order to maximize the thermal properties of the earthen walls.

Climate determines growth, type, size, and quantity of vegetation. Hence, the zones of vegetation in West Africa follow the horizontal east-west climatic belts, varying from dense forest in the south through derived woodland and extensive grassland in the savan-

nah to barren desert in the north. These zones of vegetation have had a major influence on the structure of both West African social history and its architectural expression. With rare exceptions, the rainforest vegetation has inhibited dense human settlement, and much of the history of its present populations indicates traditions of migration from the north as a result of population growth and savannah development. The longitudinal spaciousness of the long, broad belt of savannah vegetation, on the other hand, has favored population movements. The diaspora of the two major language groups critical for the arts and architecture of Islam in West Africa—the Manding and the Fulbe—is within the savannah, and it is no accident that the medieval empires of West Africa came to full fruition in the savannah or that the highland plateaus of the Fouta-Djallon and Adamawa were the scene of viable Fulbe theocracies.

The coastal forest belt varies from a narrow strip of mangrove through a freshwater swamp forest growth to a lowland rain forest. This lowland forest growth extends inland for almost two hundred miles, from Sierra Leone in the west to the foothills of the Cameroon mountains in the east. The Accra corridor, where grassland conditions extend down to the coast, is the single notable break. This corridor figured prominently in the Islamization as well as the architectural development of the Asante, an Akan-speaking people in what is now Ghana. In their natural state, the tropical rain forests constitute a dense evergreen vegetation that retains humidity and by its density and canopy spread creates a very subdued light. Trees grow several hundred feet in height and develop an extremely broad girth, with frequent trunk buttressing. This buttressing, a natural structural response to shallow root networks, reduces the possibility of overturn from horizontal wind loads (Fig. 2.2a, b).

North of the rain forest lies the savannah. Including a derived woodland and a grassland, this belt is the largest in West Africa, covering almost three-quarters of its total surface. The savannah is the setting for the great concentration of Islamized peoples. Characteristically, the ground cover is grasses which vary in texture, abundance, and length. In the southern, derived woodland, they are higher, thicker, more abundant, and interspersed with clumps of broadleafed, short-lobed deciduous trees. Much of the savannah woodland has been heavily modified by cutting and burning the vegetation cover (Fig. 2.2c). As a consequence of decreasing rainfall in the northern savannah reaches, the grasses tend to be short and feathery, decreasing to less than five feet in height (Fig. 2.2d). Broadleafed trees gradually give way to shorter thorny trees with small,

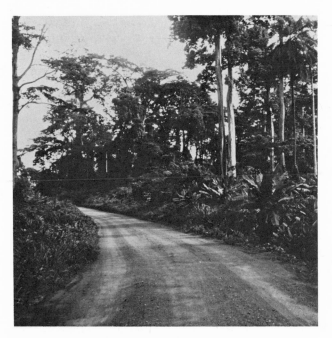

Fig. 2.2a Rainforest vegetation near Kumasi, Ghana.

Fig. 2.2b A stand of bamboo in eastern Guinea.

Fig. 2.2c Stunted tree growth in the derived woodland savannah as a result of bush burning, northern Ghana.

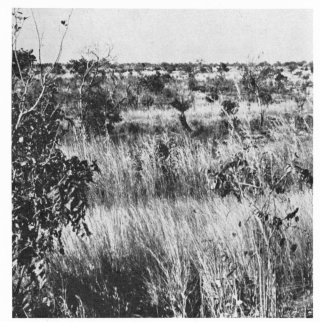

Fig. 2.2d Grassland savannah growth between Sikasso and Bamako, Mali.

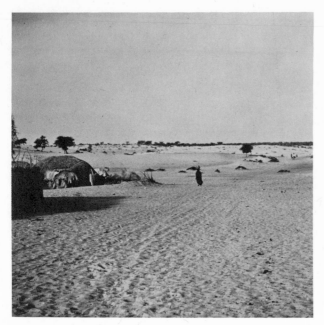

Fig. 2.2e The sahel at Tombouctou, Mali.

Fig. 2.3 A stand of dum palm in the Inland Niger Delta, Mali.

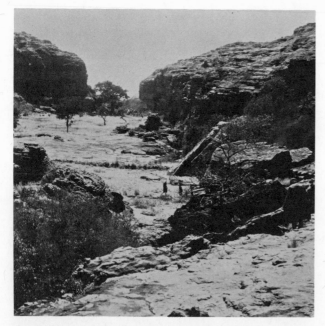

Fig. 2.4 Granitic outcroppings on the Bandiagara escarpment, Mali.

widely spaced leaves, then these in turn are replaced by scattered spiny shrubs and coarse wiry tufts of grass, affording a broad horizon.

As one approaches the desert the scanty vegetation disappears, leaving an open level pediplain broken here and there by occasional bare rock inselbergs, granitic and limestone plateaus, and a "pavement" of gravel, small stones, and shifting sand dunes, not unlike the northern desert boundaries (Fig. 2.2e). Vegetal growth can be sustained only through natural or man-made irrigation systems (Fig. 2.3).

There is little variation in soil structure and topography. The configuration of geologic features and the soil genesis do not coincide very closely with the belt-like distribution of climate and vegetation. Low elevation and broad, monotonous, level surfaces with barely discernible slopes dominate the landscape. This configuration of indiscernible contours is itself a contributing factor to the generally prevailing higher temperatures. The level plateaus are occasionally highlighted by isolated granitic outcroppings, elevated plateaus, highlands, and erosion scarps of huge weathered boulders that have eroded over time (Fig. 2.4). Thus, the Cameroon, Bamenda, and Adamawa range, the Jos Plateau, the Atakora range, the Bandiagara Escarpment, the Guinea Highlands, and the Fouta-Djallon range rise from four to six thousand feet above the plains. The much lower temperatures in these highland regions and their freedom from the debilitating tsetse

fly make them a more desirable living environment than the plains below. These highlands are the sources for the headwaters of major and minor drainage and waterway networks such as the Sénégal, the Gambia, the Volta, the Benue, and the Niger rivers. Over the millennia, the erosive action of these headwaters has contributed to the creation of the surface features of the wide, interior savannah plains into which they drain.

Unlike the topography, the broad pattern of soil surface content does in general follow the horizontal climatic belts.[7] The correspondence has been promoted by accelerated chemical reactions, weathering, erosion and leaching brought about by high soil temperatures. Much of the surface soil of West Africa is strewn with laterite, the end product of chemical decomposition of acid igneous rock which has been exposed as a result of soil erosion. Heavily laden with iron oxides, the laterite becomes a ferrugineous crust, ranging in color from reddish brown through red to reddish yellow. Upon exposure to air, the laterite hardens irreversibly; rock, rather than soil, forms. Inhibiting to the development of agricultural and pastoral economies, laterite and erosion equally limit the repertoire of building resources. Laterite does not mix easily with other soils or ancillary building materials, it is difficult to break down into a soil or a gravel, it has minimal malleability, and labor-intensive efforts are required to exploit it. This rock-like quality has tended to inhibit development of other innovative building technologies depending upon earth, because it lends itself so easily to masonry-like construction processes.

Along ancient water gulfs and erosion scarps in the upper reaches of the savannah, the pervasive lateritic soils are interspersed with configurations of sandstone, limestone, and shale. In their midst rise isolated granitic and volcanic outcroppings. The sandstones, forming a block of stony, sandy soils, predominate. Limestones, with their associated clays from which cement and agricultural limes are extracted, are rare and scarce in West Africa. Unlike laterite, sandstones tend to decompose easily under impact and to split under the onslaught of fluctuating temperatures in the northern savannah reaches. Along the coastline itself, and to a minimal extent in the Upper Niger delta, there are overlays of alluvial soils under a dense vegetal overgrowth. In the sahel the sandstones and laterites give way to a combination of gravel-like stony and sandy soils and extensive deposits of blown sand with no cohesive quality.

Every material has a specific set of structural properties which condition the creation of a built form—use of plaited grasses or fronds, wood, clay, or stone will influence the shape and volume created and will affect the formal qualities of proportion and symmetry. The two natural building resources par excellence that can be exploited within the limits of traditional technologies in West Africa are vegetal and earthen materials. These two primary resources have directly inverse structural properties. Earthen materials perform best under compression; vegetal materials perform best in tension. Although earthen walls perform best under vertical loads, they have little resistance to horizontal forces such as wind. Vegetal materials are superb in spanning across space (although they may deflect), but they bend easily when, set on end, they are subjected to vertical loads.

These materials invite contrastive solutions to spatial enclosure and demarcation; their structural shortcomings are often compensated for by the forms into which they are carpentered or molded. Curving an earthen wall and bending a wooden timber are two examples of how form itself can be made to compensate for structural deficiencies. Thus, the traditional building repertoire of West Africa combines an optimum use of the principles of engineering statics with the strength of these materials in tension and compression. The two materials have come to be associated with sedentarism and nomadism, respectively, in West Africa (Fig. 2.5a, b).

Bamboo, a building resource found widely elsewhere in the humid tropics, is not abundant in West Africa. Where it prospers, however, as along the banks of rivers on the northern fringe of the Fouta-Djallon, in the Casamance region, and in the Bamenda highlands, it is often exploited, since it can easily be bent and molded. Its hollow core endows it with exceptional strength, but fastenings are problematical and joints require complex wrapping systems. Vertical wattles of bamboo or palm frond are tied horizontally and vertically and lashed to wooden posts and rafters, but for structures of any magnitude, either a system of larger, reinforcing timbers is required or an innovative form must be devised (Fig. 2.6).

The many Western-prized hardwoods are products of the rain forest. Yet these hardwoods have rarely been exploited as a building material in Africa. Much prized for wood-carvings, for furnishings, for utensils, and for boats, they are difficult to exploit effectively with a limited tool-kit. When found in the building repertoire, they are used critically and selectively as singular architectural and structural elements in the building complex; when so used they are perceived as visual indicators of affluence, status, and position.

Tree growth becomes stunted, gnarled, and irregular as one travels north further into the woodland savannah. Slash-and-burn agriculture contributed much to their deformation, reducing their structural potential. These deformed building timbers defy precise,

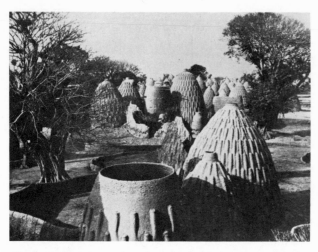

Fig. 2.5a Mousgoum housing, photographed in 1912 in the northern Cameroon. Bernatzik (1930?).

Fig. 2.5b A Fulbe encampment, southwest Niger.

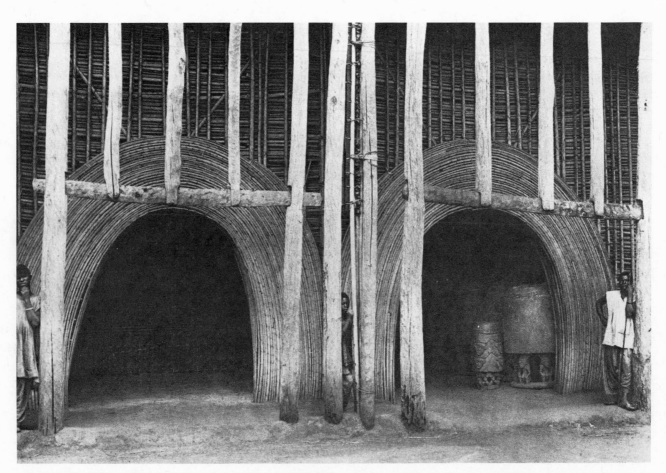

Fig. 2.6 Entrance to the king's palace at Foumban, Cameroon. Bernatzik (1930?).

straight-line geometry. The larger trees in the landscape, such as the dum palm, the baobab, the shea butter, the tamarind, the locust bean, and the kapok are nutritionally critical to subsistence economies, and they are preserved and guarded with care. The single exception is the use of split or whole sections of dum palm for structural roof systems in the historically important urban centers of the savannah. The answer to when and how their use evolved may very well be found in urbanization and the role of Islam (Fig. 2.7).

In the northern reaches of the savannah grasslands, stunted tree growth is gradually replaced by the thorny mesh and short, spindly branches of acacia brush. The acacia, now the primary vegetal material, does not lend itself easily to structural framing: it must be gathered into *fasces* or bundles, tied, and bent into ribs. The bent form, rather than the strength of the material, gives the rib its strength (Fig. 2.8a).

The sahel itself is almost completely devoid of vegetal building resources other than what is available in its irrigated palm oases. The single available natural resource is the palm tree with its fronds. Use of palm fibers for mats and basketry is closely related to their use as roof and floor mats and as wall screens, since they can easily be woven into a structural frame. This close parallel with basket- and mat-weaving techniques invites consideration of the repertoire of building construction practices as a close cognate of weaving technologies: weaving becomes part of the architectural repertoire and is incorporated into the structural system (Fig. 2.8b).

West African soils have usually been grouped into two categories, laterite soils and desertic soils. These two categories, however, only vaguely correspond to the international classification of soils used in soil mechanics (the basis for engineering analysis of building technologies), which classifies soils by the size of particles and their suitability for various construction tasks, in a range from gravels, sands, silts, and clays to organic soils. The natural soil condition most appropriate to earthen construction, a range between sandy clay and clayey sand, occurs in the savannah belts. Cohesive clayey soils are the material par excellence for pottery as well, suggesting the close parallel between the techniques of coil pottery and coil wall construction. Sandy soils lack cohesion, so that the further north one travels, the deeper below the surface one must dig to obtain a building material with adequate consistency. Given an appropriate balance within the range of sand to clay, it is possible, by adding nothing but water (for consistency and workability) to build a wall that will last a lifetime (Plate 1).

Under conditions of minimal building technology, environmental factors assume great import in the building process, and the impact of diverse economies on the natural environment prominently conditions the natural building resources. For example, the extreme diurnal and seasonal temperature changes in the northern savannah and sahelian steppes cause expansion and contraction of stratified sandstone. The stone then tends to split in flat, even planes along the lines of stratification, yielding surfaces that lend themselves readily to dry ashlar masonry. Neither surface modification nor a mortar bond is required, and few tools are necessary (Fig. 2.9). Temperature extremes have far less effect in areas where granitic outcroppings abound. Granites more often evidence surface wear and erosion, and are more difficult to split. Thus, the primary building material resource consists of large, boulder-like rounded stones that can be laid up only in combination with a heavy mortar infill.

Since water is critical for any type of earthen construction, topography also determines the choice of construction materials, as well as their derivative forms. In much of the savannah, where earth is the most logical and abundant building resource, the alternating wet and dry seasons, which dictate the availability of water, inhibit its use in the construction process. Building occurs during the dry season after the harvest, at the time when water is in short supply. The presence of surface hydrology and riverine networks facilitates construction by extending the building cycle beyond the limits imposed by seasonal rainfall. The availability of water for longer periods of time not only improves the workability of the construction material but reduces the labor time required for water transport. Thus, people living closest to riverbanks and standing

Fig. 2.7 The ceiling frame of a house in Djenné, Mali, in which two types of timber are used.

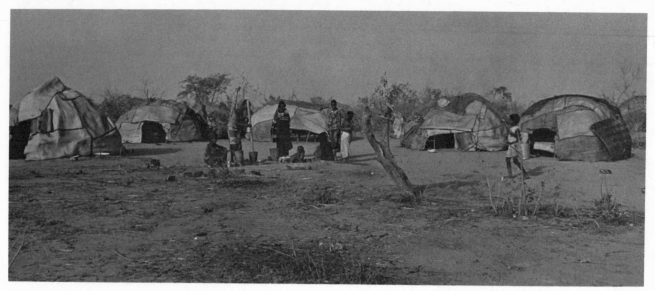

Fig. 2.8a Fulbe encampment south of Niamey, Niger.

water supplies have the most building options, since they can deviate most readily from the harsh and tightly imposed limits of the building-season norm.

The riverine networks figure prominently in modification of two other natural resources, lime and clay. Limestone is a hardening agent essential for any earthen mortar. People living in close proximity to the riverbanks have immediate access to soils already modified by alluvial deposits of clayey consistency, and to the shell and fishbone deposits of water life. Even when these primary resources for lime have not been incorporated into the soil content naturally, riverbank residents will grind them down and mix them into the clayey soil in order to increase its malleability, durability, and impermeability. Earthen walls have a concrete-like, smooth, and plastic character.

The presence of large numbers of termites, locusts, and mosquitoes in West Africa has always been a major problem for its human residents. Yet, in the course of constructing their habitat, they provide men with a naturally modified building material by introducing chemicals into the earth that improve its workability, cohesion, and durability. In the traditional oral building accounts there are frequent references to the preferential use of termite mound soils as an ingredient in earth mortars. By the same token, however, termite hills, a much-cited example of sophisticated "insect architecture," are extremely difficult to break down and pulverize (Fig. 2.10); in situ their consistency approaches the hardness of lateritic rock. In order to exploit this "pre-mix" material, a far more complex tool kit than is traditionally available is needed. Termites are

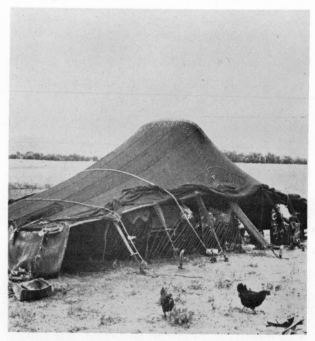

Fig. 2.8b A Berber "black tent," southeastern Morocco. Nachtigall (1966).

also a serious threat to soft timbers, precisely those which can be most readily exploited with a limited technology. Those timbers which are termite-resistant, such as the hardwoods and palm, are the most difficult to cut.

Each of the indigenous flora has qualities which both enhance and inhibit its use. For example, while the

hollow stems of bamboo enhance its tensile strength, its fibrous structure splits readily, and it is difficult to cut across the cellular grain. Even if nails were available, they would be ineffective fastenings for bamboo. The fibrous texture of timbers from palm trunk also makes them difficult to split and crosscut. In theory, they would bend admirably, but the shortage of water in those regions where they abound precludes the possibility of shaping them into arches by steaming or soaking.

The differential durability and longevity of vegetal and earthen resources also contribute to the perpetuation of particular building configurations. For example, when palm or hardwood is used in conjunction with poor soil, the earthen walls tend to disintegrate more rapidly than the structural timbers; softwoods or woven vegetal fibers used as "curtain walls" also deteriorate more rapidly than the hardwood structural

frame to which they are attached. Consequently, structural timbers are often reused. These pre-cut timbers establish the span and dictate the size and shape of the new building space, providing a template for continuity of form over time.

The absence of kiln-fired brick in the West African building repertoire has evoked frequent comment. Regardless of form, bricks derive from an earthworking process. The same clayey soils essential for good pottery yield the best bricks. But in those areas where such soils abound, e.g., the grassland savannah, wood, the fuel for the firing process, is in short supply. It is extremely difficult to reach the requisite firing temperature by burning grass.

The ways in which natural factors enhance the exploitation of building resources are matched by the by-products that traditional economies themselves unconsciously contribute. For example, much of West Af-

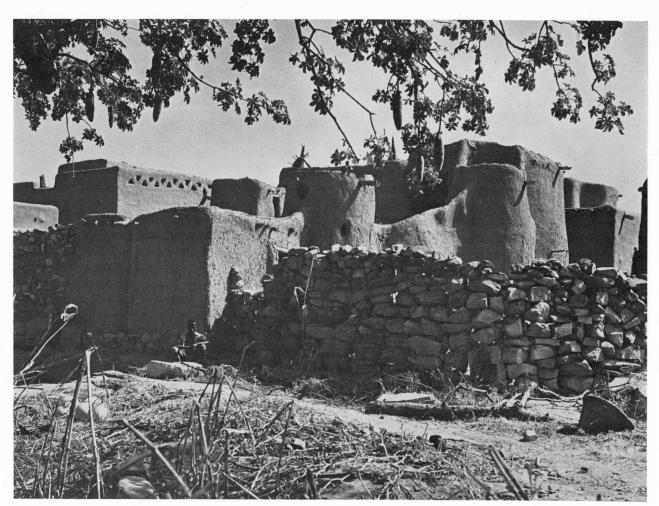

Fig. 2.9 Dry rubble masonry among the Dogon, Sangha, Mali.

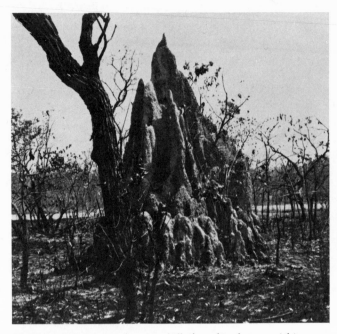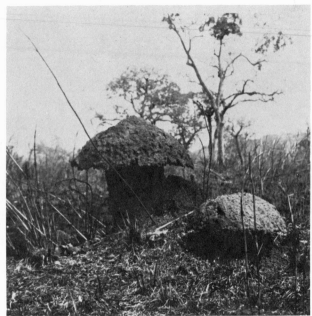

Fig. 2.10 Two types of termite hills found in the west African savannah.

rican subsistence economy is heterogeneous. Sedentary agriculture is supplemented by hunting, gathering, and fishing. Frequently, pastoralism and agricultural pursuits exist symbiotically. Midden heaps, cow dung, and stubble, located in proximity to the built environment, contain not only soil nutrients but fishbone and chafe, which enhance the quality of the most easily exploitable soils.

The best illustration of the way in which the interaction between the physical environment and economic activity can create an ideal building resource can be found in the Upper Niger delta of Mali. The sandstone cover has been overlaid with alluvial, clayey soils with a silty consistency that have been washed down and deposited on the floodplain. This surface is further modified, first by floodplain sedentary agriculture, which leaves crop stubble, and then by the annual grazing cycle of cattle driven onto the floodplain after the harvest, who supply cow dung that modifies the soil further. Finally, when the flood cycle subsides, it leaves behind a residue of crustaceous and skeletal marine life which decomposes into lime and works its way into the soil. The Inland Niger Delta soils have long been considered throughout the savannah belts as having the best workability and strength. Nothing, it has often been said, need be added to the natural soil of the Pondori plain in order to build with it.[8]

Another feature of the environment that has a direct bearing on the built form is light. Surface is revealed, in the main, through light, and as a correlate,

the physical definition of space is a function of light reflected off a surface. It has been suggested that "the ordinary experience of our visual world is that of differentiated luminous space. That is, as we look and move around in our physical environment we act, consciously or unconsciously, with regard to the information reaching us in the form of patterned light."[9] Antonio Gaudi, the great Spanish architect, was well aware of the importance of light not only in revealing the built form but in giving it meaning; he noted that light is the soul of architecture. Le Corbusier more recently suggested that light and shade are the loudspeakers of architecture. Shadow values both reveal forms and spiritualize them. Experiments in visual perception have illustrated the ways in which light and shadow introduce motion, so that while shape and form remain constant, the illusion of movement and change can be created by the manipulation of light on the surface of a shape.

Given the importance of light in the revelation of surface, the unique quality of West African light takes on special significance. Light barely manages to filter through the dense foliage and undergrowth of the rain forest. It is difficult to distinguish forms in the shadow of a leafy canopy. Light barely penetrates to eye level, and when it does the ground cover absorbs rather than reflects it. In the savannah and sahel regions, however, the sparse vegetation permits long vistas, and the unmarred, undulating, expansive surface of the earth is visible over great distances without filters. The white

sands glisten in highly reflective hues. Each form is clearly articulated in its simple, geometric shape (Fig. 2.11).

At the same time, the intensity and glare offset the virtue of light in the north. The tropical forest cover subdues the brilliant rays of the equatorial sun and filters them into a play of deep shadows, so that the sharp corners of rectangular forms are less irritating to the eye. In the north, the reflective intensity is further accentuated by the crystals of sand suspended in the air during the dry *harmattan* season and by the barren surfaces devoid of vegetation. The harsh contrast between light and shadow created by intersecting perpendicular planes is irritating to the eye, but the softly curvilinear surfaces, rounded corners, and rougher textures of the earthen walls convert sharp-edged planes into gently graded transitions from light to shade. Devices such as grilles and screens, designed to shield the viewer from the intense glare of cloudless days, highly reflective surfaces, and sharp contrastive planes of light and dark, become a distinguishing feature of the local architectural repertoires.

Water is the most highly reflective natural surface, contributing to the reflective quality of the environment in those regions where standing water remains through the cloudless days of the dry season (Fig. 2.12). The smooth, curvilinear earthen surfaces, already possessed of a fluid quality by virtue of the building material itself, are exaggerated by the proximity of the habitat to water.

Fig. 2.11 Cubical and cylindrical granaries among the Dogon on the Bandiagara escarpment, Mali.

Color and texture can also be defined in terms of patterned light, since color is a function of light refraction and surface texture is revealed at a distance by the way in which shades and shadows fall on illuminated planes. The texture of fingermarks on the finish surface of a rendered earthen wall emerges more and more sharply under increasingly intense light. The color and weave of a tapestry or mat are more brilliant and contrast more sharply with the subtle range of earthen hues, and clothing colors almost appear to be deliberately chosen in response to background conditions of color and light (Plate 2).

We have attempted to render a canvas that emphasizes the close ties among traditional building systems, the structural properties of natural materials, and the unsolicited products of traditional economic pursuits. We have suggested that the three environmental belts considered encourage three different sets of human and physical conditions, each of which has a direct relationship to the built environment. Many decades ago, the noted French Africanist scholar Henri Labouret suggested that the range of habitation in West Africa could be divided into three general types coresponding to the belts considered above: transient, mobile nomadic dwellings associated with the upper savannah and sahelian belt; round, earthen structures with conical thatched roofs, associated with the grassland savannah itself; and rectangular, vegetal, carpentered housing with pitched, sloping roofs, associated with the rainforest belt. He also noted the existence of a fourth type of dwelling, formed of earth, either round or square but with a terraced, flat earthen roof whose origin, he pointed out, was enigmatic.[10] In a subsequent distribution map of building forms, he offered a more exhaustive typology of building forms whose wealth of formal diversity and variation belied his earlier simplistic categories (Fig. 2.13). Although the categories as well as the excellently documented cartography of house forms suggest a general correspondence between environment and building materials, they are misleading because they suggest a simple cause-and-effect relationship among environment, building materials, and structural form.

A typology of pure form can only serve as a descriptive tool; it provides no point of departure for any insight into, analysis of, or explanation for the development of a wide diversity of forms within relatively uniform environments or ecological niches. In point of fact, a typology of form alone only emphasizes the shortcomings of any theory of environmental determinism for building form; it suggests, rather, that while available materials may condition or contribute to the design, they neither limit nor define it.

A number of deviations from the general relation-

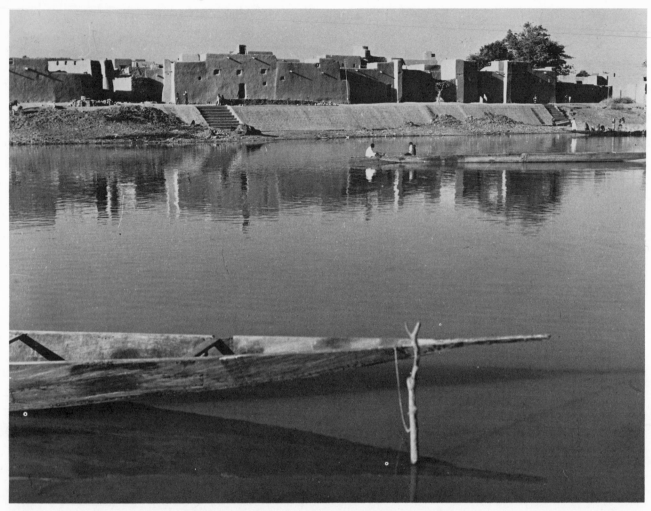

Fig. 2.12 Reflecting water surfaces surrounding Djenné, Mali, during a period of inundation.

ship between the built form, traditional building systems, structural properties of natural materials, and the unsolicited products of traditional economic pursuits suggest themselves as a baseline reference. Kiln-dried brick has been used in environments that strongly militated against its use. Hardwood timbers were used in places where it does not grow. Materials and techniques are found out of their natural milieu or technological environs. Their limited presence out of context suggests that their use resulted from critical, conscious, cultural choice. Decisions to use alien materials and technologies involved resources outside the traditional norm, so their presence implies major, albeit nascent, changes in level of technology, labor-intensive ratio, labor resources available for the building process, or socio-cultural preferences of the peoples among whom such deviations are found. Their use requires not only command over greater resources but a much heavier

investment in transport and labor differentiation. The selective use of these materials and technologies within the traditional system suggests to us that they were, and are, manipulated as indicators of power, position, status, and hierarchy and that they communicate, through the language of architecture, the efficacy of technology as a symbol. In many instances, Islam was a catalyst in effecting changes in aesthetic preference and technologies.

Rather than a typology of building *form*, consideration of the *evolution* of building technologies in a hierarchy from simple to complex (approaching the optimization of a natural material) may provide a far more fruitful analytic framework for the consideration of architectural form and its historical development. This hierarchy, consistent with generally accepted explanations for the evolution of man's control over his natural environment, takes the following into account:

1. Increasing complexity of materials involved in and requisite for completion of the built form.
2. Increasing complexity of skills, i.e., the number and diversity of requisite building operations.
3. Increasing specialization of skills.
4. Increasing potential for variability in the built form.

This suggested hierarchy begins solely with empirical factors and the laws of mechanics. Disregarding cultural preference or necessity, quality, aesthetic sensibility, and value judgments (aspects of architecture considered in the chapters which follow), the base line for this hierarchy is a prototype derived solely through an analysis of physical forces and their effects on physical bodies. Since it does not involve human conceptualization or decision, it can perhaps be compared to analyses of animal architecture physiognomy.[11]

The environment of any society constitutes resources only when the technological knowledge requisite to their exploitation is developed. The goal of any

technology is to accomplish a given task with a minimum number of tools and a minimum use of materials. The assigned "task," in its broadest definition, provides us with a lens through which to view economic, technological, and ritual behavior in space.

The two materials that are available to the indigenous savannah technologist—and we again use the term in its broadest sense—in their natural state are earthen and vegetal materials. Separately or in combination, these materials comprise almost the entire repertoire of material resources in West Africa. In addition, there are several materials derived from animals, such as tanned hides and woven fabrics, that are used as material components in the transhumant context. Each of these materials behaves differently under conditions of physical stress. Earthen construction has always been associated with sedentarism, and mobile structures using vegetal materials have always been associated with nomadism.

According to engineering analysis, the material properties of earth, for example, yield a building pro-

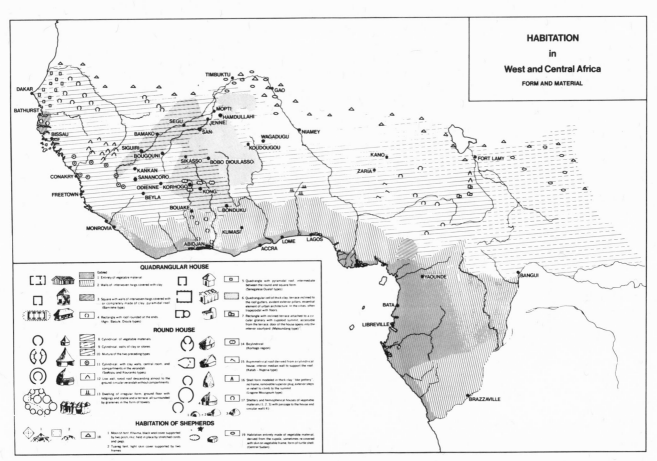

Fig. 2.13 Map of building types in West Africa, after H. Labouret, "L'habitation en Afrique occidental et centrale, Essai," Cartothèque, IFAN, Dakar, n.d.

totype in which the round rather than the square form is the appropriate and efficient configuration; it is an eminently sound solution to spatial enclosure. The traditional builder, using his hands, native ingenuity, and empirical logic to shape coil pottery, maximizes the natural properties of the material at hand. The optimum is reached in the ubiquitous, superbly formed and tapering earthen shells of Mousgoum granaries and housing in the northern Cameroon (see Fig. 2.5a). Other earth-building technologies, such as masonry or rammed earth, involve more material and labor, more tools, more complex building operations, and greater social differentiation (Fig. 2.14a–f).[12] The suggested sequence of increasing complexity is evident, for example, in the archeological remains of Dogon wall construction in the Bandiagara Escarpment of Mali. The established dates of artifactual remains associated with walls in successive occupation levels indicate that hand-molded bricks used in a type of masonry construction associated with an early Manding migration postdate coil pottery in an area already occupied by the proto-Dogon.[13] The use of masonry techniques in preference to coil pottery involved, however, the development of a set of more specialized skills: craft specialization was a function of role differentiation.

The most persuasive argument for the introduction of masonry techniques into the African savannah by Islamic agency lies in the building terminologies associated with them. While indigenous terms such as *banco, labu,* and *aru* are used for simple techniques, the various brick shapes now prevalent in the building repertoire are designated by Arabic-derived terms. *Toub, tube, tauf, tufa, tuferey, tubali,* and *ferey* can be traced etymologically to words such as *uttub.* Material evidence for our hypothesis can also be found in the thin, rectangular cast bricks of the *mihrab* of the ancient Dyula (Manding) mosque at Gao, Mali, which has been tentatively dated to the early fourteenth century (Fig. 2.15).[14]

Whether one is working with earth, wood, or fabric, the shape of the "building block" itself is an important determinant of the final form of the built structure, just as a weaving technique and materials will, in great measure, establish the pattern of the weave and the construct of the cloth. Despite their less efficient performance under minimal technologies, rectangular shapes invite a rectangular solution to the enclosure of space. Rectangular bricks also permit a number of innovative structural variations, which in turn can become handmaidens to a new architectural imagery. The so-called "Berber motifs" that announce the presence of Islam in West Africa, while originating in the stone-built *qsars* and granaries of North Africa, can be more easily emulated in earthen bricks. Rectangular bricks are essential

a

b

Fig. 2.14 Techniques of earthen construction. *a.* Detail of the coil pottery technique used at Sanga, in the ancient Tellem caves of the Bandiagara Escarpment, in the archeological context. It has been suggested, on the basis of C-14 dating, that these walls predate those using a masonry technique. *b.* Elliptical hand-molded bricks in northeastern Guinea.

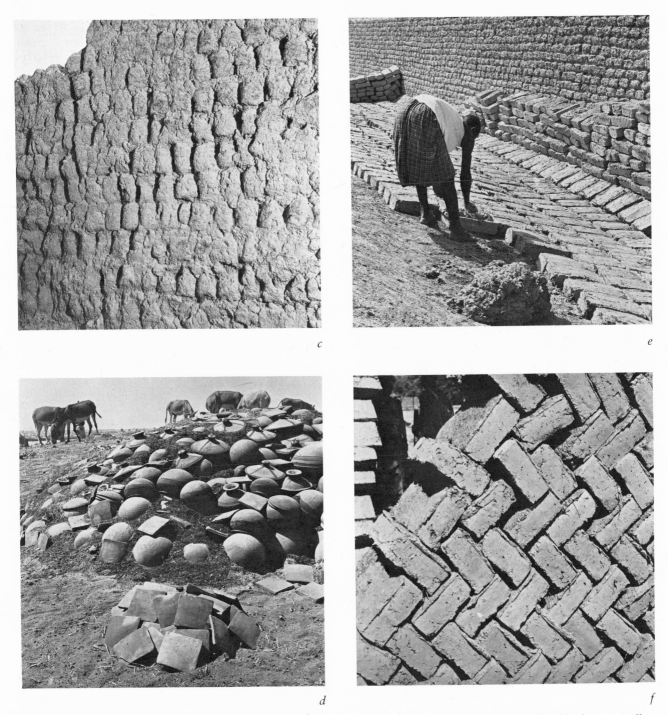

c. An old wall at Djenné, Mali, using the traditional *djenne-fere*, a cylindrical sun-dried brick, hand-rolled and laid up vertically by the *bari*. *d.* Kiln-fired pottery and paving bricks, made by the women potters at Djenné. All elements are used in an architectural context. *e.* In the foreground, cast rectangular bricks are being fabricated. Behind, an earthen wall constructed of rectangular brick. *f.* Cast rectangular bricks laid diagonally.

Fig. 2.15 Flat, rectangular earthen bricks excavated at the *mihrab* of the extinct mosque at Gao, Mali.

for the construction of a true Roman arch, as well as for the lozenge and zigzag patternwork of facades (Fig. 2.16).

Until recently, mobile structures and structures built of nonpermanent materials were excluded from the repertoire of architectural history, and little, if any, distinction was made between *temporary* and *transient* structures, despite the fact that the distinction is structurally, aesthetically, behaviorally, and conceptually relevant to any analysis of the built environment. Temporary structures rarely demand optimum performance: their life span and the care and detail required to make them stable are not apt to be critical. The meaning attached to them is minimal. Transient structures, on the other hand, are often permanent in the sense that they are required to last as long as, if not longer than, sedentary edifices, even though their life may span a multitude of sites. Tent structures using minimal materials, minimal toolkits, the lightest weight, and the least anchorage can be analyzed in a manner similar to the one proffered for the earthen prototype above. Simply, while earthen structures respond in compression, vegetal structures respond in tension.

There are two basic types of movable structures in the savannah: a "true" tent and a matframe tent. The first is associated with the Maures and Tuareg; the second is more commonly used by the Fulbe- and Songhay-speaking peoples (see Fig. 2.8a, b).[15] A minimal "tent" or tensile structure requires a stressed skin, a set of stays to anchor the skin or vellum to the ground, and a set of poles in compression. The two materials commonly used for the stressed skin are tanned hides and woven fabrics. A skin tent involves less technological modification for its preparation than does a woven tent, and among herding societies the skin tent is more easily fabricated within the traditional economy. The pole or poles that work with the stays to keep the skin in tension also require minimal modification from their natural state in order to perform successfully.

The other mobile structure is a matframe, basket-like "tent" used by semi-nomadic peoples and commonly found in the southern reaches of the savannah, where vegetal materials are more abundant. Unlike a true tensile structure, the stability of a matframe derives from its permanent ground anchorage and a set of bent-wood frames. Acacia roots, which bend easily, are more readily available, but the resulting structure has restricted mobility. The basic distinction between a stressed skin tent and a matframe tent is that the bent-wood arches in tension are independent of their covering.

The ideal form for both types of tents is a dome, in which the stays or ribs are arranged in a circle and radiate upward toward a single center point. A circle is more stable than a square, curved walls offer better resistance to horizontal wind forces, and it requires less material. Ideally, for ease of transport, the structural members should be light and of minimal bulk. In the absence of an exhaustive tent typology, it is only possible to infer that few of those documented reflect this abstract ideal. In the realm of building technology per se, there appears to be far more involved than just the basic laws of statics (Fig. 2.17).

From a purely physical perspective, it is also possible to establish critical stress points in each of these three prototypes, i.e., the coil-pottery earthen roundhouse, the stressed tensile skin tent, and the matframe "basket" tent. Any opening in the wall surface of an earthen cylinder or dome reduces its ability to transmit horizontal and vertical stresses to the ground. Hence, openings must be reinforced by thickening the opening surrounds. The embellishment and enhancement of such openings are as much a matter of structural demand as they are of conceptual rationale. Centers and, by extension, the apexes of thatched roofs not only establish the radius of a circle but are structurally required in any radiating system of rafters. In stressed skin structures, maximum tension occurs in the center, and the apex establishes stability. Hence, stressed skin tent centers are heavily reinforced, either by additional thicknesses or by a heavy embroidery. The tent poles and stays are as important as the skin itself, and they too receive particular attention in shaping and carving.

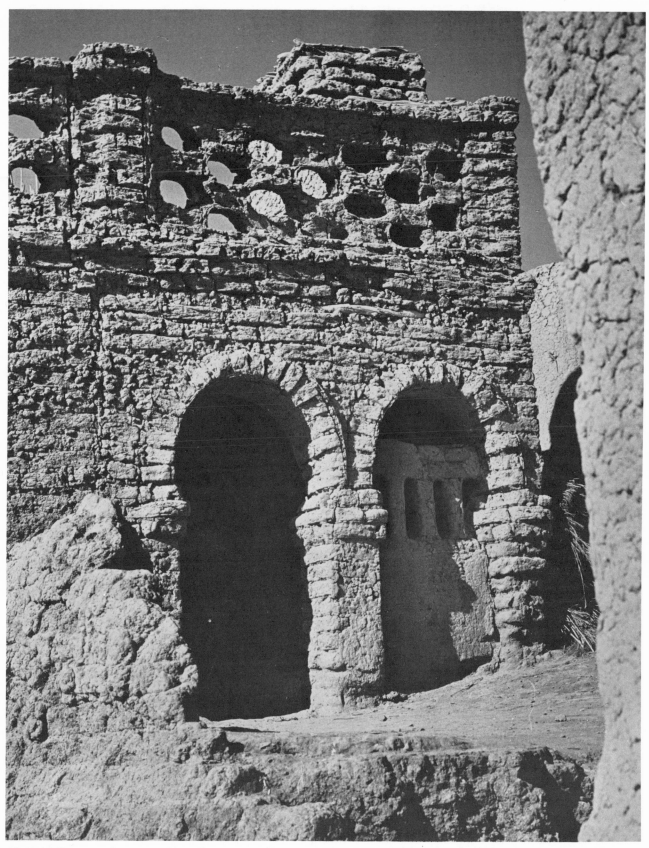

Fig. 2.16 Roman arch construction and an openwork parapet using rectangular, cast sun-dried bricks at Djenné, Mali.

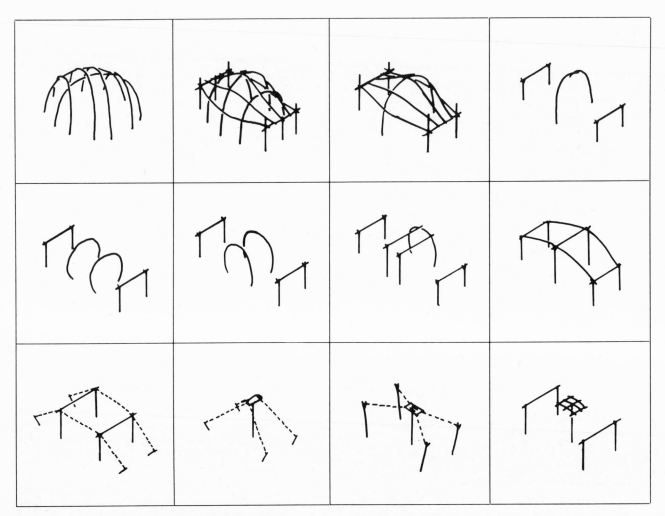

Fig. 2.17 Various tent structures used in West Africa. Drawing after Nicolaisen (1963); Lhote (1947); Andrews (1971); and Chapelle (1957).

Just as those facilities which any society recognizes as being essential to its existence are imbued with great meaning, so too those stress points which are recognized as critical to structural success become the foci of design emphasis and attention.

The discussion of building technologies above could equally well apply to the ant and termite hills, birds' nests, and spiderwebs that abound in the area of our concern. But, as has been suggested, what distinguishes the most incompetent man-built form from the best of termite hills is the template the builder envisioned in his head before he began.[16] The template is part of the patterned structure of culture as a whole, expressed verbally, visually, kinetically, and technologically. A shared cultural mode is expressed in a variety of communication channels, among which acts of behavior as well as artifacts can be reckoned.[17] Artifacts are the products of appropriate cultural performance, and technological activities constitute modes for creating the products.

CHAPTER 3

The Behavioral Environment

THE WEST AFRICAN savannah has generated two basic economic activities: sedentary agriculture and pastoralism. The same cultural group often practices both. The two economies are frequently supplemented by subsidiary activities, and they often exist in a symbiotic relationship. In general, though, one mode or the other has distinguished a culture over time and dictated the behavioral and conceptual frameworks within which it functions. The sedentary/transient contrastive life-styles, involving different relationships to the physical environment, are manifested in housing and storage requirements, in territorial needs and imperatives, in concepts of land tenure and property inheritance, in systems of social organization, and in the meanings attached to the spectrum of artifacts in the natural and built environments (Fig. 3.1a, b).

The three building prototypes considered in Chapter 2 are achieved with minimal technological differentiation or specialization. Coil-pottery earthen structures depend on communal participation and a collective work process; specialized tools and skills are not required for their erection. Labor differentiation is only between the tasks performed by men and those assigned to women. Women are responsible for bringing water to the borrow-pit and sometimes for tamping and kneading the mud into the proper consistency, while the men pack the mud into place. The borrow-pit is almost always adjacent to the building site and is sometimes within the circumference of the boundary wall itself. Every compound owner is expected to direct the construction of his own walls, and he is, so to speak, the master potter of his own built environment. The success of his creation, however, is as much dependent on the favorable disposition of the ancestors as it is on his personal command of the building material. Not only is the choice of building site a matter for magico-religious sanction, but the builder-houseowner himself must offer a number of sacrifices to propitiate those whose earthen domain he is disturbing. Like a placenta, a sacred aura enveloped the entire building process and the skills involved in it.

Although men are responsible for wall construction, traditionally the women finished the walls by rendering or "plastering" them (Fig. 3.2a, b). In contrast to the communal character of wall-building, wall surface design is an individual creative act. The collective work processes of wall construction are conservative and change slowly, whereas surface design can accommodate changing aesthetic preferences more easily and rapidly. In the traditional pattern of patrilocality and exogamous marriage the woman, through marriage and relocation, carried a mental template with her to a new residential domain, diffusing style in space. Surface pattern and iconography were in the realm of women's arts.

Social change generated by the subsequent Islamization of savannah cultures affected this differentiation between wall-building and wall-finishing. The rendering of exterior walls was included in the mason's build-

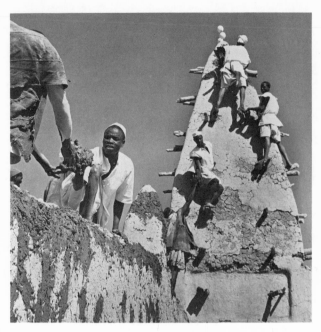

Fig. 3.1a Bari masons resurfacing a village mosque near Bla, Mali.

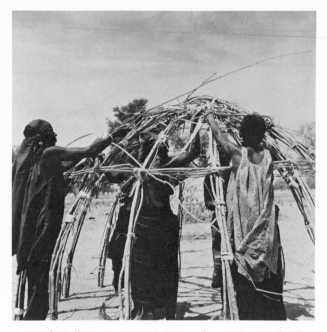

Fig. 3.1b Fulbe women erecting a matframe tent, north of Bamako, Mali.

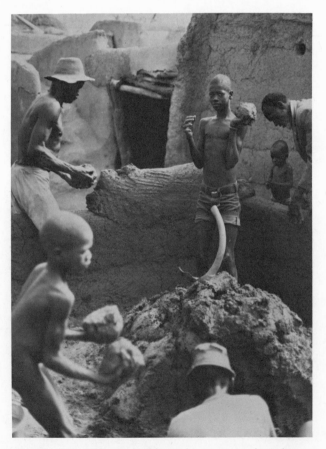

Fig. 3.2a The collective building process among the Lobi, northern Ghana.

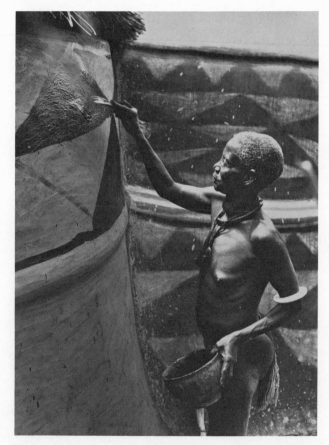

Fig. 3.2b Old woman applying the finish rendering and wall surface design to a new compound wall at Sirigu, northern Ghana.

ing responsibility, while the finish of interior room and compound walls continued to be the women's responsibility. This shift in the building process affected both the quality and subject matter of wall iconography and its role in the traditional system of visual communication (Fig. 3.3a, b). It did not, however, bring about basic changes in technological differentiation or specialization.

It was traditionally the women who tanned the skins, collected the timbers, and braided the ropes and stays for stressed leather tents. They were exclusively responsible for erecting the tent, striking it, and transporting it from one camp site to another.[1] And it was traditionally the women who braided the grass mats, gathered and bent the roots and branches into a frame, and transported the matframe tents from site to site. It was also traditionally the women who wove the strips which are sewn and assembled into the woven tent covers. The semiology of the architectural form was structured in the domain of women.

Social change that effected modification of these basic building technologies went hand-in-hand with the transition from the use of natural materials to man-modified ones. The major changes in earthen construction were kiln-firing and brick casting, involving potters and specialized masons. In construction using vegetal materials, the major modifications were the substitution of cotton or wool fabrics for tanned skins and plaited mats, involving weavers. In both building types, the cutting, shaping, and carving of wood and the fabrication of metal tools and fastenings involved blacksmiths and woodcarvers. Development of these skills was integral to *any* modification of natural materials; their role in the built environment was merely part of their total cultural performance.

These skills were the first to evolve into specialized castes in the West African savannah, in the sense of genealogically inherited prescriptions, rules about intermarriage, and restricted membership. Thus, among sedentary populations the wives of the blacksmiths are always potters and among nomadic peoples their wives are always leatherworkers. Their fidelity to traditional behavior and the absence of social mobility that characterizes these castes in West Africa has also perpetuated the coexistence of two modes of technical mastery over nature, a magico-religious one and an objective, technical one.

Craft specialization, which overlays the pattern of non-specialized and undifferentiated technologies of the rural "folk" domain, evolved in the company of emergent urbanization, hierarchical political structures, and transition from pure subsistence livelihood to an economy that allowed for the production of "luxury" goods. Technological differentiation and specialization enhanced the conscious recognition of individual mastery, the development of a more discrete

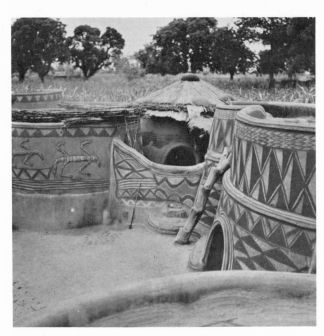

Fig. 3.3a Finished wall designs created by Kassena women, northern Ghana.

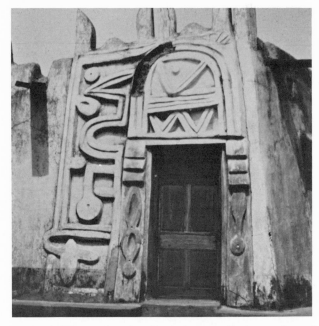

Fig. 3.3b The entrance facade of a house at Zaria, northern Nigeria, built and finished by the *magini* or masons.

technical vocabulary, and the acknowledgment of individual authorship. This specificity of behavior is reflected in caste genealogies and traditions of origin.[2]

Wherever discrete skills were culturally recognized, the oral traditions imply that they emerged within the context of a nascent Islamized urban setting. On the surface, it seems that impetus came not only from the socio-political changes wrought in the course of Islamic West African penetration but from Islamic prescription itself. Body covering and the necessity of burial shrouds contributed to the demand for woven goods, just as burial prescription required a building brick. Military conquest and the role of the horse created an additional demand for leather goods. Leatherworking techniques developed concomitantly with stitching and embroidery. Metal tools fulfilling the requirements of agriculture were called upon to accommodate the needs of warfare. The tenets and canons of Islam encouraged the building of monuments, fortification networks, and mosques. Craft specialization, if not born of, certainly matured in the service of the newly emergent Islamized political "establishment."

According to the fourteenth-century North African scholar Ibn Khaldûn, "the Craft of Architecture" is the first and oldest craft of sedentary civilization.[3] He stressed the need for architecture when "rulers and people of a dynasty build large towns and high monuments." Despite several references to their lowly position, North African and Near Eastern sources imply that the architectural discipline and architect-builders occupied a respected and venerable position over many centuries.[4] The mason is still today addressed as a *mallam*, the title of respect for a man of learning, throughout the Muslim world. The term is used not only among the Arabs and among many Berber communities of North Africa but among the Songhay, the Manding, and the Hausa peoples of West Africa.[5]

In contrast to the "collective work process," craft specialization involves a distinction between patron-owner and designer-builder. Designer and builder were the same person, but he functioned under the auspices of a sponsor. Thus, early Islamic market records that enumerated important trades and professions made no distinction between architect and foreman-mason.[6] Under the Umayyad Caliphs of Spain, the superintendent of works, the *sahib al-mabani*, was at the same time an administrative official and a man of letters. Designer-builders were also at the same time the authors of legal treatises and building codes, so common-law practices were logically incorporated into legal commentaries and into governing jurisprudence.

The necessity of geometry for an understanding of engineering problems was clearly recognized in the early centuries of Islam. The relationship between mathematics and the building sciences was even more explicitly acknowledged. Carpentry, it was suggested, "requires either a general or specialized knowledge of proportion and measurement, in order to bring the forms [of things] from potentiality into reality . . . and for the knowledge of proportions, one must have recourse to the geometrician."[7] To emphasize this point Ibn Khaldûn referred to the fact that all the leading Greek geometricians, including Euclid, were carpenters, and that "the person who knows geometry acquires intelligence."[8] Among the early Muslim architects, Shaikh Alam ad-din Qaisar was also a noted mathematician and astrologist, Maslama b. Abdallah was a tenth-century geometrician in the Umayyad court of Cordova, and Ahmad b. Muhammad al-Hasib was the designer of the Cairo Nilometer.[9] Other well-known mathematician-builders were Ibn al-Banna of Marrakesh and Abu Bakr al-Banna, grandfather of the geographer al-Muqaddasi. These architects were in general part of the retinue of their patrons. Functioning in both an advisory and an administrative role, often they were in charge of all aspects of technology called forth by the expanding sphere of Islamic politico-religious influence. As intellectual carriers of the ideological framework of Islam, they not only provided the rationale for the architectural form but also imbued it with religious meaning.

These savants fulfilled similar roles in the wake of Islamic expansion and penetration into West Africa. As advisors to the newly emergent medieval empires, they were responsible for the new building programs. Es-Saheli, the renowned fourteenth-century poet-architect, exemplifies this kind of role. Traveling in the retinue of the Mali emperor Mansa Musa on his return from Mecca, he bore the responsibility for the design, construction, administration, and documentation of the newly required "monuments" of Islam. As a superintendent of works, his contract fee would have included reimbursement for *all* these services.

The term *al-banna*, from the Arabic verb *abennai*, "to build," persists in West Africa. When Askia Muhamed, the Songhay ruler who came to power in 1493, returned from the *hajj* after having been appointed caliph of Tekrur, he was given jurisdictional rights over twelve "tribes." These were not ethnic or socio-political groups, but castes of artisans.[10] Among those listed were the *diamouasi* or blacksmiths, the *kourounkoi* or leatherworkers, and the *soro banna* or masons. The term *soro banna* derives from *soro*, the Songhay term for terraces or minarets, and *banna*, the Arabic term for masons. In the context of the account, the emphasis on castes of artisans is closely linked to the emergence of an Islamized Songhay political structure.

After he conquered Diaga, a city in the Macina,

Askia Muhamed took five hundred masons as prisoners. Their chief was a *karamoko*—a generic Islamized Manding title of respect for a man of letters. Four hundred masons were sent to Gao and one hundred were sent to build Tendirma, a new capital for Askia Muhamed's brother.[11] There the construction was directed by one Ouahab Bari, and the elders at Tendirma continue to refer to the *wahabubari* who built the Great Mosque at Tendirma during his reign.[12] While the pre-name Wahab puts one in mind of the Muslim Wahabite sect which figured prominently in the Mzab region of North Africa and early in trans-Saharan trade, the surname *bari* recalls an oral tradition from the Upper Niger Bend that referred to *bari* as a family name for the first Djenné mason, who came from Dendi.[13]

The awe in which North African scholar-architects have been held is matched by the magical powers ascribed to the masons and the supranatural aura that envelops earth-related building traditions. At the turn of the century it was observed that "the *bari* are convinced that their chief has an occult power over all their work; if he is unhappy or badly disposed toward them, he can throw an evil spell so that all they built will crumble."[14] This belief in the supranatural ability to manipulate the earth and literally to defy the laws of gravity was more recently reflected by the master-mason at Goundham, Mali, who described how a *bari* had used a verbal command to prevent a wall from falling down.[15]

The conceptual magico-religious framework within which the building process unfolds explains why the mason is frequently also the grave-digger.[16] In both earthen construction and grave-digging, the sacred realm of the world is being tampered with. In the latter instance, the act occurs precisely when direct contact is being made at the most critical life passage, the transition from life to death, from the profane to the sacred; hence it carries the strongest, yet most intimate, mystical charge. It is in this ritual context that the introduction of new building technologies would be particularly cogent. Thus, the prescription of procedures for Islamic burial specifies that a part of the excavation be sealed off by a wall of *bricks*, in contrast to the raw earth.

The northern origin of the two masons' castes in West Africa, the *bari* of the Upper Niger Bend and the *magini* of northern Nigeria, is mentioned in their oral traditions. The *bari* refer specifically to a Moroccan who built the great mosque and the extinct palace of Konboro at Djenné. "It was Mallum Idriss who taught the Djennenke people the art of building, of laying out and decorating the houses."[17] Today, reference is still made to two Songhay brothers, Mallam Idriss and Mallum Yakouba, who came from Tombouctou at the time of the Moroccan invasion of 1591 and built the first mosque at Djenné.[18] At Tombouctou itself, the two chiefs of the original eight masons were Masa Ambeli and Mallum Idrissi.[19] Ambeli remained at Tombouctou and Mallum Idrissi went to Djenné. It has also been claimed that one Malum Idriss was the architect for the *ma dugu* or palace of Biton, the first Bambara king who (in the late seventeenth century) converted to Islam.[20] Thus, while the oral traditions may be discrepant in time, they all acknowledge in one way or another the specialized building skill, the presence of Islam, and the respected position of the masons.

The frequent references to Mallam Idriss or Idrissi are of more than passing interest. According to Ibn Khaldûn, the name of Idris, the Koranic sage who is identified with the biblical Enoch, is among the most favored for the attribution of the authorship of magical works in North Africa.[21] He was the inventor of geomancy, of sand divination, and of the *za'irajah*, a mathematical system for discovering the supernatural. He is credited with the invention of crafts in general, and with weaving and tailoring in particular.

Consideration of those technological skills requisite to the creation of sedentary environments suggests a parallel with the magico-religious behavior associated with the creation of nomadic environments. The weavers and the leatherworkers are analogous to the masons. However, whereas earthen building technologies depend almost entirely on the mason—with some help from the potters and the blacksmiths—for their realization, transient architectures depend upon the leatherworkers, the weavers, and the blacksmiths. There are no specialized "tent builders." It is also these skills which come into play in the creation of all the art forms in West Africa, whether they are masking traditions, weaving, leather or metalworking, or the carving of wood furnishings. In contrast to the earthen structure, consideration of the transient mobile habitat serves as an introduction to the entire repertoire of "environmental arts" of Islamized West Africa.

The distinction between sedentarism/male owner-builders on one hand and transhumance/female owner-builders on the other hand, appears to have had far-reaching consequences in the development of the Islamized West African arts and architectures. Architectural change as well as social and technological change in the crafts themselves can be attributed to the strong emphasis on sedentarization, which, as Ibn Khaldûn pointed out, is part of the Islamization process.[22] The shift from matrilineal to patrilineal descent and from matrilocal to patrilocal residence, also consequences of "settling," influenced aesthetic preference, craft behavior, and the architectural form itself.

In the nomadic context, regardless of location, it is traditionally the women who have created, carried

responsibility for, and exercised jurisdictional rights over the tents (Fig. 3.4a, b). All property, including the tent and its armature, the furnishings and domestic utensils, was created and owned by the wife. Even in those instances where women no longer weave the mats and tapestries and where they no longer tan the skins necessary for the interior leather furnishings, it is still the wife's family's responsibility to provide them, either as part of her dowry or upon the birth of her first child.[23]

With sedentarization and Islamization, the mat and woven walls of the Fulbe *bororo* nomads in West Africa were gradually replaced by earthen walls; the tent armature was gradually enveloped in an earthen covering; and mobile interior furnishings gave way to earthen-molded ones. As the armature was gradually embedded in an earthen envelope, the wife lost proprietary rights over the domicile structure and its earth-molded furnishings. Ultimately all she retained ownership over were those furnishings that continued to constitute her dowry, such as the wedding pillow and the domestic utensils. As Islam became more heavily entrenched at various socio-cultural levels, more and more of the wife's life became concentrated on the inner courtyards of private, secluded space. However, the earth-armature combination also created an entirely new building technology and wrought qualitative changes in the architectural form. Finish-rendering, traditionally in the hands of women, devolved into part of the mason's responsibility, particularly when it involved the exterior surfaces of monumental structures associated with the new religico-political urban context.

Among the North African and Mauretanian nomadic populations, women continue to be responsible for weaving the narrow-weft bands, or *fliq*, that constitute the tensile fabric or *khaimat* of the tents.[24] The mistress of the house, aided by other female members of her family, weaves the strips on a horizontal loom; among the Maures, weaving is the single skill in which a woman of noble caste is permitted to engage. In rural sedentary North African societies, the women also continue to weave the cloth for clothing and for household tapestries and covers. They work, however, on wide, vertical looms given to them by their husbands and installed in either the vestibule or, more often, the inner courtyards of the house (Fig. 3.5).[25] Among the Berber populations the loom remains the ultimate symbol of magic protection around which the entire range of cultural behaviors revolves.[26]

Currently, however, in the urban North African centers there are groups of itinerant professional weavers who, unrestrained by the social and residential limitations imposed on women, live in and travel from town to town plying their trade on demand. In cities such as Tlemcen, these men weavers, like guild members of medieval Europe, occupy a special quarter.[27] The same pattern appears to have developed in the West African savannah, where men weavers such as the Fulbe *maboube* either live in villages acknowledged to be weaving centers or travel as itinerants from village to village, weaving on commission.

The distinction between the large North African looms used by village women and the narrow-weft horizontal looms of nomadic women is of considerable speculative interest for the history of narrow-weft weaving in West Africa. For example, if one compares the North African Mzab cloth above with the narrow-weft *tyarka* woven by a few remaining Fulbe weavers in the Niafounke region of Mali, one is struck by the sim-

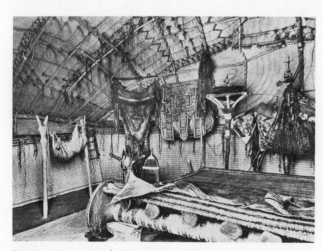

Fig. 3.4a Interior of a Tuareg tent, Niger.

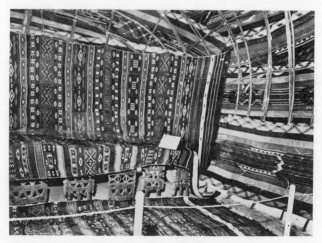

Fig. 3.4b Interior of a Wogo (Songhay) tent, Niger.

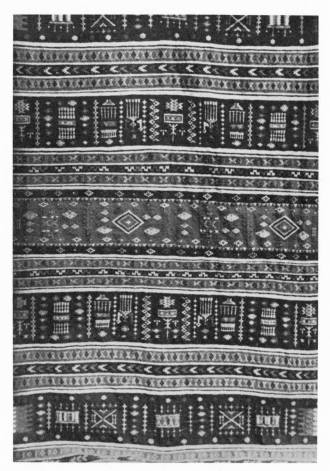

Fig. 3.5 Tapestries woven on a wide, standing loom by Beni Rached women, Qal'a, northeast of Tlemcen, Algeria. Golvin (1957).

Islamic influences. Rather than reconsider those aspects which have already received attention, here we will only weave some of the available evidence into a somewhat different warp.

The prevalent use of leather for both skin tents and wearing apparel is well documented in the earliest Islamic and European literature on West Africa.[29] Tanning and cutting skins and hides involved far less technological complexity than did weaving. The references strongly suggest that sewn and woven cloths were at first the prerogative of persons of high rank in the nascent political leadership of the early medieval West African empires. Writing in the eleventh century, El Bekri, a Muslim scholar, observed that only kings and their heirs-apparent were allowed to wear "sewn clothes" in the court of the empire of Ghana.[30] Several centuries later, in northern Liberia, the kings, chiefs, and headmen were observed wearing the Mandingo robe of stoutly woven, narrow-weft cotton (joined together in alternating stripes of blue and white), in contrast to the minimal leatherwear of the ordinary people.

The early ruling aristocracies' preference for "sewn" clothes is analogous to the selective use of particular patterns by the ruling élite in more recent history. Among the Asante of Ghana, only the *Asantehene*, or Asante king, has the right to wear certain patterns of the narrow-weft *kente* cloth. Currently, selective use of damask and brocaded cloth by the more affluent and high-ranking members of West African societies performs a similar function.

The importance of strip cloth as a measure of monetary currency also contributed to the emergence of craft specialization and the shift in sex roles that accompanied the development of weaving and its technologies. Comments by El Bekri suggest the practice of using cloth as currency as early as the eleventh century. The practice merited special mention in the West African chronicles with, for example, the arrival in Tombouctou of a caravan of traders carrying clothing and gifts—in particular, scarlet cloth. Reference to the practice can be found in the accounts of the mid-nineteenth-century explorer Henry Barth, and the commercial use of cloth persists to this day among Dyula (Manding) traders on the coast.[31] This commercial demand for cloth would logically have encouraged the growth of a class of itinerant male weavers.

References in the West African chronicles also emphasize the relationship between wearing apparel and the rituals of political investiture. For example, when Djouder, the general of the Moroccan invasion of 1591, arrived at Tombouctou, his gift to the Cadi, a robe of scarlet cloth, was a sign of investiture.[32]

Cloth figures prominently in the myth associated with the installation of Bakar, the son of the first Bam-

ilarity in pattern, despite the major difference in weaving technology involved. The *tyarka* appears to be an attempt, by sewing the narrow wefts together in a simulated pattern, to replicate the horizontal banding design more common to a wide loom (Plate 3). Again, if one compares the *tyarka* with the *dyongo* tapestries woven by male weavers, the alternating horizontal bands have been shifted one step up to create the entirely new black and white "checkerboards" (Fig. 3. 6a, b). Although there is little available evidence to support such an hypothesis, one is tempted to wonder whether the *dyongo* pattern denotes an historical shift in both sex roles and technology.

The history of weaving and weaving technologies in West Africa has interested a number of scholars.[28] For the most part, however, their focus has been on weaving in association with clothing. There are few references to weaving in the architectural context and even fewer that consider the interface between weaving and

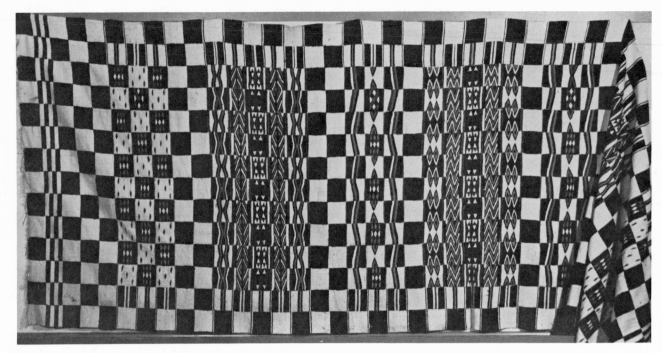

Fig. 3.6a A *dyongo* tapestry woven at Goundham, Mali, by Fulbe weavers.

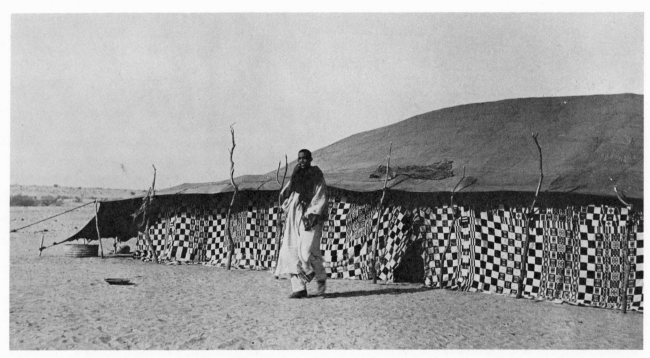

Fig. 3.6b A Tuareg Iforas tent, north of Gao, Mali.

bara king, Biton (considered equivalent to Muhamed by his followers), whom we mentioned in reference to the palace built for him by Mallam Idriss. In the course of the ritual of investiture, he took in one hand a marvelous cloth, a gift of the marabouts of Djenné, and threw it into the air; it spread out magnificently over him and his brother seated next to him. Then the *ton-masa*, the "earth-priest," passed a woven band of cotton around his neck and, giving the ends to Bakar, pledged his allegiance.[33] In the same vein, according to accredited legend, the Bambara secret society, *komo*, particularly associated with wisdom, is reputed to have been introduced by Mansa Musa, the first Islamized king of Mali. On his return from Mecca, not having obtained a pardon for his sins, he devoted himself to the study of magic and exchanged the *komo* for a marvelous blouse or *dhloki* woven by the sorcerers.[34]

The attribution of the origin of both masons and weavers to Mallum Idrissi suggests a possible symbolic union between them: the products of the two crafts play visually equivalent roles in political communication and in establishing hierarchical levels of status in previously egalitarian societies; the end product of each craft provides a stage for the drama of shifting iconographies, resulting from Islamic presence and importance; and the end products of both figure most prominently in ritual settings. Ultimately, one may well provide the basis of design inspiration for the other.

The Dogon people, like Ibn Khaldûn, consider weaving to be one of the original crafts.[35] The innumerable images associated with weaving are explained by the Dogon myth that "into the cloth, Nommo [the son of God who invented weaving] wove the words which were bringing a new order."[36] Recent archeological excavations in the Bandiagara Escarpment among the Dogon unearthed remnants of narrow-weft weaving that date back to the eleventh century A.D.[37] While the evidence definitively establishes the presence of narrow-weft woven cloth among the Dogon at this early date, it does not necessarily verify the existence of an indigenous weaving industry there, since, to the best of our knowledge, no implements associated with weaving technology were found. Among the artifacts, however, were some fragments of braiding and rug-weaving that appear to have originated north of the Sahara Desert. While one is tempted to speculate on the interpretation of the Dogon myth in the context of the role of Islam in weaving history, it is perhaps sounder only to suggest that the words woven into the cloth that brought a new order may indeed have been the words of Islam.

One is reminded of the numerous metaphors in the early North African literature that use the phrase "wove on the loom" in reference to historical copy and to poetic speech.[38] An even closer analogy is *tiraz*, the North African cloth into which phrases from the Koran—prayers, good omens, or the names of rulers and their marks—are woven. The term *reggam*, which designates the itinerant male weavers of Algeria, derives from the literary Arabic trunk "to write." This reference is not to weaving per se but to one who, like a composer, designs the motifs to be woven into the cloth.[39] The weaver-composer should therefore have at least a mental knowledge of mathematics. Indeed, there is a close formal similarity between the geometric layout of a *za'irajah* and the various intricate West African and North African weaving patterns!

Among the Fulbe-speaking peoples, when an apprentice learns to weave he is taught at the same time the genealogy of the *maboube*, the weaving families in the caste. This close liaison between weavers and the word through the agency of the *griots*, the musicians and oral historians of West Africa, was reflected in medieval history. When Askia Daoud, the Songhay ruler, went to war against the Ardo of the Macina, the cradle of Fulbe nomadism in the western Sudan, he sent back from his expedition a great number of singers or *mabi*, who, it is suggested, were *maboube*.[40] Among the Wogo weavers of Niger, it is said that to know how to weave is to know how to read.[41] But, while the weavers "read in a book," they do not understand the words. Although specific reference is to the knowledge the marabouts have of Arabic, implied in it is the use of the patterns themselves as a surrogate for written knowledge. Thus, the magico-religious framework that envelops the weaving caste finds strong expression not only in the ritual associated with the skill but in the patterns themselves and the explanation of pattern innovation through the medium of dreams and the supranatural.

The conceptual and behavioral theme of Mallam Idriss which subsumes consideration of the masons and weavers, is equally relevant for the related crafts of blacksmithing, leatherworking, and tailoring/embroidering. With increasing political bureaucracy and hierarchy, the craft castes or guilds, in the service of their patrons, incorporated more and more elements of Islamic reference into their traditional magico-religious structure.

The blacksmithing caste, perhaps the oldest caste in West Africa, was traditionally in rapport with masters of the bush, of the trees, and of the water and the rocks, which they invoked at different stages of their work. Now converted to Islam, they address themselves equally to Allah and his Prophet. Incantations to the masters of the bush begin with Muslim prayers, and myths of origin have incorporated genealogical ancestors who go back to Islamic progenitors, despite the fact that they conserve the rituals of secret ceremony and remain the most closed caste in West Africa. Con-

trolling the tools of production and the tools of war, legends say that the blacksmith has mysterious and magical powers and is in rapport with evil spirits; he is feared precisely because of his control over these tools.[42] In the Fouta-Djallon of Guinea, the myths of origin of the blacksmiths or *wailube* refer to Anabi Dauda (David), to whom God revealed the secret of working iron. Other references are made to the archangel Gabriel, who revealed the use of iron to Adam when he was chased from Paradise. The blacksmiths are also the circumcisers, diviners, and amulet-makers, and their cemetery is located directly west of the Muslim cemetery.

This ambivalent attitude toward the blacksmith, combining fear and awe, also emerges in the presence of Islam. One account relates that Muhamed, pursued by the infidels after a battle, sought refuge in a tree in which a blacksmith was working. The blacksmith, preparing to reveal Muhamed's hiding place to his pursuers, was struck mute by God at Muhamed's request. Upon their departure, Muhamed threw a malevolent spell on all blacksmiths.

In his discussion of the crafts of civilization, Ibn Khaldûn suggested that refinement and development of crafts occurs "when civilization flourishes and luxuries are in demand." Among these crafts are those of the cobbler, the tanner, the silkweaver, and the goldsmith. "Urban luxury demands them."[43] These skills, the result of further specialization evolving out of the original weaving and blacksmithing "castes," more closely served the specific demands of "establishment" rule. These artisans are also the most literate and are held in greater esteem. At Bida, the capital of the Islamized Nupe in Nigeria, the highest craft status associated with the patronage of the ruling emir belonged to the brassworkers. The blacksmiths occupy a secondary status, the carpenters and masons a third.[44]

Tanning, traditionally the responsibility of nomadic women, was delegated to men when it was incorporated into the technology concerning horses. The parallel with weaving invites comparison. Tuareg and Maurish women, many of whom still practice the skills of the leatherworker, were historically literate in either or both Arabic and *tifinar*, the written Tuareg language. They were also traditionally the poets and musicians of their matrilineal genealogies and the drum histories of the Tuareg Confederacies.[45] By the mid-eighteenth century, however, a parallel caste of male leatherworkers, the *korounkoi* of the *Tarikh el-Fettach* or the Dhiakhonke *garankhe*, a Manding-speaking people of northwestern Guinea, had come into existence.[46] The *garankhe*, who now make the horse trappings, amulet covers, Koran covers, sandals, and riding boots, are considered to be among the most puritanical, ortho-

dox, and devout *ulama*, and often comprise the Muslim leadership in the villages over which they exercise control or the villages they inhabit.

The embroiderers, equivalent to the silk weavers of North Africa, hold a particularly distinguished position, and their name, *djennenke*, itself derives from the city of Djenné, one of the great early entrepôts of trans-Saharan trade. Silk thread, like brass, gold, and silver, is a luxury material; the craftsmen who work with it are likewise held in high esteem. The respect and high regard accorded this skill in rural villages is suggested by the fact that the leading members of the *ulama* are not infrequently themselves embroiderers of clothing such as the long robes and trousers, the tunics and caps.[47] Like the brassworkers and the silversmiths and goldsmiths, they sew images onto the wearing apparel that bear a close resemblance to the patterns drawn in the margins of the corpus of the Arabic literature in West Africa. The same two-dimensional surface engages the scribe, the embroiderer, the brassworker, and the leatherworker; only the materials are different. Thus, just as the Fulbe hold those who write on paper to be magicians, so those who write in silk, on metal, or on the tanned leather also become enveloped in a magical, mystical aura.

Fischer, in his discussion of Gothic architecture in Europe in the Middle Ages, suggested that the creation of urban building fraternities or guilds, i.e., castes, "was one of the symptoms of the new age, and the fraternities themselves became the transmitters of a new style."[48] In like manner, the medieval West African development of new polities, of urbanization and sedentarization, could be viewed as a new age. Closely in touch with, often inspired by, and frequently motivated by the demands of Islam and trans-Saharan trade, the castes generated by the new age became the transmitters of a new style, a style that integrated traditional aesthetic preferences with those inherent in the newly recognized and accredited tenets of Islamic philosophy and cosmology.

Behavior in Space

Basic to man's existence is a spatially coordinated pattern of behavior. Without the capacity for spatial orientation, a person is incapable even of effective locomotion.[49] Psychological reality, it has been suggested, requires an awareness not only of oneself but of one's position in some spatial schema. Spatial disorientation is tantamount to extreme psychosis, and we are all familiar with the intense sense of apprehension that results from being "lost" in space. Space is essential to the structure of existence.[50]

Establishment of a spatially defined cosmos is the essence of both ritual behavior and cosmogony. If ritual is both the material representation of abstract ideas and a culturally determined response to objects and events in the external world,[51] it can also be defined as patterned behavior whereby human beings orient themselves in space, mediate with space, modify space, and, ultimately, take control over space. At the same time, rituals have affect and intensity: they generate an emotional involvement with space, integrating the material aspects of human behavior with the material aspects of the built environment within which they are staged.

It has also been suggested that ritual depends for its efficacy on continuity. Only when it contains an element of repetitive behavior, establishing cycles in time, is it ritual. Recurrence, inherent in ritual behavior, provides the continuity upon which people depend for their sense of identity. "It is by drawing on the memory [of ritual] that a sense of identity, security, and continuity is assured."[52] Memory is reinforced by mnemonic material devices: the artifacts of ritual reinforce identity and continuity. The ultimate in continuity and in the use of mnemonic materials in space is the permanence of the built environment—architecture.

The interface between patterned human behavior in space and the natural and/or built environment is established by ritual itself. The transition from time to space is made via ritual; the transposition of self to the external environment is effected through ritual. We would like to suggest that *mimesis*, whereby forms invented in a perishable medium for transient purposes are perpetuated in more permanent media, with lasting symbolic value, is effected by means of ritual kinesis. The projection of human movement in space onto the architecture of the built environment is a form of substitute imagery.

The close relationship between ritual behavior and the schemata of space has been dealt with at great length by a number of scholars in both the social sciences and history. All have addressed themselves to the ways in which various *rites de passage*, critical rituals in a person's life cycle, are staged at critical spatial intersections, such as the culturally defined environment of thresholds, hearths, boundaries, or crossroads. The "territorial passage" associated with ritual transformation such as birth, puberty, marriage, and death is the spatial component of behavior over time.

Within the context of the natural environment, ritual attaches meaning to the invariant configurations of the landscape and the natural phenomena of the universe. When man modifies the environment, references and meanings related to the natural environment are transferred to the built environment: we create new material forms to replicate the natural environment and to represent more accurately the spatial components of ritual behavior. As societies become more complex, ritual detaches itself from the natural environment and builds its own framework, "objectifying" and geometricizing the architectonic environment in the process. The spatial experience of ritual—effected through movement and dance—is replaced by the spatial experience of manmade, physically bounded space. The process is analogous to what Norberg-Schulz has suggested is the way in which man "takes possession" of his environment.[53]

Integral with every ritual structure is a spatial frame firmly fixed in the landscape. This spatial frame is initially a response to natural forces, those due to the symmetries and asymmetries of the human body as well as those of topographical space. "Visible wild nature is a jumble of random curves; it contains no straight lines and few geometrical shapes of any kind."[54] Ranking and orientation are human responses to these natural forces: when the natural terrain fails to provide an obvious focus, culture generates a substitute. It is only with man's control over the built environment, with the shift from atectonic to tectonic space, that the world becomes full of straight lines, rectangles, triangles, and circles. In West Africa, this geometrization of the built environment was accelerated in the wake of Islamic penetration.

Ritual performance projects spatial expression on to the natural landscape by means of an elementary organizational schema: the establishment of centers or places (proximity), directions or paths (continuity), and areas or domains (enclosure).[55] Eventually, the built form becomes the stage for ritual behavior, replicating and recalling the spatial order established by ritual itself. At the same time, human beings constantly make use of themselves as a reference point vis-à-vis the reference points anchored in the objective world. Man, professing to have been made in the image of God, has in turn envisioned the universe as a replica of himself. Since time immemorial, man has also thought of the world as being centered on himself. Legends and myths of origin throughout the world attest to the belief in a center as a point of birth, a point of origin. The center itself takes on a sacred quality; it becomes an ideal. To reach the center is to become initiated, to achieve a consecration. The center is the point from which man acquires his position as a thinking being in space. It becomes a symbol of his existence.

In traditional West African agricultural cultures, the center of the universe is atectonic, autochthonous, and anthropomorphic. Its atectonic quality emerges most clearly in the near-imperceptibility of the visual distinction between the natural setting and man's modification of it (Fig. 3.7a, b). The harvest of maize, sus-

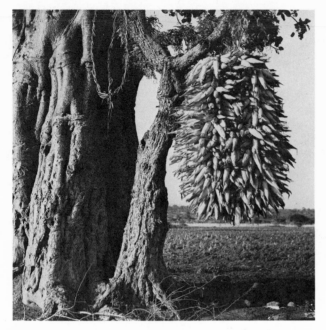

Fig. 3.7a A harvest of maize hanging from the branches of a baobab tree in the savannah landscape.

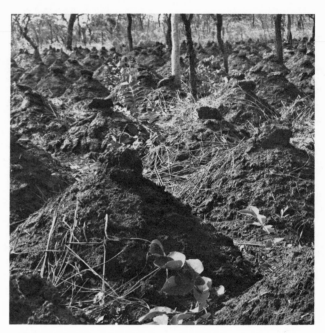

Fig. 3.7b Softly rounded yam mounds, like prototypes of ancestral earthen pillars, surround the built habitat.

pended from the knarled branches of a neighboring tree, appears an outgrowth of the tree itself, hardly distinguishable from the fruits of the tree. Rows of conical earthen yam mounds radiating on all sides of a village provide striking testimony to the associative visual imagery of the natural and man-made environments. Symbols of prosperity and continuity are integral with the landscape itself.

Unlike high-technology societies where the spatial schema is created by the built environment, here the topography and natural markers on the landscape are used as spatial referents in behavior and orientation. The elements of the natural landscape, unstructured and unmodified by the hand of man, are imbued with purpose and meaning. Mountains, hills, rivers, trees, and rock outcroppings initially establish man's position in space. These natural phenomena are rationalized into a theogony that reinforces and validates movement in space.

Cosmologies all revolve around a family or kin-based center in the earth. Myths of origin refer to a primordial emergence from the earth and to anthropomorphic ancestors who inhabit the levels below. The invocation of the ancestors has as its goal the assurance of prosperity, health, and procreation, and through much of the savannah sedentary existence, ethnographic evidence suggests that the foci of ritual, in the sense of sacrifice and prayers, are the ancestors and the earth. The ritual act of invocation is focused on the

ancestral earthen pillar or shrine—the "house" of one's ancestors.

Material expression of these myths can be found in the references to the subterranean dwellings of the primordial ancestors, to sacred groves adjoining an occupied site, and to place-names adopted by clans and families in order to anchor themselves to a particular locality. Ritual expression of these myths is found in the planting of a tree to mark the founding center of a new village, in the location of conical earthen ancestral pillars and shrines immediately adjacent to entrances or directly in the center of a compound, in the location of granaries imbued with sacred meaning at the center of residential space, and in the burial of the deceased within the boundary walls of the compound residence.

Man first "takes possession" of the natural landscape through ritual that focuses on the existing elements of the natural environment itself; then he establishes new centers by physically replicating those traditionally used as natural markers. Throughout the West African savannah these centers are consecrated by the planting of a sacred tree, the addition of stone markers, and then the substitution of earthen pillars for the stone markers (Fig. 3.8).

Whereas the natural elements, the stones and existing trees, locate generalized rituals, those places close to man's actual habitat, i.e., the built environment, are more privileged settings for the rituals associated with ancestry: the yard, the supporting pillar of a house

porch, the threshold and outer frame of a door enclosure are the foci of ritual directly associated with the ancestors (Fig. 3.9a, b). Examples abound of the use of conical earthen pillars to mark the "center" of existence. For example, among the Dogon one finds singular, as well as clusters of, earthen pillars as altars to Amma, the creator god, in courtyards, at entrances, in lanes and alleyways. Among the Minianka at Koutiala, Upper Volta, the invocation and sacrifices to the ancestors take place on a conical earthen pyramid altar or *kle* adjacent to the compound. In the built, tectonic environment, the quintessential symbolic expression of the central position of the ancestors as guarantors of prosperity in the real world can be seen among the Tayaba (Somba) of northern Dahomey (Fig. 3.10).[56] The earthen pillar marking ancestral habitation or presence is located in the center of the family habitat at ground level. Material evidence of sacrificial offerings addressed to the ancestors is evident at its base. This first level is the sacred domain. Directly above, on the second, living level, is the family granary: the symbol of family prosperity and continuity from one harvest to the next, the granary is sustained and supported by an ancestral pillar that links it directly to the earth.[57]

The sacred grove, or the site of a sacred "cosmic" tree, marks for traditional West Africans the place most directly and universally in rapport with the indigenous divinities (Fig. 3.11a, b).[58] Its direct and obvious relationship to rebirth and cyclical time, in combination with its visual ability to mark centrality and verticality on the landscape, makes it perhaps the most perfect symbolic representation of a natural temple. The material aspects of ritual, manifested in the planting of a tree to mark the founding of a lineage and of a human settlement, brings the world of human behavior into intimate rapport with the world of cosmology.

The tree figures as a cosmological symbol among many other cultures and belief systems, including that of Islam. The Islamic tree or *tuba*, which grows on top of a mythical mountain or *kaf*, represents the entire

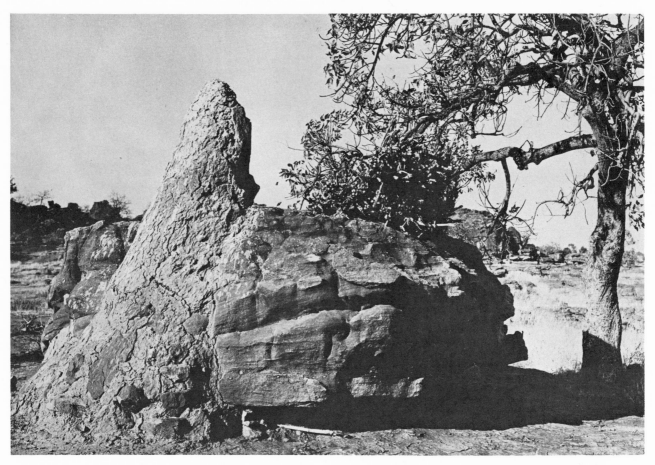

Fig. 3.8 Man and nature merge in the granitic outcropping, the cosmic tree, and the man-molded earthen ancestral pillar, among the Dogon on the Bandiagara Escarpment, Mali.

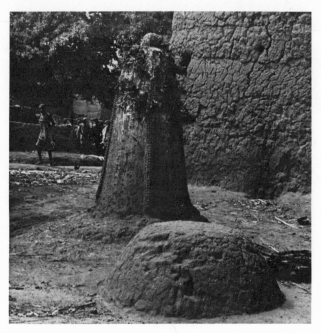

Fig. 3.9a Male and female ancestral pillars at the entrance to a Bobo compound, Upper Volta.

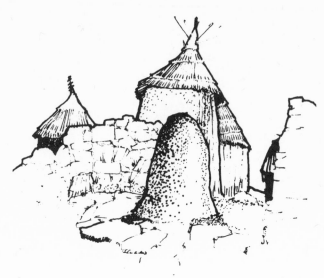

Fig. 3.9b An altar to Amma at Diamini, Sanga, Mali, in the alleyway between two compounds. Drawing after a photograph.

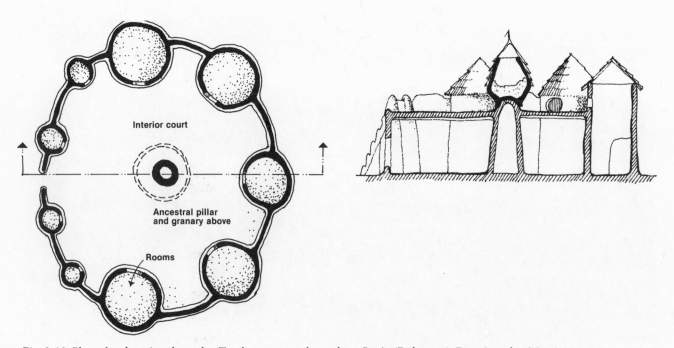

Interior court

Ancestral pillar and granary above

Rooms

Fig. 3.10 Plan of and section through a Tayaba compound, northern Benin (Dahomey). Drawing after Mercier (1954).

cosmos; it is the Tree of Knowledge, which has grown from the seed of the Divine Command.[59] Its central position in space is demonstrated by the way it sends down roots, sends up its trunk, and spreads out its branches in all directions.

The anthropomorphic centrality which envelops West African ritual behavior may well be analogous to the centers of existence that characterize many aspects of the natural world. The rings of a tree trunk are a set of concentric circles that emanate from a vertical stationary axis in space, but more commonly, when no external forces act on it, natural growth from a central seed occurs in the form of a spiral. Among the Dogon, the germ of life is symbolized by the *fonio* or millet seed, which quickens by internal vibration, then grows and unfolds along a path forming a spiral or helix, identical with the Fibonacci curve of the natural world.

The ritual world of behavior that enacts this cosmogony is expressed in the landscape by the theoretical layout of cultivated land around the three original ritual fields, assigned to three mythical ancestors. "Starting from these three fields, the various shrines are located along the line of a spiral starting from this fixed center" (Fig. 3.12a, b).[60] This theoretical layout finds application in the topography of the real world, where the contours and watering sites often do contribute to the material realization of a ritual and cosmic ideal. At the same time, however, one recalls the religious Islamic ritual *dhikr*—in which, by their progressive whirling ecstasy, the spirits of dervishes spiral up and around the celestial orbits—and the circular motion of the rite of circumambulation or *tafa*—the sevenfold path of a Muslim around the Ka'ba at Mecca, which permits one to attain the summit of a thing by spiraling around it.[61]

The way in which natural directions structure ritual space is exemplified by the Mande creation myth, which permeates much of West African cosmogony. Without entering into the complex association of related rituals and behaviors, one can cite the account of the journey of Faro, considered by the Mande-speaking peoples to be one of the twin progenitors of the human race (Fig. 3.13). Traveling northeast from Kaba (the first village, laid out at the four cardinal points around a central field), there are twenty-two place-names that follow the course of the Niger River from Kaba to Mopti which are associated with and participatory to the ritual of Faro. Direction, path, and orientation in space are accomplished by using a natural, pre-geometric schemata.[62]

For sedentary agriculturalists, the ancestral earthen pillar and the centrally located trees of a founding settlement are stationary centers validated by ancestry and ancestral worship. These stationary centers are matched by "moving centers" of ritual among the nomadic peoples of the savannah, in whose myths of origin ancestral worship is strikingly absent.[63]

The dialectic between stationary and moving centers is related to yet distinguishable from the difference

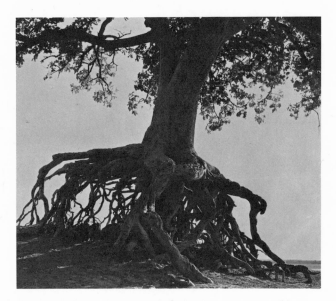

Fig. 3.11a An ancient tamarind tree, its roots exposed by soil erosion, marks a ritual center on the landscape.

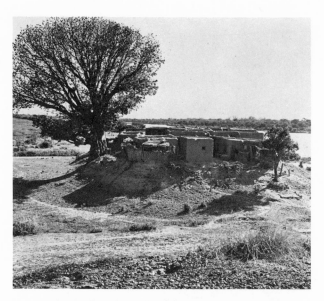

Fig. 3.11b The founding tree of the ancestors towers above a small village on the Niger River, Mali.

Fig. 3.12a Theoretical spiral layout of cultivated farms among the Dogon, Mali. Drawing after Griaule and Dieterlen (1965a).

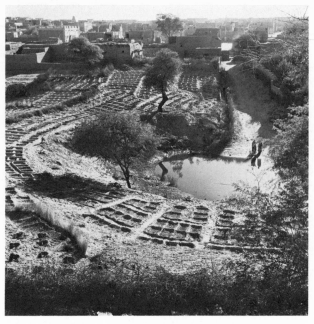

Fig. 3.12b The checkerboard-like dry-season gardens which curve like a spiral around a water source at Tombouctou, Mali. The pattern is created by the raised wall mounds around each plot, which retain water.

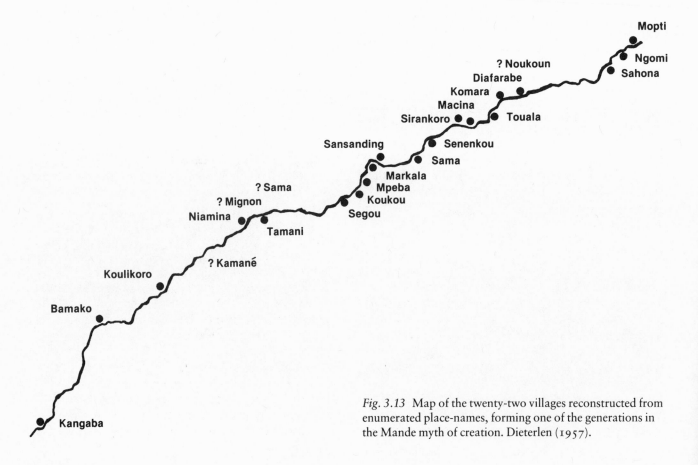

Fig. 3.13 Map of the twenty-two villages reconstructed from enumerated place-names, forming one of the generations in the Mande myth of creation. Dieterlen (1957).

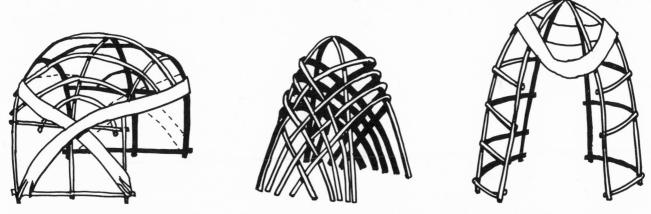

Fig. 3.14a Three types of Tuareg *nnaka*, or camel palanquins. Drawing after F. Nicolas (1950); Lhote (1944).

Fig. 3.14b The Tekna palanquin or *ufta* in southwest Morocco. Drawing after Andrews (1971).

between the spatial schemata of early agricultural civilizations and early nomadic ones. The agriculturalists are place-oriented, living a static life within a centralized "closed" area. "Their paths have a circular engirdling movement, rather than functioning as a direction toward a goal outside," in contrast to the "existential space of nomadic peoples [who] give primary importance to the domain within which the paths have a great range of freedom, but their place-concept is less developed."[64]

The myths of origin of nomadic peoples (as well as scholarly hypotheses concerning their origins), all suggest migration *to* or *from* a place, a center. Consideration of the organization of, for example, Tuareg or Fulbe space suggests that the very nature of transhumance imbues their behavior with a directional rather than a spiraling quality, just as, when a center moves horizontally, it establishes a trace or a line in space.

The moving center of the Tuareg domain, unlike the conical male ancestral earthen pillar anchored to the sedentarist landscape, is a female symbol, represented by the palanquin, the central supporting post(s)

of the tent structure, and the transportable bed (Fig. 3.14 a–b, Plate 4). The architectural concept of a transient structure itself depends upon the woman's palanquin, the mounted cages in which women of caste or aristocracy travel when a nomadic group is in transit. Among the Kababish nomads of North Africa it is the *ufta*, among the Toubou in the Fezzan it is the *dela*, among the Tuareg the *nnaka*, among the Songhay the *tongo tongo*, among the Arabs the *lhtar*. The palanquin, part of the wife's trousseau, is a symbol of transit.

The central pole is equivalent to establishing "place." The eastern Tuareg use a single central post, a *madag*, capped by an *asolan*, a curved wooden capital, to support and distribute the concentrated load of the tent vellum. The two elements together are called the *tamakait*, a term derived from the verb "to support," used in a moral sense.

The *tamakait* carries a set of four ties which extend to four elaborately carved bracing members or *sigattawin*, from which the leather baggage and calabashes are suspended. The exterior frame is composed of twelve stakes, three on each of the four sides. The

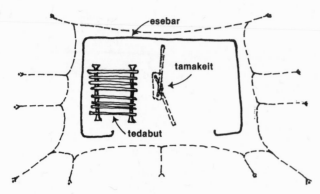

Fig 3.14c Plan of a Tuareg tent with its *tamakeit* and twelve supporting poles. Drawing after F. Nicolas (1950).

only stake that is elaborately carved is the *igem*, the one that marks the south-facing front entrance of the tent; to it is attached the highest tie of the stretched vellum.

Ehen, the term for the tent itself, is also the Tuareg term for marriage. It carries a broader meaning than "abode," implying shelter in general. *Ehen n elmusi* is the sheath of a knife, and the term has been extended to mean an entire lineage as well as any kind of house. "To mount a tent is equivalent to founding a hearth."[65]

The Tuareg ceremony of *ehen* is a *rite de passage* and, like all critical aspects of behavior, it is particularly revealing of the interface between an individual and his/her spatial environment. Among the Ahaggar Tuareg, one of the first acts following the ceremonial camel ride and the introductory wedding feast or pre-marital celebration is the preparation of a wedding place, in which bride and groom meet ceremonially for the first time.[66] The women construct an earthen sandhill, called an *adebel*, about a meter high, just large enough for the couple to sit on and over which the wedding tent is erected to the accompaniment of cheers, shrills, and drumming. Before the vellum is stretched or suspended over the mound, an old woman lies down on it with a pole, a *rkaiz*, in each hand. She presses the two poles together at the top, and while she lies there two men join her, one standing on either side of the mound. The tent vellum is thrown between them, over both mound and woman. The tent is then raised, with the vellum resting on the two poles buried in the ground. Bride and groom are brought separately and placed upon the mound, the bride behind the groom. The next morning the wedding tent is taken down and mounted like a normal tent, with the vellum attached to twelve poles. A much lower, longer sand mound, a *tuf-adebel*, is built and covered with tapestries or blankets; it becomes the sitting place for the couple. The *tuf-adebel* is built on the left (western) women's side, where the bed is located. When the camp moves, this mound will be left

standing and will remain until inclement weather erases it from the landscape.

The space defined by the tent is divided in half along the axis established by the one or two poles of its center. The "noble" eastern side, the "Levant," is reserved for the men of the family, the west for the women.[67] The large, rectangular, wooden Tuareg bed, or *tedabut*, located in the western half of the defined rectangular space, consists of two heavy wooden supports, intricately carved, mounted on four wooden or fired-clay feet. Over the two wooden cross members five secondary poles are laid, with a woven mat placed on them. The bed serves as a measure in striking the tent and staking out the poles. Thus, its rectangular configuration dictates the arrangement of interior space.

Nomadic Fulbe ritual and spatial structure suggests an analogous pattern to Tuareg space, one perhaps even more articulate in its lineality of a "moving" center by the introduction of cardinal direction. Among the still fully nomadic Fulbe *bororo*, rites of initiation all center around the transhumance of cattle. One of these rites takes place at Diafarabé, Mali, when the Fulbe move their cattle into the Upper Niger Delta for dry-season pasturage.[68] In the course of this initiation, the postulant is instructed in a traditional cosmogony which, in reflecting the entire life of the nomadic Fulbe herder in association with the transhumance of cattle, finds expression in a mythic linear, directional geography established by a moving point in space.

This spatial structure is reflected in the Fulbe homestead.[69] The homestead, a simple circular enclosure formed by a brush fence, always opens and fronts on the west side (Fig. 3.15a). Within, the bounded circle is bisected by a calf rope. The western hemicircle and its entrance, including the corral, the corral fire, and all herding activities, is the male domain. The eastern half, within which the domestic fires and women's sleeping shelters, the *bukkhu* or *suudu*, are found, is the feminine domain. Within her *suudu*, the bed and the *kakul*, the collection of calabashes which constitutes the ceremonial wedding dowry, are the two distinctive marks of a woman's married status (Fig. 3.15b). The *kakul* is associated with the *kaggu*, a sort of wicker console made of a trellis of vines placed against the west wall of the *suudu* or matframe tent reserved for the senior wife. It sits immediately at the side of the head of her bed. The *kaggu* (derived from *haggude*, "to weave" and "to attach" in the moral sense) is the most important of the pastoralist Fulbe altars.[70]

It has also been suggested that masculine hierarchies are arranged in space from south to north and feminine hierarchies from north to south. Generational depth is expressed from west to east. This spatial order is equally binding upon the "true" nomadic Fulbe, the

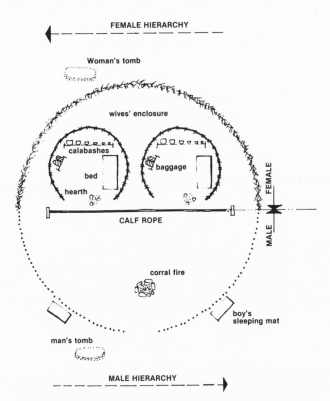

Fig. 3.15a Plan of a Fulbe nomadic compound. Composite drawing after Stenning (1964) and Dupire (1962).

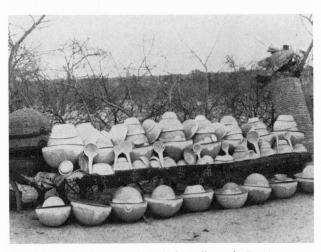

Fig. 3.15b The dowry or *kakul* of a Fulbe wife. Dupire (1970).

bororo, as upon the Fulbe of the Fouta-Djallon and the *torobe*, the most highly Islamized noble aristocracy. Even among the least Islamized nomadic groupings, it is claimed that the stringent orientation is due to advice from Uthman dan Fodio, the leader of the early-nineteenth-century Fulbe *jihad* in northern Nigeria.[71]

The linear extension from a center creates a domain within which ritual unfolds and the area of space is defined. The spiral line of Dogon ritual and behavior, for example, generates a circular periphery, whereas the cardinal extension of nomadic centers creates a set of four quadrants that extend into a square or rectangular area. This linear projection along the cardinal directions is reflected in the conical roof finials among the transient Sorko fishermen who ply the waterways of the Bani River in Mali (Fig. 3.16a). The acknowledgment of cardinal directions in space also appears to have been represented, remarkably early, in one of the rock painting frescoes from the Tassili region northeast of Djanet near the Algerian border (Fig. 3.16b). Interpretation of the text of the initiation ceremony of the Fulbe pastoralists referred to above has convinced scholars that these frescoes can be attributed to early Fulbe migrations across a once-fertile Sahara region into the Macina of western Mali.

Perhaps more surprising is the incorporation of this sign into Manding-speaking cosmography, where among the sedentary Bambara as well as the Dogon one finds a cross whose two major axes, terminated by four closed circles, divide space into four quadrants (Fig. 3.16c). Among the Dogon this is the sign of polarity, the central axis tying the star of the north to the star of the south; it is the eyes of Amma, the founding Dogon deity.[72] One is reminded of the Koranic reference to Allah as the polar star around which all others revolve, the focus of all Islamic cosmological and scientific thought.[73] The Islamic cosmos consists of five concentric circles representing various states of being emanating from a Divine Essence, the ultimate manifestation of Allah. Analogous to the cosmological model is a mathematical model of the terrestrial world, consisting of seven concentric climatic zones surrounding the mythical mountain *kaf*, at the top of which grows the Tree of Knowledge. Geographic distances are measured by the relative positions of points with respect to the Ka'ba at Mecca, which was built from a meteorite that is considered to be the direct and tangible substance of Allah.

The graphic representation of the polar star in West African cosmology also puts one in mind of a legend accounting for the design of the original mosque at Kufa near Ctesiphon, which was built in A.D. 638.[74] Once the site had been selected, an archer shot an arrow in the direction of Mecca, then one in the opposite di-

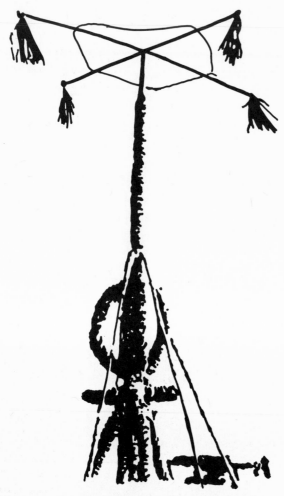

Fig. 3.16b Rock painting from the Tassili region at Ina-ouanrhat, northeast of Djanet, near the Algerian border, suggesting four cardinal directions. Drawing after Lajoux (1962).

Fig. 3.16a Conical roof finials among the Sorko fishermen along the banks of the Bani River, Mali. Leiris (1933).

Fig. 3.16c The Dogon and Bambara symbol for the polar star. Drawing after Griaule and Dieterlen (1951).

rection, then one to the right and one to the left, all from the same central point. Trenches were then dug describing a square. Three gaps on each side of the square, itself formed by the length of two arrow casts, served as entrances. (See Figs. 6.28c, 7.34b for West African parallels.)

Centers or "places," and directions or "paths," whether they be circular, spiral, or cardinal, combine to create the horizontal plane of an area or domain. When places or areas so defined interact with their surroundings, a relationship between inside and outside is created, and the concept of closure and boundary enters into spatial orientation and identity.[75] In atectonic space, boundaries and closure are defined by natural phenomena and topographic features, just as centers are. The movement in space of ritual behavior—dance and performance—also encircles and delimits an area and creates, even if momentarily, a closed, bounded form, a set of surrogate spatial perimeters for the domain.

Behavior and the Built Environment

The boundaries created by human movement can be considered as analogous to the boundaries set up by the built environment. Establishment of inner space by means of a boundary makes that inner space sacred and inviolable, just as rituals and rites of protection serve to sacralize and take possession of space. Just as a dancing ring without a break becomes the ultimate symbol of secrecy, protection and sacrality, so a diviner sits inside

a magic circle of stones that the uninitiated may not enter, in communication with the oracle and the supernatural (Fig. 3.17). The concentric circles of stone that define and bound the sacred space within which the diviner performs is identical with those circles of stones that define the sacred Islamic space of many rural village mosques in the West African savannah. The single, critical difference is the larger stone(s) indicating the *mihrab* at the point in the circle that is closest to Mecca.

There is a further distinction between observing ritual and experiencing it as a participant. As an observer, one is outside the action, whereas as a participant one is within an enclosed space and perception is heightened. An emotional association is established between the ritual behavior and the bounded space, expressed through identification with the wall surfaces that envelop the action. For example, among the B'Moba of northern Togoland, circumcision ritual takes place in the bush, in a circular palisaded enclosure (Fig. 3.18).[76] As part of the rite, the young initiates dance in a circle with their long staffs pointed inward toward the sacred tree in the center, like the spokes of a wheel. The circular wooden palisade replicates their movement in space: two concentric circles of protection are formed, one by the initiates' bodies, the other by the enclosing fence itself.

Taking possession of one's environment involves a journey, a departure and an arrival, just as Faro's journey along the Niger River symbolized taking possession of the Mande realm. That ritual journey, which is reenacted every seven years, involves renewal of the possession of place. In similar fashion, the king of Nupe mounts his horse and, accompanied by members of his household and officers of state, *rides around the walls of his house* every morning.[77] The ride, a daily ritual of renewal of the act of taking possession, is to

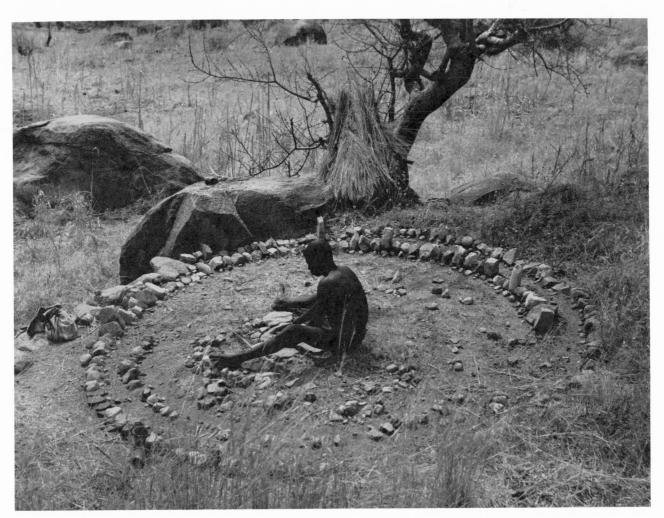

Fig. 3.17 A diviner from the northern Cameroon, within the concentric stone circles that bound his sacred domain.

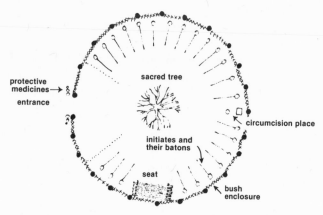

Fig. 3.18 A circumcision enclosure used by the B'Moba and the Gurma of northern Togoland. Drawing after Froelich (1949).

this day part of the king's daily routine, even though he now lives in a new brick house on a hill outside the town of Bida.

Another mythical account from Bida recalls how Mallam Dendo, the early-nineteenth-century Fulbe *ji-had* leader in Nupe, Nigeria, after performing his secret magic on some earth brought from the enemy camp, had two men scatter the magical earth by night *all around the town walls*. The next morning, a catastrophic sandstorm struck, leading to the ultimate defeat of the pagan Nupe army.[78] Surrounding the city with a protective ring of magical earth is similar to the sacrifices made to the ancestors at each of the earthen buttresses that encircled the citadel of Sikasso, Mali, the night before a French military attack.[79]

Inner space is defined by its exterior boundary; access into the space of a closed form requires an opening, which links the inner space to the outer. It is not surprising, then, that openings assume such great symbolic importance in man's mind. Openings are particularly fraught with danger as mediators between sacred and profane space. The West African ethnographic literature is remarkably rich in documentation of rituals performed at entrances and openings, whether thresholds, entrances to sacred groves, or village approaches. As far as we know, every act involving the closure or bounding of space and every act involving openings or passages through space is accompanied by some ritual behavior.

West African architecture is also rich in material artifacts of rituals that focus on openings into space. Every opening into a residential compound, into the sacred space of a shrine house, or into the city walls provides evidence—the ancestral pillars with their abundance of sacrificial feathers, bones and medicines,

the talismans hung from door and window lintels, the carved posts, the decorated door surrounds. In the B'Moba circumcision enclosure there is a single opening into the closed space of the palisade, and each side of this opening is guarded by protective medicines and sacrificial offerings. The superbly carved Dogon granary doors are perhaps one of the best-known examples of precisely this phenomenon (Fig. 3.19). Granaries (a closed form) are critical to a family's survival, and their construction and completion are accompanied by various rites and placations, addressed to the ancestors, to guarantee their successful functioning. The eighty founding ancestors represented on the door in the illustration, a visual surrogate for ritual, are located precisely at the interface in space requiring the utmost protection.

One myth of origin among the Mossi people of Upper Volta relates how the first ancestor of the founding lineage of the Savadogo of Yatenga descended from the sky in a house without a door. There was a noise inside, and those who heard it cut an opening. Within, they found an earth priest fully equipped with the accoutrements of his office: a tall red felt *tarboosh* (apparently of North African origin), a ceremonial hoe, and a pronged staff used in ritual.[80] While the presence of the red *tarboosh* leads us to a consideration of the role of Islam in the built environment, the myth of origin also

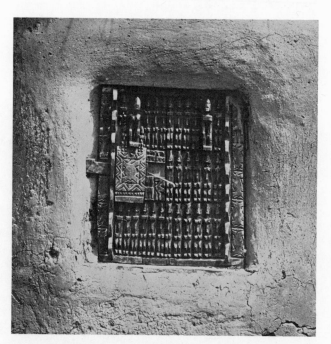

Fig. 3.19 The carved wooden door of a Dogon granary, on which the eighty ancestors of the Dogon, whose presence protects the granary and its contents, have been carved.

illustrates the nature of revelation through an opening into the sacrality of closed space. Another Mossi rite that occurs during the royal investiture involves the king passing through a new door which has been especially cut into the wall surrounding the blacksmiths' quarters. This symbolic act of opening up an entrance into the closed quarters of the most feared of all castes is like "opening the road of his kingdom."[81]

In the traditional history of Asumegya, an Asante clan, when one of its chiefs was destooled he destroyed all the regalia associated with his position.[82] Angered, his subjects seized him, bound him, and built a house around him that contained neither doors nor windows; such a house is known in Asante as a "dumb house." Although this event also takes us into the realm of the semiotic aspects of architecture, it obviously reflects the incredible psychological punishment—in effect, death—that is imposed by a closed space without an opening.

The vertical has always been considered the most sacred dimension of space, representing an *axis mundi*, a path leading from one cosmic realm to another.[83] The vertical dimension represents resistance to the laws of gravity and man's ability to conquer nature.

The prowess of African dancers is often measured by the height to which they can leap, just as those who have mastered the technique of walking on stilts, often used in West African dance, are held in awe because of their seeming conquest of gravity and detachment from the earth. In contrast, the stooping, grovelling motions of dance, as well as ritual behavior, acknowledge the pull of the earth and deny the dignity of existence. The height of a Dogon *sirige* mask, worn during the *sigi* festival which celebrates the sixty-six-year cycle of rebirth, is a symbol of verticality in the traditional, atectonic context (Fig. 3.20). In contrast, earth, the building material par excellence in the savannah, weighs heavy, offering little resistance to the pull of gravity and lacking the physical attributes of tension and soaring lightness.

The vertical dimension of space translates area into volume by its projection above the earth; it expresses the very process of building. The *sirige* mask is also called the "house" mask, perhaps not only, as has been suggested, because of its representation of the founding ancestors of the Dogon, but because it symbolizes aspiration toward verticality in an environment which is so limited in its physical ability to conquer the vertical dimension of space.

In the course of a search for the architectural aesthetic at Djenné, Mali, we asked the *bari* master mason to single out what he considered to be the most beautiful facade in the city. When we asked what had dictated his choice, he replied, "It is the most beautiful because it stands tall and straight, like a man."[84]

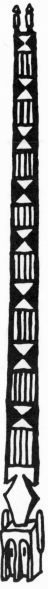

Fig. 3.20 The *sirige* or "house mask" of a Dogon family. Drawing after Griaule (1966).

The vertical dimension creates vertical planes, hence surfaces that establish the physical and visual presence of permanent bounding elements of space and provide physical continuity in the environment. Ritual establishes continuity in space through repetition over time. When these patterns of behavior engage components of the built environment, the visual elements used in ritual are transferred to the built environment. Ultimately, the built environment subsumes ritual by taking over its mnemonic role. Continuity becomes permanently anchored in the physical environment.

Ritual behavior in West Africa has been a primary medium of interaction between person and environment; the needs of psychological reality in establishing place, direction, and domain have depended heavily on natural phenomena for their satisfaction. The locations of centers, the lines of paths, follow only those rules of geometry dictated by the symmetrical, biaxial anatomy of man himself and the movement of the sun and stars across the heavens, hodological fashion.

Islam, in the course of its penetration into West Africa, contributed much to the institutionalization of a different set of prescriptions concerning behavior in space, to the transposition of hodological space into Euclidian space, and to the transformation of atectonic referents into a set of tectonic ones with a mathematical rationale. The libidinal, ego-based centers of the traditional West African universe were joined by another center removed in space—the Ka'ba—and a mathematical construct entered traditional cosmology. To spiraling motion of movement around a single center was added the lineality dictated by the binding prescription that one must face Mecca in a host of ritual behaviors (Fig. 3.21).

The plan of the Dagomba village of Kasuliyili in northern Ghana illustrates the way in which the transformation of spatial orientation occurred with the introduction of Islam (Fig. 3.22). Although the village is first and foremost a sociogram of kinship structure, and

its morphology depends on a number of traditional behaviors, it also incorporates the correspondence between centers which we have tried to suggest. The original center is marked by the ruins of the founding chief's compound and a grove of towering baobab trees. The axis through this center also separates the indigenous community from the newer Islamic community, which centers on the mosque. The twin village thus created has two centers: one representing the ancestral community, the other the Ka'ba, a new center of the universe.

There are four schools of Islamic law or *sunni*, each of which interprets the Koran, the Book and the Word, in somewhat different fashion. All of West African and much of North African Islam follows the prescription of Malekite law. Malekite law is based on the *Kitab-al-Muwatta*, written by Malik in the ninth century A.D., and the fourteenth-century *Mukhtasar* of Khalil ibn-Ishaq, a set of interpretive commentaries based on the original law.[85] The prescriptions of Malekite law address themselves specifically to ritual behavior in space. As one of the two major sources for Muslim behavior, the *Mukhtasar* constitutes an entire system of jurisprudence, elaborating in great detail the specific prescriptions and proscriptions for both religious and civil behavior binding on every true believer. This corpus of common law includes commentary on building practices as well, so it serves as both a building code and a set of zoning ordinances.[86]

The center at Mecca was represented by the Ka'ba, a simple oratory, roughly 25 by 25 elbows square. Malekite law prescribes that the cube of the Ka'ba should serve as the prototype for all places of worship, that the *mihrab* niche indicating the direction of Mecca should be located in the center of a *qibla* wall which is perpendicular to the line linking the worshipper to Mecca, and that the faithful, in prayer, should rank themselves in *sufuf* behind the *imam*, the religious community leader, in regular lines parallel to the *qibla* wall. Kinetic behavior itself is ritualized by the turns and steps, by the position of the body and its tactile contact with the peripheral plinth of the Ka'ba.

Orientation toward Mecca is specifically prescribed for the most critical *rite de passage* of life, funerary practice. The body should be placed lying on its right side facing Mecca. Although the bier of a woman might be covered with a rounded structure modelled after the shape of a camel's back, that of a man should be rectangular and flat. The tomb and its opening should preferably be built of brick, and coffins (implying mobility) are forbidden.

An assumption of Malekite law that runs contrary to the systems of traditional land tenure in West Africa is that private property and, by extension, pri-

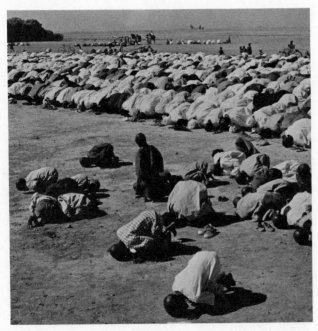

Fig. 3.21 The spatial order of Islamic ritual is reflected in the closing prayer of Ramadan at Djenné, Mali.

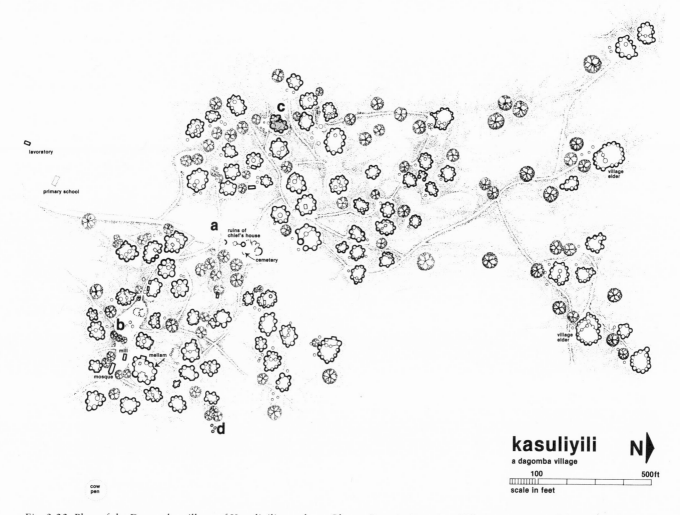

Fig. 3.22 Plan of the Dagomba village of Kasuliyili, northern Ghana. Prussin (1969). *a*. Village "center" and the ruins of the former chief's house, and an ancient cemetery. *b*. A second center around the village mosque and the *mallam*'s house, in the Muslim half of the village.

vate space are inviolable and primary. Thus, an owner who possesses houses on both sides of a public street can tie the two together by means of an overhead bridge. It is, then, possible to project one's private domain into the street itself, and many alleyways that appear to the foreign visitor to be public space are actually part of the private domain.

The introduction of the Ka'ba as a second center for the universe laid the basis for translating traditional West African concepts of space into the objective, geometrical rationale of Islamic space. The process appears to be similar to that of Islam's own early cosmological history, when the mythological perspective of traditional cosmogonies was translated into the mathematical perspective of Islam. The seven climates, the seven

planets, the three kingdoms plus the four natures, the seven active powers of the body, the number seven as the perfect number, the seven prophets related to the seven planets, the seven stars of Ursa Major, four of which form a square and three of which form a triangle, all reflect the numerology of Islamic symbolism. At the same time, this Islamic numerological symbolism was based on the unity of nature and anthropocentric, anthropomorphic analogies. The geometrization of the human body and its relationship to the hierarchy of the Muslim universe are marvelously revealed in the early Sufist writings of a number of Islamic scholars. The *Rasa'il* speaks of the body as composed of 9 anatomical elements, of 10 stages of development, of 249 bones connected by 750 tendons.[87] There are, moreover,

eleven treasures and twelve openings in the body. The nine substances of the body correspond to the nine heavens, the twelve openings to the twelve signs of the Zodiac; the seven powers of the body correspond to the seven planets and seven spiritual powers; the five senses correspond to the five moving planets; and the four parts which comprise the body correspond to the four elements.

The geometrization of the atectonic world of West Africa is exemplified in the blacksmiths' furnaces of the Ader region of Niger.[88] The furnace is in the form of an earthen cone (like an ancestral pillar), fashioned of mud mixed with medicinal plants. It is bounded by seven iron rings, which define the seven vertical levels through which man links heaven and earth in the Islamic tradition. "Four times three air holes are put in at two different levels in the directions of the four cardinal points. The pot sits or rests on seven cones of dried mud, each in the form of a half-cylinder." Thus, the blacksmiths' furnaces, like the incantations the blacksmith voices before commencing his work, reflect a set of mathematical relationships validated by the mysticism of numbers.

A related, even more clearly articulated geometric construct, particularly interesting because it involves a "moving center," is seen in the spatial organization of a ceremonial iron lamp, a *fitula* or *fitine* made by the Bambara blacksmiths at Kolenze, Mali (Fig. 3.23). The lamps have a traditional function in the ritual context of both secular *ton* associations and religious *do* associations. Planted in the ground, they are used at night to illuminate the masquerades that accompany both Islamic and secular celebrations. The lamp has a central vertical axis and four secondary stems, oriented in the cardinal directions. Two of the stems are composed of four cups each, and two are composed of two times three (six) pairs of smaller oil cups. The hierarchy of three, four, seven, fourteen, and twenty-two is more than a numerical progression; it is a tightly structured geometric construct that translates units into the three dimensions of space. In plan, the arrangement closely resembles a set of four quadrants defined by two major axes intersecting at a center—a moving center, since the candelabra is replanted with each new ceremonial event. The number clusters in the series are all frequently found in West African cosmological references, but the total number of cups, forty-six, is unique. In Islamic belief, it is the number particularly associated with the Prophet's dreams: "Dream vision is the forty-sixth part of prophecy."[89]

The transformation of atectonic space into tectonic space was accompanied by the sedentarization of nomadic groups, by urbanization, and, ultimately, by efforts to build large monuments—all dependent on the

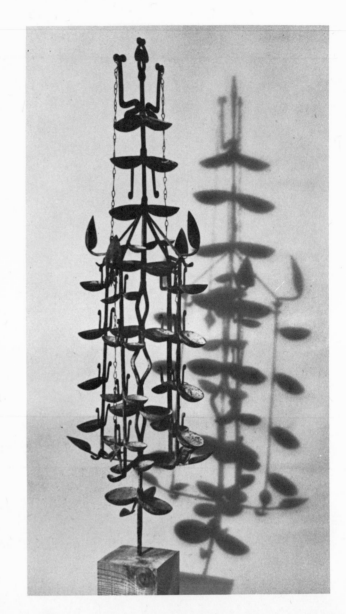

Fig 3.23 Ironwork candelabra or *fitula* from Kolenze on the Niger River, Mali. In plan (bottom), the candelabra closely resembles a number of leatherwork motifs.

The Behavioral Environment 69

mathematical sciences. The importance of sedentarization is stressed in Malekite commentary, which states that one of the primary goals of Islam is the consecration of a mosque to celebrate the solemnity of Friday. The conditions of validity for such a place of worship are that those who have consecrated themselves should intend to remain in a fixed place, that the construction be of substantial building materials, and that it have a permanent roof. Thus, not only was a new focal point referent in space established, but the ideal, in an anchored form, encouraged and justified sedentarism.

Sedentary civilization, in the minds of medieval Islamic scholars, is equated to civilization itself, and nomadic anarchy is its antithesis.[90] Ibn Khaldûn went so far as to suggest that in nomadic existence is the negation of building, which is the basis of civilization. The symbolic beginning of sedentarization among the nomadic groups of West Africa focuses on the "moving center" (referred to above), and finds expression in the anchoring of a symbol of center to the earth. Just as the planting and placation of a cosmic tree is the physical manifestation of ritual associated with the establishment of place in the universe, and just as the ancestral earthen pillar is the expression of ancestral center among sedentary agriculturalists, so the carved, forked post of the Fulbe, the *do ba*, surrogate for the tree, symbolizes the first act of settling (Fig. 3.24a). The term *do ba* literally means "place of the fathers," and the three carved prongs support a bowl or calabash containing sacrificial offerings to the ancestors. The forked post, marking the center of a settlement, is found equally and ultimately in the same location as its counterpart, an ancestral earthen pillar—in the center of newly founded and settled nomadic communities, at the entrances to compounds and converted tents that are no longer transported, and in the inner courtyards of the aristocratic, political elite of newly settled groups who, in many instances, have moved into the already sedentary agricultural community.

The symbol of settling itself underwent a process of geometrization in the course of changes in aesthetic preference (Fig. 3.24b). The *asanads* of Tuareg and Maurish nomads, now anchored to their tri-level earthen bases, reflect in their play of geometric combinations the same spatial format as the candelabras discussed above.

The antithesis of atectonic West African belief and ritual is the emphasis on monuments found in early Islamic communities. Monuments are the measure of civilization and of strong political authority, since only a strong authority can command the resources needed to construct large cities and high monuments.[91] The size of the monument is proportionate to the power of the ruling dynasty. Cities can become physical surro-

Fig. 3.24a A *do ba* or altar-shrine rising from a stone circle base, adjacent to a sacred tree.

Fig. 3.24b An *asanad* or calabash support. Drawing after Gabus (1958).

gates for a large army, affording protection and resisting attack. The mosque is in fact the quintessential monument, the formal ideal of building. The Islamic ideal of a city includes not only sedentarization, but geometrization couched in anthropomorphic terms. "The body of man was constructed like a city. The body is composed of different parts and consists of several biological systems like the quarters of the city and its buildings. The members and organs are connected by diverse joints like the boulevards with respect to the quarters."[92]

The conscious acknowledgment of the built environment is expressed in the great number of prescriptions that emphasize visual privacy and its achievement through physical means. For example, any new aperture that might provide visual access to another person's property through a wall is forbidden. Although the law does not ordinarily interfere with increasing the height of a building above that of its neighbors (even though light and air are thereby cut off), if such increased height allows one a view into a neighbor's courtyard it is forbidden. Doorways should be located so that one cannot see from one's own doorway into the vestibule of a nearby house; hence two doorways facing on an alleyway should always be located at a distance from each other. No one may open a shop opposite the entrance to another's house, and no one may climb his date palm unless he previously informs the neighbor whose courtyard may be seen from that height. The physical boundaries of space become omnipresent—and omnipotent—in human behavior, setting the stage for a new kind of visual aesthetic.

The underlying principles that unite behavior in space, cosmology, and the final projection of both onto the built environment in history are superbly documented in a germinal work on the structure of space in Hausa cosmology.[93] The felling of a tree and the hunting of an animal involve "tying up the bush," by behavior relative to the four privileged directions of the world. Among the sedentary Hausa farmers, the limits of a field enclose a sacred space and the first ritual desacralization in clearing a field involves an "opening of the bush." The directional behavior, which also involves the planting of trees, results in a diagonally oriented quadrilateral (Fig. 3.25). The underbrush is placed in five piles, one at each corner and one in the center, forming a quincunx or pentagram. The planting itself is carried out following the cardinal directions: millet, considered masculine, is planted in an east-west direction, and sorghum, a feminine plant, is arranged in a south-north direction. The whole of the planting process resembles a weaving operation and a linking or marriage between the millet and sorghum.

The same operations govern the installation of human settlement, at both the micro and macro levels:

a

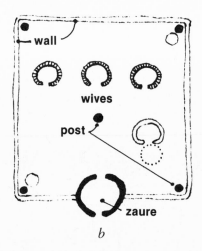

b

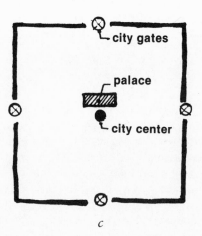

c

Fig. 3.25 The structure of space in Hausa cosmology. Drawings after G. Nicolas (1966). *a*. The directional planting pattern. *b*. Ideal plan of a Hausa domicile. *c*. Ideal plan of a Hausa city.

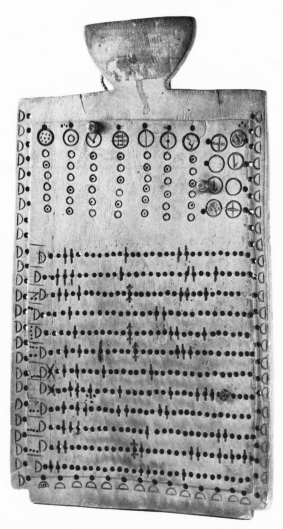

Fig. 3.26 A calendar from Benin (Dahomey) that incorporates three different systems of reckoning time: the traditional four-day calendar, the seven-day Muslim calendar, and the more recently introduced European calendar.

the traditional West African context, one finds evidence of a change in the cycles of time dictated by the tenets and cosmogony of Islam itself. Time in West Africa is dictated by patterns of economic pursuit: planting and harvesting cycles, and the periodicity of cattle transhumance according to grazing requirements. All other aspects of behavior are linked to these basic cycles: marriage, building, rites directed to the ancestors, initiation, funeral celebrations, all occur at points of time established by the basic needs of subsistence life. Islamic time relates to the lunar calendar, to the revolution of the sun through the signs of the Zodiac, and to the motions of the heavens rationalized by their cosmology.

Traditional West African time was based, in many instances, on a four-day market-week cycle. Market day was the day of rest, associated with traditional religious life. "At that time . . . time was reckoned from one week to another by means of the four days of the market . . . from one month to another by means of the moon; after that, by the seasons and the great festivals; if the interval to be expressed was over a certain number of seasons, one took as a reference point a conspicuous event: the death of a king, the return from such and such a campaign."[94]

The conversion of this four-day week into a seven-day Muslim week required considerable calculation, and one finds physical evidence of one such effort in several Dahomeyan calendars, which, it has been suggested, were introduced into Dahomey by Hausa merchants coming from Nupe country at the beginning of the eighteenth century (Fig. 3.26). The four-day calendar is represented at the upper right angle and the seven-day calendar is on the upper left part of the wooden, Koranic-type board. The two are joined by a third annual calendar more recently introduced by Europeans. The calendar was used to correlate traditional rituals and Islamic rituals by translating the temporal dimensions of one into the other. A map of market periodicities in West Africa reinforces this suggestion of the Islamic influence in changing the nature of time. All those regions which have been more heavily influenced by Islam, and particularly where the Manding, Hausa, and Fulbe trading networks are viable or were viable prior to European presence, have a seven-day market cycle.[95]

Although there is as yet no parallel evidence for the Islamic conversion of Dogon time, the choice of sixty-six years for the observation of the *sigi* ritual, the Dogon life-cycle, is noteworthy. "The Dogon have located the episodes of the first sixty-six years of the life of men on the earth, the time for initiation and the execution of certain rites."[96] Sixty-six is perhaps the most sacred number in Islamic geometria: it is, in some systems of numerical symbolism, the symbol for Allah.

if one looks at the organization of a Hausa compound and the ideal form of a Hausa city, one is immediately struck by the spatial correspondence. Pots of particularly propitious herbs and medicines, as well as objects of iron, were buried at the four openings and the center of the city, and these openings were the focus of annual sacrifices. This continuum, from the spatial organization acknowledged by a hunter in the bush to that of the geometricized ideal of a monument in the built environment, provides a remarkably succinct resumé of the continuum from traditional pagan behavior to the tightly prescribed geometry of Islamic architectonic space.

Ritual behavior occurs in both time and space. Among the changes Islamic behavior introduced into

CHAPTER 4

The Conceptual Environment

JUST AS THOSE structural elements, such as tent poles, ridge beams and corner posts, that are critical to the success of a built structure are endowed with particular meaning, so the material accompaniments to behavior that a culture perceives as critical to its existence and continuity become the receptacles for the most highly charged emotional content. In subsistence societies, the facilities critical to the maintenance and continuity of life are the basic tool-kits used in economic endeavor. Among fishing cultures such as the Sorko on the Niger River, it is the oars, weirs, and nets that receive the most attention; among hunting societies, it is the bow and arrows, the knives and traps; among sedentary agriculturalists, the granaries; and among nomadic societies, the tool-kit associated with the well-being and proliferation of a herd. In all these traditionally egalitarian societies, social control is essential for survival, so (as we suggested above), the panoply of institutionalized ritual behavior that unfolds in an atectonic environment is a guarantor of existence and continuity. The costumry, masks, instruments, and accoutrements of ancestry, of age sets and groups, and of leadership are of critical import in the service of life.

In contrast to highly differentiated, high-technology societies where art forms have been discretely circumscribed by medium and by function, in traditional West Africa art forms are multivalent and multivocal; each embodies a number of associated meanings; and each addresses itself to a number of situations. With the emergence of nascent political hierarchies, the material elements essential to, associated with, and symbolic of their establishment and reinforcement become the focus for a self-conscious aesthetic. Thus, the tools of warfare, the technology of the horse, and the personal artifacts associated with the ruling elite—such as crowns, staffs, dress, and thrones—emerge as prominent artifacts and material symbols of communication. In the course of a transformation from an egalitarian, acephalous society to a viable political hierarchy, it is the successful, property-owning institutions with a stake in the maintenance and perpetuation of the status quo who become the sponsors of investment in material goods. In the early stages of this transformation, this investment was more easily effected in the personal environment. Only subsequently, with the emergence of the building crafts and the shift from an atectonic to a tectonic society, did the built environment become the surrogate symbol through which rank and order were communicated.

The historic pattern of Islamic penetration into West Africa occurred in three stages, each characterized by a different type of interaction.[1] In the early centuries, Islam moved into West Africa through the agency of trade and peaceful proselytization. The early trading communities and individual immigrants had little impact on their host societies. Although they were treated with awe and respect because of the command they had over goods and over the written word, interaction was limited. Like all newcomers to a community, distinc-

tiveness of behavior, of belief, of dress, and of manners identified them with each other while setting them apart from local chiefs and commoners. Only when Muslims in part achieved status and in part became integrated into the nascent political hierarchies did indigenous ruling elites begin to exploit Islamic symbols and integrate them into traditional behaviors. Finally, it was only with the advent of political rule in the name of Allah that society-at-large converted to Islam. In percolating down to the commoners, the material symbols of Islam became Africanized and further abstracted.

The nature of Islamic symbol and its material expression reflected these conditions and relationships. At the establishment level, the intellectual framework of ideas in the minds and writings of Muslim savants, traders though they were, was available to the chiefs and rulers to rationalize the art form and imbue it with new meaning. At the non-establishment level, there was only the image to carry the message; thus, the visual expression of Islamic adherence differed greatly in the various contexts of social stratification.

The conceptual baggage brought by the early Muslim trader was embodied in the written word—the Koran and the commentaries on it. His visual and physical baggage consisted of those elements which could be most easily extracted from the material framework of his former milieu. The baggage he brought became the traveling symbol of his identity. A tombstone commemorating his existence was the ultimate piece of such baggage (Fig. 4.1a). It is also true that easily segregated elements of material culture are more easily incorporated into an ongoing system than those that more directly express the unity between behavior and environment. For example, it is much easier to introduce a talisman, a copy of the Koran, or a roll of cloth into the artifactual repertoire of traditional behaviors than it is to effect changes in the geometric constructs of traditional space generated by that behavior. Thus, it was the most easily available, replicable, and accessible symbols of Islamic adherence that were grafted onto the symbol system of traditional societies, just as today Islamic amulets are hung on the dancing costume of a pagan ritual.

West Africa has traditionally been non-literate; even today, literacy is limited to the elite. In a largely illiterate milieu, the visual component is far more critical than the written one in maintaining a network of communication. Visual artifacts associated with behavior have been used to communicate identity, and oral traditions have served to maintain continuity over time and space. The visual element inherent in the artifact or in the natural environment is the vehicle through which actual or preferred membership in a cultural or economic group can be overtly and publicly communi-

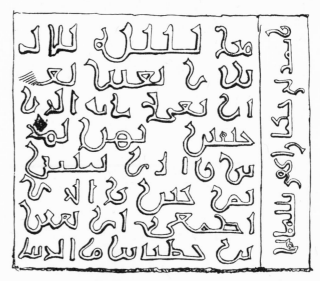

Fig. 4.1a Kufic tombstone from the ancient cemetery at Tessaoua, southern Algeria. Duveyrier (1864).

cated. Distinctiveness of dress, which is easily transportable and susceptible to emulation or imitation and reproduction, is precisely such a visual element.

Visual symbols occur both in the three-dimensional objects of ritual in space and on two-dimensional surfaces. As we suggested in Chapter 3, there is a continuum from space to time; consequently, it is possible to transfer iconographic elements from one mode to the other. Experiencing ritual is akin to experiencing architecture, and both contrast with the experience of a two-dimensional image. Everything on a two-dimensional surface can be perceived simultaneously. In both ritual and architecture, the observer perceives successively over time: either the ritual unfolds over time before the viewer, or the viewer must move through or around the built environment to experience it.

Two-dimensional symbols such as the written word are more easily effected and can be recognized instantaneously. It has been pointed out that when two-dimensional models are introduced into non-literate societies, they often have great power.[2] With the introduction of the written word, however, the multilevel complexity of oral language and physical behavior is not immediately lost; instead, the visual image is shifted to the spatial dimension. It is precisely this shift that may explain the ultimate development of the richly elegant patternwork on surfaces of both the personal and physical environment in Islamized West Africa.

The presence of Muslim scholars, preachers, healers, diviners, and advisors in the various courts of early West African empire is abundantly documented in both the written literature and oral traditions. Their knowl-

edge of canonical law, Islamic tradition, and ritual included a wide background in the religious sciences of Islam. Above all, they possessed the written word, which not only served administrative purposes but also afforded an innovative network for communication that in itself facilitated political change. The visual impact of a cursive script served as the handmaiden of a new two-dimensional iconography just as innovative building technology served as the handmaiden for a new architectural imagery. Calligraphy, critical to the consolidation of political power in medieval West Africa, emerged as a new visual metaphor and was instrumental in the creation of a new aesthetic.

The written word, it has been suggested, materializes speech.[3] Speech is given concrete embodiment in much the same way that a built environment materializes ritual behavior in space. The written word itself was translated into a singular symbolic message evoking the highest emotional response. Graphic signs that represent words are much easier to handle than the sounds are; they are capable of enduring above and beyond memory, since they have material form.[4] The visual, material representation of a word can be broken up into parts and redistributed. Arabic script, like the Tuareg script *tifinar*, lends itself to graphic manipulation. *Muthanna* (the mirror-image style of writing) and *boustrophedon* (writing like a plough, moving in alternate directions) are common to both.[5] Letters (and words) can be rearranged so that the various signs or graphemes of the writing system are not only reversible but can be written in various directions (Fig. 4.1b, c). Thus, the letters and graphemes lend themselves to two-dimensional surface arrangement. Taken out of context, they can be manipulated within a graphic frame, and the actual form of the letter can be extended and integrated into various combinations. In Islam, the redistribution of the material components of the grapheme, following the laws of geometry on the basis of mathematical theorems, formed the design patterns. Designs formed this way into rectangular polygons came to be known as *djedwal*, the term for "picture" in Arabic, or *khatem*, the term for "seal," from which the Fulbe singular, *hatumere*, derives (Fig. 4.2a–c).[6]

A grapheme, like a pictorial symbol, can contain several possible meanings, the appropriate one determined by context. Far more generic than the individual word it stands for, it can have layers of meaning. An elaborate pattern can be read in different ways, depending on the viewer's knowledge or degree of sophistication. A Muslim scholar sees in a grapheme a set of meanings related to far more than the verbal message; he sees meanings related to the entire geometric structure of Islamic cosmogony. An illiterate Muslim, on the other hand, will see even less than the verbal message; he will merely associate the grapheme with Islam per se.

Fig. 4.1b The Tuareg *tifinar* alphabet. Drawing after Duveyrier (1864). The characters have changed very little over the last century.

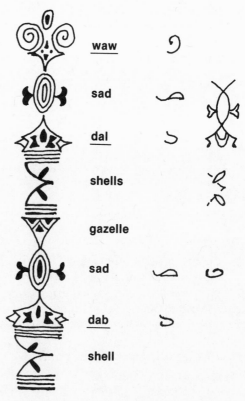

Fig. 4.1c The relationship between pattern and Arabic script on a leather pillow called a *hedbid lousada*. Drawing after Gabus (1958).

The symbolic aspect of Arabic calligraphy is complicated and enriched by *gematria*, the assignment of numerical values to the letters of the alphabet. This association of numerical values and letters is not unique to Islam—nor was it introduced by Islam, since at least one instance of its use was recorded at Babylon.[7] What Islamic *gematria* does is to establish a geometric link between the symbolic aspects of the written word and the system of symbolic numbers that are used to explain the structure of the cosmos and the hierarchy of the universe.[8] For example, the tetrad that associates Intellect, Soul, and Nature with the Creator is connected with a magic square of nine houses or stages. Thus, given the import of visual imagery in a non-literate society, the pervasiveness of number symbolism in all aspects of its material environment can be readily comprehended.

Gematria in turn provides the basis for the construction of various kinds of magic squares.[9] A magic square consists of an arrangement of numbers that add up to the same total in each direction. Magic-square construction methods differ from one culture to another. Chinese construction procedures differ from Islamic construction procedures and both in turn differ from the Western world's way of constructing a magic square.[10] These preferences of construction reflect the basic ideas inherent in the various philosophies and religions of the peoples who construct them.[11] They are related to the cosmogonies and theogonies which underlay explanations of the universe.

Islamic magic-square construction entails a system of sequential numbering along the diagonal axes, equivalent to spiraling around a cylinder in both directions. Called continuous, their construction involves motion through a middle number in the heart of the grid. Hence, that number is considered particularly powerful. At the same time, according to Cammann:

> If magic squares were, in general, small models of the Universe, now they could be viewed as symbolic representations of Life in a process of constant flux, constantly being renewed through contact with a divine source at the center of the cosmos. . . . Some more devout Muslims considered the middle number as a symbol of Allah.[12]

They therefore left a blank cell in the center, or wrote in the name of Allah (Fig. 4.2d).

Islamic continuous magic-square construction is particularly relevant to a number of design constructs in the West African context, as well as to various practices related to them. Hydromancy or *istingal*—divination by using a reflecting surface such as glass, a mirror, or ink in the center square or "house" of a nine-square construct—is common in both North and West Africa.[13] Mention of these magic mirrors occurs frequently in the early Arabic literature.[14] As part of the written format incorporated into the magic square are the four archangels Mikail, Djebril, Azril, and Israfil. The image in the reflecting surface is considered to be either one's soul, the *djinn*, or a spirit—not unlike the interpretation of images in a crystal ball. The pure state of these centers recalls, for example, a collection of Nupe "book covers" at the Leipzig Museum, all of which are constructed to accommodate a mirror on their top face.[15] A number of cloths and tapestries woven by the Fulbe and Wogo or Songhay weavers, in which the intensity of design concentrates on the center of the cloth, similarly reflect the emphasis on center.

The two types of *hatumere* most commonly used by the marabouts, diviners, and *karamokos* in West Africa are three-by-three and four-by-four squares (Fig. 4.2e).[16] The three-by-three nine-house square, which adds up to fifteen in its simplest form, has the number five in the center. The number five, symbolizing the Five Pillars of Islam, the five daily prayers, etc., is also of particular import in the design patterns and aesthetic preferences of West Africa. The center square or house is frequently referred to as the "mosque" in West Africa. This type of square is known as an Allah type when the squares are filled with numerals whose sum total is the numerical value of the letters of the word Allah, i.e., sixty-six.

The four-by-four square, whose constant sum of thirty-four (three plus four) reduces to seven, is related to the Muslim cosmogony of the seven heavens, the seven seas, the seven hells, the seven climes, the seven planets, the seven angels, etc. Seven, the sum of three and four, is, however, an ominous number among West African Muslims. There are numerous taboos against its use, taboos which obviously relate to the intense sacrality of this number.

Several other aspects related to the psychology of perception contribute further to the gradual conversion of *gematria*, geometric representation and the written word, into a preferred design *Gestalt* in West Africa. The *Gestalt* laws of proximity, similarity, continuance, and closure suggest that we tend to see shapes as symmetrically as possible, to see lines and edges as uninterruptedly as possible, and to see things that are spatially close as belonging together. Lines act as the edges of surfaces, and the patterns of line become most important in our visual perceptions. Thus, simple, regular forms with repetitive elements are the easiest to perceive. Script itself is simplified into a line, and the pattern of script remains only as a linear construct.

When a caricature of an object—in our case, the number-grapheme of Arabic—is picked up and used by less literate artists or copyists, the pattern as a two-dimensional design may, by progressive simplification in passing through the hands and eyes of successive

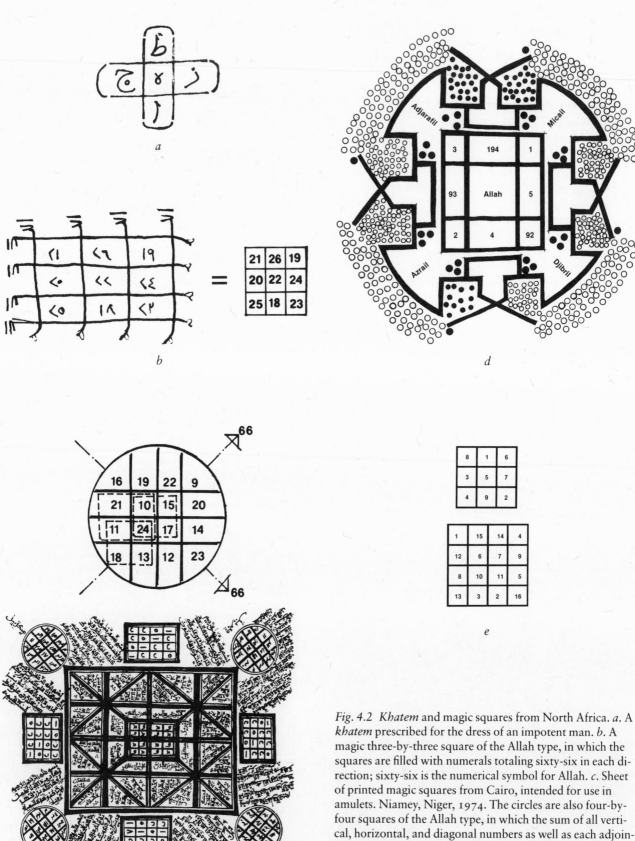

Fig. 4.2 Khatem and magic squares from North Africa. *a*. A *khatem* prescribed for the dress of an impotent man. *b*. A magic three-by-three square of the Allah type, in which the squares are filled with numerals totaling sixty-six in each direction; sixty-six is the numerical symbol for Allah. *c*. Sheet of printed magic squares from Cairo, intended for use in amulets. Niamey, Niger, 1974. The circles are also four-by-four squares of the Allah type, in which the sum of all vertical, horizontal, and diagonal numbers as well as each adjoining group of four houses totals sixty-six. *d*. A magic square from the Republic of Benin (Dahomey), in which the center square is filled by Allah. Drawing after Béart (1955), vol. 1. *e*. The basic three-by-three square or *musalasu* (Fulbe), whose sums total fifteen, and the basic four-by-four square or *sulimana*, whose sums total thirty-four.

artists, entirely lose its projective relationship with the object. Only an arbitrary relationship then remains between the symbol and its referent.[17] This seems to be precisely what happens in the process of rote visual learning of the written word in West African Islam.

A third aspect of the conversion of the written image into an abstract visual symbol is related both to the oral tradition and to the nature of Islamic prayer. The structure of much West African poetry and ritual incantation involves repetition of singular phrases, varying slightly to incorporate the continuum of content to which they address themselves. In like fashion, Islamic prayer often consists of piously repeated phrases. When translated into a graphic image, the abstract design often captures, by its multiplication, this same repetitive quality.

Many of the copies of the Koran in West Africa incorporate geometric and linear patternwork in their margins, to indicate the beginning of a phrase, a *surat*, or a chapter (Fig. 4.3). Careful scrutiny of the motifs used reveals that they formed the basis for a number of the iconographic patterns that characterize the range of art forms found in the areas of our concern. The sacred script enhances the geometric patternwork, enveloping it with its own *baraka* and by close association imbuing it with a symbolic quality and contributing further to the simplification of the visual symbol. If "the essence of symbolism lies in the recognition of one thing as standing for or representing another," and "the relation is such that the symbol itself appears capable of generating and receiving effects otherwise reserved for the object to which it refers," then the geometric motif becomes a symbol for the entire system of Islamic identity. Further, "such effects are often of high emotional charge."[18] Thus, the designs that accompany, surround, and order the script carry the power of the written word itself. The feeling aroused by religious awe through the medium of these symbols is not basically different from the emotion stimulated by an aesthetic response.[19]

The copyist tradition and the process of learning to read further contributed to the abstraction and decontextualization of script and pattern (Fig. 4.4a–c). The transmission of learning is effected through schools held in the courtyards of teachers whose knowledge of the religious sciences varies widely, and students learn using a combination of repetitive recitation and visual rote, on the Koranic boards which are the symbol of the learning process. The Islamic school in any village is recognizable by the cluster of Koranic boards resting against the wall at the entrance to the compounds of the *tiernos*, the *marabouts*, and the *karamokos*, whose more mundane skills are often supplemented by the responsibilities of teaching.

Restricted literacy in West Africa went hand-in-hand with craft specialization, and the craftsmen's

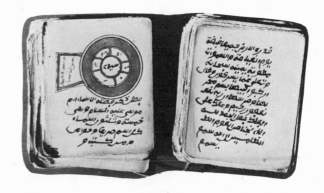

Fig. 4.3 Pages from several "prayer" and "recipe" books found in the library of King Njoya, Bamun, Cameroon.

skills merged with the power of the written word to enhance the quality of their products as well as to structure design preferences. The perceived power of the Koran—often a sacred object in its own right, housed within the hidden center of its leather covers (of which there are often three envelopes)—is reflected in its outside bound surfaces.[20] The system of communicating its power is transmitted by means of the *hatumere* design on its cover, worked by the leatherworker or *garankhe*

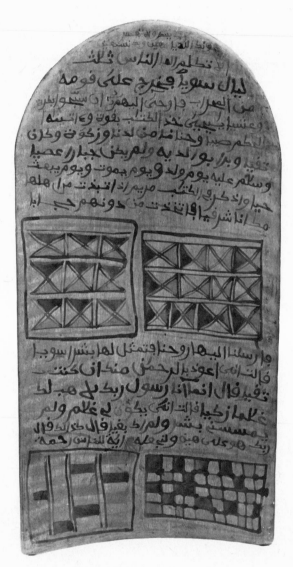

Fig 4.5 Koranic boards from various parts of West Africa.
a. Northern Cameroon.

b. Ségou, Mali.

(Fig. 4.5a). The two-dimensional patternwork of circles and intersecting axes recalls not only the structure of a magic square but the three-dimensional construct of the *fitula* or candelabra referred to in Chapter 3. The pattern becomes a surrogate for the emotional charge associated with the sacred script within it.

The *djennenke*, or embroiderers, were and are held in equally high esteem and formed part of the erudite literate community of Islam. It is hardly surprising, therefore, to find a *djedwal* and the border designs that often frame the script on the pages of the Koran embroidered on the pocket of a robe (Fig. 4.5b). When we asked about the inspiration of this and related embroidery designs, we were told that they were inspired by

the Koran or by dreams that undoubtedly reflected the hours spent perusing its pages. Only those so "inspired" could do the work. Their skills were perceived as intimately associated with Muslim scholarship.

With the infiltration of Islam into the community-at-large, the artifacts of traditional ritual, like their spatial components, were enhanced by the addition of the visual symbols of Islam. Sacrifice to the ancestors, propitiatory offerings at sacred sites and at ritual events such as baptisms, initiations, marriages, and deaths, involved not only traditional symbols of efficacy but those associated with Islam. The integration of these two components is superbly illustrated by the skull of a bull sacrificed in 1965 at Nioumoun in the Lower Cas-

c. Entrance to the courtyard of a *mallam*'s house; Koranic school is conducted here. Daralabé, Guinea.

Fig. 4.5a Leather carrying case for a Koran, with a *hatumere* design on its closing flap, made by the *imam* (and senior leatherworker) at Dionghassy, Guinea. Compare this design with the plan of the *fitula*, Figure 3.23 above.

amance region of Senegal, at the circumcision ceremony of five Muslim boys (Fig. 4.6a). After the sacrifice of the bull, its skull was covered with Arabic script and all the apertures in the skull were stuffed with scraps of paper that contained phrases from the Koran and both three-by-three and four-by-four magic squares (Fig. 4.6b). The scraps of paper also often included precise instructions for the performance of the ritual, and the phrases from the Koran were often accompanied by a description of the behavior relevant to the use of the sacrificial artifact, as well as references to totemic symbols such as lions and crocodiles.

In another example, a ram's horn was wrapped completely in a printed page of Arabic script that in-

Fig. 4.5b A *hatumere* design embroidered onto the pocket of a Fulbe tunic by the *tierno*, an Islamic dignitary, at Daralabé, Guinea. Compare with Figure 4.2a above and Figure 7.28a below.

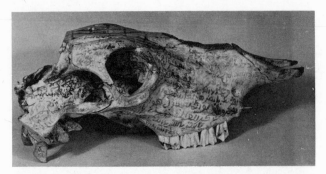

Fig. 4.6a The inscribed skull of a bull from the Casamance, Senegal.

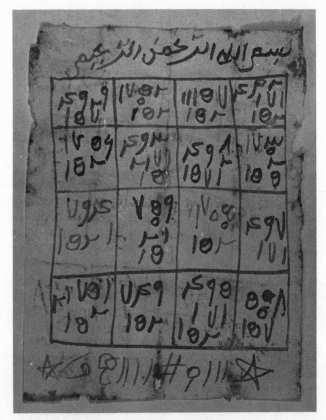

Fig. 4.6b One of the pages of script inserted into the apertures of the skull.

generally assumed that with the arrival of Islam, masking traditions suffered and ultimately disintegrated under the impetus of prohibitions against images and idols. In a recent study, however, that addressed itself to Muslim masking traditions, this fallacy of incompatibility was definitively destroyed. What emerges from the evidence is a highly flexible interface and reciprocity between "pagan" behaviors and belief systems and those of Islam.[21] One should, however, distinguish between masking traditions that accompany religious rituals in which the entire community participates, and those used by various secret and initiation societies. In many instances, masks are worn only in conjunction with the secret society's activities, so the appearance of one or another symbol of Islam in association with a mask raises questions about the *focus* of secrecy and of the *public display* of secrecy. The mystery of covering the face, when viewed in the context of Islamic prescription, in itself establishes a new relationship between the wearer and the observer.

As we mentioned in Chapter 3, anthropocentrism and anthropomorphism are of vital importance in African thought and in West African spatial constructs. It may well be that the strong commitment to ego accounts for the importance of the face of man and his propensity toward masking. Of all aspects of the body, the face is the most revealing. The Bambara say, "Show me your face and I will tell you the manner of being of your interior people."[22] Among the Bambara the face is considered to be the principal facade of the residence of *maa-nala*, the Bambara Creator. The head also represents the superior level of the being. Its seven apertures correspond to the entrances to the seven worlds or states of being in each *maa* or soul, each of which turns on a central axis. At the same time, the strong notion of self as the center of the universe is implied in much of

cluded a classic pattern of concentric circles, made of both lines and cursive script, enclosing a set of three axes. These three axes define the three dimensions of space in the universe and the six directions of the human body: right, left, front, back, above, and below (Fig. 4.6c).

Masking and masked ceremonies have always been considered a very distinctive, if not the most distinctive, feature of traditional West African ritual and of traditional plastic and sculptural art, and it has been

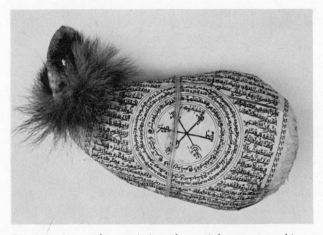

Fig. 4.6c An amulet consisting of a ram's horn wrapped in a printed sheet of Arabic script. From Sierra Leone.

Islamic doctrine. The easy juxtaposition of the two traditions should come as no surprise.

The literal interface between mask and wearer occurs at the surface, where the mask's hidden interior surface comes into contact with the face. Among the most interesting illustrations are those from the Poro society among the Dan and the Mano in the Ivory Coast and northern Liberia (Fig. 4.7a). The Poro, a men's secret society, constitutes a religious system of social control implemented through an extensive initiation process. It now also has considerable political power in the cultures within which it functions. The interior surface of the illustrated mask is covered with Arabic script and magic squares; hence the script and squares are hidden from the viewer while providing the ultimate protection on the contact surface between the spirit embodied in the mask and the person's own soul.

The use of Arabic script and the written word on this hidden interface so fraught with danger introduces the question of the use of script in both public and secret situations. Secrecy is very much a part of the network of social control in West Africa and, as elsewhere, its dual purpose is that of self-protection and of control over others.[23] Of all protective measures, the most radical is to make oneself invisible, and this to some degree the mask succeeds in accomplishing. By presenting another spirit in lieu of one's own, one indeed becomes invisible. Control over others by a secret society is accomplished through knowledge inaccessible to others. Those who *know* form a community in

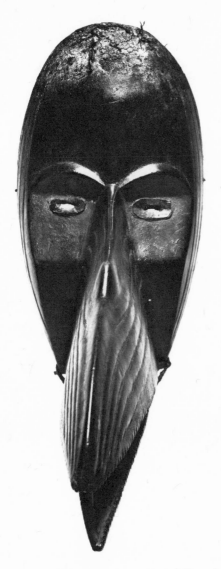
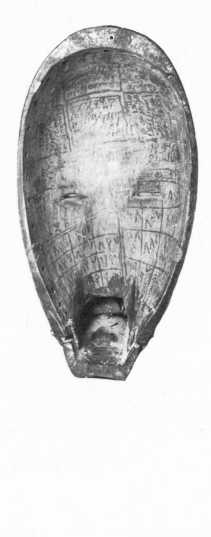

Fig. 4.7a A nineteenth-century Mano hornbill mask (*kpala*) of the Poro society in northeastern Liberia.

order to guarantee preservation of secrecy. If knowledge, real or perceived, is symbolized by the written word, then the hidden script on the inner surface of the mask (in contrast to its public display on the exterior surface) enhances the role of the secret society. The choice of a magic square, with its multiple levels of meaning in which a "revelation" is embedded, also enhances the performance of the masker.

The five horns on the Bambara *n'tomo* mask recall the efficacy of the number five in the numerical symbolism of Islam, and provide a contrastive use of Islamic symbol in masking tradition (Fig. 4.7b). If the

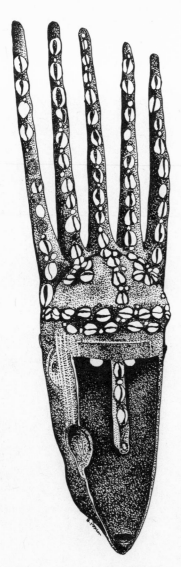

Fig. 4.7b A Bambara *n'tomo* society anthropomorphic mask with five horns, decorated with cowrie shells and red seeds (*abrus precatarius*), reputed to be from the Macina region, Mali. Drawing after Lem (1949).

face of a mask is intended to reproduce, more or less realistically, the spirit or divinity it embodies, then the five horns appear to communicate publicly the Islamic presence, just as the five earthen pinnacles rising above the facade of a house in Djenné or Tombouctou do (see Chapter 6).

In an infrequently cited article, Georg Simmel considered adornment to be the means by which one's social power or dignity is transformed into visible personal excellence; further, everything that adorns man can be ordered on a linear scale according to its closeness to the body.[24] Since in the African environment, dress is not required for physical climatic protection, it is possible to consider much of the elaborate yet standardized dress which distinguishes the Muslim from the "pagan" as the primary means by which first a sense of belonging and, ultimately, social control and power were transformed into a visual context. Adornment of the body becomes the most important (and realizable) means of visible communication in an atectonic environment. Dress also serves to mark a change in status, and just as the various stages of initiation into African society are marked by changes in dress, so the change in status from a "pagan" to a Muslim, from a commoner to a member of the ruling elite, involved the display of dress. Early European travelers made frequent references to the apparel that distinguished chiefs and rulers, and to the prescriptions for cloth and its usage in transitional social contexts.

If adornment can be ordered on a scale of proximity to the body, then scarification ranks first and hairdo ranks second. Indeed, if, as the Bambara say, the head represents the superior level of being, then the adornment of the head must be the most important consideration. In the Islamic context, since scarification is prohibited, what one does to one's hair most clearly conveys a message (Plate 5). The elaborate hairdo of the young Fulbe woman has woven into it a set of five concentric rings of amber beads, all of which revolve around that point that constitutes her personal axis in space. She, like the matframe tent she builds, is the essence of a "moving center" and the rings encircling her head reflect the importance attached to center in an ego-based world.

The counterpart to the elaborate coiffure is the traditional Fulbe herder's hat, consisting of a basketwork body embellished with incised-pattern leatherwork and five "buttons" or *hatumere* at the center and the four points of intersection (Fig. 4.8a). In plan, these become a square with four projecting triangles circumscribed by a circle, simulating a *djedwal*. The two configurations of coiffure and hat provide an interesting mathematical contrast: in one instance, the emphasis is on circularity around a center, and in the other, the four

cardinal directions of a square configuration are clearly reflected. One is tempted to speculate on the significance of this difference in gender-related representations of space.

The traditional hat worn by a number of savannah peoples is a hunter's or warrior's hat or bonnet (Fig. 4.8b). Its design and construction reflect the biaxial and symmetrical shape of the human head, in contrast to the domical shape of a Muslim cap, which focuses on a central axis of the body. The integration of embroidery motifs into the hunter's bonnet may itself be the result of an acquired preference for the numerical symbolism of Islam in the sequence of squares and the three, five, and nine houses within a magic square, but the traditional concepts of duality, of twinness and symmetry (the same design is replicated on both faces), remain the basis for the spatial construct.

The "Muslim" cap, the most easily acquired piece of clothing that significantly establishes membership in the West African Islamized world, is a highly standardized short, flat-domed cap, frequently embroidered in cotton by the tailors or embroiderers, the *djennenke*. The subject matter of their embroidery varies with individual creativity and skill as well as visual preference (Plate 6). Perhaps of greatest interest is the construction process and the meanings attached to it (Fig. 4.8c). The cap is made in two parts: the band first, and the crown second. To establish the embroidery sections, the band is folded in half and in half again, establishing eight sections. The folds mark the four vertical bands or *dari*; these bands bound the *boual* or "empty regions." These four *dari* are also the "doors" marking the four faces of a mosque, and they are the first stage of embroidery. Next, the horizontal bands, the *modtyi* between the vertical sections, are done, establishing the upper and lower regions of the *boual* and closing them. The lower regions are then filled in with interlace that is an extended version of the *djedwal*. The upper horizontal banding, embroidered last, is the "ending" or *daoual*. The embroidery process is conceptualized in terms of spatial definition and boundary.

The crown is constructed and embroidered as follows. Two squares are layered over one another to form an octagonal star, actually, a *khatem*. The intersecting points serve as guide points for stitching a circle. Once stitched, the two layers are folded in half twice. The second fold determines the center, and the creases are used as a pattern trace for the crown embroidery. To establish the radius of the crown, the band itself (= to the circumference) is folded in half, and then is folded in thirds in an approximation of π ($r = c/2\pi$). The folds establish the four directions, and the two major axes emanating from a square in the center, containing four *suudu* or houses, is called a *hatumere*. Embroidering a

Fig. 4.8a A Fulbe herder's hat, the Fouta-Djallon, Guinea.

Fig. 4.8b A traditional hunter's bonnet, Gambia.

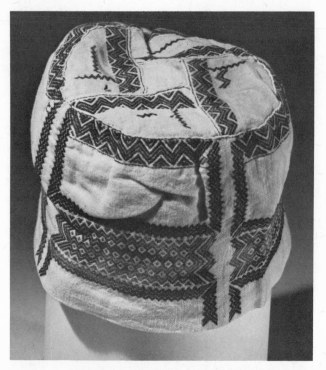

Fig. 4.8c Muslim cap with a radiating central pattern, Guinea, similar to the patternwork on the wooden doors of the Great Mosque at Kairouan, Tunisia. Compare Figure 7.11d.

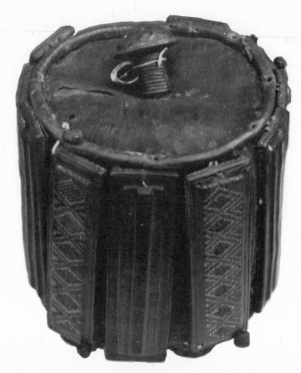

Fig. 4.9a A paramount chief's leather crown made by a local *garankhe* or leatherworker. Kabala, Koinadugu District, northern Sierra Leone. Each of the leather talismans contains sheets of Arabic script.

cap is considered a very special skill, restricted to those who know the Islamic "way." What they know, however, is the geometric order of the cosmos, translated into a very basic Euclidian theorem for the construction of a circle.[25]

The importance of head adornment finds ultimate expression in the various crowns that were incorporated into the panoply of dress with the emergence of strong cohesive chieftaincies under the influence of Islam. A pair of illustrations germane to our argument come from among the Kuranko in Sierra Leone, a Mande-speaking group, who were, in the course of the last several centuries, influenced by Islamized Fulbe herders and Manding traders.[26] The leather crown of chief Massa Gbogbah at Kabala is an exaggerated version of a Muslim cap, onto which rectangular leather amulets, each of which encloses a sheet of Arabic script, have been sewn (Fig. 4.9a). A more elaborate counterpart, in brass, claimed to be more than 140 years old, comes from the panoply of the late Masa Kama at Kemadugu (Fig. 4.9b). The eight amulets that encircle the base of the crown parallel the order of the embroidered framework of the Fulbe caps from Fouta-Djallon, and on the crown itself there are five raised metal domes

arranged in a quincunx. The center dome is emphasized by the thin metal shaft that projects up above the crown.

The magico-medical properties attributed to metals, both iron and precious metals such as gold and silver, copper and brass, form a literature of their own, and their association with talismans of various kinds can be related to the whole subject of alchemy. Their rarity or unusual characteristics obviously played an important role in communicating a status imbued with some kind of *mana* or indefinable power to ward off evil or evoke a particular response.[27] Thus, while the presence of script-enclosed amulets on the crowns illustrates the penultimate use of talismans in West Africa, it also reintroduces the relationship among secrecy, protection, and adornment.

Anyone who has lived in, worked in, or studied the material expression of West African culture cannot fail to be struck by the ubiquitous presence of amulets, talismans, and charms: on the body, on dress, on ritual paraphernalia, in architecture. Frequently hidden, most often covered to increase, through secrecy, their efficacy, they are usually less than obvious to the outsider. Every aspect of environmental arts in some way incor-

porates them into its content. Worn by persons of all ranks, attached to ritual objects of all kinds, they accompany the panoply of power, they are attached to or represented on masking costumes, they are hung on articles and tools of production, and they are suspended from doorways, lintels, and center poles and at openings and are buried under thresholds.

In addition to cicatrization, and the adornment of

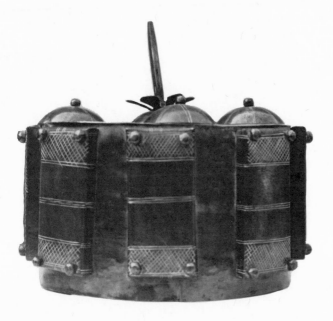

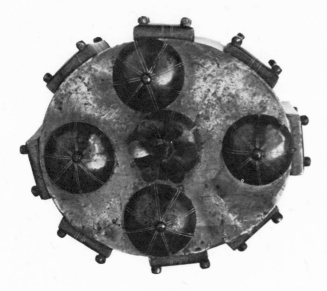

Fig. 4.9b The brass and copper crown of a former paramount chief of the Kafei chiefdom, Kemadugu, Sierra Leone.

hair and head, a person may also wear a twisted cord around his/her waist, a bracelet or anklet of twisted leather or metal, or a ring on a finger or through an earlobe for protection. In ritual, the closed ring without a break symbolizes protection. The amulet worn as adornment serves an equivalent function; its perceived efficacy heightens its symbolic quality.

Amulets and talismans traditionally take the form of wrapped bones, horns, medicinal packets, and other natural substances which were believed to be imbued with supranatural powers. Some amulets serve a protective or preventive function, designed to ward off a particular evil. Others are causative or positive, worn to obtain wealth, women, children, or power over others. Some are vindictive and some are counteractive, designed to render bad magic innocuous.

The most common form of amulet worn today consists of a piece of paper on which a short prayer, a spell, a verse from the Koran, a magical name or names, or a magic square is written, enveloped by a cloth, leather, or metal cover (Figs. 4.10a, b). It has been suggested that the use of written papers and a new terminology is all that distinguishes them from pagan charms. The inscription must be written by a Muslim savant, a *karamoko*, a *tierno*, or a *mallam* who by his *baraka*, or aura of divine grace, and secret knowledge imbues the amulet with power under conditions of secrecy. These amulets are distinguishable from traditional charms precisely because they incorporate the perceived efficacy of Islam and, indeed, they are often still used in conjunction with artifacts considered to be efficacious in the traditional context. More than simply offering double insurance, they provide a new agency through which particular actions can be effected.

Amulets are equally ubiquitous in North Africa. References to their presence there can be found as early as the tenth century.[28] Those which contained verses from the Koran were called *istirqa* or *ma'adha*. At the beginning of the twelfth century, it was recorded that Ibn Tumart, the Moroccan founder of the Almohads, had a talisman or *harz* fabricated which he sent, as a gift, to his Algerian host.[29]

In West Africa, the Portuguese Valentim Fernandes, in commenting on Moroccan marabouts among the Wolof of Senegal in 1506, added that "they wrote names in Arabic and put them around the neck of the Blacks or in their hair."[30] By the late sixteenth century, the indigenous Senegalese chiefs all wore a multitude of amulets (*gallady*) during battle and in times of great danger, suggesting that at this early date traditional charms were already being replaced by written amulets for protective and causative purposes.

On the coast, in Dahomey, one also finds early references to the presence not only of the "Mallays,

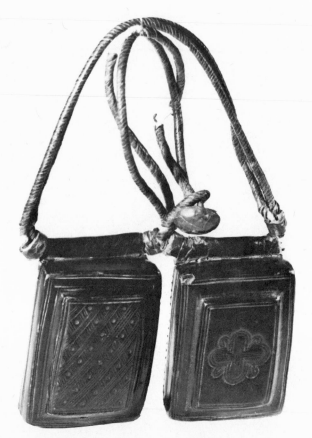

Fig. 4.10a Leather-covered amulets, Timbo, Guinea.

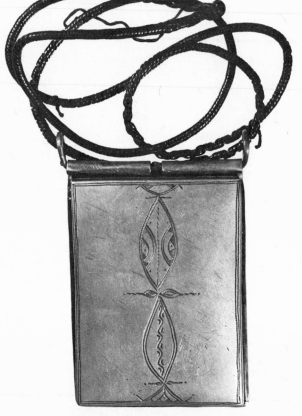

Fig. 4.10b Brass-covered Tuareg amulet from the Maradi region, Niger.

travelling merchants as the source of great information," but of the Fula coming from Sierra Leone with transcripts of the Koran to sell, probably as charms.

> Certain it is, they possess not only the art of writing, but other useful arts unknown to the savages whom they visit, and for which they are held, by great and small, in very high esteem. . . . Among the amulets or charms, the principal is, a scrap of parchment containing a sentence of the Koran which the natives purchase from the Moors who visit this country. This they hang up in their apartments, which are likewise decorated with crude, misshapen images, tinged with blood, besmeared with palm-oil, stuck with feathers, bedaubed with eggs.[31]

Obvious in this reference is the concurrent usage of traditional and Islamic systems of protection.

Barbot, writing in the early eighteenth century, frequently referred to the abundant use of amulets, which he called *grigri*, as adornment on the saddles of horses and the bodies of kings.

> I was told that Conde, king Damel's viceroy . . .

constantly wore to the value of fifty slaves in these grigri about his body; for not only their caps and waistcoats, but their very horses are covered with them in the army, to prevent being wounded.

> The grigris of the prime Blacks, and men of high posts, are wrapped up in a piece of linen curiously folded, and artificially covered with a piece of reddish leather. The smaller sorts are most worn about the hair, or in the nature of necklaces . . . intermixt with some pieces of red coral and cauris, or another sort of red shell. But some wear more of these baubles about their caps and bonnets than about the neck.

> The grigri may perhaps have been originally introduced by a certain sect of Morabite-Arabs, called *calandars*.[32]

Marmol, another European traveler, referred to *calandars* "who have a sort of cabalistical learning. They are known by certain numbers, figures or characters they wear about them in square frames. . . . Their rule was given them by one *Boni*, by the Arabs called father of enchantments and sorcery, who has writ a small treatise of the way of making those square frames or *calandars*."[33]

These *calandars* were obviously recognized by their display of magic squares, still a preferred subject for amulets and talismans in Islamized West Africa. When an amulet contains a phrase or verse from the Koran that has been incorporated into a geometric configuration, it is considered to have even greater mystical power.

Relatively few of the *karamokos* and *tiernos* currently make use of the magic manuals that still exist in the North African and Near Eastern world, although passing references suggest that such manuals were available to them in previous centuries. More commonly, a cleric will possess a book of "recipes," viewed as a "book" in the same sense as the Koran. Requests to see the *library* of a cleric often produced both (Fig. 4.10c, d). The book of "recipes" is a collection of single pages of script that incorporate geometric frames of various kinds, each reputed to serve a different purpose, which the cleric copies under commission from a "client." These pages are part of the schooling of a cleric; when he "graduates," he carries with him his

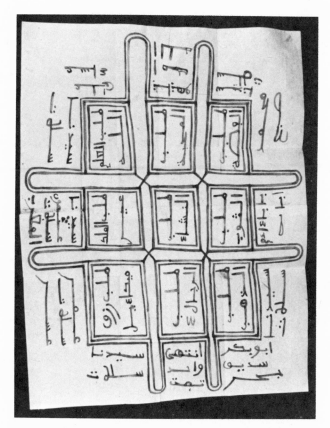

Fig. 4.10d A recently made *hatumere* design from a "recipe" book in Bafodea, Sierra Leone.

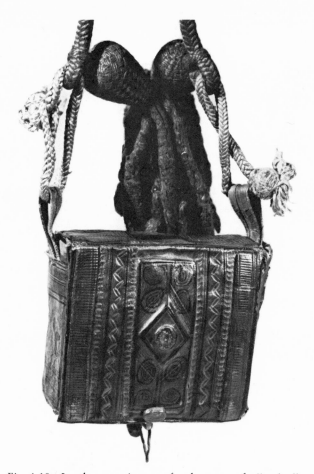

Fig. 4.10c Leather carrying case for the pages of a "recipe" book, Guinea.

lesson book. Sometimes his teacher presents him with one of the original sheets as a token of esteem and of the completion of his studies.

The "recipes" are never public knowledge. Secrecy is an essential ingredient in rendering them efficacious and imbuing them with *baraka*; they are prepared with the same precautions that attend the confection of other more traditional "medications." Muhammad ibn Muhammad, a distinguished eighteenth-century Fulbe scholar, admonished his students to "work in secret and privacy . . . The letters are in God's safekeeping. God's power is in his names and his secrets, and if you enter his treasury you are in God's privacy, and you should not spread God's secrets indiscriminately."[34] Although a client will discuss the purpose for which he is commissioning such a "recipe," and the cleric may often review his collection in consultation with the client, the preparation of each new *hatumere* is done within close confines, often at night. Upon completion, it is immediately wrapped in an envelope of some kind, usually a piece of fabric or string, and carried to either a leatherworker or a blacksmith for further enclosure or concealment. The more wrapping it has, the more powerful it is considered to be.[35]

The supranatural powers of the cleric in many instances combine with those of the blacksmith and the leatherworker, particularly when the craftsperson is also literate, and the "knowledge" they possess is used in the fabrication of bracelets, armlets, and pendants that can be viewed as surrogate amulets. The blacksmiths who fabricate these pieces say that their basic tools are the Koran and the hammer, and their own amulets render their hands skillful. These articles often transpose the written word into its numerical or geometric equivalent. The characteristic jewelry worn by Fulbe and Tuareg women is a striking illustration of this equivalence: the mathematical relationships inherent in the shape and form of the blacksmith's furnace emerge in much of their metallic adornment (Fig. 4.11a–c). These bracelets and anklets terminate in a cube whose corners, when cut diagonally, result in equilateral triangles. The form thus created is a fourteen-sided polyhedron, or tetrakaidecahedron. Fourteen is three plus four doubled, like a twin, and is also half of twenty-eight, the number of days in the lunar month and the number of letters in the Arabic alphabet. The number system is a symbol for the geometrization of space inherent in Islamic doctrine, as is the twisting into a suggested spiral form.

If one opens out the polyhedron onto a two-dimensional surface, what appears first is that most ubiquitous of patterns, a square with four projecting triangles, which appears on the Fulbe herder's hat, on textiles, and in magic-square arrangements. It is related to the *djebel* or "wise man's knot." The fourteen faces laid flat become a swastika-like swirl—again, a pattern found in a number of iconographic contexts such as embroidery and printed cloth. The quincunx design on the square faces of the illustrated bracelet, replicating in a simplified version the five domes atop the brass Kuranko crown, is perhaps the quintessential sign of protection against the evil *djinn* or spirits and against the evil eye—just as it is in North Africa.[36]

This design, of which the *djedwal* itself is an elaboration, is not only a representation of center with a vertical axis and the four cardinal directions of space, it is also a pattern generated by the construction of a three-by-three magic square. For example, if one distinguishes the odd and even numbers by light and shadow, the resulting configuration, with five in the center, takes on the form of a cross or quincunx.

Perhaps the most crucial situation of danger in which the protection of the body envelope must be attended to is in a situation of conflict, either with an animal in hunting or in human warfare. Just as, in any society, the ritual preparation for these encounters are among the most intensive, so the proliferation of amulets, like the prescribed repetition of a verse from the

a

b

c

Fig. 4.11 a. A Tuareg or Fulbe woman's metal bracelet. *b.* Diagram of the construction of the terminating knobs, creating a fourteen-sided polyhedron. *c.* When the planes are opened out flat, the configuration results in a traditional motif frequently used on cloth.

Koran, increases the arsenal of resistance to perceived danger. The traditional *batakari* or hunters' tunics are less an article of clothing than a surface onto which a multitude of amulets can be attached in locations around the body most vulnerable to attack (Fig. 4.12a). The greater the number of such amulets, the greater the resistance. Since each amulet represents a monetary outlay, the number worn indicates the power or wealth of the hunter. While the traditional *batakari* carry mostly bones, horns, teeth, claws, and medicines on them, most consist of these traditional components in combination with those in which Arabic script or magic squares have been secreted.

The Ghanaian *batakari*, presumably of Dagomba origin, are very much like those worn in hunting and war-dress situations among other cultures such as the Dan, the Maninka, and the Bambara, and one is tempted to speculate on the early Bambara king Bakar as an etymological source for the term *batakari*.[37] Made of handspun, handwoven strip cloth, the style of the tunic varies little. What is of interest is the concentration of amulets around the neck opening of the tunic and on the front and back of the bodice. Even without their sacred contents, the leather-covered accoutrements would, as was once suggested by Bowdich, provide a vest of protection.[38] The neck opening is the center of

the overall design of the *batakari*, so the concentration of amulets around the periphery of the neck opening also serves as the usual protection around an opening in space. The quintessential use of these *batakari* occurs in the investiture dress of the Asantehene of Ghana, where the intense concentration of amulets has been covered not in leather, but in the rarest of metals—silver and gold (see Plate 15).

Of particular interest to our thesis of design transformation is the emergence of script from its secreted location into a public context. The first stage of the transformation was unquestionably a tunic in which the entire cloth was itself covered in script, magic squares, and design equivalents. The quantity of amulets—hence, the efficacy of the tunic—was considerably increased when the entire fabric of the tunic could be covered. This shift marked a qualitative change in the design aesthetic of the tunic: the whole cloth was now a magic cloth. One such example is a "charm gown" or *rigan yaki* from northern Nigeria, in which the magical quality of the written word communicates the efficacy of the apparel (Fig. 4.12b).[39] The combination of script, magic squares, pentagram motifs, and crosses formed by the arrangement of script implies that the design patternwork is itself imbued with a magical quality. Among the examples of such *rigan yaki* one also finds a combination of secreted leather amulets arranged in a precise geometric order (in part established by the strip cloth framework) and the linear arrangement of magic squares in combination with extended, continuous *djedwal* or *dagi*, wise men's knots, visibly drawn on the cloth (Fig. 4.12c). Whereas the latter is undoubtedly an outer garment, the former is a close parallel to the Fulbe *diousene*, which is always worn underneath another robe and must always be hidden from view, since, as we were told, it is only efficacious when those against whom it is designed to be effective do not know of its presence.[40] Scrutiny of one such Fulbe warrior's *diousene* from Senegal reveals the richness of its contents (Fig. 4.12d). The tunic was constructed in three linear sections; the tripartite arrangement was perhaps influenced by the seam joining two widths of industrially woven cotton, but the central third, divided in two by the neck opening and equivalent to the bodice section, carries the most intense concentration of magic-square configurations. Most are readable as linear patterns rather than as actual calligraphic inscriptions. At the lower front edge there is a single representation of the sandal of the Prophet. Despite the irregularities and casual, almost incoherent *hatumere* patterns, a meticulous geometric order underlies the whole (Fig. 4.12e). The relaxed, seemingly indiscriminate shift from one pattern sequence to another clearly suggests a process of transformation from script to abstract design. The

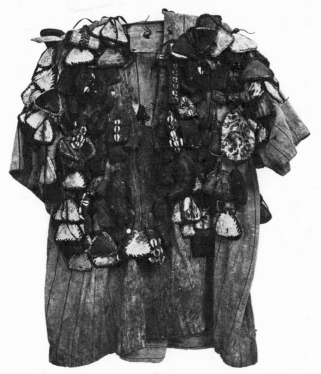

Fig. 4.12a A hunter's tunic or *batakari*, in stripwoven cotton cloth with both leather and traditional amulets sewn to it.

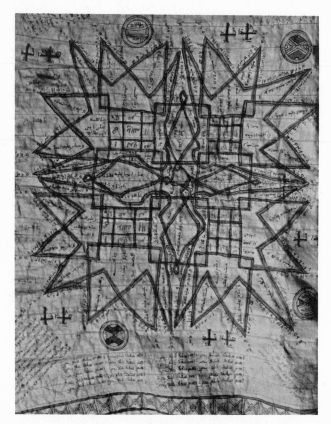

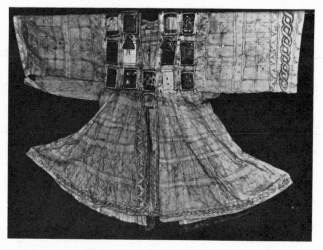

Fig. 4.12c A tunic from northern Nigeria, incorporating both painted geometric patterns and leather amulets.

Fig. 4.12b A tunic or *rigan yaki* from northern Nigeria, completely covered in Arabic script, magic squares, pentagram stars, and four-sided star patterns.

Fig. 4.12e The patternwork on the *diousene* is precisely geometric. These numerical combinations recur throughout the repertoire of West African Islamic design.

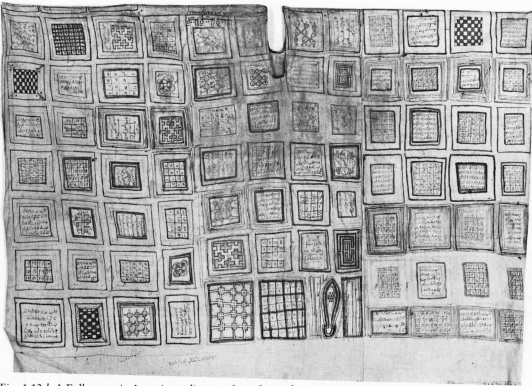

Fig. 4.12d A Fulbe warrior's tunic or *diousene* from Senegal.

multitude of smaller squares are arranged in a grid that is a vast magic square. The wearer, completely enveloped in the cloth, partakes of the same magic quality inherent in the hidden core of a protective envelope.

Although the classic decorations documented on these *batakari* or "charm gowns" may be the result of a process of assemblage, in the course of time and repetitive copying they developed logically in an aesthetic process of elaboration and simplification that contains the rationale of Islamic *gematria* and geometric symbolism. To the best of our knowledge, the earlier amulets and talismans contained true magic squares and literal phrases from the opening lines of various *surah*, or chapters, in the Koran. With the trend toward popularization of the profession of the marabouts and of Islam itself, transmission of learning resulted in an educational leveling. Squares with minimal phrases and single graphemes with simulated letter-number signs became more prevalent. Just as education eventually came to consist only of learning to recite the most important verses of the Koran, so it was no longer essential that a marabout read or write fluently. The patternwork became the medium of the message. Thus, while the writing of Arabic script is a fundamental part of the equipment of every well-educated Muslim, the quality and literacy of that written word varied considerably.

The secreted quality of the written word in the West African context is anathema to the very nature of writing, since writing is also a means whereby legal transactions, previously limited to witnesses, were transposed into the public domain. Logically, the written word in some fashion could replace previous ritual behaviors that had mnemonically served to bind and maintain social cohesion and interaction. The written word itself functioned in ways analogous to the built environment, since in both instances a material format provided a surrogate for behavior. There is, then, a contradiction or a dichotomy in the use of the new visual symbols: on the one hand, their hidden quality imbues them with greater efficacy, but at the same time, their public communicating role demands that they be visible to the general viewer.

Unlike other parts of the Islamic world, the written script of Islam is rarely visible in the public domain other than on the Koranic boards seen at the entrances and in the courtyards of the *mallams*. When the *batakari* is used as an outer garment, the amulets remain enveloped and hidden, and it is the design elements which reveal yet hide, to all but the initiated, the numerology of the divine (Fig. 4.12f). The patterns, without script, themselves communicated the hidden, magic power of the amulet, and their public display conveyed a sense of power derived from political status, rather than secrecy. The revelation, the public display of both sacred script

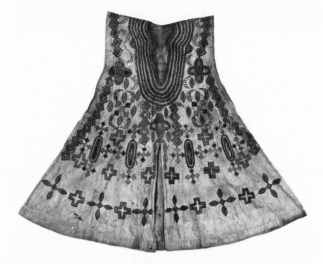

Fig. 4.12f An embroidered tunic from the Republic of Benin (Dahomey).

and its design features, occurred with the emergence of Islam as a controlling interest group within the traditional political milieu. The transformation of the invisible, secret uses of script into a visible statement was related to the development of an iconography of symbolic action.[41] In the subsequent redistribution of power, the delineation and identification of new Islamized interest groups was made manifest, by means of visible patterns of symbolic action, to the groups they wished to control. One such symbolic action is prayer itself. The Islamic design aesthetic, however—the revelation and the public display of the written word—was equally a system of symbolic action, one that reached its apogee during the nineteenth-century Islamic rise to political power and leadership. The protection previously afforded by secrecy was replaced by the public display of a symbol of group identity. Group identity went far beyond the needs of warfare, and it is on the embroidered robes of the ruling elite that one finds its most elegant expression.

This transformation of the aesthetic that resulted from the shift of Islam to "establishment" status also helps us understand the spatial selectivity of an architectural iconography in the various political capitals and entrepôts of Islam, themselves symbolic centers. In rural, traditional societies, in the lower hierarchies of power, the *sebe*, *hatumere*, or *gri-gri* is hidden within its envelope, within the closed inner spaces of the domicile, and interior courtyard decoration is the focus for surface decoration. With the emergence of a male-dominated Islamic hegemony, the interior surface decor is turned inside out, as it were, and exposed on exterior wall surfaces.

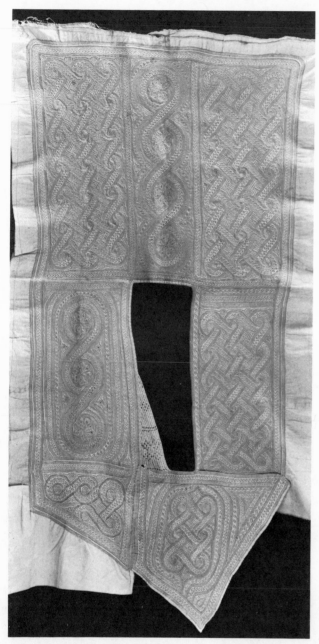

Fig. 4.12g Embroidered bodice section made by a Dyula kola-nut trader, Djenné, Mali, 1970.

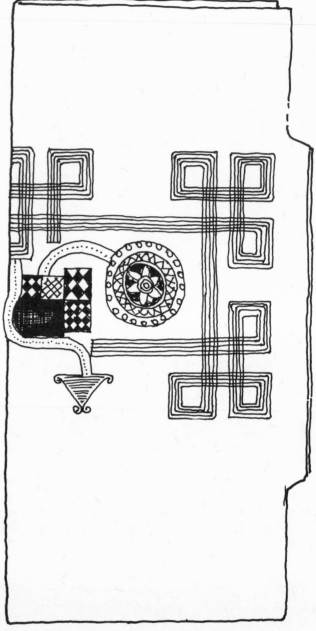

Fig. 4.12h Diagram of the embroidery pattern on a Manding-type robe from Sierra Leone. Drawing after Boser-Sarivaxévanis (1972).

The spatial dimension of the protective role of the design elements of clothing, whether it be a *batakari, diousene, rigan yaki, tilbi, dyere, riga,* or *boubou*, also reflects the organization of Islamic space. The most intensely embroidered area of concentrated design is around the neck opening and on the front and back bodice (Fig. 4.12g). Among the embroiderers we observed, this bodice is frequently made separately. It is

always the first step in assembling a total robe when narrow-weft strip cloth is used for the gown. The opening is analogous to the opening or mouth of a house, which forms the center or focus for emphasis and decoration of the facade. A common pattern for embroidered robes is a spiral that works its way around the bodice, sometimes doubling back on itself geometrically (Fig. 4.12h). This spiral symbolizes the path of

revelation, inward toward the divine center, in much the way that access to a divine state involves a vertical spiraling motion.

Another pattern found uniquely among northern Nigerian robes in combination with the spiral is a "knife" motif; the combination is called a *mallum-mallum*.[42] The clue to its origin is suggested in a war tunic, reputedly from the Maghreb, on which a very elaborate *djedwal* is inscribed (Fig. 4.12i).[43] The *djedwal* is made up of a cluster of "knives," each containing an invocation to the Prophet, that border an intricate geometry of "houses," each of which in turn contains an invocation to various angels. The four corners of the central portion, formed by magic squares that emphasize the number 28 in *'abjad* script, also play a particularly important role. If one imagines this *djedwal* located in the very center of the embroidered tunic (before it is folded to hang over front and back of the body), and the central square as the opening through which the head projects, then the representation of the "knife" pattern, albeit in a somewhat less highly structured square configuration, is a logical construct (Fig. 4.12j). Such war tunics put one in mind of early-nineteenth-century coats of chain mail (of suggested Turkish provenance) made of brass rings linked with steel. The brass rings, which form Arabic invocations requesting aid and as-

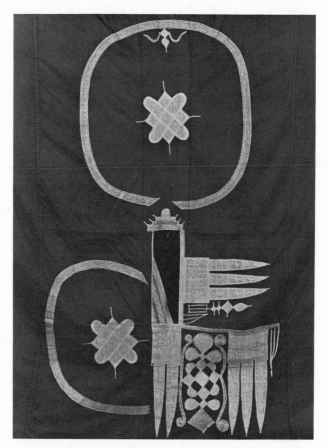

Fig. 4.12j A grand robe of blue cotton cloth, from Bauchi, Nigeria.

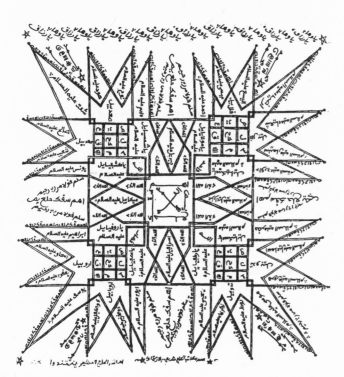

Fig. 4.12i Diagram of the script and patternwork on a tunic, reputedly Maghrebian, from which Fig. 4.12b appears to have been copied.

sistance, provide talismanic as well as physical protection for the chain-mail coat.[44]

Further west, stretching from Oualata through Djenné to Tombouctou, another set of embroidery motifs in eyelet technique is found which suggests not only geomancy traditions in the use of dots within a rotated magic square bounded by a sacred circle, but the stylized swastika and elongated quincunx found in other surface contexts (Fig. 4.12k). The magic-square pattern is called a *suleymana-dumbu-idye*, "circumcised son of Suliman." The terms for the swastika pattern or *taykobe*, the elongated quincunx or *barma-kore*, and the eyelets or *hayndi* within the intersecting ovals all appear to be an etymological derivation from Arabic.

The points at which a person touches the earth below him, that is, his feet, are the counterpart to the head of a person as the superior level of being, closest to the heavens. The foot covering, i.e., the sandal, is the most direct mediation between man and his environment. As a locus of direct contact with the earth, the sole is also symbolically a focal plane requiring precautionary measures. In Islamic prescription, this interface

Fig. 4.12k An embroidered *kasaba* from Djenné, Mali, with eyelet embroidery forming a set of magic squares and swastika-like patterns. See Figure 5.30c for a diagram of one of the magic squares.

between the lower and the upper cosmos is acknowledged by the foot covering. The importance of sandals in part reflects that need to establish a barrier between the earth and its human occupant, and the sandals of Muhamed become a symbolic artifact expressing this protective function.

By the same token, there are prescriptions against sitting on the bare ground. Anyone who has traveled through the Islamized part of West Africa is fully aware of this concern. When one takes a seat on the ground, there should always be a mat, a cushion, or a layer of some other kind of material between body and earth. The requirement that every Muslim use a mat for prayer, whether in the open air or within the mosque, appears to be related to this prescription.

At the same time, the seat and the sitting position have long been associated with authority, both in the West and in the non-Western world. The cathedra, the judge's bench, and the throne are only a few examples among many. "To sit on a holy stone or otherwise to obtain contact with it so as to contact unseen powers is

an action which is familiar not only from scripture and the legends of saints and martyrs, but seems to be a permanent feature of Indo-European folklore."[45] The seat must put a distance between the bulk of the body and the ground, since it is in that vital space that the mysterious creatures which inhabit our more frightening dreams gather. Thus, the seat, like the shoe, becomes critical in man's mediation with space. In West Africa, a man and his or her stool often travel together. It is therefore hardly surprising that the iconography and the spatial organization of Islam are both expressed in the West African seat or carved stool.

The Bambara stool is analogous to the design and configuration of a Koranic board. The handle, the rectangular seat, and, most importantly, the incised patternwork on the seat suggest association of the two surfaces, much as a leather cushion does (Fig. 4.13a). The elongated oval stool among the Toma of Eastern Guinea has on its sitting surface a replica of the classic quincunx design, suggesting the sacralization of precisely that surface which comes in contact with the human body (Fig. 4.13b).

The classic horseshoe arch associated with Islamic space on the Sorko stool is part of the same spatial definition of vital space as that articulated on the back of Sorko canoes, in Fulbe window openings, and on the leather carrying cases for the Koran. One should envision the Sorko stool as a miniature replica of any sacred enclosed space pierced by Islam-associated architectural openings (Fig. 4.13c).

The Golden Stool which symbolically validated the political hegemony of the Asante Confederacy of Ghana, while not a throne in the Western sense, also elaborates in a poignant manner on the Islamic prescription of protection against contact with the earth itself, by further involving the three dimensions of space. When viewed in plan, the stool consists of the five points of a quincunx sitting on a five-tiered pedestal that defines a rectangle, that is, an elongated square. The central point of contact or mediation with the earth—a hollow core bounded by an openwork checkerboard pattern—houses traditional protective medicines. At the same time, it is equivalent to the center house of a magic square. The concentration of protective force links a person to the earth and at the same time protects him/her. Scraps of paper with real or simulated script were often suspended from the four corners to further enhance traditional symbols of power such as brass bells (Fig. 4.13d).

The choice of a rectangular or square base, in contrast to a circular one for these stools, is also related to the geometrization of topographic space. In examining a large number of stool bases, we found that among the Manding, as well as among the Islamized leadership

Fig. 4.13a Wooden Bambara stool with a rectangular seat in the shape of a Koranic board.

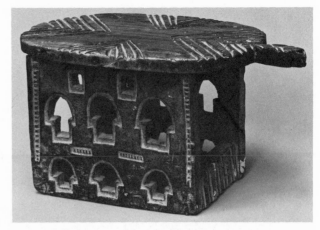

Fig. 4.13c Wooden Sorko stool, Upper Niger Bend, Mali, with simulated Saracen arches on its side panels.

Fig. 4.13b Oval wooden stool with incised patternwork, carved by the *bailo* blacksmiths in Guinea.

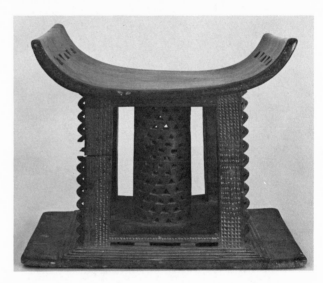

Fig. 4.13d An Asante woman's stool or *mma 'gwa*, part of the panoply of Asante power.

of other cultures where stools are made by the blacksmiths, the bases were always square or pseudo-square. For example, the circular stool or *escabo* of the Fulbe in the Fouta-Djallon, which is made by blacksmiths, always has a pair of wooden legs delineating a square base, whereas the *escabo* made by *laoube* or woodworkers who have not been schooled in traditional Islamic learning always has a circular base.

Leather cushions, with symbolic Arabic letters and geometric mandala-like designs, are also rationalized to include both traditional belief systems and Islamic spatial coordinates (Fig. 4.14a, b). They are as much a way of geometricizing space for a person as are the more distant coordinates which organize the landscape into an ordered cosmos. The saddle may be said

to perform the same function at a higher level: a moving object carried with its owner, it orders the universe into the four cardinal directions at an equivalent interface between the natural and the man-built environment. The *nnaka* in which the nomadic woman traditionally travels, seated or perched on a camel's back, is an extension of the saddle, and the arrangement of its wicker-work frame, defining the four cardinal directions as well as front and back, serves as the smallest unit of geometricized, moving space for the nomadic woman (see Fig. 3.14a).

Just as the construction and organization of clothing have a spatial referent, and just as the stools and cushions on which people sit are related to the ground on which they walk, so many artifacts, tapes-

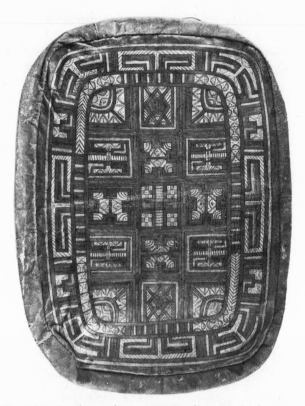

Fig. 4.14a Leather cushion cover, Tombouctou, Mali.

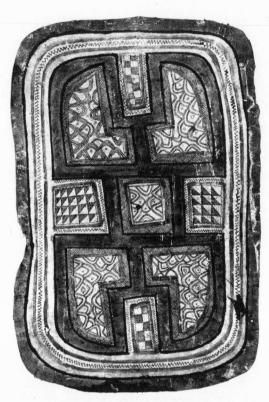

Fig. 4.14b Leather cushion cover, Oualata, Mauretania.

tries, cloths, and blankets also mediate between the natural environment, the built environment, and the person (Fig. 4.14c). In the illustrated ritual tea caddy which sits on the ground, the patternwork, reflecting cardinal directions, is located on the surface usually hidden from the participant-observer, i.e., the surface in contact with the ground itself. Thus its contents are both symbolically protected and located in space.

A number of in-depth studies have been made of the motifs incorporated into tapestries, but few have considered the overall organization of the patternwork on the traditional narrow-weft woven cloths: their organization provides a further insight into our hypothesis on the geometrization of space. Among the Dogon, it is said that "cloth is the center of the world," that it expresses everything, since the originating signs of all things are traced to it (Fig. 4.15a).[46] The Nommo who, it is claimed, invented weaving, wove into the cloth the words that were bringing a new order. In comparing the indigo-and-white checkerboard pattern of the traditional Dogon funerary cloth with a simple white one, a new ordering of space can indeed be traced. The checkerboard, akin to the geometric layout of fields, reflects the process of construction of a continuous

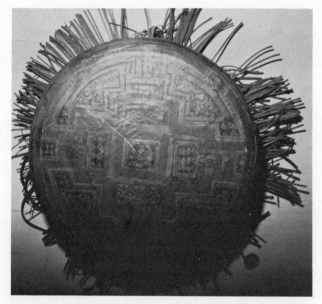

Fig. 4.14c Base of a leather tea caddy, used ceremonially among the Tuareg and Maures, northern Nigerian provenance.

magic square, in which the sequence of numbers spiraling on the diagonal is similar to the grid created by a cluster of continuous squares. To construct a simple odd-number continuous magic square, for example, one must conceive of the edges bent around first in a horizontal and then in a vertical direction, alternately forming a cylinder in each direction. The numbers are written spirally on the diagonal, and as houses are filled, breakpoints in the continuity of the operation occur. Further detail of design in the white squares seems to mark these breakpoints or breakmoves. The checkerboard cloth thus incorporates into the weaving construction what is usually written into the magic square.

The continuity in design morphology based on a magic square is elaborated and Africanized further in a chieftain's mantle collected on the Gold Coast in 1870 (Fig. 4.15b). Although using only indigo and white as base colors, the mantle reminds us of classic eighteenth-century Persian garden carpets which were used to recreate a luxuriant yet sheltered verdant growth within

houses, in reaction to the arid, sandblown environment without. A counterpoint to, rather than a simple replication of, the magic square, the mantle design integrates the concept of design construction with the end product. The central house of the square, the core, is extended horizontally, but it remains pure and white.

Applied design allows for greater flexibility, abstraction, and individual choice by the artist than does a woven pattern. Traditional West African narrow-weft weaving, however, always provides a linear frame that dictates layout along one dimension, so that the sewn seams act as a governor. When imported broadloom cloth is used, the artist must impose his or her own grid in both directions, and since the size and shape of the cloth often vary, adjustments in the prescribed geometry are made to reflect the dictates of perimeter and closure. Although the indigo dye-resist royal tapestry from the court of King Njoya at Bamun, Cameroon is clearly related to both Persian garden carpets and the Gold Coast mantle above in its design morphology, the relaxation in form permitted by the freedom of a non-

Fig. 4.15a Indigo and white, cotton, strip-woven checkerboard Dogon shroud cloth, Mali. The checkerboard pattern appears to be the simplest way to replicate the magic-square pattern used on funeral shrouds in, e.g., northern Togoland. Compare Frontispiece.

Fig. 4.15b Narrow strip-woven cotton cloth collected on the Gold Coast (Ghana), ca. 1870.

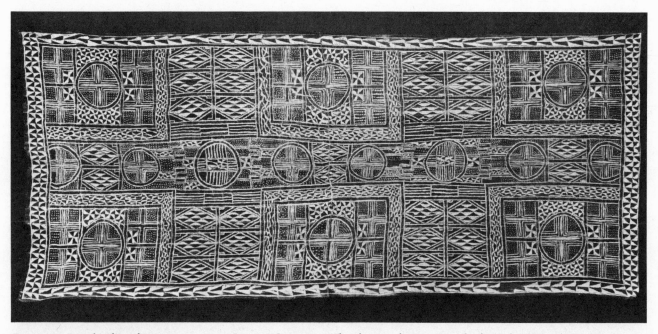

Fig. 4.15c Royal indigo-dye cotton tapestry, Bamun, Cameroon. The elongated pattern results from the artist's honoring the rectangular frame of the cloth.

directional base cloth is clearly evident (Fig. 4.15c). Despite this shift in design geometry, its source of inspiration can still be recognized in the margins of the pages of Koranic scripture from King Njoya's library (see Fig. 4.3).

Color symbolism has occupied the attention of many scholars, and while a thorough discussion of the phenomenon in West Africa is outside our present frame of reference, it is worth noting that certain colors are favored in the framework of Islamic belief (Plate 7). White as a symbol of light, of unity, and of orthodoxy is used in celebrations, in turbans worn upon return from the pilgrimage, and as a finish whitewash on almost all sacred Islamic structures in West Africa. If

white reveals all color, black or darkness is the destruction of self, the mystery of being, the prerequisite to reintegration. Friday is white and Venus, Saturday is black and Saturn. Black and white, beginning and end, the polarities of color and complement, are vividly incorporated into the checkerboard cloth patterns.

In the Sufist tradition, black, white, and yellow ochre or sandalwood constitute a group of three primary colors related to the qualities of the spirit. Sandalwood is the color of the earth, the neutral base upon which the polarity of black and white and the other colors act—not unlike the earthen architecture against which preferred clothing colors are juxtaposed (see Plate 2, Plate 11). Red, yellow, green, and indigo are related to the qualities of nature. Nature and Spirit are joined in the days of the week and the seven planets. Like alchemy and magic, the world of color works to transform the soul of the person into a state of purity. Colors are also perceived to have causative or preventive powers, and are used particularly in combat with the various malevolent spirits and *djinn*. In the context of affording protection, it comes as no surprise that the colors on *tyarka* and *dyongo* tapestries woven by the Fulbe (see Plate 3), leatherwork, decorative patterns on wall surfaces such as those at Oualata, and even the preferred ink colors on shrouds and *diousene* are sandalwood, burnt siena or red, black, and white.

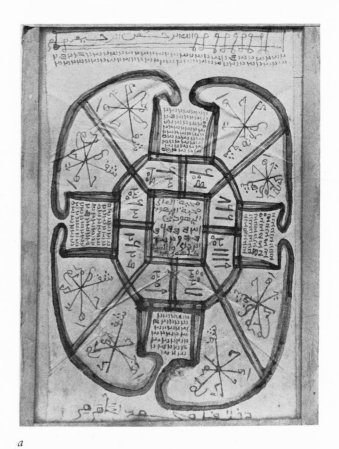

a

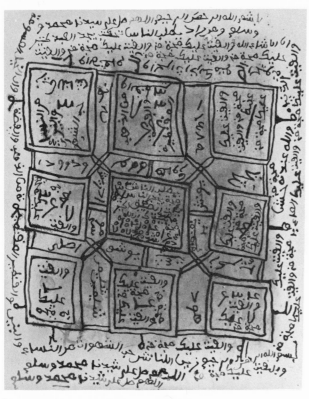

b

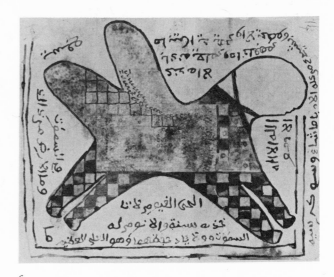

c

Fig. 4.16 A group of *hatumere* from Guinea and Sierra Leone, each located above the front entrance to a family compound. *a.* Circular quadrants. *b.* The nine houses of a three-by-three square. *c.* A *burak*, or mystical mare.

The emergence of the written word and/or its associated design morphology from a secreted space into public display culminates in the built environment itself through the use of Arabic inscriptions and *hatumere* above lintels and at the base of earthen buttresses (see Figs. 1.16a, 7.28–7.30). The same inscriptions and patternwork encased in leather amulets or embroidered on clothing are buried under thresholds, corner posts, and central pillars, and are replicated in the fully visible announcements framed over entrance lintels (Fig. 4.16). The designs and motifs, dictated by the repertoire of the resident or itinerant *mallam, karamoko,* or marabout, are remarkably diverse. In one instance, the nine houses of a three-by-three square are filled with opening fragments of various *surah* or chapters of the Koran. In the central, most sacred square, the name of Allah, magic numbers, and the signs of the planets are crowded together. The interstices between the houses are filled in with the names of prophets such as Noah, Moses, Joseph, David, Solomon, and Enoch, and the magic square is surrounded by a spiral of script taken from several chapters of the Koran.[47] In the second in-stance a *burak* (*bragu* in Fulbe), the mythical, mystical mare with wings and a human head on which the prophet Muhamed rode from Mecca to Jerusalem and thence to Heaven, has been represented on a sheet of gridpaper taken from a schoolboy's notebook. The grid provided the outline for the checkerboard pattern on the mare's legs; the phrases that encircle the *burak* are taken from the second chapter of the Koran.[48] The third example, more relaxed in line quality and more abstract in its geometry than the first, is a variant on the four quadrants of a square, rounded off into a circular format. If one follows the graphic tendencies suggested by the laws of *Gestalt* psychology, it becomes a close visual cognate to Figure 4.2d above. These lintel *hatumere* are no more than country cousins to the arabesque-like bas-relief frescos which eventually evolve into full-blown house facades in northern Nigerian urban centers (see Chapter 7). The intent of all, however, remains the same: protection of the openings into sacred spaces or places made inviolable by ritual has been replaced by a public statement of identity with the community of Islam.[49]

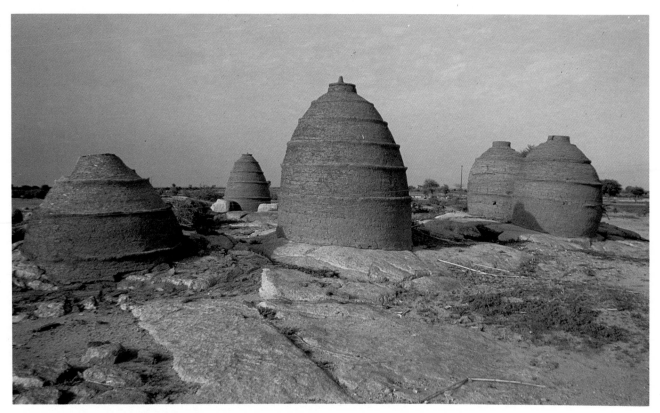

Plate 1 Granaries outside Tera, Niger.

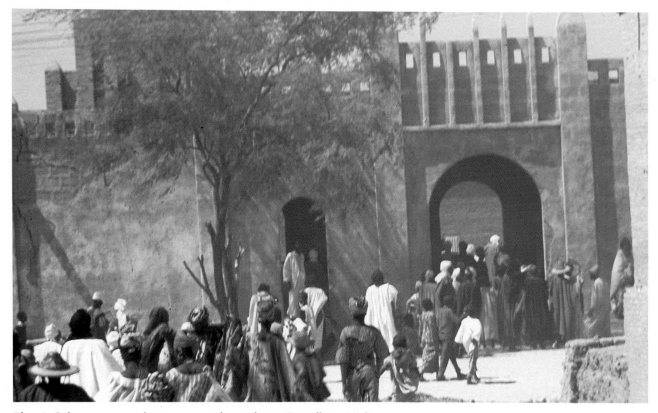

Plate 2 Color contrast at the entrance to the market at Goundham, Mali.

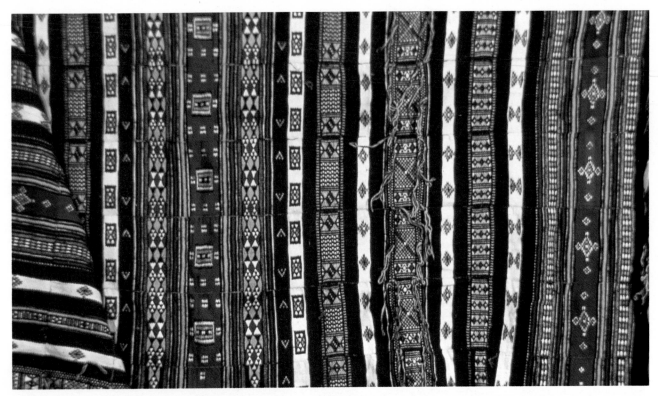

Plate 3 A *tyarka* tapestry woven by Fulbe weavers at Niafounke, Mali.

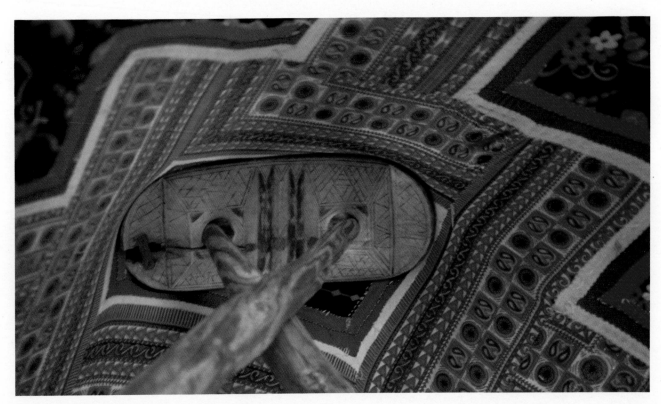

Plate 4 A Tuareg *tamakeit* at Rosso, Mauretania.

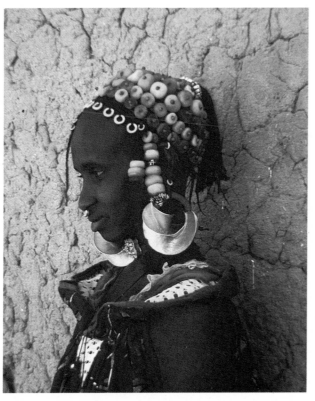

Plate 5 A young Fulbe woman, Diafarabé, Mali, with her hair plaited in concentric circles with amber beads.

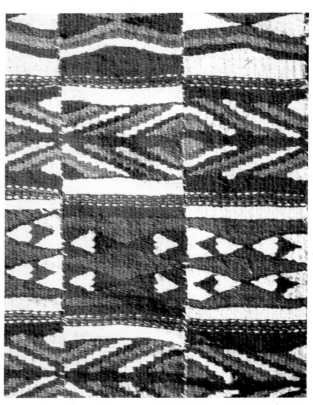

Plate 7 Detail of a *dyongo* tapestry from Goundham, Mali, with its traditionally preferred ochre, siena, blue, and white hues.

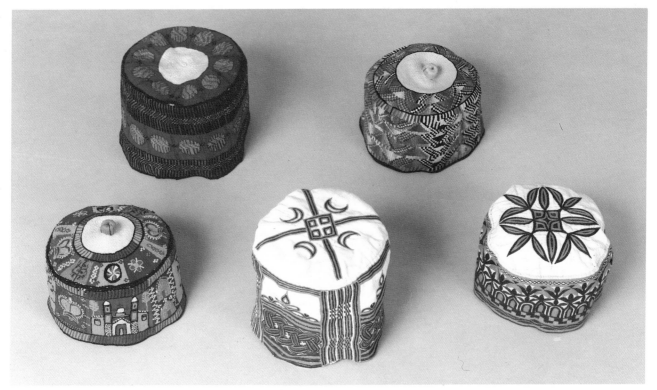

Plate 6 A collection of Muslim caps from Guinea and northern Nigeria. One of the Nigerian caps is far more literal in its representation of a mosque, and it incorporates a Tree of Life, what appears to be a pair of domed *zaure*, and a crown. The caps from the Fouta-Djallon, Guinea use more abstract geometric and arabesque patterns as iconographic symbols.

PART II

Time

CHAPTER 5

The Medieval Age
West African Empires

THE SO-CALLED Sudanese style in West Africa has been the subject of much discussion by Africanist scholars in the Western world during recent decades.[1] The term has been applied indiscriminately to the entire architectural repertoire of the savannah belt of West Africa, subsuming what is in fact a broad spectrum of complex and distinctive styles from the mouth of the Sénégal River in the west to the banks of Lake Chad in the east, from the rural earthen roundhousing of egalitarian agricultural societies to the conurbations and capital cities of medieval West African empires. Scholarship to date has thus addressed itself to a "style" which was never clearly defined formally, spatially, functionally, or temporally.

It has also been assumed, almost invariably, that the origin of this "Sudanese style" can be ascribed to Islamic North Africa, whether Egypt, Morocco, or Kairouan, evolving out of the centuries-long influences along the various trans-Saharan trade routes.[2] The "style," therefore, has always been considered to be the result of external stimuli, cultural diffusion, and "borrowings." While all three factors were indeed critical to the various architectural developments in the savannah belt, the foundation of any analysis is the context in which integration occurred—the milieu into which ideas and innovations were introduced and the soil that nourished them. Stimuli do not exist in a vacuum. The measure of their effectiveness depends upon the responsiveness of the environment into which they are introduced. Diffusion is not automatic: we shall never know

how many aspects of material innovation were introduced but rejected by host cultures. By the same token, "borrowings" from another ambience offer a valid explanation only when justifiable reasons for adaptation or integration can be established.

The North African attribution rests on three somewhat fragile interpretations of African history. The first, an Egyptian heritage, is based on the speculation that the Songhay peoples may have migrated westward from the valley of the Upper Nile into the Upper Niger Bend at some unknown period in history, bringing with them a style reminiscent of the monumental, tapered pyramidal walls and earthen construction that characterized Egyptian dynastic architecture. This view was ardently developed by early European observers who could not otherwise explain the architectural grandeur they found in the northern savannah and could not accept an indigenous origin for such sophisticated structures in an otherwise "lower order" of civilization.

The second interpretation attributes the entire monumental savannah tradition to a single individual, Abu Ishaq al-Saheli, the Andalusian poet-turned-architect who accompanied Mansa Musa, the renowned ruler of the medieval empire of Mali, on the latter's return from a spectacular pilgrimage to Mecca in 1324. So widespread is the acceptance of the theory that al-Saheli single-handedly introduced an entire style to a vast region of Africa that almost every author dealing with any aspect of West African history feels compelled

to include a reference to him. And yet, the evidence for his activity in West Africa is both sparse and contradictory.[3] Recent scholarship has established the fact that al-Saheli was far better known as a poet, calligrapher, and jurist than as an architect or master-builder. This combination is of particular relevance since, as we have suggested above, it was characteristic of medieval North African intellectual life and had considerable bearing on architectural development. A similar pattern developed in fourteenth-century West Africa with the growth of Islamic involvement. The questions to be considered refer, then, not so much to the singular talents of al-Saheli but to the nature of the design process in the West African savannah. Revolutionary structural and stylistic innovation would have required a large indigenous building workforce, immediate adoption of a new building technology paralleled by a revolution in the social organization of craft skills, and a single individual with the ability to effect radical innovations within building processes that were dependent upon communal construction and collective creativity. While these conditions are perhaps possible today, it would be an historical fallacy to project them back into the fourteenth century. Our tendency to ascribe to a single individual such a magnitude of innovation only reflects current Western ideology and practices, where an individual architect can be credited with, and sometimes does effect, stylistic innovation.

The third interpretation claims that the Moroccan invasion of the Western Sudan in 1591 was responsible for the new architectural style and technology. The Moroccan invasion did bring with it from northwest Africa and the Iberian Peninsula a large number of skilled craftsmen and mercenaries well versed in military construction, but to credit an architectural revolution to a disruptive invasion not only implies the nonexistence of any indigenous heritage but fails to explain the presence of critical stylistic features outside the pale of North Africa. Further, while the Moroccan invasion itself may have brought with it a new construction expertise, it lacked commitment to Islam, even though it was sponsored under Sa'adian rule. Unlike either the gradual, long-term, peaceful proselytism and infiltration that had marked the previous centuries of West African history, or the consciously declared *jihads* or holy wars in the centuries to follow, the Moroccan invasion lacked ideological foundation: its soldiers were, for the most part, Christian renegades and unlettered mercenaries. The building program generated by the invasion was one of military fortifications and their defense. Its major impact on the architectural scene was effected through individual efforts of those who survived and remained, and their efforts to maintain continuity and identity with the North African milieu depended heavily on mental templates, on the skills they brought with them and on the available indigenous resources.

Although various recent interpretations continue to reflect some European ethnocentrism, they suggest more appropriately that the "Sudanese style" is a synthesis of diffuse cultural elements.[4] Virtually every study of the historical dimensions of African architecture, however, still fails to put the primary emphasis on the indigenous contribution.

The capital cities and urban entrepôts of the medieval empires, as well as the bounds of empire itself, were all located in the upper reaches of the West African savannah at the junction of sahel and savannah, between the eleventh and seventeenth parallels of latitude. The savannah requires a minimal tool-kit for agricultural exploitation and building per se. It is a zone ideal for cultivating crops that have a long storage life. Its suitability for grazing, which encouraged nomadism and herding, resulted in symbiotic relationships between sedentarism and pastoralism. The natural vegetation and the terrain facilitated the development of easily negotiable networks of transport and communication.

Sahel and savannah environments and terrain required different types of transport: their interface became a line of demarcation in the transport networks. Commercial nodes frequently developed at the coterminii of these networks: goods were shifted from camel to donkey, from land to water, and from animal to human porterage. The nodes thus established were also points of cultural junction and juxtaposition: one ethnic group handed its charge over to another. All, however, were to some degree Islamized. Consequently, religious heterogeneity, multi-ethnicity and polyglot speakers characterized community interaction. The conditions were ideal for qualitative changes in architectural style.

The growth of these medieval urban centers ushered in a set of distinctions which have never been attended to in the savannah region: an "establishment" architecture which accompanied emergent polities, empires, and the increasingly important trade networks, in contrast to the more conservative, slowly unfolding, all-pervasive vernacular tradition. These distinctions, from which any interpretation of West African architectural history must derive, are in turn linked to those that existed between the rural pagan milieu and the urban Islamized milieu, between egalitarian and hierarchical social structures.

The medieval urban centers, while spanning different epochs, can be conveniently divided into two major categories: political and economic. The first group were at some time centers of a cohesive and viable polit-

ical structure. Implied is a continuity of form and style maintained to enhance and perpetuate political control by deliberate manipulation of architectural form. Also implied are the social resources to marshal a large corvée of indigenous labor. The second group, with the exception of the later Sultanate of Agades, were never seats of empire. Their birth, growth, and demise were a function of shifting economic interests. Though Islam, politics, and economics were tightly interwined during the medieval epochs of West African history, these commercial centers tended to adopt the existing indigenous architectures in a fashion somewhat different from that of the political centers. The economic elite had a somewhat more elusive set of ideals than their political counterparts and were not accountable to the indigenous population in the same way. Their ties were with North Africa. Integral to both the economic and political traditions were the nomads and nomadic groupings and the indigenous sedentary traditions.

In the chapters which follow, we have qualitatively and stylistically sorted out the "Sudanese style" into some of its architectural substyles. All depend upon the earth as a major building material and are derivative of technologies associated with earthen construction. While all were heavily influenced, directly or indirectly, by Islam, they also reflect indigenous differences in ethnicity, geographic region, and socio-cultural pattern.

Koumbi Saleh and the Empire of Ghana

The spread of Islam westward across the North African Mediterranean coast in the seventh century provided a rapid stimulus for the nascent but already viable trans-Saharan trade. Islamic expansion also created conditions conducive to the development of a more centralized political organization in North and West Africa. In the history of the Western Sudan in particular, political developments were related to the changing patterns of intercontinental and trans-Saharan trade routes (Fig. 5.1).[5]

The emergent West African savannah polities of the late first and early second millennia—the medieval "empires" of Ghana, Mali, and Songhay—were quite different from our contemporary concepts of empire. Unlike the homogeneous and nationally circumscribed political entities we associate with empire today, these early states had no precise spatially determined boundaries and no single capital place-centers until fairly late in their development. They also had no single ethnic or national identity. Political cohesion depended upon a somewhat precarious infrastructure and communication network, as well as fragmented, kin-based socie-

ties. The trade routes were their spine of infrastructure, communication, and cultural interface.

Ghana, "the Land of Gold" and the first of these medieval empires, was already well known to the North African world by the end of the eighth century. The astronomer al-Fazari made reference to it at that time, and it can be found on a map made before A.D. 833.[6] Oral tradition, recorded in the legend of Ouagadou, refers to the foundation of a black Soninke or Sarakolle state—the empire of Kayamaga with a capital at Koumbi—at some indeterminate epoch, but the origin of Ghana's ruling dynasties and its early political development are still shrouded in mystery.[7] We do know that the eighth- and ninth-century North African Islamic chroniclers considered Ghana the greatest of the Sudanese kingdoms. It was the major source of gold for North African coffers and rulers. The empire's frontiers stretched from the headwaters of the Sénégal River in the west to the Niger in the east, and northward far into the Sahara Desert. On the south it was bounded by the basin-like trace of the upper banks of the Sénégal and Niger rivers. This southern region is still inhabited by the Soninke people.

Archeological and traditional oral evidence suggests that the region in which the formative years of the Ghana empire unfolded was occupied by the Gangara, a black, sedentary, Neolithic population dating back several millennia.[8] These Gangara were ancestors of the Soninke, to whom the ancestry of the Ghana empire is attributed, and Azer, a Soninke dialect, is still spoken at Chinguit, Tichit, Oulata, and Nema by small groups of black former slaves called *harratin*. These Neolithic populations first lived in small villages at the base of the long escarpment linking Tichit to Oualata in the Tagant and Hodh regions. Subsequently, under the stress of war and intrusion by nomadic groupings, they moved to the top of the escarpment. Numerous vestiges remain of the stone construction and the stone corbelling they used. The spatial organization of individual compounds suggests an indigenous prototype for the open, internal courtyard house found throughout West Africa. It also lays a spatial foundation for the adaptation of the prototypal North African courtyard house by West African populations (Fig. 5.2a, b).

The Roman presence and expansion across North Africa in the first century A.D. is credited in great measure to the introduction of the camel as a viable means of transport in an already desiccated environment. Not only did Islam inherit the camel for trans-Saharan transport from her Roman predecessors, but she also inherited a number of architectural features, particularly the form of the Roman *atrium*, or courtyard house. By the end of the third century A.D., under the rule of the African-born Roman emperor Septimus Se-

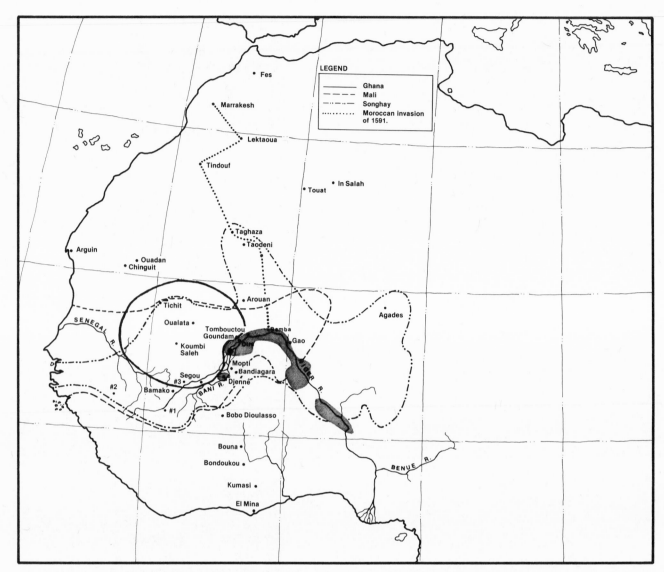

Fig. 5.1 The approximate extension of the medieval empires of Ghana, Mali, and Songhay and the location of the major cities associated with the expansion. Also indicated is the route of the Moroccan invasion of 1591 and the location of Songhay-speaking populations. Drawing after Levtzion (1973); Rouch (1953); Devisse (1975). For the route of the Moroccan invasion, see Péfontan (1926).

verus, a radical reorganization of Rome's North African frontier defense had taken place. A system of *limes* or major fortresses, *limitanei* or fortified farms, and *centenaria* or blockhouses stretched across the Roman empire's southern boundary, reaching down as far as the thirtieth parallel. The *limitanei*, granted to veterans in return for assuming defense responsibility for these outposts, generated a class of soldier-farmers concentrated in what is now southern Libya and Tunisia.

This fortified farm was typically a cubic structure built of ashlar limestone masonry, approximately fifty feet square, and accessible through a single entrance at ground level (Fig. 5.2c). Two or three stories of rooms faced onto an internal open courtyard or lightwell. Scaled-down models of elaborate *limes* such as those located at Bu Ngem, el-Gheria el Garbia, and Cydamae (Ghadames), and the *centaria*, they were a simplification of the classic spatial scheme of Roman domestic architecture, itself derived from the Roman cosmos. At the same time, the courtyard house was an admirable answer to the hot, dry climates both north and south of the Sahara, and it was readily incorporated into the lives of the peoples who intermingled with and moved in and around North African settlements. The *lime* and

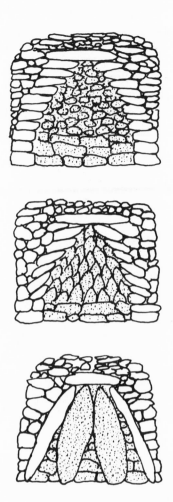

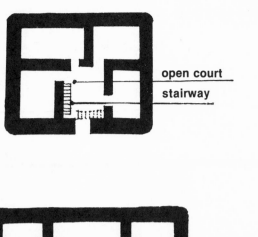

open court

stairway

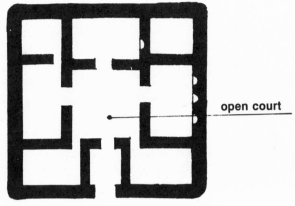

open court

Fig. 5.2a "Gangara" stone housing in the southern Tagant region, Mauretania. Drawing after Du Puigaudeau (1967). Not to scale.

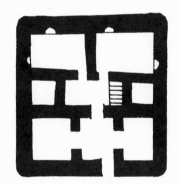

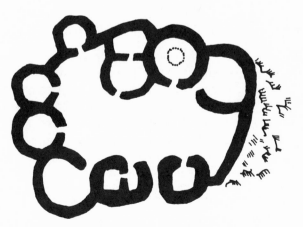

Fig. 5.2b Plan of a compound at Moujeria, Tagant. Drawing after Jacques-Meunié (1961).

| 0 | 5 | 10 | 15m |
| 5 10 | 20 | | 50ft |

Fig. 5.2c Plan of several Roman *limitanai* or fortified farms in Libya. Drawing after Haynes (1959).

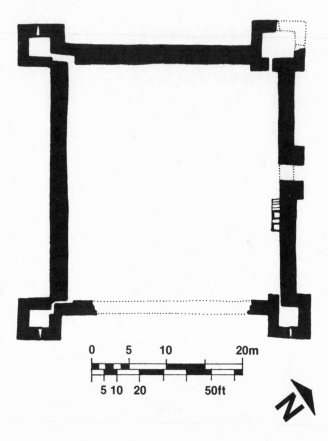

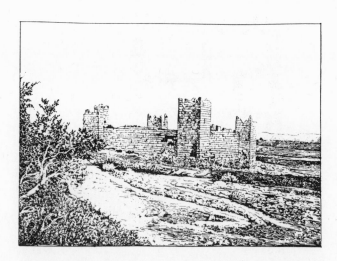

Fig. 5.2d Plan and view of a Byzantine citadel at Lemsa in central Tunisia. Diehl (1896).

limetanei served as models for the Byzantine and Islamic military and residential occupation that followed (Fig. 5.2d). Although the uses of space within the courtyard and the rooms that ringed it were gradually modified, the basic spatial order has persisted to this day. Present-day housing at Ghadames and Tozeur in Tunisia, both former Roman cities and subsequently major entrepôts in the Islamic trans-Saharan traffic, bears a close resemblance to the classic Roman prototype (Fig. 5.2e).

Through its trade routes, Ghana was linked to two critical North African termini: the Maghreb city of Sijilmasa in what is now Morocco, and the Mzab Ibadite city-state of Tahert, founded at the end of the eighth century in what is now Algeria. The wealth of Sijilmasa was attributed precisely to this gold trade with Ghana. When Tahert fell during the ninth century, the eastern terminus merely shifted further east to Ouargla in the Mzab.[9] Hence, at the height of its power Ghana was connected to two quite discrete North African cultural traditions, one in the Maghreb, the other in the Mzab. The routes that linked the Maghreb, the Mzab, and Ghana wove their way through the Berber *ksars* of the Sanhaja nomads, Roman and Byzantine ruins, the stone-built entrepôts of western Mauretania, and the indigenous Neolithic Soninke villages. Its fame was widespread, yet practically nothing is known of this empire or its capital cities. The only description to date is hearsay from the pen of the Andalusian El-Bekri.[10] The name Ghana is itself an enigma, since it was applied generically to the name of the king, to the capital city or cities, and to the empire as a whole. A reasonable explanation for this lack of specificity may lie in the well-known Arabic process of attribution, *nisba*, whereby a toponym may be derived from a tribe, a sect, a town, etc.[11]

Until recently it was believed that Koumbi Saleh, on a site some three hundred miles west-southwest of Tombouctou, was Ghana's capital city.[12] Koumbi has never been definitively established as its capital city, however; moreover it has not been established that the empire had only a single capital. Current thinking has raised the possibility of a "floating" capital, i.e., a number of urbanized centers which may have served, either concurrently or in turn, as the seat of empire. Under this hypothesis, Koumbi Saleh would have been at most its *capital principale*.

This concept has interesting architectural ramifications: on one hand, the idea of a "shifting" capital implies an element of transience in the royal life-style not at all inconsistent with the early Berber practices that created the great Saharan *ksars* or granary-citadels; on the other hand, a shifting capital city is incongruous with the emphasis placed on the funerary rites

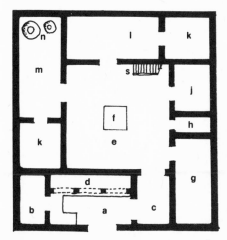

Fig. 5.2e Plan of an old house at Tozeur, Tunisia. Drawing after Borg (1959). Not to scale. Legend: *a. Sgifa* or entrance vestibule. *b.* Guest room. *c.* Second, courtyard entrance. *d.* Arcaded earthen bench. *e.* Open courtyard. *f.* Refuse pit [*sic*]. *g.* Stable. *h.* Latrine. *j.* Kitchen. *k.* Sleeping room. *l. Kebou* or living-reception room. *m. Kebou. n.* Granaries.

In addition to the hundreds of simple stone circles and spirals that have been recorded in the Sahara Desert and have received various inteptations regarding their funerary function (Fig. 5.3a), there are a number of more complex tumuli that merit closer consideration. A number of these latter have been excavated in southeastern Morocco in the Tafilelt region where the city of Sijilmasa flourished (Fig. 5.3b). All are large domical forms, approximately sixty feet in diameter, built up of stone over a central burial pit which, while inaccessible, is on axis with what seems to have been a ceremonial place framed in timber within the earthen or stone mound. Although these tumuli may not be precise prototypes for or replicas of the funerary mound built for the king of Ghana, El-Bekri's description and the archeological record from Tafilelt bear a haunting resemblance to each other.

These southeast Moroccan tumuli also carry a strong resemblance to what may indeed have been their model, the so-called Tomb of the Christian, located west of Alger, near Tipasa (Fig. 5.3c). The European title, bestowed on it because of the crosses represented on its doors, is a misnomer. Properly called K'bour Roumia, it is reputed to be the tomb of Juba II, the last member of a ruling dynasty in one of the Numidian Berber kingdoms that had appeared in the last two centuries B.C.—toward the end of a long struggle between Carthage and Rome. This mausoleum, a magnificent

held in honor of the ruler of the empire of Ghana described by El-Bekri:

> On the death of the king, they construct, with the wood of *sadj*, a great dome, which they set on the place which ought to serve as a tomb; then they place the body on a couch covered with tapestries and pillows, and place it in the interior of the dome; the structure is then covered with mats and cloth; the entire assembled multitude flocks to throw earth on the tomb, forming thereby a large hillock. They surround the monument with a trench, which offers a single passage to those who would like to approach.[13]

Such ceremonies imply a strong attachment to a single site or "place," and what El-Bekri described was the construction of a great funerary mound. Of all the extant monuments of North Africa, perhaps the tombs, the memorabilia of funerary custom, are the most revealing for African architectural history. They are a quintessential human statement of ritual behavior in space and time, of belief system and human values. By nature conservative in their "design" (perhaps because their function is to acknowledge the past), they provide an illuminating insight into a subject whose written records and archeological resources are scarce. Like any architectural configuration that emanates from the activities and behaviors associated with critical life-passages, funerary monuments are a particularly clear and intense expression of the organization of living space. El-Bekri's description becomes visually clear when viewed in the context of other North African tumuli.

Fig. 5.3a Prototypical Saharan tumuli with their characteristic circular or elliptical spiraling stone configuration, a center, and an axial corridor. Not to scale. Drawing after Lhote (1944), fig. 13, and Savary (1966).

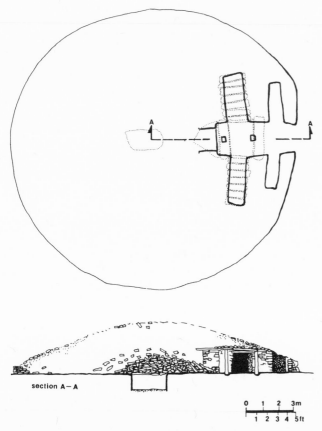

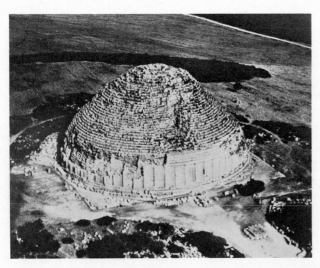

Fig. 5.3b A funerary mound in the Tafilelt region, southeastern Morocco. Drawing after Meunié and Allain (1956).

earthen mound rising over one hundred feet above the ground, was originally belted with a circular ring of sixty Doric columns broken by four cardinally aligned false doors. Despite extensive excavation and restoration over the last hundred years, the tomb remains an enigma. Nevertheless, it provides a spectacular visual image of what may have been a forerunner to the Tafilelt tumuli and the tomb of the king of Ghana described by El-Bekri.

El-Bekri's description of the construction of the tomb of the king of Ghana suggests the re-creation of the interior of a tent structure with its tapestry-covered and pillow-strewn couch. The interior was then enveloped in a matframe structure, a "wooden dome" overlaid with mats and cloth. Only then was the sacred place covered with earth to create the great tumulus. The use of a wooden dome instead of stone corbelling, as distinct from its central Saharan neighbors, from its southeast Moroccan neighbors, and from the Tomb of the Christian, also evokes wooden roof-framing practices then current in Islamized Spain and North Africa.

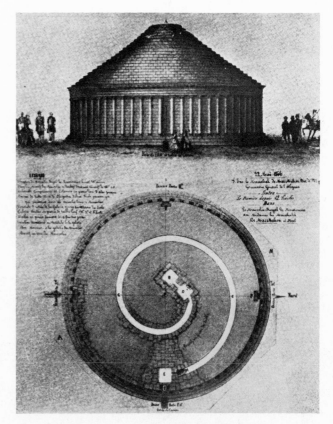

Fig. 5.3c The Tomb of the Christian near Tipasa, Algeria, as published in 1866 by its first archeologist, Adrien Berbrügger. Christolfe (1951).

The preference for a wooden funerary dome is also curious in the light of observed construction practices in the capital city itself. El-Bekri states:

> The city is composed of two cities, located in a plain. The one inhabited by the Muslims is very large and includes twelves mosques, one of them a Friday mosque. All these mosques have their imams, their *moueddins* and their salaried readers. The city has jurists and men of wisdom. The city inhabited by the king is six miles distant and carries the name of *el ghaba*, "forest, woodland." The area separating the two is covered with habitation. The buildings are constructed of stone and acacia wood. The residence of the king is composed of a palace and many huts with curved roofs, and all is surrounded by an enclosure similar to a wall. In the city of the sovereign, not far from the royal tribunal, is a mosque which the Muslims who come to fulfill their missions with the prince attend. The city of the king is surrounded with huts, massive trees and woodland, which serves as residence for the magicians of the nation in charge of the religious cult; it is there that they have placed their idols and the tombs of their sovereigns. . . . The interpreters of the king are chosen among the Muslims, as is the steward of the Treasury and most of the *viziers* or ministers. . . . When he grants an audience to the people . . . he seats himself in a pavilion, around which are ranked ten horses covered with trappings of gold cloth. . . . The governor of the city is seated on the ground in front of the king and all around are the ministers in the same position.[14]

Presumably the wooden dome was a tomb in the woodland and the woodland itself was a sacred site. The king's palace, his royal tribunal, and a mosque were probably in close proximity to, or perhaps actually within, this sacred site. This "principal capital" was morphologically a "twin city," a phenomenon still common throughout Islamized West Africa, reflecting the city's dual role as an economic and a religico-political center. The description further implies that walls were constructed of stone and that the ceilings of the more luxurious structures were built of timber, just as they still are in the Mauretanian stone cities of Tichit, Chinguit, and Qasr el-Barka. Translators have always interpreted the huts to which El-Bekri refers as earthen roundhouses with conical thatch roofs, but it seems equally reasonable to interpret them as domical mat-frame tents or as stone-corbelled domed Gangara houses (mentioned above).[15]

Most importantly, El-Bekri's description suggests that by the late eleventh century the Muslim presence in the court of the Ghanaian empire was considerable. The king's interpreters, his chief treasurer, and most of his ministers were Muslim. At least the architecture of his palace would have reflected this marked presence.

Certainly, the reference to a pavilion and its gold-bedecked horses puts us in the realm of a royal baldachino or Tent of Appearances—a prototype for those who followed in the course of West African political history.

Some initial excavation at the site of Koumbi Saleh was begun in 1914, and a number of additional excavations continued over the years; together they reveal one of the most impressive sets of archeological ruins in all of West Africa.[16] Although the disappearance of much of the artifactual data from the earlier excavations has created an irreparable hiatus, the currently available data provide a fascinating avenue for architectural speculation.

One of the most interesting but, unfortunately, most disturbed constructions is a square stone tomb, approximately sixteen feet square (Fig. 5.4a). Each of its corners has been recessed to receive a cylindrical column. The tomb was obviously designed initially to have four openings, each centered in a wall and facing a cardinal direction. Two were subsequently filled in on one occasion, and the third apparently later, leaving a single western entrance. A descending stairway built of kiln-dried brick within the tomb structure itself led into a subterranean chamber whose stone walls had at one time been covered with plaster over which designs had been painted in red. Although the record is not clear, three sarcophagi had apparently been housed in the tomb recess.

It has been suggested that the Tomb of Columns at Koumbi Saleh recalls the many Ibadite *kubbas* found in the Mzab region.[17] The suggestion is particularly persuasive in the light of the close relationship between

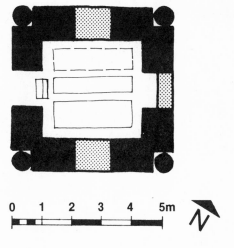

Fig. 5.4a Plan of the tomb excavated at Koumbi Saleh, Mauretania. Drawing after Mauny (1961).

Ghana and Tahert in the eighth and ninth centuries, but close comparison between them raises several questions: the presence of *three* sarcophagi within the single tomb structure, the configuration of recessed corners and non-engaged columns, and the kiln-dried brick staircase leading into a subterranean chamber. North African *kubbas*, with few exceptions, house a single saintly personage. No extant *kubbas* in either the Maghreb or the Mzab have this kind of circular, column-recessed corner configuration. Finally, the preference for a kiln-dried brick subterranean staircase for any tomb, let alone one in an area of abundant stone, is curious.

There are a number of Roman mausolea in both the Maghreb and the Mzab that suggest in plan precisely the configuration found at Koumbi Saleh. The inverse corner quoins, which are directly comparable to those on a mausoleum at Tolágga, Algeria, are still visible (Fig. 5.4b). Related structures, such as cisterns and triumphal arches, built at Dougga, Volubilis and Lepcis Magna during the Hadrianic period are close parallels in plan. A kiln-dried brick stairway suggests the site of a cistern, a well, a spring, or a bath.[18] The unique arrangement of the archeological core, as well as the subterranean kiln-fired brick construction, suggests a Roman or a pre-Roman presence.[19]

The closest Islamic architectural relatives come not only from the North African mandala-plan *kubbas* and from mausolea such as that of Khwaja Rabi at Mashhad, Iran, but from the Bab Lalla Rayhana or Bab Sahoun vestibule of the Great Mosque at Kairouan, which dates from A.D. 1293 (Fig. 5.4c). Another parallel whose stylistic configuration closely resembles the vestibule itself is the baldachino-type tier that crowns the minaret of the mosque at Kairouan (see Fig. 5.15c).

The similarities between the plan of the tomb at Koumbi Saleh and the Kairouan vestibule entrance are perhaps particularly important in the light of the building program of Mansa Musa and the poet-architect al-Saheli in the early fourteenth century. Of equal but highly speculative interest is the similarity between the plan representation of the Tomb and the Mauretanian motif *dar sanduk* or "house," frequently used by the female leatherworkers throughout this region (Fig. 5.4d). Bab Lalla Rayhana, for whom this Kairouan vestibule-entrance is named, was a female saint who is interred nearby.

The Tomb with Columns is bounded by five or six successive square walls, at varying distances from each other. Attached to the northwest corner of the first encircling wall and the northeast corner of the next wall are what may have been either simple, square, tombed enclosures or simply sheltered enclosures for a "guardian" at the single entrance into a sacred space.[20] Inter-

Fig. 5.4b Roman mausoleum at Tolágga, Algeria. Barth (1857–1859), vol. 1.

spersed throughout, particularly in the area between the tomb and its first encircling wall, are vestiges of the more classic, prototypal *kubbas*. One can only conclude that these successive walls were built at different times, and they may, in sequence, indicate successive occupations of the city site. They also recall the concentric circles of stone that characterize so much of the tomb repertoire of the central Sahara; their rectangular configuration may reflect the way Islamic prescription

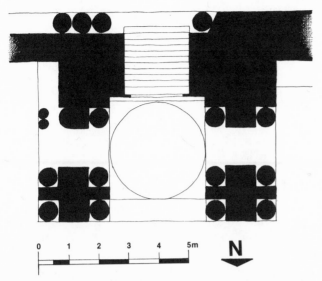

Fig. 5.4c Plan of the Bab Lalla Rayhana vestibule entrance to the Great Mosque at Kairouan, Tunisia, the traditional seat of Malekite law and learning in North Africa. Drawing after Sebag (1965).

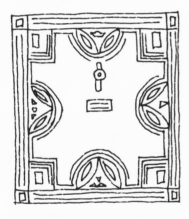

Fig. 5.4d Leatherwork design from Mauretania and Mali. *Dar sandouk*: the house, or *gfal sandouk*: the lock of the coffer or trunk. Drawing after Gabus (1958).

subsumed former funerary practices. A close parallel can be seen in the recent excavations of another mausoleum at Souk-el-Gour, between Meknes and Fès, which also suggests a newly Islamized indigenous tradition.[21] This continuity in sacred space and its spatial organization, in which a central tomb is bounded by sequential, concentric walls, appears to have evolved into a template for Islamized West African space. It also suggests a point of departure for our analysis of the

arrangement of the Tomb of Askia Muhamed at Gao, for the configuration of the extinct mosque at Djenné, and for the classic mosques at Tombouctou.

Subsequent excavations in a residential quarter of the Koumbi site provided further insights into the city's history.[22] The plan and construction differ from both the classic earthen prototypes of the West African savannah and the North African atrium or impluvium. Instead, there is a row of streetfront shops or storerooms, framed in heavy stone contraforts (Fig. 5.5a). The arrangement recalls what might have been a predecessor to the *sigifa* or *skiffa*—the narrow rectangular pair of entrance-vestibules fronting on an internal open court. Within the first entrance chambers there are innumerable niches built up of triangulated stone chevron-type motifs. Within these narrow, elongated entrance chambers, at one end in each "row shop" is a stone bench. These were presumably used as bed platforms for the guardians or "keepers of the entrance." In every instance there is a staircase opposite the platform bench which led up to a second level or to a terrace. Beyond this entrance corridor the long narrow rooms all run parallel to it along a north-south axis. The parallel walls were spanned by short beams running perpendicular. The strongly north-south orientation of the parallel walls recalls the north-south alignment of *kibla* walls in this region.

The total absence of any traditional internal courtyard suggests that these spaces were designed, not to accommodate family life or the presence of women in an Islamic context, but to display the wares of the itinerant merchants who came and went with the trans-Saharan caravans. The artifactual ware retrieved from the interiors and the substrata of these storerooms and from adjacent cemeteries suggests an occupation extending into the mid-seventeenth century. Thus, while Koumbi Saleh may have been at its political apogee when El-Bekri wrote, it continued to be a viable entrepôt, if not the seat of political power or empire, long past its conquest by the Almoravids in 1077, and presumably past its conquest by the newly emergent forces of Mali in A.D. 1240.[23]

Another city, now in the course of excavation, equally associated with the empire of Ghana was Tegdaoust, the provisional Audoghast destroyed by the Almoravid invasion several decades before the conquest of Koumbi Saleh. The city lay considerably northwest of Koumbi and directly west of the city of Oualata, Mauretania. Recent archeology at the site has revealed the close formal stylistic affinity between the two Ghanaian cities: the same triangular niches, the same stone platforms, and the same central pillar support systems (Fig. 5.5b).[24] Excavation has also established five successive occupations on the site, extending from the sev-

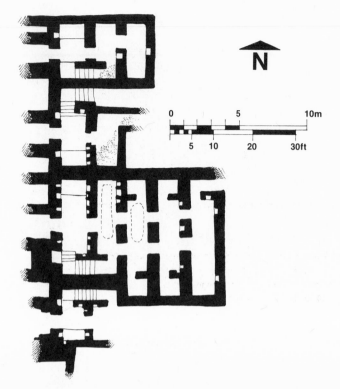

Fig. 5.5a Plan of the excavation in the city of Koumbi Saleh, Mauretania. Drawing after Thomassey and Mauny (1956).

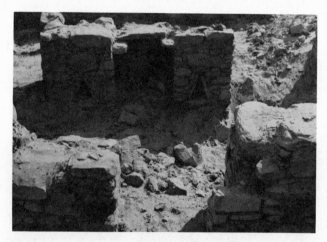

Fig. 5.5b Archeological ruins at Tegdaoust, Mauretania.

enth to the thirteenth century. In contrast to Koumbi Saleh, however, there was no indication of an indigenous "pagan" sister-city despite the fact that the ruler was not a "believer" in A.D. 872, and there are references to the presence of black women slaves from the Sudan. The reference to Sudanese women slaves is particularly noteworthy in light of subsequent architectural developments in Islamic West Africa.

Mauretanian Ksars

Koumbi Saleh and Tegdaoust are now part of the archeological record, but a clear image of their architectural configuration and the urban environment it reflected can easily be reconstructed from their sister cities—the now greatly reduced but still inhabited remains of Chinguit and Oudan in the northern Adrar and of Tichit, Tijikja, and Qasr el-Barka in the southern Tagant region of Mauretania.

Since the earliest Arabic expansion to the west, the vast region in which these sister cities are located has been the refuge of the Sanhadja confederation of *murabitun*, a loosely knit empire of Berber tribes who were instrumental in the Almoravid invasion north to the Maghreb and the Iberian Peninsula in the eleventh century A.D. While the northern Berber confederation was short-lived, the southern Sanhadja confederation continued inviolate until the sixteenth century. Influenced by the mystical doctrine of Sufism and by the military tone of its new adherents, the Islam of the *murabitun* underwent further transformation when imposed upon the sedentary Black populations of the Tagant region. The southern region also witnessed the expansion of the Beni Hassan (an Arab tribe) through the mid-sixteenth century. Their slow progression, first to the Atlantic coast and then south—marked by alternating alliances and ruptures with the various Sanhadjan factions they encountered—culminated in the lengthy conquest of Chinguit. While many Sanhadja abandoned their arms in the peaceful transition to Islam, others joined the Beni Hassan as warriors. It is out of this duality that the tradition of the *zawiya* and *ribat* emerged.

The similarity between the architectural motifs found in the Mauretanian *ksars* and Berber architecture elsewhere in the North African world has been considered at some length in several detailed studies of these cities.[25] Whether founded as *zawiya* or as *ribat*, all these cities in the Mauretanian desert and southern sahel were also relays along one or another trans-Saharan route. All in turn provide evidence not only for the architecture of Koumbi Saleh and Audoghast or Tegdaoust, but for an architectural iconography that was subsequently integrated into the more southerly and westerly West African centers of commerce and polity. The motifs executed in stone are directly translatable into earthen construction and continue, to this day, to be a hallmark of the Manding style.

Chinguit is perhaps the best-known city in this cluster of dry-stone architecture; it is also considered to be the oldest continuous settlement in the region. Founded in the mid-thirteenth century, it must initially have been a fortified site, a *ribat*, but its walls have long

since disappeared. Oral tradition suggests that the building of its first mosque, in the fourteenth century, was facilitated by supernatural assistance. It is referred to by the early Arabic chroniclers, and when the Beni Hassan conquered it in their sixteenth-century expansion the name Chinguit was extended by the Arabs to encompass the entire western Sahara. Over these centuries, it contained a number of mosques, schools, and an important market; a flourishing oasis, it served as the southwestern rallying point for caravans embarking for Mecca. Chinguit is one of the seven cities of Islam that are considered to be sources of both saintliness and science.

The Friday mosque was restored some decades ago, but after the city was abandoned, the encroaching sands accelerated deterioration. The minaret, however, remains the best conserved of all those found in this region; building techniques derivative of earlier traditions are clearly visible. Solidly founded on a plinth six to seven meters on each side, its square tower tapers gradually and is crowned by a triple-stepped cornice and four corner acroteria (Fig. 5.6a). The walls are carefully laid up in dry stone, and the nuances of its yellow and rose-colored ashlar faces echo the tones of the mountains and dunes that surround the city.

The classic triangular cellwork, corbelling, lines of chevron-laid stone, and stepped terracing reflect in stone the geometric earthen intricacies of the Moroccan *ksars* in the Draa and Dades valleys. However, in contrast to the sharp corner quoins in the north, here corners are softly rounded, a memory, perhaps, of the circular housing that was the earliest form in that part of the desert (Fig. 5.6b).

Although it was effectively abandoned as a trade center, Chinguit continued until quite recently to support castes of *ma'allemin*, the blacksmiths and silversmiths who fabricated both building and agricultural tools, and the women leatherworkers continued to produce the camel saddles renowned for their richness of decoration.[26]

Out of the Beni Hassan occupation of Berber country evolved a revised written language, *hasaniya*, related to classical Arabic. *Hasaniya* incorporated numerous Berber and Azer words, primarily in the realm of trades and crafts, that their tributaries and slaves continued to use. In turn, a number of socio-cultural elements, including monogamy, were incorporated into the new Arabic hegemony and served to modify Islam.

If Chinguit can serve as a prototype for the northern Adrar, it is Tichit in the Tagant region, closer to the savannah and to the seats of medieval empire, that provides us with a more accurate picture of the role of Islam in the stylistic continuum linking the north to the west. Tichit sits at the interface between an architec-

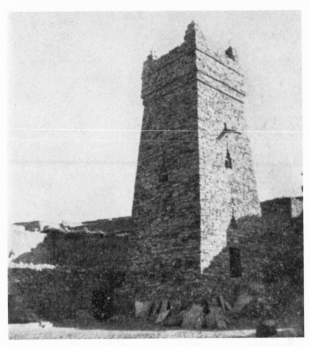

Fig. 5.6a Minaret of the mosque at Chinguit, Mauretania. Du Puigaudeau (1967).

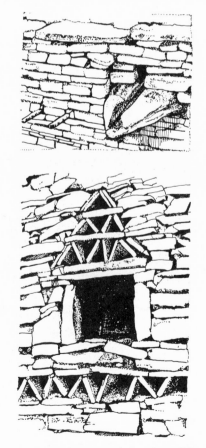

Fig. 5.6b Facades and stonework details at Chinguit. Drawing after Du Puigaudeau (1967).

tural style derived from the use of split flagstone and an architecture derived from molded earth. Unlike the architecture of the innumerable villages in ruins that dot the length of the Tichit escarpment—the Dhar Tichit—the urban architecture of Tichit itself has rectangular foundations, right angles, rectangular rooms, and interior courts comparable to the more usual North African housing. Wall remains suggest the exercise of extreme skill. Surfaces are smooth, and stones are carefully laid. It has been suggested that "it is at Tichit that the stone architecture seems to have reached perfection."[27] The traditional themes, the decorative elements are the same: triangular niches, zigzags forming a line of triangulation like an insert of Arabic script, corbelling and blind facades. The few window openings look out only onto an interior court (Fig. 5.7a).

According to tradition, Tichit was founded in the eighth century, but its history, like that of Chinguit, is shrouded in mystery. Undoubtedly a Soninke village originally, its architectural character changed with the southern Berber penetration. The major part of the city, when documented by Jacques-Meunié several decades ago, was inhabited by the Massena, who speak *azer*, the original language of the Soninke.

Although on the surface the architecture of Tichit resembles that of Chinguit, several unique differences merit mention. Although exterior walls are left bare, revealing in their nudity the superb craftsmanship of cut stone, interior wall faces are stuccoed over with clay. The split-stone masonry is itself laid up with an earthen mortar, in contrast to dry-stone construction. Another curious tradition, recorded only at Tichit, is that of leather-covered ostrich eggs hung from the ceiling in the mortuary chambers of the founder of the Zawiya Taibiya de Quezzan. These were brought by the various pilgrims to what has become his shrine.[28] Unique to Tichit, too, are the pairs of windows whose lintels elaborate into a simulated arrowhead, recalling the decor of the more northerly *ksars*.

It is at Tichit that the transformation of space appears to be most sharply defined. The gradual expansion and geometrization of interior courtyards can be traced from the earliest Neolithic Gangara ruins to the signorial two-court Massena mansions (Fig. 5.7b). These geometrically organized spaces are a reminder of the carefully wrought eight-sided ceilings of Chinguit, Ouadan, and North Africa in general (Fig. 5.7c).

The ceilings are framed on the diagonal, using the trunks of date palms as primary members. Above them, a matting of split fronds is laid chevron-fashion to support an earthen roof. The arrangement of graduating timbers, which provides a means for creating a square space with far greater dimensions than the available short lengths of palm trunk would otherwise permit, recall the *artesonado* ceilings of wood that simulated a truncated pyramidal form during the thirteenth and fourteenth centuries of Almohad rule in southern Spain and Morocco. This basic structural design persisted through the centuries, albeit in simplified form, as a nineteenth-century Spanish carpentry manual clearly illustrates (Fig. 5.7d). Ceilings framed identically are also one of the hallmarks of the architecture of Djenné (see Chapter 6).

It has been suggested that in the Sahara there are no architects properly speaking to whom one can credit this form of architecture. When a person decides to build a house, he explains to a master mason just what it is he wants. The architectural plan is only an outline traced with a finger in the sand, not unlike the designs a marabout will trace in the sand in divination practices. The enterprise is facilitated by the fact that the architecture is strictly traditional. The masons faithfully copy the existing models, since their repertoire, given the limitations of technology, is limited to the exigencies of the available material in combination with the mathematics of mysticism.

Niani, Kangaba, and the Empire of Mali

The demise of the Ghana empire and the emergence of that of Mali were accompanied by a gradual shift and extension of the trans-Saharan trade routes

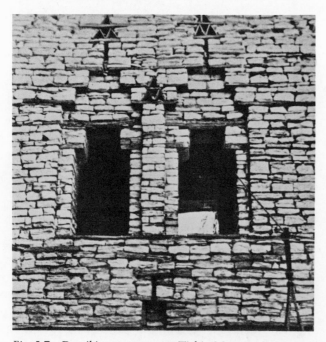

Fig. 5.7a Detail in green stone at Tichit, Mauretania.

southward into a newly discovered region of auriferous ore at Bouré in the upper reaches of the Niger River. This shift, which moved the seat of West African political power into the savannah, was also the harbinger of new architectural phenomena at both the monumental and the vernacular level. The rise of Mali, and the southern shift of political centers into a new ecological niche, ushered in the beginnings of monumental, earthen architecture, an architecture that eventually replaced its northwestern stone predecessors.

Malian expansion was made possible by the unification of two groups of Manding—an earlier consolidation of northern chiefdoms, with a later development of southern chiefdoms. The merger of the two created the nucleus of the Malian empire. Tradition also associates the emergence of kingship with the southern expansion of the Wangara or Dyula traders.[29] The northern chiefdoms had long been in contact with Muslim traders: fourteenth-century traditions refer to the pilgrimages made by the ancestors of the Keita, the lineage that produced the first kings of Mali. It is equally clear from the oral traditions that the Keita trace their ancestry back, not to the "whites," as is so often the case in Muslim hagiography, but to *Bilal*, a "black."

The symbolic act consolidating the northern and southern chiefdoms, recorded in the epic of Sundiata, was the gathering of all the Malinke chiefs at Ka-ba (or Kangaba) on the Malian border upon the successful conclusion of their "war of independence." A loose confederation of independent polities based on kin-group alliances was transformed into an empire with provinces, with the Keita as ruling clan. Kangaba was the birthplace with which the newly forged empire identified itself, but it was not the site of the village itself. "If you go to Ka-ba, go and see the glade [i.e., the woodland] of Kouroukan Fougan, you will see a *linke* tree planted there, perpetuating the memory of the great gathering which witnessed the division of the world."[30] Kangaba was the sacred center which commemorated the foundation of a cohesive political entity, established its cultural identity, and forged its unity—and, like similar traditions worldwide, its symbol was a tree (Fig. 5.8).

The ancestral capital of the Keita chieftaincy and the birthplace of Sundiata, the epic hero who effected political consolidation, was the village of Niani, two or three days' march from Kangaba "across the river." After the ritual of unification at Kangaba, Sundiata marched back to Niani, to settle there and maintain the continuity of his ancestral heritage. "The triumphal march [from Kangaba] ended outside Niani, Sundiata's own city." The city was rebuilt after its destruction by the Sosso, and Sundiata had his father's "old enclosure, where he had grown up, restored in the ancient style."

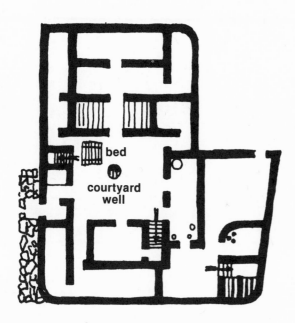

bed

courtyard well

courtyard with beds

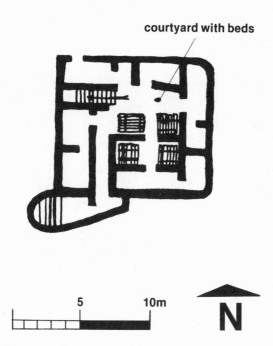

5 10m

N

Fig. 5.7b Plan of compounds at Tichit. Drawings after Jacques-Meunié (1961).

Fig. 5.7c Ceiling construction at Ouadan, Mauretania. Drawing after Du Puigaudeau (1967).

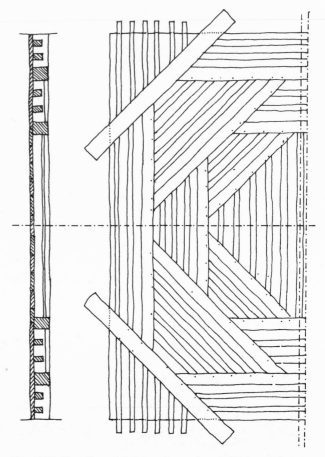

Fig. 5.7d Framing of simulated wooden vaults in southern Spain. After a drawing by F. de Arias (1860?).

The town was enlarged and new quarters were built for each kin-group in the enormous army. After one year, a new assembly of dignitaries was held at Niani. Sundiata "made the capital of an empire out of his father's village and Niani became the navel of the earth." Thus, while Kangaba remained the spiritual shrine commemorating consolidation, Niani, validated by ancestral continuity of the Keita lineage, became the political, administrative capital.[31]

For more than a century, scholars have speculated on the site of Niani. Reference to several successive capitals has led some scholars to suggest that, as in Ghana, "the site has little real significance in Sudanese history, for the residence of the ruler was continually changing."[32] And yet, any cultural—certainly, any political—entity requires at least a symbolic identity in space: a *place* in the environment. The need to establish such a place in the history of Mali is conceptually linked with birth in the reference to "navel." What is intriguing is that whereas the site of Kangaba, with its small roundhouse ancestral shrine, remains a ritual center associ-

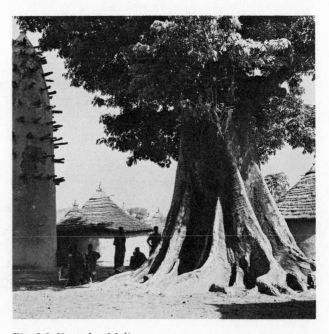

Fig. 5.8 Kangaba, Mali.

ated with ideological legitimacy, the site of Niani, the ancestral birthplace of the northern Keita, is an enigma.

Attention has focused on three possible sites: Niani-en-Sankorani; a site between two tributaries to the Sénégal and Gambia rivers; and a site on the north bank of the Niger River between Bamako and Ségou (see Fig. 5.1).[33] Although written references, linguistic evidence, oral traditions, archeology, geographic analysis, and logic have all been brought to bear on the problem, the question remains open.

In the great Sundiata epic that sings of the formation of the empire, there is a reference to the crossing of the Niger on the march from Kangaba to Niani, in order to enter "old Mali."[34] Since "old Mali" refers to the northern chiefdoms, one can assume that Sundiata was traveling north from Kangaba. We are also reminded of the Mande creation myth considered in Chapter 3, whose associated ritual involves the participation of twenty-two riverine villages, all on the Niger River. A more northerly site would conform more closely to the oral traditions of the Keita *griots* or praise-singers at Kangaba: "It is the mountainous region of Kri, in Mali of the north, which the Keita consider as the cradle of their family, and it is at Kangaba, the modern sanctuary, where the ancestral rites are perpetuated."[35]

In singing their praises of Sundiata, the *griots* suggest that it is they who keep the keys to the twelve doors of Mali: the analogy is to the twelve provinces that comprised ancient Mali. The same choice of architectural imagery that highlights the importance of openings into a bounded space also suggests that the twelve doors could be projected onto a square plan with three entrances on each of the four faces cardinally, not unlike the ideal form of many traditional Islamic cities and mosques—in the plan of a magic square.

Two fourteenth-century Arabic accounts—one based on firsthand information, the other an eye-witness account—paint remarkably vivid images of the capital at the height of its power. According to al-Umari, who gathered his information from a Moroccan who had spent thirty-five years in Mali, Bina, or Bita:

> [The capital] extends in length and breadth to a distance of approximately one *barid*. It is not surrounded by a wall and most of it is scattered. . . . The town is surrounded on four sides by a branch of the "Nile." On one (or some) of them a crossing can be made on foot when the water is low, while on others a crossing can only be made in boats. The buildings of this town are made of *ivad* or clay like the walls of the gardens of Damascus. This consists of building two-thirds of a cubit (i.e. about one foot) in clay, then leaving it to dry, then building above it in the same way . . . and so on until it is complete. The roofs are of wood and reeds (*qasab*) and are generally domed or conical, in the form

of cupolas or camelbacks, similar to the arch shaped openings of vaults.[36]

And Ibn Battuta says:

> We left Carsakhou and travelled towards the river Sansarah, which is around ten miles from Mali. . . . When I arrived at the said river, I crossed it in a ferry. . . . Arriving at Mali, the capital of the King of the Blacks, I descended close to the cemetery of this city, and from there I went to the quarter occupied by the white men.[37]

From these accounts it is clear that Niani or Bina was no mere village but an extensive seven-mile-square conurbation, sitting on an island or on a peninsula projecting into either a tributary of the Niger River or the Niger itself.

Al-Umari's description implies that the city may have been located on one of the many *togguere* or pseudo-islands which are subject to the ebb and flow of a major river-stream, and which mark the course of not only the Niger but the Sénégal and Gambia rivers as well. His reference to sandy soil suggests that the site was north of the region of heavily laden laterite soils. The construction process he refers to is precisely the "coil pottery" technique of earthern wall building (see Chapter 2). The presence of both domed and conical roofs recalls prototypal Malinke architecture, but it is equally descriptive of the camelback tents and the mat-frame Fulbe tents whose residence patterns overlap the entire region from the mouth of the Gambia River eastward.[38]

Ibn Battuta also described the audience chamber of the king:

> The Sultan has a raised cupola whose door is found in the interior of his palace, and where he is frequently seated. On the side of the audience place, it is provided with three vaulted windows in wood, covered with silver plaques, and below them, three others garnished with goldleaf. These windows have a wool drapery which is raised the day of the Sultan's séance in the cupola; one knows thereby that the sovereign ought to come to this place. When he is seated, a silk cord, to which an Egyptian-fabricated, striped handkerchief is attached, emerges from the lattice of one of the wickerwork [grilles]; on seeing it, the drums were beaten and the horns played. From the door of the "chateau" emerge three hundred slaves, having in hand some bows, others small lances and shields. The former stand up to the right and left of the audience place; the latter seat themselves in the same manner. One leads two saddled and bridled horses, and accompanied by two rams. These people claim that the latter are useful against the evil eye.[39]

This description recalls another, by Ibn Khaldûn, of the work of Abu Ishaq al-Saheli, commissioned by Mansa

Musa, the king of Mali, upon his return from the *hajj*:

> We accompanied him up to the capital of his kingdom, and, as he wished to construct an audience hall, he decided that it would be solidly built and faced with plaster; because such buildings were unknown in his country. Abou-Ishaq-et-Toueidjen ... built a square room, surmounted by a cupola. ... Having rendered with plaster and ornamented it with arabesques in glowing colors, he made there an admirable monument. As the architecture was unknown in this country, the sultan was charmed and gave to Toueidjen twelve thousand mithcals of gold dust as witness of his satisfaction.[40]

This audience hall attributed to al-Saheli, the Andalusian poet-architect, may well have been a baldachino-type oratory—a square-sided cupola—with grillework and free-standing courtyard walls, comparable to the court of the Alberca at the Alhambra in Granada or the *mihrab* of the mosque of Sidi bel-Hasen at Tlemcen. Built in the late thirteenth or early fourteenth century, both carry a triad of window grilles in the upper register above a central arched doorway and exhibit a similar relationship between an open interior courtyard and a free-standing baldachino oratory.[41] This baldachino may also have resembled the "cage" used by the sultan of Bornou at Kouka, further east, as it was described by Denham, Clapperton, and Oudney during their travels in northeastern Nigeria in the mid-nineteenth century (see Fig. 7.8).

The audience chamber itself, when viewed in the context of either North African or West African indigenous patterns of spatial enclosure, could be interpreted as an open, bounded but central courtyard or *mashwar*, onto which the baldachino faced. According to Ibn Batūtta:

> Sometimes the sultan holds his séances in the audience place; there is in this corner a platform, located under a tree, provided with three steps and called a *bembe*. It is covered with silk, adorned with pillows, and above it rises a parasol which resembles a silk dome, and on the summit of it one sees a golden bird, large as a hawk. The sultan emerges through a door set in at a corner of the palace; he carries a bow in his hand and a quiver on his back. On his head is a gold skullcap, attached by means of a small gold band. He is most frequently dressed in a rough red tunic, made of European fabricated cloth.[42]

The reference to a tree recalls the long-standing indigenous tradition of the sacred tree; the entrance at a corner of the audience space recalls the corner location of the entrances to courtyards seen in the stone entrepôts of Mauretania as well as the bounding walls of the Tomb of Columns at Koumbi Saleh.

How and with what materials were this "audience place" and the square-sided cupola with its door and grillework built? Can we assume that the grilles were assembled in a manner similar to that used in North Africa? If so, it is not clear what woods were used, since the fibrous palm timber does not lend itself to parquet construction. How were the arabesque walls of the audience place created, since fine plasterwork depends upon stuccos and limes? Were the arabesque screens devised by means of a woven wickerwork not unlike Asante screens (considered in Chapter 8), or by means of a simulated parquetwork like the upper-floor hardwood grilles at Tombouctou and Djenné, Mali (considered below and in Chapter 6)? These latter could easily have been covered with an overlay of gold and silver leaf.

It has often been assumed that the impressive sum presented to the architect presupposed a vast building program. Since the general practice during this period in history and in the Muslim world combined compensation for the costs of construction with payment for the services of the master builder, the "gift" was not exorbitant, particularly since silver and gold detail were an important part of the work executed.[43]

The two descriptions by Ibn Battūta imply two alternative rituals for holding court. In one instance, audiences were held under the baldachino; in the other, the king held court in the open courtyard itself, seated on a dais, under a vast parasol in the manner of a Tent of Appearances, dressed in the garb of a Malinke, Keita hunter. The *counterpoint* presence of traditional hunters and well-equipped warriors suggests a ritual in transition in which the traditional panoply and the Islamic architectonic model existed side by side.

During attendance at one of the two major Islamic festivals observed during his long visit to Niani, Ibn Battūta described the arrival of the *djoula* or *griots*, the poets or minstrels of the king:

> They make their entry, each of them enveloped in a costume of feathers resembling a chikchak [a type of sparrow], to which a wooden head provided with a red beak has been attached, in imitation of the head of this bird. ... I have been assured that it is a very ancient custom, prior to the introduction of Islam among these peoples, and in which they have always persisted.[44]

The presence of the masquerade within the context of Islamic festival suggests a close parallel to the two architectural settings of audience ritual. One reinforces the newly emergent political role of the sovereign's office through traditional behavior; the other incorporates Islamic symbols of political leadership. The description also vividly recalls the way in which traditional and Islamic arts coexist in masquerade, as

well as the pair of masking traditions recorded in the early nineteenth century in the Kajaaga region between Galam and the cataract of Fetou (see Fig. 1.13). The reference to a pair of horses and a pair of rams as protection against the evil eye is perhaps the earliest reference to the importance of the ram and the role of the horse in political and ritual aspects of West African Islam.

In contrast to his rather detailed description of the audience place of the king of Mali, Ibn Battūta had little to say about the mosques in the city, but several passing references are of architectural interest:

> I found myself in Mali during the two festivals of sacrifice and the feast breaking. The inhabitants rendered themselves to the vast prayer space [*musalla*] or oratory, located in the neighborhood of the sultan's palace; they were dressed in beautiful white habits. The sultan emerged on horse, carrying on his head the *thailecan*, a sort of hood. The blacks make use of this headdress only on the occasion of religious festivals, except, however, the judge, the priest, and the jurists, who carry it constantly. . . . In front of the monarch one sees some flags of red silk. A tent had been raised near the oratory, where the sultan entered and prepared for the ceremony; then he rendered himself to the oratory.[45]

A *musalla* in the Islamic tradition is a large open prayer enclosure, often (in West Africa) demarcated by a circle of stones. The close proximity of palace to *musalla* also recalls an urban pattern already common to North Africa: the proximity of mosque, palace, and marketplace.

Archeological research, undertaken in the early decades of this century on the basis of a rich corpus of oral traditions, has centered on a site near the Sankarani River, a southwestern tributary to the Niger River. More recent archeological efforts have been undertaken at the village of Niani-en-Sankarani, Guinea, directly south of Kangaba, but the results of more than ten years of effort have been disappointing. The entire settlement has been mapped, including a large complex consisting of a fortified royal quarter, a dozen or so tells in the residential district, places of metallurgical production, and numerous burial grounds.[46] A possible mosque site has been suggested—an adjacent square in the vicinity of which the Arabic community is reputed to have resided—and a cemetery with supposedly pronounced Muslim features has been located. Recent excavations have unearthed a perimeter foundation wall approximately twenty meters square, constructed in *banco*, or earth. This structure is reputed to be the audience room mentioned in the earliest Arabic accounts. Close to the square structure another, smaller circular foundation of stones was located which, it has been

suggested, was the palace. The mapped settlement consisted mainly of earthen roundhouse construction on stone foundations, and tombs marked by circles of stones suspiciously similar to those found much further north and west (Fig. 5.9). Although tentative carbon-14 dates suggest an occupation from the sixth through the seventeenth century, the artifactual yield from the site has been scanty and inconclusive, particularly in the realm of luxury goods, which would normally be found in a site of such importance.

What has been published, despite the claims of its principal investigators, raises as many questions as it answers. The site location and the archeological evidence are inconsistent with any of the evidence extracted from early accounts. The archeological characteristics described could be found in almost any significant settlement involved in the trade network of the western Sudan.

Fig. 5.9 Foundations excavated at Niani. *Not to scale.* Drawing after Filipowiak (1968).

Considering the richness of the panoply of ritual, the continuity of masking traditions, and the organization of space, we are led to suggest a more northerly location than has been assumed to date. At the time the Arabic accounts were written, the "Nile" was taken to be a combination of the Niger and Sénégal rivers (see Fig. 1.1). A more northerly site would conform more closely to the oral traditions of the Keita *griots*. References in the written record to the presence of Massufa merchants from the north and to the exclusive use of camel transport (camels cannot survive in the south) reinforce the likelihood of a northerly location.

If place names are viewed in a more generic context than European habit allows, there is some cartographic evidence that raises the possibility of a site in the southerly reaches of the Ferlo upper savannah belt. Various mid- and late-nineteenth-century European maps refer to a region of Niani west of the Bambouk gold fields, from which a number of routes linking Oualata and Tichit emanate.[47] This suggestion of a more northwesterly location is not new; it has already been tentatively raised and perhaps merits serious consideration, since the travel conditions linking Oualata and the capitol of Mali reflect Ibn Battūta's description of his itinerary more accurately.[48]

Gao and the Empire of Songhay

The city-state of Ghana, the far-western terminus for trade from Sijilmasa and Tahert, was matched in the central Sudan by the emergent splendor of Gao. The Arabic geographer al-Ya'qubi wrote in A.D. 872:

> Then there is the kingdom of KawKaw [Gao], which is the greatest of the realms of the Sudan, the most important and powerful. All other kingdoms obey its king. . . . Under it there are a number of kingdoms, the rulers of which pay allegiance to the king of KawKaw, and acknowledge his sovereignty, although they are kings themselves in their own lands.[49]

An eighth-century account suggests that Gao was particularly important to the merchants of Tahert, a Mzab city in the north. The city was a crossroads linking the Sijilmasa-Ghana route in the west with Tahert and Ouargla in the north, in a circular network of trade.[50] The city's fortune was thus directly tied to the Ibadite cities in the north, to the gold resources in the west and, to a lesser extent, to Cairo and the northeast African littoral. Geographically, it linked the entire western half of the African continent.

Little is known of Gao's population, political structure, ethnic composition, or physical configuration during this period. Written sources refer to the close ties it maintained with its northeastern neighbor Tademekket (the ruins of Es Souk, north of Kidal, Mali) and to its mixed population of Berbers, Muslims, and Blacks. Little is known of its early history, but the rich and complex cultural traditions of the region suggest that it is to the Songhay people that we must turn for the zenith of West African monumental architecture in the Middle Ages. If it is by monuments that dynasties are remembered, then perhaps architectural monumentality in West Africa can be measured from this early date. "Monuments," Ibn Khaldûn noted, "can only materialize when there are many workers and united action and cooperation. When a dynasty is large and far-flung, with many provinces and subjects, workers are plentiful and can be brought together from all sides and regions. Thus, even the largest monument can materialize."[51] Certainly it is to the Songhay empire that we are indebted for the largest architectural monument in West Africa. (Fig. 5.10).

The rich architectural heritage is manifest in the complexity of the Songhay religious belief system. Although the "masters of the earth" were at the heart of the ancient Songhay belief system, the "*zin* [*djinn*] were the ancient proprietors of the sky, earth and waters," and the "cults of the ancestors [were] often cults superimposed on those of *zin*."[52] The ancestral cults of the earth were introduced by the small, localized divinities of incipient agricultural groupings along the Upper Niger Bend. The gods who wished to have mastery over the river belonged to the transient fishermen; the *gow* or hunters were the "masters of the bush"; the *zin* bespoke the earliest presence of Islam. The integration of these components is reflected in the cultural history of the city of Gao. The religious core of the early ninth-century flourishing metropolis initially consisted of the numerous "white traders." They could only subsist with the support of the sedentary Kurumba and the Gurmantche, who introduced the religious concept of "masters of the earth." The "mastery of the river" was in the hands of the Sorko, Songhay-speaking fishermen who in time came to control the riverine network linking Gao to its southwestern termini, and the "masters of the bush" perhaps refer to the later arrival of the Malinke from the west, the Keita hunters of northern Mande.

The resultant Songhay cosmological-mathematical format provided an ideological framework for the emergent architecture:

> The world is formed of the earth [*gandu*, "below"] and of the sky [*bene*, "on high"]. The earth is considered as a sort of disc [*feni*]. It is divided into uninhabited lands [*gandyi*, "bush"] and inhabited land or villages [*kyra*], all the bush being sewn together by the river [*issa*], thus evidencing on the one hand a direction of orientation

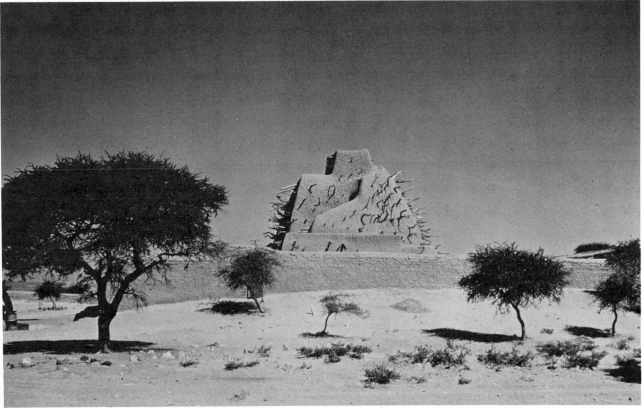

Fig. 5.10 The mausoleum-tomb of Askia Muhamed at Gao, Mali.

(the line of the river) and on the other hand, an attitude of security (village) or of fear (bush). The sky is formed of seven superimposed beds.[53]

This hierarchy of skies appears to have been borrowed in great measure from Islam; at the same time, by emphasizing the vertical structure of the universe, it introduces an important emphasis on *built* space.

The earliest description of Gao, from the end of the tenth century, implies that it functioned in a manner similar to its sister city, Koumbi Saleh. Like its Ghanaian counterpart, it was composed of two sites separated by a mosque.[54] Al-Muhallabi, writing in A.D. 996, noted that:

> The king of this people [Koukou] gives to his subjects the example of the profession of Islam and most among them follow his example. There is a city on the east river of the Nil [Niger] by the name of Sarna; this city contains markets and merchandise and is regularly frequented by the people of all countries. The king also has a city west of the Nil where he lives with his nobles and confidants. There is a mosque where he says his prayers, whereas the people have their *musalla* between the two *madrasa*. The king possesses in his city a palace which no one but he resides in.[55]

El-Bekri, writing in A.D. 1067, also referred to Gao's twin-city morphology: one part was inhabited by the king, the other part occupied by Muslim traders.

The place of the Songhay ancestors at Tombouctou was referred to in one of the West African chronicles as a *musalla*.[56] A *musalla* is a sacred *center* or *place* of worship, implying neither a built structure nor a monument but merely a bounded *space*. In the West African context of ancestor worship, the term is most readily interpreted as a center of the universe, a ritual center.

A *madrasa* is a combination of cells and prayer room used by visiting students who follow the courses of the mosque-universities, as distinguished from a *zawiya*, a chapel dedicated to and containing the tomb of a saintly personage or brotherhood. *Madrasa* and *zawiya* were often associated with a mosque, and the three building types also served as caravanserai, on the long-distance trade routes followed by Muslim traders. The sacralization of places by the presence of a saintly personage, in life or in death, found ready acceptance in the West African tradition of ancestor worship, and it is in this context that the association of the mosque with a burial site marking the place of the ancestors can

be explained. Thus, the site of the Songhay ancestors (the "masters of the earth"), the *musalla* of the Arabic chronicle, and the *zawiya* or tomb of Askia Muhamed all carry the same spatial referent.

One question that has not been resolved is the relationship of Gao to the "ancient Songhay capital" of Koukyia, a site reputed to have been a hundred kilometers south of Gao on the Niger River. Koukyia, the oral traditions claim, was the first seat of Songhay's pagan rulers, the Za or the Dia. Gao was then founded in the late seventh century by Sorko fishermen who had migrated northward along the Niger River.[57] In response to the expansion of trade in all directions, the traditional capital was removed to this more advantageous site early in the eleventh century, and the Dia king Kossoi was converted to Islam. Gao's new political position would have enhanced the Sorko role in expansion of the upper savannah trade networks, for, as trade intermediaries, they would have been in close contact with Muslim traders from the very inception of trans-Saharan traffic.

The Koukyia-Gao shift as outlined above is somewhat inconsistent with Arabic sources from North Africa. Archeological evidence from the suggested site of Koukyia is minimal, and a cursory exploration at Bentyia, a neighboring island site, has only yielded data establishing occupation in the fifteenth century.[58] The evidence from the present city of Gao, however, when placed in an architectural context and interpreted within the frame of Songhay cosmology, religious belief, and oral tradition, suggests that perhaps Koukyia and Gao were part of the same urban complex.

Three archeological sites have been investigated in the environs of Gao proper: Gao-Sané, approximately four miles east of the present city center, Old Gao, approximately one-and-a-half miles northeast of the city, and the mausoleum-mosque of Askia Muhamed, directly north of the present city, close to the banks of the Niger River (Fig. 5.11).[59]

The configuration of this archeological ensemble per se evokes a pattern and sequence of occupancy; when viewed in the light of the early Sorko role in founding the city, the location of the mausoleum-mosque of Askia Muhamed also takes on added significance. We would like to suggest that this vast tumulus sits on the sacred ancestral place of the pre-Islamized Dia kings. The site of Gao-Sané, four miles directly east of this presumed seat of indigenous rule, is a likely location for the Muslim center, given the city's overland connection to Tadmekket (Es Souk). The two in combination, then, create the twin cities of the earliest written references; although the question of the "Nil" between them remains unresolved, their orientation vis-à-vis each other is accurate.[60] The move from the site

currently marked by the mausoleum to the site of Gao-Sané, referred to in the records, was a short distance—but a highly symbolic one. The third major archeological site, Old Gao, would then have assumed prominence during the period of Malian overrule in the fourteenth century.

The Songhay regained power in the fifteenth century under the leadership of the "magician" king Sonni Ali, and presumably the original ancestral site (with its residential surrounds) would have once more become a symbol of Songhay independence and political viability. The great expansion of the Songhay empire in the early sixteenth century under Askia Muhamed called not only for a major ritual rebirth in terms of political identity, but a reconsecration to Islamic orthodoxy. The renewal of and revision to the Songhay ideological framework would also explain the elaboration of the same symbolic ancestral site by this other great figure in Songhay history.

In the course of excavations at Gao-Sané, a number of twelfth- and thirteenth-century tombstones were discovered (Fig. 5.12a). The epitaphs inscribed on them were in Kufic script; their diacritic marks and punctuation suggest a Maghrebian origin. A number of royal, marble tombstones dating from the same period were also found, several of which were located in a pair of kiln-dried brick-lined subterranean vaults. The size and shape of these vaults differ radically, however, from the perfectly square Tomb of Columns at Koumbi Saleh, where subterranean kiln-dried brick was also found.

The use of kiln-dried brick in such a selective building situation assumes greater import when considered in the light of the third archeological site, Old Gao (Fig. 5.12b). Here, kiln-dried brick was used solely for the *mihrab* of a rather large mosque, while the *kibla* wall itself was built of sun-dried brick. The choice of a very select material for two related functions—the lining of the housing for the deceased, and for the most critical component of a mosque, its *mihrab*—forcefully suggests an association between the house of the ancestors and the ancestral earthen pillar that eventually came to be associated with the *mihrab*. Equally relevant to the use of kiln-dried brick in a milieu in which it required a major technological effort is the brick architecture of the Ibadite cities of Tozeur and Nefta—critical North African entrepôts on the central trans-Saharan trade route to Gao—and the established presence of brick masons at Kairouan in the ninth century.

By the early fourteenth century the Mali empire had reduced the Songhay to a vassal state, yet when Ibn Battūta visited Gao in 1353 he judged it to be one of the largest and most beautiful cities of the entire Sudan. (When he arrived, he was received by the head of the

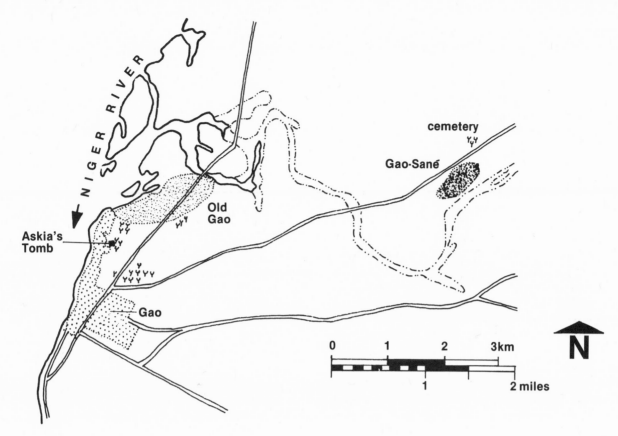

Fig. 5.11 The various archeological sites in the vicinity of the present-day city of Gao. Drawing after Mauny (1951).

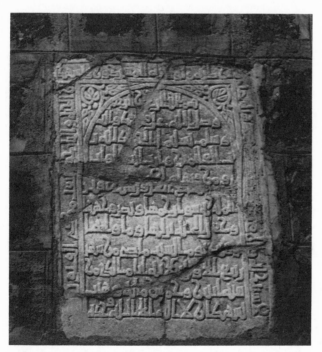

Fig. 5.12a Marble funerary plaque inscribed in the Almerian style for Queen Swa, who died in A.D. 1108. The plaque was found in one of the subterranean mausolea, lined with kiln-dried bricks, at Gao-Dyula.

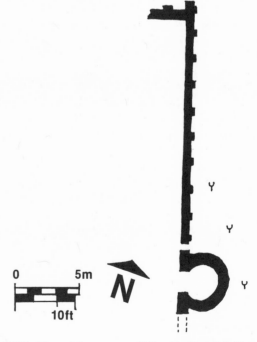

Fig. 5.12b Plan of the excavated kiln-dried brick *kibla* wall with its contraforts and circular *mihrab*, ca. 1325. Drawing after Mauny (1961).

mosque of the Whites, a jurist from Tafilelt).[61] The single reference to the architectural impact of Malian rule, however, is by Es-Sadi, who mentions the building of a mosque at Gao by Mansa Musa, the king of Mali, on his return from the *hajj* in 1324–1327.[62] Although it has been suggested that the circular, kiln-dried brick *mihrab* and its adjacent section of buttressed *kibla* wall at Old Gao are the remains of the mosque reputed to have been built under the supervision of the Andalusian poet-architect al-Saheli, its circular *mihrab* plan has no Maghrebian predecessor.[63]

Three rectangular tombs were found in a cemetary adjacent to the *kibla* wall, although the majority of the tombs in the cemetery are of a traditional oval form. An extant tombstone carries an epitaph dated 1364. This single epitaph has been used to date the mosque and assign Malian authorship to it—even though its orientation deviates from traditional Muslim practice, which prescribes that the headstone should face toward Mecca, i.e., northeasterly.[64]

The circular remains of the *mihrab* and the buttressed earthen *kibla* wall do suggest the presence of a Manding architectural tradition. Any architectural reconstruction may be far beyond the realm of possibility, but the *jami* or Friday mosque at Tendirma, built a hundred and fifty years later, offers a probable model (Fig. 5.13). In 1495, the Songhay ruler Askia Muhamed invaded Diaga, in the Massina, and took prisoner five hundred masons, together with their chief, Karamogho.[65] Four hundred were sent to Gao for his personal service, and he gave one hundred to his brother, Amar-Komdiago. During that same year, his brother was invested with the title *kanfari*, and the building of the new city of Tendirma was begun.

All that remain of Amar-Komdiago's city are several massive earthen palace walls and the Friday mosque.[66] The elders at Tendirma affirmed that the mosque had undergone only one major alteration since its original construction: a courtyard cemetery bounded by a low wall extending eastward from the *kibla* wall had been added immediately after the Moroccan invasion of 1591.

Built completely of hand-molded, spherically shaped earthen bricks, the mosque sanctuary consists of three seven-foot-wide bays running in a north-south direction. The roof is framed with a combination of primary palm beams and secondary acacia timbers. The single tower located at the center of the *kibla* wall is the *mihrab*. This towering earthen pillar, with *toron* or wooden pickets projecting around the curved surface of its eastern face, is a parabolic conic section. Its western face, a flat plane, is an extension of the *kibla* wall below, recalling a monumental ancestral earthen pillar sliced vertically in half. The plan of the Tendirma *mihrab* at its ground-line is identical with the semicircular plan of the kiln-dried brick *mihrab* at Old Gao.

The construction of the mosque at Tendirma was carried out under the Songhay aegis and for Songhay political purposes, but those who built it were Manding masons from Massina. Karamogho, the title of the chief mason, has been used in the past, and continues to be used, to denote a professional scholarly class in Manding Dyula society: a *karamoko* or a man of learning. The name of the superintendent of works, i.e., the man who directed the construction of the city, was Ouahab Bari.[67] *Bari* is a Manding term for any person with a particular skill; eventually it became the genealogical protonym for the well-known caste of Djenné builders. Ouahab, the prename of this superintendent/builder, brings to mind the early presence of the Wahabites (a branch of the Ibadites from the Mzab) in this region and their critical role in its early history.[68]

Malian overlordship in the Gao region began to wane toward the end of the fourteenth century. A century of petty skirmish and political fragmentation followed, which enabled the Songhay vassal rulers to wage a kind of war of liberation during the early decades of the fifteenth century. Their efforts culminated in the reestablishment of Songhay rule and the extension of the area of its effective control. The establishment of the Sonni dynasty in 1464 by Sonni Ali, the "true founder of the Songhay empire," was a milestone in the process of consolidation.[69]

Oral traditions and mythology credit Sonni Ali with transforming the Songhay empire into a coherent cultural-political-economic entity. The establishment of his dynasty would have generated the need for a strong symbolic, visual statement. Like national movements elsewhere, Songhay unification rested on an ideological base—in this instance, a renewed validation of the ancestral tradition of the "masters of the earth." Sonni Ali's reputation as a magician-king, used to argue the persistent presence of the indigenous Songhay magico-religious belief system within an increasingly Islamized framework of allegiance, reflects this cultural rebirth. The reaffirmation of an indigenous tradition, even though permeated with Muslim elements, focused on the ancient *musalla*. Acting as a focal point in space, the site would have provided major mythological support for the investiture of Sonni Ali's kingly authority.

In the indigenous rural Songhay tradition sacred places are not marked by man-built structures; altars and natural cult places are considered to be "high places," the residences of the *holey*.[70] The myth of the *holey*—anthropomorphic deities—forms the essential element of Songhay mythology. There are only a few examples of even minimally built altars. One such is the *holey hu* ("house of the *holey*") of Simiri among the

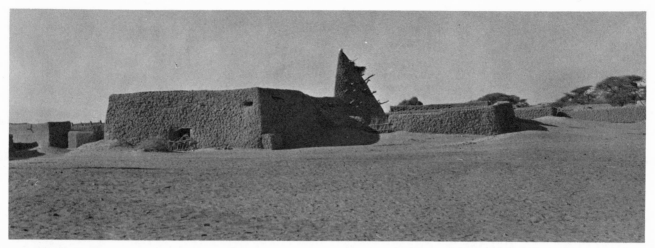

Fig. 5.13 The Friday mosque at Tendirma, Mali, built in 1497 by Manding masons for Amar-Komdiago, the brother of Askia Muhamed.

Dyerma, a Songhay-related group of sedentary agriculturists living in the bend of the Niger River. Behind the "house" there is a stone-marked quadrilateral space called the *sadvara zingare,* the "mosque of the rainbow." Within the house—a large, grass, mat-frame structure—there is a termite hill which dedicates the place of the house to its founder. Other examples are the tomb-shrine of Zoa, the ancestor of the Sangare people at Anzourou, and the tomb-shrine of Mali Bero a Sargan in the Dyerma-Ganda, which extends ten meters, from the tree marking his head to the tree that marks his feet.[71]

Analogously, then, the establishment of a monument reasserting Songhay unification and political cohesion by a magician-king—i.e., one who continued to seek support from his indigenous cultural heritage—would be through the rededication of an ancient *musalla,* or place of the ancestors. There is, however, absolutely no concrete evidence to suggest the elaboration of an ancient *musalla,* even in nascent form, during the reign of Sonni Ali. In point of fact, there is a great mystery surrounding Sonni Ali's burial site—a mystery that may be explained by his successors' wish to suppress his contribution as a supernaturally endowed ruler. We are inclined to speculate on the possibility that the ancient *musalla* was not only Sonni Ali's burial site but was subsequently enlarged to become the mausoleum of his successor, Askia Muhamed—a ruler far more acceptable to the seventeenth-century Islamic chroniclers.

The urban ambience, gradually incorporating the built features of Islam into its architectural repertoire, increasingly emphasized the elaboration of natural symbols into man-built symbols. The growth of the mausoleum-tomb is to us no more than a vast, cumula-

tive build-up of successive funerary layers, each validating anew the sacred place of the Songhay ancestry in the Soninke tradition. To postulate the building of such a vast monument in a short period of time is to belie the historical reality of the period in which it is reputed to have been built.[72] A cumulative process more logically explains both the persistence of indigenous Songhay practices and the magnitude and formal configuration of the present structure.

Askia Muhamed assumed power in 1493, at the height of Islam's influence and presence in the Western Sudan. Shortly afterward, he made the pilgrimage to Mecca, where he was invested as Caliph of Tekrur. If his accession heralded a golden age of Islam in the Songhay empire, the period of his rule was equally important as a golden age of architecture, one that ushered in an entirely new variation of the generic Sudanese style and a vast century-long feverish building program. Under his rule, the Songhay empire was extended from Hausaland in the east to Fouta and the ocean in the west, and from the oases of Touat in the north to Wangara and Mossi at the Niger Bend in the south. At the zenith of its power, the sixteenth-century Songhay empire manifested a far more complex politico-social structure and a greater commitment to Islam than any of its predecessors. Western Sudanese monumental architecture, while perhaps a child of the Malian tradition, matured under Songhay sponsorship.

The mausoleum of Askia Muhamed at Gao has most often evoked comparison with other stairways to the gods, the early *mastabas* and later *ziggurats* of Mesopotamian history.[73] Towers composed of a series of stepped terraces, involving vast, historically cumulative building enterprises, these Mesopotamian monuments

came to be the ultimate man-built statement of their religion and cosmology. The idea of the *ziggurat* has been related to the idea of a sacred mountain which, wherever it arose, served to indicate the center of the world. The *ziggurats*, with their spiral stairways, are also considered to establish a link between sky and earth. A similar development took place in the mausoleum of Askia Muhamed, where a number of shifting cosmologic systems were, over time, woven into a single monumental statement of the Songhay belief system.

In the Songhay tradition, the sky is "formed of seven superimposed beds. In the highest is God, in the sixth an intermediary divinity. . . . In the first, just above the earth, are found the *Holey* [genies]."[74] Although it is suggested that this numerical hierarchy was borrowed in great part from Islam, *holey* organization itself reflects this emphasis on seven. Thus, for example, there are seven great *holey* families, corresponding exactly to the distribution of the Songhay men over the terrain (space) and in the course of history (time).

In 1852, Barth observed

> the ruined massive tower, the last remains of the principal mosque or *djingere ber* of the capital, the sepulchre of the great conqueror Mohammed. According to all appearance, the mosque consisted originally of a low building, flanked on the east and west side by a large tower, the whole courtyard being surrounded by a wall about eight feet in height. The eastern tower is in ruins, but the western one is still tolerably well preserved, though its proportions are extremely heavy. It rises in seven terraces, which gradually decrease in diameter, so that while the lowest measures from 40–50 feet on each side, the highest does not appear to exceed fifteen. The inhabitants still offer their prayers in this sacred place, where their great conqueror, Haj Mohamed, is interred.[75]

The eastern tower, "in ruins," was probably the *mihrab* tower, perhaps extending as high as, and in the same form as, its close relative at Tendirma. The western tower, still in reasonable condition and still the center for religious ritual addressed to Songhay's most important mythological hero, was Askia's tomb. At the time of Barth's visit, this tower was some sixty feet high and its seventh, uppermost level, approximately fifteen feet square, was precisely in scale with many of the *kubbas*.[76] The seven levels must have impressed Barth: his accounts make several references to the fact that both the mausoleum-tomb at Gao and the mosque minaret at Agades had seven levels.

Only three levels are visible today, and the mausoleum sits directly in the center of a large walled *sahn* whose eastern face is punctuated by a rather humble sanctuary and two *mihrabs* (Fig. 5.14). Although nothing remains of the ruined eastern tower, we presume

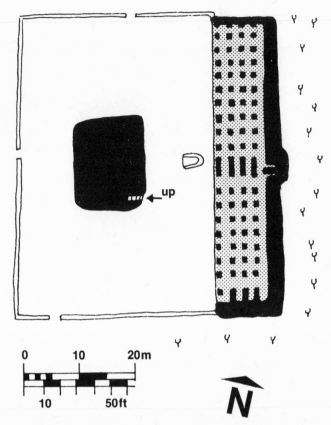

Fig. 5.14 Diagrammatic plan of the mausoleum of Askia Muhamed in the center of the mosque *sahn*. Drawing after Mauny (1950).

that the present *mihrab* in the *kibla* wall marks the center of the former eastern tower.

One of the curiosities of the sanctuary-*mihrab*, unique to the West African tradition, is its double niche. The right niche is not a *mihrab* but a *minbar*. In keeping with a common architectural tradition of the Malekite mosques of Berriane, of Ghardaia, and of Metlili, in the Mzab region of North Africa, the *minbar* is built of the same material as the mosque and becomes, in effect, a niche let into the wall thickness.[77] The absence of such a *minbar* characterises Ibadite mosques in general, although it is considered an infraction of strict Malekite doctrine. Since the presence of a *minbar* indicates the existence of a Cadi, a politico-religious leader in the community, this *mihrab-minbar* combination should be dated to a period in Songhay history when an *imam* was invested with political power at Gao and the religious community adhered more tightly to orthodox Malekite doctrine. Although this sanctuary wall may have been built during the early epoch of Malian overlordship, it is much more likely, give the pervious quality of earthen construction, that it was reconstructed

during one of the great nineteenth-century West African *jihads* waged in the name of orthodox Islam.

Barth referred to seven tiers and a sixty-foot height in his description, but his accompanying illustration indicated only three levels, similar to its present configuration, and the tomb now stands only thirty-five feet high (Fig. 5.15a).[78] The discrepancy is difficult to explain. Simple erosion could not have resulted in such a reduction in height. If Barth's description was accurate, a vast remodeling and restructuring of this monumental symbol must have taken place in the course of the last century, but the written sources and oral traditions make no mention of such a reconstruction program.

We are inclined to speculate that the seven levels referred to by Barth were not seven telescopic levels but, perhaps, seven successive stairway levels spiraling around the four sides of a square. When viewed from a distance, the pyramid thus created does appear to have three levels on two of its faces. The common Islamic numerology of seven, three, and four is thus translated into a three-dimensional form. The establishment of three *visual* levels suggests an attempt to impose a new tradition, the stairway-minaret, onto an already existing proto-Songhay tumulus (Fig. 5.15b).

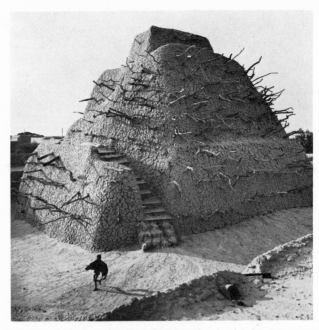

Fig. 5.15b A closer view of the mausoleum of Askia Muhamed at Gao, with projecting *toron* and stair-ramp access. The differential use of knarled acacia timbers for the *toron* and split palm for the stair treads of the ramp suggests at least two possibilities: distinct construction phases at different times or the deliberate choice of two different woods for symbolic reasons.

Fig. 5.15a View of Gao or Gogo, with the mausoleum-tomb of Askia Muhamed in the background. Barth (1857–1859), vol. 3.

Askia Muhamed assumed power in 1493, and under his caliphate leadership a more orthodox Islam was enforced. This enforcement was effected by encouraging the presence of Kounta scholars, members of the Ibadite sect, from the Mzab region of southern Algeria. Among the Kounta of Zenata origin who had come to the Sudan from the oasis of Touat, toward the end of the fifteenth century, were such distinguished scholars and proselytizers as Sidi Mohamed-el-Kounti, his son Sidi Ahmed-El-Bekkay, and Mohammed ben Abd el-Krim-el-Maghili. All are frequently referred to in the West African *Tarikh*s. The latter in particular made his persuasive presence well known at Gao, Katsina, and Kano in the early sixteenth century, after the Songhay empire expanded into northern Nigeria. A North African theologian who was ardently received in the Sudan as an authority on orthodox Islam, Al-Maghili resided at Gao, eventually returning to Touat, where he died in 1503 or 1504.

Askia Muhamed's reputation as a pious, devout, orthodox believer was expounded upon at great length in the West African chronicles, where he is very favora-

bly compared to his less orthodox, so-called pagan predecessor, Sonni-Ali. Given this strongly orthodox persuasion and the presence of an increasing number of orthodox Ibadite savants versed in Arabic sciences and mathematics throughout his realm, we can only infer an attempt on the part of him and his advisors to adhere in a more orthodox and stringent manner to the geometric forms that characterized the architecture of the Mzab oasis cities. These forms succinctly express, in three dimensions, the basic mathematical constructs used in Islamic design. Numerological combinations of threes, fours, and sevens, which are easily conceptualized, provided a workable model.

The original, key Ibadite monument was the singular, three-level minaret of Kairouan's Great Mosque (Fig. 5.15c). Another already prevalent architectural expression of Ibadite belief and practice was the proliferation of *zawiyas*, which evolved from the tombs of saintly personages into *mosque-madrasas* or schools. The Kairouan minaret and the *zawiya-madrasa* tradition are the progenitors of the distinctive Songhay three-stepped, strongly articulated stairway-minarets. The tombs of saintly personages are the counterpart to the ancestral tumuli which, surrounded by a wall, become the sacred places in West Africa. The three forms—minaret, tomb, and sacred enclosure—came together in Songhay architecture to reflect and express the uniqueness of West African Islam.

The Kounta *zawiya* at Tidikelt in the Touat oasis, Algeria, suggests how the mausoleum-tomb of Askia Muhamed may have appeared soon after its completion. The most striking difference between the two is the presence of projecting wooden *toron* or timbers at Gao. These timbers also project from the *mihrab* of the mosque at Tendirma, suggesting a Manding contribution and a new interpretation of wooden scaffolding used, for example, in Syrian dome construction (Fig. 5.15d).

Al-Maghili and Sidi-Aboul-Qasem-el-Touati were two key figures in the early years of Askia's rule (i.e., the first two decades of the sixteenth century). In northern Nigeria, then under the Songhay aegis, a number of mosques were credited to them. The minarets of the ancient mosques at Katsina and Birni, dated to this period of their presence, exist to this day (Fig. 5.15e). Both minarets clearly represent attempts to replicate the four faces, three telescopic levels, and interior staircase of the Kairouan minaret as a mathematical and architectural symbol of Islam.

In summary then, several concurrent traditions explain the creation of this monumental structure: the Songhay heritage and its political manifestations, the role of orthodox Kounta in the political and economic sectors of the Songhay administration, and the Man-

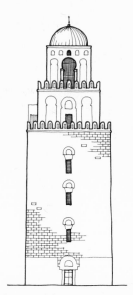

Fig. 5.15c The minaret of the Great Mosque at Kairouan, Tunisia. Drawing after Sebag (1965).

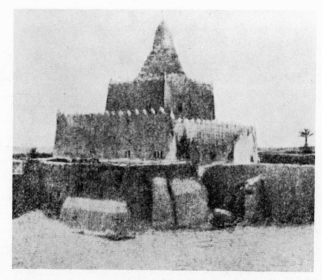

Fig. 5.15d The *zawiya* of a Kounta marabout at Tidikelt, southern Algeria. *L'Illustration* 3070, 28 December 1901, p. 419.

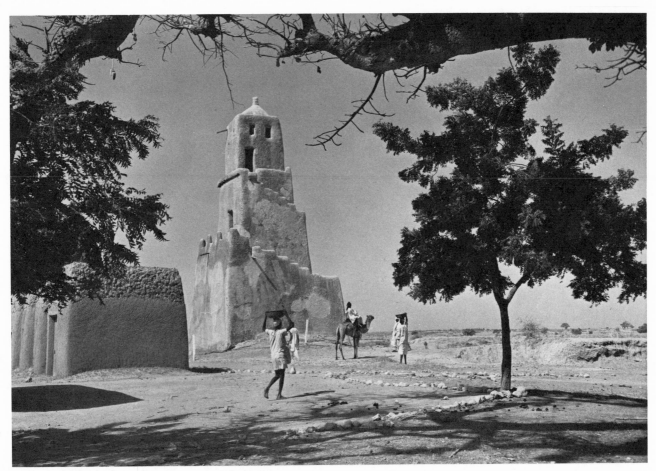

Fig. 5.15e The minaret of the mosque at Katsina, Nigeria, presumably built ca. A.D. 1520.

ding tradition of the masons involved in its construction. There also appear to have been several stages in the construction of the monument: first, a vast sepulchre in the form of a pyramidal pillar; second, the articulation of three telescopic levels on its four cardinally oriented peripheral faces; and third, the cutting-in of a ramp-stairway in order to provide easier access to its summit. This third phase of construction, an attempt to convert the mausoleum into a stairway-minaret, is suggested by the use of split palm treads in the stair-ramp, in contrast to the more knarled, haphazard, and obviously weatherworn *toron*. The other three faces continue to convey the original three-step pyramidal form. The less spectacular *sahn* and the *mihrab-minbar* may have constituted a fourth construction stage.

The import of the Songhay contribution lies in the establishment of stylistic uniformity, at the monumental level, throughout a vast region. The more generalized conical form of popular architecture—the earthen pillar and mound—was mathematically articulated into a discrete three-level, four-sided pyramidal one, just as the traditional ancestors were enveloped in the robes of Islam and magic squares. The dating for the Songhay contribution is linked to the merger between Ibadite traditions of Islamic adherence and Songhay political power during a period of heightened economic prosperity and expansion. The highly structured Songhay empire had the ability to command and organize the labor force required to implement a design prototype introduced by Ibadite scholars. Its architectural contribution is in many ways the fulfillment of Ibn Khaldûn's treatises on the necessity for monumentality. The tomb of Askia Muhamed is the quintessence of "establishment" architecture in West Africa. In form and scale it constitutes a statement of the highest political order.

Its counterpart in the realm of popular, vernacular architecture is the *saho*, the age-set houses built by young Sorko fishermen at the village level.[79] The role of the Sorko first came to the fore in the Songhay naval organization, which contributed to the early expansion

of the empire under Sonni Ali's rule. Indeed, the strength of this naval arm explains Sonni Ali's plan to dig a canal from Ras El Ma on the Niger River to Oualata, at that time still a major Maghrebian terminus for trans-Saharan trade. The Niger River was not only a communication spine, it dictated the geography of expansion. The entire naval organization was in the hands of the Sorko. The *hi koy* (equivalent to the Admiral of the Fleet) was a Sorko chief and the entire flotilla was composed of Sorko boats. Oral traditions are vague about the precise relationship between these "masters of the waters" and the developing political organization of the Songhay empire, but their contribution to the economic and commercial life-support system of the Songhay empire has never been in doubt.

With the sixteenth-century shift in the primary trans-Saharan trade network from Oualata to Tombouctou, water navigation acquired greater commercial import. The Sorko, who controlled the Niger River, were in constant contact with the Muslim merchants who plied its waterways, interacting far more frequently than their rural sedentary kin with the bearers of Islam from both the Maghreb and the Mzab. The extent of the integration of Islamic symbols into their life can perhaps be measured by the prevalent use of Islamic designs on the tools essential to their livelihood (Fig. 5.16a, b). Early incorporation of these motifs into the Sorko aesthetic are evidenced by the use of horse-shoe arches, which are associated with Islam, on the stern of the impressively large Sorko boat—a critical component of the Sorko life-support system. Their paddles were recipients of an even more obvious system of protection, well-being, and success: magic squares in combination with Arabic calligraphy were painted on them.

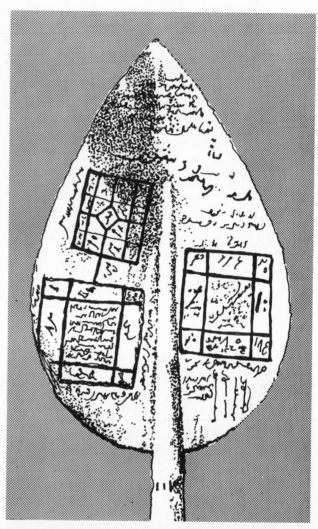

Fig. 5.16b A Sorko paddle inscribed with magic squares and Arabic script, at Kocri, Mali. Drawing after Ligers (1967–1969), vol. 4.

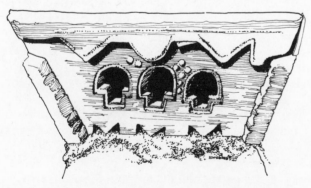

Fig. 5.16a The stern of a Sorko canoe, with its horseshoe-arched window-like openings and brass bosses. This woodwork is the work of the blacksmiths, who are also the woodcarvers. Drawing after Ligers (1967–1969), vol. 4.

Songhay establishment architecture is almost bare of iconography on its exterior surfaces; the Islamic input is only vaguely suggested by structural, formal, geometric features. The *saho*, on the contrary, manifests an intense concern with exterior architectural detail. Instead of the architectonic *form* it is the *surface* that communicates (Fig. 5.17a–c).

In complete contrast to monumental architecture, which seeks permanence and eternal existence, the lifespan of the *saho*, because of its ephemeral function, rarely extends for more than a decade. Built by young men in the course of rites which transform them into eligible marriage partners, the *saho* is occupied only until they marry. With the marriage of the last member of the age-set it is finally abandoned and, sitting empty

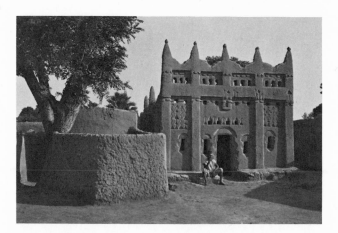

Fig. 5.17a A Sorko *saho* at Nouhou-Bozo on the Niger River, Mali, 1945.

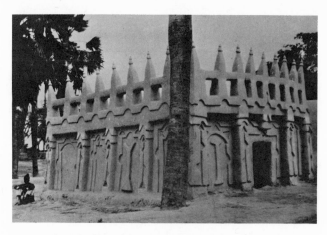

Fig. 5.17b A Sorko *saho* at Diafarabé, Mali, 1942. Others in the same style can be seen in Desplagnes (1907).

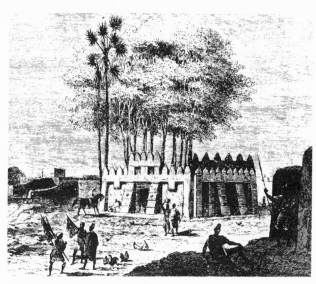

Fig. 5.17c Somono "maison commune" at Ségou, Mali, 1864. Mage (1868a).

and unattended, it deteriorates quickly, leaving little material remains of its prior existence. Although the earliest architectural example—a mid-nineteenth-century Somono age-set house for young celibates at Ségou, Mali—is more modest, the *saho* today is immediately recognizable by its characteristically intense surface detail and structural expression. The *saho* is a counterpart to the boat: its verandah arches are identical to those carved into the rear closure panels of the boats.

The visual richness of Maghrebian surfaces, posed against the more austere and puritanical Ibadite tradition that underlies Songhay monumental architecture, suggests a strong Malekite undercurrent. Their flamboyance recalls the granary-shrine at Amzaourou in the Dades valley of southern Morocco (Fig. 5.18); the decorative, sun-dried brick geometry found on the upper registers of the great *ksars* and *zawiyas* there appears to have softened into more modest chevrons and lozenges below layers of earthen rendering. The wall motifs likewise recall, in a less articulated vein, the patternwork in the *mihrab* niches of mosque *sahns* at Tombouctou. This more fluid quality is perhaps a result of the attempts to replicate in bas-relief the stone and sundried brick patternwork commonly found in the urban strongholds to the north. The structural regimen imposed by stone and cast brick in wall decoration disappears when the designs created by them are replicated in applied earth. Structural restraints no longer exist, but the iconographic intent remains. Like the still-viable Sorko age-sets, the underlying aesthetic of the *saho*

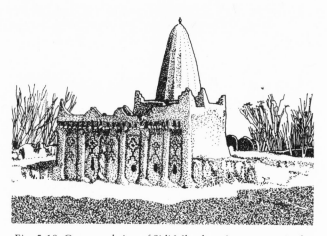

Fig. 5.18 Granary shrine of Sidi Mbark at Amzaourou in the Dades valley of southeastern Morocco. The elongated white cupola of this tomb and its location in a sacred grove, unique in this region, bring to mind traditional sub-Saharan or Mzabite forms from southern Algeria. Drawing after Jacques-Meunié (1962).

persists to this day, translated into a new but closely related imagery through the introduction of innovative building technologies and new twentieth-century status symbols (Plate 8).

Interlude

Though they also played a considerable economic role, the three urban centers of Koumbi Saleh, Niani, and Gao were the political capitals of cohesive and viable cultures. The evolution of their architectural character was therefore heavily imbued with indigenous and traditional meaning. Their iconographic content was intended to evoke identity with those aspects of the culture that validated the continuity of political and administrative institutions. As such, these three urban centers should be viewed in a very different light from three others that are equally well known in West African medieval history and have occupied the attention of archeologist and historian alike: Oualata, Tombouctou, and Agades. These latter, while they may have been at one time or another "city-states" in the classical sense, were first and foremost commercial centers, caravanserai and entrepôts. Their populations were heterogeneous, they were subject to the vicissitudes of overlordship under various empires and marauders, and their ethnic identities were diverse. Their styles more directly expressed the skills and preferences of those involved in the building process and those who occupied the residential domain itself.

Oualata

The first references to the caravan center of Oualata occur in the aftermath of Ghana's demise in the early thirteenth century. Soninke cities such as Audoghast, that were under Ghana's tutelage, were overrun by the Sosso, and their leading Muslim families fled to the small village of Birou (Oualata) in A.D. 1224. These families were in all probability those of Arabic and Berber traders, of their Islamized Soninke associates, and of the neighboring Massufa nomads. All three groups contributed to the economic prosperity of the newly founded city.[80] The Arabo-Berbers maintained their leading economic position and constituted the core of the religious Islamic community; the Soninke occupied a subsidiary position, lending their services to both local and foreign traders; and the Massufa took on an increasingly critical role as guides and caravan leaders in the burgeoning trans-Saharan trade.

The rise of the Malian empire subsequent to Ghana's demise caused a geographic shift of political power toward the south, which further contributed to the heterogeneity of Oualata's population. The city emerged as a cosmopolitan center in which early Berber populations, nomadic Massufa groupings, and pseudo-Islamized black, sedentary, savannah populations joined together in the pursuit of commerce and trade.

When Ibn Battūta visited Oualata in 1352, he wrote without hesitation that it was "the first province of the Sudan, i.e., the land of the Blacks."[81] Its fame continued posthumously, moving Es-Sadi to write centuries later that "caravans used to come there from all points of the horizon. The pick of scholars, pious and rich men from every tribe and country lived there; people from Egypt, Awjila, Fezzan, Ghadames, Touat, Dar'a, Tafilelt, Fès, Sus, Bitou and other places."[82] At the time of Ibn Battūta's visit, the city was administered by a deputy governor representing the king of Mali, but the majority of the city's population were Massufa, proto-Tuarag clans. (These Tuareg elements were also resident in other stone-built cities of Mauretania such as Qasr el Barka, Tichit, Chinguit, and Ouadan.)

Oualata fulfilled a role similar to that of its more westerly and more northerly stone-built sister cities, but its prominence—and its architecture—were linked more closely to developments further south. Despite the fact that the city is north of Koumbi Saleh, its milieu is of another world, and its architecture belongs more properly in the northern savannah realm (Fig. 5.19). Although its walls are of stone, every wall is completely rendered with earth. And while the iconography on its rendered walls finds frequent parallel across the upper savannah belt, nowhere else is the intensity, profusion, and overt symbolism matched.[83]

At the height of its prominence, Oualata sat on a route between Sijilmassa (Tafilelt), Fès, and Tlemcen in Morocco and the capital of Mali. The traders who settled in Oualata were agents, partners, and relatives of their counterparts across the desert, in the Maghreb and in the Mzab. These traders were originally Ibadite. Trader and scholar were often one and the same, at least in many of the Kounta families. For example, the thirteenth-century Maqqari family maintained a network of trade linking Tlemcen, Sijilmassa, Oualata, and the capital of Mali. The family subsequently became deeply involved in Malian court life and politics.[84] Another example is Es-Saheli's progeny, who chose to settle in Oualata, where their father had resided for some time before his final return to Tombouctou. Since Muslim wives traditionally (to this day) do not travel with their husbands, such progeny were begotten of local inhabitants. In point of fact, traders frequently married local women, possessed slaves, and maintained a household in which indigenous and North African cultures were combined within the bounds of a single residence.

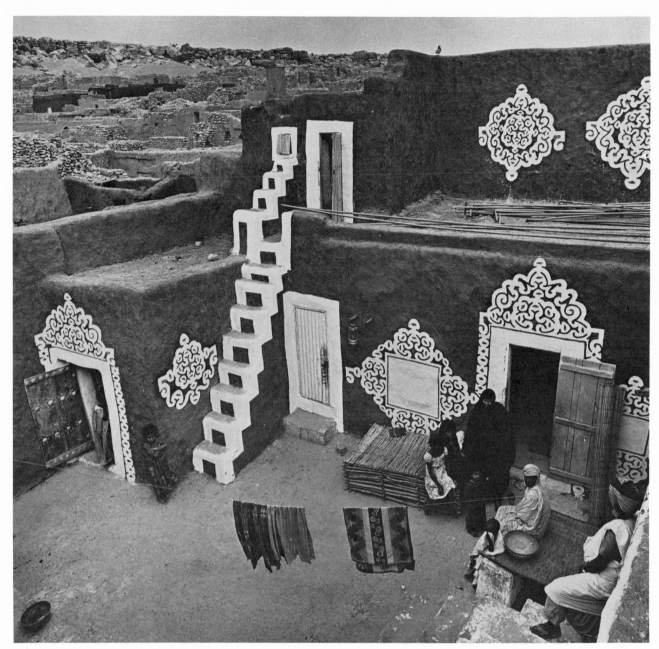

Fig. 5.19 Courtyard interior of a chief's house in Oualata, Mauretania, 1980.

At the time of Ibn Battūta's seven-week sojourn in Oualata in the mid-fourteenth century, the city was the primary commercial outpost for the capital of Mali. Thus, when Mansa Musa undertook his pilgrimage to Mecca, it was from Oualata that he set out to cross the Sahara Desert. Upon his return he commissioned an audience chamber at Oualata, and it was at Oualata that the Andalusian poet-architect al-Saheli resided.[85] Within a century of its founding, therefore, the city had acquired a heavy Manding veneer.

Most of the city's inhabitants, however, were Massufa, one of the many Berber tribes that had spread across the entire southwestern Sahara by the end of the ninth century. Referred to in the Arabic sources as *mulaththamin*, they were men of the veil and progenitors of the great Tuareg confederacies. Political authority was measured, as it is today, in tents and camels. Their importance derived from the position they held as masters of the trade routes across the sandy wastes of desert in the post-Almoravid eras. This role was analogous to

that of the Sorko, who were masters of and controlled the Upper Niger riverine trade routes.

As Ibn Battūta noted, women occupied a prominent position in Massufa society, which was both matriarchal and matrilineal.[86] More promiscuous than their North African sisters (according to pious Muslims), Massufa women during this early period were fully literate. As poets and musicians, the transmission of the oral and written Massufa heritage was in their hands. Increasing sedentarization and Islamization, with its more puritanical prescriptions, gradually imposed greater restraints on their public profile and on their movement outside the sequestered domestic realm. Oualata's architectural heritage can be attributed to this "domestication" of the Massufa class of literate women wrought by Islam and the settling process.

Important groups of Soninke sedentary populations lived in the midst of the Massufa—occasionally as partners-in-trade, more commonly as slaves, captives, and tributaries. These Soninke groups eventually evolved into the *harratin* castes that constitute the basis of Oualatan society today. Crafts ranging from blacksmithing, leatherwork, and pottery to wall decoration are today in the hands of the *harratin*.

The Beni Hassan also played a role in the city's history. Invading what is now Mauretania in the fifteenth century, they settled in the environs of the desert cities. Successive waves continued to move into the region in the sixteenth and seventeenth centuries, reinforcing their political control in the region. One lasting result of their presence is the *hasaniya* language, which is spoken at Oualata and its neighboring cities to this day. *Hasaniya* has a strong undercurrent of Berber and Soninke borrowings; Azer, a Soninke-related language, is also spoken in Oualata. The history of this complex cultural interaction is ultimately reflected in the richness and diversity of the architectural lexicon.

Historically, the leading position held by women in Massufa society reflected the traditional role of women in nomadic society in general; thus this urban, sedentarized community had a strong nomadic heritage. Women retained jurisdiction over the domestic realm at the height of Oualata's prosperity. The respect and freedom that had been accorded Massufa women has considerably diminished: seclusion and the practice of *purdah* developed in the course of the settling process. Women were first discouraged and later prevented from traveling with their husbands. Women of the aristocracy, often literate, remained "at home," constituting a stable residential base. Restained movement outside the home made them in great measure dependent upon the company and services of the Soninke women, the *harratin*. As a result, it seems that the *harratin*

women themselves acquired some literacy in either Arabic or the Tuareg *tamachek*.[87]

Authors who have concerned themselves with the distinctive wall murals in the city have sought its origins in North African Islam, in Byzantine Christianity, and even in a cultural chain linked to the Celtic designs of Great Britain.[88] The style has also been attributed to al-Saheli, who resided in the city for some time. While there can be no doubt that Islamic calligraphy was the initial inspiration, the iconography that evolved can only be explained by the centuries of socio-cultural interaction within the city itself. Symbiotic relationships that forged religico-commercial Ibadite communities into the Kounta kinship structures; the developing craft castes of Soninke-speaking slaves and tributaries; the overlordship of the empires of Mali and Songhay; the proto-Tuareg nomadic kin groups who gradually settled; and, finally, the wave of Beni Hassan all contributed to the unique urban aesthetic.

Although he was an observant voyager and had frequent access to the interior courtyards of the most respected elite of the city, Ibn Battūta made no mention of the unique wall decorations. However, on one occasion he noted:

> I betook myself . . . to Abou Mohammed Yandecan the Massufite, in whose company we had arrived at Oualata. He was seated on a carpet, whereas in the middle of the house there was a bed of repose, surmounted by a canopy, on which his wife was in conversation with a man seated at her side.[89]

These frame platform beds, sometimes canopied, sometimes no longer so, traditionally (to this day) constitute the center of the woman's domain among Maurish, Songhay, Tuareg, and Fulbe nomadic groups. They are still evident in the interior Oualata courtyards (Fig. 5.20). In terms of a spatial continuum, the rendered walls that bound the interior courtyards could be interpreted as a transposition from the canopied bed interior.[90]

The entire rendering process that constitutes the basis for the elaborate arabesque wall decoration, the city's most striking architectural feature, is in the hands of the women. This same responsibility, a result of the division of labor in many of the sedentary and quasi-sedentarized savannah cultures of West Africa, continues to be characteristic of rural, non-Muslim communities; it is rare in urban Muslim centers, only occurring, to the best of our knowledge, in those urban settings where nomadic societies once played a critical role, and sometimes remaining for the interior of single house units inhabited by women. In like manner, the technology and design of the rendered patternwork also differs radically. Oualata is a rare illustration of

tures, and in the role of women in its execution. The contrast is also very much in keeping with the model we have suggested for the architectures that carry a nomadic heritage: the ascetic geometry of the public domain and the richly adorned interior surfaces of the private domain.

A simple white chain design, flanked by a pair of rosette-like rectangular niches, reinforces the door surrounds of entrances from the public way. The rendering is modest and, with the exception of the arabesque work around the niches, differs little from entrances in other urban centers. The massive plank doors are heavily encrusted with classic Moroccan metalwork strapping and reinforcement, recalling the brass bosses, hinges, and entrelacs of Fès and Marrakesh (Fig. 5.21). But, in lieu of the North African lock and hinges, one finds the classic carved wooden bolt and bolt housing common to other West African savannah cultures.

Passing through the entrance vestibule opening, or *fumm ed dar*, and the vestibule, or *segefe*, into the

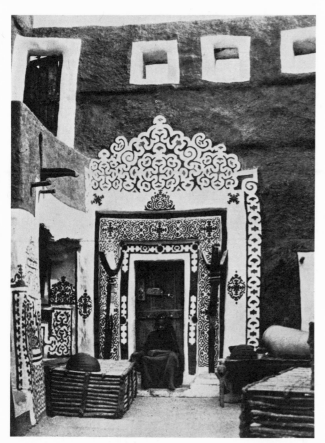

Fig. 5.20 Fulbe bedframes in the interior courtyard of a house at Oualata. Jacques-Meunié (1961).

earthen rendering over stonework masonry construction. *Banco*, the term used for earth rendering at Oualata, is a Manding term used throughout the savannah for the more traditional earthen construction practices.

Unlike other areas where wall decoration is common in the indigenous tradition, in Oualata the wall treatment is not obvious to the observer. It is employed modestly on building facades around the entrances to compounds, but the richest and most abundant wall murals are found in the interior, sequestered women's courtyards, which the casual passerby does not see and to which the stranger rarely has access.[91]

The Massufa constituted the majority of the city's population in the mid-fourteenth century, but over the centuries the Kounta, descendants of the influential Sid-Ahmed El Bekkay who resided in Oualata in the fifteenth century, have become the main ethnic group. How, then, is one to explain the rich decor within a Kounta tradition of bare walls and the cubist geometric forms of its monumental architectures? The explanation may well lie in the opposition between exterior and interior spaces which behavior dictates, in the distinction made between monumental and popular architec-

Fig. 5.21 Brass medallions and bosses found on Oualata reception-room doors. Drawing after Jacques-Meunié (1961).

interior courtyard, one encounters around each of the interior doorways intricate arabesque patternwork, rendered in browns and whites. Each doorway leading into a woman's quarters seemingly carries a hanging floral tapestry from its parapet. The magnitude and intensity of this ornamentation around each doorway matches the hierarchy of the wives who inhabit the courtyard, increasing in complexity from the junior to the senior (Fig. 5.22).

Although the decoration is most intensely concentrated around the doorways, the same motifs are combined and applied to places of repose in the courtyard. A combination of no more than half a dozen motifs is repeated ad infinitum in spirals and arabesques over the stone-built benches on which the *harratin* sleep and around niches and stairways of the courtyard. Here the husband is a transient guest, while the women spend most of their time in this courtyard, sequestered and secluded even when the prescriptions of *purdah* are not stringent.

Each elaborate entrance leads into a wife's narrow, faintly lit, whitewashed room. The right half of the space within is taken up by an immense *tara* or platform bedframe, canopied and covered with tapestries and mats and adorned with a profusion of leather pillows. This deep interior of the conjugal domain is, thus, no more than a replica of the tent interiors among many of the nomadic peoples from the anti-Atlas mountains in the north to the sub-Saharan upper savannah in the south.

The decorative elements on wall surfaces are replicas of the elements found on the innumerable domestic furnishings associated with the intimacy of the women's domain. The motifs are used only for ornamenting furnishings associated with women (Fig. 5.23a–d). The most significant of these furnishings is a round, fringed, leather pillow given to a young wife. In contrast to the rectangular pillow decorated primarily with geometric elements that is given to the young groom, this round pillow is covered with symbols whose sense remains evident despite their extreme stylization. The same elements occur on the great leather carrying cases or *tisroufen* in which the woman carries and stores her belongings, and on the central section of her camel saddle. The elements appear as silver appliqué work on the coffer in which she stores her jewelry and on the *ardin* or harp, exclusively a woman's instrument, which she uses to accompany her recitation of the oral traditions.

Although an Islamic referent is discernible, the meanings attributed to these elements, often couched in abstract terms, strongly suggest sexual iconography in both form and location. One of the most common motifs, *waw*, the twenty-seventh letter of the Arabic alphabet, is associated with virility (Fig. 5.24). The motif called *et-tebel* ("drum"), and variously interpreted as "people" or "amulet," is selectively used over the lintel-pediment and at the center of each jamb-surround. When interwoven with other motifs such as the *waw*, a variety of patterns are generated. The drum motif may well be directly related to the drum groups which define the basic social units on which the Tuareg Confederacy's political organization rests.

Perhaps the most telling evidence for the nomadic heritage at Oualata is the carved, wooden, forked-post calabash supports, called *asanad* in *hasaniya*, which mark a primordial "center" in the courtyard of each compound (Fig. 5.25a).[92] These *asanad* (considered in an earlier chapter), now sedentarized, have been implanted in a three-tiered, four-sided pyramidal earthen base. The care, detail, and geometry of their carving, the location (immediately flanking the entrance into the senior conjugal chamber), and the proximity to the bed support system in the courtyards recall the behavioral patterns of nomadic life. The contents of the calabashes themselves range from the sealed magical articles connected with medicine or with ancestor-worship, to the foods used in daily subsistence (Fig. 5.25b). All these items, from the most sacred to the most profane, are associated with the concept of well-being and the continuity of life. The associative meanings of the iconography are reflected in the entire spectrum of the built environment.

The resurfacing and renewal of the wall design was traditionally the work of the Soninke *harratin*, under the direction of the literate, cultured wives of the

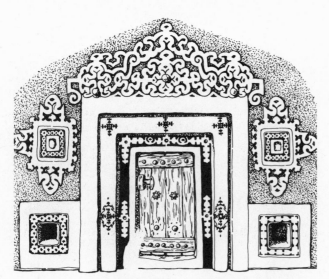

Fig. 5.22 Interior courtyard facade of the senior wife of Sherif Guig, the village chief of Oualata. The *et-tebel* drum motif is clearly seen in each of the composite designs. Drawing after Du Puigaudeau (1968).

Fig. 5.23a Woman's circular leather pillow at Oualata. Drawing after Du Puigaudeau (1957).

Fig. 5.23b Man's rectangular leather pillow.

Fig. 5.23c Silver appliqué work on a wooden coffer. Drawing after Du Puigaudeau (1957).

Fig. 5.23d A wooden coffer with silver, copper, and brass appliqué.

Oualatan aristocracy—i.e. the Beni Hassan. Now, there are far fewer literate women, and the few women who continue to resurface walls are Sarakolle potters, wives of the local blacksmiths or masons. They belong to the same social caste as their sister leatherworkers, who are also the wives of blacksmiths. The caste system into which these various artisan skills are organized explains in great measure the continuity of the wall patterning and the relationship of its designs to other art forms at Oualata.

Today there are no women left who are skilled in creating new wall murals, so the creative process and its transmission must remain unknown. It is obvious, however, that a long process of abstraction has taken place, in which sharply articulated and meaningful Islamic motifs have been softened and diffused in a manner similar to that of leatherwork design. The traditional literacy of the nomadic aristocracy, in combination with matriliny and the prominent role of women in traditional Oualatan society, unquestionably ac-

Fig. 5.24 Drum and *waw* motifs at Oualata, found in a continuum from a woman's most personal possessions to the entrance decoration leading into her personal space. Drawing after Du Puigaudeau (1968).

Fig. 5.25a *Asanads* or calabash supports in the courtyard of Oualata compounds. Drawing after a photograph, Jacques-Meunié (1961).

Fig. 5.25b Designs on calabashes supported by the *asanad*. Drawing after Gabus (1958).

counted for the early development of the architectural decor, but its subsequent relaxation reflected shifts in sex roles and skills that accompanied sedentarization and urbanization.

In the course of this development, Oualatan mural decoration emerged as the quintessential architectural expression of the basic function of woman in African society—her sexuality and fertility. Motifs were imbued with new meanings more in keeping with the changing socio-cultural character of the city. Her command of the oral traditions, poetry, and music through which her traditional freedom was expressed has been translated into a new medium: the exuberant wall decoration of her own domain within a city of men continues to be a symbol of her dignity.

Tombouctou

"The prosperity of Tombouctou was the ruin of Biru [Oualata]."[93]

Tombouctou is the best known of the great medieval cities of West Africa. Although it was founded by Tuareg nomads at the beginning of the twelfth century, frequent references to the city began to appear only during the sixteenth century, when, under Songhay rule, the city reached its zenith.[94] Despite the gradual subsequent decline of the city, its fame persisted in the European mind, to become the primary impetus for a number of nineteenth-century explorers such as Caillié

and Barth. However, as we suggested in Chapter I, the lure of Tombouctou as an ultimate expression of African exoticism was in great measure the aftermath of the world publicity that accompanied its conquest by the French at the end of the nineteenth century.

Within West Africa itself, the city's fame accrued from its tradition of intellectual Muslim life centered around the "University" of Sankore and from its key role as an entrepôt for the easterly-shifting trans-Saharan trade routes. Like Gao, the city has a particularly favorable geographic location, on the crown of the Niger River. Goods brought down by camel across the desert were easily transferred to boats or to head porters for distribution to more southerly, secondary distribution centers in the savannah. As elsewhere, trade went hand in hand with Islam: the growth of Tombouctou as a center of Islamic learning matched its growth as a commercial center. The reputation of its scholars was already well known during the reign of the Malian king Mansa Musa. There were "black" Sudanese scholars, but the "white" Sanhaja, from the desert and from cities such as Chinguit, Tichit, Touat, and Ghadames were in the majority.

The city was always polyglot and heterogeneous. From the north came the North African merchants and the various Tuareg clans; from the west, the Soninke, the Manding, and the Fulbe; from the east, the Songhay-related peoples, including the Sorko; and from the south and southwest, the complex trade network of the Manding Dyula.

Oral tradition attributes the foundation of Tombouctou to a Tuareg summer camp early in the twelfth century; the written record reveals a complex and arduous history.[95] Never the seat of a political capital or the spiritual center of a single culture-complex, it successively fell to various medieval empires: one hundred years of Manding rule, in the fourteenth century; then forty years of Tuareg rule; Songhay rule from the mid-fifteenth to the late sixteenth century; Moroccan rule, albeit token, in the seventeenth and eighteenth centuries; another brief Tuareg suzereinty; and, finally, Fulbe control in the nineteenth century. Its entire turbulent history unfolded within the framework of Islam. Finally, the city fell to the French at the turn of this century. To understand Tombouctou arts and architecture, therefore, account must be taken not only of Islam but of the heterogeneous, commercial character of the city, and the successive periods of rule to which it was subject.

Starting as a transient encampment of matframe and skin tents, the city had, by its apogee, been transformed into a city of two-story earthen and stone structures and a host of mosques, very much in keeping with the morphological character of Muslim cities elsewhere (Fig. 5.26a, b).[96] The narrow alleys and winding streets have changed little since Caillié, the first European to visit the city and record his impressions, described them in 1828 (see Fig. 1.15):

> The city of Tombouctou forms a sort of triangle, measuring about three miles in circuit. The houses are large, but not high, consisting entirely of a ground floor. In some a sort of water closet [*cabinet*] is constructed above the entrance. They are built of bricks in a round form, rolled in the hands and baked in the sun. The walls, except as regards their height, resemble those of Djenné.[97]

Barth, who visited the city thirty years later, was far more detailed in his description.[98] In addition to noting the types of earthen housing and the conical matframe tents on the city's outskirts, he described the layout of the housing, the mosques, the various city quarters, and apparently changing configuration of the city's boundaries. The Sané-gungu quarter, once the site of the *madugu* (royal palace) of the Songhay and the site of the Moroccan-built *kasbah* inhabited by the many Ghadames merchants, was still the wealthiest and contained the best houses. In the southwestern, low-lying area closest to the Niger River itself was the Djinguéré Ber quarter, so called from the name of its great mosque. The Djinguéré Ber quarter has been inhabited, from the most ancient times, by Muslim descendants of the followers of Mansa Musa. At one time it may have been set apart from the rest of the city by its

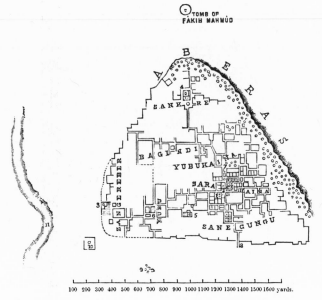

Fig. 5.26a The plan of Tombouctou recorded in 1854. Barth (1857–1859), vol. 3.

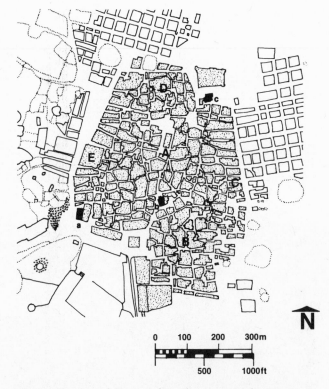

Fig. 5.26b Plan of the city of Tombouctou, Mali. Drawing after Brasseur (1968). Legend: *a*. Djinguéré Ber mosque. *b*. Sidi Yahyia mosque. *c*. Sankoré mosque. *A*. Ba Dinde quarter. *B*. Sare-kaina quarter. *C*. Bella Faraji quarter. *D*. Sankoré quarter. *E*. Djinguéré Ber quarter.

own wall. The configuration, as Barth himself suggested, resembles the traditional twin-city layout of other early West African savannah cities.⁹⁹ The Sankoré quarter, at the northernmost angle of the city, was formerly occupied by Sanhaja, Songhay, and Tuareg. It was founded, it is claimed, by Sidi Mahmoud, whose family came from Oualata.

The quarters of the city thus reflected, over the centuries, the ethnic heterogeneity of its population. The five present neighborhoods also represent the Islamic astrological symbol of four stars around the four cardinal points before they exploded from the first star. Each quarter has a corresponding constellation. The Ba Dinde quarter in the center is Orion; the southern, Sarekaina quarter (into which the Sané-gungu quarter has been absorbed) corresponds to the Scorpion; the eastern, Bella Faraji quarter, to the Ram; the northern, Sankoré quarter, to the Great Bear; and the western, Djingueré Ber quarter, to the Scales.¹⁰⁰

Streets are narrow and tortuous, wall surfaces broken only by engaged buttresses that mark the facades of the entrance or *sigifa*, pierced only by entrance doors and singular *funey soro* or windows at the upper levels of two-story housing. Most of the two-story housing, the "elevated mansions of the Ghadamsiye merchants," is found in the once wealthier and more populous Sané-gungu quarter, and whatever exterior ornamentation there is in Tombouctou is found in this quarter as well (Fig. 5.27). Doorways, now simplified and abstract echos of their Chinguit and Tichit prototypes, are flanked on each side by earthen benches projecting into the narrow street. These, used for sitting, are also used by visitors waiting to be received into the first *sigifa*. Occasionally, a rounded threshold stoop extends beyond the entranceway itself, emphasizing the mediating ritual in the transition from public to private space. The highly ornamental, heavy plank doors, once adorned with an arabesque of brass and iron florets, bosses, and rings, are now replicated in snipped tin.

The upper window opening was always screened with a Moroccan-type grille, constructed of hardwoods imported from the south (Fig. 5.28a). This one upper-level window is always located at the center of the outside wall of the *tafarafara*, the house-owner's upper-level audience room (jacket photo). The work of the blacksmiths, it is a less elaborate version and constructed differently from its North African prototype, yet, visually, it reproduces the same configuration of a *khatem*, the eight-sided polygonal void which, with the doorway itself, constitutes the most overt, comprehensive, and succinct statement of the Islamic presence (Fig. 5.28b).

The traditional facade of the house receives particular attention: it is the "face" of the house. The door

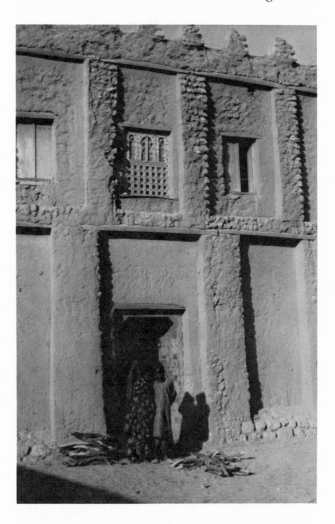

Fig. 5.27 Housing in the Sané-gungu quarter of Tombouctou.

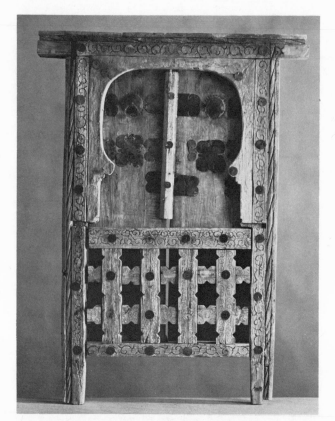

Fig. 5.28a Moroccan-type grille from Tombouctou.

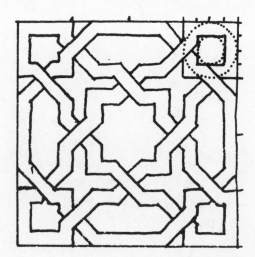

Fig. 5.28b North African wooden grillework. Drawing after Ricard (1924b). The primary octagonal star is called the *khatem*.

is the representation of the face of man, the grille above is the spotted skin of the serpent, the parapet is the turban of the house, and "the image of man is equally that of the cosmos and each of its parts, corresponding to a particular configuration."[101] Person, house, city, and cosmos are organized into a set of correspondences.

The spatial organization of housing itself falls into the same continuum manifest in the other cities we have considered (Fig. 5.29a). In the older, more modest quarters, the single courtyard houses are a mathematically structured version of the ubiquitous West African compound, just as the meanings and ritual attached to their construction are rich in indigenous cosmology, the mysticism of numerology, and astrological correspondences:

> To build a house, the mason begins by tracing its perimeter on the soil. All houses are rectangular and their walls are, in principle, oriented toward the four cardinal points. The perimeter is an image of the blacksmith, with his arms forming a cross and his head to the south. It is the square of the field and of the tomb. At the four corners . . . one buries a stone, as well as at either side of the entry door and under the central pillar. Under the stones, especially those of the entry, objects of protection, prepared by the marabout and the chief mason, are buried. One knows, however, that under the foundation of the chief of Djingueré Ber, a living Touareg and his horse were buried, in order to "tie up the power of these nomads."
>
> After having traced the general plan of the house, the walls are raised, beginning with the south facade. The right side of the entry door is done first, then the east, north, and west, back to the south by the left side of the door, in the direction of the upper tree from which the house descended. At one time, the two sides of the door were in stone. Like the entry door of the mausoleum of Sidi Mahmoud, the lintel of the door is made of five posts.[102]

The interior walls are raised so as to divide the surface of the house into nine principal squares forming the rooms and the interior courtyard (Fig. 5.29b). Each of the squares is itself imbued with anthropomorphic associations: the vestibule is the head, the courtyard is the stomach, the right side is the arm of man, the left side is the arm of woman. In its entirety, the house is a symbol for man. Moreover, as an ideal, the squares replicate a magic square.

In the more grandiose and spacious houses, there are two interior courtyards: the first is the male domain, the second the female domain (Fig. 5.29c). The proportions of these two-courtyard houses are precisely two to one, and the central rooms which provide the mediating space between the two domains serve as an axis of symmetry.

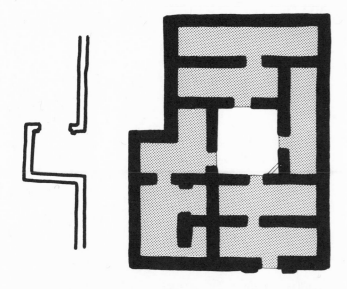

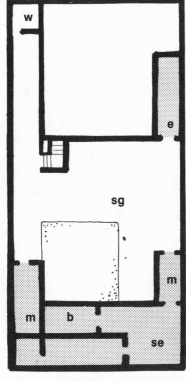

UPPER FLOOR

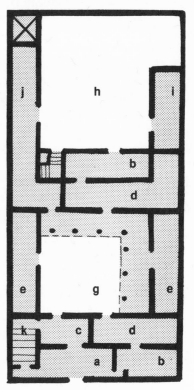

GROUND FLOOR

Fig. 5.29a Plan of a traditional one-story house, Tombouctou. Not to scale. Drawing after Dupuis-Yacouba (1921).

Fig. 5.29b Diagram of the conceptual spatial order of a traditional house, Tombouctou. Drawing after Pâques (1964). Legend: 1a. Head of the woman (vestibule). 1b. Head of the man (door). 2. Stairway to the terrace. 3. Woman's storeroom. 4. Stomach (courtyard). 5. Right arm (man's room, on the east). 6. Left arm (woman's room). 7. Room for pounding millets and other grains. 8. Storage for domestic utensils. 9. Kitchen. 10. Water closet.

Fig. 5.29c Plan of a two-story house recorded early in this century at Tombouctou. Drawing after Dupuis-Yacouba (1914). Not to scale. Legend: *a. Sifa ber* or first vestibule. *b. Tasika* or storeroom. *c. Sifa-keuna* or second vestibule. *d. Almesouar. e. Galia* or living room. *f. Bari-tende* or horse-tether. *g. Batuma* or open courtyard. *h. Hu kore batuma* or women's courtyard. *i. Futey.* *j. Soro-djinde. k.* Stairway. *m. Tafarafara* or houseowner's reception-room. *se. Soro galia. sg. Soro batuma* or upper courtyard. *w.* Latrine and latrine shaft or *sekudar.* The shaded areas designate roofed-over portions of the upper level.

Although construction is in *banco*, using sun-dried bricks, stone has traditionally been used at critical intersections, i.e., at corner quoins, under a central pillar if one is used, and as engaged pillars at either side of the entry door. At one time, "eight hundred stones were required (the symbol of woman), for the twelve doors each house should contain."[103] One is tempted to recall the twelve doors of Mali referred to in the Sundiata epic that sings of the founding of the Mali empire.

The various terms used to designate architectural elements and spaces at Tombouctou are close cognates of building terms used in other medieval cities. A mix of Azer (Soninke and *hasaniya*), Arabic, Manding, Tuareg *tamachek*, and Fulbe, the richness itself is witness to the city's heterogeneity, despite the fact that the masons are a closed caste: terms such as *soro* (terrace), *sigifa* (vestibule), *fum* (opening), *dar* (house) are only a few of many examples.[104] These same terms are also applied to iconographic elements on other art forms not only in Tombouctou but in sister cities.

It has been suggested that the conceptual topographic analogies above are associated with particular castes of builders and artisans.[105] Of special interest are the tailors and embroiderers, the leatherworkers and masons. The embroiderers and leatherworkers inhabit the noble quarters of Sankoré and Djinguéré Ber; the masons reside in the Birinje Kounda quarter, southeast of Sankoré. These three skills are associated in turn with the three great classes which were recorded at the turn of the century: the Alfa, the Arma, and the *gabibi*. The culture bases of their development were the Songhay, the Tuareg, and the Arabs.[106] The Alfa are a noble, literate caste, with no particular ethnic identity; inheritance is a function of literacy and the transmission of knowledge. The Arma are descendants of the sixteenth-century Moroccan invaders and their Songhay spouses. The Songhay-speaking *gabibi*, a lesser caste, are the offspring of indigenous serfs who have acquired the skills of carpentry, smithing, and construction.

The Alfa are the marabouts of Tombouctou, charged as elsewhere not only with the transmission of learning but, most importantly, with the maintenance of the faith, the belief in Allah and religious ritual. Their knowledge is the basis for their aura of divine grace, *baraka*, and they are called upon to provide efficacious *tira* or *tirka*, as the amulets and charms are called. Although the Alfa are outside the guild system and, theoretically, anyone can become an Alfa, training tends to be limited to the sons of Arab or Songhay marabouts. The maraboutic role of teaching, healing, charm-making, and copying books is augmented by tailoring—in particular, embroidery. It has generally been agreed that both robe-making and embroidery

were introduced from North Africa along with Islam, long before the arrival of the Moroccans at the end of the sixteenth century: "Mohammed ben El-Mouloud told me that he had seen in this city [Tombouctou] twenty-six tailoring establishments, called *tindi*, each having a chief at its head under whom fifty apprentices worked."[107]

Embroidery is exclusively in the hands of the literate Alfa. Almost all the embroidery motifs they use are direct patternwork transfers from the geometric designs found in the texts and recipe books used in scholarship and healing. The association among embroidery, tailoring, and scholarship was even reflected in the *Tarikh el-Fettach*, where the reference to tailoring establishments was followed immediately by a discussion of the great number of Koranic schools in the city and the large number of Koranic boards seen in every school courtyard. Thus, the geometry of an embroidered five-by-five square on an old *tilbi* or robe from Tombouctou is a direct copy of the patternwork on a Koranic board, the design accompanying the introductory phrase of a *surah* in the Koran (Fig. 5.30a, b). A very similar design of equal benefit used on leatherwork, of nine circles arranged in a three-by-three square, is called *dar el bassarat* or the "house of the spectacles."[108] (Spectacles are a symbol of literacy and wisdom.)

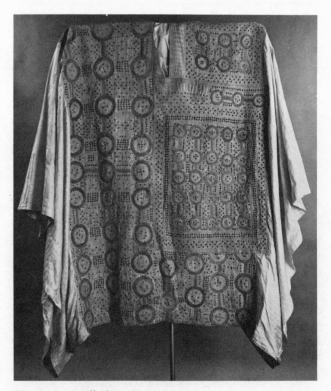

Fig. 5.30a A tilbi *from Tombouctou.*

Fig. 5.30b *Dar el bassarat* motif used on leatherwork. Drawing after Gabus (1958).

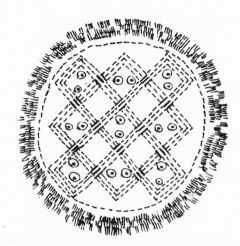

Fig. 5.30c The embroidery of a magic square on the *tilbi*, worn in Oualata, Tombouctou, and Djenné. These robes are worn exclusively by older women.

It is curious that the motifs which are exclusively in the hands of the Alfa at Tombouctou are executed at Oualata by women (Fig. 5.30c).[109] If, indeed, the techniques of embroidery were introduced from Morocco, then presumably they were brought down by the traditional female embroiderers at Fès and other Moroccan cities. The process may have been analagous to weaving, where men have taken over what were traditionally women's skills.

The Arma at Tombouctou have exclusive control over the leather slipper-making craft—which, it is suggested, was also introduced from Morocco. Although no guild exists, only the sons of the Arma can become apprentices, and it is a casted skill.[110] They make embroidered slippers, distinct from the more commonplace sandals made by Tuareg and Fulbe leatherworkers. The knowledge of slipper-making and the ornamental motifs embroidered onto them calls for a knowledge of the social and religious laws, as well as the rules of mathematics. The first sandal is said to have been made by the Prophet and to have contained the religion, customs, laws of marriage, and all the divisions and measures of the world.[111] A representation of this sandal is incised or painted on walls in the Djingueré Ber quarter.

All other leatherworking at Tombouctou is in the hands of either Tuareg women or the Alfa embroiderers. Apparently, the nomadic tradition of female leatherworkers is of as long standing at Tombouctou as it is at Oualata.[112] They made the braided cord from which the leather and brass amulets are suspended, and they continue to fabricate leather cushions with incised and painted patterns similar to those seen at Oualata (Fig. 5.31a, b). These patterns are a relaxed version of the magic-square geometry of house plans. As the wives of the blacksmiths, the women also create the leatherwork associated with metal products such as the sheaths of knives and the bits and bridles for horses and camels. The Alfa marabout-embroiderers are, however, the only persons who can make the amulet covers enclosing the written prayers and Koranic verse which they themselves have been commissioned to make in secret. By extension, it seems they have gradually become involved in all forms of leatherwork that involve embroidery techniques. Their expansion into and current involvement with the leatherworking industry is in all likelihood analogous to that of the weavers suggested in Chapter 4.

The *gabibi* masons of Tombouctou are lower in status than either the Alfa or the Arma families who sponsor them. Although they are not casted, they have a rich mythology of origin and a complex interpretation of their relationship to the earth and to the structures they build. Much of this cosmogony rests on their

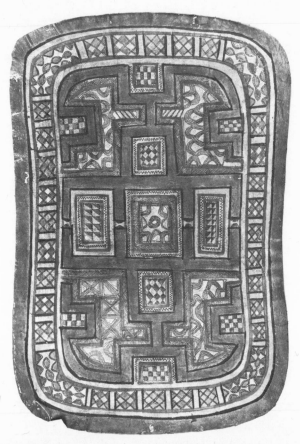

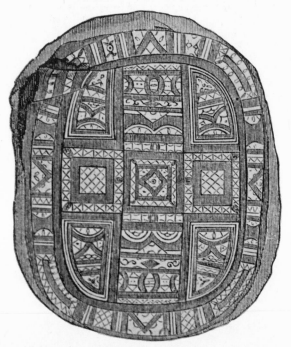

Fig. 5.31a Leather cushion cover made by Tuareg women at Tombouctou.

Fig. 5.31b Leather cushion cover, Tombouctou, 1854. Barth (1857–1859), vol. 3.

role as gravediggers and therefore their proximity to the ancestors.[113] According to their myth of origin, eight masons arrived under the direction of two brothers who came from the Sahel in the north: one, Masa Ambeli, remained at Tombouctou and the other, Mallum Idrissi, went on to Djenné. The guild that was formed upon their arrival had four chiefs or *mala* (?from *mallam*) at its head. Another myth speaks of a mythical ancestor, a *malu* who descended, standing up, from the sky onto a terrace and then to the ground by way of a staircase with six steps.

The patron saint of the masons is Sidi Mahmoud, a mid-sixteenth-century Cadi of Tombouctou. Myth attributes to him the building of the first earthen and stone house, reputed to have been located in the northern part of the city. Since the masons are also the gravediggers, much of the symbolism and meaning associated with building per se relates to his tomb as a center with burial sites for various ethnic groups and castes organized around it. "The work of the mason is essen-

tially the work of the dead; the mason can turn the earth into a living thing; to build a house is to give life to a dead thing."[114] When the masons finish their work they invoke the name of Sidi Mahmoud and dance, decked out in their distinctive hats and with their work tools in hand.

Sidi Mahmoud's son and successor, the Cadi el-Aqib, has been credited in oral tradition and the written chronicles with the reconstruction of the city's three most important monuments, each located in a different quarter: the Sankoré, the Djinguaré Ber, and the Sidi Yahyia mosques. These three mosques, also best known to the Western world, remain to this day a symbol of the city's long religious and cultural history. Like every major building enterprise in West Africa, they have been built and rebuilt over the centuries so that scholars have almost despaired of unraveling the history of their evolution.[115]

The Sankoré is reputed to be the oldest of the three (Plate 9). It was originally "built by a woman, a

great dame, very rich, very desirous of doing good work, such is it told; but we do not know at what date this mosque was built."[116] It is located in the northern part of the city, whence the caravans from the desert would have arrived. As a consequence, Sanhaja, Tuareg, and Songhay traditions of architectural style would have molded its form over time. While its initial configuration is buried in time, the fact that it was sponsored by a woman suggests, considering Tuareg matrilineality and the reputation of Tuareg women as scholars and as keepers of the oral tradition, that construction was begun in one of the epochs of Tuareg rule in Tombouctou.

Several other rebuilding efforts are of more lasting architectural interest, however: that of the Songhay rulers of Tombouctou, Sonni Ali, Askia Muhamed, and Askia Daoud; that of the Aqit family of leaders of the Sanhaja *ulama*; and that of Cadi Mansour. What is evident from the plan of the mosque is that the pyramidal minaret, the *sahn*, the *sufuf* or ambulatory rows, and the *mihrabs* derive from different building periods (Fig. 5.32a). The Sankoré quarter has always been occupied by the Sanhaja, kinsmen of the Tuareg. Under Songhay rule, the Sanhaja community of Islamic scholars, the *ulama*, led by members of the Aquit family, not only dominated the city but was influential in the councils of its Songhay government. Despite its internal-stair system, the pyramidal configuration of the minaret is a close formal replica of the stepped-pyramid mausoleum of Askia Muhamed at Gao, and it is tempting to suggest that a similar process of elaboration took place under

the aegis of Songhay rule in Tombouctou during the sixteenth century. This minaret, or perhaps a smaller version of it, may already have been in place when the Cadi el-Aqib returned from the *hajj* in 1581:[117]

> El Aqib, having ended his pilgrimage, prepared to leave and take the road to Tombouctou, then asked . . . for authorization to determine the number of feet that the Ka'ba measures in length and breadth. Accorded permission, he measured them by means of a cord on which he marked the two dimensions, and then carried this cord to serve as a measure. When he was ready to build the Sankoré mosque, he unrolled the cord and delimited the emplacement by means of four pickets planted on the four faces; thus, it had exactly the dimensions of the Ka'ba.[118]

The interior bounding walls of the *sahn* do indeed conform precisely to the exterior dimensions of the Ka'ba. The interior faces still retain the lozenges, the triangulated brickwork so common to the Berber stone cities of Mauretania, executed here in sun-dried brick (Fig. 5.32b). Thus, the *sahn*, the most important space of the mosque, was indeed built (or rebuilt) in 1581.

The configuration and construction of the various *sufuf* that extend beyond these bounding walls suggest that they were added later, perhaps during the reign of Cadi Mansour.[119] The minaret of the mosque "fell in 1678" and in the early eighteenth century, under his rule, attempts were made to rebuild it. The *mihrab* on the exterior wall, similar in appearance to that of the Djingueré Ber mosque, bears a close resemblance to the work of Manding masons. The Shar'ia Court or en-

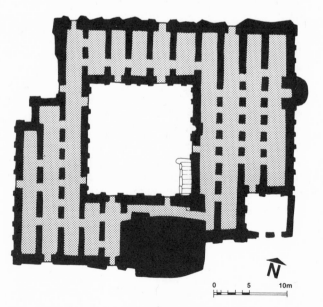

Fig. 5.32a Plan of the Sankoré mosque. Drawing after Mauny (1952).

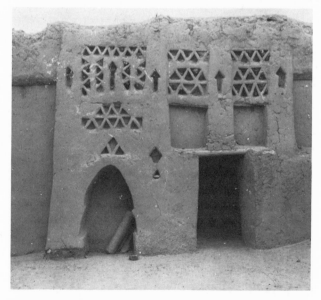

Fig. 5.32b Eastern, *mihrab* wall of the interior courtyard, Sankoré mosque.

trance vestibule may subsequently have been built under Fulbe rule.

The better-known Djingueré Ber mosque, while it has a number of analogous architectural features, is of a totally different spatial genre from the Sankoré mosque (Fig. 5.33a). Although it is referred to by its Songhay name (*djinguere ber* means great mosque), it has always been associated with Manding rule and the efforts of Mansa Musa. When Barth visited Tombouctou, in 1854, the inscription, while barely legible, was still in place.[120] Commissioned in the course of Mansa Musa's return from the *hajj* in 1324–1327, after he took possession of the city, the mosque has always been associated with the building of an audience chamber, a *madugu*, to house his resident representative in the city. Both mosque and *madugu* have been attributed to the Andalusian poet-architect al-Saheli. Presumably, the audience chamber would have been built in an architectural style similar to the one at Niani, in the capital city of Mali. The *madugu* has long since disappeared: its devolution is easily accounted for by the subsequent major political shift of power, and, despite several suggestions, its location remains an enigma.

The Djingueré Ber mosque, like the Sankoré, has undergone innumerable periods of reconstruction, many of them occasioned by inundation, since the mosque is located on low terrain that is subject to occasional flooding from the Niger River. When Caillié visited Tombouctou, he recorded the then-apparent

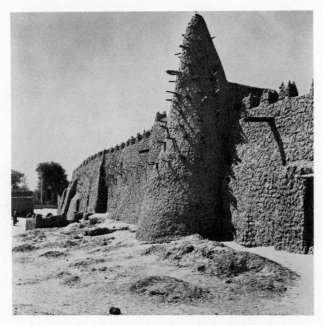

Fig. 5.33a The Djingueré Ber mosque and its *mihrab*.

building variations and suggested that the western section (Fig. 5.33b) was the oldest:

> The west quarter of the mosque appeared to be of very ancient construction, but the entire facade of that side has fallen into ruins. There are some vaulted arcades from which the plaster has fallen away. This edifice was built of sun-dried bricks, of nearly the same form as ours. The other parts of the edifice appear to have been built after the western part was in ruins . . . and appear to be quite inferior to the ancient remains.[121]

An early source suggested that the mosque was a "most stately temple" built of limestone masonry and mortar.[122] And although Caillié says that the mosque was built of sun-dried brick, the vaulted arcades to which he referred were actually built of limestone, using a true Roman arch (Fig. 5.33c). These vaulted limestone arches (rather than arcades) in the "ancient remains" are unique to the West African architectural repertoire. The present-day arches at Goundham and Djenné, Mali, built of either sun-dried or kiln-fired brick (see, for example, Fig. 2.16), are a result of and in part inspired by the French military construction efforts that accompanied their late nineteenth- and early twentieth-century expansion across the savannah and sub-Saharan sahel. There are innumerable references and considerable documentation of their use in various French fortifications and administrative buildings from this period. Although limestone is used for corner quoins and jamb reinforcement at the entrances of Tombouctou housing, and there is now a caste distinction between those who work with earth and those who work with stone, there is no other extant indigenous historical monument in which these stone arches can be found.

In North Africa, however, there is abundant archeological and ethnographic documentation on the use of stone arches and barrel vaulting, from the earliest Roman presence through the many centuries of Islamic expansion. The arch, along with the dome, is a hallmark of the architecture of Islam. We are tempted to suggest that these stone arches in the Djingueré Ber mosque may indeed have been the result of efforts to simulate or replicate a North African model but that such efforts were in great measure thwarted by the absence of building materials such as lime and timber, and limited by the lack of appropriate tools and the available technological skills.

> In the extension of the west part is a large tower that faced on an interior court, closed to the west by the ruins; it is of a square form and is ended by a small truncated pyramid. . . . Trunks of the dum palm split in four support the roof of the structure; these beams are spaced one foot apart; above, pieces of wood, cut the

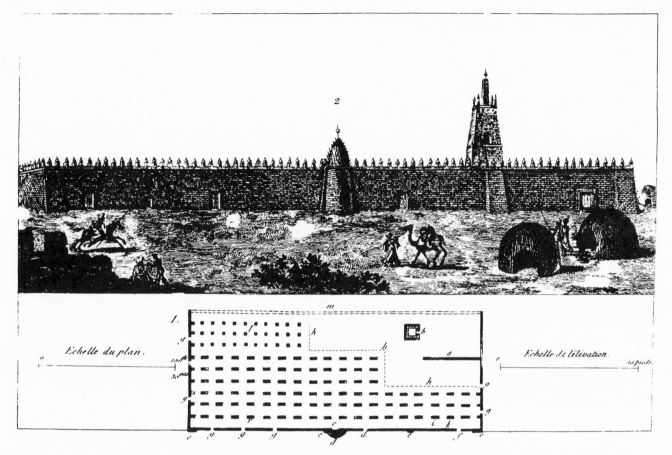

Fig. 5.33b The Djinguéré Ber mosque recorded in 1828. Caillié (1965), vol. 4.

length of the beam spacing, are set obliquely in a double rank and in crosses; then woven mats of dum palm fibers are placed above and covered with earth.[123]

The roof structure as described by Caillié is identical with the framing of ceilings already noted at Tichit and Oualata; it also closely parallels the roof framing for the *tafarafara* and *sigifa* of the more elegant houses in Tombouctou.

The earliest reference to this oldest part of the mosque suggests that it had a tower (*sawma'a*), five *sufuf*, and graves adjoining it on the south and west sides (Fig. 5.33d).[124] Although the reference to five *sufuf* has been interpreted as a reference to the levels of the tower, because only three aisles are extant, an alternative interpretation based on the generic term *suffa*, a covered gallery supported by columns, seems more appropriate. Comparison, for example, with the Ummayad mosque at Medina suggests that the earliest construction may have consisted of a central *sahn* flanked by five *sufuf*.[125] The western boundary—repeatedly in ruins, according to the sources—was evidently washed

away, and the preoccupation with reconstruction reflected in the many references is evident in the western extensions.

The Sankoré and Djinguéré Ber mosques appear to be vastly different in their general spatial organization, but the relationship between the interior courtyard *sahn* and the pyramidal minaret is identical (Fig. 5.33e). Since the same stylistic paradigm was used for at least that part of the new construction or reconstruction, then presumably both might be attributable to the efforts of the Cadi el-Aqib.[126] The presence of these pyramidal minarets may also well relate to passages in the *Tarikh es-Soudan* in which it was first noted that the western Sudanese tradition is to bury the dead in the mosque courtyards or around the edges of the mosques; if so, when the Cadi el-Aqib rebuilt the mosques he included the tombs within them, thereby considerably increasing their boundaries.[127]

The exterior *mihrab* of the Djinguéré Ber mosque contrasts sharply with the pyramidal form of its minaret. It is far more in keeping with the style of the many Manding Dyula mosques, a style that recalls the conical

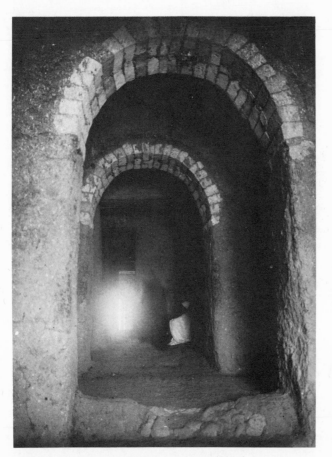

Fig. 5.33c Limestone arches in the oldest section of the mosque, photographed in 1907.

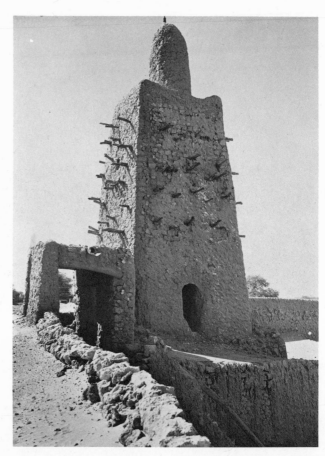

Fig. 5.33e The interior courtyard or *sahn* of the Djingueré Ber mosque, with its tapering, four-sided minaret.

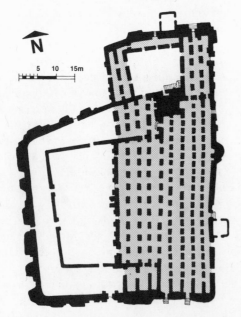

Fig. 5.33d Plan of the Djinguéré Ber mosque. Drawing after Michell (1978).

ancestral earthen pillars of indigenous southern cultures. There are a number of references to reconstruction during the rule of Cadi Mansour and under the order of Pasha Ahmed in the early decades of the eighteenth century, as well as references to the introduction of a new building technology,[128] but whether these are in any way related to renewed efforts in the eighteenth century will only be revealed by archeological research. For the moment, one can only marvel at the maintenance of a stylistic continuity from the earliest Manding presence in the most critical architectural element of a mosque, the *mihrab*.

Although it is the smallest of the triad of mosques, the Sidi Yahyia mosque, close to the center of the city and at one time adjacent to the central market, holds particular meaning for the city's residents (Fig. 5.34a, b). Reputed to have originally been built around 1440 by Mohammed Naddi, the Tuareg chief who controlled Tombouctou at that time, it was named after its first *imam*, and one tradition claims that his tomb is located directly under the minaret of the mosque.[129] This tradi-

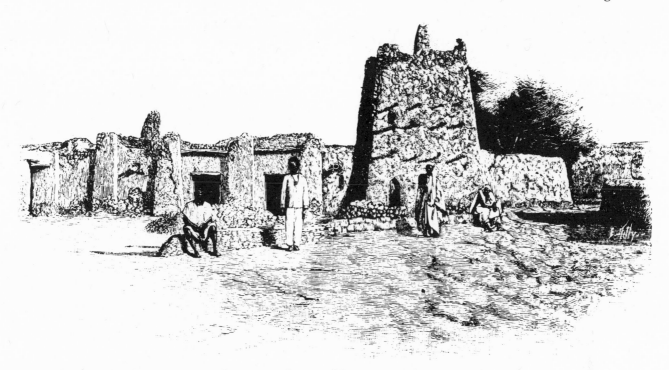

Fig. 5.34a The Sidi Yahyia mosque, Tombouctou, at the turn of the century. Dubois (1897a).

tion appears to validate the hypothesis we have suggested for the others: the tapering pyramidal minaret may in all cases mark the site of the ancient tombs of the most venerable savants and marabouts of Tombouctou.

These three mosques have always been considered the principal mosques of the city; they are the only mosques named in the historical accounts. For the inhabitants of Tombouctou, they continue to be the pivots around which the city revolves. Despite the stringency of the Muslim prescriptions concerning their spatial organization and the need for monumentality, the mosques are enveloped in the same anthropomorphism that rationalizes the conceptual framework of the house and the behavioral framework of ritual. Even for the marabouts, the Djingueré Ber mosque represents a man in prayer with head to the north, and the Sankoré mosque, a woman in prayer with her head to the south; the Sidi Yahyia mosque is in between. In each mosque, the minaret is the head, the *sahn* is the stomach, the west galleries reserved for the women are the

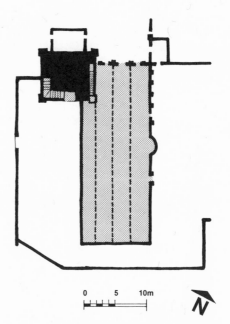

Fig. 5.34b Plan of the Sidi Yahyia mosque. Drawing after Mauny (1952).

feet, and the northern aisles the left arm.[130] Each of the aisles or galleries symbolizes one of the positions of prayer. Thus, these key monuments in the history of Islam in West Africa are at the same time a quintessential expression of an Islam now Africanized.

Agades

Agades, more than any of the political and commercial centers considered so far, is inextricably tied both to Tuareg history and ethnology and to influences from the Mzab. Tuareg culture and the Ibadite Kounta have left their imprint on the Agades aesthetic in the verticality of its mosque minaret and in the profuse, three-dimensional decoration of interior surfaces.

Aïr, the region in which Agades is located, was originally part of the kingdom of Gobir, and while tradition suggests that the city was founded by Tuareg, other sources claim that its original population was black, i.e., peoples from the south.[131] Unfortunately, many of the Arabic-transcribed tribal histories that were housed in the city were lost when a 1917 rebellion drove much of the population from the region.[132] One of the two remaining books was in the custody of a woman resident, suggesting that the tradition of literacy and poetry that placed Tuareg women in a key position in Tuareg society was still viable. Although the arrival date of the first Tuareg group into the region is unknown, when Ibn Battūta passed through in the mid-fourteenth century the Tuareg dominated it entirely.[133] Tuareg domination culminated in the establishment of the sultanate of Aïr in A.D. 1405, and according to historical manuscripts of Agades, the sultan was sought and found in a country whose name is written *arim sotafan*, "black town." The implication is that the first sultan was chosen from a southern savannah region. The early sultans continued to lead a nomadic life—as did the Tuareg leadership at Tombouctou—settling into the city only at mid-century, when Agades had grown into a center for the flourishing trade between Tombouctou and Cairo on the one hand and the Fezzan, through Rhat, on the other.[134]

Shortly afterward, Sonni Ali, the Songhay ruler, ascended the throne at Gao and initiated the great expansion of the Songhay empire. In the early sixteenth century, Askia Muhamed marched against Adil (one of the two sultans of Agades), drove the Tuareg from the city, and established a Songhay colony.[135] The Songhay remained, mixing with the Tuareg and resident sedentarists from the south, imposing the Songhay language on the city, and retaining a key political position in it. Although the Moroccan invasion of 1591 never directly affected Agades, trade routes were disrupted and the decline of many of the entrepôts that depended on the trans-Saharan trade followed. By 1790, the city was almost completely deserted when the majority of its residents migrated south to Katsina, Tasawa, Maradi, and Kano.[136]

Thus, Rennell Rodd's suggestion that Agades is not a Tuareg city, that "the houses of Agades are those of a Sudanese town and not those of the People of the Veil," and that "the character of the city must inevitably partake rather of the south than the Sahara" is somewhat simplistic:[137] it fails to take into account the complex set of relationships among the peoples of the Mzab, the Fezzan, and the savannah, urban and rural, sedentary and nomadic, who contributed to the city's history. One cannot ignore the reference to the "well-built houses in the Barbary mode" by Leo Africanus, who reputedly visited the city in the sixteenth century, or the observation by Barth, the first European eyewitness in the 1850s, that the people of Touat in the Mzab were still the principal merchants and that there were distinct residential quarters inhabited by the people from Gourara, Touat, Tafimata, and Ghadames.[138] Barth also commented on the presence of indigenous merchants (presumably Hausa and Manding), all of whom maintained their ties with the southern entrepôts of Katsina, Tasawa, Maradi, Kano, and Sokoto—the southern Fulbe-Hausa emirate cities.[139]

The oldest, southern quarter of the city was already partially abandoned by the mid-nineteenth century, and the city had been expanded northward by means of a *katanga* or city wall.[140] Among the ruins in the southern quarter of the city were "the pinnacle walls of a building of immense circumference and considerable elevation" which, it was suggested, may have been a public building—a large *khan* or market enclave—rather than a chiefly residence.[141] Given the traditional configuration of a Muslim town, however, these ruins may well have been related to the citadel built, at the time Agades was first settled, by the founding Tuareg clans who united to create the sultanate.[142]

In addition to the *khan*, there were some very well-built houses, "the walls of which were of so excellent workmanship that, even after having been deprived of their roofs for many years, they had scarcely sustained any injury. One of them was furnished with ornamental niches, and by the remains of pipes, and the whole arrangement, bore evident traces of warm baths."[143] The plans rendered by Barth evidence the same spatial arrangement and architectural features as those of Tombouctou and Oualata. Within the courtyards one found an "enormous bedstead with canopies on three sides and above. . . . Such a canopy looks like a little house by itself."[144] This enormous bedstead is,

of course, the canopied *tara* or *nnaka*, the most important part of a Tuareg woman's dowry, located in the same space and performing the same role at Agades as it did in Oualata. Another equivalent architectural feature observed in the houses of the Touat traders was the cluster of earthen pottery aligned on the eastern interior courtyard wall parallel to the bed-canopy, stacked as nests for turtledoves. This recalls the formal arrangement of pots and calabashes not only in the granary—citadels of southeastern Morocco, but along the eastern interior wall of Tuareg and Fulbe matframe tents (see Fig. 7.22a, d).

Barth's reference to the "rambling earthern construction which characterized the southern quarter of the city" contrasts sharply with the permanent stone structures that the sedentarized Tuareg still build in this region.[145] Carefully constructed of stone and mortar (mud is not generally used by the Tuareg, except when southern masons are employed), the Tuareg dwelling has a definite formal and rectangular character. It rarely consists of more than two rooms, intensely individual, sharply distinguishable from its southern neighbors and from the city housing itself (Fig. 5.35a).[146] The layout and orientation parallel that of the Tuareg tent or *ehen*, which suggests that the spatial organization of the nomadic structure has merely been transformed into a sedentary one. The houses consist primarily of a single elongated rectangular space, divided into two rooms, one larger, one smaller. The orientation of the rectangle is along a north-south axis, and the smaller, more elaborately decorated room, with its two pylons and niches and its Oualata-type ceiling, is equivalent to the women's side of a tent. The two entrances along the longer sides of the rectangular house recall the position of the two central poles that constitute the critical conceptual and structural support system of the Tuareg tents of the Aïr region. When extensions are made to the original stone structure, they are most frequently built of earth, but in space they echo the location of the thorn-brush fences enclosing the forecourts of nomadic Tuareg skin tents.[147]

The Tuareg term for any solid house, either of earth or stone, is *tarahamt*, a close cognate of the word for west, *ataram*, and perhaps the term *tarafara*, used elsewhere in the savannah for the main, framed audience chamber of the head of the household. The entrance to a Tuareg skin tent is always on the west side. Interestingly, however, it was always the east doors of the old houses that were emphasized by token buttresses at their jambs. The same arrangement of space is emphasized by the location of exactly six pinnacles above the low parapet: one at each corner, and two midway at the east and west faces of the structure, above the entrances.

Another characteristic feature of older housing was the niches on either side of the entrance into the smaller room (Fig. 5.35b). Within the inner rooms, small niches were constructed by inserting clay pots into the wall. In many instances, shelves were built into the corners at mid-height by using heavy palm beams on the diagonal, echoing the more articulated *khatem*-type *tafarafara* ceilings elsewhere.

The modest surface decor found on sedentarized Tuareg housing has been currently translated, among the most distinguished houses, into a fantastic arabesque that permeates the entire space within the en-

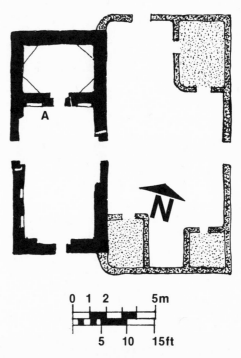

Fig. 5.35a Tuareg stone-built housing in the Aïr region, Niger. The secondary courtyard is an addition built of earth. Compare Fig. 3.14b. Drawing after Rennell Rodd (1926).

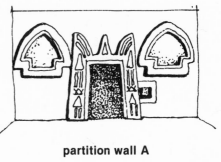

partition wall A

Fig. 5.35b Interior, southern wall of the *tarahamt*, with its recessed horseshoe-arched niches. Drawing after Rennell Rodd (1926).

trance audience chamber (Fig. 5.36a). While this elaboration may be a recent development, it is unmatched in the richness of its wild flamboyance. In plan, the four central columns recall the baldachinos of the Maghreb and the *kubbas* of the Mzab, but the architectural heritage of the nomadic Tuareg can be recognized in the simulated Tuareg bedstead now used as a shelf, and in the earth-enveloped Tuareg *tazikant*, relatives of the Hassaniya *asanad*, Fulbe *do ba*, and Asante *nyame dua*.

This arabesque, colorful interior again contrasts sharply with the more recent configurations of vestibule exteriors, built, it is suggested, by Hausa immigrants to Agades (Fig. 5.36b). Whereas the interior was created by enveloping a wooden armature in earth, the exterior depends on the more precise geometry of its Berber heritage—manipulation of earthen bricks into lozenges and diamonds.

These rectangular house forms of the sedentarized Tuareg at the same time recall the spatial configuration of the multitude of small mosques in the region. The north-south orientation, the midpoint emphasis which parallels the *mihrab* of the *kibla* wall, and the proportions all suggest that in the minds of the inhabitants, there is a corresponding sacrality defined by spatial similarity.

The most spectacular monument in the city of Agades, and perhaps all of West Africa, is the minaret of the Great Mosque (Fig. 5.37a). A single vertical shaft rising high above the low roofscape of both the mosque that envelops it and the northern quarter of the city around it, it points, like a single finger, to the heavens above. The rather dull uniformity of the city's earthen mass below emphasizes the verticality of the minaret. Strangely enough, the architectural history of this singular monument is even more of an enigma than that of its near relatives throughout the Islamized West African savannah. Although the present construction date (1844 to 1847) is well documented, the background to its present state and style remains in the realm of speculation.

Any attempt to explain the evolution of the present minaret must begin with the transformation of a pre-Islamic sacred place per se into the structure of an Islamic place of worship. The tomb of Tin-Hinan, the maternal ancestor of all the noble Tuareg tribes, is located outside Abalessa, fifty miles west of Tamanrasset, close to a trans-Saharan route linking Gao to the Mzab. Her tomb, carefully built of dressed stone and laid out in a slightly elongated square, its four corners carefully and clearly demarcated, is part of a cluster of storerooms forming a *kasbah*, recalling the function of the *ksar-citadels* of the Draa and Dades valleys of southeastern Morocco and the *zawiyas* of the Mzab. The bed fragments on which she was laid to rest had a series of simple, geometric, rectilinear patterns analogous to the ornamentation of tent-pole supports used by the present Tuareg inhabitants of the Hoggar region.[148] The reputed tomb of her faithful follower Takamet, ancestor of the black serfs of Hoggar, consists of a very regular, cylindrical wall, bounded by a second, square en-

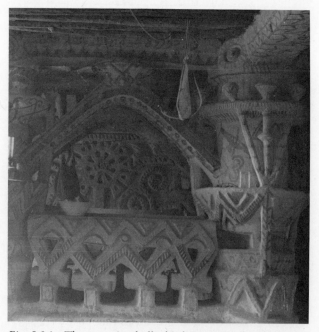

Fig. 5.36a The reception hall of Sidi Kâ at Agades, Niger.

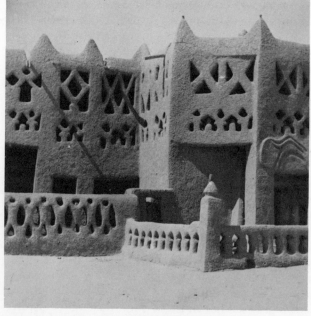

Fig. 5.36b "Hausa" facade at Agades.

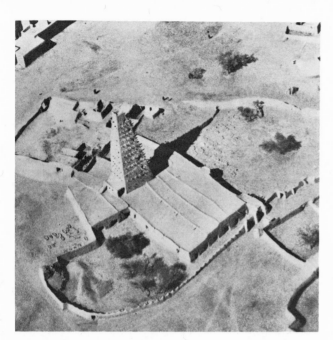

Fig. 5.37a Aerial view of the Great Mosque at Agades.

closure, a *musalla*, consecrated to Muslim prayer. In noting the many instances where these *musallas* have served to Islamize the pre-Islamic *chouchets* or circular tombs, Reygasse has suggested that the tomb of Takamet "is a matter of, without doubt, an Islamic *musalla* built subsequently onto the primitive pagan tomb."[149]

Related to both this phenomenon of transformation and the Agades mosque is a similar square enclosure north of the city itself, observed by Rennell Rodd sixty years ago. The square enclosure was defined by what appeared to be the remains of stone wall foundations immediately above ground level:

> The four sides, each some fifteen feet long, were true and square and oriented on the cardinal points. At each of the four corners of the square, there was a large stone. In the center of the eastern side, two standing stones had been set up about two feet six inches apart.[150]

In keeping with Tuareg tradition, the two standing pillars may have been sepulchres, but they also demarcated the *mihrab* and *kibla* wall of a sacred Muslim space. In the vicinity were a group of graves, some of which were circular enclosures, others of which were oblong and oriented according to Muslim prescription. The configuration follows the pattern of Islamized Tuareg tombs found throughout the central Sahara.[151] Little distinguishes the stone enclosures with their erect headstones from the open prayer spaces of Islam, where the same headstone marks the *mihrab*. The formaliza-

tion of the sacred enclosure into the precise corners of a square provides a conceptual transition into the foundation and base of the Agades minaret. Another parallel at Agades itself can be found in the shrine-mosque known as Sidi-Hamada, an open prayer place "of much sanctity and reputed to be the oldest place of worship in the neighborhood," immediately outside the southwest walls of the city.[152] The *kibla* wall is a low bank, faced with dry stone walling and sloping down a few feet on each side of the niche, to the level of the surrounding ground.

In 1850, when Barth visited the area around the mosque, he noted the ruins of an older tower, "still rising to a considerable height, on the southwestern corner, quite detached from the mosque sanctuary."[153] The existence of two towers, one in ruins, one newly built, recalls the spatial pattern prevalent in other Islamic monuments we have already considered, where one of the towers may have marked a mausoleum. The minaret-tower, completed shortly before Barth visited the city, is square and measures some thirty feet on each side of its base at the mosque roofline. From the roofline, the tower rises to a height of ninety feet, tapering to eight feet on each side at its summit (Fig. 5.37b). There are seven openings on each side, and the four walls are structurally tied on the interior by thirteen layers of dum palm; these project three or four feet beyond the minaret faces. Palm timbers also frame the interior stairway leading to the rooftop. The entire structure rests on four massive earthen pillars, forming a square, below the roofline. These pillars are not visible from the exterior, but are hidden within the core of the sacred enclosed space of the *sahn* below.

This foundation of four pillars is what distinguished the minaret from its relatives at Gao and Tombouctou—where the minarets rise from a solid earthen core—as well as from the ruins of the older tower observed by Barth. We would like to suggest that the ruined tower may indeed have been the result of Songhay efforts at some earlier date, but that the present tower was inspired by the more characteristic *kubba*-type tombs in the Mzab, where the tomb is sheltered by a four-pillar superstructure surmounted by a cupola or an extended tower. The great height, which led Barth to suggest a watchtower role, vividly recalls the singular minaret pinnacles that rise above the hilltops of the Mzab cities of Touat, Murzuk, Ouargla, and Ghardaia (Fig. 5.37c). Given the fact that at the time the new minaret was built the people of Touat were still the chief merchants at Agades, and therefore presumably the core of the spiritual leadership or *ulama* at Agades, the similarity comes as no surprise.

Although Agades was in many ways peripheral to the unfolding panorama of Islamic arts and architec-

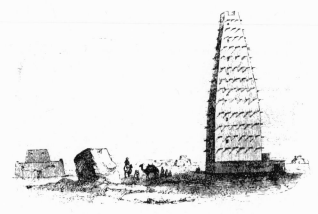

Fig. 5.37b Minaret of the Great Mosque at Agades, recorded in 1849. Barth (1857–1859), vol. 1.

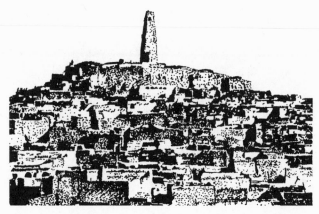

Fig. 5.37c Ghardaia, Algeria, with the minaret rising above this hillside city. Drawing after Mercier (1922).

ture in West Africa, it represents the quintessence of a centuries-long heritage. Its spectacular minaret, reaching to greater heights than any of its counterparts or forerunners, marks a supreme achievement in ancestral verticality in West Africa. The flamboyant interiors of the homes of its wealthier residents and religico-political leadership represent the architectural culmination of a heritage grounded in the ideals of nomadism. Both aspirations, realizable through the mechanisms of Islamic prescription and Islamic-introduced technologies, found expression in a new architectural imagery.

Islam, expanding economically and politically, came to medieval West Africa along trade routes that clearly influenced, and often dictated, the sites of early urban centers and political capitals. Their locations coincided with nodes of changing systems of transporta-

tion. It was out of this golden age of medieval empire and trade, whose needs for political coalescence and trade economics encouraged craft specialization, that the tenets of the Islamic design aesthetic came into being. The written word, a prerequisite to commerce and political administration, brought North African savants into medieval courts and commercial houses. Monumental architecture, espoused as a fourteenth-century Islamic ideal, as one of the "crafts of civilization," found new expression in a milieu limited in materials, tools, and technologies. Manipulation of surfaces became the means by which the concepts brought from North Africa could be expressed. Islam was not culture-bound: its universal perspective inspired religious self-sufficiency and cultural heterogeneity in West Africa.

CHAPTER 6

The Manding Diaspora
Trade Networks, Integration, and Urbanization

THE MONUMENTAL archi-
tecture and the settlement patterns that evolved out of
the epochs of medieval West African empire-building in
the northern savannah provide the backdrop to Islamic
architectural developments in parts of the southern sa-
vannah. Although not monumental in the accepted ar-
chitectural sense, the southern development was far
more pervasive. Other indigenous traditions, a different
weave in the fabric of Islamic adherence, attachment,
and expansion, and shifts of emphasis in the urbaniza-
tion process combined to bring a new architecture into
being. This architecture, long subsumed under the same
generalized "Sudanese" title as its predecessors, devel-
oped hand-in-hand with a secondary trade network
linking the southern termini of the trans-Saharan trade
to the centers of the extractive gold industries and for-
est produce along tributaries to the Sénégal, Niger, and
Volta rivers in the forest belt. The network, still in its
fragile infancy during the period of early empire, gained
tremendous force following sixteenth-century Songhay
rule in the north and the European arrival on the
Guinea coast. Whereas earlier epochs witnessed first
the extension of trade by itinerant Muslims from North
Africa, and then the establishment of discrete Muslim
communities within the gradually expanding bounda-
ries of the Islamic world, this second phase was marked
by their integration into the indigenous socio-political
structure and, finally, the gradual conversion of the lo-
cal leadership in host societies.

During this last quintennium the trade network
was primarily in the hands of the Dyula or Wangara,
i.e., the Islamized Mande.[1] Moving out from the heart
of Mande country at Kangaba, Mali, during the six-
teenth and seventeenth centuries, they spun a web that
stretched from Senegal to northern Nigeria, from the
Upper Niger Bend to the Guinea coast, in response to
both external stimuli and internal developments. By the
end of the seventeenth century, one section of the net-
work, centering on Kong in the Ivory Coast, was heav-
ily concentrated in the Voltaic Basin. Kong was itself
strategically located: it lay close to several arteries that
traversed the regions inhabited by Bambara, Bobo,
Minianka, and Gurunsi populations and converged on
Djenné, Mali, in the Upper Niger Delta (Fig. 6.1a, b).

The trade network was closely associated with the
spread of Islamic sciences and mysticism, but, unlike
the interface which had characterized its earlier north-
ern development, Islam moved into the southern savan-
nah in what might be characterized as "non-disruptive
infiltration." Dissemination occurred at a slow and
steady pace without disturbing the cultures through
whose milieu it spread. Within the broader rural fabric
was created a distinctive pattern in which small, urban
nodules established themselves in a discrete crystalline
"hierarchy of places." Around major centers a number
of smaller satellites clustered, each approximately a
day's march from the next along the traces of the trade
routes.

The networks centered in the Manding core area
were part of a greater network, linked lineally, even if

159

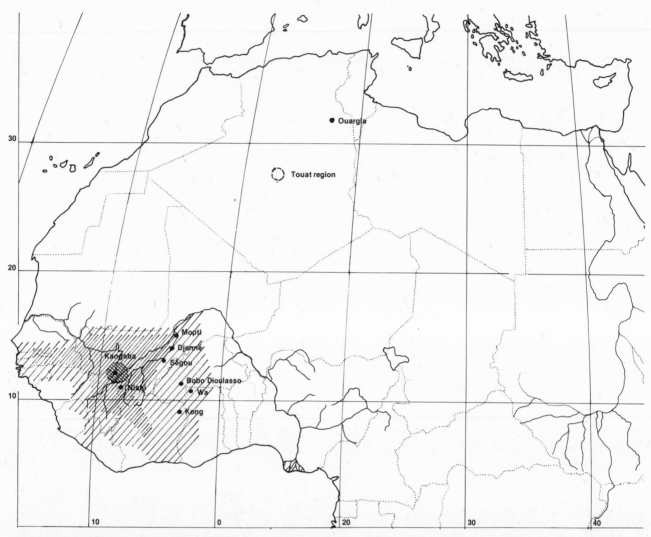

Fig. 6.1a Map showing the extent of the Mande-speaking populations in West Africa. The area considered to be under the aegis of Islam, traditionally shown on maps of West Africa, has not been included. In reality, Islam exerted considerable impact and left its mark at various times in West African history on populations far beyond its assumed sphere of influence. Drawing after David Dalby, "Distribution and Nomenclature of the Manding People and Their Language," in Carleton T. Hodge (1971).

tenuously, to far-flung kin. Dyula had more in common with Dyula families hundreds of miles away than they did with non-Dyula secular nobility or with the rural peasantry among whom they resided. The cross-cultural trade established in the course of the diaspora was closely bound not only to cultural self-identity but to religious adherence. Dyula towns were "linked by common commercial interest and by joint commercial enterprise, a network of alliances based upon kinship and marriage, and by Islam."[2]

The Islamized Mande, however, could not escape their environment. A pluralistic structure evolved in which commerce, Islam, and the underlying indigenous systems supported the urban network. This pluralistic structure created a tendency toward assimilation into the host society on the one hand and a "constant and conscious concern for the renewal and invigoration of the Muslim content of Dyula, Manding culture" on the other.[3] The result was a precarious balance between local ritual prescriptions and those of universal Islam—symbolically expressed architecturally. Initially associated with commerce, Islam found physical expression in material artifacts of Muslim allegiance and adherence, such as writing and luxury goods. Ancestral earthen pillars, singly or in clusters, validated through genealogy and earthbound cosmologies and mythologies, could be associated with the indigenous ruling elite. Ultimately, it was the dichotomy between Islamic

self-identity and integration that provided the new symbol-system for an architectural style born of the diaspora (Fig. 6.2).[4]

In a recent germinal study on Islam and the African arts in this region, Bravmann referred to the ease of transformation and incorporation of cultural elements within this symbiotic relationship; to the ease of passage from one socio-religious cultural context to another; and to the "high degree of compatibility, ranging from quiet tolerance to total acceptance, [which] has often characterized the relationship between Islam and local art traditions in West Africa."[5] Architectural evidence suggests an even more strongly worded interpretation. Not only was there compatibility but, contrary to long-accepted European interpretations, indigenous cultural traditions exerted considerable influence on the carriers of the new religion. Contrary to the suggestion that "ancestor houses gradually disintegrate under wind and rain and are not renewed,"[6] in fact the imagery and iconography of ancestral pillars, altars, and shrines inspired a new Islamized style of architecture, the "Sudanese" style. As we suggested in Chapter 4,

many elements of Islamic material culture such as charms, amulets, clothing, prestige goods, and magical elements were readily integrated into the panoply of indigenous host societies. The newly emergent, Islamized Mande urban setting in turn drew heavily upon the rural hinterland for its architectural imagery, raised that imagery to a higher level of architectural consciousness, and imbued it with new meaning within the context of Islamic adherence. This emphasis on the indigenous source is, as we have suggested earlier, characteristic of traditional cultures.

The western zone within this vast trade network, close to the Bouré and Bambouk auriferous regions, was most active during the earlier centuries of its growth. The earlier Muslim communities west of the Black Volta still speak a Mande dialect as their primary language, whereas those east of the river have abandoned their Mande dialects and adopted the language of the rulers of respective states in the area. In the west, "Dyula communities kept their identity, among other reasons, because they operated within the Mande trade system, keeping in constant communication with other

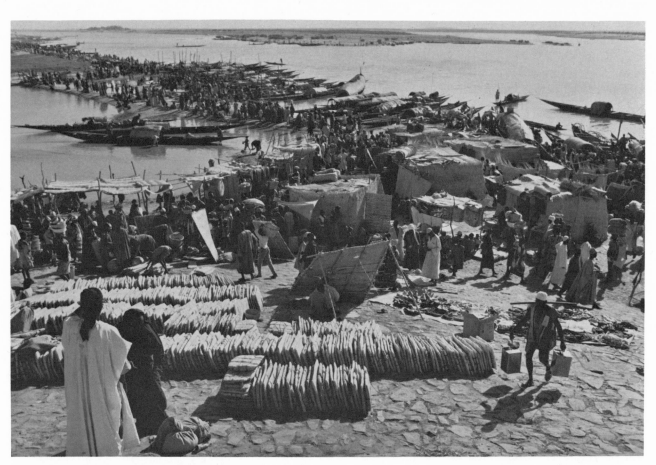

Fig. 6.1b Dyula salt-traders at Mopti, Mali.

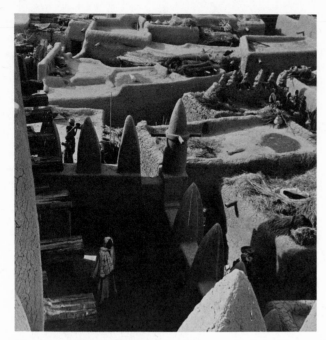

Fig. 6.2 Roofscape of the village of Sirmou, Mali. In the foreground, rising in sharp contrast to the built environment around them, are the earthen pinnacles of the *sahn* or courtyard of the village mosque.

regions of Mande peoples."[7] This historical shift perhaps also accounts for the selective use of particular architectural symbols in predominantly non-Dyula landscapes. The tightly structured style was able to reinforce visually ties which distance tends to weaken. The architectural symbols contributed to a sense of distinctiveness and authority by expressing the presence of Manding Muslim nodes in a trade network.

Maintenance of cultural identity—to renew, transmit, and invigorate Muslim content—was effected via a network of family allegiances or *lo*, and *isnads* or chains of Islamic learning, within the Dyula society.[8] The cadres of scholars, the *ulama* in the various localities, exercised control over a field of technological enterprise, i.e., writing. They also exercised design control over another field of technological enterprise, that of building, for architectural style was as important as writing in maintaining and reinforcing identity and cohesiveness.

Against the more general patterns of earthen architecture in the savannah belt, where diffuse forms and surfaces are identified with underlying cultures and belief systems, the urban, Islamized Mande style stands out through its use of pillar-like buttresses and pinnacles. The attached pillar and projecting pinnacle, a unique feature, constitutes the "code" of the Dyula architectural symbol system. Extension of these pillars as corner quoins and pinnacles above earthen parapets, incorporation into portal entrances and extended architraves and lintels, integration into an intricate register of balustrades, and arrangement into a cohesive cluster bounding space are elaborations on this central theme.

In Chapter 3 we suggested that the ancestral earthen and stone pillars ubiquitous in the savannah landscape express the traditional ethos and mythos of the peoples who molded them, and that they are frequently located in the immediate environs of the family habitat (see Fig. 3.9). The area of heaviest concentration coincides with the habitat of those cultures where ancestral worship obtains, i.e., among the autochthonous peoples in the Voltaic Basin. It also coincides with the centuries-old trade network of the eastern Dyula in southeastern Mali and western Upper Volta, down into the northern Ivory Coast and Ghana. The ancestral earthen shrines and pillars in the public forecourt of compound entrances are most frequently found in association with a pair of gateway pillars, suggesting a close spatial relationship between the invocation to the ancestors and the well-being of the compound. The gateway pillars which establish the viability of a new farming unit among the Tallensi have been elaborated by their northern Kassena neighbors into a clearly demarcated portal entrance (Fig. 6.3). Instead of merely designating the opening edges of the circumferential wall, the two Kassena pillars that flank the entrance are directly attached to a vestibule, thus establishing a conceptual relationship between the sacred ritual space of ancestral residence in the forecourt, the entrance, and the social behavior in the vestibule itself. The development into a portal entrance is equally clear in the group of doorways recorded by Leo Frobenius early in this century, among the Gur-speaking people of Upper Volta (Fig. 6.4).[9] The anthropomorphic representation was presumably rendered in bas-relief on the lintel itself to protect the opening, in a manner not unlike the Do-

Fig. 6.3 Entrance pillars and ancestral markers of a Kassena compound near Léo, Upper Volta. Drawing after Dittmer (1961).

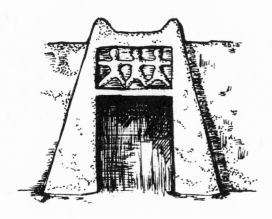

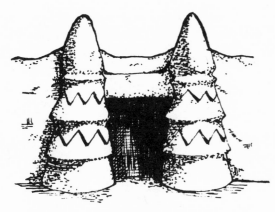

Fig. 6.4 Entrance portals among the "Gurunsi," Upper Volta, recorded in the first decade of this century. After a drawing in Frobenius (1923).

new iconography (Fig. 6.5). The erosion reveals the use of sun-dried rectangular bricks; the way in which they have been set on end in the corpus of the lintel recalls similar methods in stonework and cast earthen brickwork found in the entrepôts and capital cities of the northern savannah. These lozenges could only have been effected in brick or stone masonry. The architectural detail on many of the facades illustrated in this chapter are derivative of this technology.

Reference has already been made to the conical earthen pillars that serve as altars to Amma, the creator-god of the Dogon, in the courtyards of the founding ancestors of Dogon villages. At Barkommo, in the Mori region of the Bandiagara escarpment, one finds cones of dried mud, either singly or in pairs, to the left of the *ginu* or compound entrance. Tradition in this village claims that these conical sculptures, constructed by the village founder, were formed by mixing earth from the altar *manna amma* of Arou-pre-Ibi, an altar which was itself made of clay brought from "Mande."[10] Implied is a link between the earthen cone and the Manding presence in Dogon mythology. The gradual replacement of anthropomorphic sculpted wooden piers under the *to-guna* by earth-covered stone pillars simulating these

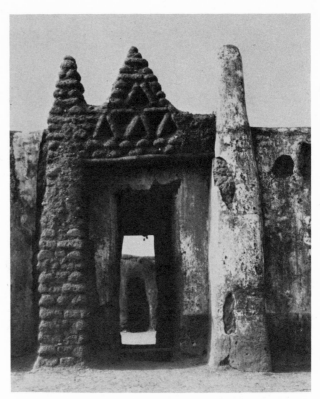

Fig. 6.5 Facade of a compound near Bole, northern Ghana, 1965.

gon representation of ancestral figures on carved wooden granary doors.

In Chapters 2 and 5, the introduction of hand-molded or cast rectangular brick into the indigenous technology of the Voltaic Basin was attributed to the Islamized Manding. The effect of this new technology on architectural imagery is clearly evident in the deteriorating facade of a compound south of Bole in northern Ghana. The proportions and anthropomorphism recorded by Frobenius have been subtly revised into a

same cones is equally suggestive of an affective Manding presence. The tradition culminates in the projecting acroteria above the facade of the *hogon*'s *ginna* or house at Arou-pres-Ibi (Fig. 6.6a). As senior member of the community, the *hogon* is closest to the ancestors. At the same time, technological development explains the facade of many of the *ginnas* recorded at the turn of the century. Although the original surface is now thickly coated with countless layers of earthen rendering and with a new set of meanings related to Dogon cosmology, the geometrical arrangement of solids and voids on the facade is, in fact, nothing more than the manipulation of brickwork patterns (Fig. 6.6b).

The Dogon explanation for the origin of the house is equally revealing of this suggested homologous relationship. After copying the shape of the anthill and "advancing toward a less primitive way of life . . . they noticed the growth of teeth around the opening [and]

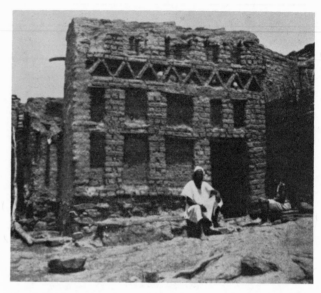

Fig. 6.6b A newly constructed Dogon *ginna* before its finish rendering has been applied. The earthen bricks that dictate the *ginna* motifs are clearly seen. Desplagnes (1907).

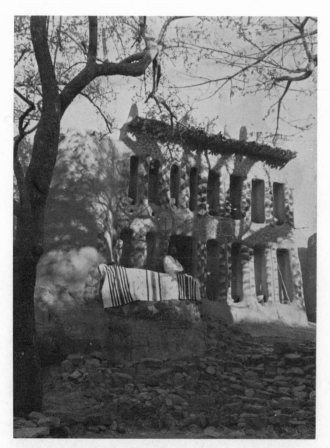

Fig. 6.6a The *ginna* of the Dogon *hogon* at Arou-près-Ibi, near Sanga, Mali. The ancestral pillars representing the founding ancestors of the four Dogon clans can be seen projecting above the *toron*-like parapet. In this instance there are nine pillar extensions, which, inversely, seem to create eight voids in space.

they imitated these too as a means of protection. They molded great teeth of clay, dried them and set them up around the entrances to their dwellings."[11] Rather than a simple association between similar forms, the "teeth" are apparently the earthen cones which conceptually protect the inhabitants of the house. It is the ancestors who, by their encircling presence, protect the consecrated, inhabited space.

In contrast to the later pluralism that characterizes Dyula residential and socio-cultural relationships, among indigenous societies the religious role of land chief and the secular role of political chief are often vested in the same person.[12] The same symbol of validation is used in both contexts—i.e., for rituals associated with the ancestral earth, and for his own residence—thus enhancing and protecting his position. This dual role would explain the cluster of earthen pillars that comprises the palace of the Gur-speaking chief in the village of Sapouy, Upper Volta (Fig. 6.7a). This palace, with its engaged and projecting pillars, encloses and protects the space consecrated by the head of the society and, by extension, insures the viability of the entire kin group. The cluster of forms here simulates particularly closely the cluster of funerary pillars found at the entrances to the compounds of Lobi village chiefs and elders (Fig. 6.7b). Assuming that sacredness is associated with wisdom and leadership in the traditional, indigenous context, it is not difficult to foresee how the respected position the Islamized Mande came to assume within the fabric of rural society found expression in the related iconography of the Dyula mosque.

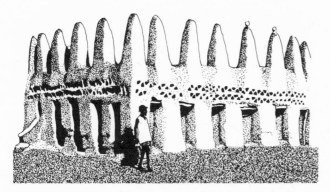

Fig. 6.7a Residence of the *peo* or chief of Sapouy, Upper Volta. Drawing after Dittmer (1961).

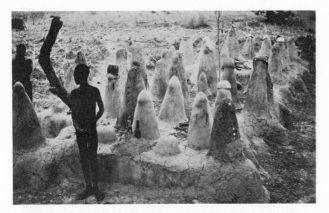

Fig. 6.7b A cluster of Lobi ancestral pillars, Birifu, northwestern Ghana.

The examples up to this point are all drawn from so-called pagan societies, characterized by strong ties to the earth, generational continuity through patrilineage, and politico-religious leadership. To one degree or another, however, all were subjected, exposed, or superficially converted to Islam. In his discussion of Bambara traditions a number of decades ago, Tauxier noted that the Ramadan and Tabaski celebrations, both critical to the establishment of Islamic allegiance, were consecrated to rites and festivals to the ancestors (Fig. 6.8). Sacrifices during these celebrations were made at the threshold of the entrance doorways, on the *bolo*, and at both sides of the doorway. The more southerly Bambara, i.e., those living in the area of Bamako and Bougouni rather than around Ségou, preserved more of their ancestral customs, continuing to sacrifice to their ancestors on the *boli* or tombs themselves. Tauxier also suggested that the *sou-son*, mortuary gifts offered at the doorway, have been transformed into *saraka*, alms-giving in the Muslim tradition.[13] In his description of the Bobo living in the Pondori of the Upper Niger Delta, Tauxier also suggested that although the Bobo have in principle remained pagan, they too have translated their sacrificial rites to the earth into a sacrifice to Allah at the doorway to the village chief's compound.[14] The same ritual transfer was observed at Djenné in 1900.[15]

This transfer of imagery is clearly seen in a "fetish temple" photographed in 1898 at Yatenga, Upper Volta

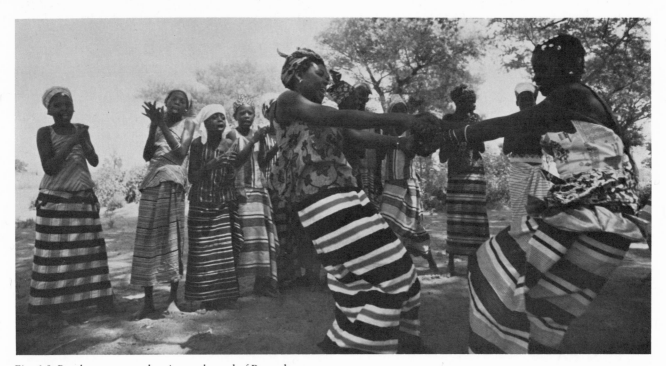

Fig. 6.8 Bambara women dancing at the end of Ramadan.

(Fig. 6.9).[16] Its painted geometric patternwork is identical with that on the Dogon *ginna* above, on the ancient mosque, and on the house of Madani, Ségou (see Fig. 6.20 below). The abundance of painted geometric designs throughout this entire region, commented upon by French observers who crossed it in the last decades of the nineteenth century, is still evident today. The three colors, white, red, and black, represent the "foundations" of creation. While one is tempted to wonder whether the painted geometric motifs were an attempt to simulate structural patternwork, which involves a more complex manipulation of building blocks by more highly skilled builders, the persistence of the role of women in applying the final surface seems a more reasonable explanation.

The building's *form*, however, is more closely associated with the classic Dyula mosque. The cluster of earthen buttresses is highlighted at each end by two projecting pinnacles, evoking the imagery of *mihrab* and minaret. The "fetish temple" was published in conjunction with a "mosque" at Léo, Upper Volta, in order to distinguish and compare the two, but it is not difficult to recognize the same forms in both. What primarily distinguishes them is the geometric patternwork painted on the "temple" in contrast to the pristine bareness of the mosque. The juxtaposition only highlights the way in which continuity of form evolves with multiple layers of meaning and the built form takes on a multivalent, multivocal quality. The crenellations on the "temple" are of related interest: rather than being single, solid cones, they are constructed by counterpoising two rectangular bricks in a technique similar to that found on the Dogon *ginna* facade.

The most striking example of the transformation of the traditional altar-shrine into the house of another god was a mosque built at Ségou in 1899–1900, after the French conquest had destroyed part of the city (Fig. 6.10a).[17] The physical configuration appears to parallel the suggested analogy between the Bambara creator-god Ngala and Allah,[18] but at the same time it repre-

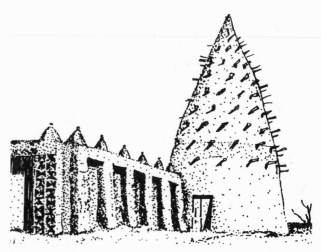

Fig. 6.10a The extinct mosque at Ségou, Mali, 1900. Drawing after Perignon (1901).

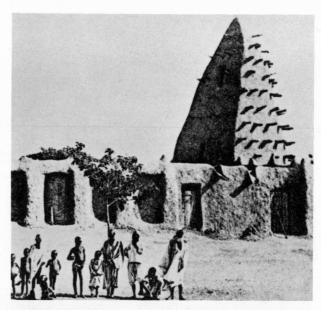

Fig. 6.10b Another view of the same mosque. Delafosse (1912), vol. 2. The same sheared face occurs on other mosques in the vicinity of Ségoukoro.

sents a qualitative leap into verticality and mass far beyond its forebears. The single, towering earthen cone is now the *mihrab*, complete with a system of projecting wooden pickets or *toron*, and extending out from this massive earthen cone as from a pivot are the enclosing, buttressed walls, covered with geometric designs and surrounding an open courtyard or *sahn*.

From the exterior, the tower appears to be a perfect cone, but a subsequent photograph reveals that the tower was sheared vertically so that the side facing the enclosed courtyard was a flat *kibla* wall (Fig. 6.10b). The pair of doors, as well as several openings in the

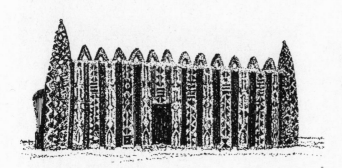

Fig. 6.9 A "fetish temple" at Yatenga, Upper Volta. Drawing after a photograph, Chanoine (1898).

upper portion of the flat face, suggest that the tower may also have served as a minaret. The single pyramidal ancestral cone was thus transformed into a combined *mihrab*-minaret, following in the same tradition as the mosque at Tendirma. The center of the indigenous universe, marked by an ancestral conical pillar, was thus transformed when direction toward a new center—Mecca—was introduced.

In 1880, Bamako was still of minimal import, and although the city had a surrounding wall, the only structures of note were the homes of the Bambara chief and of a family of "Maures."[19] If a mosque existed at all at that time, it must not have been distinctive enough to merit the attention of a French observer. The now-extinct mosque, then, presumably dates from the period of intensified building activity immediately after the French conquest (Fig. 6.11a). In contrast to its sister mosque at Ségou, there was no surface decoration, and the pillar-turned-*mihrab* sat clearly on the axis of a *kibla* wall. Symmetry was reinforced by the two flanking pillar-buttresses and their courtyard wall extension. The arrangement of these two flanking elements recalls the flanking pillars of "Gurunsi" compound entrances; they convey the same sense of protection and guardianship to the conical *mihrab* tower. The entire structure has been carefully ordered into an approximate square with a cardinal orientation, but its anchor point remains the earthen center of the pseudo-Islamized convert. To be sure, there has been a realignment in spatial organization and orientation, but the symbol of ancestral centrality, with its equivalent extension of sacred forecourt, remains. If the structure was in fact built after the arrival of the French, the achievement of precision and symmetry requisite to Islam may have been made easier by the French military building program, which influenced indigenous construction.[20]

The maintenance of traditional stylistic continuity among the Bambara can be documented in many other ways. In the middle decades of the nineteenth century, Ségou suffered defeat at the hands of several puritanical Muslim conquerors. Its shrines were periodically destroyed; its *bori* or *boli* alone were, for various political reasons, deliberately left standing.[21] Local administration was left intact, still responsible to the *fama*, the Bambara king of Ségou. Both of these factors implied a strong attachment to traditional symbols, and it may be that the mosques were in reality merely an appendage to the *boli*, previously existing but now much elaborated upon.

The iconography of the indigenous tradition is reflected in several ways. Besides the pillar itself, almost every Islamized Mande mosque has, in association with it, a tree of great age and magnitude. This tree, usually the tallest in the village, recalls the *balanza* tree of Bambara ritual and myth, where it was the scene of sacrifice to Mousso-koroni, the mother of magic and transformation.[22] The *balanza* tree itself was formed out of the essence of Bemba or Ngala, the creator-god. While the tree adjacent to the mosque may not be the identical tree associated with the sacrifice, the conceptual transfer or symbolic association is implied by its presence.

One of the ancestral cults among the Bambara is the *dasiri*, derived from the bonds that link the deity to the founding of a human community and its organization. Essential to the cult is the assignment of a given locality to the *dasiri* mystery, a fixed point in space.

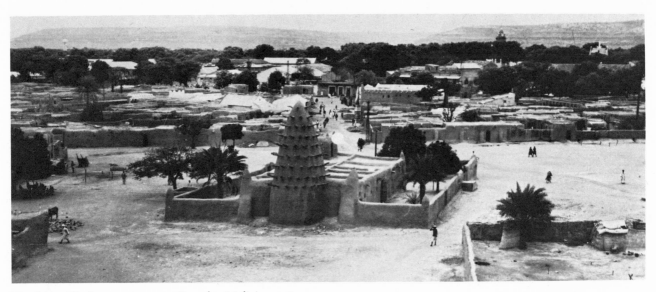

Fig. 6.11a The former mosque at Bamako, Mali, in 1948.

Every year, the initial act of founding a settlement is recalled by sacrifices to the *dasiri* in order to renew initial attachment. Every territory has its own *dasiri* in the form of a tree and an animal counterpart. The stationary tree is a material expression of the attachment of creation to the founding of a settlement. Given the pattern of new settlement implied by the Manding diaspora, tree and mosque become associative symbols of primordial settlement, and the renewal of initial attachment is expressed through the annual resurfacing ritual which surrounds every mosque.

The term *toro* (pl. *toron*) has been used in reference to the projecting wooden pickets which are found, if not over the entire surface of the Dyula mosque, at least almost always on its *mihrab*-minaret. One is reminded of the Bambara term *sutoro*, used in association with the *komo*, the initiatory society specifically associated with human knowledge. Knowledge has four parts, represented by four "mothers," of which the second is called *sutoro*. "The *toro* symbolizes germination, proliferation, and rebirth. The name *sutoro* alludes to the funerary custom of burying a branch of this tree with the dead, to represent rebirth. This mother represents enlightenment, and teaching by demonstration."[23]

In a discussion of the historical interconnections between the Muslim elite and masking traditions, René Bravmann cited a Bambara tradition of origin for the *komo* society recorded by Joseph Henry, which credits its introduction to the Islamized ruling elite.[24] According to the legend, Mansa Musa, while on his famous pilgrimage to Mecca in 1324, traded one of his magical robes for the spirit of *komo* and numerous *boli*. These *boli* are a necessary feature of the *komo* shrines, vital to the functioning of the cult. Thus, while there is no doubt that the *toron* serve a practical and structural purpose in reinforcing the earthen mass and as scaffolding in resurfacing of the mosque each year, they, as well as the *dasiri*, evoke human knowledge, rebirth, and renewal within the context of a new system of "revelation" and revitalization.

The similarity between the *toron* on the *mihrabs* and minarets of Manding mosques and the structural scaffold timbers found in, for example, Syrian vernacular architecture was pointed out in our discussion of Askia Muhamed's tomb at Gao. Their select, preferential use on minarets, *mihrab* towers, and the tombs of saintly Muslim personages such as that of the marabout in the Touat region of Algeria appears to be a West African contribution to the iconography of the North African Mzab (Fig. 6.11b). We are reminded of the fact that in his pilgramage to Mecca, Mansa Musa left a large part of his entourage at Touat.

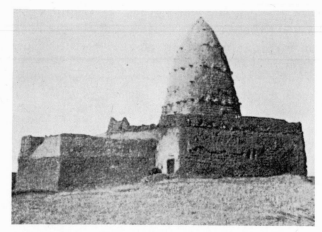

Fig. 6.11b Marabout's tomb at Mereguen, Touat, Algeria. *L'Illustration* 3070, 28 December 1901, p. 419.

There can be no doubt that Islam, in its movement south, inspired the preferential use of certain architectural features. There was at the same time, however, a considerable northward movement of Black Sudanese populations, forcibly via the slave trade as well as freely along the viable trans-Saharan routes, and the Mzab region currently has one of the largest Black populations. Too little attention has been paid to the impact on North African life of the traditions of these Blacks. The great similarities between the funerary practices and architectures of Mzab cities such as Ghadames, Ouargla, Melika, and Touat and those of the West African savannah were noted at the beginning of this century by scholars such as Mercier and Desplagnes, but even the meager extant evidence makes it clear that this subject merits far more attention than it has received to date (Fig. 6.11c).

In the region of Ségou and the Massina, Fulbe, Marka (Islamized Bambara), and Sorko (Somono or Bozo) maraboutic traditions overlay the pagan Bambara cultural foundation; the mosques at Ségou, for example, were under their control at various times. The Somono controlled the river route on the Niger which linked the savannah trade routes with their northern entrepôts, the terminal entrepôts of the Sahara routes, and this link may have contributed to the Islamic architectural development at Ségou, Bamako, San, and other river ports along the Niger. It may also help to explain the stylistic affinity of the earlier Ségou and Bamako mosques with the mosque at Tendirma, Mali. For example, while the Marka and Sorko mosques at Bamako and Ségou were actually built by "pagan" Bambara masons, the role of the Muslim clerics consisted in establishing the proper orientation and making a daily token survey. "To preserve appearances, however, a

Muslim came every day during the construction to carry a stone or to shake up a little earth, hoping that this gesture would sanctify the remainder of the day's work."[25]

At the beginning of the eighteenth century, two groups of pagan Wattara immigrants, one from the region of Ségou and Djenné in the north, the other from Tengrela, founded the kingdom of Kong.[26] The ruling Wattara, in the course of the century, became intricately involved with the trade and learning network linking one Dyula community to another in the region and, because the prosperous Dyula community made the capital city, Kong, a center of learning, it came to be considered the center of a Muslim kingdom.[27] The tightly circumscribed, distinctive Dyula architectural style can, in the main, be attributed to Kong's role as a major center of Islamic learning and commerce. Its origin is in the Manding world, but its geographic concentration is along the southern boundary of the Gur-speaking culture.

None of the mosques built during the eighteenth century at Kong still stand to provide us with an early example of Dyula architecture. All succumbed to the ravages of time, periodic disuse, and the various conquests and raids that swept across the region in which they were located. Though it is claimed that the pres-

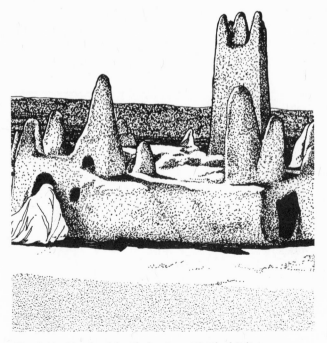

Fig. 6.11c Tomb of the Shehu Ammi Saïd of Sidi Assa at Touggourt, between Biskra and Ouargla in the Mzab region, Algeria. Drawing after Roche (1970).

ent-day mosque at Kawara, northern Ivory Coast, dates from the seventeenth century, it serves as a case in point for the process of renewal and, we believe, as a model for how these early mosques may have looked (Plate 10). Located in a Senoufo-speaking region, tradition claims that the town was founded by Nampou warriors or hunters who came from the north, after having founded the town of Niellé.[28] By the mid-nineteenth century the town had become the terminus of a route leading down from Sikasso.[29] In 1883, the town was subjected to heavy raiding by Samori, a local Muslim leader resisting French colonial expansion; presumably the original mosque was destroyed at that time. A new one was built in its place which reflects what we consider to be the primordial model for a Dyula mosque. There is no *sahn* or interior courtyard square in the prescribed sense. The doorway is of minor import, with no embellishment, so low that one must stoop to enter. The Friday prayer is performed in the open verandah-like space between the mosque proper and its surrounding wall of tooth-like, whitened pillars. Although it does emanate a quality of fluidity which may derive in part from the heavy white cement coating that now protects it, this very negation of enclosed space gives the mosque a sculptural solidity similar to the Lobi shrines considered above. Obviously identifiable as a Dyula mosque, in its architecture can also be found both a reference to the traditionally low, reputedly semi-subterranean compounds associated with Senoufo housing, and to the protectively encircling ancestral pillars described in the Dogon myth of the origin of the house. These encircling pillars define, not the mosque itself, but the sacred prayer space of its encircling verandah. The spatial configuration is at variance with the traditional Manding model, yet it superbly fulfills its ideological function: visual communication by means of a discrete sculptural symbol.

Close to the sources of gold and kola nuts, and with direct routes to Djenné through Gurunsi country, the Kong community flourished. Kong itself became the urban fountainhead for a group of *isnads* that established schools and Islamic communities in one town after another. These chains centered around the Saghanughu *ulamma* who in the seventeenth century had moved out of metropolitan Mali across a network of southerly Muslim trading towns. Most of these Dyula chains are traced back to Muhammad al-Mustafa Saghanughu, who lived in the late eighteenth century. His eldest son was invited by the Wattara leadership to settle in Kong. There was already a mosque in Kong, but the arrival of the Dyula cleric occasioned some controversy over its correct construction and a new mosque was built under his aegis in 1785.

A century later, the city had five mosques (Fig. 6.12a; cf. 1.16c), almost identical in style, each identifiable by the conical pinnacles with projecting wooden pickets and ostrich-egg caps rising above the roofscape. The *misiriba* or Friday Mosque, at the edge of the marketplace, had in addition, in front of its south face, an earthen pyramid some two meters high.[30] Binger took this to be the tomb of a venerated Muslim cleric, but everyone he questioned denied this, insisting that it meant nothing. Perhaps his informants' reluctance stemmed from their unwillingness to admit to the close proximity in which Islamic and non-Islamic practices could coexist. The clearly delineated pair of pillars flanking the entrance to the recorded mosque recall, in size, proportion, and position, the underlying pattern of rural, indigenous entrances considered above.

In 1897, Kong was pillaged by Samorian soldiers when the city fathers attempted to negotiate with the French colonial invaders. Many of the Dyula Muslims were massacred, and the Friday Mosque was heavily damaged. A new mosque was subsequently built close by (Fig. 6.12b).[31] The present-day structure looks much like its predecessors, but it differs in one major respect: wooden horizontal crossbraces have been incorporated into the building structure. Wooden cross-members linking one earthen buttress to the next are more frequently found in Dyula mosques south of Kong, closer to the rainforest belt, where timber is more abundant. Their apparent absence in less humid climates suggests initially that they may serve a structural function, compensating for the weakness of earth under heavier rainfall. On the rare occasions in which these cross-members are used further north, the longer-lasting build-up of surface rendering has often hidden them.

If the earthen buttresses which establish the Dyula architectural symbol-system derive from indigenous sources, the geometrization of these symbols of ancestral worship into a discrete building block in space, observable from a distance and perceived in its entirety, can be attributed to Islam. In contrast to the focus on the open interior spaces of the courtyard *sahns* in the great mosques of North Africa, here the prescribed square is defined on the outside by its exterior walls. This perceptual reversal accounts for the sculptural quality of the Dyula mosque structure, in which interior space is barely acknowledged and also for the intensity and intricacy of the external surface decoration. The emphasis on external imagery is a logical response to the need for visual identification and maintenance of stylistic cohesion and consistency. The Dyula trade network involved a high degree of mobility from one node to another, and the distinctive mosque could be recognized long before one set foot in a town. The towering spire, the cluster of buttresses, the whiteness, the deep shades and shadows created by strongly articulated surfaces, and the isolation in which it sits contrast sharply with the subtle earthen hues of the evenly rendered walls that surround it. The mosque served as a visual cue, facilitating orientation in an alien environment, through a cognitive, affective, and connotative symbol system.

This tightly circumscribed, easily recognized style appears to deny individual creativity, yet no two mosques are identical: they do not adhere rigidly to a prescribed model. While a set of recognizable features are common to all—e.g., the earthen buttresses tapering into acroteria, a pair of pinnacles with projecting *toron* which rise above the building mass in locations cardinally prescribed, and a towering tree at their entrances—their size, their surface treatment, and the ways in which entrances are represented vary considerably.

The presence and locations of these mosques closely follow the residential pattern established by the Dyula network in the transmission of trade and learn-

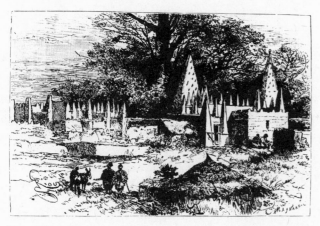

Fig. 6.12a A former mosque at Kong. Binger (1892), vol. 1.

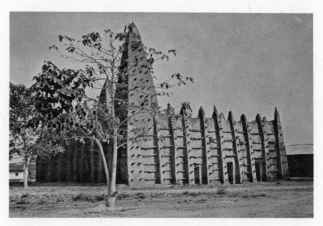

Fig. 6.12b The mosque at Kong as it appeared in 1965.

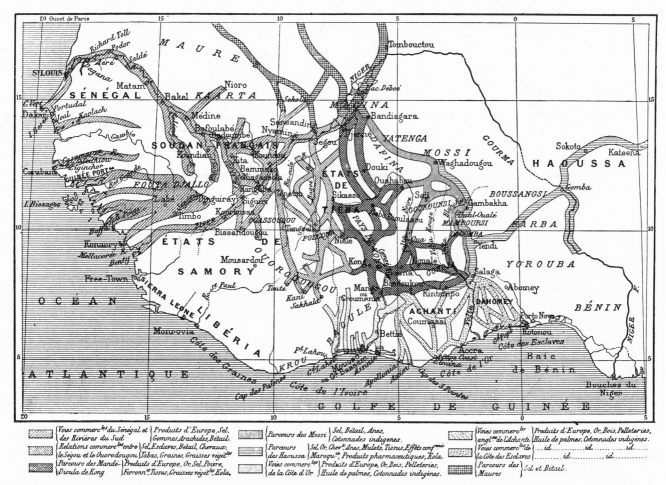

Fig. 6.13 Dyula and Hausa trade routes recorded in 1890. Binger (1892), vol. 2.

ing. The nodes created by intersecting routes, traced a century ago by Binger, pinpoint their previous and present locations (Fig. 6.13). The transmission of Islamic learning and its repertoire of scholarship suggests, furthermore, that the *karamokos* were the architects, if not the actual builders. But what were the mechanisms by which the style was transmitted? In the answer to this question lies the explanation for stylistic continuity combined with creativity. Without architectural drawings or diagrams and without the templates imposed by pre-structured and pre-formed material sizes, interpretation rests in the conceptual and perceptual template of a single master builder, and the maintenance of a consistent, recognizable architectural format depends on the memory of habitude. Unlike elsewhere, where the permanence of material guarantees a model to copy, in the rapidly disintegrating surfaces of the lower savannah the memory of habitude went hand-in-hand with the learning process that provided the mechanisms of revitalization. Much of that revitalization depended

on commitment to memory of the scholarly texts; these texts in turn became mnemonic devices for the internalization of an identifiable architectural configuration. The milieu, however, into which the *karamoko* came with his mental template, with the geometric patterns scattered amid the phrases of the Koran, and with his repertoire of *hatumere* or *sebe*, was a rural one; the labor force employed was still steeped in a communal building process. The translation of a mental or graphic template into reality was heavily conditioned by the traditional building process, the limitations of the physical environment—and the indigenous, collective memory.

In the early fifteenth century a group of Mande settled in the region of Dafina.[32] A second wave of Mande traders and clerics moved down from Djenné about 1750; from these latter developed the creation of a Saghanughu Imamate at Bobo-Dioulasso, and the subsequent state of Ouahabou. In the Dafina region, the spine of Islam extends from Safané in the northeast

of Upper Volta to Bobo-Dioulasso in the southwest. Safané's reputation as a center of learning dates to the late eighteenth century, when two sons of the founding Saghanughu family of Kong settled in Dafina country.[33] Despite subsequent realignments in the network of trade, Safané was still described as "a great town with a Friday mosque" in the early nineteenth century (Fig. 6.14).[34]

Whether or not the mosque in its present form dates back to 1824, its impressive size more than justifies the city's reputation, and its configuration of forms vividly recalls its predecessors, the traditional shrines. Although barely discernible, its interior courtyard is well announced by two vestibule entrances, one on the left and one on the right. Close by is an ancient acacia tree, such as have always been associated with the founding of a village and located in its center. Both the entrance to the left of the *mihrab* and the one on the northern face of the courtyard are nearly identical to the facades of shrines found at the entrances to Bobo, Minianka, and Bambara villages; the horns have been translated into a set of three earthen acroteria, recalling the masks themselves. The triangulated, lozenge-like voids in the face on the right are identical to those found on the facades of the houses of notables, dignitaries, and political and religious leaders throughout the regions in which the Islamized Manding tradition prevails.

Bobo-Dioulasso, like Safané, was a Dafina center, equally influenced by the *jihad* that established Ouahabou and equally dominated by the Saghanughu *ulamma* (Fig. 6.15). Like Kong, Bobo-Dioulasso originally had Wattara rulers, and in the mid-eighteenth century one of the sons of the founding Saghanughu family at Kong settled in Bobo-Dioulasso and became its

imam.[35] Thus, while the three cities of Kong, Safané, and Bobo-Dioulasso formed an architectural triad in the urban Dyula tradition, each was rooted in a different cultural subsoil: Senoufo, "Gurunsi," and Bobo respectively. These in turn contributed to the stylistic variation of the three mosques.

The military explorer-negotiator Binger, who so meticulously documented architecture in his travels, made no mention of the spectacular mosque at Bobo-Dioulasso, so presumably the present mosque postdated his 1879 visit to the city. Tradition says it was built by Karamoko Sakidi, who had pursued his scholarly Islamic studies at Dia, in the northern Massina. The entrance to the mosque at Bobo-Dioulasso does not have the shrine facades found at Safané; instead the barely perceptible swelling lintel over its central courtyard entrance recalls the traditional portal facade of older houses at Djenné and the northern schooling of its master builder. This Massina thread is also evident in the clear rectilinear definition of its interior space. On the other hand, the swollen bases of the pinnacled buttresses on its exterior faces resemble many of the Bobo shrines which can still be found in the rural hinterland.

In tracing the evolution of a style, we have until now stressed the underlying integration of pagan and Muslim ideologies. But these mosques are in reality the counterpart to gradual assimilation: they show a conscious concern with apostasy and are a deliberate attempt to renew the Muslim content of Dyula culture in the community setting.[36] Despite the broad range in dating, all these mosques make full use of the meaning and imagery of the ancestral cones in the critical component of any mosque—its *mihrab*-minaret. Yet they differ in their spatial configuration from both the great

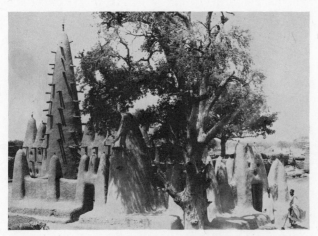

Fig. 6.14 The mosque at Safané, near Dédougou, Upper Volta.

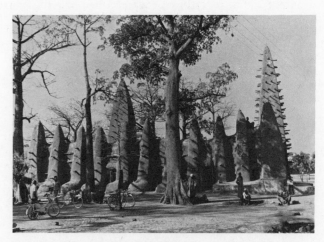

Fig. 6.15 The mosque at Bobo-Dioulasso, Upper Volta.

mosque-mausolea of the early entrepôts of empire and the very particularized, two-towered Dyula mosques north and south of them. In the former, the central tower-turned-mausoleum was originally located in the center of the *sahn* or courtyard enclosure. In the latter, the exterior walls are composed of a cluster of earthen buttresses. The *mihrab*-minaret is also at variance with the Ibadite Mzab tradition, where the minaret alone rises in a single tapering vertical shaft, with the Great Mosque at Kairouan, which depends upon a strong vertical minaret in conjunction with a separate domed mihrab, and with the two-towered Maghrebian tradition, whose nascent form is the ancient mosque at Djenné.[37]

Earlier, we suggested that the close formal relationship between clusters of ancestral shrines and the residences of traditional leaders of various cultural groups in this region culminated in the development of the unique, immediately recognizable architectural form of the Dyula mosque. In many instances, although the traditional leadership remained animist, echoing only token membership in the Islamic community, the Dyula Islamic architecture was adopted as a symbol of indigenous leadership. The thread of our argument, begun at Sapouy, can be extended to the palace of the chief of Korhogo in the heart of Senoufo country, Ivory Coast, and the residence of a notable in the neighboring Palacca region (Fig. 6.16a, b).

Korhogo, at the southwest corner of a geographic square formed with Sikasso, Bobo-Dioulasso, and Kong, consisted of a pair of twin villages, Korhogo and Koko, when Paul Marty visited the region in 1922.[38] Approximately three-quarters of the population was animist Senoufo, and Korhogo itself was their center. The remaining population was Dyula, linked through

various *isnads* and genealogies to Kong; they inhabited Koko, the Islamic center. Although there was a small mosque in Korhogo, the Friday mosque, an impressive structure in the Dyula style, was at Koko.

The Senoufo chief Gban Koulibaly, the recognized head of the traditional political structure, presided over all matters of traditional Senoufo law, with the counsel of the resident Dyula marabouts. Although he claimed to be a Muslim, he was apparently ignorant of all but the most elementary prayer. His palace, towering like a donjon in the midst of a conglomerate of traditional circular thatched roofs, achieves its remarkable height by the extension of its terrace parapet and earthen pinnacles into a third story. Also unique is the translation of more common triangular lozenges into a set of pointed arches and simulated niches, enriching and enhancing the play of shade and shadow on exterior wall surfaces.

This elaboration contrasts with the sombre exterior treatment on the house of a notable in the equally animist Palacca region just north of Korhogo. Minimal openings in the forms both of horseshoe arches and of triangular lozenges are the only evidence that this is a residence and not a mosque. Like its palace neighbor, the residence seems to defy gravity, rising like a sculptured earthwork above its surrounding crazed-*banco* walls—a major achievement in traditional technology. The vestibule entrance recalls the square entrance towers of indigenous fortification systems, and the form of the extinct mosque at Kano (see Fig. 7.3). The verticality created through the use of engaged earthen pillars announces to the pagan world the residence of the power elite in traditional society. The formal configuration, however, is that of a Dyula mosque.

Several decades ago, a new cult of northern ori-

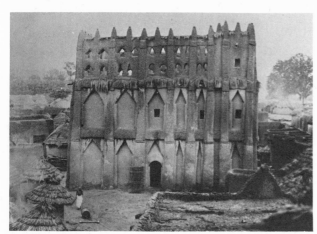

Fig. 6.16a The palace of the chief of Korhogo, Ivory Coast, in 1925.

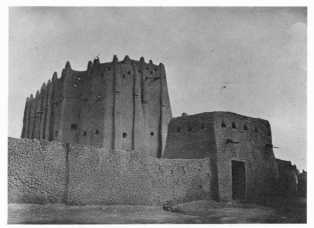

Fig. 6.16b House of a notable, region of Palacca, Ivory Coast.

gin, the *massa* or *alakora*, was introduced into Senoufo life from a small village in the vicinity of San, Mali.[39] The creation of the cult dates from 1946, when Mpeni Dembele, then the Minianka head of the tribal cult of Nya, experienced a revelation. An analysis of the stresses in the religious life of the Senoufo that explain the popularity of this cult is outside the domain of our current interest; what is relevent is the adaptation by an apparently unrelated, pagan sect of an architectural form that had become fully identified with the Islamic content of traditional societies (Fig. 6.17). The *massa* chiefs, it has been suggested, were individuals without tradition, so it could be that they sought to validate the efficacy of their position by adopting an iconography associated with a more prestigious religious tradition.

Every village that adopts the cult constructs a small offering house or altar on its periphery, in keeping with timeless tradition, and its immediate environs are carefully leveled and maintained in the manner of any consecrated space. The central object of the cult is the ram's horns, symbolically associated with fertility and well-being; their carved wooden images have replaced ostrich eggs and antelope horns as the crown of the sculptural altar form. The *massa* cult has thus carried the architectural process a step further in the spiral which, we have suggested, underlies the aesthetic continuum of this region: the visual format of Islam has evolved into the new iconography of a non-Islamic religious movement.

The ritual imagery characteristic of traditional West African society finds its architectural counterpart specifically in the facade of a built form.[40] By extension, the Dyula concern with exclusiveness and with self- and community-identity finds strongest expression on facades. Grafted onto traditional spatial configurations and using traditional technologies, they were a rela-

tively easily achieved architectural system of communication. The key elements that combine to create a form are manipulated in space like the masks that accompany indigenous rituals and masquerades: the mosque facade has become the ritual mask of Islamic affiliation.

Just as the ancestral pillar was incorporated as the identifying element of the Dyula mosque form, so the facades of village shrines were transposed onto the housing of traditional religious personages. The tradition of village shrines among the Bobo, Minianka, and Bambara populations provide a classic background for this development, out of the dual religious and political role of leadership (Fig. 6.18a–d). Conical pillars converted into pyramids have been hollowed out and magnified into vestibules. Two of the examples shown incorporate horns, which are integral to the iconography of masking traditions and to entrances, into the facade. The pillar-turned-vestibule leads to the circular enclosure in which the sacred accoutrements of ritual are housed.

An early twentieth-century record of Senoufo housing exemplifies the continuing process of stylistic integration (Fig. 6.19). Two architectural elements, a lintel built up of triangulated brickwork and an enlarged, pyramidal shrine-vestibule, were wedded to the facade of what was termed *Soudanese terrace housing*. The entrance on the left, with its swelling, reinforced earthen surrounds, has incorporated chevron-like motifs; a second entrance has borrowed the face of the "Case à gris-gris" or fetish houses, located at entrances to Bobo villages north of Senoufo country. This example also illustrates the frequent location of shrine houses within the compound of their custodian, who is traditionally the senior religious personage in the community.

Another example of the plural character of religious and political leadership can be cited from Ségou, Mali, the capital city of the Bambara kingdom, linguistically and culturally related to the Manding. The effect of Bambara resistance to Islam, coupled with the increasing attention to visual communication necessitated by political control, can be seen in the singular facade of the house of Madani, son of Ahmadu (Fig. 6.20). Several aspects of the striking facade are familiar: the intensely decorated surface with its painted geometric patterning (traditionally women's work) and the combination of earthen pilasters and lintels around the portal itself.[41] The former is reminiscent of the Dogon *ginna* at Arou-pres-Ibi, of the decorated walls on traditional circular compound walls and shrine houses, and of surface geometry on the mosques at Yatenga and Ségou itself. The arrangement of flanking doorway pillars, the upper lintel, and the three projecting pinnacles recall the facades of traditional shrines as well as the

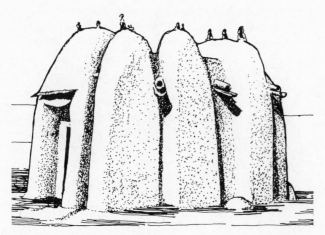

Fig. 6.17 Altar-shrine of the *massa* cult, Ivory Coast. Drawing after Himmelheber (1960).

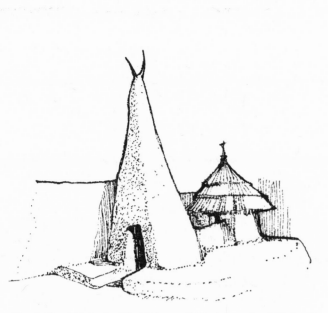

Fig. 6.18a Minianka "fetish house." Drawing after Méniaud (1912), vol. 1.

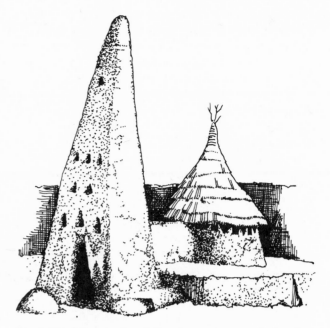

Fig. 6.18b "Case à gris-gris," at the entrance to a Bobo village. Drawing after Brossard (1906).

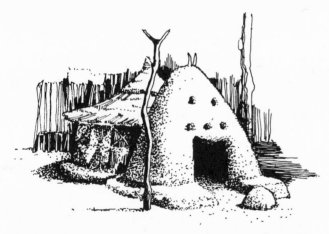

Fig. 6.18c A Bambara *komo* sanctuary. Drawing after Goldwater (1960). Compare Figure 6.14.

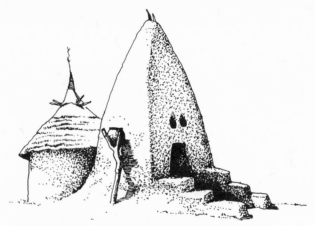

Fig. 6.18d Bobo "house of sacrifices" near Bobo-Dioulasso, Upper Volta. Drawing after a photograph.

entrances and interior courtyard *mihrabs* of Dyula mosques.

Several other important examples are found in northern Ghana. The kingdom of Wa was founded by Dagomba invaders who, in the middle of the seventeenth century, moved into what is known as Dagbana territory. Directly across the Volta River and the gold fields of the Lobi-speaking peoples, it had already attracted Wangara settlers. After the Dagomba invasion, a secondary group of Muslim cleric-traders were attracted to the area. Thus despite the fact that the king-

dom became historically and culturally part of the Mossi-Dagomba group of states, the Muslim community of Wa, "in its style, origin, scholastic genealogies . . . is part of the Dyula zone."[42] The tendency in Wa today is to regard its chiefs as Muslim, and this explains the selective use of a Dyula facade configuration on the houses of a number of notables (Fig. 6.21a, b). The *imam*'s entrance facade, with its three projecting earthen horns, its triangular openwork masonry (long muted by overlays of stucco), its whiteness, and the clearly visible Islamic script at its jambs, is a mirror-

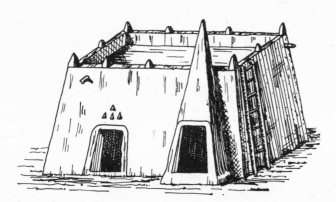

Fig. 6.19 "Housing among the Senoufo." Drawing after Delafosse (1908b).

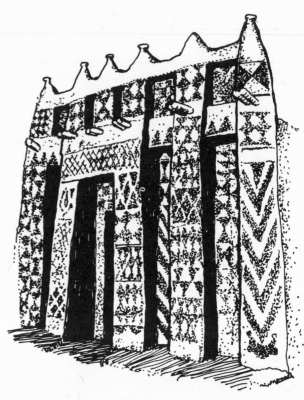

Fig. 6.20 Entrance facade of the house of Madani, the son of Ahmadu, ruler of Ségou at the time of the French conquest in 1890. After a drawing in Méniaud (1931), vol. 1.

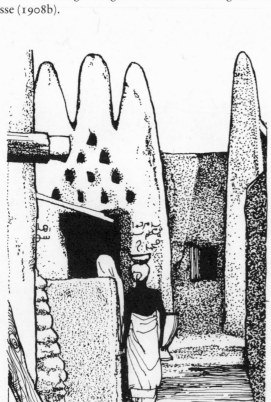

Fig. 6.21a The facade of the *imam*'s house at Wa, northwestern Ghana.

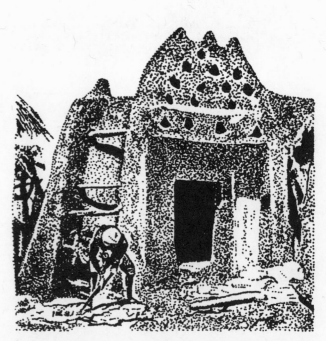

Fig. 6.21b The house of a Dyula salt-trader. Drawing after Brossard (1906).

image of the entrance to the former mosque.[43] This facade is also replicated on the entrances to the chief or *naa*'s palace, the house of the chief butcher, a Dyula salt-trader, and other lesser members of the elite.

The incorporation of these elements into the indigenous architectural tradition is analogous to the role the written word played in the African historical process. Both rest on the relationship between verbal and visual communication which characterized the transformation of Arabic script into sacred script and upon the juxtaposition of time and space in African life. In oral civilizations, "the word engages the man, the word *is* the man."[44] In the house of the *griot* Soukoutou at Ségou-Sikoro (Fig. 6.22), the "mouth," elaborated into an entrance facade, recalls the opening phrases of the Sundiata epic that sings of the history of the Mali empire: "It is by my mouth that you will know the history of Mali."[45] The elders were the repositories of knowledge, while the oral historian was its loudspeaker. Verbal and visual symbol merged; the temporal dimension was translated into a spatial one. This same multi-dimensional analogy led Hampaté Ba to suggest that "when an elder dies, it is like a library which burns."[46]

The pluralistic structure that developed in the regions of the Islamized Manding diaspora is reflected in the marked opposition between town and countryside. The clearest physical manifestation of this pluralistic structure is the distinction between rural and urban settlement patterns and between "the circle and the square." This distinction is a key to the problem of the scattered but common presence of "Sudanese-type," i.e., flat-roofed and rectangular, earthen housing, within an overall substratum of thatched, round housing in the West African savannah, first noticed decades ago by Henri Labouret. Various and complex exceptions to the pattern do exist, but in general the rectangular house organized around an open, internal courtyard is the prevailing pattern in every quarter inhabited by Dyula residents. Where the prevailing pattern is circular housing around a court, Dyula occupancy is recognizable by a simulated rectangularity and flat roofs; where the prevailing pattern is quasi- or pseudo-rectangular, Dyula occupancy is recognizable by the presence of a central, internal courtyard.

Up to this point, we have stressed the iconographic, externally visible aspects that communicate either the presence of Islamized Manding or the elites within non-Islamized, non-Manding groups. These architectural aspects, like other easily acquired material aspects of Islamic culture, are most readily incorporated into the traditional building repertoire, they are most easily transmitted, and they are clearly visible to the observer. Their adaptation requires minimal spatial reorganization. The modification of space, however, is

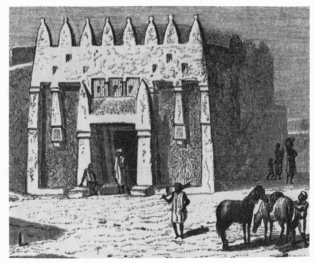

Fig. 6.22 House of the *griot* Soukoutou at Ségou, 1868. Mage (1868a).

a more reliable indicator of intrusive cultural presence—as the comparison between a traditional Bobo compound and its Dyula neighbor illustrates (Fig. 6.23a, b).

The spatial arrangement of traditional Bobo housing (as well as that of a number of contiguous cultures) is characteristically cumulative or additive: one room is added to another in a maze-like but linear order; longitudinal walls tend to run parallel to each other; and central or internal courtyards appear as appendages to an agglomerate of nuclear, elongated "cells." In rural Dyula housing, the same rectangular forms are organized around an open courtyard, and the encircling wall is pierced by a single entranceway. The clearly articulated vestibule in one corner contrasts with the long, narrow corridor that leads into Bobo houses. It is also quite obvious that once the reception threshold of the Dyula compound has been passed, there is no sharp distinction between domains within the habitat. The Dyula compound echoes the traditional Malinke organization of space, now translated into a rectangular format. Thus, the presence of even small nuclei of Dyula is communicated by their preference for a house form organized around an internal but open courtyard, as well as by their entrance architecture.

This manifest preference can also be seen as a measure of an indigenous people's tendency toward apostasy and assimilation by intrusive Dyula groups. At the time of his visit to Kong in 1888, Binger noted that all the city's housing was flat-roofed and rectangular. Many decades later, although many of the residents were Mande, Islamized Dyula remained in several quarters of the city, and it was only in these Dyula quarters that "Sudanese-type" housing could be found:

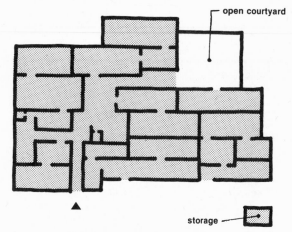

Fig. 6.23a Diagrammatic plan of Bobo housing at Dédougou, Upper Volta. Archives IFAN Doc. XII/6, Dakar.

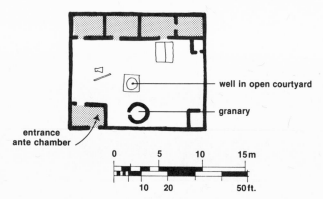

Fig. 6.23b Diagrammatic plan of a Dyula compound near Dédougou, Upper Volta. Archives IFAN Doc. XII/6, Dakar.

everywhere else, circular, thatched-roof earthen housing had become the dominant form.[47]

Buttressing is essential for any rectangular earthen structure that has no internal reinforcement, in contrast to circular housing built in like fashion. The required structural buttressing in turn becomes the functional base upon which the iconography of the earthen ancestral shrine can be projected, and contributes to the proliferation of buttresses on the rectangular structure. Their dual function—as structure and as symbol—also helps to explain their otherwise irrational locations in earthen walls.

The rural Dyula housing found throughout the region covered by the trade networks is a simplification of the more sharply articulated and more precise realization of tight Islamic prescriptions in the long-standing urban centers such as Kong (Fig. 6.24a). Despite its seeming apostasy, Kong continued to guard its primary position as an Islamic religious center under the author-

ity of El-Hadj-abou Saganiogo, a leading member of one of the Saghanughu families.[48] The plan of his house approaches the more stringent spatial organization found further north. The large, roofed entrance vestibule is preceded by an open but bounded forecourt and emphasized by a pair of projecting pillars which can be observed from the public way. The entrance vestibule leads into a "men's courtyard" around which the various functions associated with the role of the El-Hadj as a leading cleric in Dyula society were grouped: his reception and sleeping rooms, stabling for his horses, the meeting-place, rooms for his students, and, on a second level, his library, his personal reading room, and the prayer terrace. This "men's courtyard" is sharply divided, physically and visually, from the women's courtyard and quarters. The binary arrangement varies little from the format described for Tombouctou, in which two worlds exist side by side, carefully shielded from each other, each revolving around its own center.

Although it is not as explicit in its designation of room uses, a recently recorded plan of the "Builder's House" in the Dondoli quarter at Wa suggests the way in which the Dyula patterns have been integrated into the substratum of non-Islamized cultures (Fig. 6.24b). The entrance/reception hall is the most clearly articulated and consciously structured space in the complex. It is in fact a precise replica of the prototypal Dyula mosque that sits adjacent to it, complete with engaged pillars and interior columns. The facade faces a narrow but public alleyway, but the entrance to the vestibule is off a small forecourt, directly opposite the adjacent mosque. Beyond this primary reception hall, rooms have been casually added on, interspersed with small open courtyards. These courtyards are little more than unroofed spaces, in contrast to the bounded courtyards that are a central focus in both rural and urban Dyula housing. The additive, linear quality of the complex suggests a spatial pattern closer to that of the Bobo and the Lobi peoples.

The "Builder's House" at Dondoli is so called because it is the house of the builder of the mosque adjacent to it. The facade of the entrance hall duplicates that of the mosque. No mention is made of either the background or the name of the builder, but the replication and close juxtaposition suggest the conceptual mechanism by which stylistic features are grafted onto the surfaces of two apparently functionally discrete spaces. In point of fact they are not discrete; the use of an identical format communicates the association between the cleric-builder's habitat and the sacred space he has created. Divine grace and well-being, *baraka*, emanating from the mosque, envelops the residential space of its creator.

The pattern at Dondoli recalls a comment made

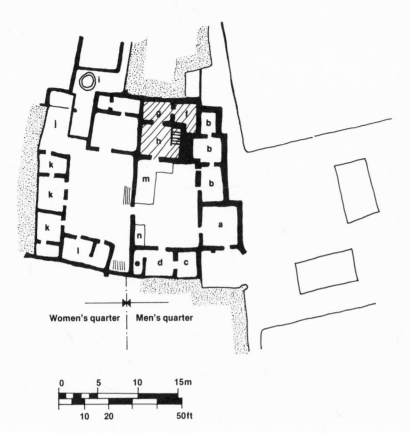

Women's quarter | Men's quarter

0 5 10 15m

10 20 50ft

Fig. 6.24a Plan of the compound of El-Hadj-abou Saganiogo at Kong, Ivory Coast. After a drawing in Bernus (1960). Legend: *a*. Entrance vestibule. *b*. Lodging for students. *c*. "Living room." *d*. Reception room of the Al-Hajj. *e*. Washing space. *f*. Latrine. *g*. Storeroom. *h*. Reading room. *i*. Granary. *j*. Bathing space. *k*. Women's rooms. *l*. Communal cooking space. *m*. Men's gathering space. *n*. Horse tethers. The upper level of the compound, indicated by the shaded area, houses the El-Hadj's library, a personal reading and lecture room, and a prayer terrace.

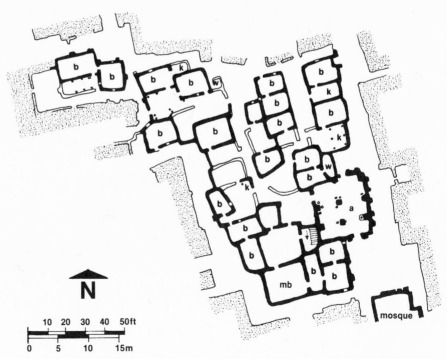

N

10 20 30 40 50ft

0 5 10 15m

Fig. 6.24b Plan of a "builder's house" at Dondoli, near Wa, northern Ghana. Drawing after Hyland (1975). Legend: *a*. Entrance hall. *b*. "Living room." *mb*. "Master bedroom." *k*. Cooking space. *w*. Open bathing space.

by M. E. Mage in 1864 when he visited Yamina, a Bambara city southwest of Ségou on the Niger River.[49] Stopping at a corner at the door of a house, he took it at first to be a mosque, "since it was ornamented with large sculptures in molded earth which are one of the hallmarks of this country" (see Fig. 1.16a). At the base of these "sculptures" were Arabic inscriptions; above were the familiar earthen pinnacles. He learned later, however, that this was the house still inhabited by a daughter of the last Bambara king of Ségou. Thus, while the cultural and geographic contexts of the two references may be far apart in space and time, the parallels between associated meaning and architecture suggest an underlying continuity in the multivalent iconographic scene far beyond that found currently in the Western world.

According to historical evidence and prevailing scholarly attribution, any consideration of Manding architecture in general and Islamized Mande architecture in particular should have begun with the city of Djenné.[50] Its founding traditions certainly pre-date the Marka and Dyula settlements which have thus far occupied our attention, and Islamic tradition from the city of Kong, the nodule from which many of these communities spread, itself points to an original migration from the Massina or from Djenné. The currently accepted chronology has been reversed here for several reasons. First, we prefer to dispel the simplistic diffusionary stance, fed by the standard chronology, which has been used to explain the entire "Sudanese" architectural tradition. Such an approach belies the realities of the African architectural process. Second, just as we have argued for a sub-Saharan wellspring for the general development of indigenous architectures, so the ultimate crystallization at Djenné itself resulted from the city's unique geographic setting: the centuries-old networks of trade emanating from the Manding diaspora converged on the city, and it is here that one finds the quintessence of the Islamized Mande tradition.

Developing at the junction of a trans-Sudanic and trans-Saharan route the city looks out, Janus-like, on both savannah and desert. This northern terminus for the savannah network projects, like a peninsula, into the sahel, subject to periodic washover by waves of northern influence. Her roots, however, are in the south. Thus her architecture consists of an indigenous savannah fabric into which select salient features of North African Islam are woven like gold or colored threads.

The Upper Niger Delta in which the city sits has long fired the voyager's imagination and has evoked comparison with another delta—that of the Nile River.[51] One result of this comparison was a long-prevalent hypothesis that Egypt had provided the architectural heritage from which the city drew its inspiration and that the Songhay were of Egyptian ancestry. This unfortunate and misleading interpretation aside, the physical milieu does indeed evoke parallel imagery. The city sits on what appears to be an island within a vast network of waterways or *marigots*, protected on all sides by formidable desert barriers. Barely accessible for much of the year, the city seemed to have a long, virtually unbroken continuity, to be impregnable to conquest, impervious to invasion.[52] The seasonal and annual rhythms created by the rise and fall of the Nile River are equally characteristic of the Upper Niger Delta, and the fertility of its soils suggested to the French colonial mind an unlimited potential for agricultural development, a suggestion itself inspired by local sources.[53] Above all else, it was the heavy cubic massing and tapering pyramidal walls, accentuated by the intense light and shadows of the earthen hues and the isolated, waterbound, mirage-like quality, that evoked a parallel visual imagery in the mind's eye.[54] To the foot-weary traveler, the city rose from the waters below like a local Mecca teeming with activity—the goal of the trader's long journey (Fig. 6.25). At dusk, the profusion of moving lights at Djenné's waterline cast flickering shadows on the seemingly impenetrable walls of a medieval fortress.

The history of the city is still shrouded in conflicting oral and written traditions and the literary sources raise innumerable problems of interpretation.[55] What is clearly evident from the available documentation is that although reference to a city-state of Geni can be found as early as 1447, North African references are virtually nonexistent and almost nothing was known in North Africa of the precise whereabouts of Djenné until centuries later; on the other hand, the first Portuguese accounts of the West African coast carry references to the city and to the Wangara or Dyula traders associated with it. Djenné was reputed to have been founded close to a millennium ago, but it did not assume great importance until the sixteenth century. At that time it became the point of convergence for goods brought up from the rich hinterlands of the lower savannah and rain forest. Never the political capital of a viable West African empire, its primary role was as a port of commerce, which may explain why the city seems to have been far better known to those involved in trade south and southwest of the city than to those who viewed her from a northern perspective. By the same token, it is only from a southern perspective that architectural interpretation finds validity.[56]

The major written references to the city can be found in the *Tarikh*s, the indigenous chronicles of West African history. But while these references are rich in materials relating to personages and events in the city,

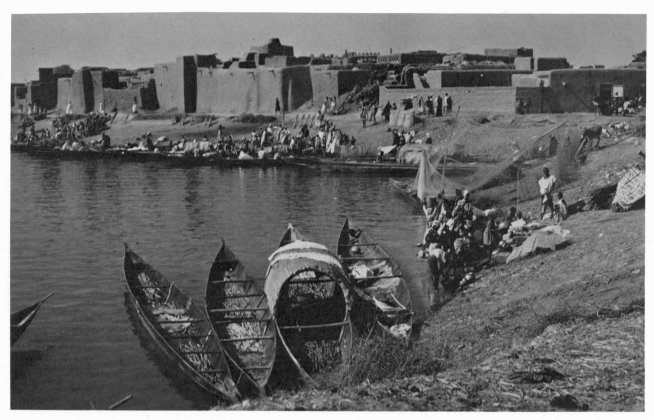

Fig. 6.25 The approach to the city of Djenné from the new "commercial" port. Compare Figure 2.12.

they lack descriptive data on which to build an architectural history. The only extant European eyewitness account of the city prior to the arrival of French troops is from René Caillié, who reached Djenné in 1828, en route to Tombouctou.[57] His remarks are a far cry from the laudatory description proferred by Es-Sadi a century and a half earlier, and barely stand up to his more detailed, far more favorable description of Tombouctou—his ultimate goal. Within a decade after the French arrival in the city, two monographs appeared in Europe, the first a widely publicized journalist's account by Félix Dubois, the second a superbly detailed and documented ethnography by Charles Monteil. The former, rich in misinterpretation and fallacy, continues, unfortunately, to be considered an acceptable research document. The latter, which originally appeared in a very limited edition, was subsequently revised into a more palatable format for wider distribution.[58] Even the former volume is of more than passing interest, however, since within it lies the key to an understanding not only of French colonialism at the turn of the century, but of the city's Great Mosque.

Really a peninsula, the city's island-like quality derives from the annual inundation to which its lower

section is subject (Fig. 6.26). Accessible only by boat for much of the year, its main port of entry was, and continues to be, its fishing port on the southeast. This port leads directly into the vast market square and the oldest sections of the city: the Djoboro and Kanafa quarters, originally inhabited by Sorko (Bozo) and Bobo groups respectively. Spread out on the low-lying ground, the houses are rarely more than a single story in height and little distinguishes them from their Delta neighbors other than an occasional arch or roof parapet marking the residence of an elder or a city dignitary (Fig. 6.27).

The land rises gently toward the east and the contours turn northward to the Al Gazba, Sankoré, and Dambougal-soria quarters. The Al Gazba was the site of a fort built after the Moroccan invasion of the city in 1591, and the residence of the Moroccan chief was located in the Sankoré quarter. The Dambougal-soria is known as the "terrace of the island," its high point.[59] It is also within this northeastern half of the city that the majority of Djenné's two- and three-story houses with elaborate entrance portals and simulated wooden Moroccan grilles, and the so-called "Moroccan houses" can be found. After the French conquest, the Residence

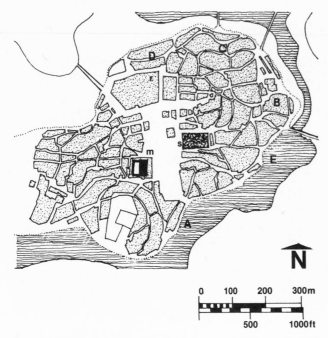

Fig. 6.26 Plan of Djenné, drawn from an aerial photograph taken in 1959. Legend: *A.* Fishing port. *B.* Al Gazba quarter. *C.* Sankoré quarter. *D.* Dambougal-soria quarter. *E.* The new "commercial" port. *r.* The Residence, now the compound of the Commandant du Cercle. *m.* Mosque. *s.* Secondary school.

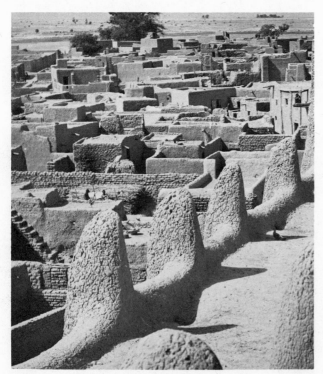

Fig. 6.27 Roofscape of the Kanafa quarter of Djenné, seen from the roof of the women's gallery in the mosque.

was built on these same heights which had previously been occupied by Songhay, Moroccan, and Fulbe-speaking overlords.

The mosque, which rises majestically along the western side of the market square, was built in 1909, "on the site and according to the ruins"[60] of the former Great Mosque. Although said to be a precise replica, its size, its organization, and its style differ considerably from even the suggested reconstruction (Fig. 6.28a–d).

There are also several disparate versions of its history. According to the *Tarikh es-Soudan*, the first mosque at Djenné was built by Koy Kounboro, at the end of the thirteenth century, when he was converted to Islam.[61] At that time, he demolished his palace, erected the mosque in its place, and built another palace east of it, to house his court. The successor to the *koy*-cum-sultan installed the towers of the mosque, and his successor in turn built the rampart that enclosed the mosque. Caillié, who visited the city in 1828, described the mosque as follows:

> There is at Djenné a large earthen mosque, dominated by two slightly higher massive towers; it is crudely constructed, but very large; abandoned to the thousands of swallows who make their nest there . . . the infectious odor has led to the custom of performing the prayer in a small exterior court.[62]

Apparently, though the two towers still existed, the mosque was in a rather sorry state—presumably a reflection of the political tenor of the time. Many decades later, in 1895, Félix Dubois suggested a reconstruction of this ancient mosque on the basis of the ruins he observed.[63]

According to a more recent interpretation, the mosque built by Koy Kounboro was located on the site of the present-day school.[64] It was razed by his successor, Malaha Tanapo, the first *Djenné-were* or chief, who was a non-believer. Tanapo built a new mosque, on the site of the present Great Mosque. It was divided in two: half for the faithful and half for the infidels. When the city was conquered by the Songhay at the end of the fifteenth century, Askia Muhamed judged this practice to be incompatible with Islamic canons, so he rebuilt the original mosque of Koy Kounboro. At that time, a Cadi was installed. With the Moroccan invasion, the Songhay mosque was again destroyed and that of Tanapo rebuilt. This rebuilt mosque, then, was the mosque referred to by Es-Sadi in the *Tarikh es-Soudan*, the one in which a number of noted Wangara (or Dyula) savants were buried, the one observed by Caillié and reconstructed by Dubois.[65] The Moroccan mosque was far too sumptous for the puritanical tastes of Sheku Ahmadu, the Fulbe Massina ruler who controlled the city early in the nineteenth century, so in

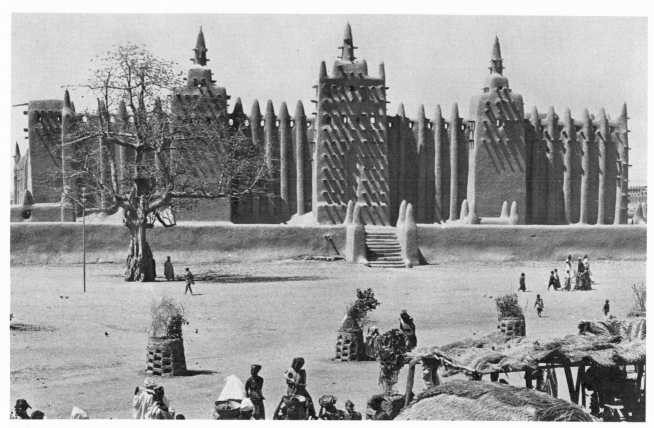

Fig. 6.28a The *kibla* facade of the Great Mosque, seen from the vast marketplace.

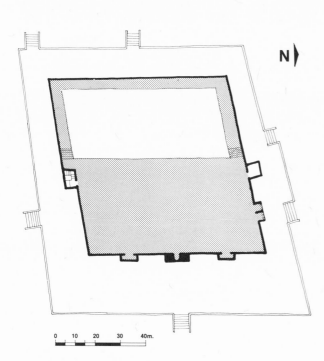

N▶

Fig. 6.28b Plan of the Great Mosque. Based on a measured drawing by Carl Anthony, 1972.

1830 he removed its roof timbers and had a more austere structure built on the site of the original Kounboro mosque. He then ordained that all official prayers be said in the new mosque.[66] The Sheku Ahmadu mosque was replaced by a French-sponsored *madrasa* or Koranic school built at the same time as the new Great Mosque—in 1909—and the site is now occupied by a secondary school.

This more recent version of the mosque's history, when considered in combination with references to the residence at Djenné of the Songhay rulers Sonni Ali and Askia Muhamed, and to the traditional African custom of burial within the residence courtyard, sheds light on the architectural configuration. When Sonni Ali conquered the city of Djenné shortly after his ascendency to the throne (ca. 1467), he installed himself in the residence of the Djenné-*koy* (whom he had defeated), but he was chased out by vipers, scorpions, and serpents. He then moved into a house located south of the Djenné-*koy* residence and east of the Great Mosque. He remained there for the duration of his stay in Djenné—a year and a month—and when he departed the house was left in the hands of his own people. This same house was inhabited by Askia Muhamed when he in turn conquered the city.

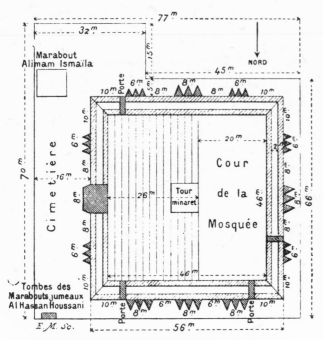

Fig. 6.28c Plan of the extinct mosque by Dubois (1897a).

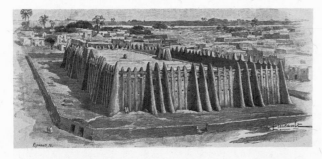

Fig. 6.28d Reconstruction of the extinct mosque at Djenné by Dubois (1897a).

Discrepancies remain in the mosque's architectural history, but the meager references do open some interesting avenues for speculative architectural interpretation. Reference in the *Tarikh*s to the replacement of the consecrated seat of a pagan ruler, i.e., his palace, by a mosque reflect the kind of conceptual transference of functions suggested above for the Dyula mosques. The interchangeability of the functions of palace and mosque may explain the confused references in the various sources. Reference to tower-building by Kounboro's successor recalls the building tradition of Askia Muhamed's mausoleum at Gao. It is tempting to suggest that of the two towers the principal one may have been the tumulus of the first king at Djenné, located in the palace courtyard. When the palace was converted

to a mosque, the tumulus-tower remained and the second tower, on the east face, was built as the *mihrab*. Dubois's suggestion that "with its ridged buttresses alternating with pylons, and with no doors or windows to break its uniform grandeur by a note of life, the eastern facade gave a very forcible impression of a mausoleum," may indeed have some merit.[67] The rampart surrounding the ancient mosque, also mentioned in the *Tarikh*, may refer either to the elaboration of minimal sacred boundaries into a square *sahn* or to the extension of the sacred space to include the various recorded tombs associated with the sacred structure.[68] Thus, the ancient mosque, even in its questionable reconstruction, is evidence of the continuity between ancestry and Islam and has the same underlying conceptual spatial organization as its more humble Dyula neighbors. This helps to explain the square shape of the interior courtyard (the roofed section is of secondary import in such a concept), as well as the suggested buttress reconstruction—three groups of three, precisely ordered on each face. The *mihrab* rises in place of one group on the eastern face. The perfectly square interior courtyard finds its model in the prescriptions of Malekite law, and the manipulation of the number three vividly recalls the magic squares so critical in Islamic mysticism. This structural pattern, clearly expressed on the exterior walls, uses the same geometric basis as the Fulani-Hausa domes and city walls with their twelve doors (3 × 4) considered in Chapter 7.

Even a cursory comparison of the reconstruction proferred by Dubois with the present-day Great Mosque reveals vast differences in both style and spatial organization. The only similarities are the approximate overall dimensions, the position of the *mihrab*, the recall of three groups of buttresses on the *kibla* face, and a part of the encircling ambulatory—now the women's gallery. Despite the centrally located stair and Western tradition, the major eastern facade, which faces onto the market, is not an entrance: it is the *kibla* wall. The *mihrab* is reflected on the exterior by the gentle recess at the head of the stair, but the remainder of the wall has been ordered in a precise symmetry by means of two false flanking towers that serve no functional purpose. Projecting from all three towers are the fascies-like dentils or *toron*, bundled with phalanx-like regularity into groups of six or eight. This *kibla* wall is the mosque's colonial face. Built under the aegis of French administration, with French funds and according to the advice of French military engineers, not only was the choice of site a reflection of colonial politics but its very organization reflected French influence. Most importantly, the mosque at Djenné became the symbol of French colonialism and a prototype for a "neo-Sudanese style" (Fig. 6.29a).[69]

The marketplace facade and the expansive vista which the marketplace itself affords the mosque reflect the preference and influence of French colonial military administrators trained at the Ecole Polytechnique and the Ecole des Beaux Arts. Traditionally, West African mosques were never, to our knowledge, set up to accommodate the laws of perspective, as anyone who has tried to photograph them well knows. More often than not, they are enveloped on all sides by narrow alleys and earthen walls, protected as it were by the density of human occupancy which surrounds them and defying any wide-angle lens to capture their image (Fig. 6.29b). Contrastive surface, rather than space, sets them apart.

The design inspiration came, to be sure, from its predecessor; at the same time, the emphasis on environmental adaptation and the use of local materials which the French military brought to the scene resulted in a remarkable indigenous marriage. For their model the French drew upon the reconstruction of the Palace of Ahmadu at Ségou, undertaken shortly after the city's conquest in 1893 (Fig. 6.29c). According to Lt. Col. P.-L. Monteil, Lt. Underberg, who formerly had studied architecture, reconstructed the Residence on the ruins of the ancient *dionfoutou* (palace) of Ahmadu; he maintained respect for the local architecture and, judging by the reproduction, the Residence had an air of greatness, with its conical ornaments setting off the copings.[70] It was this reconstruction for the new French Commandant du Cercle which was popularized in a host of European Expositions Universelles (see Figs. 1.19a, 1.20). The balanced, symmetrical arrangement of buttresses and towers into a tripartite neoclassical mode in turn became a new mosque prototype, emulated in the mosques at Mopti and San, among a host of others.

In 1935, the French administration at Mopti, inspired by the style of the mosque at Djenné, decided to support the construction of a new Friday mosque (Fig.

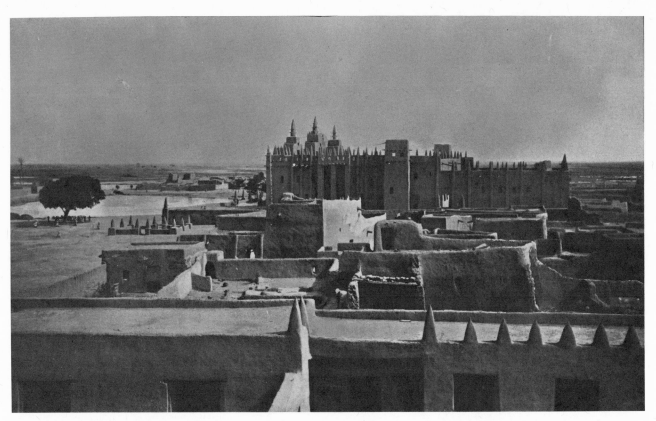

Fig. 6.29a The new mosque at Djenné in 1911. *L'Illustration* 3586, 18 November 1911. The original title, "Le Plus Important Monument d'Art Soudanais de Notre Empire Africaine: La Mosquée de Djenné," was accompanied by the following caption:

In the midst of the Soudanese brush, 30 kilometers from the Niger, there is a city, Djenné, that can almost be called sumptuous. With its high walls, architectural motifs, towers, and imposing mosque whose ornate minarets resemble the steeples of a desert cathedral, it appears to the traveler like a mirage. . . . The residences, solidly built, sometimes constructed with great imagination, have an impressive appearance. Djenné is—with Tombouctou—the only Sudanese city that has extracted from ordinary clay the elements of a true architecture—quite evocative of the catacombs and the Egyptian monoliths—and from which all the pavilions of West Africa in our great European Expositions borrow their character.

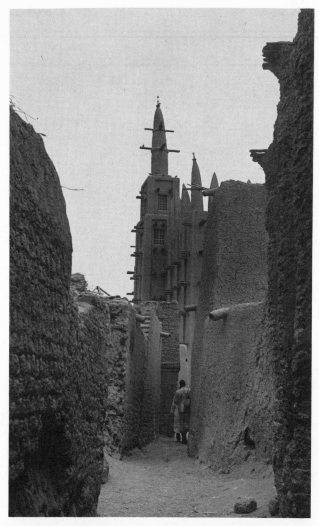

Fig. 6.29b Village mosque at Gomitogo in the Inland Niger Delta, Mali, 1970.

6.29d). Despite many inquiries, the city's colonial administrator, M. Cocheteaux, claimed he could obtain no information from the local inhabitants regarding the proposed construction. For the *imam* and the local Muslim notables, the only imperatives were an eastern orientation and a minaret. Cocheteaux's description of his negotiations with the local Muslim community sheds light on the merger between Islamic prescription and French interests: "I had designed the major facade [to be] the most beautiful, but its required eastern orientation made it invisible from the *digue* of Sevaré and the approach from Komoguel, both of which were essential from a tourist point of view. In order to mitigate this inconvenience, I built two identical facades."[71] Thus, the organization of both Muslim and indigenous space was modified to accommodate tourism and a European mode of visual perception.

At Djenné, the mosque's true African countenance is on its north entrance facade, where the formal arrangement echoes the innumerable carved wooden countenances in masking traditions and the facades of altar shrines (Fig. 6.30a and Plate 11; see also Fig. 4.7b). Above this major entrance five earthen acroteria point upward like fingers on a hand. They are the five pillars of Islam, the newly adopted ancestors. No sculpture, bas-relief, or calligraphy relieves the starkly geometric, shadow-lined walls. In many ways, the two faces of the Great Mosque are statements of the old and the new: the more subtle, casual and relaxed arrangement of solids and voids of the entrance bears no relationship to the perfectly aligned, geometrically ordered, axially symmetrical marketplace face.

As we suggested elsewhere, West African indigenous savannah housing often consists of a central courtyard bounded by a ring of closed room units.

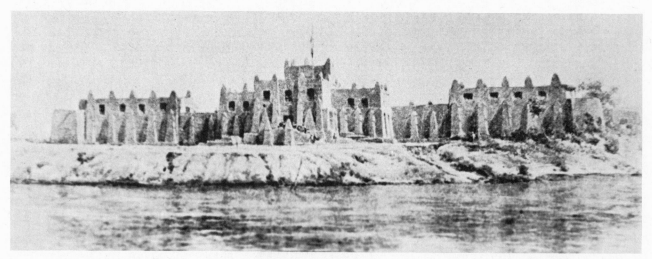

Fig. 6.29c La Residence at Ségou. P.-L. Monteil (1894?).

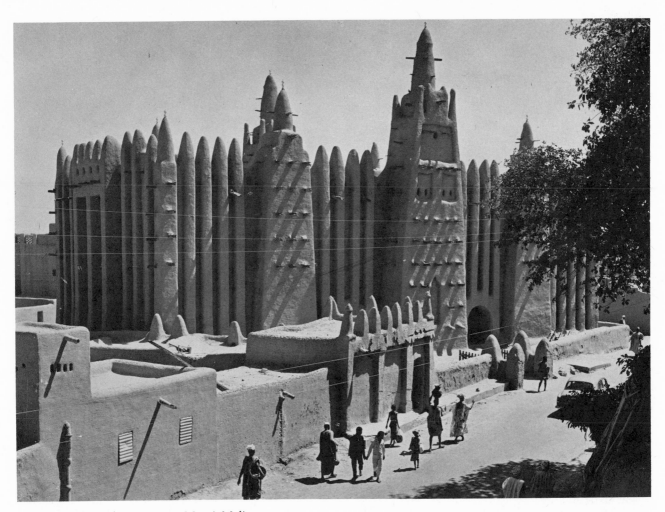

Fig. 6.29d The Friday mosque at Mopti, Mali.

Whether Muslim or pagan, it is the central, open court that constitutes the center of life both behaviorally and conceptually. In much the same way the mosque court-yard, i.e., its *sahn*, is the essential, sacred gathering-space. Thus the Malekite prescription that a mosque should be square is carried out not on the external pe-riphery of the structure but on the perimeter of its open interior. In a manner of speaking, the ritual act of main-taining contact with the plinth of the square *ka'ba* at Mecca is inversely expressed. The roofed-over section of the *sahn* should be seen as secondary to the primary underlying requirement of a square courtyard for worship.[72]

The Africanization of internal space further finds expression in the often anthropomorphized *mihrab* it-self. For example, the Friday mosque at San, Mali, built in 1941 as a modest replica of its forerunner at Djenné, varies from it in one respect: there are two *mihrabs*. One is in the exterior *kibla* wall, and the other faces into the *sahn* (Fig. 6.30b). The latter, hidden from pub-lic view, evokes the image of a face or a mask even more strongly than the entrance facade of its Djenné prede-cessor does. Secreted within the sacred center in much the same way as are the contents of an amulet, it also recalls the sequence of spatial layers observed in the Poro mask considered in Chapter 4, where the Arabic script was located on the inner surface of the mask be-tween its own visage and the face of its wearer.

Except for the occasional ray of light that falls in an oblique ellipse across the forest of pillars within the roofed-over section, the interior of the Djenné mosque is cool and sombre (Fig. 6.31). The dense earthen pil-lars, with their alien, Gothicizing verticality, obscure the importance of the *mihrab* niche, now elongated into the proportions of a Gothic window frame. To reach the roof, one climbs a set of winding stairs within, through the darkness of one of the massive earthen towers on the north and south walls. There are no min-

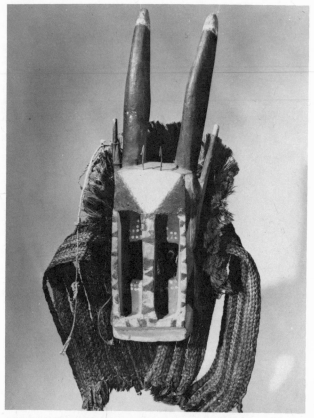

Fig. 6.30a Dogon mask from Sanga, Mali, whose solids, voids, and proportions match those of the entrance to the Great Mosque at Djenné.

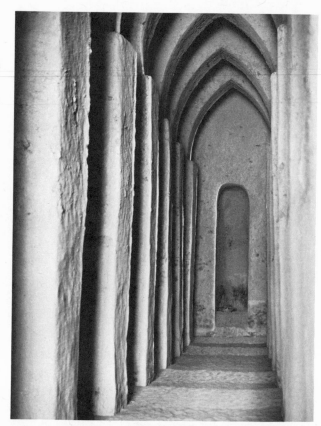

Fig. 6.31 The interior aisle and prayer space of the Great Mosque at Djenné, looking toward the *mihrab*.

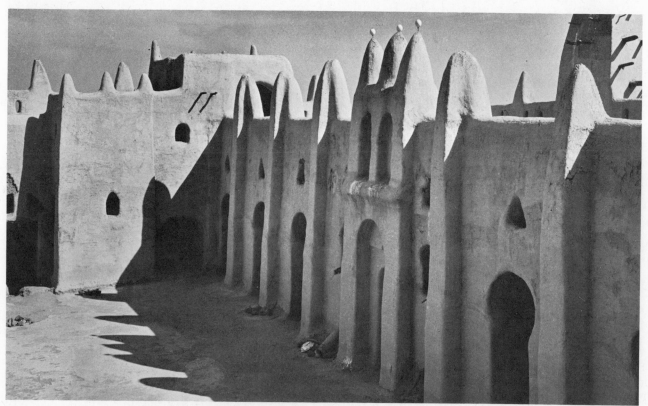

Fig. 6.30b Courtyard *mihrab* of the mosque at San, Mali, in 1970.

arets in the classic sense. (The call to prayer is now made from the northeast corner of a lower ambulatory surrounding the mosque.) From the rooftop the earthen pinnacles which appeared as buttresses below now suggest a profusion of ancestral earthen pillars capped with ostrich eggs, marching in ordered rank around the periphery of an earthen arena pierced by regular rows of *dyonfu* or skylights. These skylight openings are a feminine counterpoint to the masculine pillars—softly rounded miniature domes built up around open-ended clay pots and matching lids (Fig. 6.32).

Djenné's pivotal location in the Upper Niger Delta between the savannah trade network and the waterway to Tombouctou—which contributed to the city's success as a major historical center of commerce—also contributes to the region's complex cultural symbiosis and the city's heterogeneity. Sedentary Bambara agriculturalists, Sorko (Bozo) fishermen, Fulbe pastoralists, and elitist Dyula and Djennenke (Songhay-Moroccan descendants) merchants and traders mutually interact in seasonal cycles. Following the fall harvesting of crops by the Bambara farmers, the Fulbe herders bring in their cattle to winter on the plain and to graze on the stubble. The lime deposit from fish and fishbone left in the clayey alluvial sediment after the delta waters recede and the Sorko fishermen have left combines naturally with the stubble and the cowdung to produce a soil consistency and composition superbly suited for pottery and for the fabrication of

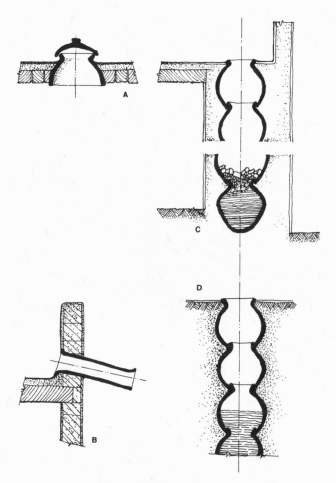

Fig. 6.33a Construction details illustrating the integration of pottery into the architectural repertoire. Legend: *A.* Skylight construction. *B.* Terrace waterspouts. *C.* Latrines. *D.* Wells.

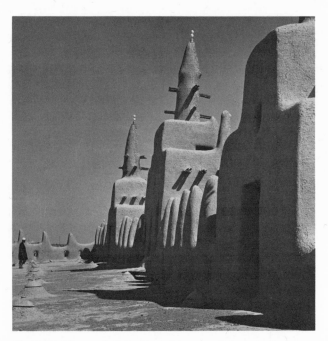

Fig. 6.32 The roof of the Great Mosque with projecting towers, pillars, and skylights.

the *djenne-fere*, the unique, handmolded cylindrical bricks that establish the modular system of the city's architecture (see Fig. 2.14c). "Here," the *bari* say, "nothing is added to the earth to make it more workable."

At Djenné, more than anywhere else in West Africa, pottery and architecture constitute a unity. Djenné pottery is architectural pottery: it is used to line the wells and the latrines; the waterspouts and the rainwater leaders are made of pottery; the skylights and courtyard paving are of pottery, and the same pottery is used to protect the pinnacles of quoins and engaged buttresses (Fig. 6.33a). And finally, the same pottery finds a resting place as a grave-marker in the Muslim cemetery across the way from the city proper. All these pottery elements are identical to those made for everyday domestic use by the women potters (Fig. 6.33b; cf. 2.14d). Wives of the blacksmiths, the potters occupy a

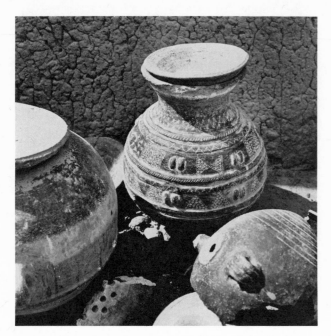

Fig. 6.33b Traditional pottery, Inland Niger Delta, Mali.

special place in the life of the city; like the masons who work with the earth, they are held in considerable awe.

The ecological balance of the Delta is further enhanced by an ingenious man-made contribution: the latrine (Fig. 6.34). Although, like those of their northern neighbors, Djenné latrines were traditionally located behind the house, they are now found with greater frequency on the facade (like their counterparts at Tombouctou, mentioned by Caillié)—an obvious addition to the traditional composition of the house face. The latrine access itself is on the terrace, hidden from public view. What is visible is a massive earthen shaft. This mass, reinforced with palm timbers, is the envelope of an interlocking clay pottery shaft that runs from the roof terrace to the ground. When the pottery shaft is full, an opening is cut into its base and the decomposed waste is easily drained off and transported to the neighboring fields, where it is used as fertilizer.[73]

The architectural element that sets the city apart from the hundreds of neighboring plateau villages in the Delta is its unique facade or *potige* (Fig. 6.35a). These facades, with their intricate, geometrically ordered shades and shadows, solids and recesses, emerging and receding surfaces, and their horizontal wooden dentils projecting from the tapering earthen buttresses, provide contrastive relief to the stark, bare surfaces rising around them on all sides. They are the city's exclamation points, the architectural expression of its *genius loci*. Extending the entire height of the building, the *potige* hangs like a tapestry suspended from the sky.

René Caillié made no mention of these facades when he visited the city in 1828, but by the turn of the century they were a point of major interest to French observers not only at Djenné itself but throughout the region (Fig. 6.35b).[74] They have not changed much over time. A facade recorded by the Frobenius Expedition in 1907 showed little alteration when it was photographed thirty-five years later; another facade photographed in 1931 is equally easily identifiable today (Fig. 6.35c).

The Djenné style has often been attributed to the group of three "Moroccan" houses in the Dambougalsoria quarter which, it is claimed, date from the Moroccan invasion of 1591 (Fig. 6.36a). Although the formal detail associated with the "traditional" facades is absent, the two architectural elements that are the essence of the unique pattern configuration—the projecting timber *toron* and the five earthen pillars of the register above—are ever-present. The emphasis on an intricate upper register, and the integration of projecting consoles and real or simulated openings above forcefully remind one of the entrance to the Medersa Bou Inaniya at Fès, and the portal entrance to the *ksar* at Goulmina in the Tafilelt region, southeastern Morocco (Fig. 6.36b, c), but they also recall the Bagdad gate at Raqqa and the side entrance to the Great Mosque at Cordova. In the house on the left, with its heavily weathered (presumably original) timbers, there is a deeply sunk courtyard well which, it is claimed, also dates from the pe-

Fig. 6.34 The earthen shaft of an old latrine, using traditional sun-dried bricks and timber reinforcing.

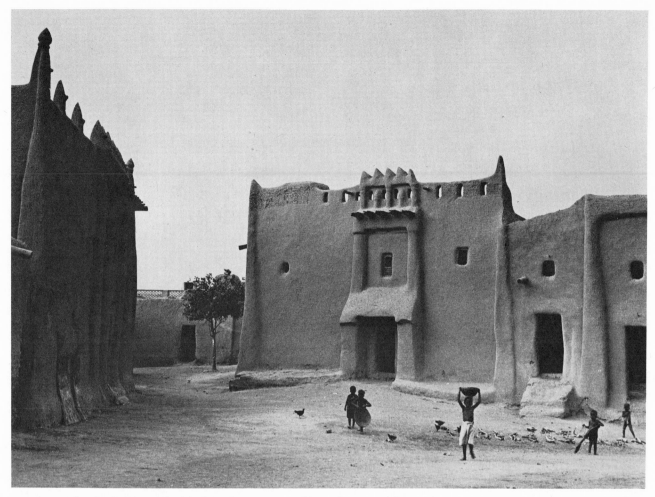

Fig. 6.35a The classic Djennenke facade with its *potige* and bounding *sara fa bar.*

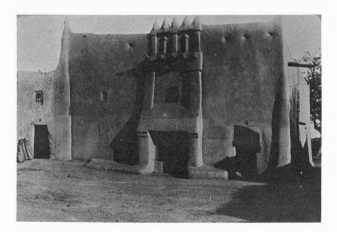

Fig. 6.35b A Djennenke facade at Ségou, Mali, in 1895.

riod of the Moroccan invasion. Since courtyard wells are extremely rare in the city, the well itself may indeed mark the former residence of the Moroccan ruler, even though the earthen configuration of the facade tapestry has long since been altered. The custom of continuing to call these "Moroccan houses," even though they have long been occupied by others and long been altered in form, reflects the continuing indigenous emphasis on *place* rather than on the built form.

Although Songhay is the lingua franca at Djenné, the term *potige* is a Bambara nasalized pronunciation of the Manding term *fo tige*. These two phonemes designate the act of greeting a master, a chief, or an elder.[75] Among the Islamized Mande, the term *fotige* is used to announce a man of letters. Thus, the entrance portal announces to the world the residence of a man of letters, a master of words and wisdom (Fig. 6.37).

The three major registers which comprise the *potige* or *fotige* are equally rich in meaning (Fig. 6.38).

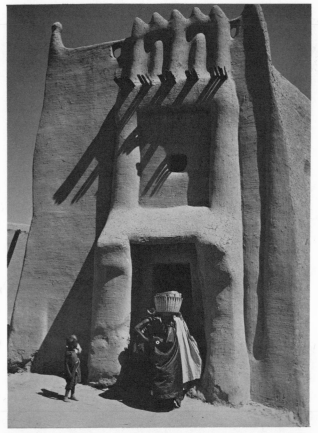

Fig. 6.35c The present appearance of a facade originally photographed fifty years ago varies little from its original. See C. Monteil (1932).

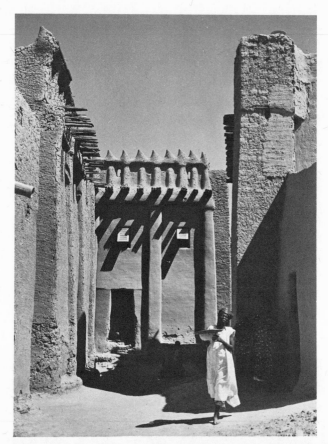

Fig. 6.36a The group of "Moroccan" houses in the Dambougal-soria quarter of Djenné. The latrine in the foreground is a recent addition.

The architectural terminology used to refer to these elements is not Manding but Songhay. The lower third consists of a projecting foyer or vestibule, a *goum hu* or "mouth arch" created by a pair of earthen pillars or *saria* which support a set of wooden beams covered with an earthen "awning." At their base the two surrounds or *saria* turn and fold flat, becoming a pair of earthen benches similar to those found on many Bambara and Bobo shrines. While the vestibule projection recalls the entrance *zaure* or *sgifa* of a number of neighboring Islamized peoples, what is unique here is its concentrated elaboration. Framed within the *goum hu* is the *hu me*, the "mouth of the house," and within the mouth, the door or *gambu*. The door has a wooden lock or *kufal*, similar to locks used from Egypt across North Africa and throughout much of Islamized West Africa. The lock housing or *kufal nya* carries a maternal connotation, and the bolt is its offspring.[76]

The earthen "awning" gradually recedes into a second register flanked by the two *saria*, now called *sara fa wey* or engaged "feminine pillars."[77] These in turn frame the *soro funey* or "upper terrace opening"

which announces the bedroom-reception chamber of the house owner, his *hu gandi* or "talking room."[78] Traditionally, a Moroccan-type wooden grille made of hardwoods imported from the rain forest was set into the *soro funey*. Although these grilles are now gradually being replaced by either simple wooden shutters or the more prestigious corrugated aluminum awning sash, the singular location of this one upper window remains: it announces the most important room in the house, the owner's reception chamber.

Projecting from the lintel above this second register are the five traditional clusters or *toron* made from the split timbers of the dum palm. Their shifting shadows in the course of the day give life to the portal. A distant echo of the Maghrebian console friezes referred to above, they are likewise closely related to the *toron* of the Bambara tradition, considered earlier. Immediately above them rises a false gallery of five smaller engaged columns. The two rounded, intermediate columns are the *potige idye*, the "sons" of the facade. Of the remaining three rectangular ones, two are extensions of the *sara fa wey* below. These are all capped by

Fig. 6.36b View of the projecting wooden consoles over the entrance to the Medersa Bou Inaniya at Fès, Morocco. Drawing after Italiaander (1956).

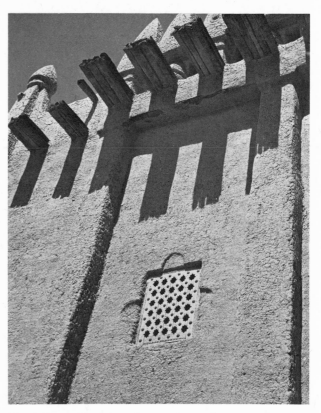

Fig. 6.37 Looking up at the *soro-funey* of a Djennenke facade.

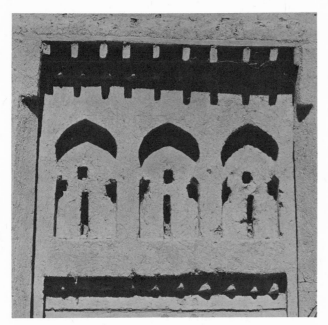

Fig. 6.36c Register over the portal at Goulmina in the Tafilelt region, southeastern Morocco.

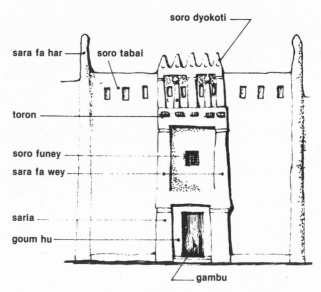

Fig. 6.38 Architectural terminology used to designate the elements of the traditional *potige*, Djenné.

a third lintel above which rise five smaller fingers or pinnacles, called *soro dyokoti*. Because they never carry the protective pottery caps, these tend to erode over time, shaped by the wind and rain. The five *soro dyokoti* are replicas of those at the main, north entrance to the mosque. The five fingers of Islam have replaced the three traditionally found on Dyula housing elsewhere and the theoretical eight found on the Dogon *ginna*.

The *potige* is flanked on each side by a *sara fa har* demarcating the side boundaries of the house. Their height above the *soro tabai*, the parapet or "turban of the terrace," is dictated by a prescribed number of courses of the *djenne-fere*, the vertically stacked cylindrical earthen bricks. Fewer than seven courses would reflect on the poor skill of the *bari* or mason, more would invite structural failure: thus, according to the master mason at Djenné, the most beautiful facades in the city are those with precisely seven courses. In reality, the height is determined by the owner's affluence, since it is the owner who provides the required number of bricks.

Although only the facade boundary is demarcated today, at one time all four corners of the house were marked by these buttress pinnacles, recalling building ritual not only in North Africa—in which the corners of *ksars* and citadels were heavily reinforced and emphasized—but among a number of West African peoples. In structuring residential space, these four corners are the inverse of the rectangular courtyard interior.

The more current term *sara fa har* is synonymous with the previously recorded *lo buru*.[79] Both terms, multivocal and multivalent, emphasize the concept of ancestral continuity in the underlying aesthetic. Verticality has become synonymous with knowledge, drawn from the wellspring of one's forebears, and the entire facade is a study in complementary opposition. The balance and unity are more than purely formal. They exist in the gender assigned to each of the architectural elements and in the way each element intertwines and flows into its opposite, architectonically and conceptually, recalling, in another idiom, the gender complementarity on the roof of the mosque.

The traditional *potige* has in recent decades been elaborated upon and extended into a continuous upper register (Fig. 6.39). While the number of elements and their proportions have been modified, and the precise rules that governed the singular, tapestry-like portal have been relaxed, the underlying meaning of the facade remains. *Sara fa har*, *potige idye*, and *toron* are no longer circumscribed within a clearly bounded, well-defined portal but have proliferated as horizontal registers above shops and residences of the newly affluent members of Djennenke society. The underlying belief

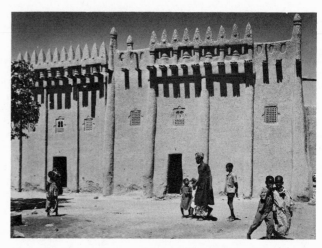

Fig. 6.39 The extension of the traditional *potige* into a continuous register on a row of shops facing the marketplace at Djenné.

that the greater the number of sons, i.e., *potige idye*, the more prosperous the homeowner is, or will become, has been projected onto the facade. Wealth is a function of fertility as much as of entrepreneurial acumen.

Passing through the *hu me* is a ritual act of transition from the exterior, public space to the interior, private household space. The *hu me* is preliminary to the *sifa*, the vestibule reception-room (Fig. 6.40). The *sifa* at Djenné is the *shigifa* of Tombouctou, the *segifa* of North Africa, and the *sigifa* of the Fulani-Hausa *gida*. This mediating space and the formalities it witnesses are of the greatest import, involving considerable time and formality. Because there is usually only one entrance into the house, both men and women pass through this *sifa* en route to the courtyard, the upper terrace level, and the *hu gandi*. Located directly above the *sifa*, it is the penultimate space of the masculine domain, in which the house owner's personal property and his library, his status and wisdom are kept and displayed, and to which only the most respected—usually male—guests are admitted.

Although the first room of the compound is always referred to as the *sifa*, room types are additionally defined by their ceiling frames: a *tafarafara*, a large, almost square space, and a *soro dyindi*, a long, narrow chamber, most often found on the upper floor.[80] The third type, *al maruba*, is an adaptation of the *tafarafara* into a longer, narrower space (Fig. 6.41a, b). The polygonal ceiling, found only in the reception chambers and the upper *hu gandi*, makes use of a maximum number of *hum bundi*, short timbers, and a minimum number of longer *kandye bundu*. The system is identical to those found in medieval city architectures along the

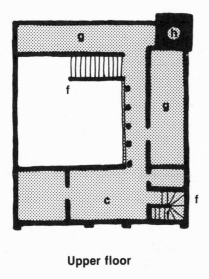

Upper floor

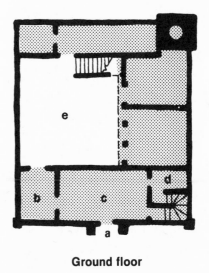

Ground floor

Fig. 6.40 Traditional floorplan of a house at Djenné. Not to scale. Legend: *a*. Entry vestibule or *goum hu*. *b*. Doorkeeper's room or *kanido*. *c*. Reception room or *tafarafara*. *d*. Storeroom or *tasika*. *e*. Open courtyard or *batuma*. *f*. Stairway or *soro tye*. *g*. Upper-level room or *soro djinde*. *h*. Latrine shaft or *salanga*. The latrine is on the terrace above the upper story.

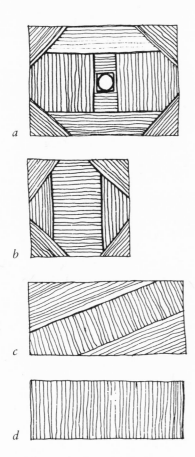
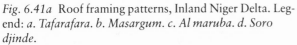

Fig. 6.41a Roof framing patterns, Inland Niger Delta. Legend: *a. Tafarafara. b. Masargum. c. Al maruba. d. Soro djinde.*

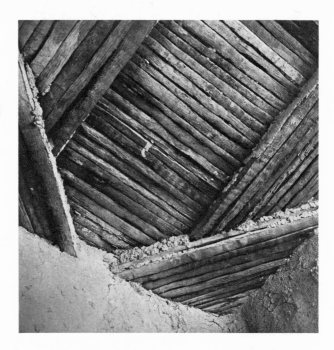

Fig. 6.41b Looking up at a *tafarafara* ceiling, Djenné.

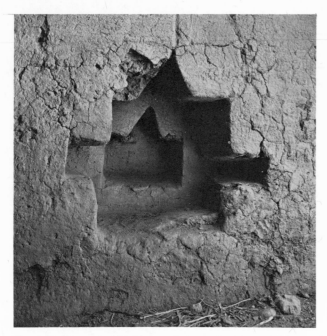

Fig. 6.42 The *al-kubba* frequently located in the *tafarafara*.

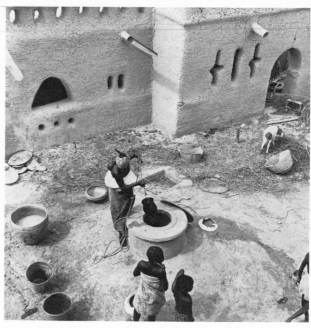

Fig. 6.43 A typical *batuma*, or interior courtyard, recently resurfaced.

western trade routes that linked Sijilmassa to the sub-Saharan entrepôts through the Mauretanian *ksars* (see Fig. 5.7c).

These timbers of split palm are almost indestructible. When walls crumble or houses are abandoned, they are salvaged and reused. Given the laws of Euclidian geometry, they become a governing factor in establishing the proportions of new housing. Spatial boundaries become ossified. Unlike the *soro dyindi*, which can, with the addition of laths, be extended lengthwise *ad infinitum*, the *tafarafara* permits only minimal plan variation. The masons or *bari* at Djenné simply say that "the dimensions of the ground correspond to the measure of the wood."

The generic name for the corners of the *tafarafara* is *kandye*, and in older Djenné houses they can still be found diagonally spanning the corners of the open interior courtyards on an upper level.[81] These *kandye taki* are the internal counterparts to the four *sara fa har* that originally marked the four corners of a classic Djenné house, replicating in space the openwork motif of the Moroccan grille. This octagonal format dominates not only the ceiling and window but the traditional design of wall niches, the *al-kubba* or "wardrobes of the wall," which once housed books and now house the oil or kerosene lamps (Fig. 6.42).

The transition from exterior to interior, mediated by the *goum hu* and the *sifa*, is also a transition between two totally different architectural settings. The exterior facades' modular proportions derive from the *djenne-fere* bricks; the facades of the interior courtyards reflect quite a different building technology and spatial organization (Fig. 6.43). True Roman arches, built with cast rectangular bricks or *tubabu fere*, frame the open galleries (see Fig. 2.16). They are in-filled with earthen balustrades and supported from below by massive round columns. The courtyard or *batuma*, in which none of the masculine elements of the exterior facade are present, is truly the women's domain. The rooms and recesses revolve around this square, not unlike the galleries of a mosque around its *sahn*.[82]

The building of Djenné facades has always been associated with the *bari*, a cast of masons whose traditions of origin, like those of the city itself, are multiple and discrepant. The *bari* are reputed to be Songhay or Dendi in origin, but there is a heavy Bambara component in their past. Today, most of the masons are Sorko, and they are not casted. While few continue to work at Djenné itself, their reputation has carried them far and wide and examples of both their work and their tradition live on throughout the Upper Delta region.

The recent introduction and adaptation of new

building technologies has tightened up the geometry and straightened the walls of new construction. The *djenne-fere* have been abandoned in favor of rectangular cast brick and concrete block. Surfaces are now plumb, carefully aligned in horizontal and vertical registers, and lack the casual, softly rounded quality of their ancestors. But again, despite these technological "improvements" and innovations, the underlying ethos that brought both the Manding style and the Djenné facade into being remains (Fig. 6.44). In the entrance to a new mosque at Koa on the Niger River, the solid, flanking pillars are echoed by their complementary opposite: the profile of the opening itself in the shape of a horseshoe arch. In the center of the threshold there is an earthen depression, the physical indicator of sacrifice and alms-giving, precisely at the interface between the sacred and the profane.

This interpretation of the Manding architectural style assumes an underlying pattern of cognitive behavior and aesthetic expression that permeates all aspects, and rests on the religious, philosophic base of the indigenous rural milieu. It is in the funerary form of the ancestral pillar and the sacred founding tree, the symbols of the past, that the imagery and meanings of the Islamized Manding symbols can be found. Onto these were grafted singular, identifiable elements of North African imagery perceived to be Islamic. Further, the very nature of Islamic architecture itself, so heavily dependent upon surface for communication, facilitated the borrowing of discrete features, their transplantation into fertile virgin soil, and their propagation in the West African milieu. Specific elements both on the exterior and in the interior bear a striking resemblance to their North African counterparts. The use of consoles, the organization of false galleries on the upper registers, the selective use of specific engineering and building techniques, the incorporation of Arabic and Berber building terminologies into the local languages, the pervasive emphasis on an octagonal format in space—(i.e., the *hatumere*)—all reveal the affecting presence of a North African template.

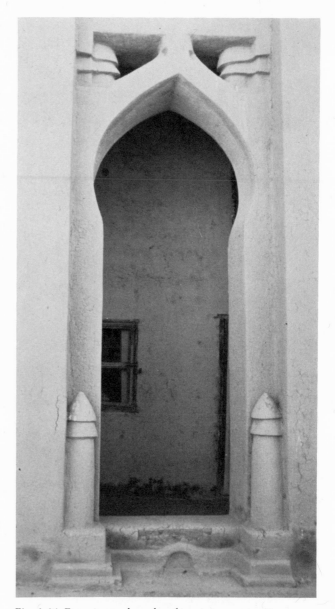

Fig. 6.44 Entrance to the *sahn* of a new mosque at Koa, on the Niger River between Diafarabé and Kouakourou, Mali. This mosque was built by Sorko *bari*.

CHAPTER 7

The Fulbe Diaspora
Politics and Sedentarization

FULBE-SPEAKING peoples have been moving across a once-fertile Sahara for several millennia, populating areas as far west as the banks of the Sénégal River. Wherever they were and wherever they went they carried with them a strong sense of cultural identity grounded in an emotional attachment to the virtues of a nomadic life-style. Fulbe cosmologies and myths of origin continue to reflect this attachment to transhumance and to a previous matrilineal inheritance system, and the iconography of nomadism persists to this day, despite sedentarization and their rise to power in several parts of West Africa.

In 1804, after the defeat of the numerous Gobir cavalry at Tabkin Kwotto, Usman Dan Fodio's daughter exulted:

> Yunfa fled from bare-legged herdsmen,
> Who had neither mail nor horsemen;
> We that had been chased like hares
> Can now live in houses.[1]

Embodied in this verse is an architectural aspiration reflecting the transformation wrought by the centuries-old sedentarization process among the Fulbe-speaking nomadic populations. In the course of this transformation, they assumed political hegemony under the flag of *jihad* in three distinct regions at three different periods: in the Fouta-Djallon, Guinea; Sokoto, Nigeria; and Adamawa, Cameroon (Fig. 7.1).[2]

The earliest Fulbe migration into northern Nigeria occurred during the fifteenth century as part of an eastern movement toward Bornou. According to tradition, the first Fulbe who settled there were literate Muslims attached to the nascent Hausa city-state leadership in northern Nigeria. Between the sixteenth and nineteenth centuries, Fulbe continued to penetrate in small groups, some as pastoralists, some settling into the emergent, nominally Muslim Hausa states. The Fulbe *jihad* launched early in the nineteenth century was led by urbanized Fulbe; within a matter of years, all the Hausa states were defeated and a Fulbe-ruled califate was formed with Sokoto as its new capital.

The Fulbe entered the highlands of Guinea—the Fouta-Djallon—in two distinct waves. Until the seventeenth century they came in small, pagan groups and were gradually assimilated into the sedentary, resident Djallonke people. A more intensive wave of migration in the late seventeenth century, composed of strongly committed Islamized Fulbe, culminated in a *jihad* led by Muslim clerics representing nine leading families. A century later, after long and weary skirmishing, Muslim Fulbe hegemony was finally consolidated into a Fulbe Confederacy with its capital at Timbo, Guinea.

Pagan Fulbe penetration into what was later to become Adamawa took place mainly in the eighteenth century. Migrating slowly and peacefully, they accepted local pagan rule. In the early nineteenth century, frustrated by allegiances to the local rulers and inspired by the success of the Sokoto Califate, local Muslim Fulbe led by Modibo Adama launched a *jihad* from the newly founded capital of Yola in the Benue valley. Adamawa

198

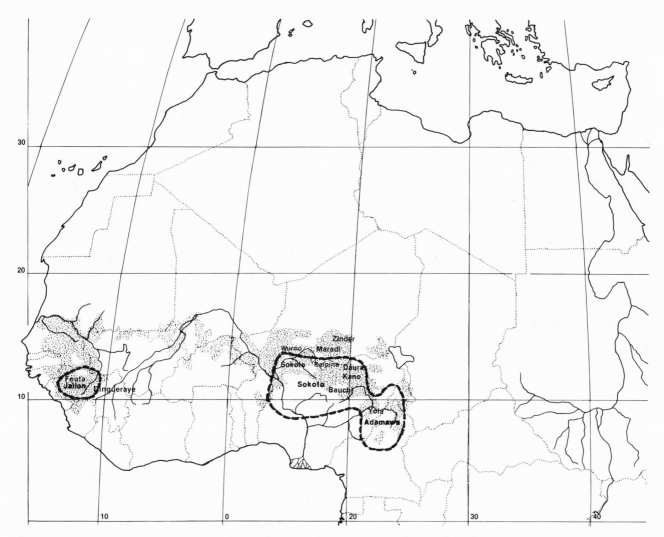

Fig. 7.1 Map showing the extent of the Fulbe-speaking populations in West Africa, and the three areas of Fulbe conquest. Drawing after Dupire (1970) and Azarya (1978).

eventually became part of the Sokoto Califate itself in the course of the *jihad*'s hundred-year history.

While the original aim of these *jihads* may have been Islamic reform, it has been suggested for Hausaland that "the lasting consequence of the movement was a profound political, social, cultural, religious, economic, demographic, and intellectual revolution."[3] Although the profound changes were not as marked in either Adamawa or the Fouta-Djallon, revolution and Islamic reform were still key factors in understanding the development of the Fulbe architectural tradition. The successful Fulbe-inspired, Fulbe-led *jihads* in each of the three regions consolidated the isolated and alienated Fulbe groupings into a single community with common interests, objectives, and standards. Most importantly, they wrought in the name of Islam a transformation from a pastoral nomadic existence to a seden-

tary life-style, a transformation from social networks based on kinship structures and earth-based centers to a political network with allegiance to a centralized state structure in an urban or semi-urban setting.[4] Out of this process a new architectural aesthetic and a new architectural language, differing radically in technology, form, and iconography from those of its savannah neighbors, came into being.

In contrast to the Manding tradition, whose imagery had its roots in the sedentary earthen ancestral pillar, the Fulbe architectural tradition originates in the nomadic domical tent. Elaborate, intricate surfaces and expansive enclosed spaces contrast sharply with their severe, almost puritanical Manding counterparts, reflecting not only a different set of architectural emphases but a different relationship between Islam and its indigenous African hosts. In many ways the Fulbe

tradition is closely related to that of Oualata in the far west and to Agades in the northeast. In point of fact, the exposition of the Fulbe development serves to explain many of the features of these other two architectural developments. Further, comparison of the three Fulbe-speaking regions provides a fascinating study of an architecture in transition from nomadism to sedentarism, a transition whose impetus can be traced to social, political, economic, and religious change within the framework of universal Islamic prescription.

The architecture that concerns us here has traditionally been called "Hausa" architecture, and Hausa builders were indeed instrumental in its development. The Hausa people were skilled in working with the earth, perhaps as slaves at first, then as an organized building group. It was these builders who transmitted the architectural components of the emerging style.[5] But since the ideology that motivated the new architecture developed out of the aspirations of the emergent Islamized Fulbe ruling aristocracy, we prefer to use the term *Fulani-Hausa* to designate what is undoubtedly the most spectacular indigenous development in the history of West African architecture (Fig. 7.2).

It has generally been acknowledged that the beginnings of Hausa society date from about A.D. 1000 and that the formation of the seven city-states of the Hausa *bakwoi*—Daura, Kano, Gobir, Katsina, Zaria, Biram, and Rano—developed gradually over the following centuries.[6] These seven states never constituted a single monarchical system, unilateral political action was generally absent, and the architectural language of the emergent states during this formative period appears to have been couched in vernacular, culturally identifiable terms rather than in a vocabulary of political symbol.

It is generally agreed that the Fulbe appeared in northern Nigeria as small groups of Islamic clerics and savants, from the direction of Mali, during the fifteenth century. They quickly became established in Bornou and Hausaland by virtue of their literacy—a critical asset to nascent Hausa politics. Their initial administrative position rapidly expanded into an intellectual one, so that by the early sixteenth century Kano and Katsina had become seats of Islamic learning and Hausaland's tributary city-states were Muslim in outlook and allegiance.[7]

During these early centuries, Hausaland was also heavily influenced by Songhay and Bornou.[8] The Songhay empire was in its ascendency during the sixteenth century; "monumental" buildings in Hausaland at that time would have reflected religious and cultural ties with the Mzab, filtered through the screen of Manding expansion and Songhay conquest. Al-Maghili, a celebrated Muslim jurist from Touat who visited Katsina in

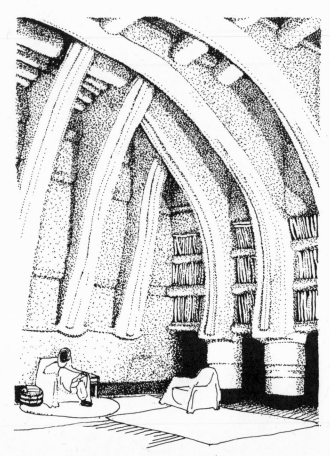

Fig. 7.2 The palace council room of the Emir at Bauchi, Nigeria. Drawing after a photograph.

1493, later became one of the chief advisers to the Songhay ruler Askia Muhamed. During the forty-year period that Katsina remained under Songhay rule, the city was frequently visited by eminent scholars from Tombouctou. In 1529 the Cadi of Katsina was a scholar from the Sankoré mosque at Tombouctou. This early Songhay-Malian heritage is manifest in the extant minaret of the mosque at Katsina (see Fig. 5.15e) and the now extinct mosque at Kano (Fig. 7.3).

Evidence of the early Songhay influence in Hausaland can be found in the etymology of several architectural terms. Two of them, *soro* and *bene*, are used throughout the savannah in reference to earthen construction: they designate respectively any square, earthen house with an upper story or terrace, and any tower-fortified wall system of earthen construction. Even at the turn of this century, all the larger earthen dwellings in Hausaland were called *soron beni*.[9] The Fulbe terms *sorowol* and *soroji*, now used in reference to all rectangular, flat-roofed earthen houses, derive from the same root. Their adoption into the Fulbe-Hausa lexicon was a function of the sedentarization

process. Early in this century the largest houses in Hausaland were called *tafafara*, a term related to the Songhay *tafarafara* and used specifically to designate the first entrance chamber and its unique ceiling structure. Finally, the term *sigifa* or *shigifa*, selectively used in much of Hausaland today for only the second entrance chamber and ubiquitous in Songhay-speaking urban centers (e.g., *sifa* at Djenné and Tombouctou), is of North African derivation.

The early seventeenth century marked a watershed in the history of West Africa as a whole and in northern Nigeria in particular. Along with the formation of strong aristocracies, the appearance of prominent urban centers, large-scale commerce, and the use of money, there was a major shift in the alignment of trans-Saharan trade routes from the Maghreb, disturbed by the Moroccan invasion of 1591, to routes more directly on an axis with the North African centers of Tripoli and Cairo.[10] As a result, closer ties were established between Hausaland and Tripoli, and an increasing number of Tripolitanian merchants appeared on the sub-Saharan urban scene.

The realignment of trans-Saharan trade routes also implied closer links with cities such as Agades, a former Songhay vassal city with a concentration of Tuareg in its population. Agades became one of the two great centers through which Islamic learning and trade were transmitted, and it has been suggested that Agades had a more direct influence than Tombouctou on the corpus of Fulbe scholarship during this later period. In 1790, a decade before the *jihad* in Hausaland, the greater part of the Agades population emigrated to the Hausa cities of Katsina, Tasawa, Maradi, and Kano,[11] and photographs of housing at Kano taken in the first decades of this century show a marked affinity with Agades housing.[12] Tuareg scholars were held in great respect by Muhamed Bello, who had a number of

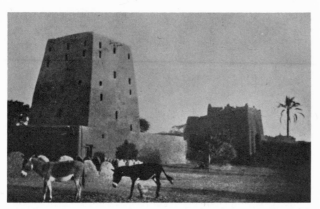

Fig. 7.3 The former mosque at Kano, Nigeria, "claimed to be a thousand years old." Campbell (1928).

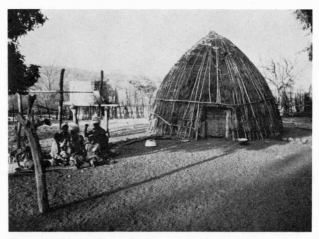

Fig. 7.4 Semi-nomadic housing in the Fouta-Djallon region, Guinea.

Tuareg war leaders in his retinue.[13] To this day, the Fulbe consider the Tuareg a superior people and their borrowings from Tuareg culture have become a criterion of wealth and social prestige.[14]

The Maghrebian heritage had colored the development of Islamized Manding architecture; now it was the Oriental tradition that came to serve as an inspiration for architectural imagery and emulation. While the ancestral pillar of the Voltaic tradition found a kindred symbolic soul in the minaret form at Kairouan, the thatched domes from the Fouta-Toro, Senegal, and the Fouta-Djallon, Guinea—whence the Fulbe *torodobi* had come—were more in keeping with Kairouan's ribbed pumpkin domes (Fig. 7.4; see also Figs. 1.8, 1.16b).[15] This tradition also found spiritual reinforcement in the domed cities of Tripoli and Cairo—cities visited en route to Mecca—as well as the domes of maraboutic shrines and sacred cemetery tombs (Fig. 7.5a–c). But North African domes were built of stone or kiln-dried brick and dependent upon wooden centering. Neither stone, kiln-dried brick, nor wood was at hand in the sub-Saharan savannah, nor were the requisite socio-technological skills available. This new preference, then, called for an innovative building technology by which domes could be replicated in easily exploitable materials and skills.

There is a tradition of earthen dome-building among indigenous sedentary populations in the West African savannah, perfected in the course of granary construction and related to the coil-pottery techniques of Mousgoum housing in northern Cameroon. The magnitude of the domical granary is limited, however, even when bands of horizontal reinforcement are introduced to carry tensile stresses. The maximum magnitudes appear to be those achieved by the Dyerma, a

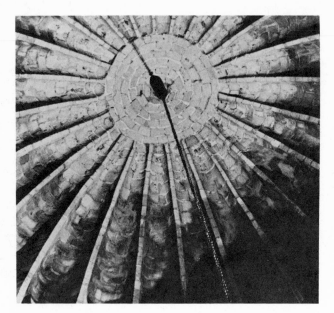

Fig. 7.5a One of the ribbed stone *mihrab* domes in the Great Mosque at Kairouan, Tunisia.

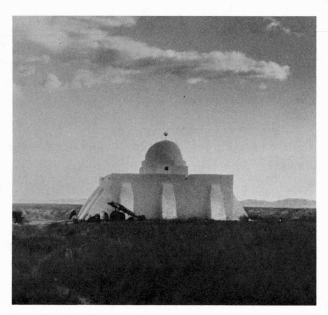

Fig. 7.5c Marabout's tomb at Kassenine, Tunisia. Kassenine stands on the site of a former Roman city.

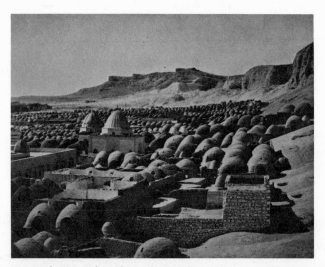

Fig. 7.5b Domed tombs in the Muslim cemetery at Zawijet-el-Metin, Egypt. Kruger et al. (1967).

Songhay-related people south of Gao (Fig. 7.6a–b).[16] If one considers the granary as a symbol of prosperity, well-being, and fertility, then its spherical roof-form could also have visually reinforced the preference for domes.

The Fulani-Hausa domes are distinguished by their magnitude and by their vaulting system, a technology unique to Hausaland and its environs. They are totally absent in the Western Sudan and in the Fouta-Djallon and are barely discernible in Kanem to the east, but all those peoples who came in direct contact with, or were subsumed under, Sokoto Califate hegemony in the Central Sudan—from the eastern bank of the Niger River to Adamawa in the northern Cameroon, from Tahua and Filingué in Niger to Nupe and Ilorin in southcentral Nigeria—show the impact of this new building technology in their architecture.

The Fulbe heritage is a nomadic one, and the symbol of mobility is a tent—a domed, matframe tent. The emergent hegemony would see in the dome the stylistic continuity of a tradition that symbolized both their independent identity and nomadic heritage, and their commitment to Islam. The need to maintain the myth of mobility which persists in the ethos and mythos of any transient society was met by this structural innovation. The Fulani-Hausa dome can be construed as a visual synthesis of several contradictory aspirations into a unified image: mobility, identity with Islam, and sedentarization.[17]

If cast in the frame of Islamic reform, then Islamic prescriptions are particularly relevant to the process of sedentarization upon which success depended. Malekite law in North Africa evolved out of social and behavioral practices generated by gradual settlement. One of the prescriptions echoing North African sedentarization is the condition of consecration and validity

for a mosque: intent to remain in a fixed place. The mosque must be constructed of substantial building materials, and it should have a permanent roof. The tent is not considered a fixed residence but a mobile shelter which, "like a boat, can at any moment be transported elsewhere."[18] The idea of fixity was extended first to mosques, then to the personal lodging of the religico-political leaders, and finally to whole citadels and cities. Changes in social organization wrought by sedentarism and Islam involved a shift in jural and proprietary rights over residential property.

In Chapter 3, in discussing nomadic peoples, it was noted that the tents, the bed with or without canopy, the household implements, and all portable do-

mestic property traditionally belonged to the women. They were responsible for the creation, assembling, and dismantling of the tents, whether skin or matframe. In the process of settlement, nomadic women gradually lost their rights over the residential domain.[19] The earthen *zaure* or *katanga* built by men gradually replaced the mat *danfami* or *bukka*. The armature, at first still the woman's property, remained intact. As it became embedded in the walls and ultimately enveloped in earth, its ownership was transferred to her husband (Fig. 7.7a, b). As portable furnishings were replaced with earthen molded hearths, benches, beds, and bedposts, these too changed hands. Eventually, all that remained in the wife's possession were her domestic uten-

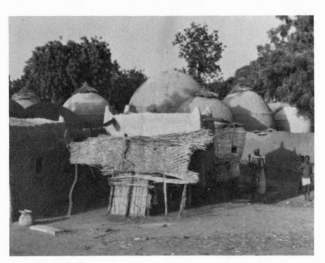

Fig. 7.6a Granaries rising above the enclosing walls of a Hausa compound north of Sokoto, Nigeria.

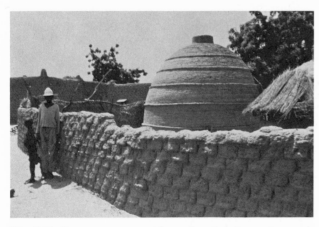

Fig. 7.6b Dyerma granary with tension rings in a compound at Tera, Niger, on the Niger River.

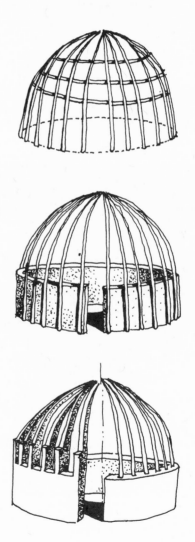

Fig. 7.7a The theoretical transformation of a circular-type tent frame.

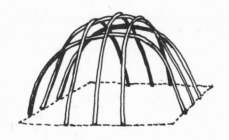

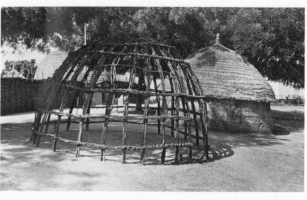

Fig. 7.7c The framework of a circular Fulbe matframe tent.

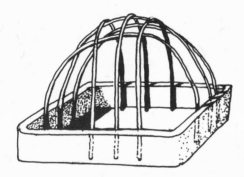

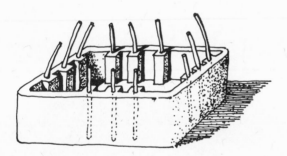

Fig. 7.7b The theoretical transformation of a rectangular-type tent frame.

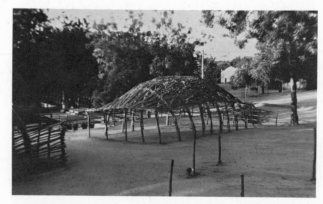

Fig. 7.7d The framework of a rectangular Songhay-Tuareg matframe tent.

sils and detachable, "soft" architectural furnishings associated with her marriage inheritance, such as tapestries, hangings, leather, and calabashes.

The innovative building technology on which the vaulted domes or *baka* are based involved a structural principle quite different from stone and brick vaults and domes.[20] There are two spatial formats in which these vaulted domes are used: a circle and a square (Fig. 7.7c, d). The circular "beehive" *bukka* or hut, with its converging ribs, is characteristic in one form or another of all Fulbe pastoralists, whereas the Tuareg and Songhay nomadic and semi-sedentary groups throughout this region use a rectilinear format for their matframe

tents. In one case, the reinforcing armature members are laid out in a circle, converging to a center; in the other case, the reinforcing armature consists of two sets of arches, called *igegan* in the Tuareg language, placed parallel and perpendicular to each other. The *atram* or *tatramt*—"beehive" housing of Tuareg, Songhay, and Hausa sedentary cultivators in the southern Tuareg-dominated regions—although circular in plan, still follows this second pattern. Both have been subsumed under the term *beehive*, but the structural distinction is important, since the latter lends itself more obviously to a rectilinear plan and the former to a circular plan. The latter also lends itself more readily to various bar-

rel-vaulted systems which, with minimal modification and no change in spatial configuration, can be converted to domical forms resting on a square base.

Although one could typologically distinguish a "beehive" hut from a "barrel-vaulted" hut, both rest on the same structural principle. In the latter case, two or three arches are set parallel to one another in one direction only; in the former, two sets of arches are placed perpendicular to each other. *Ehen*, the term used for the barrel-vaulted hut, is generic for all types of Tuareg "tents." The stationary structures "seem to have been adopted as a result of contact with pastoralists, largely because village farmers married pastoral women, for barrel-vaulted huts, like beehive huts, are built by women and the portable barrel-vaulted dwellings are also made by women among the pastoral Tuareg."[21]

Denham and Clapperton, two early-nineteenth-century visitors to this region, were received by the Sultan of Bornou "in an open space in front of the royal residence," and the sultan "was seated in a sort of cage of cane or wood, near the door of his garden."[22] When the Sultan gave an audience, strangers were allowed to approach within seventy or eighty yards of his person, and he looked at them through the bamboo bars of the "cage" (Fig. 7.8). A similar arrangement in the reception chamber of the Serki at Zinder, Niger, was recorded at the turn of this century.[23] The reference to a

"cage" clearly implies the use of a matframe tent as part of the panoply of ritual in the early nineteenth century. At Sokoto, the seat of the Califate, the two travelers observed a domed ceiling "supported by eight 'ornamental' arches," the bright, centrally placed brass plate, and the encircling balustrade within a thirty-foot-square tower at the sultan's residence.[24] It was also suggested that the design of Sultan Muhamed Bello's main suite of reception rooms was a model for all the most important families in Hausaland. The mosque, "like all mosques, ... was of a quadrangular form, the sides facing the four cardinal points, and about 800 [*sic*] feet in length. . . . The roof of the mosque was perfectly flat, and formed of joists laid from wall to wall, the interstices being filled up with slender spars placed obliquely from joist to joist. . . . The roof rested on arches, which were supported by seven rows of pillars, seven in each row. The pillars were of wood, plastered over with clay and highly ornamented."[25]

The persistence of circular entrance chambers, on the other hand, is suggested by a mid-nineteenth-century description of a palace at Kano as a "labyrinth of courtyards, provided with spacious round audience huts built of clay, with a door on each side. . . . The governor's hall was very handsome . . . and it was the most imposing, as the rafters supporting the very elevated ceiling were concealed; two lofty arches of clay, very neatly polished and ornamented, appeared to support the whole."[26] The same round, clay audience chambers were more fully described in 1892, when it was remarked that the palace audience hall was a "large, round, earthen house, of proportions which were larger than any seen [east of Kano]. . . . The mass of earth was contained by wooden arches, and the diameter was ten to twelve meters on the interior; the height to the center was from seven to eight meters."[27] In a description of the *tata* or citadel of a notable at Zinder, a decade later, it was noted that "the interior of one of the halls . . . is above all remarkable on account of the ribbed ogival vaults which support the roof," and in a reference to the house belonging to Ahmadou-Kelili, a Tuareg of the Kel-Azaniarez clan, not only was the remarkable facade noted but "its interior rooms which carry ribbed arches are also very typical."[28] The house had previously been occupied by Mostapha-el-Aïd, a Tripolitanian from Iferouane. These descriptions provide a number of insights into the evolution of the ribbed vaulting system as associated with audience halls and circular reception chambers, in contrast to the square form and framing of the mosques.

In contrast to the more general usage of such terms as *soro*, one finds very specific terminologies associated with the vaulted domes. The term for the entire dome, *baka*, appears to be derived from the Fulfulbe

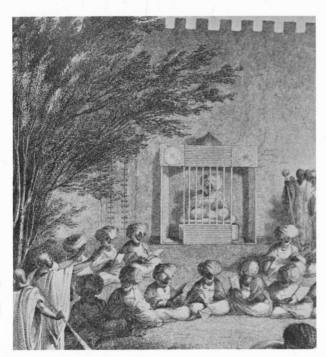

Fig. 7.8 The reception of the Mission by the Sultan of Bornou. Denham, Clapperton, and Oudney (1826).

verb *bakka*, "to smooth over, as wet clay, or to daub over." The verb *bakkana* means "to daub on." Both describe the actual building process of daubing wet clay over the wooden armature. A related term, *bake* or *bakeji*, a scabbard or sheath, carries the associated meaning of enveloping or covering over. *Gangawal*, another Fulfulbe term, referring to both the inner bands of conical thatch roofs and to basket rims, is a cognate of the Hausa term *gwangala*, currently used for the raffia palm fronds.

The selective use of the terms *zaure* and *sigifa* advances our argument. In the urban setting the term *zaure* is used specifically in reference to the first, circular entrance chamber. At Damagaram, the Hausa distinguish between the settled *Fulaanin Zawre* and the *borooji* or nomadic Fulbe.[29] Implicit is the association with *zaure* as an architectural symbol of sedentarism. *Sigifa*, a term of North African derivation, is always used in reference to the second, inner reception chamber, which in the urban areas is almost always rectangular.

The circular form with its converging ribs is likely to have derived from the Fulbe building tradition; the square form is more likely to be an extension of the Tuareg-Songhay heritage. Whereas the nascent Hausa city-states were able to incorporate the Songhay-inspired roof systems most easily into their existing technology, Fulbe sedentarization brought into use the innovative, armature-reinforced vaulted domes. The envelopment of the wooden armature with earth marked a qualitative structural advance. This innovation in building technology permitted the vast increase in span and stability which led to the creation of what

are probably the most expansive internal spaces found anywhere in traditional West African architecture (Fig. 7.9a, b).

The vestige of nomadic, matrilineal inheritance remains in the ritual act that marks the completion of a Fulani-Hausa dome: the placement, by the women of the household, of a brass plate at the apex of the interior converging ribs of the dome (Fig. 7.10a–c). A "bright plate of brass" was observed in the inner apartment of the palace at Sokoto early in the last century.[30] Its presence there is particularly interesting since it was the inner apartments that were originally the women's domain. Although china and enamelware have replaced brass, this ritual practice survives, based on the belief that a plate placed at the intersection or apex of convergent ribs is a structural requisite. "When the plate loosens and falls, the arches are no longer stable."[31] While it is true that the small cracks that loosen the plate may be the harbingers of a collapsing roof, it is equally tempting to propose that the plate symbolically marks the center of "place," a distant echo of the Fulbe *bororo* saying that "without a wife there is no house." Equivalent symbols, such as written charms buried in the floor precisely under the apex of the dome, and talismans hung from the apex itself, also persist, recalling practices still prevalent among nomadic peoples.

Just as Malekite law implied sedentarism by its insistence on a stationary mosque, so its guiding set of commentaries, the *Mukhtasar* of Khalil ibn Ishaq, insisted that the ideal form of a mosque should be a square, in emulation of the Ka'ba at Mecca. Reference has already been made to magic squares in the North African setting and to the ubiquitous talismans and

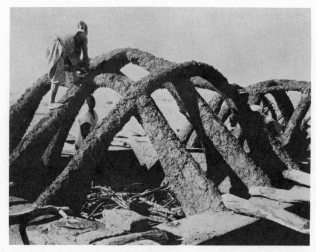

Fig. 7.9a Construction of a ribbed vault, using bent acacia and palm fronds, at Tahoua, Niger.

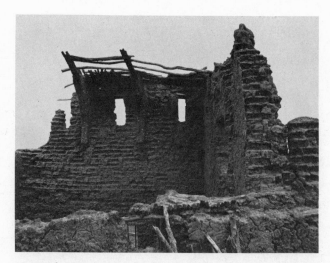

Fig. 7.9b Devolution of a ribbed vault system using *azara*, in the abandoned compound of a deceased Fulbe chief at Maradi, Niger.

Fig. 7.10a The converging ribs of a circular dome at Dosso, Niger. Note the plate inserted into the apex. Drawing after Gardi (1974).

Fig. 7.10b The intersecting ribs of a square-based dome in the reception chamber of the *imam* at Dosso, Niger. Drawing after Gardi (1974).

amulets in all aspects of West African life. The configuration of the Songhay-Tuareg square-based *atam* offered a ready-made visual frame onto which the two-dimensional Euclidian frame of a magic square could be projected. In like manner, the dome could be construed as a three-dimensional projection of the magic square (Fig. 7.11a, b). While the two diagonals of the structural frame are not obvious in the square, their conceptual existence is implied by the numerical addition along the diagonal and within each subset of squares. Although it is not immediately perceptible to the uninitiated Western observer, the domes at Filingué, Tahoua, Bauchi, and Kano all illustrate this subtle superimposition of an Islamic paradigm. The lines of the square become synonymous with the structural ribs, and their importance in defining the square spaces is emphasized by the insertion of plates at the points of intersection. The magic-square configuration of the structural frame imbues the interior with sacrality. The power attributed to the magic script contained within the envelope of an amulet conceptually permeates the interior of mosques, personal apartments, and the reception chambers of the coterie of religious-political personages associated with the success of the *jihad*. The interior space, like that of the amulet, has been imbued with meaning.

At the same time, architectural models from North Africa also suggest the prototype from which

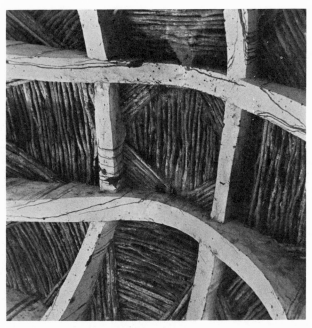

Fig. 7.10c A square-based dome using two pairs of perpendicular, intersecting ribs at Tahoua, Niger. The flat *tafarafara* ceiling structure can be clearly seen between the ribs.

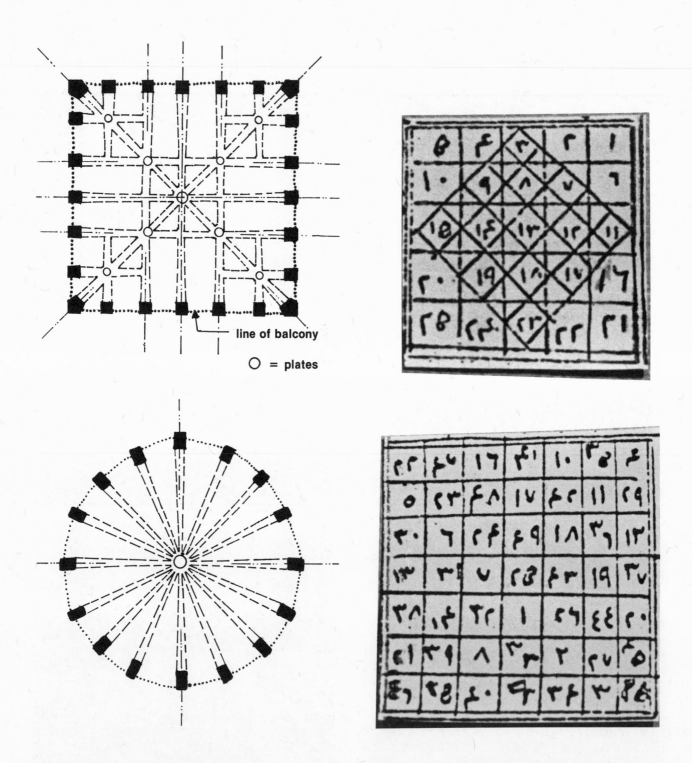

Fig. 7.11a The two spatial formats in plan.

line of balcony

○ = plates

Fig. 7.11b Magic squares appearing in an early eighteenth-century treatise by Muhammad ibn Muhammad.

these Fulani-Hausa ribbed domes may have derived. Several of the ribbed cupolas in the Bib Mardoum mosque at Toledo, Spain, for example, invite comparison, although the materials and structure differ. The Ummayad rulers of Spain were also in close touch with the rest of the Islamic world and the simple geometry of a quincunx within a square is equally at the base of, for example, the patterns on the wooden doors of the Great Mosque at Kairouan in Tunisia (Fig. 7.11c, d).

According to an early Hausa dictionary, the noun *bango* can be interpreted as either the mud wall of a house (similar to the Manding term *banco*) or the stiff cover of a book.[32] Perhaps, just as the covers of a book were seen to enclose sacred, Islamic knowledge, so the earthen walls were interpreted as enclosing sacred space. Another Hausa term from the same lexicon, *bakan gido*, means both the arched ceiling of a house and a white turban, a symbol of piety and allegiance to Islam. The synonymity recalls the common custom of whitewashing the arched ceilings, as well as the embroidered designs on the caps traditionally worn by Fulbe Muslims (see Plate 6). Both terms, then, evoke associative conceptual imageries.

The concomitant presence of totemic or natural symbols of efficacy such as horns and feathers, and amulets and talismans containing Arabic script and magic squares, is also found in the spatial context. On the structural armature of the palace reception chamber at Daura, one finds both Islamic symbols and the totemic representation of the Hausa myth of origin. The snake which tradition says was killed at Daura by the founder of the Hausa *bakwoi*, the sword with which the snake was killed, and the stylized tortoise are represented jointly with the crescent of Islam (Fig. 7.12).[33] The rendering of both on the same armature ribs parallels the practice of protecting one's body with both totemic and Islamic charms.

Another kind of relationship between magic squares and the structure of the domes is suggested by the writings of Muhammad ibn Muhammad, a Fulbe astronomer-mathematician writing at Katsina in the mid eighteenth century. Many of his writings were concerned with magic-square arrays (see Fig. 7.11b). One can assume that while these were abstract treatises of arithmetic and astronomic import, they would have permeated magico-religious belief, acquiring emotional value in the process. Their presence takes on critical import where mathematician-scholar and architectural design-builder were the same person. The intellectual-professional combination is suggested by the inclusion of the plans of Muhamed Bello's house and those of his neighbors in a work on the virtues of Usman Dan Fodio by the Vizier Gidado, as well as by Muhamed Bello's own treatises on town building and ribats.[34] The master

builder of the original Friday Mosque at Zaria was called Babban Gwani Mallam Mikhaila; the Hausa affix *babban malami* is an honorific title for a great scholar or doctor of learning.[35] The master builder for the mosque at Sokoto, funded by the Vizier Gidado in 1824, "was a native of Zeg Zeg [Zaria], and . . . his father having been in Egypt, had there acquired a smattering of Moorish architecture, and had left him at his death all his papers, from which he derived his only architectural knowledge."[36] Implied are a literary heritage and the close working relationship betwen vizier and builder.

An interesting tradition recorded at Zinder in 1945, implying an Arab, Tuareg, or more vaguely Eastern origin for the Fulani-Hausa domes, emphasizes the importance of the Tuareg contribution already noted above.[37] At the same time, reference had also been made a century and a half ago to Habe (Hausa) slaves employed in the various building trades.[38] The explanation lies in the emergence of a specialized skill out of a rural, non-differentiated communal building process, to meet the exigencies of urban life. Although the Hausa builders, the *magini*, are not organized into a caste, their knowledge is handed down from father to son. The head of the leading family of builders at Zaria, the *Sarkin magina*, for example, was a direct male descendant of Babban Gwani Mallam Mikhaila. The specialized skills were concentrated in a tightly knit, discrete, kin-based Hausa "guild." The Fulbe aristocracy, like the early Songhay empire-builders, was steeped in its nomadic tradition; at the same time it was consciously concerned with the material symbols of its conquest. Lacking earth-building traditions, it depended heavily on its Hausa subjects. The new architecture took form out of the union of Fulbe client and Hausa builder. The specialized building skills, the newly independent economic role of the builders, and the geometric "pattern book" quality of the available architectural literature also help to explain the uniformity and continuity of the architectural style at different places and times. Like the *bari* of Djenné, the *magini* moved from one commission to another on demand, replicating a singular Muslim-inspired image in one emirate city after another. The consistency of style itself served to reinforce political cohesion.

Perhaps the clearest illustration of the relationship between the circular, Fulbe-inspired form of an entrance *zaure* and the square enclosing walls of the *sahn* prescribed by Islam is the Friday Mosque at Zaria (Fig. 7.13a, b).[39] The entrance chamber or *shari'a* court is not an open court but a *zaure*, framed exactly like other circular entrance chambers. The square format of the *sahn* is emphasized by both the repeated square framing of the interior arches and the location

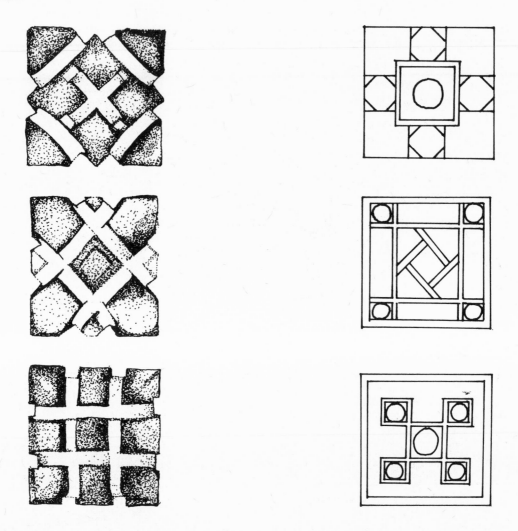

Fig. 7.11c Ribbed stone cupolas of the Bib Mardoum mosque at Toledo, Spain, ca. A.D. 1000. Drawing after Marçais (1954).

Fig. 7.11d Patterns on the wooden doors of the Great Mosque at Kairouan, Tunisia.

of the three ablution chambers and the *mihrab* on the eastern face.

The Great Mosque at Zaria dates, it is claimed, from the first decades after the establishment of the emirates at Sokoto and Wurno, but there is conflict among the dates recorded: 1824, 1830, and 1862 have all been suggested. It may well be that the discrepancy reflects a two-part building sequence; the *sahn* and its ablution chambers aligned along the four cardinal directions may well have been built first, reflecting the greater concern with the more stringent Islamic model

voiced by Sultan Muhamed Bello, and the circular *zaure*-type vestibule built some years later, reflecting the Fulbe preference of the Emir of Zaria, Abdulharim. Women, barred from the *sahn*, are relegated to the minimal *zaure* vestibule when they attend services.

A parallel to the *zaure-sahn*, circle-square spatial relationship in housing was recorded by Barth at Wurno, a sister city to Sokoto, during his stay there (Fig. 7.14). In the house of the notable who accommodated him the boundary walls were square, but the entrances were circular. At the turn of this century Tre-

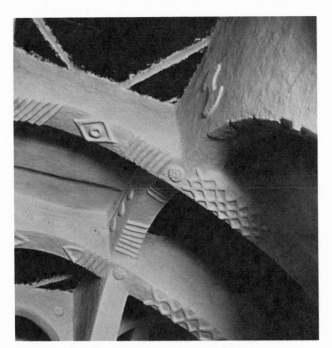

Fig. 7.12 Interior of the mosque at Daura, Nigeria.

mearne suggested that it was still only the mosques and the largest houses of the Hausa, i.e., the *tafarafara*, which were square.[40]

Equally relevant to the sedentarization process are those prescriptions that refer to visual privacy in the organization of space. When seen in the light of the rural-urban transition, these strictures take on critical import. The traditional nomadic compounds are lacking in any overt architectural emphasis on entrance, and physical demarcation of boundaries is minimal. Since Fulbe compounds sit at a considerable distance from each other on the open landscape, visual privacy does not require physical barriers. Sedentarism increased urban population density, so that Islamic prescriptions concerning visual privacy became increasingly important: as urban density increased, the physical boundaries became more pronounced and overt. An emphasis on enclosing walls was the most obvious, immediate response. And an enclosing wall implies an opening, since any closed form has to be entered.

As earthen walls replaced the traditional woven

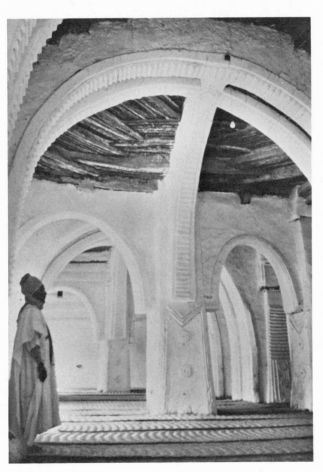

Fig. 7.13a The *sahn* of the Friday mosque at Zaria.

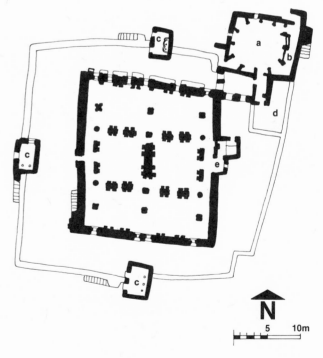

Fig. 7.13b Plan of the Friday mosque at Zaria, Nigeria. The *Shar'ia* court is a framed circular dome, whereas the *sahn* is composed of a set of intersecting rectangular frames. Legend: *a. Shar'ia* court. *b.* Screened area for women. *c.* Ablutions chamber. *d.* Latrine. *e. Mihrab.* Drawing after Moughtin (1972).

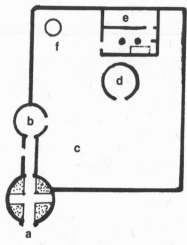

Fig. 7.14 Barth's compound at Wurno, Nigeria, in 1854. Drawing after Barth (1857–1859), vol. 3. Not to scale. Legend: *a*. Entrance "hut" or parlor. *b*. Inner entrance. *c*. Open courtyard. *d*. Hut for Barth's chief servant. *e*. Hall with columns and a storeroom behind. *f*. Granary.

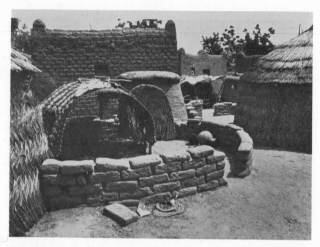

Fig. 7.15a The curb walls of a compound entrance, Bandio, Niger.

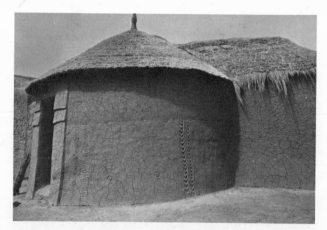

Fig. 7.15b A completed *zaure* at Zaria, Nigeria.

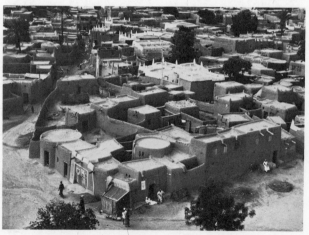

Fig. 7.15c Part of the roofscape of the old quarters of Kano, Nigeria.

mat or brush enclosures, so the entrance *zaure*, mediating between public and private space, grew more pronounced, presumably reflecting a psychological response to "protect" or "guard" an opening under conditions of increased density (Fig. 7.15a–c). In the first instance, the edge of one of the matframe walls is still visible, but attached to it are the first courses of a solid, mudbrick circular wall. The beginning courses are also an elaboration on the general pattern of semicircular earthen platforms found in a number of West African urban settings. It was particularly pronounced at Zinder at the turn of this century.[41] A traditional Dyerma bedstead with its protective barrel-vaulted *tongo-tongo* stands in the demarcated space, suggestive of the "guardian's" role in reception ritual. In the second instance, the structure has been completed, becoming the circular entrance *zaure*.

The result of increased concern with visual privacy is illustrated by the street pattern of a neighborhood in Daura (Fig. 7.15d). The high compound walls on both sides of the street are pierced only by the *zaure* doors. The door openings become visual foci, and all interaction becomes concentrated around these points in space. The doorways are staggered, preventing any direct view into the entrance way. Equally obvious is the gradual encroachment of these entrances into the public domain, creating a pattern that closely parallels its North African counterpart (Fig. 7.15e). The roofscape of Kano and the streetscape at Daura are prototypal for all Fulbe emirate cities.

This interface between entrance and enclosure is

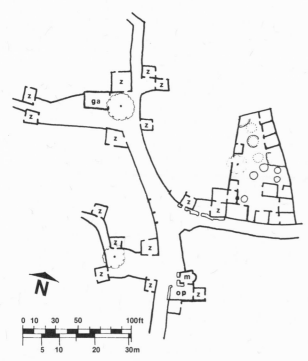

Fig. 7.15d Street pattern in Daura, Nigeria. Legend: *ga.* Garage. *m.* Mosque. *op.* Open place. *z. Zaure.* Drawing after Moughtin (1964).

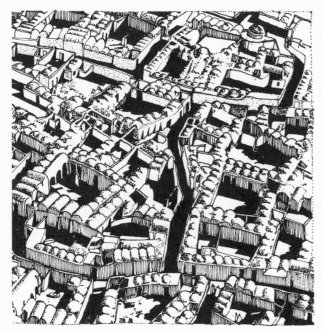

Fig. 7.15e Aerial view of the city of El Oued, central Algeria. Drawing after Italiaander (1956).

also clearly evident in the building process of a Fulani-Hausa compound over time (Fig. 7.16). Over three generations of occupancy, only two of the original architectural elements remained intact: the perimeter wall defining the boundary of the extended family unit, and the *zaure* with its adjoining stable and storeroom. Every other structure had been replaced or rebuilt, reflecting changes in family composition, size, and architectural preference. This same pattern was more recently observed in the building sequence of a squatter compound outside Niamey.[42] The initial ritual act of settlement was not the planting of a central post, as in the traditional Hausa milieu, but the building of a perimeter wall high enough to obstruct an outsider's view.[43] Next the entrance gateway was built. Then a well was dug within the enclosed space and a matframe tent moved onto the site—eventually to be replaced by an earthen structure.

Two other factors in the history of the successful conquest have bearing on the entrance emphasis. One is the importance of the horse (Plate 12).[44] An integral part of the male domain, the horse was—and still is—stabled in the entrance chamber or immediately adjacent to it. Thus, the military ritual and the political meaning associated with the horse are conceptually linked to entrance per se. If the success of the Fulbe military was dependent on cavalry, then the horse would become the focus of major ritual, and the space it occupied would assume an equally important position. This was indeed the case throughout the Fulbe conquest area. The automobile shelter, or garage, located adjacent to a *zaure*, invites a contemporary analogy with the accommodation of horses in Kano, Bida, and Garoua compounds.

The second factor relating to entrance emphasis concerns the intellectual and administrative role of the *vizier*, second only to the caliph at the Sokoto court. The *viziers* (the term is obviously derivative of the early North African *wazir*) were the repositories of the written record; they were also the heads of the Chancery or secretariat essential to the administration of the court. Their role as ritual mediators in establishing political allegiance can be seen in the fact that the *bay'a* or oath of allegiance to the Sokoto Caliphate was administered at the *vizier*'s house on at least two occasions.[45] Nineteenth-century travelers also frequently refer to their dealings with the *vizier* as a preliminary to negotiations with either caliph or emir.

In the North African tradition, the office of *wazir* often coincided with that of the *hajib* (who guarded the door); he was the "doorway" to an audience with the sultan. At Sokoto, where the caliph's court was the final court of appeal, the court officer was known as *kofa*, a term for "gateway" or "door" in both Hausa and

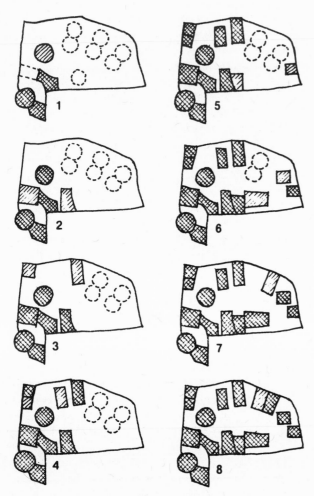

Fig. 7.16 Evolution of a Hausa compound at Zaria, Nigeria. Not to scale. Drawing after Schwerdtfeger (1971).

that not only the vaulted domes themselves, but the elaboration of their interior surfaces and the openings into them, should be viewed.

At its inception, the *jihad* was a military venture, and the consolidation of the Sokoto Caliphate necessitated an extensive building program, but the almost obsessive preoccupation with construction during the first decades of rule was more than a matter of military exigency. The building of a new capital city for each new Emirate was a quintessential statement of the politics of architecture, of ethnic identity and Islamic commitment. There are innumerable literary and oral references to the conquest and destruction of Hausa "fortresses" and to the building of new Fulbe cities during this formative period. Most revealing of all is a building manual for new towns written by Muhamed Bello in 1815, and a subsequent treatise written for his son that defined a *ribat* (a fortified town) and the duties of a *murabit*. Both volumes drew heavily on the classical authorities and the lessons of earlier Muslim conquests.

If the ideal shape of a mosque was a square *sahn*, the military *jihad* strove to achieve that ideal in fortification and building programs.[47] In 1850, the original walls of Sokoto formed a perfect square, with two gateways on each of its four faces (Fig. 7.17). These walls, built by Muhamed Bello in 1818 after the death of his father, Usman Dan Fodio, presumably reflected the prescriptions set forth in his manual, as well as in Euclid, an Arabic copy of which he possessed.[48] When Clapperton visited Sokoto three decades earlier, he mentioned three gates on each face; in all other respects, his description is consistent with Barth's later drawing. He also noted that Sokoto was "unlike most other towns in Hausa," and that "it was laid out in regular, well-built streets."[49] The walls of the cities of Bauchi and

Fulfulbe.[46] The gateway was thus a threshold setting that physically accommodated the rituals necessary to establishing social or political relationships. The role of the *vizier* in many ways parallels the verbal role of the linguist as an intermediary or threshold between commoner and chief in the non-literate West African context. He too was, and is, a ritual mediator in defining allegiances and alliances.

The *vizier*'s reputation as a man of the pen is a sign of the importance of literacy in establishing political hegemony over non-literate societies. By association, the surfaces that enveloped the greeting formalities took on the aspect of a graphic surrogate for verbal exchanges, matching the visual role of the linguist's staff. (The ethnographic literature is filled with references to the linguist's staff as a symbolic surrogate for the chief's presence.) It is within the context of this interface between verbal and visual communication

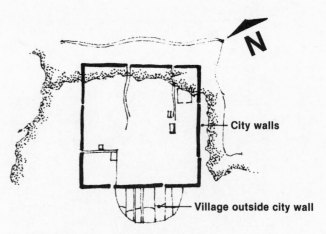

Fig. 7.17 The city walls of Sokoto, Nigeria, in 1853. Not to scale. Barth (1857–1859), vol. 3.

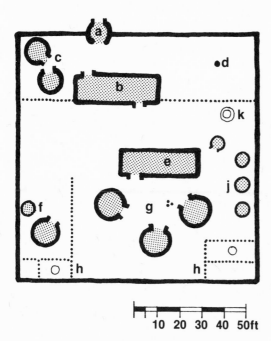

Fig. 7.18 A Hausa *gida* at Kano, 1954. Legend: *a. Zaure.
b. Shigifa. c.* Huts of unmarried sons. *d.* Horse tether.
e. Turaka or compound owner's house. *f.* Married sons.
g. Compound owner's wives. *h. Bayan gida* and washplace.
j. Granaries. *k.* Well. Drawing after Mary Smith (1954).

Doutchi, whose populations were originally Fulbe, were built after the *jihad*. Both cities originally had four cardinally oriented gates, implying a square format.[50]

Perhaps the most convincing argument for the internalization of the Islamic ideal of a square comes from a Hausa text on building:

> Take Tanko, for example. He had plenty of money and everything. He wanted to build a new compound. He was not able to do it himself, but had to call in Audu the builder. . . . Tanko said he wanted a good square compound with four huts, a mud-roofed house, a square house and an entrance hut; the door of the house to face south or west.
>
> One must take care about the height, lest one hut be higher than another. It is better to arrange it so that they are all of the same level.
>
> When they are about to lay the foundations of the wall, it would be best if Tanko gave them ropes and pegs to set up. They should tie the rope to the pegs and align the sides lest they be crooked, or lest one be longer than the other. It is best that the compound should be exactly rectangular. The plan of the house is best if laid out this way.[51]

The plan of a more recently recorded Hausa compound or *gida* is a precise physical translation of this text (Fig. 7.18). Its square shape demarcated by earthen walls or *katanga*, its circular entrance chamber or *zaure* leading,

by means of an enclosed corridor, into a reception chamber or *shigifa*, and the offset doorways or *kofa* had become an archetype. The mat fence extending from the *shigifa* defines the boundary of the first, male courtyard and blocks the view into the inner, women's courtyard. Within it are the huts of the unmarried sons and the horse tetherpost. Beyond, in the second courtyard, is the *turaka*, the compound owner's room, to which his wives come in turn; behind it are the wives' huts. In the rear, shielded with a mat fence, are the washing place and the latrine or *bayan gida*, at the back of the house.

Katanga, the designation for earthen walls, is a Hausa term. When a stalk fence is used to define the boundary of the *gida*, the Fulbe term *danfami* is used. In adopting the term *katanga* for earthen walls, the Fulbe have changed it to *katangawol* and equated it with *mahol*. The noun *mahol*, also designating the outer wall of a compound, is derived from the verb *maha*, "to build with mud." Another argument for the *zaure* as a uniquely Fulbe contribution is the concurrent usage of a circular entrance chamber and an inner, rectangular reception chamber. The term *shigifa* is specifically associated with the inner, quadrangular room. The circular *zaure* space projects into the public domain, reinforcing the mediating character of entrance. As has been noted, the Songhay *shigifa* derives from a previously existing tradition, whereas *zaure* is a later, Fulbe-inspired development related perhaps to *sare*, the term for compound or village used in the Adamawa region.

The square spatial format of the architecture and urban setting of the Sokoto Caliphate cities contrasts sharply with that of peoples geographically and culturally on its periphery—Adamawa in the east, and Nupe in the south. Both eventually fell to Fulbe conquest, and Yola and Bida became provincial capitals. Adamawa has retained a strong Fulbe heritage, and while Islam is a characteristic feature of sedentarized, urban Fulbe society there, the other peoples in the region, as well as the rural Fulbe, have retained far more of their traditional belief systems than elsewhere.

Since Adamawa was one of the most distant of the states that owed allegiance to Sokoto, its population was less involved in and less affected by revolutionary changes than were those closer to the political center.[52] The geometric formality of the capital is less evident in both spatial organization and architectonic definition in Yola, the capital of Adamawa, and its architecture appears to be in a state of transition from a casual nomadic settlement pattern to a denser, geometrically prescribed one. Only the *jihad* leadership at Adamawa appears to have attempted to replicate the Islamic architectural ideal realized at Sokoto. Barth, who vis-

ited Yola in 1854, noted that the city was "a large open place, consisting with few exceptions of conical huts surrounded by spacious courtyards ... the houses of the governor and those of his brothers alone being built of clay."[53] His observation on the urban form reflects the limited impact of a Muslim minority ruling over a non-Muslim majority, in contrast to the pervasive supremacy of the Islamized Fulbe in Hausaland.

Yola was founded at the time Adamawa declared its allegiance to Sokoto in 1809; yet the mid-nineteenth-century description of its palace or *lamorde* evokes an image more in keeping with the architecture of an earlier Kano:

> [The] *sigifa* or *zaure* here was formed by a spacious flat-roofed room supported by massive square pillars. The audience chamber was a separate hall, built of clay ... forming ... quite a notable mansion. ... From without, especially, it had a stately, castle-like appearance, while inside, the hall was rather encroached upon by quadrangular pillars, two feet in diameter, which supported the roof, about sixteen feet high, and consisted of a rather heavy entablature of poles.[54]

This description contrasts sharply with the spectacular, expansive thatched roof and circular form of the *lamido*'s audience chamber of Garoua, a lesser Emirate east of Yola in the Cameroon (Fig. 7.19). Its architectural style is more in keeping with the vernacular non-Islamic Fulbe tradition. Nonetheless, modestly decorated portals, similar to those recorded in the mid-nineteenth century, and earthen wall niches shaped like the horseshoe arches of Agades communicate an adherence, albeit token, to Islam (Fig. 7.20a, b).

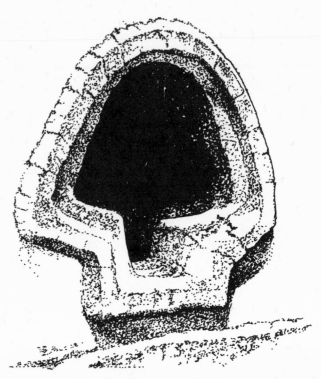

Fig. 7.20a An earthen wall niche at Garoua. Drawing after Beguin (1954).

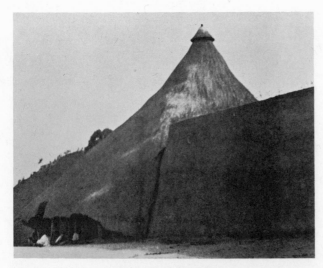

Fig. 7.19 The entrance chamber to the *lamido*'s palace at Garoua, Adamawa, Cameroon. Beguin (1954).

The term *sare*, a cognate of *zaure*, is used to designate the entire family compound in Adamawa. The spatial organization of a *sare* is similar to that of a *gida*, but walls are used much more casually to articulate public and private space, male and female domains (Fig. 7.21). Kinship structure is not as clearly evident in the morphology of the compound, and the *dammugaru*, the circular antechamber with its directly opposing doorways, serves several household units all related to the local *lamido* or household head. The mat walls or *dangami* suggest a less stringent observation of *purdah*, and the arrangement of beds and the position of domestic equipment and women's property more closely resemble traditional nomadic arrangements of space. The single exception is that the private quarter of the household head, the *sifa kare*, is always square or rectangular and located directly in the center of the compound.

Women's house units, even when they are built of earth, continue to follow the configuration of a nomadic *bukka*. The calabashes still provide the primary interior visual richness, but these calabashes themselves frequently convey reference to Islam, either voiced or by association (Fig. 7.22a, b).[55] Koranic boards, mosque motifs, and strong biaxial symmetry are major aspects of the iconographic repertoire. For comparison,

one can turn to the quincunx patternwork that characterizes much of the pottery among sedentarized Berbers in North Africa, and the intensive use of brasswares on the courtyard wall that leads into the bridal room of an old Berber house at Ghadames (Fig. 7.22c, d).

The Nupe, who live south of Sokoto, were brought into the Fulbe fold in 1810 by Mallam Dendo, an itinerant preacher, diviner, and maker of charms.[56] In contrast to Adamawa, where pagan, nomadic Fulbe were subjected to the rule of sedentary, Islamized Fulbe, the Nupe were traditionally sedentary agriculturists, and both the ritual and architectural responses of its Islamized leadership are more closely related to traditional symbol and ritual. The memory of Mallam Dendo has been sanctified and his tomb at Raba, over which a mosque has been built, has become a place of pilgrimage, much like the *kubba* in Algeria and the

Fig. 7.21 Plan of a Fulbe compound at Garoua. Not to scale. Legend: *a*. Entrance vestibule. *aa*. Inner reception-room. *b*. Reception room of the household head. *bb*. Sleeping room of the household head. *c*. Woman's room. *cc*. Room of the senior wife. *d*. Stable. *g*. Granary or storeroom. *k*. Cooking room. *l*. Latrine. *w*. Well. Drawing after Beguin (1954).

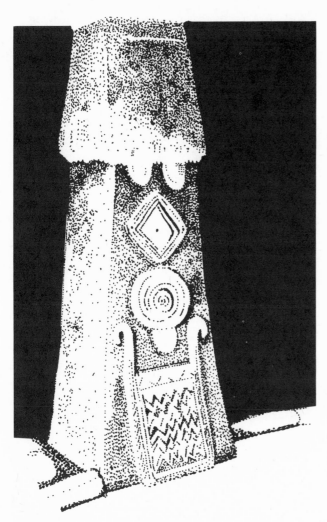

Fig. 7.20b Square central pillar in a reception chamber of the *lamido*'s palace at Garoua. Drawing after a photograph.

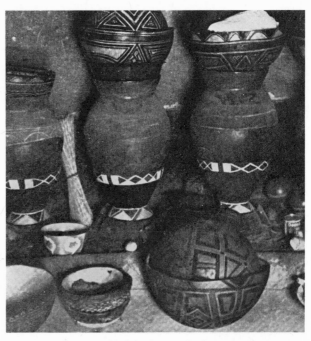

Fig. 7.22a Decorated calabashes stacked against the interior wall of a woman's room at Garoua, Cameroon.

Fig. 7.22b Decorated calabash from the Adamawa region.

Fig. 7.22c Berber pottery of the Kabyl in the Mzab region, Algeria. Drawing after Benoit (1931).

Fig. 7.22d The *addou-n-chebbak* wall of the *temenaht* or courtyard in a traditional Ghadames house, Algeria. Aymo (1958).

mosque-tomb tradition elsewhere in Islamized West Africa. According to tradition, the conquest was achieved by magical means.[57]

Although the former Nupe kings had been absolute masters in their own country, the Fulbe emirs were vassals of a larger state. There was minimal interference in its internal affairs and little impact on the traditional, rural society, and its earthen wall-building tradition provided the base from which a strong architectural response could develop. In Nupe, magic ritual associated with earthen building merged relatively easily with political status under the new hegemony, and as in Hausaland, the built form was easily translated into a vehicle for political expression. The ornate and elaborate entrance *katamba* became the focus of an ostentatious architectural display, first by nobility and subsequently by local chiefs and prosperous family heads in Nupe villages. "Its style and layout, and the state it is in, indicate better than anything else the status and position of the people who live there."[58] The exterior of the magnificent domed *katamba* or audience chamber of the palace of the rulers at Bida, the Nupe capital, is quite different in genre from the Fulani-Hausa prototype (Fig. 7.23a). The great thatched roof is clearly related to the *lamorde* at Yola and the mosques of the Fouta-Djallon; only the barely discernible triangular niches and horseshoe-arched openings in its circular earthen walls reveal its Islamic character. The magnitude of the structure belies its thatch imagery and, indeed, the interior vaulted dome system, complete with brass plate at the apex, reveals the hand of a Hausa mason (Fig. 7.23b).

Spatially and functionally, the Nupe *katamba* is synonymous with the Fulbe *sare* and the Hausa *zaure*. There are frequently two *katamba* in Nupe compounds, paralleling the Fulani-Hausa *zaure-shigifa* duality and emphasizing concern with privacy and spatial mediation (Fig. 7.24). A concentric verandah wall at the entrance *katamba* echoes the daily ritual of the Nupe king riding around the walls of his house on horseback each morning. The stress placed on these particular enclosed spaces is directly related to the importance of "members of privileged classes, titled nobility, and Mohammadan priests sitting in the inner courtyard and in *katamba* . . . who gather for the Friday reception given by the Etsu, the Nupe king."[59]

Nupe royalty expresses itself not only in ostentatious architecture but in the emphasis on luxury goods within the court: for example, Nupe brassware (Fig. 7.25). The concentration of a brassware industry at Bida is itself a mark of status, and the court is still the most important client for the Bida brass-smiths. While the origin of the specialized craft is subject to debate, its encouragement by the nineteenth-century court at

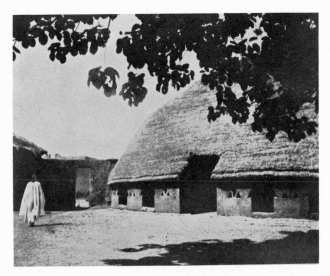

Fig. 7.23a The palace at Bida in 1907. Frobenius (1923).

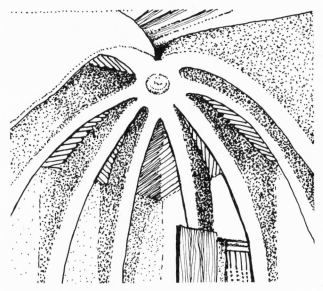

Fig. 7.23b Interior of the palace *katamba*. Drawing after Frobenius (1923).

sophistication of surface design wanes as one moves further from the spiritual and political center of the Caliphate, even superficial comparison with the pristine surfaces of the western Sudanese tradition suggests this to be a distinctive Fulbe contribution to architectural innovation that developed concomitantly with the vaulted dome.

Reference has already been made to the *vizier*'s role as a man of the pen and to the location of the *kofa* and the *zaure* in mediating social interaction. All the writing necessary to administer the Caliphate effectively was the responsibility of the *vizier*; his scribes were located in either the antechamber or the courtyard immediately behind it.[61] The antechamber was also the place where literacy, learning, and wisdom were acquired. Its sacred atmosphere provided an appropriate setting for dialogue and for study of the Islamic texts. Usman Dan Fodio himself was supposed to have spent many of his early years of study in the entrance room of his compound at Degel.[62] Today, the lecture rooms of the most prestigious schools of learning are located in these same places, and the *babban malami*, surrounded by stacked texts stored in adjacent arch-shaped wall

Bida accounts for much of its development.[60] The richness of detail and the shapes of the vessels reveal a close affinity with North African wares. Despite the simplified techniques and the less refined detailing, the geometric and arabesque motifs are equally close relatives to the repertoire of architectural iconography on decorated walls.

The structural innovation of the vaulted dome throughout the region of the Fulbe *jihad* was accompanied by an elaborate arabesque surface ornamentation first inside and then outside. Although the intensity and

Fig. 7.24 Plan of the compound of a Nupe village chief at Bida, Nigeria. Not to scale. Legend: *aa.* Outer *katamba.* *ah.* Inner *katamba*, which also serves as a stable for the chief's horse. *a.* Inner *katamba* leading to the various subcompounds. *b.* Sleeping room, family head. *c.* Sleeping rooms, other family members. *g.* Granaries. *k.* Cooking space. *A.* Family head. *B.* Unmarried sons. *C.* Unmarried daughters. *D.* Married sons and younger brothers. Drawing after Nadel (1965).

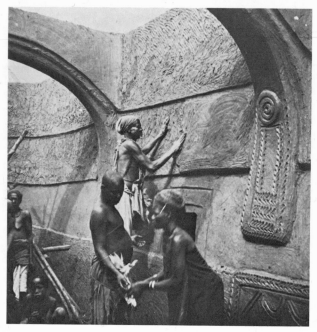

Fig. 7.26a Restoration of the interior of the *zaure* of a dignitary in northeastern Nigeria.

Fig. 7.25 Bida brassware.

niches, continue the practices initiated centuries ago (Fig. 7.26a, b).

The *baraka* of the *mallam*, which already permeated the atmosphere within these entrance chambers by means of a three-dimensional magic square, was enhanced by a select iconography, originally applied by women. The building of earthen walls is men's responsibility throughout the West African savannah, whereas the rendering of finished surfaces, whether elaborately embellished or simply applied, has traditionally been in the hands of women. The pronounced exception to this traditional division of labor occurs in the Islamized urban centers, where today men perform both tasks. In the Fulani-Hausa cities, however, while the masons or *magini* apply the final plaster coat (and hence the surface relief) to all *exterior* walls, it is the women who continue to decorate the *interior* of their own room or set of rooms. The woven tapestries that line the mat-frame tents, together with the ordered, formal arrangement of circular pots, pans, calabashes, and baskets, have been superimposed on a stationary setting.

The most prominent aspect of the built environment also emphasized calligraphy: to use a sacred Arabic script over the entrance is a public statement of allegiance (Fig. 7.27a, b). Since the form of Arabic script was considered to have supernatural powers, it could be divorced from its meaning and stylized. Forms abstracted from script were manipulated for protective purposes and applied in concentrated doses to protect both real and simulated openings. The medium, like a

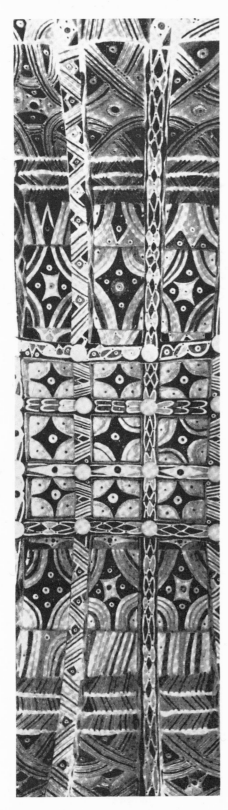

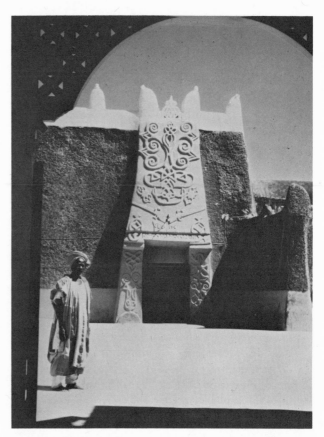

Fig. 7.27a Entrance to the Emir's palace at Bauchi, Nigeria.

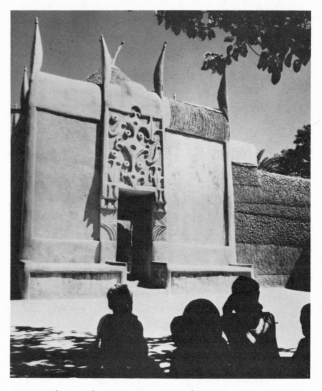

Fig. 7.26b The decorated ceiling in the house (presumably *zaure*) of Alhaji Ado, Kano. (Moughtin 1964). The reception room of the Emir of Kano had a similar ceiling: see Trowell (1960).

Fig. 7.27b Another entrance at Bauchi.

flag, had become the message. The *dagi* or "wise-man's knot," a descendant of the North African *djedwal*, continues to be used extensively as a central embroidery design in Hausa, Tuareg, and Fulbe robes, and it is prominent on the lintels and surrounds of entrance facades and real or simulated windows (Fig. 7.28a–d). The process is identical with the development of calligraphic surfaces in North African Islam, but available skills and the materials have limited the vocabulary of forms. Tools, the fineness of the lines that could be drawn, the literacy level of the majority of the laborers, and impermanent materials militated against precise replication of Kufic script. In the same way that script was abstracted into simulated letters and numbers on war tunics and in talismans, the wall inscriptions, while retaining the verve and spirit of the cursive letter, relaxed into abstraction.

The most persuasive illustration of the efficacy of the magic square as an iconographic and a spatial model occurs in the molded decorations on the outer circular wall of a modest *katamba* from Bida (Fig. 7.29a). If one were to roll the built surface out flat, what would appear is the grid system of a magic square. This configuration suggests a transition from the previous emphasis on secretive, enclosed spaces to a new focus on the exterior surfaces of the compounds. While

Fig. 7.28b Window surrounds at Zinder, Niger. Drawing after Gardi (1974).

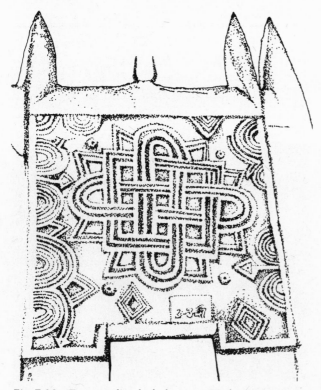

Fig. 7.28a Entrance lintel of a house at Zinder, Niger. Drawing after Gardi (1974).

Fig. 7.28c Epigraphic inscription in the mosque at Tozeur, Tunisia. Drawing after Marçais (1954).

Fig. 7.28d Kufic script over the portals of the Alhambra in Granada, Spain, and the mosque at Tlemcen, Algeria. Drawing after Ricard (1924b).

the imported plates and disc-covers located at intersections are reminiscent of those inserted on the inner surfaces of arched domes elsewhere in northern Nigeria, the motifs are also close to those found on leatherwork or calabashes; there is also a surprising resemblance between the forms of the linear patternwork within each of the squares and the screens found on traditional Asante shrine houses (see Fig. 8.20).

Instead of emphasis on critical architectural features of the building, the entire building surface is enveloped in a decorative skin, much as one envelops one's entire body in a protective sheet. The *zaure* on the Filingué-Niamey road recalls, in its overall pattern, the distribution of magic squares on the tunic of a Fulbe warrior or the padded-quilt armor worn by man and horse in ceremonial panoply (Fig. 7.29b). A building standing alone is totally revealed—and vulnerable—and, as with costumry throughout the world of Islam, there is a need to envelop the corpus in its entirety.

The *zanko*, earthen horns of earth that project from the corners and above the entrance parapet of compounds, accentuate boundaries of residential jurisdiction and acknowledge the "corners" of a square *zaure*. On circular entrance chambers they are found

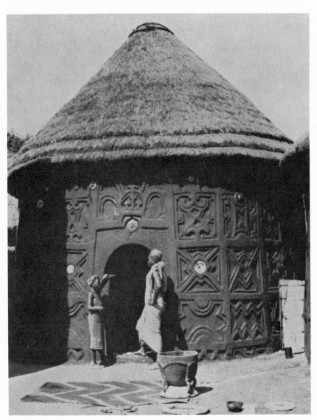

Fig. 7.29a The *katamba* of a Nupe compound at Bida, Nigeria. Trowell (1960).

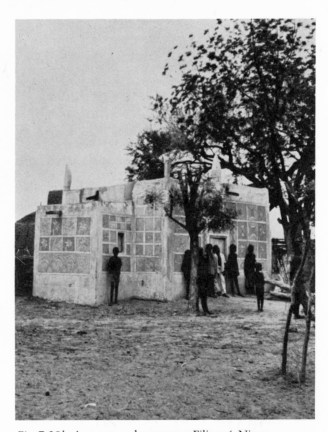

Fig. 7.29b A compound *zaure* near Filingué, Niger.

only at the apex of the domical roof. It is tempting to suggest a relationship to the *sara fa har* of the Manding-Songhay tradition, particularly since in both traditions, a pair of horns is frequently mounted directly over the center of the portal architrave or projected from the apex of the dome behind it.

With the passage of time, conscious association between present-day decoration and its calligraphic ancestry is lost, but the elaboration and workmanship which emphasizes entrance portals has remained. Equivalent representational symbols of Islamic adherence have merged with the geometric, calligraphic repertoire: writing boards which are used in learning the Koran in its written form, tea kettles used in performing the daily ritual ablutions, the scimitar used in military *jihads*, and the clock which marks the precise time of day when Muhamed reached Mecca are as efficacious today as the calligraphy itself once was (Fig. 7.30). Even here, however, a new value system has begun to emerge. Now, interspersed with artifacts associated with devoutness to the Muslim world are material symbols of wealth, status, and position: the bicycle, the airplane, and the car. The decorated surfaces extend beyond the confines of the portal, across the entire width of a compound's street face, communicating, to the passersby, the interface between public and privately owned space.

The Fouta-Djallon, by virtue of its temperate environment, its early history, its commitment to the Tijanniyya, and the strong and cohesive political structure of its more recent history, occupies a special position in the Fulbe diaspora. At the same time, it provides us with yet another model for comparative interpretation of the interface betwen Islam and traditional West African systems of aesthetic preference.[63]

The Fouta-Djallon was the setting for one of the earliest, southeastern Fulbe migrations. Starting in the late fifteenth century, small nomadic, pagan groups coming from the Fouta-Toro in Senegal slowly began peacefully to infiltrate the highlands of the Fouta-Djallon range, a region occupied by Djallonke sedentary agriculturists. These Fulbe were absorbed into Djallonke society. At the end of the seventeenth century a second wave of Fulbe, strongly committed to Islam and linked to their brethren in the nascent urban centers further northeast, came from the Macina. This second migration instigated the formation of a strong feudal, theocratic structure under the flag of a *jihad*. Led by Karamoko Alfa, the country was organized into first seven and then nine *diwal* or provinces and consolidated into a confederacy. The bases of organization were the *missidi* or parish, the *tedu* or district, and the *diwal* or province. Although the act of consolidation took place at the sacred center of Fougoumba, where its architect received the turban of investiture, the seat of the confederacy and Islamic learning was at Timbo.[64]

The essence of the sedentary Djallonke architectural heritage which still permeates the Fouta-Djallon is best illustrated by the tomb of Toumani, a Djallonke chief at Toumania, just east of the mountain range (Fig. 7.31a). The remains of the tomb consist of a pair of concentric foundation walls, in the center of which rises an impressive fig tree—planted, it is claimed, at the time of Toumani's entombment. The tomb was apparently located in the center of his house, since its configuration recalls the concentric walls that define the spatial organization of Djallonke housing throughout the region (Fig. 7.31b). The centrality and biaxial symmetry of the house unit are echoed in the larger configuration and form of the compound of the chief at Soulimania, another Djallonke chieftaincy (Fig. 7.31c). The larger circle is defined by three circular entrance vestibules (very much like the *zaure* of northern Nigeria) with their opposing doorways, and, on the fourth side, the tomb of the founder of the chieftaincy. At the intersection of these two cardinal axes, in the center, a fig tree marks a buried shrine. Adjacent are two carved

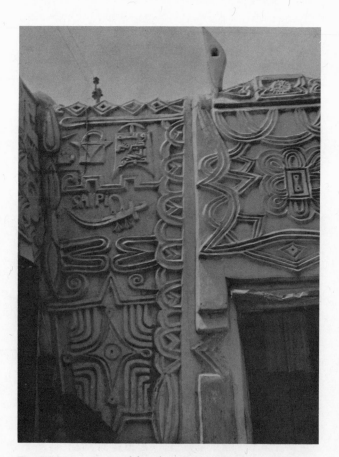

Fig. 7.30 A compound facade at Zaria, Nigeria.

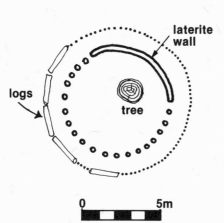

Fig. 7.31a Plan of the tomb of Toumani, chief of the Djal-lonke, near Toumania, Guinea.

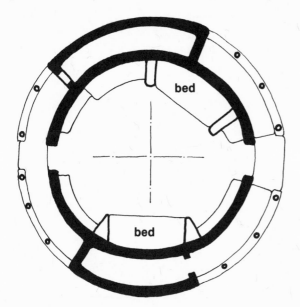

Fig. 7.31b Plan of a wife's *suudu* in the compound of a Djal-lonke *chef de canton*, Soulimania, Guinea.

pillars and the support for the *tabala* or drum, the symbol of chieftaincy.

Traditional Fulbe housing at Timbo, while similar, articulates geometric space more faithfully, reflecting stringent Islamic prescription (Fig. 7.32). The *suudu* or house unit is circumscribed by its pair of concentric walls, but the earthen bed, a sedentary version of the traditional movable frame, is located directly opposite the entrance. On the right is the *kakul*, the calabashes and domestic utensils which comprise the inheritance of the wife, arranged in identical fashion to those already considered elsewhere. Within this circular space is a square platform mounted on four posts, which serves as storage for provisions and food-

stuffs. At the time of construction, a slip of paper containing a verse from the Koran is buried under each post.

In considering the relationship between Islam and traditional Fulbe housing form, one aspect of the Fulbe concept of space bears mention. The *suudu* is a place where a being or thing finds shelter: it carries with it the notion of compartment and a sense of hiding.[65] Thus, the term can be used not only in reference to the place in which a person sleeps but to the envelope of a letter or to a box in which something is hidden. The concept is associated with the way in which an amulet cover envelops, hides, and protects its sacred contents.

It is this concept which explicates the unique quality of mosques in the Fouta-Djallon, and underlies the evolution of their form. From the exterior, they all appear to be no more than vastly magnified editions of traditional nomadic housing. The oldest mosques were in fact replicas of the thatched dome shelters which served as village meeting-places. Such a shelter consisted of a slightly raised floor bounded by a low earthen wainscot wall in which a circle of wooden posts was embedded. The posts supported a set of rafters that emanated from a central apex to carry the thatch roof. This was true of the first mosque at Fougoumba, reputed to be the oldest in the region and built when the confederacy was consolidated. When a new mosque is built, the old one is converted into either a reading room or a women's mosque and the same palisade-enclosed sacred space is enlarged to envelop both. The new mosque, however, has a different architectural configuration within: the dome accommodates, in hidden fashion, an earthen cube (Fig. 7.33a, b). Although in recent years the thatch domes on many of these newer mosques have been replaced with a corrugated metal roof resting on new concrete block walls, in almost all instances the original earthen walls of the mosque cube were retained within. Thus, the earthen walls continue to define the sacred space within while the new concrete block walls form a square ambulatory around them.

When a French mission visited Fougoumba in 1888 they were received in the audience hall directly across from the mosque compound (see Fig. 1.16b). This hall was the large reception vestibule at the entrance to the compound residence or *wuro* of Alfa Ibrahima, the original architect of the Fulbe Confederacy. The close proximity of mosque and "palace" compound followed the traditional Muslim model: together they visually communicated the religico-political identity of the Fulbe theocracy.

In the mid-nineteenth century El Hadj Umar, a Toucouleur from the Fouta Toro in Senegal who has been credited with the introduction of the Tijanniya sect into

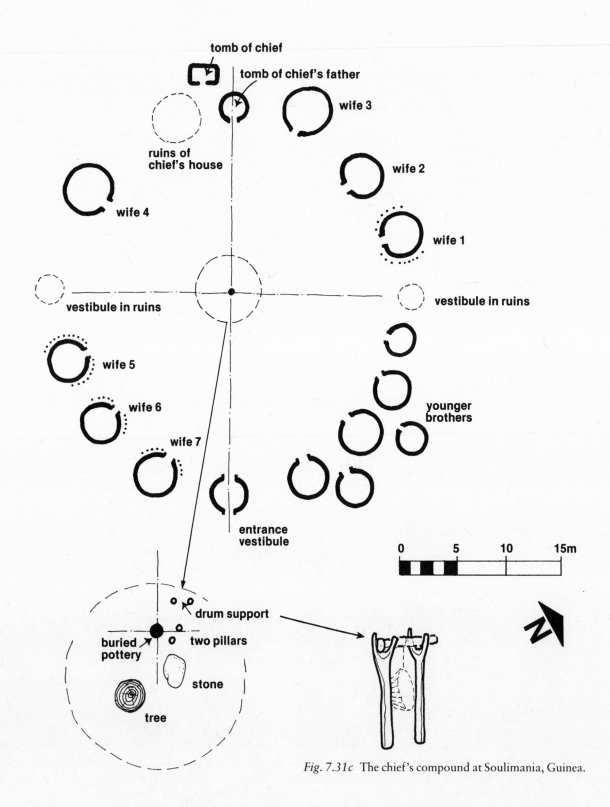

tomb of chief

tomb of chief's father

wife 3

ruins of
chief's house

wife 2

wife 4

wife 1

vestibule in ruins

vestibule in ruins

wife 5

younger
brothers

wife 6

wife 7

entrance
vestibule

0 5 10 15m

drum support

buried
pottery

two pillars

stone

tree

Fig. 7.31c The chief's compound at Soulimania, Guinea.

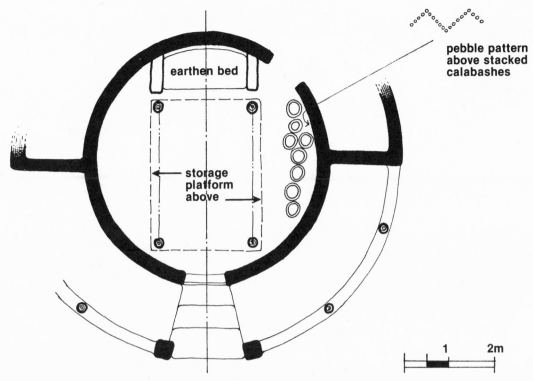

pebble pattern above stacked calabashes

earthen bed

storage platform above

1 2m

Fig. 7.32 Plan of a traditional Fulbe *suudu* at Timbo, Guinea.

Fig. 7.33a The Friday mosque at Fougoumba, Guinea, before its thatch roof was replaced with a corrugated metal one. The exterior of the audience hall of the chief of Fougoumba is identical: compare Figure 1.16b.

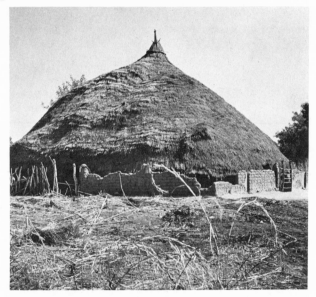

Fig. 7.33b The *missidi* (mosque) at Kamale Sibi on the Mali-Guinea border. Despite its seemingly circular perimeter, the interior plan is square. The remains of its external courtyard fence reflect the four earthen walls of a perfect square within, with its three doors and *mihrab* located along the two axes.

West Africa, waged a *jihad* that led him from Dingue-raye in the Fouta-Djallon foothills east into the Macina region of Mali. Puritanical, Sufist and fervently committed to a more orthodox Islam, he greatly influenced the political viewpoint of the Fulbe Confederacy as well as its architecture. Installing himself at Dingueraye in 1849, El Hadj Umar soon acquired a large following; the village population grew rapidly into a center of more than eight thousand people. The *jihad* leadership was thus able to marshal the labor force necessary for the construction of an immense city wall and a spectacular mosque.[66] Furthermore, El Hadj Umar had within his immediate retinue a number of skilled artisans who had trained under the French at St. Louis, Senegal, and who were familiar with European fortification procedures.

The Great Mosque at Dingueraye remains the quintessential model of the Fulbe mosque in the Fouta-Djallon (Plate 13). Although no known records of what the original mosque looked like have been found, the extant mosque, built in 1883 by El Hadj Umar's family on the site from which he departed to wage his *jihad*, is a close cousin to those found in every parish center or town in the Fouta-Djallon with a Friday mosque, a *missidi*. The single drawing the *jihad* leader left to guide the construction is a mandala-like magic square, carefully guarded and hidden among the pages of the Dingueraye *tarikh* (Fig. 7.34a). The seeming incongruence between "plan" and finished structure is easily understood in the light of how the users define the mosque: the mosque is not what is visible from the outside, but is *only* the earthen cube within (Fig. 7.34b). The thatched dome, we were told by the elders, "is only for protection." Its interior earthen cube closely resembles the square mosque structures found elsewhere in West Africa.

The thatch superstructure is framed by a radiating rafter system. The rafters, in turn, are supported by a ring of wooden pillars forming a circular ambulatory. A single central earthen column carries a core of secondary rafters that flare out, umbrella-fashion, above the flat earthen roof of the earthen cube within. This system of construction is, in its own way, as sophisticated as what we have described for the architecture of the Sokoto Caliphate. But the central post, the perimeter columns, and the thatched dome are structurally separate from the earthen cube within, which is formed by heavy walls and a ceiling supported by four ranks of wooden columns defining the nine houses of the confederacy in each direction. Three sets of three openings on each of three sides plus a fourth on the *kibla* wall recall other Islamic models of space—e.g., the former Great Mosque at Djenné and the city walls of Sokoto. The locations of entrances and *mihrab* also echo the

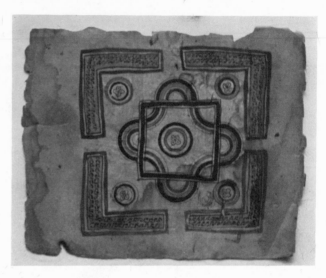

Fig. 7.34a Hatumere construction template, Dingueraye mosque, Guinea.

organization of the Djallonke chief's compound at Sou-limania, where the founder's tomb occupies the same position as the *mihrab*, as well as traditional Fulbe housing, where the bed sits directly opposite the entrance, in line with the four pillars supporting a square or rectangular storage loft. And, like every other sacred place or space, a magnificent tree (in this case, a mango tree planted when El Hadj Umar first arrived at Dingueraye) spreads its branches adjacent to the mosque.

The strong preoccupation with numerology in the Sufist tradition in the Fouta-Djallon is evident in the extensive repertoire of recipes that every marabout or *tierno* has in his possession. The larger part of each collection consists of various kinds of magic squares and *djedwal*. One such *hatumere*, in the collection of a *tierno* from Conakry who had studied at Timbo, provides an even more accurate graphic representation of the plan of the mosque at Dingueraye than does its original inspiration (Fig. 7.34c). The concentric circles of script, excerpts from two *surah* in the Koran, recall the perimeter ambulatory and the prescribed daily ritual of walking around its *tapade* or palisade fencing. Within, at the center, the *djedwal* carries the name of Muhamed; surrounding him are the four archangels and the names of his original followers. Thus, the square is enveloped and hidden within its protecting concentric circles like the core of a *suudu*.

The entrances to these vast thatch structures are low and almost invisible under the sweeping eaves, and there is no visible emphasis or elaboration of entrance into a sacred space other than the often elaborately carved pair of wooden posts that flank the opening into

the circular or rectangular *tapade*. But once within the ambulatory, the doors leading into the earthen mosque proper are heavy wooden planking. Like their residential counterparts, the most elaborate statement of entrance is the *kufal* or lock (Fig. 7.35). The locks, which have become transitional control points, carry the format of spatial organization in their very design and motifs. The geometry and axiality of the four incised circles replace the anthropomorphism of similar locking devices elsewhere. The verticality of the housing and the horizontality of the bolt converge on the single, center metal rosette. Frequently, behind and totally invisible, as on the back of a mask, an inscription in Arabic is inscribed.

In considering the various Fulbe-inspired architectures, we have stressed the import of interiors and the nomadism-inspired role of women in architecture. While the mosques of the Fouta-Djallon have, like their northern neighbors, bare, white, and simple walls, the emphasis on interior space finds full expression in a more recent aesthetic preference, evidenced in the compounds of *chefs de canton* created during the French presence (Fig. 7.36a–c). Although male-executed, all were requested and commissioned by the wives. While the arabesque flamboyance is of recent vintage, inspired often by recent imports of patternwork on the carpets and mats brought back from a *hajj*, their very presence

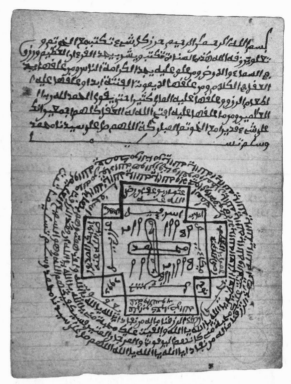

Fig. 7.34c A *hatumere* made by Balde Tierno Abdul of Conakry, Guinea, to be carried in one's pocket or car for good luck.

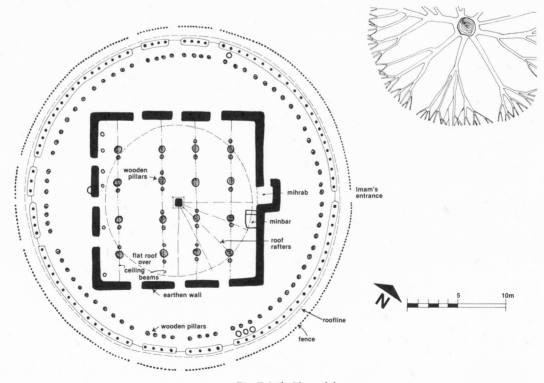

Fig. 7.34b Plan of the mosque.

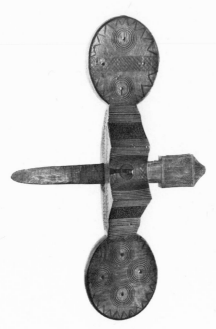

Fig. 7.35 Door latch with incised designs from the Fouta-Djallon, Guinea.

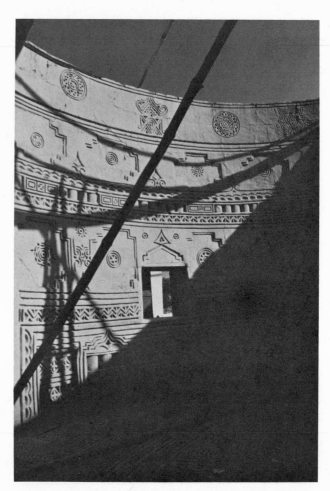

Fig. 7.36b Restoration of interior bas-relief walls at Dalaba, Guinea.

Fig. 7.36a Interior bas-relief wall motifs in a wife's *suudu* in the Fouta-Djallon.

Fig. 7.36c Arabic script marking the direction of Mecca on the interior wall of a Fulbe *suudu* in the Fouta-Djallon, Guinea.

within the hidden female domain recalls the same nomadic heritage evident not only in northern Nigerian Emirate cites, but at Oualata and Agades.

In contrasting the Fulbe architectural tradition with that of those surrounding it on all sides, the question that comes to mind is why it was uniquely this area which gave rise to such visual intensity. We have tried to suggest that the answer lies in a nomadic heritage already extremely rich in surface articulation, and in the critical politico-religious role Islam played in urbanization. Feelings of religious awe are closely related to emotions stimulated by artistic creativity. The Fulani *jihad* was the first instance in which nomadic sedentarization and hegemony occurred concurrently. Unlike the gradual process of urbanization, sedentarization, and Islamization that had heretofore marked the course of West African history, for the first time the visual imagery of a tent, symbol of the conquest, meshed perfectly with the dome, formal symbol of Islam. The spatial organization of nomadic space lent itself with the greatest of ease to Islamic tenets of spatial orientation, and the lavish, color-saturated surfaces provided a logical transition for its distantly related kin, sacred script. The analogies we have suggested find poetic expression in a classic Fulbe epic of the early twentieth century:

> [Prayer], in religion, makes for stability;
> It is the mortar used in masonry.
>
> Without prayer, religion will decay
> Like a foundationless wall, crumbling away.[67]

CHAPTER 8

The Asante Confederacy:
Islam in the Rain Forest

THE DEVELOPMENTS in the savannah regions of West Africa during the eighteenth and nineteenth centuries were matched by the emergence of a strong, politically cohesive power close to the coast. The Asante Confederacy has always been considered to be a pagan "forest" kingdom, but the ascription is misleading.[1] Although it is true that its traditional capital, Kumasi, was located close to the edge of the forest zone, the greater part of the territory over which the confederacy exercised control at the height of its power lay north of the capital, in the grassland savannah (Fig. 8.1). Overlooked in many interpretations and analyses of the arts of the Akan-speaking peoples, this "northern factor" is of critical import to their architectural history.[2]

The traditional Asante style has been described by a number of authors, past and present, but there has been virtually no attempt to trace the origins or development of this unique architecture of the West African rainforest belt, an architecture that reminded its first European observer of English Gothic tracery, being composed of "intricately arranged arabesque reliefs, sculpted columns, arches, incised spandrels, lace-like screens, and ornately chased pilasters" (Fig. 8.2). He also noted, in passing, that its character was an adaptation of that found in the countries of the "interior."[3]

The traditions of origin of most of the Akan-speaking peoples suggest that they migrated from the north into the periphery of the forest zone early in this millennium; by the sixteenth century their trade presence on the coast itself was being recorded with increasing frequency in European accounts.[4] The seventeenth century in turn witnessed a period of migration, flux, and the northward drift of Twi-speaking peoples from the coastal Adanse region. These two demographic movements resulted in a meeting of diverse cultural traditions and in their social and political consolidation under two lineages, the Ekuono and Oyoko. The vernacular architectonic response of each, one from the coastal rain forest and the other from the grassland savannah, also merged to generate a unique Asante architectural style which, like the *kente* cloth that accompanied it, carried a double weft of Islamic and European silk threads (Fig. 8.3).

This process of cultural integration and political consolidation is reflected in an Agni folktale recorded at Sanwi in the coastal region of the eastern Ivory Coast which concerns itself with the origins of Akan architecture:

The Spider and Beautiful Houses

At one time, the "blacks" did not know beautiful houses. One day, as the spider strolled in the bush, she spied a rectangular house suspended in mid-air. Hiding herself and watching from a distance, she suddenly heard someone call out "Descend." The house descended, settled on the ground, and out of it emerged two giants who then proceeded to take a stroll. Upon their return they reentered the house, called out "Rise," and the house rose into the air again. The spider Ekennaba observed this procedure for some time. One day,

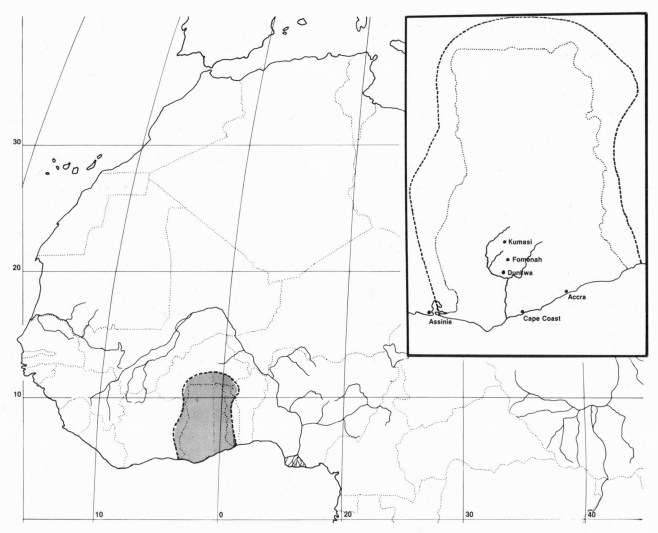

Fig. 8.1 Map of the area over which the Asante Confederacy exercised control in the early nineteenth century. Drawing after Fynn (1971).

profiting from their absence, she entered the house, pronounced the magic formula, and the house rose into the air. Within, it was even more marvelous than without. She found many riches and much food. Joyously, she began to pound the food in preparation for a feast. But the noise of the pestle striking the mortar was so great that the giants heard it. Returning in great haste, they saw their house up in the air and commanded it to descend. Within, Ekennaba countered with the command to rise. Alternating and increasingly loud cries and commands only succeeded in sending the house adrift toward an unknown country. Eventually, having consumed all the food in the drifting house, the spider was forced to bring the house down and it descended into the country of the "whites." Those who saw this house of the giants there were filled with wonder, imitated it, and made many more like it in their own country. Then, they came to the land of the "blacks" and

built similar houses. The "blacks" in turn imitated them. Everyone now knows how the beautiful houses are made.[5]

The capital of Sanwi was Kankyeabo, a terminus for one of the great southern routes from Kumasi to the coast. It was in this area, at Assini, that the French built a fort in 1701, composed of a court and two demi-bastions, with a palisade ten to twelve feet high and an external moat. One could interpret the country of the "whites" to be either in the north or on the coast.

Another oral tradition recalls Bouna, an important Islamized Manding (Dyula) trading town lying on a northern extension of one of the great roads linking Kumasi to Bondoukou, another Dyula center. Referred to in the early literature as Inkassa, Bouna brings to mind the "ancient and seldom discussed links . . . be-

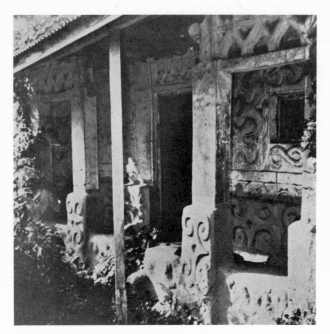

Fig. 8.2 An abandoned pantheon at Asomanso (Abuaka-Kwanta), Ghana.

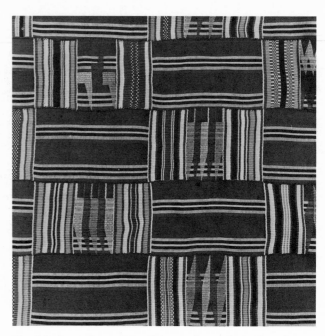

Fig. 8.3 An early traditional Asante *kente* cloth, Bonwire, Ghana.

tween the ruling dynasties of Asante and Bouna," and the intimations that the ruling Oyoko dynasty (one of the two founding lineages) had its origins in Bouna.[6] Both the content of the Agni myth and the oral tradition of the Oyoko dynasty highlight the complex interaction between north and south, "black" and "white," forest and savannah, and among Muslim, European, and indigenous building technologies, ideologies, iconographies, and iconologies.

As was suggested in Chapter 1, the valid historical reconstruction of any African architecture must begin not with the highly visible architectonic components of the built environment but, rather, with those features of the natural environment which were initially manipulated and incorporated into a conscious spatial frame, through ritual behaviors associated with the establishment of location in space.

The equivalent of "founding a hearth" among the Asante is materially expressed by a single symbol, the *nyame dua*, literally, "God's tree" (Fig. 8.4).[7] At one time, the courtyard of every Asante compound contained an altar, a *gyase dua*, either a tree or a branch set in the ground between whose forks a calabash or brass pan was wedged and in which sacrificial offerings were deposited. The two can be seen in close proximity in the forecourt of the entrance facade of the Asantehene's bedroom in his palace at Kumasi (Plate 14). The stunted silk-cotton and mancineal trees, accompanied by a pair of forked posts in the top of which "brass

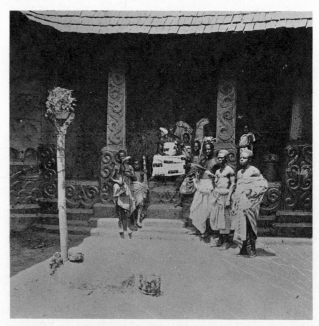

Fig. 8.4 A *nyame dua* or altar to the Sky God in the now-extinct palace courtyard, Kumasi, Ghana.

cups" were set, were located directly to the right of the entrance.[8] Their position, regardless of functional context, is the same in every interior residential courtyard or *gyase*. This same altar, although perhaps less apparent because of the elaborate walls flanking it, can be found in the courtyard of every extant shrine house. Though in some cases all that remains is the tree stump, it is the focal point of every interior courtyard.[9]

Among nomadic peoples, the forked post is a surrogate, man-made image for tree and ancestry. Among sedentary peoples, the earthen pillar carries the same connotation. When viewed in the broader cultural context, the use of a forked post as a symbol for the *nyame dua* implies a tradition of migration to a new *place* or settlement site. Its presence in the Asante spatial realm seems to reinforce the migration myths of Oyoko founding ancestors coming from the north.

Another aspect of ritual behavior that bears on architectural historiography is revealed by a passing reference to the "two orders of fetishmen" who were observed at Kumasi in the early nineteenth century: the first class dwelt with the "fetish," who had a small, round house, generally built at a distance from the town (Fig. 8.5).[10] The round house referred to is a savannah phenomenon, and the description, albeit meager, recalls the religious shrines to the god Ntoa outside

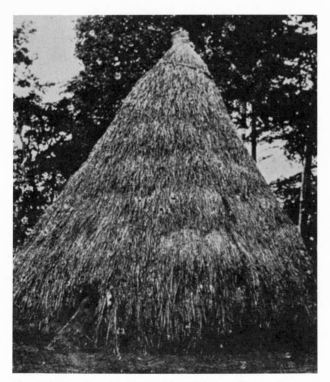

Fig. 8.5 Temple to Ntoa, near Tano Obuase, Ghana. Rattray (1923).

the villages of Tano Obuase and Nkoranza, as well as the sharp formal distinction between the shrine houses of the Kulango and the Abron-Agni: the small, round, open Kulango shrine house with its leather-enveloped "fetish" hanging from the center of the roof is in contrast to the rectangular "fetish" houses of the Abron and the Agni, with their altar space at the base, and large-scale clay representations of pythons, crocodiles, etc., on the walls. However, the Abron shrine of the god Tano (the father of the Asante pantheon) is housed in a small, open, cylindrical shelter similar to the shrine houses seen among the Kulango at Nassian and in the region of Bondoukou, Ivory Coast, rather than in a rectangular shelter. The circular type, it has been suggested, may have been borrowed from the Kulango people.[11]

Although these circular shrine houses are somewhat outside the realm of our discussion, they continue to be a viable tradition in the Techiman region, where they have sprung up recently in conjunction with the increasing rise in witchcraft beliefs.[12] The witch-catching shrine is in the form of an elongated earthen pillar with a small aperture close to its pinnacle, similar to the ancestral pillars found throughout the Voltaic Basin.

One is tempted to suggest not only the viability of a northern component in the traditional Asante repertoire in the built environment, but, more critically, a conscious, deliberate, architectural distinction between those structures associated with the spiritual world and its powers and those structures or shelters directly associated with the human act and its present reality. The former finds circular expression; the latter, rectangular. Further, rectangular spaces may be related not only to human reality or to man's transition from the real to the spiritual world, but to those acts ritually associated with the political realm. We are tempted to suggest a parallel with equivalent symbols in Islam, where the square relates to the Earth and the circle relates to the Spirit.

For example, while the circular shrine to the god Ntoa stood outside the village of Tano Obuase, in the center of the same village, surrounded by the living, stood the rectangular shrine house to the god Ta Kora (Tano), claimed to have been built on a Friday after the war waged by Osei Bonsu against Adinkira, the king of Gyaman.[13] Until then, Ta Kora had resided "in the rocks." The structure, which dates from the early nineteenth century, appears to have been one quadrant of a shrine complex. Careful scrutiny reveals the presence of arabesque, Islamic-type designs at each side of the entrance steps. The total absence of the *suman* or charms that usually adorn the interior walls of the sanctuary suggests that Islam may have been a factor not only in reinforcing the rectangularity of the spatial format but in effecting use of arabesque wall patterning in lieu of

attached charms. Material artifacts specifically associated with ritual behavior thus appear to have been projected onto the wall surface.

The presence of traditional arabesque designs at a critical, meaningful spatial juncture suggests that the shrine was an early example of the Ashanti "fetish" houses documented in recent years.[14] These fetish houses are a spatial prototype for the entire traditional Asante style. In contrast to the Kulango-type circular shrines dedicated exclusively to the gods, they are, more properly, stool shrines. The plan of the shrine consists of an open, square, interior courtyard or *gyase*, bounded by four rectangular building units called *dampon* or *pato* (Fig. 8.6a). The term *gyase*, used to designate the courtyard of any house, means, literally, "below or beneath the hearth." Every *gyase* is consecrated by its *nyame dua* or what subsequently came to be known as its *gyase dua*. One interior face is the facade of the shrine room itself, in which the stools are kept. Opposite the shrine room is the drum room. To the left is a *dampon* for the singers, i.e., oral historians, and across from it is the kitchen. Although the complex seems to have had a decorated entrance facade, other external bounding walls had no surface elaboration. The great emphasis on the elaboration of the interior facades facing *onto* the *gyase* suggests that the critical spatial concept was a bounded internal courtyard (Fig. 8.6b).

A description of customary building practices in the coastal kingdom of Fetu (near Cape Coast Castle) in the late seventeenth century conveys what may have been a predecessor for the spatial configuration of these courtyard shrines:

> The inhabitants first take four strong corner posts which they drive with all their might into the earth, so that the place so measured off is four-cornered. Between these they set other posts [by means of which] the walls will be divided. At the same time they tie [the corner posts] together with long cross poles [transversely]. Then they dig mud and work it with their hands and feet until it becomes quite adhesive [*zehe*]. This is molded into clumps the size of a man's head and thrown with all their might from both within and without onto the wall of bound sticks until it is firmly stuck into the armature. What is then found to be uneven, they smooth over with an additional wooden wedge [*spane*] or with their wet hands.[15]

Following a description of the procedure for roof-building and the laying of roof thatch, the author notes that the houses consisted of many rooms and corners, so that only a four-cornered interior courtyard remained in the center, and this courtyard was kept clean by the daily application of red and white earth. The house was without windows; sun and air entered only

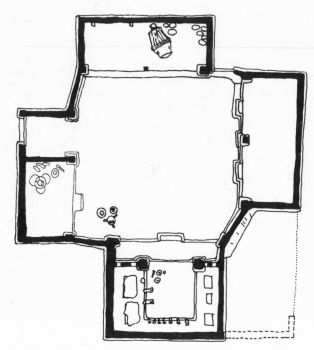

Fig. 8.6a Plan of an Asante shrine house. Drawing after Swithenbank (1969). Not to scale.

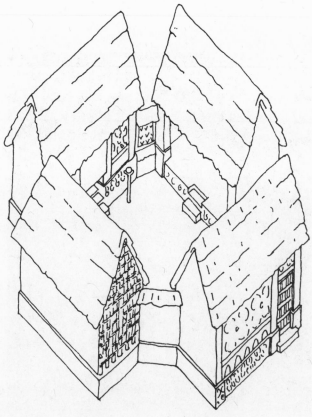

Fig. 8.6b A traditional Asante compound. Drawing after Swithenbank (1969).

through a high, small hole in the wall. It was necessary to kneel down to the ground to enter through the door, and the eaves hung so low that the doors could not be seen. The houses were grouped together in four, six, or eight units, leaving a four-cornered courtyard which was used for cooking, washing, and other housework. Everyone, it was noted, knew how to build his own houses; there were no building specialists or specialized carpenters.[16]

This early description of indigenous housing seems to give us an historical basis for the still-common wattle-and-daub technique, the square, open, interior courtyards, and the rectilinear spatial order which comprise the underlying structural, visual, and formal character of Asante architecture (Fig. 8.7a). The richly arabesque "alto-relievo," the decorative hallmark of the style, depends entirely upon a basic vegetal wicker-work armature—i.e., wattles—to which supple intermediary members could be laced and onto which mud could be daubed (Fig. 8.7b, c).

Earlier in the seventeenth century, it had been observed that the Akan traders coming down to the coast from Insoco in the north, who were famous for the very fine clothes they wove and wore, lived in "fortifications." The use of the term *fortification* suggests a conceptual distinction in the minds of the Dutch observers and/or their informants between coastal housing and savannah housing. When viewed through the seventeenth-century mind's eye, it evokes an image of solidly built, massive earthen walls and ramparts—perhaps what eventually came to be known as *swish* construction.[17] *Swish* construction, however, characterized by consecutive courses of either packed or rammed earth, does not lend itself technologically or conceptually to the techniques used in Asante surface decoration. On the other hand, wattle-and-daub construction is never designated by "courses" or "layers" (a cumulative process), nor does it lend itself to the manipulation of height or verticality as a measure of position or status. Some of the ambiguous and conflicting descriptions found in the single attempt to trace the origins of Akan architecture can be unraveled by consideration of such technological limitations.[18]

Another factor in the explanation of traditional Asante architecture is the panoply of arts that enveloped the political administration. Here, too, traditional Islam itself was historically instrumental in elaborating not only the body envelope but the "clothed" environment. Early European observers on the West African coast frequently commented on the absence of any architectural distinction between the housing of "commoners" and that of their leadership. Hierarchical distinctions were communicated visually, through adornment and display of one's garb. Thus, the immediate envelope of the body was used to communicate rank in society. The extension from adornment of one's person to adornment of the built environment reflected an increasing consciousness of the built environment as a means of communication. Ritual behavior in space was reinforced by a material, fixed counterpart.

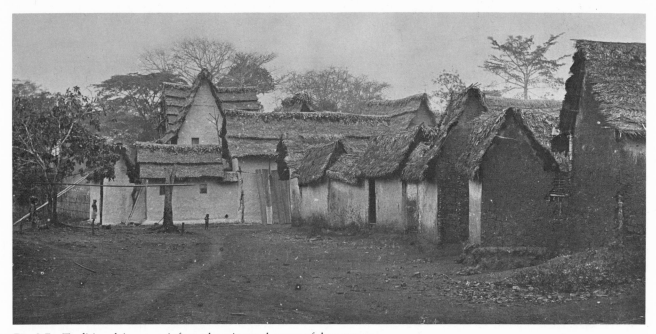

Fig. 8.7a Traditional Asante rainforest housing at the turn of the century.

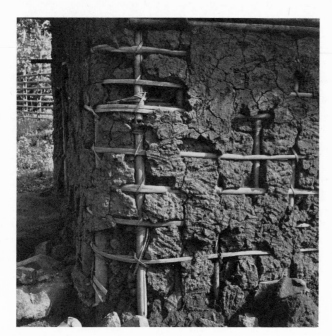

Fig. 8.7b Typical wattle-and-daub construction.

In the shift from the behavioral level to the architectural level, the transfer from the verbal to the visual mode is easiest on flat surfaces, in the context of ritual. When Bowdich described the dress worn by the *caboceers* or war captains during his reception at Kumasi in 1817, he mentioned a scrap of Moorish writing attached to the long iron chain they held between their teeth (Fig. 1.14b). Thus, the visual aspect of the written word, regardless of its inherent meaning, had been incorporated into public ritual behavior. A critical shift in the process occurred when the multitude of amulets and talismans, whose contents had been made increasingly potent by the enclosure of Arabic script, emerged from their enveloped, hidden location (secrecy being essential for efficacy) into open view. Warriors' or *caboceers*' tunics acquired at great cost from the Dagomba in the north consisted of a vast armorial collection of leather amulets, within each of which a scrap of Arabic writing was encased.[19] These tunics or *batakari* were first cousins to the cloth *diousene* (see Fig. 4.12a-d). The Islamic script, frequently ordered into cabalistic and astrological magic squares, itself became a publicly displayed protective envelope for the highest political office, the head of the entire Asante fighting force, as evidenced by the appearance in public of Osei Bonsu, the early-nineteenth-century Asantehene, in a cloth "studded over with Arabic writing in various colored inks."[20] The costume worn by the recently enstooled Asantehene further illustrates this critical shift from the secreted to the open, visually communicative medium (Plate 15). His military tunic consisted of an envelope of amulets, but he also held a fan, like a warrior's shield, upon which a geometrically organized system of Arabic script and squares had been carefully composed (Fig. 8.8).

The costume of ritual behavior is clear to the viewer; the accompanying spatial parameters in which

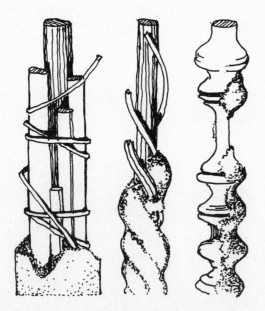

Fig. 8.7c Column construction details in wattle-and-daub technology. In one instance split bamboo is wrapped around the timber core, and in the other instance mud is daubed directly onto an already turned column, suggesting the presence of a wood lathe. The presence of a turning lathe at Kumasi was recorded as early as 1842 by Thomas Birch Freeman. The column ties are called *ntwea*. Drawing after Rattray (1927); Swithenbank (1969).

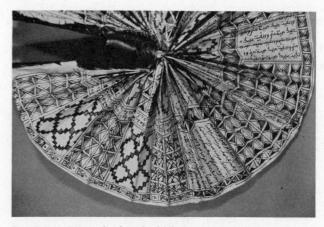

Fig. 8.8 A Dagomba fan-shield from northern Togoland.

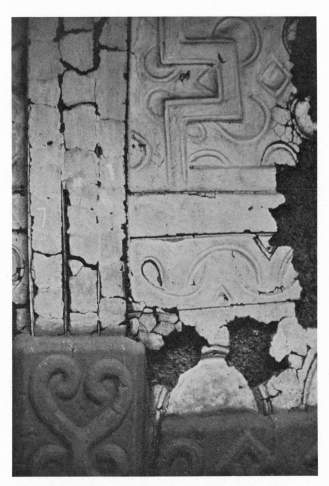

Fig. 8.9 Wall surface detail on an Asante shrine house.

fabric, *adinkra* patterning depends on an applied process, whereby individual patterns are repetitively ordered in a geometric checkerboard frame. It has been suggested that *adinkra* cloth is of Muslim origin.[21]

In his discussion of the arts of Kumasi, Bowdich noted that "the white cloths, which are principally manufactured in Inta and Dagwumba [Dagomba], they paint for mourning with a mixture of blood and red dye wood. The patterns are various, and not inelegant, and painted with so much regularity with a fowl's feather that they have all the appearance of a coarse print at a distance. I have seen a man paint as fast as I could write."[22] The motifs Bowdich recorded are in use to this day, although the painting technique referred to has been replaced by stamping. Although not noted as *adinkra* or as having any provenance more specific than northern Ghana, another well-published cloth uses a simulated (painted) Arabic script organized into a checkerboard pattern defined by the motif *papani amma yenhu kramo*, closely related to the "wise man's

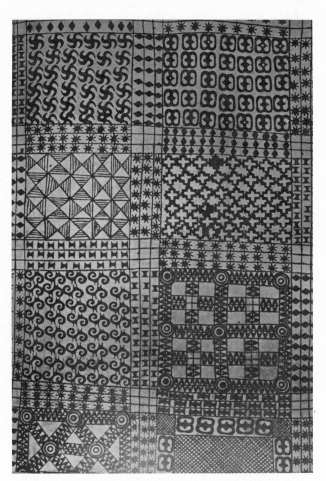

Fig. 8.10a *Adinkra* cloth, collected by Captain Bowdich, 1817.

ritual occurs reveal their attributes more subtly. Perception of the material attributes of power by the uninitiated is facilitated when icons are rendered on two-dimensional surfaces. It is therefore not surprising that as the symbols of efficacy were incorporated into the expanding Asante political scene, their two-dimensional surfaces became critically important as a system of direct communication. Flat surfaces such as leather, cloth, wood, and walls provided the most expedient background for such two-dimensional rendition. Not only are similar motifs found on all these surfaces, but the same motifs occur most prominently in the architectural context of political validation (Fig. 8.9). It seems appropriate to suggest that the incorporation of these motifs into Asante society testified to the visual efficacy of the written word, introduced from the north.

The patterns of the particular motifs used in the architectural context are directly comparable to *adinkra* or mourning cloth (Fig. 8.10a). Unlike *kente* cloth, in which the symbolic motifs are woven into the

knot" pattern frequently found in embroidery and architectural decor throughout the north (Fig. 8.10b).

Any study of the origin of *adinkra* cloth and the development of its iconography should begin with the underlying meaning of the word *adinkra*. According to Danquah, the word is clearly made up of *di*, "to make use of, to employ," and *nkra*, or "message." In current usage, the two phonemes in combination mean "to part, to be separate, to leave one another, to say goodbye." The word *nkra*, in its broader sense, means not only message but intelligence or wisdom. Hence, in connection with human destiny or the life span, it refers to the intelligence or message which each soul takes with him from God upon his obtaining leave to depart the earth.[23] If the surface of the cloth can then be construed as the medium by which the message is communicated, then use of Islamic script, real or simulated, is particularly revealing (see Frontispiece).

A number of *adinkra* stamp patterns directly associated with Islam were used in the architectural set-ting (Fig. 8.10c). For example, a motif similar to the one illustrated in Bowdich's early drawing was stamped on paper and hung over the lintel of a door in the palace. The Asantehene used to touch first this lintel, then his forehead, then his breast, repeating with each touch the words associated with the pattern. A cloth on which the *musuyidie* motif was imprinted lay beside his sleeping couch and every morning, when he arose, he placed his left foot upon it three times. The motif originally illustrated by Bowdich also recalls the Manding-Songhay term *soro*, extensively used in reference to height and to two-story buildings in the savannah region.

A number of other *adinkra* patterns have a direct architectural reference. Thus, a plane representation of the *nyame dua* and an *aban*, a pattern which was formerly worn only by the Asantehene, were part of the design repertoire. Phonetically, the Asante term *aban*, used extensively in the palace context, is a close cognate of the Arabic-related term *abanna*, "to build," used in the northern savannah regions. The builder there was

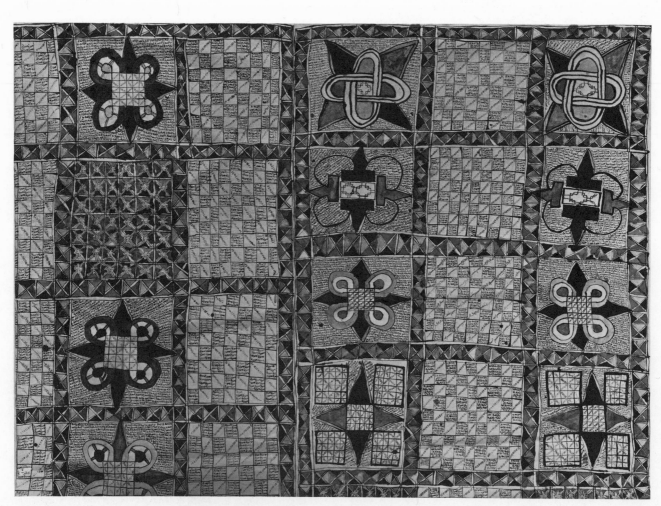

Fig. 8.10b Painted cloth, Ghana, no provenance.

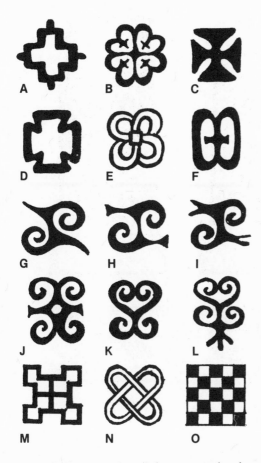

Fig. 8.10c *Adinkra* mourning-cloth patterns related to architecture and Islam. Drawings after Rattray (1927). Legend: *A. Aban*: circular house. *B. Nyame dua*: an altar to the Sky God. *C. Musuyidie*: something to remove evil. *D. Finhankra*: circular house. *E. Papani amma yenhu Kramo*: those who claim to be devout Muslims prevent us from knowing the true believers. *F. Nyame, biribi wo soro, ma no me ka me me nsa*: Oh God, everything which is above, permit my hand to touch it. *G. Nsa*, from a design of this name found on *nsa* cloth. *Nsa* cloth, made from camel's hair and wool, was used for the umbrellas or *katamanso* (the covering of the nation) used in all Asante political ritual. *H. Gyawu atiko*: literally, the back of the Gyawu's head. *I. Kwatakye atiko*: literally, the back of the Kwatakye's head. *J. Dwenini aben*: the ram's horns. *K.* and *L. Sankofa*: turn back and fetch it. Also the hawk, totemic symbol of the Oyoko lineage. Patterns H, I, K, and L all imply a conceptual reversal. *M.* The mark of a Hausa (Muslim) man. *N.* A wise man's knot. *O.* Checkerboard. While many of the patterns carry different names and meanings, they are, in fact, quite similar in form.

called an *al banna*. The Manding-Songhay term *soro banna* means "builders of terraces," i.e., two-story houses. The pattern could refer to either the circular shrines discussed above or to northern roundhouse construction. The motif most frequently transposed onto wall surfaces is *dwennini aben* or "rams' horns" (Fig. 8.11a). Found with equal frequency on *asipim* chairs or thrones, on geometric goldweights and on the leatherwork associated with political ritual and financial administration, this is also the motif most frequently ascribed to a Muslim source—not only because of its arabesque quality but, presumably, because of the symbolic use of the ram for sacrifices, for gifts, and for feasts such as that which occurs at the Tabaski festival, held in connection with Islamic celebrations.

Among the many Akan folktales, there is one which relates how Kwatima the ram acquired the name Odwenini in the course of a housebuilding effort. The leopard *osebo* and the ram *kwatima* each having decided to build a house, the two, unbeknownst to each other, began construction on the same site. The wattle-and-daub building went on apace, each ascribing the unseen, unaccountable daily progress to their respective ancestors. Finally confronting each other at the point of occupancy, the two agreed to settle down in it together. The ram, however, ran to the python for protection, which he earned by shaking hands with him. Hence the name, *odwa-nini*—literally, "shake hands with the python"—was given to the ram.[24] One is tempted to see in this mutual house-building effort not only the incorporation of the ram and its horns (traditionally associated with Islam) into the Akan pantheon, but perhaps the symbolic incorporation of stylistic Muslim elements into Akan buildings (Fig. 8.11b).

The relationship between the ram and the python also recalls the prevalent use of rams' horns in the military garb of the Asante fighting forces from the north. Bowdich described the projecting gilded rams' horns atop Asante war caps (see Fig. 1.14b), and Dupuis in his description of the plume on the headdress of the Asantehene's guards referred to an "arching pair of rams' horns, cased in gold and attached by the centre to several charms and amulets, neatly sheathed in Morocco leather."[25] The gold mask of a ram's head was looted from the Asantehene's palace in Kumasi at the end of the British-Asante War of 1874, and we are reminded of the rams' head masks and marionettes, often with metal appliqué, used in Bambara masquerades and festivals (Fig. 8.12).

Adinkra cloth motifs occur most frequently on leather artifacts incorporated into the Asante court panoply from the courts of her northern neighbors and subjects. In contrast to *adinkra* cloth, which is associated with life and death, leatherwork is related to the

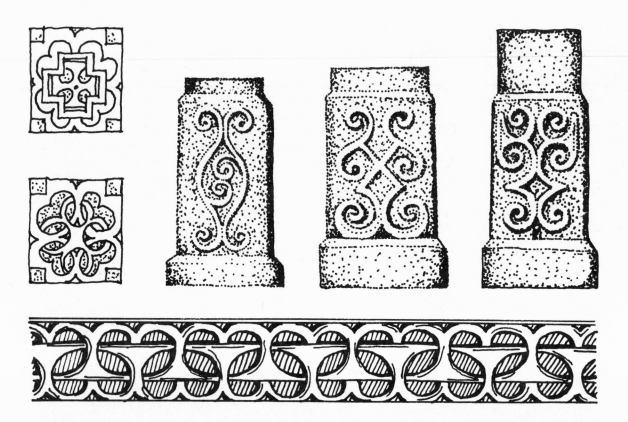

Fig. 8.11a Arabesque patterns and motifs used in various architectural contexts such as on dados, end walls, lintels, and columns. Drawing after R. A. Freeman (1898), and Swithenbank (1969).

Fig. 8.11b Among the Maures of Mauretania, a motif similar to the "ram's horns" is referred to as *eddar*, the house. Drawing after Gabus (1958).

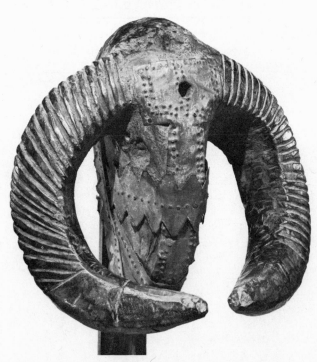

Fig. 8.12 A wooden Bambara or Sorko ram's head marionette from Mali, to which cloth and metal have been attached.

ceremony of the court, particularly in those contexts critical to the maintenance of its hegemony and viability: war and finance. Leather is scarce in the forest zones; it is a product of cattleherding on the savannah. In Asante, leather was most frequently used as an envelope for the amulets and talismans worn by commoner and king alike; it was also used extensively in a range of political situations requiring a protective envelope either conceptually or in reality (Fig. 8.13a, b).

The earliest published record of such a motif is on a leather sack or pouch collected in 1817 (Fig. 8.13c). These leather sacks, used extensively in the north as horse and camel saddlebags, appear to have been the predecessors of the *fotuo* or *nkotokwaa*, the Asante State Treasury. Early in the nineteenth century, the *foto* (the bag itself) was under the jurisdiction of the *gyasehene*, the head of the courtyard.[26] A more recent example of the *fotuo*, using a related motif, carries a metal lock superimposed on it, one not unlike those still frequently found in use among the Maures and the Tuareg. The design on the *foto* recorded by Bowdich is identical in form and patternwork to those found on Tuareg leather bags referred to earlier. The court treasury was heavily dependent upon the writing skills of the Muslim savants present at the court; while these were not court treasurers per se, they were critical to its successful function. What could be more logical than to incorporate the iconography of their own northern heritage into the new role they came to perform? The use of leather carrying cases as depositories persisted, despite the introduction of European-type coffers or treasury chests, in the nineteenth-century Greater Asante financial structure.[27]

Leatherwork was also an integral part of the trappings for horse and rider associated with early Asante military conquests. Although horses could not be used effectively in southern conquest, ceremonial use of the horse during the earliest period in the history of the Asante Confederacy implies that the horse may already have assumed a symbolic meaning in political ritual.[28] The subsequent formation of a strong military force based on northern Dagomba cavalry, the creation of the Kambonse, the conquest of the Dagomba, and the tribute demanded of them in the latter part of the eighteenth century all contributed to the increasing import and visibility of a northern iconography (Fig. 8.13d). The ceremonial ritual with its equestrian emphasis would presumably have come to be associated with rituals relating to the built environment, and the motifs on the protecting garb that enveloped warrior and horse alike would have been projected onto the ceremonial "stage" (Fig. 8.13e).

Variants of the *dwennina aben* pattern can also be found on many of the *asipim*, the thrones of leading

Fig. 8.13a Leather sandals collected by Captain Bowdich in 1817.

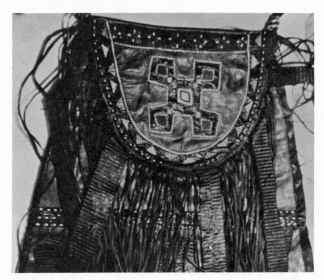

Fig. 8.13b Leather pouch collected by Bowdich in 1817.

personnel in the confederacy (Fig. 8.14). In contrast to the Asante stool and to the leatherwork-cushion thrones used by northern rulers (e.g., the Ya Na of Dagomba), the *asipim* is European in concept and construction, and there are references to its early introduction by the Portuguese on the coast. The process of Africanization and Islamization that it underwent in the course of its integration into the court panoply not only attests to the genius of Asante creativity but provides us with a model for the way in which the architectural repertoire evolved. Like the Golden Stool, the *asipim* provides yet another insight into the Asante homology of regalia, another indication of the increasing elaboration from simple shelter to meaningful architectural communication.

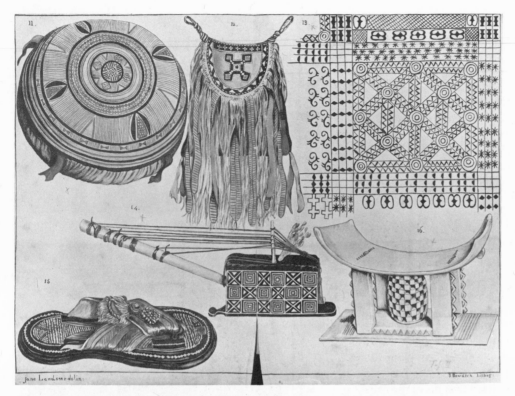

Fig. 8.13c Drawing of various artifacts collected by Bowdich in 1817. Bowdich (1821).

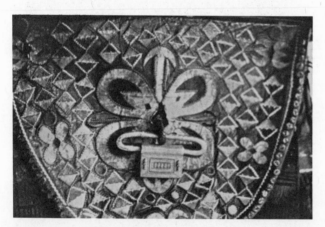

Fig. 8.13d Leather bags or *fotuo* used by the Asantehene's treasurers. The way these bags are carried can be seen in Kyermaten (1964), and Rattray (1929).

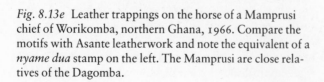

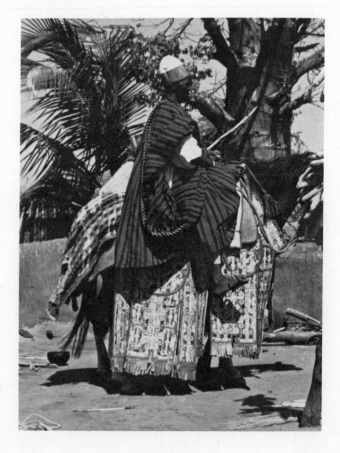

Fig. 8.13e Leather trappings on the horse of a Mamprusi chief of Worikomba, northern Ghana, 1966. Compare the motifs with Asante leatherwork and note the equivalent of a *nyame dua* stamp on the left. The Mamprusi are close relatives of the Dagomba.

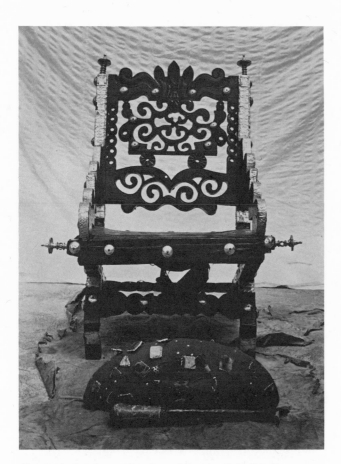

Fig. 8.14 *Asipim* or *akonkromfi* throne of the Berekum Hene of Brong-Ahafo, Ghana.

The extent to which the magico-religious aspects of Islam had infiltrated Asante society by the first decades of the nineteenth century, while documented by a number of scholars, has yet to be fully acknowledged. By the time the first European observers arrived in Kumasi, it was clear not only that Muslim iconography had enveloped traditional ritual but that its message had been visually transferred to the built environment. The style we have come to associate with traditional Asante culture had reached full maturity. The use of amulets on the body of everyone from king to commoner was matched by their use on buildings "from the palace to the slave's hut."[29] Concomitantly, Arabic script, actual or simulated, had become fully integrated into the Asante aesthetic. Nowhere was the effect of this transformation more obvious or overt than in the capital. One can only conclude that this formal shift mirrored the increasingly important role played by the Muslims in the unfolding drama of Asante state formation during the eighteenth century. Encouraged by the favorable attitudes of Asante rulers such as Osei

Kwame toward their northern neighbors both east and west, it presumably reached its peak in the last decades of that century.[30]

The earliest detailed rendering of Kumasi's architecture already illustrates the integration of Islamic symbols into the iconographic repertoire (Fig. 8.15). In the oldest house in the city, Bowdich found, adjacent to the oldest part of the house with its bare, unadorned wall surfaces, a recently built wing with highly ornamented surfaces, elaborate and extensive screenwork, and a very detailed upper-story register. One is led to conclude that the intensive elaboration of elegant wall surfaces developed after the initial construction, i.e., in the eighteenth century. Although the possibility of establishing a precise construction date for this "oldest house" appears remote, a clue may be the presence of an architectural feature totally alien to traditional rainforest custom: a built-in upper-level latrine. Bowdich called attention to its presence in both his rendering and his text. "Every house," he noted, "had its own cloacae, besides the common ones for the lower orders without the town. They were generally situated under a small archway in the most retired angle of the building, but not infrequently up stairs, within a separate room like a small closet, where the large hollow pillar also assists to support the upper story: the holes are of a small circumference, but dug to a surprising depth."[31] Despite some stylistic differences, the upper-level latrine and the use of an earthen pillar to house its wastepiping recall building practices in the northern savannah urban center of Djenné, as well as several Malekite prescriptions bearing on personal behavior which might call forth a unique architectural solution to sanitation and waste disposal.

Fig. 8.15 "The Oldest House in Coomassee" in 1817. Bowdich (1819).

The biography of Akomfo Anotche, the sorcerer-magician advisor to Osei Tutu who effected the descent of the Golden Stool, includes an account of the introduction of a new sanitary system. Once, while using the village latrine at Ntonso (the center of *adinkra* cloth-making north of Kumasi), Anotche was abused by the villagers. He "thereupon invoked a curse upon the town and foretold that quarrels would arise whenever it became necessary to make a new latrine. The Ntonso villagers therefore invented a new kind of latrine that did not necessitate constant renovation."[32] The term renovation in this context could be construed as either rebuilding or cleanout.

In Bowdich's drawing of the exterior of the king's bedroom, with its two doors opening onto an inner, thirty-foot-square courtyard, the *nyame dua* and the classic, ornamented *dados* and screenwork should be noted (see Plate 14). Moreover, "the colored bags hanging over the round doors (the chequering of which is in relief) contain Moorish charms."[33] These bags hiding script recall the *hatumere* over lintels, in which exposed Arabic script is used similarly for protection. The rounded corners of both the lintel and the threshold are quite out of context in wattle-and-daub construction; they recall, rather, the round openings which we have argued are a logical consequence of solid, earthen construction common to the savannah: presumably they were in this instance effected by means of a bent armature. The checkerboard pattern on these doors recalls the traditional Fulbe *khasa* and Dogon mourning cloths, which are often hung at door openings. The king's bedroom was ventilated by means of two carved, grillwork screens, the one on the left cased in silver, the one on the right in gold. Presumably, they would have been similar to the last remaining grills found in the shrine house at Kenyasi, although in the former instance, the design is an abstract one and in the latter, presumably of later date, there is an attempt to stylize the representational birds, symbol of the Oyoko lineage (Fig. 8.16).[34]

Bowdich described the palace complex:

[It was] an immense building of a variety of oblong courts and regular squares, the former with arcades along the one side, some of the round arches symmetrically turned, having a skeleton of bamboo. . . . They [the oblong courts] have a suite of rooms over them, with small windows of wooden lattice, of intricate but regular carved work, and some have frames cased with thin gold. The squares have a large apartment on each side, open in front, with two supporting pillars which break the view and give it all the appearance of the proscenium or front of the stage of the older Italian theatres. They are lofty and regular, and the cornices of a very bold cane work in alto relievo. A drop curtain of curiously plaited cane is suspended in front, and in each we observed chairs and stools embossed with gold, and beds of silk, with scattered regalia. The most ornamented part of the palace is the residence of the women. . . . The fronts of the [women's] apartments were closed by panels of curious open carving, conveying a striking resemblance at first to an early Gothic screen; one was entirely closed and had two curious doors of a low arch, and strengthened or battened with wood-work, carved in high relief and painted red.[35]

The contrast between the oblong courts with their upper stories and latticework screens and the square courtyards with their open, stage-like proscenia suggests a development of the prototypal spatial order of the south originally described by Müller, through the addition of two-story arcaded, oblong spaces. These latter are equivalent to the long narrow courts and upper-floor registers of cities such as Djenné, Tombouctou, and even Koumbi Saleh. They presumably reflected the developing complexity and the increasing economic and commercial functions of an expanding government administration. The arches with their bamboo armatures are related structurally to the earth-enveloped columns which, as we suggested above, are technologically derivative of wattle-and-daub construction; they also recall the traditional technology of Fulani-Hausa domes and the king's palace at Foumban. The far greater decorative emphasis on the walls of the women's quarters also invites comparison with nomadic architectures of the north.

The palace is easy to visualize when one studies a plan suggested as a prototype of a palace or *abanmu* for the provincial Asante capitals of the *omanhene* (Fig. 8.17).[36] Entrance is through the *gyase*, an open courtyard enclosed on four sides by *patos* or closed-in rooms and *dampons* or roofed-over spaces (a). The *patos* and *dampons* are three to four feet above the courtyard level. This first courtyard serves as an entrance or reception court; its form is a precise replica of the traditional stool shrinehouse. On the left are the drumhouses, and

Fig. 8.16 The carved and gilt wooden shutters from a shrine house at Kenyasi, Ghana. The hawks have been incorporated into an otherwise nonrepresentational arabesque patternwork. Drawing after Swithenbank (1969).

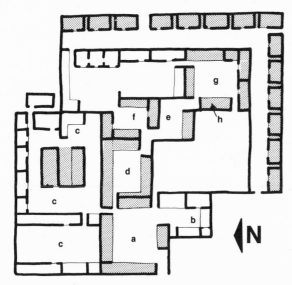

Fig. 8.17 Plan of the palace of an *oman hene* or regional chief. Drawing after Rattray (1929).

the drummers are on the south, opposite the reception dais occupied by the *omanhene* after the Adae Festival.[37] A smaller, appended courtyard is devoted to functions related to bathing (b). On the left, to the north, are areas for those activities associated with the mausoleum, the ancestry, and the *samanfo* (c). Directly above (a), the courtyard called the small *gyase* is used for lesser official affairs (d). Adjacent is the space where the chief and his guests eat, and beyond, the "big sleeping place" (e, f) with its associated functions and storage. On a diagonal axis from the dining area is the *abenase* (g), the courtyard where the chief and his elders discuss matters in private, and facing the *abenase* is a *pato* in which the goldsmiths work (h). The peripheral alleys that circumscribe the two distant sides are the wives' quarters, their linear arrangement quite distinct from the quadrangular courtyards of the palace core, the *gyase*.

Although it is in the palace, the *gyase* is an architectural replica of the traditional shrinehouse and the paradigm core-unit is replicated cumulatively in the process of extension and enlargement. In this context an early account that "the houses are all erected on the same plan, from that of the King, down to the lowest rank of Captains" can be easily understood. European visitors to the king in Kumasi were received in this first courtyard, a "large open, slightly oblong, square yard about 80′ × 45′."[38] It was in this courtyard that the king sat to receive presents, i.e., it was the scene of ritual exchange. The dais on which the king sat was in precisely the same cardinal relationship to the courtyard as

the *dampon* that houses the actual stool shrines in the shrine prototype.

Despite the attention paid to this traditional Asante architectural style by numerous authors, almost no consideration has been given to those responsible, either individually or collectively, for its creation—i.e., its architects and builders. Here we can only call attention to several historical factors that bear on that creative building process.

The Asante policy of eighteenth-century northern expansion, in which the Dagomba fighting force was welded into a powerful military arm of the Asante Confederacy, brought with it an increasing flow of northern slaves into Greater Asante and down to the coast.[39] The household slaves and "pawns" worked and slept in the *gyase*, the internal, central courtyard of the compound. Indeed, it has been suggested that the *gyase fo*, the people of the courtyard, were originally recruited from the slave class. The emergence of the *gyasehene* as a critical household administrator followed the growth of the household into a vast building complex. By the early nineteenth century, the *gyasehene* or head of the exchequer employed a Muslim secretary to keep records of political events. Equally relevant in this context is the fact that the *asuman dan*, the fetish house in each residential complex, was built by subjects of the *gyasehene*—presumably northern slaves or *donkor*. It is tempting to conclude that the inner core, the spiritual heart of the compound, had in its germinal stage a northern component, introduced by a labor-force well versed in the building technologies of the derived forest savannah in the Asante hinterland. The presence of large numbers of Muslims in areas of political concentration early in the nineteenth century, both as slaves and as freemen, contributed further to the architectural aesthetic of their host culture.[40]

The *abanase*, the courtyard of deliberation and decision-making, the political core of the building complex, was surrounded by *dampons* and *patos* built under the supervision of the *sana hene* or court treasurer. He and his assistants were officers of the *abanase*, and he had in his labor force a Muslim scribe. The hallmark of his office, in its formative stages, was the *foto*, the leather pouch of northern provenance referred to above. The need for the skills of the Islamized record-keeper in the bureaucratization of the finance system suggests that his role became more critical as time went on: the visual import of the written word would have found architectural expression on the walls that bounded his working spaces, analogous to similarities between design motifs on the earlier geometric gold-weights and wall patterns (Fig. 8.18).[41]

The Muslims' record-keeping role was not limited to the exchequer. By the late eighteenth century, they

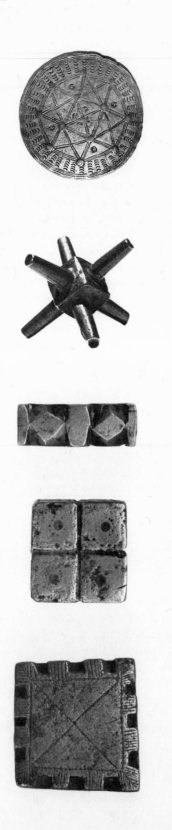

Fig. 8.18 Asante goldweights, incorporating various geometric and arabesque patterns as well as spatial configurations into their design format.

had begun to play a far more complex, integrative role as practitioners of preventive medicine. The so-called court physicians who may have been responsible for the creation and administration of protective and healing medicines, many in the form of charms and amulets, performed an equally important function as recorders not only of battle casualties but of military events themselves. Thus, the "Arabic medical staff" on the coast in 1807, in attendance on a Muslim Hausa chief who participated in the Asante military thrust to the coast, was present to administer medical aid and to record casualties. This composite role of diviner, magician, scribe, and physician—particularly in light of the efficacy of the written word as visual communication in both a religious and a secular context—may well have affected the character and quality of traditional architecture.

In traditional shrines and houses, the facade of the raised *dampon* faced into the interior courtyard; in Kumasi, the capital city, *dampons* faced out, like porches, onto the main, ceremonial ways leading to the palace, creating a grand piazza approach. This architectural reversal, reflecting the increasingly complex functions of the capital, the various regulations relating to attendance at politically instituted festivals, and the ritual formalities associated with them, ushered in a new system of visual communication.

The towns of regional rulers were all on the model of the capital; in addition, each regional ruler had a private establishment in Kumasi. The *dampons* became the facades of these townhouses, and the configuration which in the regional capital faced into the courtyard now faced onto the main public way in the manner of a proscenium. Each regional chief and his entourage were expected to be present at a number of festivals, and his *dampon* was in itself a symbol of ritual participation. Its position visually expressed the entire supportive network of the confederacy along the major approach to the palace entrance.

Since family and kin remained behind in the provincial capital, there was no major household to be accommodated. The representative in the capital had no need to accommodate an extensive court, but he had to communicate his presence there. The architectural reversal therefore paralleled the shift from the private, internally oriented efficacy of the script to the public display of script which we suggested above in the context of the body's envelope. Overt architectural communication enhanced status previously validated only through dress.

The accelerated proliferation of the *asuman dan* or stool shrine reflected the changing quality of the expanding confederacy from a religious to a politically based structure. As religious symbols of political power, stool shrines legitimized political status. Thus,

the corporate nature of a clan owning a determinate parcel of land was symbolized by its stool or *abusua dua*, the first ancestor to assume the land in question. The distribution of stools, not only to lineage but to nonlineage kin, i.e., commoners or those who earned their political position by merit rather than inheritance, generated a further proliferation of stool shrines.[42] Settlements were transferred by sale or pledge in order to enlarge the distribution of political power. Again, since political power required religious sanction, and the stool became synonymous with the unified ancestry of the Asante nation, each land transfer required a new stool and a new stool shrine. This custom explains a number of shrines distant from the capital and the use of the style as a symbol of allegiance. As late as 1898, the style could be found wherever the political arm of Asante rule extended (Fig. 8.19).

As early as 1817, Bowdich observed "a new house somewhat in the Ashantee fashion" at Dunkwa. It had been built by the *caboceer* Payntree, an Asante headman who, with the approval of the Asantehene, had founded the new town of Dunkwa.[43] Several years later, Dupuis, en route from the coast to Kumasi, described the architecture of the new town in greater detail:

> The houses of the inhabitants are built in the style of those of the Ashantees. A piece of ground is first cleared, and a framework according to the plan and dimensions of the intended edifice is erected, with some regard to regularity. This frame consists of long poles, sunk below the surface at each angle. To these poles they attach hurdles by means of a strong lashing of fibrous twigs ... the interstices being afterwards closely filled up with clay, which is smoothed over with rubbing stones; this gives it solidity and uniformity. Bamboo and palm boughs are employed for the thatch, which from its regular structure has a more pleasing effect than the rude boughs and grass used on the coast. The house of the Caboceer consisted of an assemblage of apartments quadrangularly enclosed in the form of three squares; linked together by avenues. ... I could not avoid remarking that the plan upon which the more wealthy part of the community built their homes, resembled that of the Moors of Barbary; the only striking difference was between the thatched roofs of the former, and the terraced covering of the latter.[44]

In 1820, when Dupuis passed through Fomenah, he had found it only "another little village," but in the course of the nineteenth century it underwent tremendous growth as a result of Kumasi's increasingly important southern connection. By 1862 the city was on a major route from Anomabu to Kumasi northeast of Dunkwa, and a decade later, by 1875, it was the capital of Adansi, one of the territories of the Asante metropolitan region and clearly a place of considerable import.

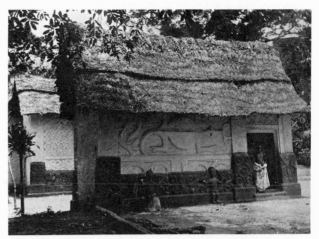

Fig. 8.19 Entrance room facade of a shrine house at Ajwinasi, Ghana, in 1896. The shrine room, with its elaborate screenwork, is visible behind. The two figures sculpted in mud appear to be a later addition to the wainscoting. The courtyard facade of the shrine room, one of the four units bounding the *gyase* or courtyard, can be seen in Hodgson (1901), p. 168.

The continuing presence of the Asante style many decades later in Fomenah (Fomena), was noted in an eyewitness account of 1874. While en route to Kumasi, Stanley commented on "the broad avenue flanked by family residences one story high with their very steep roofs, crossed by an equally broad street and at whose crossroads the king's house was located." He described the house in which he was lodged as "a fair specimen of Ashantee architecture. Externally this house presents us with four houses, each of which is about ten feet long by six feet wide, standing corner to corner and enclosing a quadrangle or court."[45] The exterior of the house was unpretentious, but he and his colleagues were struck by the originality of the interior, its cleanliness, and the elaborate ornamentation:

> For a height of three feet above the ground, the walls are painted a reddish ochre color, and so is the floor, but above this they are of a waxen white, covered their entire length and breadth with designs in alto-relievo, half an inch thick, cornices are set off with many grooves, friezes with singularly bold-diamond-shaped designs with embossed centres, pediments are something of the Ionic order, severely plain and square, the walls with intricate scroll-work relieved by corollas in alternate squares.
>
> The alcoves are open, raised to the height of the ochrish-coloured portion of the walls, and are six feet in depth, by about eight feet in length. In the inner courtyard, the front of the alcoves are divided by one or two round columns supporting an open lattice-work in waxen-hued plaster obtained from white clay. ... In the center of the inner courtyard is a little tree.[46]

Stanley's eloquent description, if taken at face value, suggests that the architectural style was still being actively reproduced in the heyday of Asante rule in key regional capitals, in sharp contrast to the basic unadorned forms which had given rise to it in Adanse, centuries before.

The open latticework and simulated fretwork screens of so much of Asante architecture, particularly in its interior courtyard facades, were not only a continuing expression of cultural and political cohesion; they were still using Islamic design aesthetic and Islamic spatial organization. Although materials and technology—the medium—differ, these openwork screens vividly bring to mind the geometric configuration of a *hatumere*, a magic square, which governed the two and three dimensions of space in the wooden grilles of Djenné and Tombouctou and the walls of Bida, and in the space frames which evolved in the architectural history of the Fulbe-Hausa Emirates (Fig. 8.20). Even when the design configuration incorporated new totemic and anthropomorphic representational subject-matter in order to transmit a new message, the structural grid remained.

The traditional, distinctive architectural style remained both viable and consistent throughout the nineteenth century—with one exception, a stone structure within the Kumasi palace compound. Its presence suggests the ambivalent political ideology manifested by confederacy leadership during the early decades of the century. In the early nineteenth century, under the aegis of Osei Bonsu, the Asante government not only maintained a strong northern, pseudo-Islamic connection but more intensively developed its northern trade connection. At the same time, however, events along the coast demanded increasing attention to the south. Asante policies were forced to become increasingly Janus-faced. Thus, while the earlier years of Osei Bonsu's reign were steeped in Muslim-oriented tradition, the later years included ideological conflict between an increasingly active, anti-European war party in his court and direct contact with the Europeans on the coast.[47] Increasing military preoccupation with the European presence found its symbol in a new architectural ideal: the castle.[48] Considering the political atmosphere, Osei Bonsu's interest in a European castle and flags, English architecture, and the British Museum is readily understandable.[49]

The original intention of building some kind of "palace" (and not a castle) for a personal residence has been attributed to Osei Kwaduo, a former Asantehene whose reign had been heavily imbued with Muslim tradition. When Osei Bonsu voiced his intent to build immediately upon the termination of the Gyaman war of 1818–1819, what he had in mind was a house for his

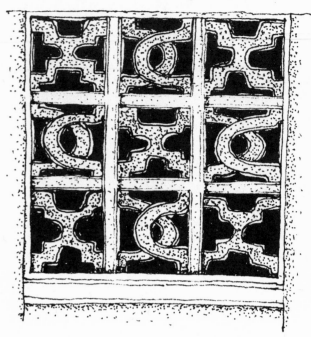

Fig. 8.20 A screen from the shrine house at Abirim, Ghana, recalling the three-by-three magic square. Compare this screen with the *katamba* at Bida, Nigeria (Fig. 7.29a) and the facade of the Old Halls of Justice below (Fig. 8.21). Drawing after Rattray (1927) and Swithenbank (1969).

own residence, a "private apartment." This idea was quite out of keeping with the character of a traditional palace complex and indigenous non-Islamic patterns; while the Asantehene may have expressed an interest in English architecture, the model in his mind's eye appears rather as an elaboration of the existing architectural style. The house was to be "roofed with brass pans, beaten into flat surfaces, and laid over an ivory framework appearing within. The windows and doors to be cased in gold, and the door posts and pillars of ivory. Whether the Moors originated or encouraged this extravagance . . . or whether it was the scheme of his own disposition . . . the King dwelt ardently on the intention."[50] We are reminded once again of Ibn Battūta's description of the audience chamber of the king of Mali in the fourteenth century.

In 1820, Dupuis observed the palace-*cum*-castle under construction, and reported two conversations. "That building you see is to be made very grand. The inside shall be gold, ivory and *brass-pan*." Arriving at the palace, Dupuis found the king "actively engaged in a crowd of artificers, soldiers, captains and laborers. 'I am building,' said the King to me as I entered, 'a fort like Cape Coast Castle; but I shall make it very high that I may look out and see all the town.' A number of large and small trees had been cut in the forest and

dragged to the spot with infinite labor. These were sunk two or three feet in the ground, and reared at certain distances apart, forming in mass a small quadrangular enclosure, supported by other trees of less dimension, attached crossways by horizontal and diagonal supporters, lashed together by fibrous vegetable cordage."[51]

The king's desire to emulate a European model is clear; the described building process, however, was the traditional wattle technology. Dupuis recorded the building of the protective shroud of palisaded walls which, while reminiscent of traditional fortifications, are also, to this day, a prerequisite to the construction process of any sacred artifact or structure. The palisading is removed upon completion of the more permanent structure only after appropriate sacrifices have been performed for its consecration. The palisade provides surrogate protection until ritual itself, celebrating completion, is able to establish a more conceptually efficacious protection. This concept of protection through secrecy parallels the behavior associated with the creation of new masks, the preparation of magic talismans and charms, and the building process for all sacred structures throughout West Africa.

Although the "castle" was reported to have been completed in early 1822, Osei Bonsu's persistent and well-documented adherence to Muslim tradition and a policy of peace makes his reported preference for European military imagery ambiguous.[52] In any case, there can be little question that the final structure was the singular architectural expression of a strong military ideology rather than a quintessential statement of Asante nineteenth-century culture.

The stone house, "called the Castle and standing on the royal premises," was observed again in 1842. Aside from a reference to a set of stone steps and the comment, "It is built of stone, has a flat roof, and is about the size of many of the small villas in the vicinity of London," there is no architectural description.[53] However, the abundant display of both European and indigenous artifacts within the confines of the Asantehene's private apartments, elaborated on in great detail, suggests a display of wealth associated with the European palace tradition.[54]

Apart from the stone structure, "all other buildings are of wood and swish, erected on the same plan from that of the King down to the lowest rank of Captains; and these are, with few exceptions, the only persons who are allowed to build in any public situation."[55] The proscription against building in a public situation presumably referred to the *dampons* permitted to regional representatives. Thus, while the stone "castle," an equivalent to the *abenase*, remained completely hidden in the inner recesses of the palace complex, the *dampon* of the court emerged into public view.

Although Europeans came to visit Kumasi with increasing frequency in the decades that followed, the only other detailed references to the Stone House are found in the various accounts of the Asante-British War of 1873–1874. Two observers to the scene were Henry Brackenbury, a professor of military history who accompanied the British troops sent to loot the palace, and Henry Stanley, the well-known British journalist from the *Illustrated London News*.

Brackenbury first observed "the high wooden paling which bounds the enclosure of the palace. Entering by the gate in the paling, we found ourselves in the enclosure of the palace—a very large irregular pile of building, partly formed of thick walls of masonry, enclosing rooms two-stories high, and partly of great open courts, similar to those already described at Fommanah, only on a far larger scale, with raised rooms open to the court and the same high, pitched roofs."[56] According to Stanley, the palace was composed of "a number of houses with steep pitched roofs, clustered together and fenced round with split bamboo stakes, occupying an area 400–500 feet square, at one corner of which rose a two-storied stone building. In appearance it was like any of those merchants' residences which we saw at Cape Coast Castle." After describing the contents in the "alcoves" or *dampons* of the palace complex, he and his companions "on proceeding finally to the stone structure, which is the king's private residence, found the interior court and rooms opening upon it filled with curious but intrinsically valueless articles, while the upper story contained much valuable plunder," all located on "the interior of the king's bedchambers, his private apartments and storerooms."[57]

Thus, the major part of the wealth and treasure of the government was not on public display but, rather, was concentrated and secreted within the confines of the Asantehene's private upper-story domain. Its location again recalls the preferential use of a second story for the personal residence of those in high position—not unlike the pattern common in northern Islamized urban centers.

There can be no doubt that the purpose of this Stone Castle was to reflect the increasing militarism and the focus of the Asante Confederacy on its southern hinterland. But like a shrine house, like a coffer or treasure chest, like an amulet, it remained deeply hidden within the recesses of the palace complex, barely projecting above the steeply pitched thatch roofs of the great courts that surrounded it.[58]

Despite the favoritism extended to the Christian presence in the capital at mid-century, political and ideological attachments to its northern hinterland continued as a strong undercurrent. This was a period of great political stress, and its leadership relied, as a last

resort, on "the Moorish Necromancers and fetish priests [who] continue to be the guiding spirits in Ashantee politics."[59] Indeed, evidence for the viability, vitality, and vibrancy of the traditional style appears in the rapidity with which much of the palace was rebuilt in the decade after its destruction. Despite suggestions that the city never recovered from its 1874 holocaust, by 1883, under the stimulus of a popular regime, a considerable reconstruction of *dampons* and palace courtyards had taken place. The Halls of Justice, presumably destroyed in 1874, would have been rebuilt in this period or shortly thereafter, upon the enstoolment of Prempeh I in 1888 (Fig. 8.21).

The regeneration was short-lived. Hampered by the disruption of a monolithic political structure, the eruption of civil war, the fragmentation of tribute-paying constituencies, and the general breakdown of a tightly controlled leadership, efforts to rebuild were limited. The architecture, once the political symbol of a unified empire, received its deathblow in the wake of the British conquest. In 1896, the mausoleum or *barem* at Bantama—the key monument in the ancestral legitimation of the empire—was destroyed, and by 1900 little remained of the Asantehene's palace: "The stone buildings of which it had been composed had been pulled down and the stone used in the work of building the fort."[60]

The degree to which the traditional style was an integral expression of Asante political cohesion is best illustrated by the still-extant stool shrine houses, many of which were built during or immediately following the final Asante resistance to the British in 1901.[61] These buildings, with their rich open-fretwork lintels and screens, often adjoin the chief's house, in which an equally elaborate internal courtyard or *gyase*, on which the still-sacred chief's bedroom faces, can be found.

In the decades following the British conquest in 1896, another style, based on *swish* technology with its three-foot-high courses, entered the architectural scene. Once the wattle-and-daub technology fell into disrepute, the technique of *alto-relievo*, achieved by bending strips of bamboo into an arabesque fretwork tied to the wattle framework, was no longer possible. Mural decoration was executed by an applied bas-relief or painted surface. The abstraction and symbolic quality of the earlier high relief was gradually replaced by two-dimensional flatwork, in emulation of the photographs and drawings brought to Kumasi by Europeans. Mural designs, with easily identifiable, literal subject-matter, were painted on *swish* walls.

This transition in technology and iconography can be seen at Adarko Jachi, whose traditional buildings were reputed to have been built about 1870. Superimposed on the pilasters and columns that flank the

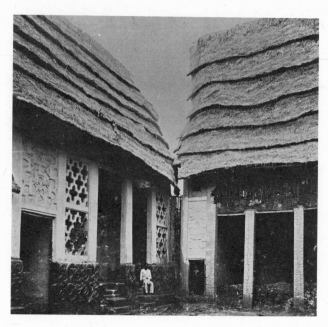

Fig. 8.21 The Old Halls of Justice, Prempeh's Palace, Kumasi, Ghana, 1896.

older arabesque screens and lintels are a hunter, a gun, a lion, an elephant, and a leopard, all sculpted in earthen bas-relief. The walls of an outer courtyard, added on after the 1901 uprising, were built of solid *swish*, and clumsily executed representational motifs have been applied on them. A similar development is in evidence at Abirim, where the house occupied by the Oyokohene when he visits the village, sits in close proximity to the older shrine house. The polychrome *sankofa* or bird, the inscribed plaque (similar to a Koranic tablet), a hawk (symbol of the Oyoko clan), and a small tree (presumably a *nyame dua*) are a new representational artistic vocabulary for the same subject-matter that the older style had abstracted. Finally, in the courtyard of the temple to Ta Kora at Tano Obuase, the single remaining indication that the shrine was originally in the traditional mode is the pair of arabesque motifs that flank the steep steps leading into the shrine room on the face of the threshold.

This new style was a direct outcome of changes due to English colonization. The introduction of European education and literacy, the building skills generated by the requirements of the Colonial Service, the build-up of service industries and European communication networks—and, above all, the introduction of a new political order—brought about a new, status-laden set of architectural symbols and a new set of media to convey them. However, the underlying relationships that created the spatial frame of the traditional style

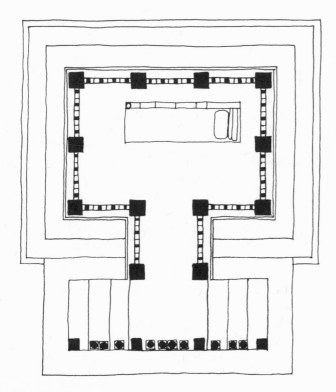

persist to this day, finding new expression, for example, in the recent proliferation of monumental tombs and mausolea (Fig. 8.22).

The mausolea in Patakro, in Bonwire, and in Kumasi are a few examples out of many. Built now by apprentices to those trained in the European-run workshops of the former Public Works Department and Missions, they utilize a new iconography. Concrete balustrades and railings have come to replace the traditional screenwork and arabesque moldings on monuments, not to political power per se, but to individuals still important in the traditional social structure. Thus, after seventy-five years of the European presence, a new set of symbols, in a new vocabulary, has been integrated into the Asante aesthetic, but the aesthetic itself still derives from the deep-seated spatial structure that initially gave rise to the Asante style. *Dampon* and *gyase* are integrated into a new relationship.

Recent documentation of the shrine in the village of Patakro in Adanse reveals the meaning-in-context of these shrines (Fig. 8.23).[62] Immediately adjacent to the four-unit shrine house is a more recently built mausoleum of the village chief, an equivalent to the *barim*.

Fig. 8.22 A tomb at Ahwia on the Mampong Road near Kumasi, Ghana, completed in 1947. Drawing after Rutter (1971).

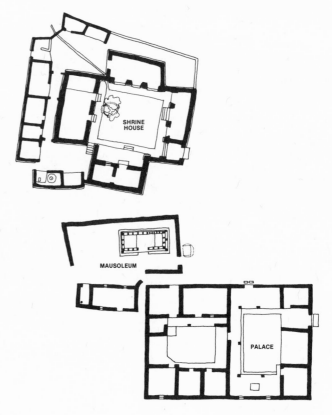

Fig. 8.23 The shrine house, palace, and mausoleum of the chief of Patakro, Adanse region, Ghana. Drawing after Hyland (1975).

South of the shrine house and the mausoleum, the "palace" of the chief—actually, his private residence—continues to reflect traditional spatial organization. This close spatial relationship of shrine, mausoleum, and residential complex reflects the continuum of ancestral validation and legitimation described in other cultural contexts.

In tracing the course of development of the traditional Asante architecture, we have stressed the ideological and complex intellectual contribution of Islam and northern cultures to Asante affairs during both its period of growth and its nineteenth-century apogee. Perhaps our emphasis is due partly to the fact that Islamic involvement in shaping Asante destiny is easily discernible in the realm of the arts, where it finds overt expression. It is equally true that more than elsewhere during those same epochs, Islam penetrated deeply into the indigenous Asante politico-religious structure, and it is less than surprising that this contribution should coalesce in the architecture. After all, while architecture does address itself to man's basic needs, it is a medium par excellence through which ideology is communicated in non- or pre-literate societies. When a strong polity is brought into a previously egalitarian society, architecture can, by its iconography and visual form, imbue the deeper spatial structures of the habitat with appropriate new meanings. In essence, then, we have attempted to suggest that while the spatial, behavioral, and ritual structure upon which the architecture was based varies little from that recorded by Müller in 1676, the built environment that materially and physically enveloped that structure was a function of political communication.

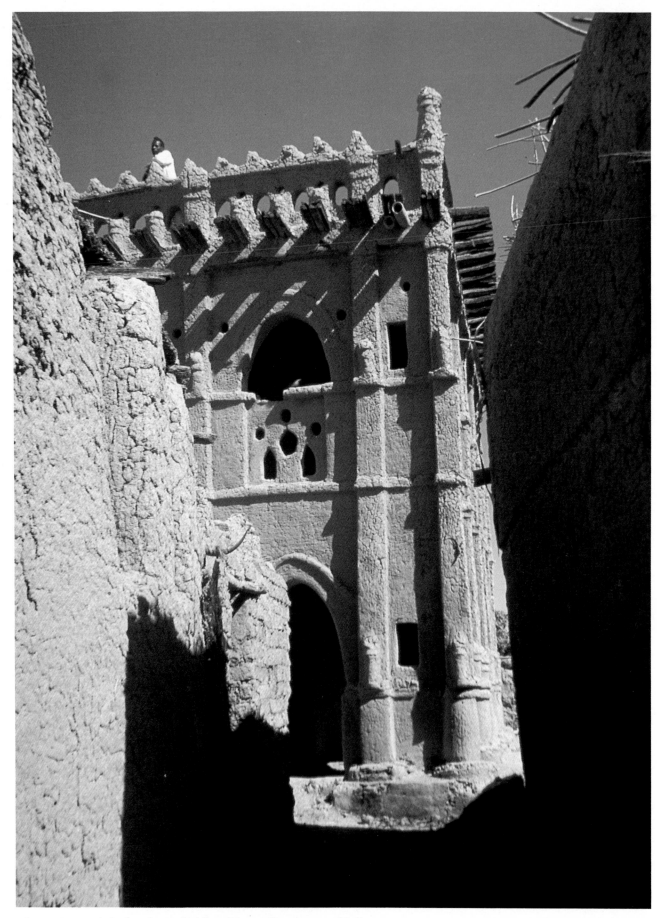

Plate 8 A recently built *saho* on the Niger River at Kouakourou, Mali.

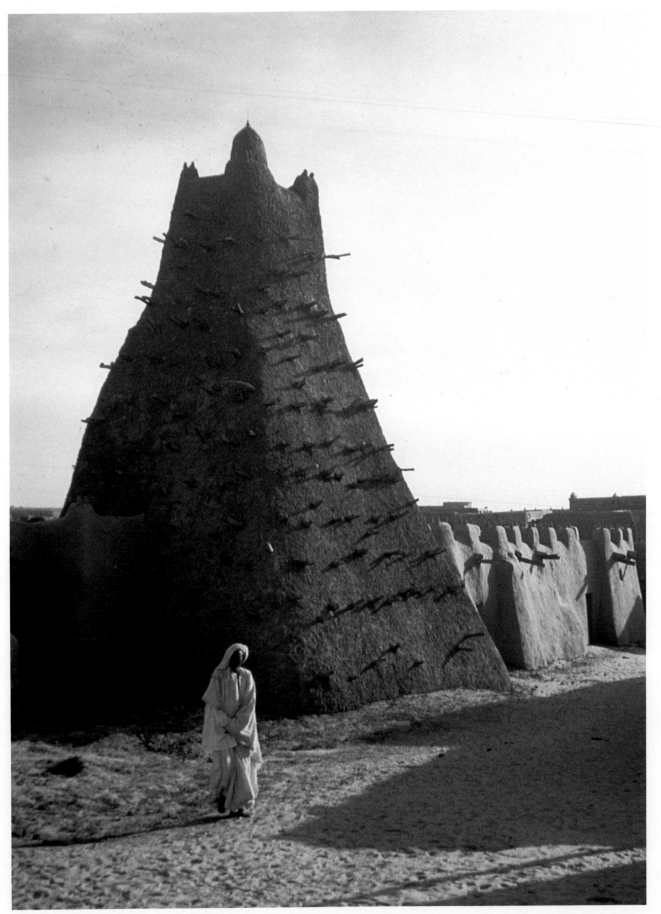

Plate 9 The Sankoré mosque at Tombouctou.

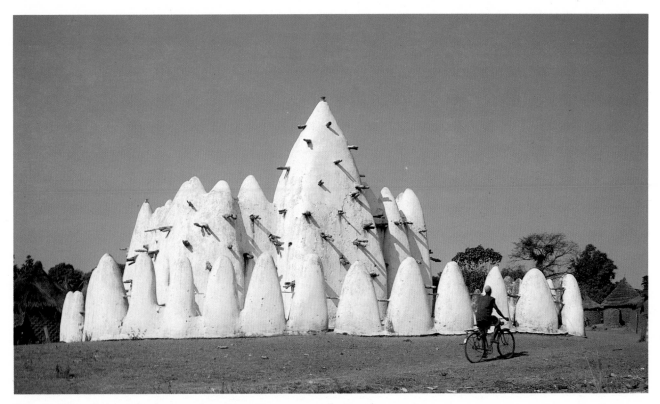

Plate 10 The mosque at Kawara, northern Ivory Coast, among the Senufo.

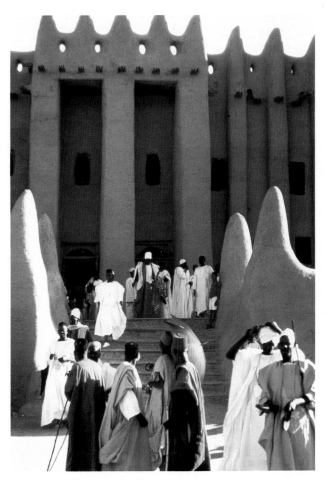

Plate 11 The entrance to the Great Mosque at Djenné, Mali.

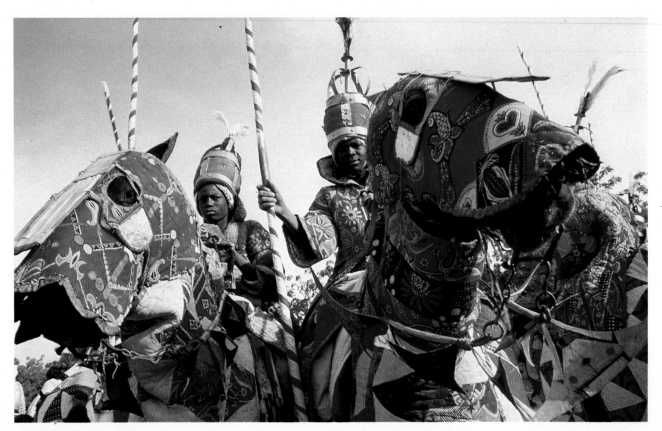

Plate 12 Northern Nigerian cavalry.

Plate 13 The Great Mosque at Dingueraye, reputedly built in 1883 by the family of El-Hadj Umar.

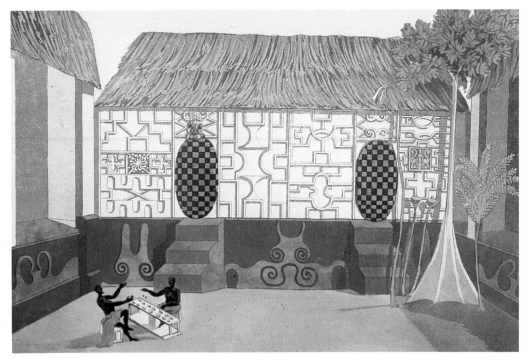

Plate 14 The courtyard of the king's sleeping room, Kumasi, 1817. "The stunted silk-cotton and the mancineal tree are fetish or sacred, as are the white and red flags at the top of the pole, and the small brass cups supported by the forked sticks." Bowdich (1819).

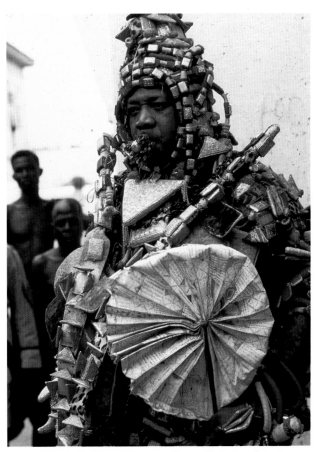

Plate 15 The Asantehene Prempeh II at his enstoolment, Ghana.

AFTERWORD

Discovery begins with the exception. In the course of our researches on the Islamic presence in West African design, it was often suggested to us that if we searched deep and looked long enough, we would discover parallels with and recognize traces of Islam in everything. It is this moment of recognition that spells solution in the arts as well as in the sciences.

Merit and demerit, praise and castigation, will invariably attend the evidence we have selected to present and how we have chosen to interpret it. Some may object to our use of the exception to argue the rule, to our claim of Islamic attribution when available documentation belies such assignment. Some may likewise argue that long-term experience in the context of heavily Islamized cultures has itself strongly biased *our* observations. It is not our intent to wage a *jihad* in the field of traditional West African design, but, rather, to weave a new interpretive design by enriching the warp of tradition with the weft of Islam.

Our experience has suggested that the Islamic presence is far more pervasive than has been admitted to date. It is like the amulets and talismans in West African dress: only when the layered envelopes of gold, silver, grass, leather, cloth, or thread are stripped to the inner core does Islam, hidden—like so many aspects of West African life—from the observer's eye, reveal itself.

At the same time, the scholar who peers at traditional behaviors through a Western lens will often, albeit unconsciously, filter out images clearly recognizable to those who gaze through the lens of Islam. We

are reminded of a researcher who looked at the entrance of a house every day for months but never "saw" the design detail of a written charm framed and mounted over the door lintel across the way. Only when attention was called to it did it register in the mind's eye as a feature worth observation, and only after comparison with others in the same genre did its similarity to a *hatumere* become evident.

Critical questions of definition constantly confronted us from the beginning. What is Islamic? What are the measures of its expression in the traditional context? Is there an Islamic system of visually perceptible signs and symbols? If such a system exists, how universal is it and what are its variants? These are the same concerns that occupy all scholars of Islam.

In the course of its spread into West Africa, Islam encountered traditional practices, doctrines, and customs. Some of these were receptive: they accommodated and assimilated the new "way." On occasion, traditional practices were contravened by Islamic practices. And Islam could itself accept some aspects of customary law and behavior and accommodate itself to certain forms of animist belief. In this process, changes occurred that permitted the integration of minimal requirements associated with the principles of the Islamic faith into traditional systems.

This multi-valence takes expressive, physical form in the facade of the Poro hornbill mask and the incantations to Allah inscribed on its inner, hidden face; in the sacrifice of a bullock and the Arabic script

255

applied to its skull; in the random application of both animist and Muslim charms to *batakari* and *diousene*; and in the multiple names attached to residential space in traditional urban centers.

In the course of West African history, traditional signs and symbols were more often enriched by the introduction of new levels of meaning than "destroyed" by or transformed into Islamic precepts. The most valid criterion for the presence of Islam in design appears to be in a collective recognition of particular concepts and behaviors as uniquely associated with the bearers, adherents, practitioners, and proselytizers of the new faith, and in turn, with the perceived efficacy of the signs and symbols such association imparts to them. As throughout the world, Islam in West Africa inherited many symbolically rich cultural traditions and was often integrated as one facet of a multivalent expression. The formal expression of Islam is rarely discrete and specific in the indigenous context. Rather, self-determination and self-identity in various contexts establish the Islamic content of traditional design.

One of the exciting discoveries for us was the recurrence of signs and symbols—recognizable and identifiable motifs and patterns—in the fabric of many diverse cultures. While it is true that extensive ritual and conceptual "borrowing" among peoples with supposedly discrete linguistic and socio-cultural traditions has tended to blur the evidence, so that the expression of ethnicity is not quite as clear as some would presume, the cultural differentiation itself highlighted the framework into which para- and supra-ethnic expressions of Islamic identity and definition could be integrated. It is in the cosmopolitan, pluralistic and heterogeneous realms beyond ethnicity that these pan-African, Muslim-associated modes and patterns are most prevalent and evident. Ties to *place* assume equal value with ties to kin in establishing self- and group-identity. Concepts of territoriality defined by kin-circumscribed boundaries often give way to concepts of territoriality defined by economic and political linkages. While identity with Islam may originally have been established and reinforced through family affiliation, it is now equally recognized by and acknowledged through toponymic association. Kin-group allegiance is joined and sometimes replaced by a political or state allegiance phrased in the religious tenets of Islamic universality. What emerged with great clarity was that the most obvious illustrations in our assemblage came from the context of political, elitist functions in traditional West African society. In other words, the Islamic component of the traditional art form found quintessential expression in the "arts of the establishment." The architectural and decorative imageries born of sedentarization and urbanization not only transcended cultural identity

and the specifics of ethnicity, but assumed political dimensions in the name of and under the flag of various *jihads*. The ethnic imprint waned as the imagery assumed increasing political meaning; its symbolic aspects were nurtured by social and class identity rather than ethnic affiliation.

Islam has always been considered to be an urban religion, and the artifactual evidence from West Africa supports that generalization. However, it became evident to us in the course of our researches that gradations of commitment from ethnic self-identity to Islamic self-identity extended across the entire spectrum of the rural-urban continuum and that the material evidence of Islamic expression common to the urban environments of the savannah were quite different from that generated by Islam's subtle infiltration into rural cultures. Traditional behaviors and beliefs seem to have absorbed and integrated more of the magico-religious elements of the Islamic faith, though the hidden realms of divination and augury vary little from the Arabic *sihr* or "magic." Frequent references in the past to the production and prevalence of *gri-gri* and "recipes" for the common man and to the influential role of "physicians," diviners, advisors, and scribes in the entourage of traditional African courts indicate the intensity with which Islam permeated the traditional rural ethos. Contemporary documentation, rich in references to Allah and Medina in ritual, to Muhamed as a genealogical ancestor, and to world views bearing a close resemblance to Near Eastern cosmologies, is further testimony to the facility with which the conservative tradition could accommodate Islam. This rural interface became a caveat: comprehension of the more overt, recognizable, and acceptable material evidence of the Islamic presence necessitated consideration of this covert presence—and vice versa.

In our effort to establish the Islamic parameters and content of West African design, we used the social character of the art form as our point of departure. Realization of any art form requires consideration of the conceptualization of an idea for the work; the limitations imposed by the artifacts associated with its creation; and the development of a conventional language through which the artist can communicate to the audience. Two corollary considerations in this interpretation are the division of labor within the creative process, and the dialogue between creator and client or audience, which modifies the language of expression.

The Muslim came to West Africa as an immigrant. As with any immigrant traveling under harsh conditions, the major portion of his cultural baggage was conceptual. He brought with him from North Africa fixed ideas about the way to accomplish a given task: how to welcome the newborn, how to acknowl-

edge maturity, how to marry a woman, how to bury the dead, how to build a house, and what a sacred site should look like. When reinforced by group isolation, such concepts are particularly durable. At the same time, the conservative setting of the host culture tended to maintain and perpetuate its own system of conceptual baggage. It is the radical process of change, involving the breakdown of traditional social networks, that facilitates receptivity to new ideas and their realization in new forms of expression.

Muslim immigrants carried few tools or furnishings with them, but they carried a more important resource, a "visual" bank of images from North Africa of what environments ought to look like and how artifacts ought to be made—the design resources of the written word. The written word with its design constructs was the mnemonic device that provided the continuity of conceptual imagery. Islamic calligraphy, its graphemes organized in the formal configuration of geometries rationalized through astronomy and theology, served as the equivalent of a set of working drawings for a new system of spatial organization and surface delineation in the built environment. The content of the written word established new three-dimensional orientations in space and behavioral prescriptions appropriate to them, and the two-dimensional surface patterns that ordered the words on a page reinforced North African memories through visual identification.

Traditional African society depended on the oral arts for the transmission of knowledge; the learning process, social control, and definition of time were effected through verbal communication. Introduction of the written word not only enhanced the traditional oral mode, it was instrumental in the development of a new visual mode of communication. Initially, traditional symbols of communication and control such as the drum, the linguist's staff, and the chief's crown and stool or throne merely incorporated the written word into their design repertoire and imagery. The written word, abstracted from its content into pure form, required few changes in traditional technologies or systems of long-distance communication. The oral tradition, subject to the vicissitudes of idiosyncratic interpretation and the frailties of human memory, was joined by a mode that enhanced permanence, reinforced memory, and provided a *mimesis* or substitute imagery. The written word and those who possessed and controlled knowledge of it assumed omnipotence.

Even when illegible to a non-literate audience, or perhaps *because* it is illegible, calligraphic inscription became sacred and evolved into a new symbol system. Arabic calligraphy, like the Japanese *kanji*, integrates meaning with the art form: the two are often interchangeable. Abstracted and stripped of its *specific* con-

tent or meaning, the medium itself, the geometric patternwork, became the message. The symbolism of the written word became an aspect of the decorative surface. Its sacrality was extended to any patternwork associated with Islam: *hatumere* became a generic term.

The Muslim immigrant's visual memories, sacralized in the pages of the Koran and the "recipes" that derive from it, was reinforced by transportable artifacts: woven, embroidered, and metal goods imported from the North provided aesthetic models. In time, while technological limitations blurred the meaning of the grapheme, they enhanced its geometric form. The latter became the basis for the design motifs which occur again and again and for the etymology of Islamic symbol in West Africa. Stripped of its ideological and conceptual rationale, the patternwork on artifacts associated with the Muslim presence, power, and status was abstracted into a visual sign-symbol system to communicate affiliation and self-identity.

The immigrant's visual memories of Islam also included a knowledge of the properties of familiar building materials, of technologies for processing them into usable form, and of methods for assembling them. For the most part, however, this knowledge was inapplicable in West Africa. Replication of imported models was impossible using local resources. When an artist depends on the services of others for some necessary component, he or she must either accept the constraints they impose or expend the time and energy necessary to provide that component in some other way. This dependency puts a number of conceptual and physical constraints on the creative process. Unfamiliar materials, less familiar climates, and less developed technologies affected volumetric characteristics as well as preferences in color, texture, and decorative detail.

At the same time, out of this framework of constraints new designs, new technologies, and new skills came into being. The horizontal patternwork of Berber tapestries, born of a broad loom, could only be simulated on a narrow weft loom; assemblage of a large number of small, finely cut and carpentered wooden elements into a Moroccan *khatem* grillework could only be emulated by cutting and carving voids from a solid wooden block; cast, sun-dried brick and cut, dressed stone required a new set of technologies in wood and metal; architectural tile, characteristic of Islamic architectural orthodoxy, was impossible; North African domes could be simulated only through an innovative technology of reinforced earthen ribs; embroidery techniques on cloth and leatherwork required the importation of appropriate tool kits. For us, technological change is the key to understanding and interpreting not only West African building, but weaving, leatherworking, embroidery, and even sculptural traditions.

Technological change obviously occurs in the context of sociological change. Under conservative conditions, technological modification is gradual, incremental, and limited; it is primarily at critical disruptive or constructive junctures in the social process that the opportunity for major technological innovation presents itself. In the rural hinterland, the infiltration of Islam had little technological impact. Traditional forms were at best modified only enough to accommodate a new symbolic repertoire into an existing framework; to maintain continuity with the past remained paramount. For example, hand-molded bricks or puddled-mud techniques continued to be used for village mosques, and symbolic representations of ancestral earthen pillars were incorporated into them. Under conditions of radical change such as urbanization, the introduction or emergence of new technologies not only brings into play innovative aesthetic criteria born of the technology itself, but provides a more receptive field for new symbols. The development of embroidery, leatherworking, and cast-brickmaking in West Africa are cases in point.

The acceleration of the urbanization process in the West African savannah, which Islam was so instrumental in, provided a radically new social setting, one in which new technologies could develop and a new design aesthetic could more easily evolve. Under these new conditions, the skills that matured and flourished were those that accommodated themselves to the shift from a characteristically conservative, collective production process to a specialized one with its attendant procedural complexity. Weaving, for example, seems to have developed in West Africa much as it did in the course of medieval Europe's early urbanization. The builders, the weavers, the leatherworkers, the embroiderers—and to some extent the metalworkers—were consolidated into specialized castes and guilds. A restricted membership, defined by inheritance and validated by knowledge (albeit minimal) of the written word, acquired proprietary rights over the production processes essential to the creation of an art form.

The shifts in the production processes accommodated by the emergent urban setting also involved a shift in gender roles. Changes in design format, in aesthetic preferences, and in the content and meaning of the West African art forms are also better understood when examined in the light of the division of labor by sex. In rural West Africa, particularly prior to Islam, skills such as weaving, leatherworking, and wall finishing were in the hands of women. These were the very skills increasingly demanded by the Islamized client. The Muslim immigrant, however, was almost always male, and even today Islam continues to be male dominated and male focused. Its iconography continues to be derived from masculine skills and techniques. Urbanization and the social heterogeneity that followed Islamization opened up new social niches into which male craftsmen and artists could enter but into which women had no access. In response to increasing demands for leatherwork, for woven goods, and for new construction, a new class of craft itinerants emerged. Men could move with far less restraint from one urban scene to another on demand, they were more immediately responsive to the commercial and ideological requirements of the new Islamized elite, and they were more receptive to the male-oriented symbolism of Islam. This gender transfer in the control over traditional technologies also had considerable impact on the organization of and orientation in space. Indeed, future research on the design changes that have resulted from gender-role shifts, rarely considered to date, promises a wealth of insights into the West African aesthetic process.

Restrictions on membership in the emergent castes of specialized skills perpetuated ethnic identity, but at the same time the mobility, urban contact, and aesthetic requirements imposed by Islamized, ruling clients weakened the ethnic expression inherent in the product. The iconography of the patternwork woven, embroidered, tooled, or built into the art product is now referred to in the etymology of Arabic terms and explained with reference to Islamic symbols as frequently as to indigenous ethnic ones. Furthermore, since members of these newly emergent craft fraternities now depended on an urban clientele, they identified far more strongly with their resident quarter than with distant kin. Often called upon to travel long distances in order to fulfill commissions on demand, they became better known by association with a particular urban enclave than by their ethnic affiliation. This association with place is even more evident in the case of skills introduced by Islam itself.

Changing systems of power and control affected the perception of space and shifted the foci of its definition. Knowledge, a primary source of power, was traditionally acquired and transmitted through the secret societies and their initiation rites staged in the hidden depths of the natural environment. With the introduction of the written word, knowledge could be acquired and transmitted outside the ethnic group. Power derived from secrecy was matched and superseded by power derived from public display of group identity. And just as those associated with the production of the secret symbol were perceived as possessing supernatural powers, so were those associated with the production of a public symbol of knowledge. The secrecy

which continued to reinforce the efficacy of an amulet, whether its contents were animist or written, was joined and occasionally replaced by the open display of signs and symbols of membership in the newly acknowledged political and economic status groups. A public announcement communicating political control can be as efficacious as the word hidden in the recesses of a talisman or amulet.

Changing systems of socio-political organization under Islamic hegemony also altered concepts of space. Subjective space and anthropomorphic imagery were joined by, and eventually replaced by, objective, *ka'ba* centered space and geomorphic imagery. Aniconic, hodological space linked to natural symbols was joined by and eventually gave way to cosmological space mathematically defined by the heavens. Atectonic space gave way to architectonic space and aspirations of verticality in the built environment.

In traditional West African belief it is in the natural world that harmony with a divinity is sought. The idea of a public, religious edifice is in direct opposition to the indigenous religious assignment of sacrality to the natural symbols in the landscape. Traditional West African belief and ritual are marked by pseudo-edifices. At the same time, the natural schema of traditional belief uses the four classic elements of water, fire, earth, and air—a division that also lies at the basis of Islamic cosmogony. With the introduction of Islam, traditional symbols were readily integrated into the cardinal directions of space and a mathematical, volumetric construct. Brought from the spiritual world of the bush into the world of the living, symbols such as the cosmic tree now designate the living, human-built centers of compounds, villages, and towns.

Changing the world of natural symbols into a world of mathematical built ones involved a shift from anthropomorphic to geomorphic centers. Cosmologies and cosmogonies which revolved around a family or kin-based center in the earth below foot were transformed into myths that spoke of an origin in the East. Anthropomorphic symbols of ancestry and sacrality such as the earthen pillar and the forked post began to merge with the geometry of sacred Muslim space, enveloping the living as well as the dead, in the form of sacred circles of stone or monumental mosques. Thickets and groves, the hidden sites where initiates acquired maturity and wisdom, were enhanced by a built shrine, and matched, in the center of the village, by the new symbol of knowledge: the mosque and its facades. It comes as no surprise that almost every mosque in West Africa is accompanied by a tree visible to the community. In like manner, the mosque's location is of necessity adjacent to the tree that marks the founding of a community and defines its center. Natural sites endowed with sacrality were thus linked with man-created sites, sacralized through human involvement and new allegiances.

The shift from anthropomorphic to geomorphic space involved a parallel transfer from a subjective to an objective interpretation of space. Such a shift logically includes substitution, in the liturgical realm, of geometric imagery and iconography for the anthropomorphic representation that lies at the basis of the African sculptural tradition. For us, it is not so much the Muslim prescriptions against the graven image per se which led to the gradual demise of the African traditional sculptural heritage in those regions where Islam took hold, but, rather, a gradual shift in ontology. The characteristic continued use of both iconographies in a single work of art reflects the duality inherent in the organization of West African aesthetic expression.

This shift from the world of natural symbols to a world of man-made ones also helps us understand the new concern with "monumental" architecture and its symbolism as much as does the urban ideal espoused by the Muslim commentaries. The political hegemony that evolved in the course of Islamization transformed architectural symbols from ancestry-related forms to political forms. Palaces, city walls, and gateways as well as housing and mosques became the architectural signs and symbols of status, elitism, establishment, and urbanity.

The interface between human behavior and the physical environment, codified in ritual patterns, generated substitute imageries: in the realm of the natural world, elements of nature provided the subject-matter for iconography; in the Muslim realm, mathematical and geometric imagery provided the subject-matter for symbol. The same behavior-environment interface contributed to the process of spatial reorganization. The new, universal concept of the cosmos not only introduced a new way of relating to space but another way of moving in it. Institutionalization of a new set of behavioral prescriptions involved the elaboration, and ultimate substitution, of the kinetic of circularity around a localized center into a directional kinetic oriented toward a far distant center: Mecca.

Ritual behavior occurs in both space and time, and among the changes Islam wrought was a shift in the way cycles of time were reckoned. The patterns dictated by the immediate environment were translated into cycles based on the lunar calendar and rationalized by the astrological perspective of a zodiac whose twelve signs summarized the principles governing the cosmos. Time in West Africa, like space, is reckoned ambiguously: the Muslim New Year and the observation of Ra-

madan are precariously balanced each year against the seasonally imposed calendars of agricultural activities.

Although we have suggested a conceptual transformation in the organization of space, its realization in the built environment was difficult. Symbolic and iconographic aspirations were often out of phase with what could be achieved with the existing building form, dependent as it is on conservative technologies and traditional behaviors. Because it is easier to manipulate surfaces than forms, recipient walls, like clothing, became critical in establishing and communicating a new identity. The imprint of sacred Arabic calligraphy on an architectural facade is far more easily achieved than a new architectonic configuration that necessitates a complex set of technological changes.

In sum, we have attempted to suggest the nature of Islam's role in transforming traditional West African aesthetics and technologies. The mechanisms of this transformation can be found in the development of craft specialization, in the requirements of emergent political and economic systems, in nascent urbanization, and in the exigencies of military expansion. Encouragd by Islamic patronage, inspired and rationalized by Islamic belief and adherence, and influenced by immigrant preferences, these mechanisms found aesthetic expression in the formulae of the written word. The visual symbols of Islam devolved into surrogate expressions for indigenous meaning; the symbolic expression of indigenous meaning evolved into new visual forms associated with Islam.

In explicating the process of change that resulted from identification with and allegiance to Islam in various strata of traditional societies, we have suggested a set of transformations in the aesthetic itself. Both symbols and their meanings underwent change. The shift in emphasis from a system of natural symbols to a system of man-created symbols was accompanied by a shift in preference, from anthropomorphic to geometric referents, and from atectonic to architectonic environments. The shift from ethnocentricity to universality, in conjunction with the development of new building technologies, led to a preference for square and rectangular forms over circular ones which was in turn expressed in both behavior and the built environment. The incorporation of Islam into the political structure of indigenous leadership caused a shift from a belief in the power of secrecy, to power derived from the public display of group identity. The process of sedentarization, to which Islam contributed, witnessed not only a critical shift in sex roles associated with various art forms but a reversal in design emphasis from interior to exterior surfaces. The values associated with the transmission of learning through oral communication were enhanced by values associated with the use of the written word and its visual attributes. Structure of space and sense of place were redefined in terms of verticality and light as the sources of existence.

We have argued, perhaps more forcefully than others, for the sometimes barely discernible, yet subtly omnipresent, Islamic imprint on traditional West African societies. In every instance, the transformation was derived from a reinterpretation of indigenous aesthetic preferences and symbol systems, starting with the biogrammar of the human body and ending in the universals of the sun, moon, and stars. We have also stressed the more overt expression of Islam in those realms in which the religion was closely associated with instruments of political, economic, and social change. Most importantly, we have sought to convey the nature of the aesthetic of African Islam as a continuum of commitment from token to orthodox. In so doing we hope some new light has been shed on the ways in which Africans themselves express that commitment.

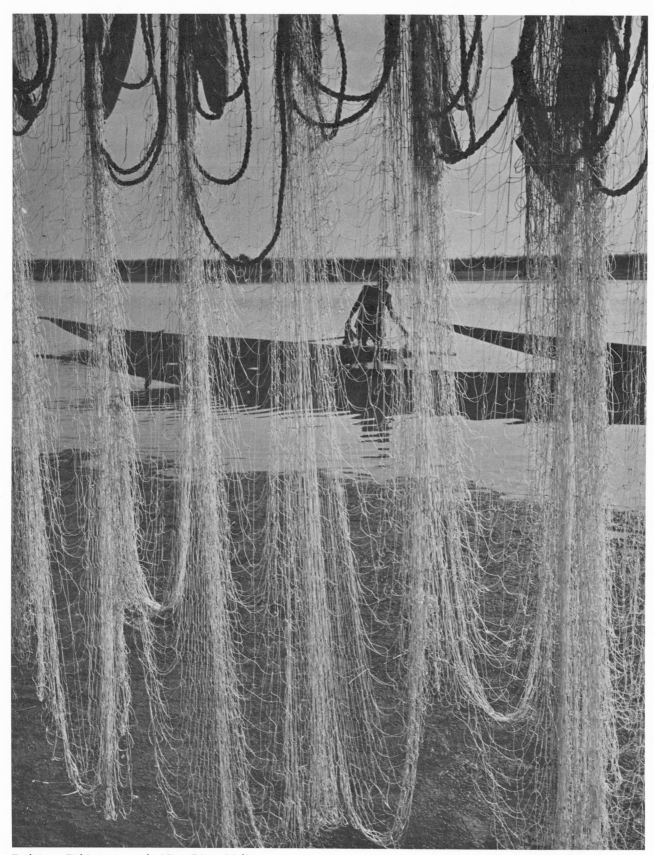

Endpiece. Fishing nets on the Niger River, Mali.

NOTES

Chapter 1

1. J.-C. Froelich (1962), p. 11, describes the unique nature of Black Islam as "bien particulier, très différent de l'Islam méditerranéen ou proche-oriental, différent aussi de l'Islam maure; Islam repensé, repétri, négrigié, adapté aux caractères psychiques des races noires." A. Hampaté Ba (1972), p. 41, using a more eloquent metaphor, suggests that "il peut arriver, il arrivera très fréquemment, qu'en s'islami-sant, un pays adopte une des couleurs multicolores que le gigantesque prisme triangulaire islamique peut offrir, en dé-composant la blanche vérité divine dont l'Islam diffuse la lu-mière. . . .

En Afrique, l'Islam n'a pas plus de couleur que l'eau; c'est ce qui explique son succès: elle se colore aux teintes des terroirs et des pierres."

2. Victor Turner (1974), p. 161, for example, calls at-tention to the "fascinating historical and diffusionist problem . . . posed by the close resemblance between Dogon myth and cosmology and those of certain Neo-Platonist, Gnostic and Kaballistic sects and 'heresies' that throve in the understory of European religion and philosophy. One wonders whether, after the Vandal and Islamic invasions of North Africa, and even before these took place, Gnostic, Manichaean and Jew-ish-mythical ideas and practices might have penetrated the Sahara to the Western Sudan and helped form the Dogon *weltbild*."

3. Gutkind (1953), pp. 121–124.

4. S. and P. Ottenberg (1960), p. 67.

Julius Gluck (1956), pp. 65–82. The article was trans-lated and republished in *The Many Faces of Primitive Art*, ed. Douglas Fraser (Englewood Cliffs, N.J.: Prentice-Hall, 1966)

and again more recently in *Peoples and Cultures of Africa*, ed. Elliott P. Skinner (Garden City, N.Y.: Natural History Press, 1973).

In Oliver (1971), the irony of using the term *shelter* is dramatically illustrated by the dust jacket, where the title has been superimposed on the color photograph of a Fulani-Hausa facade in northern Nigeria whose very existence de-rives from a symbolic expression of meaning and not from its function as part of a physical shelter per se.

5. This new awareness is exemplified by the establish-ment of the Aga Khan Program of Islamic Architecture at Harvard–MIT and the encouragement of contemporary ar-chitectural expression in the spirit of Islam through the Aga Khan Awards. See, for example, Michell (1978) and Heath-cote (1976).

6. A notable example is Bravmann (1974).

7. Denyer (1978), Oliver (1971), Willett (1971). For an annotated bibliography of architectural references in North and West Africa see also Prussin and Lee (1973).

8. A particularly relevant discussion, in which it is sug-gested that the advent of linear perspective is directly related to the way people began to "structure" the physical world in their mind's eye appears in Edgerton (1975). Dorothy Lee (1960) has also suggested, for example, that the Trobrianders act according to a non-lineal pattern, whereas in Western cul-ture the line is so basic that we take it as a given in reality.

9. Vansina (1965).

10. David (1971), Bedaux (1972), Posnansky (1973), McIntosh (1974).

11. El Bekri (1965).

12. Ibn Battūta (1929); Ibn Khaldûn (1967). The reports of the Arab geographers writing about Africa have been assembled in Yūsuf Kamāl (1926–1951).

13. Ibn Battūta's *Travels*, written with the eye of a geographer, is the first exhaustive eyewitness account of sub-Saharan Africa by an Arab scholar. The details of the report are in many instances precise enough to permit comparison with current building practices in the Western Sudan, which he visited several times. For example, in his discussion of shea butter, *gartī*, he noted that it was often used as a binding agent in building construction, a practice continued to this day: "They mix it with the earth and spread it on the houses as one does with a lime wash." Ibn Battūta (1966), p. 45.

14. Es-Sadi (1964), Kâti (1964), *Tedzkiret en Nisian* (1966).

15. For a discussion of the probable nineteenth-century additions and revisions see Levtzion (1971).

16. Préchaur-Canonge (1962). Reference to these *mapalia* can also be found in the writings of Pliny the Elder.

17. The Roman mosaic image appears to have remained in the mind of classical scholars centuries later. Henry Barth, the nineteenth-century German classicist-turned-explorer, rendered an almost identical variation on the *nouala* in an otherwise precise drawing of the matframe tents in the Kanem region of West Africa. Traveling south along a route through the Fezzan, past the ruins of Roman sepulchres and funerary monuments into the Kanem region, it is hardly surprising that his classical background, with its pre-formed imagery, was reinforced in his mind's eye. The association is clearly evident in a description of the matframe tents that he noted in the Damerghu region ([1857–1859], vol. 1, pp. 415–16; vol. 3, p. 604): "In examining these structures, one cannot help but feel surprised at the great similarity which they bear to the huts of the aboriginal inhabitants of Latium, such as they are described by Vitruvius and other authors, and represented occasionally on terra cotta vessels." Vitruvius, a Roman engineer in the Augustan era, wrote a highly influential treatise on Roman architectural principles.

18. These accounts have been summarized most recently by Joseph M. Cuoq (1975).

19. For an excellent analysis of the difficulties of interpretation of medieval European cartography, see Kimble (1938).

20. See, for example, the accounts of J. de Barros, *De Asia*, in Crone (1937); Fernandes (1938); and Pacheco Pereira (1937).

21. Jannequin (1643).

22. Dapper (1668), Müller (1676).

23. Le Maire (1695), Froger (1698).

24. I am grateful to Marian Johnson for pointing out the close parallel between the Dapper plates and those in Pierre Van der Aa Marchand, *La Galerie agréable du monde*, 1648, in the Bibliothèque Nationale, Paris. See Hirschberg (1962), p. 55; Loyer (1714). Loyer visited a number of villages along the littoral from Rufisque and Cape Verde to the Gold and Ivory Coasts. In contrast to the very clear indication of major architectural differences in the text, the housing in all these places is represented identically. Perusal of the text is revealing: in several instances not only were drawings borrowed, but Le Maire's phraseology and descriptions were merely elaborated. In all fairness, however, it should be noted that a number of Loyer's descriptions, in no way corresponding to the plagiarized drawings, do reveal critically relevant details. For example, he describes the two-story palace of the king of Issyny, with its "entrelace" of woven laths covered with mud and painted in earthen colors, types of stairs, condition of the wives' quarters, and arrangement of courtyards (para. 123).

25. Compare Mage (1868b), p. 31; Skertchily (1874), p. 319; and Piétri (1885), p. 157.

26. Barth (1857–1859).

27. Verne (1863).

28. Drawings which initially appeared in serialized accounts not only reappeared in published volumes but in other, unrelated volumes of the same publisher, in the same and in other languages. Various national geographic journals also freely borrowed drawings from each other in unrelated accounts. Figures used in this chapter reappear in J. E. Chambliss, *The Life and Labours of David Livingstone* (Philadelphia, 1875); in E. Chaudoin, *Trois Mois de captivité au Dahomey* (Paris, 1891); in Richard Burton, *Two Trips to Gorilla Land* (London, 1876); in Richard Oberlander, *West Afrika* (Leipzig, 1878); in various French and English editions of Réclus's *Universal Geography*; and in *Globus*.

29. In the course of his advance from the coast to Kumasi at the time of the British-Ashanti wars of 1874, Henry Brackenbury (1874), vol. 2, pp. 4–5, spoke of the "dreary, oppressive monotony of the great primeval African forest, in which not a spark of color lit up the endless green. To live from day to day always shut in by this dense wall of foliage on either side, always the same dark-green, always the same luxuriant growth of huge ferns, palms, and creepers interlaced and tangled in a thousand weird forms; for days and weeks never catching a glimpse of a real horizon—always enclosed by these walls, which none the less imprison because they are of leaves and not of stone. . . ."

30. Mollien (1820a), p. 122.

31. Dalzel (1793).

32. Victor Hugo, *Büg Jargal* (Paris, 1826); Alexandre Dumas, *Le Véloce* (1848–1851), an account of a visit to Tangiers, Alger, and Tunis; Fromentin (1857), (1859); Delacroix was an official member of de Mornay's embassy to Morocco in 1832. For a comprehensive survey of the exotic attraction North Africa held for metropolitan France, see Lebel (1952); Pierre Jourda, *Du romanticisme à 1939* (Paris, 1956), vol. 2, pp. 59–75.

33. See Brunschwig (1966), pp. 24–30, for the relationship between geography and colonial expansion in France.

34. Caillié (1965); Denham, Clapperton, and Oudney (1826); Park (1799).

35. The Société de Géographie at Paris began publishing its *Bulletin* in 1822, and the Royal Geographical Society of London first published its *Journal* in 1830–31, but the flood of pseudo-scientific, geographical journals only began in the 1850s and '60s. *Petermann's Mittheilungen* appeared

in 1855, *Le Tour du Monde* in 1861, *Globus* in 1862, *De Aarde en Haar Volken* in 1865, and the *Geographisches Jahrbuch* in 1866. Although the *National Geographic* did not appear until 1901, the American Geographical Society was founded in 1852.

36. The only other novel in the corpus of the Voyages Extraordinaires that deals with West Africa is the posthumously published *L'Etonnante Aventure de la mission Barsac* (1919). The setting for this final work included parts of what are now Guinea, Mali, Upper Volta, and Niger.

37. Since many of Riou's drawings continue to be used to illustrate the contemporary literature on the history of Islam in West Africa, his work merits particular attention. Edouard Riou made his debut at the Salon of 1859 with some early Egyptian landscapes, and while they were judged mediocre, it was presumably his familiarity with Egypt that several years later netted him a contract to illustrate Jules Verne's novel set in West Africa. His familiarity with the Egyptian milieu explains the spirit of his illustrations, and the choice of both illustrator and rendering style unquestionably reflected France's then-current preoccupation with Egypt, Islam, and North Africa. Riou's illustrations reinforced the prevailing ethos, which endowed the West African savannah and sahel with a North African flavor, but the seeds of an almost schizoid imagery were already apparent in a set of drawings he had just finished in collaboration with Biard for the latter's series of articles, "Voyage au Brésil," *Le Tour du Monde* (1861), pp. 1–49, 353–400. The comic, disparaging caricature of Brazilian Black society intensified in the decades that followed, paralleling the ideological distinctions being made more and more frequently between White and Black Africa.

The geographical, technological, and colonial fervor of the times, within which the close ties between Verne and his publisher Hetzel unfolded, led to new commissions for Riou. Hetzel was also the publisher of *Le Tour du Monde* and *Le Temps*. Verne's *Voyage to the Center of the Earth*, *Captain Hatteras*, and *Around the World in Eighty Days* were all illustrated by Riou. Since the original plates for the Verne novel were also used in foreign editions, the impact of this single illustrator extended far beyond the bounds of metropolitan France.

Many of the military, pseudo-geographical exploratory missions into West Africa were first or concurrently serialized in weekly journals such as *Le Tour de Monde*, *Le Temps*, and *L'Illustration*, so it comes as no surprise that the accompanying illustrations carried Riou's signature. Thus, by the last decades of the nineteenth century, at the height of France's colonial fervor, Riou had virtually become the official illustrator for the innumerable primary accounts of French military, colonial, and exploratory involvement in West Africa. Yet his denigrating caricatures had turned him into an outstanding visual polemicist for racism—although, to my knowledge, he himself had never set foot in West Africa.

The publication sequence of *La Vie au continent noir* illustrates the way in which the shifting visual imagery gradually emerged. The book, a predecessor to Félix Dubois's far better publicized *Tombouctou la mystérieuse*, was first serialized in *L'Illustration* in 1892 as "La Vie noire," and was illustrated with the watercolors of Adrien-Marie. This painter, who worked in the tradition of Delacroix, accompanied the Brosselard-Faidherbe Mission to Guinea and the Fouta-Djallon. Each serial installment reported on the mission's adventures. A year later, when these were published in book form by Hetzel, the romantic, soft-toned, imaginative, and sensitive aquarelles were replaced by Riou's distorted, polemic hard-line drawings "according to the Marie documents." Yet, in the same year, Riou equivocally rendered the former palace of Ahmadu at Ségou, Mali, in the heart of the Islamized savannah (Fig. 6.30c) in a most realistic, sympathetic, and sensitive style, reminiscent of the North African milieu.

38. See Collins (1965) for a discussion of the theoretical training of military engineers in France in the nineteenth century, with its heavy emphasis on architecture "in harmony with the usages, climate and constructional materials of the locality" (p. 194).

39. Zola (1899). Félix Dubois was first and foremost a journalist, or, as he called himself, a "publiciste." Prior to 1892, he contributed brief articles to *L'Illustration* that dealt with religious matters and the Near East. At the end of 1890, he was sent by the journal to accompany the Brosselard-Faidherbe Mission, whose purpose was to reach the source of the Niger River in the Fouta-Djallon of Guinea. The account of his trip appeared in serial form in *L'Illustration* and was then published in book form with new illustrations by Riou. On his return, he was sent to Jerusalem, where he wrote a special Noël supplement on Christmas in Bethlehem. Equipped now with a knowledge of West Africa and the Near East, he was the logical choice for an assignment to Tombouctou. Fresh from travels in a milieu comparable to the West African savannah (in contrast to his earlier rainforest trek), one can assume a bias conditioned by his Near Eastern experience. Using Egypt as his frame of reference, he suggested that the entire middle Niger valley was another valley of the Lower Nile, but even vaster and more opulent. At the same time, he laid the basis for the hypothesis—which has persisted to this day—of Egyptian origin for the architectural style in the area of our concern.

40. The Senegalese Village was part of the auxiliary Exposition Coloniale, while the "house of a Muhamedan from the Western Sudan" formed part of a third exposition complex, an "Histoire de l'Habitation" assembled and designed by the architect Charles Garnier. The inspiration for both pavilions was directly derived from drawings in the published accounts of Mage and Gallieni.

41. Form was defined as "cone-on-cylinder," "cone-on-cube," "pyramid-on-cube," etc. Such formal typologies were (and are) misleading and of little analytic use in the West African setting, since they failed to acknowledge the properties of building materials, variation in building technologies, and use of space itself.

42. Concern with these divergent approaches was raised by Victor Turner in *African Systems of Thought*, ed. Meyer Fortes and Germaine Dieterlen (London, 1965), pp. 9–15. The subject is also of critical concern in the *Colloque sur les cultures voltaïques* (1967).

43. Viollet-le-Duc (1895), p. 9, suggests that "the

beauty of a structure [lies] . . . in the judicious employment of the materials . . . placed at the disposal of the constructor." This theme is developed subsequently in *Habitations of Man in All Ages* (1876), pp. 381ff.

44. Sir Banister Fletcher, in *A History of Architecture on the Comparative Method* (New York, 1948), the architectural bible for several generations, divides his monumental work into two parts: "Historical Styles," and "Non-Historical Styles." Under the latter he includes all non-Western subjects.

45. Read (1965), p. 98; Pollio Vitruvius (1914), pp. 38–39; Bruno Zevi, *Architecture as Space* (1957); Gideon (1964), pp. 176ff.

46. A ludicrous but apt analogy might be the removal of Ghiberti's "Gates of Paradise" from the Baptistry in Florence, the Erechtheum caryatids from the Acropolis, and the Sainte Chapelle gargoyles from Paris, all for display in an African museum.

47. Leach (1974), p. 133.

48. Norberg-Schulz (1971), p. 41.

49. Shepard (1971), p. 41.

50. Lévi-Strauss (1966), p. 263.

51. This idea developed out of a discussion with a former student, Dennis Doxtater, on the spatial components of ritual behavior. Alfred Irving Hallowell (1974), p. 202, touches on this point: "If we could illuminate the conditions and purposes in any given society which are relevant to the refinement and development of space perception, we would approach an answer to the historical question."

52. Langer (1953), p. 103.

53. Le Corbusier (1927), p. 73.

Chapter 2

1. Our summary of the West African physical environment is merely intended to highlight those features that are particularly relevant to our understanding of the technology of the built environment and to the Islamic contributions that wrought changes in it. See Hance (1975), Gourou (1970), Church (1960), and Stamp and Morgan (1972), for background.

2. A. L. Mabogunje, "The Land and Peoples of West Africa," in *History of West Africa*, ed. J. F. A. Ajayi and Michael Crowder (New York, 1973), vol. 1, p. 1.

3. It is not our intent to imply a hierarchy of civilization, but only to emphasize the role of technology (which *can* be measured in terms of increasingly complex relationships) in regulating the interface between man and his environment.

4. For an excellent early study on the nature of this variability among the Basuto in southeast Africa, see R. U. Sayce, "The Ecological Study of Culture," *Scientia* 63 (May 1939): 283–84.

5. The cypress groves, cattle *kraals*, and granaries illustrated in Roman mosaics from North Africa convey the changing nature of life styles during the final Saharan desiccation process.

6. Gsell (1913–1928), vol. 1, pp. 59–61; Thomas (1965).

7. The study of West African soils in past decades has, understandably, focused almost entirely on them as mineral and agricultural resources. The documentation and analysis of soil mechanics for purposes of building potential is only of recent interest. As a consequence, the understanding of traditional building processes is limited by the absence of pertinent data.

8. See Prussin (1973) for a more detailed analysis.

9. Thiel (1970), p. 612. Rudolf Arnheim in considering the psychology of art has suggested that visual space itself is created by light: *Art and Visual Perception* (Berkeley and Los Angeles, 1966), p. 300.

10. Labouret (1931).

11. In his classical study, D'Arcy Wentworth Thompson (1966) suggested that the form of matter and the changes it undergoes are the results of a set of forces—the manifestation of energy. His concern was with the development of natural forms such as leaves, snow crystals, animal physiognomy and bone structure, etc., but comments on tension, compression, form, and strength are relevant to our argument. Karl von Frisch provides a more up-to-date survey of animal building activity in which similar systems of mechanics function (*Animal Architecture* [New York, 1974]).

12. For an in-depth analysis of the evolution of earthen building technologies in West Africa, see Prussin (1981).

13. Bedaux (1972).

14. Mauny (1951).

15. Although recent interest in tents has been accompanied by several surveys of nomadic architecture, the literature on tents in Africa is almost nonexistent. For North Africa, little has been researched since Laoust's study (1930, 1932, 1934). For West Africa, the ethnographic literature, dealing primarily with Tuareg tents, is the sole source of information: see, for example, Lhote (1944) and (1947), Nicolaisen (1963), and F. Nicolas (1950). Rich as these are in ethnographic information, in no instance is there any analysis of structural principles.

16. Fischer (1963), p. 17.

17. Heather Lechtman, "Style in Technology—Some Early Thoughts," in *Material Culture*, Proceedings of the American Ethnological Society, 1975.

Chapter 3

1. Nachtigall (1966), Andrews (1971), Du Puigaudeau (1967), and Stenning (1964).

2. See Prussin (1973) for a discussion of the etymology of builders and building terms in the Upper Niger Delta.

3. Ibn Khaldûn (1967), vol. 2, pp. 355, 357–63.

4. Marçais (1954), p. 40, cites a text of religious history by Abou'l-Arab, *Classes des savants de l'Afriqyia*, ed. Ben Chenab, p. 195, for the existence of a saintly personage of Kairouan in the ninth century who was skilled in the fabrication of earthen bricks, and for the exalted position of masons at Kairouan; Jacques-Meunié (1962), p. 98, cites the *Kitab-al-Istibcar* (1911), for the existence of a caste of Jewish masons at Sijilmassa, Morocco, in the twelfth century; El Bekri (1965), p. 284, also refers to a caste of Jewish masons at Sijilmassa in the eleventh century.

5. See Laoust (1934), p. 177, for the term *maeellem*; Ricard (1924a), p. 211, for the term *mwaline*; and Jacques-Meunié (1962), p. 63, for the term *maâllem*.

6. See Lewcock (1978), for a discussion of architects and design techniques in the Muslim world.

7. Ibn Khaldûn (1967), vol. 2, pp. 363–65.

8. Ibid., vol. 3, pp. 130–31.

9. Mayer (1956), pp. 19, 24.

10. Kâti (1964), p. 20. This reference appears in a chapter that has recently been subject to question, and may have been rewritten, or perhaps added, in the early nineteenth century. See Levtzion (1971): 591.

11. Kâti (1964), p. 118.

12. Prussin, fieldnotes, Tendirma, 1971.

13. Prussin (1973), appendix D. The origin of *bari* is difficult to establish. Among the Manding people, the verb *bari* means to build, and the noun *bari* indeed refers to a mason. The Fulbe use the term *baredjo* for mason, and one is reminded of the intensive building programs undertaken in the early nineteenth century as a result of the various Muslim, Fulbe-led *jihads* in West Africa.

14. C. Monteil (1903), p. 196.

15. Prussin, fieldnotes, Goundham, 1971.

16. Dupuis-Yacouba (1921), p. 9; Pâques (1964), pp. 266–67.

17. C. Monteil (1903), pp. 286–87.

18. Prussin, fieldnotes, 1971.

19. Pâques (1964), p. 265.

20. C. Monteil (1903), p. 287.

21. Ibn Khaldûn (1967), vol. 1, pp. 229, 240; vol. 2, pp. 317, 367; vol. 3, p. 213.

22. Ibid., vol. 2, p. 347, says that "the crafts are perfected only if there exists a large and perfect sedentary civilization."

23. Stenning (1964), pp. 120–21; Prost (1954), pp. 191–92; Olivier de Sardan (1969), pp. 109–114.

24. P. A. Andrews (1971), p. 126; Du Puigaudeau (1967), pp. 150–51.

25. Golvin (1957), pp. 70–71; Gallay-Jorelle (1961–1962).

26. P. Bourdieu, "The Berber House," pp. 98–110 in Mary Douglas, ed., *Rules and Meanings* (New York, 1973).

27. Golvin (1950–1953), vol. 1, p. 171.

28. See, for example, the recent surveys by Lamb (1975), Boser-Sarivaxévanis (1972), Picton and Mack (1979), and Imperato (1973) and (1976).

29. See Boser-Sarivaxévanis (1972), p. 89, for a survey of these references.

30. El Bekri (1965), p. 329.

31. *Tedzkiret en Nisian* (1966), p. 123; Lamb (1975) citing Barth, p. 81.

32. Es-Sadi (1964), p. 222.

33. Monteil (1924), p. 52.

34. Ibid., p. 270.

35. Griaule and Dieterlen (1965a), pp. 106–107; Ibn Khaldûn (1967), vol. 2, pp. 366–67.

36. Griaule (1966), pp. 35ff.

37. Lamb (1975), p. 80.

38. Ibn Khaldûn (1967), vol. 2, pp. 65–67.

39. Golvin (1953), p. 113.

40. Gaden (1931), p. 322, quoting the *Tarikh es-Soudan*, p. 168.

41. Olivier de Sardan (1969), p. 108.

42. For the importance of tools of warfare, see Lombard (1957). For other studies of the blacksmith in West African society see, for example, Appia (1965), McNaughton (1977), Echard (1965).

43. Ibn Khaldûn (1967), vol. 2, p. 348.

44. Nadel (1965), pp. 269–74.

45. Although Johannes Nicolaisen (1963), p. 9, found no proof of greater literacy among Tuareg women, early references stress it. See, for example, Duveyrier (1864), pp. 386–88.

46. Kâti (1964), p. 20.

47. Prussin, fieldnotes, Guinea, 1980, and Djenné, 1971.

48. Fischer (1963), p. 145.

49. Hallowell (1974), p. 186.

50. Norberg-Schulz (1971), pp. 9–36.

51. Edmund Leach, *Culture and Communication* (Cambridge, England, 1976), p. 37.

52. Margaret Mead, "Ritual and Social Crisis," in *The Roots of Ritual*, ed. James D. Shaughnessy (Grand Rapids, Mich., 1973), pp. 94–95.

53. Norberg-Schulz (1971), pp. 9–36.

54. Leach, *Culture*, p. 51.

55. Norberg-Schulz (1971), p. 18.

56. Mercier (1954).

57. Prussin (1972).

58. Zahan (1970), pp. 49–50.

59. Bakhtiar (1976), p. 57.

60. Griaule and Dieterlen (1965a), p. 94.

61. Sultan (1980), pp. 154–55.

62. Norberg-Schulz (1971), p. 18, suggests: "To orient himself, man above all needs to grasp the relations [among centers, directions, and domains], whereas geometric schemata develop much later, to serve more particular purposes.

In fact, primitive man manages very well without any geometric notions." It is of particular interest that in the myths of origin among the Dogon, the Mande, and the Fulbe, the number twenty-two figures prominently. One is reminded forcefully of the writings of Augustine, whose *De civitate Dei* is carefully organized into twenty-two books, the number of books in the Old Testament and of the letters of the Hebrew alphabet. Rabanus, an outstanding practitioner of arithmology during the early Middle Ages, similarly implied that the sum total of knowledge is contained in the twenty-two books of his treatise *De universo*.

63. Dupire (1962), p. 226, and (1970), pp. 100, 325, 378.

64. Norberg-Schulz (1971), p. 24.

65. F. Nicolas (1950), p. 155.

66. Nicolaisen (1963), p. 471.

67. Ibid., p. 351.

68. Ba and Dieterlen (1961), pp. 15–16.

69. Stenning (1964), p. 104; Hopen (1958), p. 57; Dupire (1962), p. 157.

70. Ba and Dieterlen (1961), pp. 15–16.

71. Dupire (1962), p. 157.

72. Griaule and Dieterlen (1965a), p. 468.

73. Nasr (1964), p. 96. According to the Koran, "Allah is the Light of the heavens and the earth. His Light is a niche, wherein is a lamp. The lamp is in a glass. The glass is, as it were, a shining star."

74. Creswell (1940), vol. 1, p. 23.

75. Norberg-Schulz (1971), p. 25.

76. Froelich (1949).

77. Nadel (1965), pp. 91–92.

78. Ibid., pp. 78–79.

79. Méniaud (1935), ch. 2.

80. Hammond (1966), p. 168.

81. Zahan (1973), p. 107.

82. Rattray (1929), pp. 132–33.

83. Norberg-Schulz (1971), p. 21.

84. Prussin, fieldnotes, Djenné, 1971.

85. Khalīl ibn-Ishāq (1848–1852).

86. For detailed discussions of Islamic urbanization and building prescriptions, see Marçais (1957); Grunebaum, "The Muslim Town," in (1964); and Brunschvig (1947).

87. Nasr (1978), pp. 99–100.

88. Echard (1965).

89. Ibn Khaldûn (1967), vol. 1, p. 208.

90. Ibid., pp. 303, 306.

91. Ibid., pp. 356ff.; vol. 2, pp. 233–308.

92. Nasr (1978), pp. 99–100.

93. G. Nicolas (1966).

94. Marti (1964).

95. R. H. T. Smith (1971), pp. 319–43.

96. Griaule and Dieterlen (1965b), p. 468.

Chapter 4

1. Levtzion (1979).

2. Edmund Carpenter and Marshall McCluhan, eds., *Explorations in Communication* (Boston, 1960), pp. 43, 159.

3. Goody (1968), p. 226. Our attempt to relate the Islamic written word to an overall design aesthetic owes much to the pioneering work of Jack Goody on literacy in traditional societies.

4. Doutté (1909), pp. 150–52.

5. *Tifinar*, the Tuareg alphabet, is related to the ancient Libyan script. The geometric quality of precise curves, straight lines, and dots, in contrast to the flowing cursive style of Arabic script, lends itself to more angular design abstractions.

6. Doutté (1909), pp. 150–52.

7. Vincent F. Hopper, *Medieval Number Symbolism* (New York, 1938), pp. 62ff.

8. Ibn Khaldûn (1967), vol. 3, p. 174: "The relationship between letters and numbers . . . is not a matter of science or reasoning. According to the [authorities on letter magic], it is based on mystical experience."

9. One of the most extensive Arabic sources is al-Buni's thirteenth-century *Shams al-ma'arif al'Kubra*.

10. W. S. Andrews (1960).

11. Cammann (1969), p. 183.

12. Ibid., p. 199.

13. Doutté (1909), p. 391.

14. El Bekri (1965), and Africanus (1896), both refer to the use of magic mirrors at Fès.

15. Göbel (1973).

16. See Zaslavsky (1973), for a brief resumé of the construction of African magic squares.

17. Julian Hochberg, "The Representation of Things and People," in Gombrich, Hochberg, and Black (1973), p. 76.

18. Raymond Firth, *Symbols: Public and Private* (Ithaca, N.Y., 1973), p. 15.

19. Rosenthal (1971), p. 54.

20. Wilks (1968), pp. 192–93, cites instances in which the Koran is regarded as a sacred *object* (my italics) in its own right, no longer read, but worshipped.

21. Bravmann (1974).

22. Ba (1973), p. 188.

23. Kurt H. Wolff, ed. and trans., *The Sociology of Georg Simmel* (Glencoe, Ill., 1950), p. 345.

24. Ibid., pp. 338ff.

25. Prussin, fieldnotes, Guinea, 1980.

26. M. Jackson (1977), p. 2.

27. Doutté (1909), pp. 82–85.

28. V. Monteil (1964), p. 140, citing the *Risala*.

29. Ibid., citing Lévy-Provençal.

30. Ibid., citing Valentim Fernandes, *Description de la côte occidentale d'Afrique*, trans. Th. Monod, R. Mauny, and T. da Mota (Bissau, 1951).

31. Dalzel (1793), p. xxii.

32. Barbot (1732), pp. 61–62.

33. Ibid., citing Marmol, p. 62. Obviously, Boni is a reference to al-Buni (cited in note 9 above).

34. Zaslavsky (1973), p. 139.

35. Printed *hatumere*, like the one from Cairo (see Fig. 4.2c), have far less value. They lack the "virtue" which can only be imparted by the cleric, hence they are much less effective—and much less costly. When we commissioned several *hatumere* from a cleric in Conakry, we were able to reduce the price of each considerably by explaining that our interest was only in the finished products and not in the efficacy that preliminary incantation and divination would impart to them.

36. Edward Westermarck (1933) has dealt at great length with the various quincunx designs used in North Africa as a symbol for the five fingers or the eyes themselves in protection against the evil eye. While there is nothing to suggest that the quincunx in West Africa is specifically used as protection again the evil eye, its use as protection against various *djinn* is ubiquitous.

37. These *batakari* have been illustrated in a number of recent exhibitions. See, for example, Sieber (1972), and Cole and Ross (1977).

38. Bowdich (1819), p. 272.

39. Heathcote (1974).

40. Prussin, fieldnotes, Bafodea, Sierra Leone, 1980. Despite the fact that these *diousene* (Djallonke and Fulbe) or *durukilamini* (Manding) are only worn by men, and women are forbidden to look at them for fear of sterility and other

dire consequences, the *imam* of Bafodea made one for the author—at night and in great secrecy. The recipes used were taken from a collection he had inherited from his father, who in turn obtained them from a *garankhe* or leatherworker from Touba, Guinea. Today, they are still commissioned by important people, at great expense; they are secretly worn under other clothing to major political meetings and receptions, since they are reputed to provide the wearer with great power over others.

41. See Cohen (1974) for a brilliant discussion of symbolic strategies in group organization. The private and public display of an Islamic aesthetic by means of dress and selective iconographies is for us a part of the symbolic strategy used by Islamized groups within the traditional milieu.

42. Heathcote (1972).

43. Philip Demonsablon, personal communication, 1980.

44. Welch (1979), p. 106.

45. Rykwert (1969), p. 237.

46. Griaule and Dieterlen (1965a), p. 107.

47. *Surah* 3. Ali 'Imran, v. 14 and *Surah* 20. Ta Ha, v. 39. We would like to thank Professor Farhat J. Ziadeh for his help in translating the calligraphy on these *hatumere*, for a forthcoming in-depth study.

48. *Surah* 2. Al-Baqarah, v. 255. Among the Fulbe, this chapter, The Cow, is important not only because it contains mention of all the essential points of the Revelation, but presumably because of the traditional importance of cattle in Fulbe life. This *bragu* or *amburaku* (Arabic) was learned from a Manding *karamoko* at Boké, Guinea. (Personal communication, Simon Ottenberg.)

49. Although there were a number of instances in which the house owners were vague about the strength of identity and considered these more as additional insurance to be used in conjunction with traditional talismans hung from lintels, there were many who, on inquiry, told us that these are put up "so people passing will know this is a Muslim house, just like we did." (Prussin, fieldnotes, Bafodea, Sierra Leone, 1979.)

Chapter 5

1. The term *Sudanese* did not appear in the European literature on Africa until after the turn of this century; it was introduced in the wake of the French conquest of the Western Sudan and was subsequently popularized. The term derives from the Arabic *bilad-es-Sudan*, "land of the Blacks."

2. The first European reference implying an Islamic origin for the style is a brief description of the four towns of Ségou, Mali, in 1799, when Mungo Park referred to "Moorish mosques in every corner." Nineteenth-century explorers and travelers, while they provided descriptions, never referred

to a specific style, nor did they specifically give a northern attribution. At the turn of the century it was suggested that Songhay migration from the upper Nile valley would explain the similarity between Egyptian architecture and that of Djenné, Mali. Other turn-of-the-century authors argued for a North African origin, specifically, for a Moroccan inspiration. More recent attributions, while less specific, continue to argue for a North African inspiration. Most recently, it has been suggested that the prototype for the Dyula mosque was the Great Mosque at Kairouan, Tunisia. See Park (1799), p.

195; Desplagnes (1907), p. 365; Dubois (1897a), pp. 169–75; Monteil (1903), p. 286; Chudeau (1910), p. 402; Delafosse (1924); p. 159; Trimingham (1962), p. 69n.1; Monod (1946), p. 179; Miner (1965), pp. 35–36; Bovill (1970), p. 195; P. F. Stevens (1968).

3. A recent discussion of the life of Abu Ishaq al-Saheli summarizes the misconceptions surrounding his architectural contribution. The sources, taken as a whole, imply that he may have supervised the construction of a mosque at Gao, Mali, a royal residence and a mosque at Tombouctou while he was living in that city, an audience chamber in a not-yet-located capital city, and a residence at Oualata, where he lived for a time and to which his offspring returned after his death. It has also been suggested that the audience chamber referred to by Ibn Khaldûn and so frequently cited by scholars was not at the Mali capital but in Oualata. A single reference in the *Tarikh es-Soudan* suggesting that Mansa Musa caused a mosque to be built in each locality through which he passed on a Friday, on his return from the *hajj* to Mecca, has given authors license to credit Abu Ishaq al-Saheli for all of them, on the assumption that he alone would have been the "innovator" of the "style." See Hunwick (1972); De Puigaudeau (1968), p. 407; Es-Sadi (1964), p. 15.

4. Labouret (1931), pp. 52–53; Engeström (1956); Brasseur (1968), p. 443.

5. Levtzion (1973), p. 10.

6. Lewicki (1962), p. 517.

7. C. Monteil (1953). *Kaya-magha* means "king of gold" in Soninke.

8. Levtzion (1973), p. 6.

9. Lewicki (1962), p. 532, documented the founding of Tahert by Ibadites from Kairouan who fled the Abbasid army late in the eighth century. When Tahert was conquered in A.D. 909 by Fatimid troops, Ouargla emerged as the major oasis city.

10. El Bekri (1965). His chronicle was written in A.D. 1068, only a few years before the fall of the empire of Ghana to the Almoravids.

11. See U. al-Naqar, "Takrur, the History of a Name," *Journal of African History* 10, 3 (1969): 365–74.

12. See Es-Sadi (1964), p. 18, and Kâti (1964), p. 76. Koumbi is located in the Wagadu region, and according to Es-Sadi, the *kayamagha* were the sovereigns of Ghana. The city of Djenné, Mali, was referred to in 1447 as a *civitate*, implying that it had a king (which it did) with an extensive hinterland under his control.

13. El Bekri (1965), p. 330.

14. Ibid., p. 328.

15. See Du Puigaudeau (1967), pp. 163–67; D. Robert, S. Robert, and Devisse (1970), pp. 79–83.

16. See Thomassey and Mauny (1951), pp. 437–62. Investigations at the site of the great mosque in the center of the ancient city have recently been undertaken by Jean Devisse. Although carbon-14 dates suggest a ninth-century occupation in the lower strata of the mosque site and indicate three successive mosque-building programs, further details await publication. See Devisse (1975), p. 123.

17. Thomassey and Mauny (1951), p. 440. See, for example, M. Mercier (1922), pp. 86–87, for a suggested paradigm in the Ibadite tomb of Berrian, outside Ghardaia in the Mzab region of Algeria.

18. In the world of Islam, the *kubba* is rarely used solely to house a tomb. There are a number of instances in which the prototype structure was built to house a fountain or an ablutions basin. Nor is the combination of a holy place or tomb and a cistern unique; it can be found throughout the anti-Atlas region of Morocco, particularly in the *ksars* or citadel-granaries. See, for example, D. J. Jacques-Meunié and Henri Terrasse, *Nouvelles recherches archéologiques à Marrakesh* (Paris, 1967), pp. 43–44.

19. André Jodin, "La Datation du mausolée de Souk-el-Gour," *Bulletin d'Archéologie Marocaine* 7 (1967): 260–61. The almost identical style of the motifs found on some of the decorated plaques excavated from the residential quarter of Koumbi Saleh and in the Roman ruins at Hippone has been pointed out by Thomassey and Mauny (1956), p. 130n.1.

20. Such forecourts were often located at a corner of the mosque *sahn* enclosure; the Bab Lalla Rayhana vestibule performs precisely this same function in space. The uncertainty about the number of successive walls results from a discrepancy between the earlier reports and later aerial photographs. One is tempted to wonder whether in fact the ideal was originally a set of seven walls, in keeping with Islamic as well as indigenous systems of numerology. Equally an enigma are the traces of two southern, non-parallel but contiguous walls which appear to have been an attempt to realign the boundary of the entire area more precisely with Mecca and the northwest, since the tomb and its encircling walls do not conform to the prescriptions of a *kibla* wall.

21. Jodin, "Datation," pp. 221–58. The mausoleum consists of two concentric, carefully dressed stone circles some forty feet in diameter, forming a stepped mound approximately fifteen feet high.

22. Thomassey and Mauny (1956), pp. 117–40.

23. Inscriptions on tombstones in an adjacent cemetery at Sokobi have been calligraphically dated to ca. A.D. 1650: Thomassey and Mauny (1951), p. 445. As late as 1337, the sovereign of Ghana continued to exercise the right to be called "king" and as late as 1393, reference was made to the "mufti of the inhabitants of Ghana." See Mauny (1970), p. 147.

24. Al-Ya'qubi, *Les Pays*, cited in D. Robert, S. Robert, and Devisse (1970), p. 19; and El Bekri (1965), p. 300.

25. Terrasse (1938); Monod (1948), pp. 1–30; Du Puigaudeau (1967, 1968); Jacques-Meunié (1961).

26. Du Puigaudeau (1968), p. 334.

27. Jacques-Meunié (1961), p. 59.

28. Du Puigaudeau (1968), p. 396.

29. Niane (1965), pp. 78–82. The Keita still meet at Kangaba every seven years to reenact the building of an ancient sanctuary: Dieterlen (1957).

30. Niane (1965), p. 78.

31. Similar examples for Western urban history, where one site remains the ideological center of political cohesion, the "founding place," and another one develops as an administrative seat can be cited ad infinitum: Philadelphia and

Washington, D.C., Leningrad and Moscow, Paris and Rheims, Edo and Kyoto are only a few examples.

32. Trimingham (1962), p. 65n.2. The changing residence is reminiscent of the practice of the dukes of Orleans as well as the sultans of Morocco. In both instances, however, a single, ancestrally validated seat was always maintained.

33. For a summary of the scholarship devoted to the site of Niani, see Hunwick (1973).

34. "Old Mali" refers to the northern chiefdoms and "New Mali" refers to the southern kingdoms: Levtzion (1973), p. 54.

35. Mauny (1961), p. 123.

36. Hunwick (1973), p. 198, citing al-Umari's, *Masalik al-Absar*. Bita or Bini, the name by which the capital became known to the outside world, is similar, without diacritic marks, to the Manding term *bembe*, a ruler's dais. The first European reference to this name occurs in early sixteenth-century Portuguese accounts of trade along the Gambia River. A *barid* is equal to seven miles.

37. Ibn Batouteh (1874–1879), pp. 396–97.

38. See Dieterlen (1957) for early Fulbe-Manding interfaces in this area suggested by similarities in oral traditions in the realm of myths of origin and creation.

39. Ibn Batouteh (1874–1879), vol. 4, p. 403. The reference to horses suggests their early use as a symbol of political control. The reference to rams is of particular interest in the light of their subsequent importance in West African ritual and iconography.

40. Ibn Khaldûn (1927), vol. 2, p. 113, quoting Abu Abdullah al Koumi.

41. The great similarity to the Alhambra in Granada has been suggested by Hunwick (1972), p. 6.

42. Ibn Batouteh (1874–1879), vol. 4, pp. 405–406.

43. Related to this practice is the combined price quoted by African goldsmiths for labor and materials. A piece is always sold by weight, regardless of the skill or time involved in its creation.

44. Ibn Batouteh (1874–1879), vol. 4, pp. 413–14.

45. Ibid., p. 403.

46. Filipowiak (1969).

47. See, for example, Piétri (1885); Ministère de la Marine et des Colonies (1884), vol. 2, map 5; K. Johnston (1879).

48. Meillassoux (1972).

49. Levtzion (1973), pp. 15–22.

50. Lewicki (1962), pp. 531, 579.

51. Ibn Khaldûn (1927), vol. 1, p. 356. Further, "the monuments of a dynasty are its buildings and large edifices [*haykal*]. They are proportionate to the original power of the dynasty."

52. Rouch (1960), pp. 9, 33, 39. Throughout Songhay country the earth is considered as belonging to certain divinities of *place*, the *zin*, to whom only the "masters of the soil" have access. These divinities are located in a given place—a tree, a rock, a mountain—all residences from which they survey their earth.

53. Rouch (1960), pp. 17–18.

54. Mauny (1951).

55. Cited in Lewicki (1962), pp. 534–35. El Bekri never visited the region of Gao; it has been suggested that he may have drawn his references from earlier Arabic sources such as al-Muhallabi.

56. *Tedzkiret en Nisian* (1966), p. 71. This chronicle is primarily an enumeration of rulers and savants in the western Sudan during the eighteenth century.

57. Rouch (1953), pp. 172ff. According to Ibn Hawqal, Kawkaw—i.e., the ancient Koukyia—was abandoned in the tenth century. Rouch (1960), p. 5, citing the *Tarikh es-Soudan*, has suggested that it was upon the conversion of the Songhay ruler in A.D. 1010 that Koukyia was abandoned and the seat of Songhay power transferred to Gao. Also see Hunwick (1966), p. 297.

58. Malekite tombs dating from A.D. 1110–1111 have been unearthed at Es-Souk (the "Tademackhat" of the early chronicles), forty-five miles northwest of Kidal: Mauny (1961), p. 46.

59. Primary references are Mauny (1951), pp. 845–48; Sauvaget (1950); Viré (1958), (1959).

60. Mauny (1970), p. 167.

61. Ibn Batouteh (1874–1879), vol. 4, pp. 435–36.

62. Es-Sadi (1964), p. 14.

63. Schacht (1954), p. 19; Marçais (1954), passim. *Mihrabs* in the Maghreb tend to be octagonal in shape, and in the fourteenth-century Maghreb they were uniformly so.

64. Bourilly and Laoust (1927), p. 5.

65. Kâti (1964), pp. 118–19. Although our argument is based on a section of this chronicle that may have been rewritten in the nineteenth century, the etymology of the terms used emphasizes the Manding contribution to the evolution of a new architectural imagery.

66. Prussin, fieldnotes, Goundham, Mali, 1971. The palace ruins still had remnants of red plaster clinging to what was presumably an interior courtyard.

67. Kâti (1964), p. 123.

68. Schacht (1954) has suggested not only that Gao was a center of Ibadism but that Sonni Ali's dynasty, forerunner to Askia Muhamed, was Ibadite.

69. Rouch (1953), pp. 179–86. The title *Sonni* means "substitute for the chief."

70. Rouch (1960), pp. 150–52.

71. Ibid., p. 45.

72. Mauny (1950), p. 66. The assumption has always been that the entire structure postdates the death of Askia Muhamed in 1538.

73. Gideon (1964), pp. 215–41, 264–68; Frankfort (1960), pp. 30–31. The Arabic term *mastaba* means "bench." Although it is well established that Islam borrowed much from its religious predecessors in the Near East, it is not our intent to suggest that Songhay culture is derivative of the Near East, but merely to point out a similarity in the symbolic process.

74. Rouch (1960), pp. 18, 48.

75. Barth (1857–1859), vol. 3, pp. 480–82.

76. Barth (1861), vol. 4, p. 161. The English edition makes no mention of the height of the tower or its similarity to the Agades minaret.

77. Schacht (1954), pp. 16–19, 26. The absence of a *minbar* in Ibadite mosques can be explained by the nonobservance of the special Friday prayer in the *imam*'s name. The fall of the kingdom of Tahert in A.D 909 brought about the demise of the *imams*, who were "more political than religious heads of their community." Schacht further notes that, in effect, "the great Friday ritual prayer is not only a religious duty, it is also a political manifestation."

78. Barth (1857–1859), vol. 3, p. 478.

79. The most comprehensive study of the Sorko to date is Ligers (1967–1969).

80. Levtzion (1973), pp. 26–27, 147ff. The founding date for the city is uncertain. Although these families fled in A.D. 1224, Oualata is reputed to have been founded in A.D. 1240. Du Puigaudeau (1968), p. 405, has recorded several oral traditions that suggest that Oualata and Birou, while proximate, are not identical. According to one account, the refugees from Ghana would have constructed the city on virgin soil, thus avoiding the *djinn* (harmful spirits) who inhabited the ruins of Birou.

81. Ibn Battūta (1966), pp. 36–38.

82. Es-Sadi (1964), p. 36.

83. Nema, due south and founded by Oualata merchants in the early nineteenth century, is the only other city that has a similar mural decoration.

84. Levtzion (1973), pp. 161–62. The family of five brothers originally came from Tlemcen. They are credited with having sunk and maintained all the wells on the route from Sijilmassa in southern Morocco to Oualata, with responsibility for obtaining guides, and guaranteeing the safe conduct of travelers along the routes linking these two cities. The head of the Maqqari household resided at Sijilmassa, where he directed transactions; two of the brothers lived at Tlemcen; and two maintained residence in Oualata: Jacques-Meunié (1961), p. 73.

85. Du Puigaudeau (1957), p. 161.

86. Ibn Batouteh (1874–1879), pp. 387–90.

87. Ibn Battūta (1929), p. 335.

88. Duchemin (1950), p. 1096; Du Puigaudeau (1957), pp. 152ff.; (1968), p. 408; Jacques-Meunié (1961), p. 118.

89. Ibn Batouteh (1874–1879), p. 390.

90. An evocative phonetic relationship exists between the term *tara*, used in association with the canopy of the bed, and the term *tafarafara*, used to designate a "square house" as well as the larger rectangular ceilings and reception rooms of the compound owner in both northern Nigeria and the western Sudan.

91. Although admiration for these bas-relief murals has been voiced by many, it is of interest that the only two in-depth studies of them were done by women: Du Puigaudeau (1957); Jacques-Meunié (1961).

92. See Gabus (1955, 1958), for numerous other examples. An early photograph of an elaborately carved, forked post mounted on a square dais adjacent to a framed bed canopy (similar to those we have considered) was published in 1921: Marty (1920–1921), vol. 3, plate facing p. 12.

93. Es-Sadi (1964), p. 37.

94. Though he praises Gao extravagantly, Ibn Battūta barely mentions Tombouctou.

95. The *Tarikhs* are the primary sources for much of the city's history.

96. G. E. von Grunebaum, "The Muslim Town," in Grunebaum (1964).

97. Caillié (1965), vol. 2, pp. 311–13.

98. Barth (1857–1859), vol. 3, pp. 315ff.

99. Ibid., p. 326.

100. Pâques (1964), p. 277. Although spellings vary, the names given by Pacques are phonetically similar to those recorded originally by Henry Barth.

101. Ibid., p. 276.

102. Ibid., pp. 268–69.

103. Ibid.

104. A comparative linguistic study of the repertoire of architectural terms throughout West Africa would without question unearth a treasure of information and provide valuable insights into the historical dimensions of both the arts and the architecture of West Africa.

105. Pâques (1964), p. 244.

106. Dupuis-Yacouba (1921), Miner (1965).

107. Kâti (1964), p. 315.

108. Gabus (1955, 1958), vol. 2, p. 89.

109. Ibid., p. 154; Du Puigaudeau (1968), p. 413.

110. Miner (1965), pp. 53–54; Pâques (1964), p. 205. Dupuis-Yacouba (1921), p. 61, points out that leatherworking must be distinguished from the tanning process itself, which is not a restricted occupation.

111. Pâques (1964), p. 205.

112. Barth (1857–1859), vol. 3, pp. 357–58.

113. Pâques (1964), pp. 264ff.

114. Ibid., p. 267.

115. The most recent attempt is by Hunwick (1972). No archeology has been attempted other than the pioneering efforts of Raymond Mauny several decades ago, and knowledge of the sequence of building efforts has depended primarily on interpretation of references in the *Tarikh es-Soudan*, the *Tarikh el-Fettach*, and the *Tedzkiret en Nisian*.

116. Es-Sadi (1964), p. 101.

117. Since the Cadi of Tombouctou who had come from Oualata ordained the reading of half of a *hizb* in the Sankoré mosque during the last years of Malian rule, there must have been a mosque prior to Songhay rule.

118. Kâti (1964), p. 222.

119. *Tedzkiret en Nisian* (1966), pp. 16, 57–58.

120. Barth (1857–1859), vol. 3, p. 323.

121. Caillié (1965), vol. 2, pp. 334–35.

122. Africanus (1896), vol. 3, p. 824.

123. Caillié (1965), vol. 2, pp. 333–34.

124. Es-Sadi (1964), p. 91. We would like to thank Professor John Hunwick for the translation from the Arabic.

125. See Golvin (1970), pp. 41, 61, for comparative models.

126. Kâti (1964), p. 222.

127. Es-Sadi (1964), p. 91. This reference is contrary to orthodox Islam, which considers that the dead should never enter the mosque.

128. *Tedzkiret en Nisian* (1966), pp. 154, 158, 215–16.

129. Pâques (1964), p. 258.

130. Ibid., p. 262.

131. Data on the history of the city can be found in the archives of the family of the ruling Sultan, in various Tuareg tribal oral histories, and in passing references by early travelers. See Urvoy (1934); Rennell Rodd (1926); Nicolaisen (1963), pp. 141ff.

132. Rennell Rodd (1926), pp. 360–62.

133. Although Ibn Battūta does not mention Agades, he visited Takadda, the site of some copper mines on the southern boundary of the Aïr region, then continued northwest to the Touat region: Hamdun and King (1975), pp. 55–59.

134. This route was taken by Barth on his mid-nineteenth-century journey of exploration.

135. Es-Sadi (1964), p. 129.

136. Barth (1857–1859), vol. 1, p. 371. This migration is particularly relevant to the subsequent development of Fulbe-Hausa architecture.

137. Rennell Rodd (1926), pp. 87, 118. The original suggestion that the city was a "black" city comes from Leo Africanus, cited by Barth (1857–1859), vol. 1, p. 362.

138. Ibid., pp. 317, 351.

139. Ibid., pp. 371, 375.

140. Barth (1857–1859), vol. 1, p. 371.

141. Ibid., vol. 1, p. 352. The term *khan* is apparently a cognate of the Arabic term *khanga* used in reference to a *zawiya* or *madrasa*, which additionally served the function of almshouse and relay station: Rennell Rodd (1926), p. 255; Golvin (1970), p. 206.

142. Urvoy (1934), pp. 154–55. There is an unexplainable discrepancy in the oral tradition as to whether there were four or five founding clans.

143. Barth (1857–1859), vol. 1, p. 329.

144. Ibid., vol. 1, p. 350.

145. Ibid.

146. Rennell Rodd (1926), p. 89.

147. Nicolaisen (1963), p. 329. Earthen construction was introduced by the *harratin*, the black serfs who migrated from Tidikelt.

148. Reygasse (1950), pp. 89–117.

149. Ibid., p. 116.

150. Rennell Rodd (1926), pp. 258–59.

151. Reygasse (1950), pp. 39–43.

152. Rennell Rodd (1926), p. 95.

153. Barth (1857–1859), vol. 1, p. 356.

Chapter 6

1. References to the Islamized Mande or Wangara can be found in the earliest European literature dealing with the West African coast as well as in the earliest Arabic sources that treat of the sub-Saharan trade. Termed Dyula in the western savannah, they are called Marka in the Upper Niger Delta, Dafing in the bend of the Black Volta River, and Yarse in the area south of the Niger River Bend.

2. Wilks (1968), p. 164.

3. Ibid., p. 192.

4. See Abner Cohen (1971), pp. 266–79, for an analysis of the ideology of the Manding diaspora. Our architectural interpretation owes much to his discussion.

5. Bravmann (1974), p. 36.

6. Trimingham (1959), p. 38.

7. Levtzion (1968), p. 13.

8. Wilks (1968).

9. The term Gurunsi as used by a number of early writers subsumes a large group of Gur-speaking peoples in southern Upper Volta, northern Ghana, and northwestern Ivory Coast.

10. Dieterlen (1941), p. 185, pl. 6.

11. Griaule (1966), p. 26.

12. Zahan (1974), p. 10.

13. Tauxier (1927), pp. 188–92, 459.

14. Tauxier (1921), p. 78.

15. C. Monteil (1903), p. 116.

16. Yatenga is not a place-name but an entire region, extending from the base of the Bandiagara escarpment southeast through what is now considered Mossi country, into what has come to be generally known as Gurunsi in the middle belt of Upper Volta. The site of this particular monument may have been at Ouadougou, located on a direct route from Yako in Upper Volta to Bandiagara, and suggested as being the most important center of the Yatenga region in the late nineteenth century. See Binger (1892), vol. 1, p. 505.

17. Perignon (1901), p. 151: "A beautiful mosque, built after the remains of that of Djenné, rises on the Place Huillard." His suggestion touches on some of the perplexing questions considered below in our discussion of the Djenné mosque. When Mungo Park mentioned the "Moorish mosques . . . seen in every quarter" in his description of the city at the end of the eighteenth century, his reference included the four towns of Ségoukoro, Ségoubougou, Ségoukoura, and Ségou-Sikaso, the current city of Ségou: Park (1799), p. 195.

18. C. Monteil (1924), p. 332.

19. Le commandant Gallieni (1885), pp. 244–46, 594–95. At the time of his first visit, Gallieni estimated its population to be one thousand. Although Bamako was ruled by a Bambara family, Gallieni noted that the commerce of the

city was entirely in the hands of the family of "Maures" and that Kharamokho Oule, its youngest member, was the wealthiest and most influential man in the whole country.

20. Le lieutenant-colonel Gallieni (1891), p. 174.

21. Ọlọruntimẹhin (1972), pp. 134, 136, 161.

22. Zahan (1974), pp. 2, 6, pl. III.

23. Ibid., pp. 17–18.

24. Bravmann (1974), pp. 48–49. See C. Monteil (1924), p. 270, for a similar tradition.

25. Marty (1920–1921), vol. 4, p. 187. Of the six mosques mentioned by Marty, the Great Mosque and three others were in the hands of the Somono (Sorko), another was in Marka hands, and a sixth was in Fulbe hands.

26. Bernus (1960), pp. 246ff.; Person (1964), pp. 326–27; Binger (1892), vol. 1, p. 325.

27. See Wilks (1968) for Wattara patronyms in the various Dyula communities.

28. Binger (1892), vol. 1, p. 258.

29. Sikasso was founded by Dyula Kong of the Traoure family who moved north in the early nineteenth century: M. Perron, "Histoire du cercle de Sikasso," *Bulletin du Comité d'Etudes Historiques et Scientifiques de l'A.O.F.* (1923): 497–511.

30. Binger (1892), vol. 1, p. 298.

31. Bernus (1960), p. 274.

32. Bravmann (1974), p. 50.

33. Wilks (1968), pp. 173–74. Safané was also on a direct route from Dobrya (Daboya?), a salt-producing center in northern Ghana, through Yako, across the lower reaches of the Bandiagara escarpment to Djenné: Levtzion (1968), p. 70.

34. Dupuis (1966), MS. 8.

35. Binger (1892), vol. 1, p. 371; Wilks (1968), pp. 173–74.

36. Wilks (1968), p. 165. The process is described by the Arabic term *tajdid*.

37. It has been persuasively argued on the basis of Islamic politics that these "stairway-minarets" can be attributed to Fulbe influence, but again, the argument rests on the presence of a spatially discrete *mihrab* and a *minbar*: Schacht (1954), pp. 14–15.

38. Marty (1922), pp. 172–86.

39. Holas (1957), pp. 155ff.; (1960), p. 51.

40. Holas (1968), p. 596. Our discussion in Chapters 3 and 4 is particularly relevant to this point.

41. The preference for exterior wall decoration is in marked contrast to the interior decoration that characterizes several other Islamic architectural traditions in West Africa, such as at Oualata and among the Fulbe, where the most highly decorated surfaces of the residential complex are to be found in the inner court onto which the wives' rooms face.

42. Levtzion (1968), pp. 139–43.

43. An early photograph of this mosque appeared in Delafosse (1908a).

44. Ba (1972), p. 25.

45. Niane (1965), p. 1. The *griots* are the custodians of oral tradition, minstrels in the traditional sense.

46. Ba (1972), p. 21.

47. Bernus (1960), p. 310.

48. Holas (1957), p. 161.

49. Mage (1868a), p. 177.

50. Our discussion of Djenné is drawn from fieldwork notes and archival research during 1970–1971. See Prussin (1973).

51. Although Félix Dubois was perhaps the first to popularize the comparison, he was certainly not the last. As late as 1939, the Upper Niger Delta was still referred to as "l'Egypte français ou la Mésopotamie nigérienne."

52. The earliest traditions emphasized the impregnability of the city. The Malian invaders, despite ninety-nine attempts, failed to conquer the city. It ultimately required a siege of seven years, seven months, and seven days before the Songhay gained control over the city in the fifteenth century: Es-Sadi (1964), pp. 21, 26.

53. Reference is made in Es-Sadi (1964), p. 24, to the 7,077 villages that surrounded and supported the city. Perhaps one of the most eloquent expressions of French hope for its exploitation was voiced by Emile Zola (1900), p. 474, who saw the key to France's future in the colonization of the Upper Niger Delta: "He [Father Niger] is the ancestor, the founder, the fertilizer of the Western Sudan . . . he is the father of untold generations, the creative deity of a world as yet unknown . . . and the valley of the Niger [is] the good giant's colossal daughter. All the food needed for a great nation will be reaped there."

54. It is within this visual context that the sense of the oft-quoted reference to Djenné as a "blessed city, large, prosperous and flourishing," by reason of which "the caravans flock to Tombouctou from all points of the horizon," can be understood: Es-Sadi (1964), p. 23. When the first French commander arrived, he commented on the fact that his French officers compared it to Kairouan, and his African troops with St. Louis, Senegal: Archinard (1896), p. 13.

55. See Prussin (1973), pp. 62–97, 351–57, for a detailed consideration of the sources. The first reference to the city-state was made in 1447 by Antonio Malfante, a Genoan resident of Touat, Algeria. The most detailed subsequent references are to be found in the *Tarikh es-Soudan*, whose author was not only a notary in the city but also a seventeenth-century *imam* of the mosque: Es-Sadi (1964), p. xiii. The city was not precisely located on a European map until the arrival of the French in April 1893.

56. Perhaps the most convincing argument for the southern focus is the frequent references to the city in the accounts of Mungo Park and René Caillié, early explorers who traveled from the Guinea coast in the company of Dyula traders. Henry Barth, who traveled to West Africa via the Sahara, makes almost no reference to the city.

57. Caillié (1965), vol. 2, pp. 183–228.

58. Dubois (1897a), C. Monteil (1903), (1932).

59. A reference in the *Tarikh es-Soudan* to the Sankoré mosque at Djenné as the Great Mosque in the seventeenth century is not clear on whether there was a second mosque in the Sankoré quarter, whether the Great Mosque was Moroccan-built, or whether the Great Mosque was in the hands of "white Muslims" from Tombouctou. The Dambougal-soria quarter was the site of the residence of the Songhay rulers.

60. Prussin, fieldnotes, Djenné, Mali, December 1970.

61. The Songhay honorific term *koy* refers to the chief of a village.

62. Caillié (1965), vol. 2, p. 206.

63. Dubois (1897a), p. 179.

64. Ba and Daget (1962), p. 154.

65. Among those buried in the courtyard of the mosque are the theologian Foudiya-Mohammed-Foudiki-Sanou-El Ouankori, an ancestor of the Saghanughu family of Kong: Es-Sadi (1964), pp. 30–33.

66. The removal of roof timbers is still a common practice in rebuilding. Presumably Sheku Ahmadu reused the timbers to build his new mosque.

67. Dubois (1897a), p. 178.

68. Until the arrival of the French, the major cemetery and the burial site for Djennenke dignitaries was, if not within the mosque courtyard itself, in its immediate vicinity, close to the walls of the mosque: Dubois (1897a), pp. 184–87; Marty (1920–1921), vol. 2, p. 295. The presence of the tomb invests the space with *baraka* or spiritual force.

69. *L'Illustration* 3586, 18 November 1911, pp. 390–91.

70. P.-L. Monteil (1894?), p. 20.

71. M. A. Cocheteaux, personal communication, Nice, 27 June 1968.

72. Golvin (1970), pp. 41, 45–46. In plan, the Djenné mosque closely resembles that of the Ummayad mosque at Harrân, originally built ca. A.D. 750 and remodelled over the years.

73. A similar practice is described by Etherton (1971), p. 188. The technology of using timber reinforcement horizontally (found at Djenné only on the latrines) was a common practice in central Morocco. See Laoust (1932), plate XXI.

74. Caillié (1965), vol. 2, p. 203, merely referred to the "thirty or forty Moorish traders" at Djenné who occupied "the most beautiful houses," all located in the environs of the market. Félix Dubois (1897a), pp. 169–75, was an ardent proponent of a Songhay, Egyptian-derived attribution for these facades. Maurice Delafosse (1924), p. 159, suggested that the style was introduced by the Andalusian Abu Ishaq who had returned with Mansa Musa from Cairo in 1324, and was therefore of Maghrebian inspiration. Charles Monteil (1932), p. 194, took considerable issue with Dubois, suggesting in turn that the traditional Sudanese housing had been transformed by the Moroccan invasion of 1591.

75. In Songhay as well as in Manding, the prefix *fo* connotes a greeting or "speech." In Manding, the term *tige* or *tigi* designates a master, a chief or an elder. Thus, *fodigui* Mohammed Sano is interred in the *kibla* wall of the Great Mosque at Djenné. Variants of the term are *fode, fodie,* and *fodio,* as in Dan Fodio, and it is synonymous with *mori* and *alfa.*

76. In Songhay, *nya* means "mother." The term for the bolt, *kufal idye,* means "sons of the lock."

77. *Wey* is the Songhay term for "woman." In Songhay, *sara* means "grave" or "tomb." It is also used in reference to "alms" or "justice," presumably derived from the Arabic terms *ziara* and *chara.* In Manding the term also has several related meanings, one of which is "beauty" or "beautiful aspect." Used as a substantive it means "sperm," and as a transitive verb it becomes "to fertilize." Meanings associated with *fa* all imply "father" or "master" and are used as a prefix when addressing a senior, a respected elder, or a leader. *Har,* first recorded by Anne Raffenel (1856), pp. 399–418, in a small Arama (Soninke) dictionary, is used throughout the western Sudan in various related contexts. In Songhay, as *aru,* it defines the masculine gender; as *yaru* it refers to "courage, masculinity, and bravery." The Manding term *yar* carries the same connotation. The Songhay also use the term *yar* in referring to the earth used in wall surfacing, and one finds the same term used generically throughout the western Sudan for "earth." Thus, the traditional building tool at Djenné was known as *yar bundi,* and *aru,* as in Arou-pres-Ibi above, refers to earth brought from Mande, among the Dogon.

78. A reference to this upper story with its single grille can be found in René Caillié's description of the house of al-Haggi Mohamed, which he inhabited during his stay in the city: Caillié (1965), vol. 2, p. 196.

79. *Lo* has several translations in Manding in addition to "family alliance." It designates a "vertical position," "that which is vertical," "a raised stone," "a truncated conical earthen altar," and "knowledge" or "to know." Among the Bambara, *buru* translates as "supreme chief, king, or governor"; it is synonymous with *fa.* An interesting related aspect of the term *buru* can be found in Dogon usage, where it refers to the horn whose voice was believed to be that of the *hogon* summoning the elders for the convocation of a new *hogon.* A Bambara loan-word, it is apparently derived from the ivory trumpet used in the military music to rally the *sofa* or Bambara military elite: C. Monteil (1924), pp. 314–15.

80. The term *tafarafara* was also used at one time in Fulbe-Hausa architecture.

81. Caillié (1965), vol. 2, p. 196, referred to a similar arrangement in the house he occupied: "The court on the first floor [the upper level] was in part closed on the four corners: some pieces of wood, resting on the walls a small distance from one another and covered with earth, formed a kind of terrace, with a slightly elevated parapet." The term *kandye* derives from the Songhay verb *kandyi,* "to attach, to fix to the earth or to drive into the earth."

82. The Songhay term *batu* means a circle or "an assembly of people." *Ma* is a term for "master." For example, the Sorko call the city of Djenné *masakonala,* "the door of the king." Marty (1920–1921), vol. 2, p. 53, noted that the open prayer spaces, demarcated in stone or brush and common throughout the smaller villages, are called *dyinguere batuma,* an assembly place for Islamic prayer.

Chapter 7

1. Cited by Fisher (1973), p. 361. There are few in-depth resources for the arts and architecture of the Fouta-Djallon, Adamawa, and Nupe. The survey given here owes much to the pioneering studies by Heathcote (1972), (1974), (1976), and Moughtin (1964), (1965), (1972). See Prussin (1976) for an earlier discussion of Fulbe-Hausa architecture.

2. A recent comparative socio-political study of these three regions is Azarya (1978).

3. Adelaye (1971), p. 21.

4. The Futa Confederacy of the Fouta-Djallon was composed of the first nine Muslim families; in the Sokoto Confederacy, all but one of the eight traditional rulers of the emirates was descended from a clan of pastoral or semi-sedentary Fulbe: Low (1972), p. 66; Diallo (1972), p. 28. The process that occurred in the west-central Sudan under Fulbe impetus appears to parallel closely the model for the early development of Islam in northeast Africa suggested by Wolf (1951), pp. 355–56.

5. Last (1967), p. xlviii, noted that Fulfulde was still widely spoken at the caliphate court in Sokoto at the end of the last century. It also seems possible that Western usage of the term "Hausa architecture" reflected early-twentieth-century British attempts to reestablish traditional Hausa leadership and minimize the role of the defeated Fulbe ruling aristocracy. An excerpt from a report by Sir Frederick Lugard in 1903 noted: "The original Hausa rulers are very pleased with us for having avenged their defeat on the Fulani, but they show no signs of wanting to assert their independence": Hopen (1958), p. 16.

6. The most extensive bibliography of sources on Hausa history can be found in Low (1972).

7. M. G. Smith (1964), p. 353.

8. Hogben (1967), p. 82; M. G. Smith (1964), pp. 350–51.

9. Tremearne (1910), p. 177.

10. Low (1972), p. 64; Salifou (1971), pp. 32–33.

11. Barth (1857–1859), vol. 1, p. 371.

12. See plates in Campbell (1928).

13. Last (1967), pp. 107–113.

14. Dupire (1962), p. 322.

15. Mervyn Hiskett (1963) in his introduction to *Tazyīn Al-Waraqāt* describes the author as a member of the Torodi, and a descendant of Musa Jukulla, who in the fifteenth century led the Torodobi from Fouta-Toro and settled in the area of Birnin Konni. From Konni, the Fulbe spread through the country of the Hausa.

16. Du Picq (1933).

17. The development of the Fulani-Hausa dome is in many ways analogous to its suggested development elsewhere: in E. B. Smith (1950).

18. Khalīl ibn-Ishāq (1848–1852), vol. 1, pp. 248–49.

19. Prost (1954); Stenning (1964), pp. 120–21; Olivier de Sardan (1969), pp. 109–114.

20. For a detailed description of the building of these vaults and a glossary of Hausa terms associated with their construction, see Daldy (1941).

21. Nicolaisen (1963), p. 347.

22. Denham, Clapperton, and Oudney (1826), vol. 1, pp. 230–31; vol. 2, p. 184.

23. Foureau (1902), p. 546.

24. Denham, Clapperton, and Oudney (1826), vol. 2, p. 372.

25. Ibid., p. 263.

26. Barth (1857–1859), vol. 1, pp. 493–94.

27. P.-L. Monteil (1894?), pp. 275–76.

28. Foureau (1902), pp. 514, 523.

29. Salifou (1971), p. 35.

30. Denham, Clapperton, and Oudney (1826), vol. 2, p. 372.

31. Daldy (1941), p. 19.

32. Robinson (1913).

33. Moughtin (1965), p. 121.

34. Last (1967), pp. 76–77, 210.

35. Robinson (1913), vol. 1, p. 22.

36. Denham, Clapperton, and Oudney (1826), vol. 2, p. 364.

37. Gouvernement Général de l'Afrique Française (1945). It is of interest to note that the building terms given in this report from the Department of Public Works, Zinder and Niamey, to the Director of IFAN, Dakar are in both Tuareg and Hausa.

38. Denham, Clapperton, and Oudney (1826), vol. 2, p. 364.

39. Moughtin (1965), pp. 111–13; (1972).

40. Tremearne (1910), p. 178.

41. Foureau (1902), p. 520.

42. Prussin, fieldnotes, Maradi, Niger, Summer 1974.

43. G. Nicolas (1966).

44. Goody (1971b), ch. 4.

45. Last (1967), pp. 180–81. His discussion of the *vizier*'s role is particularly useful in the interpretation of nineteenth-century architectural developments.

46. Adelaye (1971), p. 49; Labouret (1955), notes the verb *kofnol*, "to greet," and the plural *kofli*, "greeting"; Taylor (1932) gives the following definition for *kofa*: "A slave on duty at the palace door—one to be propitiated before access can be had to the king." The first courtyard is often called a *kofar gida*.

47. Last documents references to these building programs and includes a map of the *ribats* built during the caliphate. The *Tazyīn Al-Waraqāt* (Hiskett, 1963), pp. 115–17, is rich in references to fortresses, cities, and citadels.

48. Clapperton (1829), pp. 198–99.

49. Denham, Clapperton, and Oudney (1826), vol. 2, p. 377.

50. Foureau (1902), p. 520.

51. Taylor and Webb (1932), pp. 169, 177, 179.

52. In his discussion of the relationship between Adamawa and Sokoto, Barth referred to the comments by messengers of the Adamawa governor who exclaimed that "Katsina and Kano . . . are large and busy thoroughfares, while Adamawa is a distant territory in the remotest corner of the

earth, and still a fresh, unconsolidated conquest": Barth (1857–1859), vol. 2, p. 187.

53. Ibid., p. 179.

54. Ibid., p. 182. The name Yola comes from the princely quarter of the town of Kano, called by the same name.

55. Chappel (1977), pp. 52, 60, figs. 52, 146, 153, 155, 161.

56. Nadel (1965), p. 76.

57. Ibid., pp. 78–79.

58. Ibid., p. 41. House-building is the most overt example of ostentation and a high priority for display of status in Nupeland.

59. Ibid., p. 93. The pair of concentric walls structurally allow for increased magnitude. A similar architectural practice obtains in the Fouta-Djallon.

60. Frobenius (1923); Göbel (1970); Nadel (1965), pp. 269–74.

61. Last (1967), p. 190.

62. Hiskett (1973), pp. 33–34.

63. The discussion of the architecture of the Fouta-Djallon is extracted from an in-depth study based on field-work in Guinea in 1979–1980. Earlier studies of the architecture of the Fouta-Djallon are Pougade (1948), Vieillard (1940), and Creach (1951).

64. The classic study for the history and culture of the confederacy is Tauxier (1937). For Islam in Guinea, see Marty (1916–1918).

65. Riesman (1977).

66. According to Lieutenant Bouchez, the *tata* or city ramparts consisted of three walls. The first was an outer crenellated wall approximately 4 meters high, built of stone and mortar, which formed an ellipse some 1,800 meters long. The second, most important wall was 6 meters high and formed an irregular octagon each of whose sides was 100 to 150 meters long. There was a circular, multiple story turret at each angle of this wall. The third wall, also 6 meters high, followed in part the trace of the second, thereby creating a protected circular road between 40 and 60 meters wide between the two walls: "Historique de Dingueray," *Bulletin du Comité de l'Afrique Française* 7 (1913): n.p. All that remain today are the ruins of several turrets.

67. Sow (1967), p. 32.

Chapter 8

1. This chapter is an abridged and edited version of a paper presented to *The Arts of Ghana Symposium*, UCLA, November 1977, which was subsequently published: Prussin (1980). Our interpretation of Asante architectural history draws heavily on the documentation in Ivor Wilks' superb study of nineteenth-century political history (1975).

2. Wilks (1975), p. 243, has suggested that the forest-kingdom stereotype developed out of the more abundant and available evidence of a southern, coastal connection, in contrast to the sparse documentation for Asante's relationship to the north. The nineteenth- and twentieth-century European presence itself colors our interpretation of pre-colonial history.

3. Bowdich (1819), p. 57. His insightful reference to a northern factor assumes new meaning in the light of recent scholarship which has argued, with increasingly convincing documentation, for the presence of a major northern component in the development of the Asante Confederacy. Recent studies in archeology, in weaving traditions, in the system of goldweight measures, and in Islamic records suggest that even the startling suggestion proffered two decades ago is a considerable understatement: Wilks (1961b), p. 34.

4. Portuguese sources referred to the "King of Acanes" as early as 1520, and the Akan were located inland and southeast of Insoco on a Dutch map of 1629: Fynn (1971), pp. 3–19.

5. Tauxier (1932), pp. 159, 233. The *ananse*, or spider, is the heroine of a number of Asante folktales and proverbs. See n. 18 below for the Kankyeabo laborers who figure in a related oral tradition.

6. Wilks (1975), p. 315.

7. Rattray (1923), p. 142.

8. Bowdich (1819), p. 308. When Dupuis, another early observer, commented on an intrusion into his apartment at Kumasi by its rightful proprietor, who had come with a daily offering to "his tutelary god" to be fixed to the "sacred tree" at the door of his apartment, he was obviously referring to this central feature of Asante housing: Dupuis (1966), p. 56.

9. Swithenbank (1969).

10. Bowdich (1819), p. 263. Although the second class is described as "inferior," one is tempted to wonder, on the basis of tangential textual references, whether they were the producers of the Islamic amulets so prevalent in late eighteenth- and nineteenth-century Greater Asante, since they lived "in society."

11. Tauxier (1921), pp. 192, 353–54.

12. For a full discussion of this recent phenomenon, see Dennis Michael Warren, "Disease, Medicine and Religion among the Techiman-Bono of Ghana: A Study in Culture Change," Ph.D. dissertation, Indiana University, 1973.

13. Rattray (1923), pp. 190–92.

14. Swithenbank (1969), Hyland (1975).

15. Müller (1676), pp. 144–45.

16. Ibid., p. 276.

17. *Swish* construction is a puddled-mud technique in which layers of earth are sequentially and cumulatively tamped into place to achieve a considerable wall thickness. Although the term is associated with coastal building, it is technologically distinct from wattle-and-daub techniques, which derive their stability and strength from a reinforcing armature. While *swish* walls are considerably thicker than northern circular walls simply built of earth, where the circular form itself compensates for resistance to horizontal forces, they are close relatives. To the best of our knowledge, the first reference to *swish* was recorded by an English governor in 1696, when "northern" slaves were employed in European fortification-building on the Gold Coast. The etymology of the term is difficult to ascertain. Early references occur in accounts of repairs to the Accra fort at Prampram in 1789, in a discussion of the state of Cape Coast Castle in 1822, and in reference to the tower in the rear of the Castle. Presumably, the French fort built at Assin would have used *swish* construction as well.

18. Meyerowitz (1951), pp. 186–91. In Bono-Mansu, the capital of the northerly kingdom of Bono until its destruction by the Asante in 1740, a distinction was made in the number of *swish* layers permitted to commoners, to chiefs, and in the king's palace: "commoners were allowed only five layers, each three feet high, the chief's houses could be two stories, and only the king could build a three-story palace." While this tradition relates to the "fortifications" associated with the Akan traders and reflects a northern building technology, the author's suggestion that it was the basis for the later development of Asante architecture is technologically untenable. A suggestion that the origin of the style can "be traced to the city of Twifo-Heman, founded by the Aduana who had emigrated from the northwestern Ivory Coast," is equally problematic. Meyerowitz states: "At Twifo-Heman, the Aduana clan people also built rectangular houses. The homes of the aristocracy were richly decorated, not only with mural sculptures in relief [*abankuo*] but with colonnades, pillars, arches, and friezes, the arrangement and proportions of which were precisely similar to those used by architects in European buildings. When [the] Aduana were dispersed, the refugees took this new type of architecture all over the forest region and it was finally adopted by all other Akan people, including the Asante." The location of Twifo in the forested region southwest of Akan offers a more viable basis for the development of elaborate alto-relievo surfaces but is inconsistent with the attributed Aduana origin. The confusion is compounded by another architectural tradition recorded by the same author—the building of a stone house by Asare Niansa at Fomase, with laborers from Kankyeabo, "after the pattern of stone houses his ancestors built in the North." Kankyeabo, as noted above, is a region on the coast not far from Assin. On the basis of a reference to stone, the author suggests a link to the so-called "stone ruins" in the northeastern Ivory Coast and in southwestern Upper Volta, reported by Delafosse early in the century. These ruins are actually of oxidized laterite soils which, when exposed to the air, harden and resemble stone.

19. Bowdich (1819), pp. 32, 35, 271, 277. The king of Dagomba was given as many as thirty slaves for a lavish, "saphie"-encumbered war coat worn by an Asante *caboceer*.

20. Dupuis (1966), p. 142.

21. Rattray (1927), p. 264. Tradition has also attributed the name of the cloth itself to Adinkira, the king of Gyaman who, having angered the Asante king Osei Bonsu by making a replica of the Golden Stool, was defeated and slain by the latter in 1818–1819. The Gyaman-Asante relationship considerably pre-dates the 1819 war, and the chronology of Abron rule includes an earlier king, Adinngra, who ruled in the latter part of the seventeenth century. If the naming tradition is grounded in reality, the *adinkra* cloth itself could be of much greater antiquity than is suggested by association with the later king of Gyaman. The extensive friction which marked Gyaman-Asante relations in the decades prior to 1818, and which was occasioned by the question of Muslim allegiance, may be of greater relevance to the question.

22. Bowdich (1819), p. 310.

23. Danquah (1944), pp. xxxvii–xxxviii.

24. Rattray (1930), pp. 39–41.

25. Bowdich (1819), p. 32; Dupuis (1966), p. 74.

26. The office of *fotosanfohene* or head of the "weighers," responsible for the *fotuo* or treasury proper, was created in 1722–1723, immediately following the Techiman campaign, by Opoku Ware, an early Asantehene. See Wilks (1975), pp. 415ff., for a detailed discussion and Bowdich (1819), p. 297, for references to the *fotoorh* or treasury bag. Keys eventually became the insignia of offices related to the Great Treasury.

27. The distinction between a Great Chest and a leather bag was apparently already being made at the time of Bowdich's visit, since he makes reference to both ([1819], p. 276). Thomas B. Freeman (1968), p. 142, also observed several velvet and silk-covered trunks of indigenous workmanship on his visit to the Kumasi palace in 1842. One is reminded of the trunks introduced by various European coastal traders, as well as the silver and wood coffers made and used by the Tekna and Trarza of Mauretania.

28. A report from 1709 made reference to the small-bodied horses used for ceremonial purposes in the court of Osei Tutu: Fynn (1971), p. 32.

29. Dupuis (1966), p. xi.

30. According to Wilks (1961b), p. 340, "in the late eighteenth century, even Ashanti seemed likely to become a Muslim state." Osei Kwame was a son of the former Mamponhene Safo Katanga, himself favorably inclined toward Islam. With maturity, in the consolidation of his own power during the last two decades of the eighteenth century, Osei Kwame apparently antagonized indigenous forces opposed to Islam. His deposition in 1798 has been attributed to this attitude and to his attempts to establish Koranic law as the civil code. Despite indigenous opposition, the Muslims continued during the reign of Osei Kwame's successor, Osei Bonsu, to exercise a multifaceted influence on the cultural and political affairs of the capital quite incommensurate with their num-

bers. By 1810, the Muslim community numbered close to a thousand: Wilks (1975), p. 256.

31. Bowdich (1819), p. 306. The proscriptions relating to natural needs include the avoidance of cracks and crevices, the wind, watering places, public ways, shady places, hard terrain, and, above all, orientation toward Mecca. *Khalīl ibn Isḥāq* (1956), pp. 28–29. The only way to accommodate these proscriptions in an urban area is to place the latrine on an upper level.

32. Rattray (1929), pp. 271–72.

33. Bowdich (1819), p. 308.

34. Swithenbank (1969), p. 58.

35. Bowdich (1819), pp. 56–57.

36. Rattray (1929), pp. 56ff.; Meyerowitz (1951), pp. 186–91. Although it has been suggested that Rattray's plan is that of the Kumawu palace, there is no specific indication that it is any more than a prototype. Our interpretation as well as Rattray's plan varies considerably from others recorded.

37. Although there was a major approach leading up to the entrance, lined with *dampon*, entrance itself was through this first vestibule into a court. An analogy that comes to mind is the military ritual wherein the approach to present arms is created by a flanking bodyguard arranged lineally.

38. T. B. Freeman (1968), pp. 58, 138.

39. Fynn (1971), p. 117, citing Bowdich, notes that most of the slaves in Kumasi were sent as annual tribute of the Inta, the Dagomba, and their neighbors.

40. After the Gyaman revolt subsequent to the destoolment of Osei Kwame at the end of the eighteenth century, "upwards of five thousand Muslims were enslaved and distributed in the provinces and the capital city." Wilks (1975), p. 263.

41. See Timothy Garrard, "Studies in Akan Goldweights," *Transactions of the Historical Society of Ghana* 13, 1 and 2 (1972), and 14, 1 and 2 (1973), for the extent and dating of various kinds of geometric goldweights, including the prevalence of the "ram's horn" motif and its innovative appearance in the goldweight repertoire.

42. Rattray (1929), pp. 72–73. In the early part of the eighteenth century, during the reign of Opoku Ware, for example, a Mamponhene had sold the three villages of Safo, Nantan, and Asoromanso—all in the vicinity of Ntonso—to the Asantehene. They were used to strengthen the new Dadiesoaba stool of Kumasi: Wilks (1975), pp. 106–107.

43. Bowdich (1819), pp. 156–57.

44. Dupuis (1966), pp. 13–14.

45. Stanley (1971). The author's preliminary description of the city, its palace, and Bantammah Tower or "Louvre of Coomassie" (p. 61) is misleading: it was not yet based on firsthand observation, but was presented as preliminary historical background before he embarked for Kumasi.

46. Ibid., pp. 166–67.

47. The war party commanded a majority in the council by 1822, and opposition to English education and an anti-European attitude continued from 1823 to 1826: Wilks (1975), pp. 485–87.

48. The importance of the Stone House or *aban* as a "palace of culture"—a major architectural image of Kumasi's economic buoyancy and a symbol of its status as a national capital in the early nineteenth century—has been strongly argued by Wilks (1975), pp. 200–201. Our interpretation of its architectural symbolism differs considerably from his.

49. Bowdich (1819), pp. 147, 177.

50. Ibid., p. 309.

51. Dupuis (1966), p. 137–38.

52. Wilks (1975), p. 178n.65, says that the prayers of northern *imams* were solicited for the well-being of the castle.

53. T. B. Freeman (1968), p. 141.

54. Among the articles that attracted particular attention were a pair of coffers of "native workmanship," covered with velvet, tacked with gold and silver studs, "like an English trunk." Presumably these were part of the Great Treasury which had come to replace the leather *foto* upon the installation of a *fotohene*. Such "trunks" were frequently represented in the repertoire of Asante goldweights and may have reflected the increasing focus on Europe. Stanley (1971), p. 61, suggested that it was the Bantama rather than the palace which was the actual treasure house, the "Louvre of Coomassie," and this terminology may have invited comparison to the British Museum.

55. T. B. Freeman (1968), p. 56.

56. Brackenbury (1874), vol. 2, pp. 233ff.

57. Stanley (1971), pp. 232–33. A single drawing of the burning city's roofscape from the parapet of the palace by Melton Prior, an artist from the *Illustrated London News* who also accompanied the 1874 British Mission, suggests that subsequent renderings of what this Stone Castle looked like may be suspect. For example, the illustration of the "Burning of Coomassie" accompanying the Stanley text was reproduced in an almost identical plate in Grant (1873–1875), vol. 3; see Wilks (1975), pl. XIII. The only difference is that the conflagration has been omitted from the drawing. The stone parapet in the illustration and Freeman's reference to a small English villa appear to have provided the inspiration for a rather fanciful rendition published in 1890, some sixteen years after the destruction of the palace: Wilks (1975), pl. V. The bias of the news coverage of the period emerges even more clearly when one compares Stanley's introductory description of "a large and capacious structure of stone with great squares, lofty and commodious rooms" with his subsequent eyewitness account.

58. In 1898, T. B. Freeman (1968), p. 125, went in search of the palace remains. When found, "it proved like the rest of the city, a disappointment. I could only see part of it, as it was hidden by trees and lay inside a fenced compound, but it appeared to have been a building of no great size."

59. Wilks (1975), pp. 238–39.

60. Hodgson (1901), p. 67.

61. Swithenbank (1969), pp. 14–21.

62. Hyland (1975), pp. 30ff.

BIBLIOGRAPHY

Abdul, M. O. A. 1970. "Yoruba Divination and Islam." *Orita* 4, 1 (June): 17–25.

Adam, André. 1951. *La Maison et le village dans quelques tribus de l'Anti-Atlas*. Collection Hespéris XIII. Paris: Emile Larose.

Adelaye, R. A. 1971. *Power and Diplomacy in Northern Nigeria, 1804–1906*. London: Longman.

Africanus, Leo. 1896. *The History and Description of Africa, 1600*, ed. Robert Brown; trans. John Pory. 3 vols. London: Hakluyt Society.

Alexandre, Pierre, ed. 1973. *French Perspectives in African Studies*. London: Oxford University Press.

Andrews, Peter A. 1971. "Tents of the Tekna, Southwest Morocco." In *Shelter in Africa*, ed. Paul Oliver. New York: Praeger.

Andrews, W. S. 1960. *Magic Squares and Cubes*. New York: Dover.

Antubam, Kofi. 1963. *Ghana's Heritage of Culture*. Leipzig: Koehler and Amelong.

Appia, B. 1965. "Les Forgerons du Fouta-Djallon." *Journal de la Société des Africanistes* 35, 2: 317–352.

Archinard, Colonel. 1896. "La Campagne 1892–1893 au Soudan français." *Bulletin du Comité de l'Afrique Française et Renseignements Coloniaux* 1: 1–36.

Ardalan, Nader, and Laleh Bakhtiar. 1975. *The Sense of Unity: The Sufi Tradition in Persian Architecture*. 2nd ed. Chicago: University of Chicago Press.

Arias, F. de. 1860(?). *Carpintería, antigua y moderna*. 2 vols. Barcelona: n.p.

Aymo, J. 1958. "La Maison ghadamsie." *Travaux de l'Institut de Recherches Sahariennes* 17, 1–2: 157–191.

Azarya, Victor. 1978. *Aristocrats Facing Change*. Chicago: University of Chicago Press.

Ba, A. Hampaté. 1972. *Aspects de la civilisation africaine*. Paris: Présence Africaine.

———. 1973. "La Notion de personne en Afrique Noire." In *La Notion de personne en Afrique Noire*, ed. Germaine Dieterlen. Paris: CNRS.

Ba, A. Hampaté, and Jacques Daget. 1962. *L'Empire peul du Macina (1818–1853)*. Paris: Mouton.

Ba, A. Hampaté, and Germaine Dieterlen. 1961. *Koumen*. Paris: Mouton.

Bakhtiar, Laleh. 1976. *Sufi: Expressions of the Mystic Quest*. London: Thames and Hudson.

Bannā, Ibn al-. 1948. *Risalat al-anwâ: Le Calendrier d'Ibn al-Banna de Marrakech 1256–1321*, trans. H. P. J. Renaud. Paris: Emile Larose.

Barbot, Jean. 1732. *A Description of the Coasts of North and South Guinea*. Churchill's Collection of Voyages and Travels, vol. 5. London: Printed for A. J. Churchill.

Barth, Henry. 1857–1859. *Travels and Discoveries in North and Central Africa*. 3 vols. New York: Harper and Bros.

———. 1861. *Voyages et découvertes dans l'Afrique*. 4 vols. Paris: A. Bohne.

Béart, Charles. 1955. *Jeux et jouets de l'Ouest africain*. Mémoires IFAN 42, 2 vols. Dakar: IFAN.

Bedaux, R. M. A. 1972. "Tellem, reconnaissance archéologique d'une culture de l'Ouest africain au moyen âge: recherches architectoniques." *Journal de la Société des Africanistes* 42: 103–185.

Beguin, Jean-Pierre, et al. 1954. *L'Habitat au Cameroun.* Paris: Editions de l'Union Française.

Benoit, Fernand. 1931. *L'Afrique Méditerranéenne.* Paris: Editions G. van Oest.

Bernatzik, Hugo A. 1930(?). *The Dark Continent, Africa.* New York: B. Westermann.

Bernolles, J. 1963. "Note sur l'ornementation d'un chapeau Peul en usage dans la région de Djougou." *Notes Africaines* 98: 47–50.

———. 1966. *Permanence de la parure du masques africaines.* Paris: Maisonneuve et Larose.

Bernus, Edmund. 1960. "Kong et sa région." *Etudes eburnéennes* 8: 293–364.

Binger, Louis. 1892. *Du Niger au Golfe de Guinée par le pays de Kong et le Mossi.* 2 vols. Paris: Librairie Hachette.

Bivar, A. D. H. 1968. "The Arabic Calligraphy of West Africa." *African Language Review* 7: 3–15.

Blyden, Edward W. 1967. *Christianity, Islam and the Negro Race.* Orig. publ. 1887. Reprint Edinburgh: University Press.

Bonnet, L. 1929. *L'Industrie du tapis à la Kalaa des Beni Rached.* Oran: Carbonel.

Borg, André. 1959. "L'Habitat à Tozeur." *Cahiers des Arts et Techniques d'Afrique du Nord* 5: 91–108.

Boser-Sarivaxévanis, Renée. 1972. *Les Tissus de l'Afrique occidentale.* Basel: Pharos-Verlag Hansrudolf Schwabe.

Bourilly, Joseph. 1932. *Eléments d'ethnographie marocaine.* Paris: Librairie Coloniale et Orientaliste Larose.

Bourilly, Joseph, and E. Laoust. 1927. *Stèles funéraires marocaines.* Collection Hespéris 3. Paris: Emile Larose.

Bousquet, G. H. 1959. *Précis de droit musulman principalement malékite et algérien.* 2 vols. Alger: Maison des Livres.

Bovill, E. W. 1970. *The Golden Trade of the Moors.* 2nd ed. London: Oxford University Press.

Bowdich, T. Edward. 1819. *Mission from Cape Coast Castle to Ashantee.* London: John Murray.

———. 1821. *An Essay on the Superstitions, Customs and Arts, Common to the Ancient Egyptians, Abyssinians and Ashantees.* Paris: J. Smith.

Boyle, Laura. 1968. *Diary of a Colonial Officer's Wife.* Oxford: Alden Press.

Brackenbury, Henry. 1874. *The Ashanti War.* 2 vols. London: William Blackwood and Sons.

Brasseur, Gérard. 1968. *Les Etablissements humains au Mali.* Mémoires IFAN 83. Dakar: IFAN.

Bravmann, René. 1974. *Islam and Tribal Art in West Africa.* Cambridge, England: Cambridge University Press.

Brossard, Charles. 1906. *Géographie pittoresque et monumentale de la France et ses colonies.* Colonies Françaises, vol. 6. Paris: Flammarion.

Brunschvig, Robert. 1947. "Urbanisme médiéval et droit musulman." *Revue des Etudes Islamiques* 15: 127–155.

Brunschwig, Henri. 1966. *French Colonialism 1871–1914.* New York: Praeger.

Buel, James W. 1894. *The Magic City.* Philadelphia: Historical Publishing Co.

Caillié, René. 1965. *Journal d'un voyage à Tembouctou et à Jenne.* 4 vols., orig. publ. 1830. Reprint Paris: Editions Anthropos.

Cammann, Schuyler V. R. 1969. "Islamic and Indian Magic Squares, Part 1." *History of Religions* 8, 3: 181–209.

———. 1972. "Symbolic Meanings in Oriental Rug Patterns." *Textile Museum Journal* 3, 3: 5–54.

Campbell, Dugald. 1928. *On the Trail of the Veiled Tuareg.* Philadelphia: J. B. Lippincott.

Champault, F. D. 1969. *Une Oasis du Sahara nord-occidental: Tabelbala.* Paris: CNRS.

Chanoine, Lt. 1898. "Le Gourounsi." *Bulletin du Comité de l'Afrique Française* 8: 48–51.

Chapelle, Jean. 1957. *Nomades noirs du Sahara.* Paris: Plon.

Chappel, T. J. H. 1977. *Decorated Gourds.* Lagos: Nigerian Museum.

Christolfe, Marcel. 1951. *Le Tombeau de la Chrétienne.* Paris: Arts et Métiers Graphiques.

Chudeau, R. 1910. "Le Bassin du Moyen Niger." *La Géographie* 21: 389–408.

———. 1909. *Sahara soudanais.* Missions au Sahara, vol. 2. Paris: Armand Colin.

Church, R. J. Harrison. 1960. *West Africa: A Study of the Environment and of Man's Use of It.* 2nd ed. London: Longmans.

Clapperton, Hugh. 1829. *Journal of an Expedition into the Interior of Africa.* London: John Murray.

Cohen, Abner. 1974. *Two-Dimensional Man.* Berkeley and Los Angeles: University of California Press.

———. 1971. "Cultural Strategies in the Organisation of Trading Diasporas." In *The Development of Indigenous Trade and Markets in West Africa*, ed. Claude Meillassoux. 10th International African Seminar. London: Oxford University Press.

Cole, Herbert, and Doran Ross. 1977. *The Arts of Ghana.* Los Angeles: Museum of Cultural History, University of California.

Collins, Peter. 1965. *Changing Ideals in Modern Architecture.* London: Faber and Faber.

Colloque international sur la notion de personne en Afrique Noire. 1973. Paris, 11–17 October 1971. Paris: CNRS.

Colloque sur les cultures voltaïques. 1967. Recherches Voltaïques 8.

Creach, P. 1951. "Notes sur l'art décoratif architectural Foula du Haut Fouta-Djallon." *Africanistes de l'Ouest. Compte-rendu* 2: 300–312.

Creswell, K. A. C. 1940. *Early Muslim Architecture*. 2 vols. Oxford: Clarendon Press.

Critchlow, Keith. 1976. *Islamic Patterns: An Analytical and Cosmological Approach*. New York: Schocken Books.

Crone, Gerald R., ed. and trans. 1937. *The Voyages of Cadamosto and Other Documents on Western Africa in the Second Half of the Fifteenth Century*. London: Hakluyt Society.

Crooks, J. J. 1973. *Records Relating to the Gold Coast Settlements from 1750–1874*. Orig. publ. 1923. Reprint London: Frank Cass.

Cuoq, Joseph M. 1975. *Recueil des sources arabes concernant l'Afrique Occidentale du VII^e au XVI^e siècle (Bilad al-Sudan)*. Paris: CNRS.

Curtin, Philip D. 1964. *The Image of Africa: British Idea and Action, 1780–1850*. Madison: University of Wisconsin Press.

Daldy, A. F. 1941. *Temporary Buildings in Northern Nigeria*. Technical Paper No. 10. Lagos: Public Works Department.

Dalzel, Archibald. 1793. *The History of Dahomey*. London: T. Spillsbury and Son.

Danquah, Joseph B. 1944. *The Akan Doctrine of God*. London and Redhill: Lutterworth Press.

Dapper, Olfert. 1668. *Neukeurige beschrijvinghe der Afrikaensche gewesten van Egypten, Barbaryen.* . . . Amsterdam: J. van Meurs.

David, Nicolas. 1971. "The Fulani Compound and the Archaeologist." *World Archaeology* 3: 111–131.

Delacroix, Eugène. 1930. *Voyage au Maroc*. Orig. publ. 1832. Reprint Paris: Les Beaux-Arts.

Delafosse, Maurice. 1908a. *Les Frontières de la Côte d'Ivoire, de la Côte d'Or et du Soudan*. Paris: Masson et Cie.

———. 1908b. "Le Peuple Siena ou Sénoufo." *Revue des Etudes Ethnographiques et Sociologiques*. 1: 81–92.

———. 1912. *Haut-Sénégal-Niger (Soudan français)*. Le Pays, les peuples, les langues, l'histoire, les civilisations. Series 1, 3 vols. Paris: Emile Larose.

———. 1923. "Terminologie religieuse au Soudan." *L'Anthropologie* 33: 371–83.

———. 1924. "Les Relations du Maroc avec le Soudan à travers les âges." *Hespéris* 4: 153–174.

Delange, Jacqueline. 1963–64. "L'Art peul." *Cahiers d'Etudes Africaines* 4, 13: 5–13.

Denham, Dixon, Hugh Clapperton, and Walter Oudney. 1826. *Narrative of Travels and Discoveries in Northern and Central Africa, in the Years 1822, 1823, and 1824*. 2 vols. London: John Murray.

Denyer, Susan. 1978. *African Traditional Architecture*. New York: Africana Publishing Co.

Desplagnes, Louis. 1907. *Le Plateau central nigérien*. Paris: Emile Larose.

Despois, Jean. 1946. *Géographie humaine*. Mémoires de la Mission scientifique du Fezzân, vol. 3. Institut de Recherches Sahariennes de l'Université d'Alger. Paris: Lechevalier.

———. 1953. "Les Greniers fortifiés de l'Afrique du Nord." *Cahiers de Tunisie* 1: 38–60.

Despois, Jean, and René Raynal. 1967. *Géographie de l'Afrique au Nord-Ouest*. Paris: Payot.

Devisse, Jean. 1975. *Actes de Colloque*. Premier Colloque International de Bamako, 1975. Paris: Copedith.

Diallo, Thierno. 1972. *Les Institutions politiques du Fouta Dyalon au XIX^e siècle*. Dakar: IFAN.

Diehl, Charles. 1896. *L'Afrique Byzantine*. Paris: E. Leroux.

Dieterlen, Germaine. 1941. *Les Ames des Dogons*. Paris: Institut d'Ethnologie.

———. 1951. *Essai sur la religion Bambara*. Paris: Presses Universitaires de France.

———. 1957. "The Mande Creation Myth." *Africa* 17, 2: 124–138.

———. 1959. "Mythe et organisation sociale en Afrique Occidental." *Journal de la Société des Africanistes* 29, 1: 119–138.

———. 1965. *Textes sacrés d'Afrique Noire*. Paris: Gallimard.

———. 1973a. "A Contribution to the Study of Blacksmiths in West Africa." In *French Perspectives in African Studies*, ed. Pierre Alexandre. London: Oxford University Press.

Dittmer, K. 1961. *Die Säkralen Hauptlinge der Gurunsi im Ober-Volta Gebiet*. Hamburg: Museum für Völkerkunde.

Doutté, Edmond. 1909. *Magie et religion dans l'Afrique du Nord*. Alger: Typographie Adolphe Jourdan.

———. N.d. *Les Tas de pierres sacrés et quelques practiques connexes dans le Sud du Maroc*. Alger: Imprimerie Administrative Victor Heintz.

Dubois, Félix. 1892. "La Vie Noire." *L'Illustration*: 2591–2596.

———. 1893. *La Vie au continent noir*. Paris: J. Hetzel.

———. 1897a. *Tombouctou la mystérieuse*. Paris: Flammarion.

———. 1897b. *Timbuctoo the Mysterious*, trans. Diana White. London: Heinemann.

Duchemin, G. J. 1950. "A propos des décorations murales des habitations de Oulata (Maurétanie)." *Bulletin IFAN* 12, 4: 1095–1110.

Dumas, Alexandre. 1848–1851. *Le Veloce; ou, Tangier, Alger et Tunis*. 4 vols. Paris: Alexandre Cabot; Bertonnet.

Du Picq, Ardant. 1933. *Une Population africaine, les Dyerma*. Paris: Presses Universitaires de France.

Dupire, Marguerite. 1962. *Peuls nomades*. Travaux et Mémoires de l'Institut d'Ethnologie 64. Paris: Université de Paris.

———. 1970. *Organisation sociale des Peul*. Paris: Plon.

Du Puigaudeau, Odette. 1949. *Tagant*. Paris: René Julliard.

———. 1957. "Contribution à l'étude du symbolisme dans le décor mural et l'artisanat de Walata." *Bulletin IFAN* 19, B, 1–2: 137–183.

———. 1960. "Architecture maure." *Bulletin IFAN* 22, B, 1–2: 91–133.

———. 1967, 1968. "Arts et coutumes des Maures." *Hespéris Tamuda* 8, 1: 111–196; 9, 3: 329–427.

Dupuis, Joseph. 1966. *Journal of a Residence in Ashantee*. Orig. publ. 1824. 2nd ed. London: Frank Cass.

Dupuis-Yacouba, A. 1910, 1913, 1914. "Notes sur Tombouctou." *Revue d'Ethnologie et de Sociologie* 1: 233–236; 4: 100–104; 5: 248–263.

———. 1921. *Industries et principales professions des habitants de la région de Tombouctou*. Paris: Emile Larose.

Duru, Raymond. 1960. "Une Qasba des Aït Ouarrab." *Hespéris-Tamuda* 1, 1: 143–155.

Duveyrier, Henri. 1864. *Les Toureg du Nord*. Paris: Challamel Ainé.

Echallier, J. C. 1966. "Sur quelques habitations rurales du Souf." *Travaux de l'Institut de Recherches Sahariennes* 25: 129–136.

———. 1968. "Essai sur l'habitat sédentaire traditionnel au Sahara algérien." Thesis, Institut d'Urbanisme de l'Université de Paris.

Echard, Nicole. 1965. "Note sur les forgerons de l'Ader." *Journal de la Société des Africanistes* 35, 2: 353–372.

———. 1967. "L'Habitat traditionnel dans l'Ader." *L'Homme* 7, 3: 48–77.

Edgerton, Samuel Y. 1975. *The Renaissance Rediscovery of Linear Perspective*. New York: Basic Books.

El Bekri, Abou-Obeid. 1965. *Description de l'Afrique septentrionale*, trans. MacGuckin de Slane. Rev. ed. Paris: Adrien-Maisonneuve.

Engeström, Tör. 1956. "Wall Decoration of the Oualata Type at Bamako." *Ethnos* 21: 216–219.

Es-Sadi, Abderrahman-ben-Abdallah-ben-' Imrân-ben-'Amir. 1964. *Tarikh es-Soudan*, trans. O. Houdas. Reprint Paris: Adrien-Maisonneuve.

Etherton, David. 1971. "Algerian Oases." In *Shelter in Africa*, ed. Paul Oliver. New York: Praeger.

Fage, J. D. 1958. *An Atlas of African History*. London: Edward Arnold.

Fernandes, Valentim. 1938. *Description de la côte d'Afrique de Ceuta au Sénégal*, trans. and annot. P. de Cenival and Th. Monod. Paris: Publications du Comité d'Etudes Historiques et Scientifiques de l'Afrique Occidentale Française.

Filipowiak, W. 1968. "Les Recherches archéologiques Polono-Guінéenes à Niani en 1968." *Materially Pachodnio-pomorskie* 14: 621–648.

———. 1969. "L'Expedition archéologique Polono-Guínéenne à Niani en 1968." *Africana Bulletin* (Warsaw) 11: 107–117.

Fischer, Ernst. 1963. *The Necessity of Art*. Baltimore: Penguin.

Fisher, Humphrey J. 1972, 1973. "He Swalloweth the Ground with Fierceness and Rage: The Horse in the Central Sudan." *Journal of African History* 13, 3: 367–388; 14, 3: 355–380.

Forde, Daryll, and Phyllis Kayberry, eds. 1967. *West African Kingdoms in the Nineteenth Century*. London: Oxford University Press.

Fortes, Meyer. 1957. *The Web of Kinship among the Tallensi*. London: Oxford University Press.

Fortes, Meyer, and Germaine Dieterlen, eds. 1965. *African Systems of Thought*. London: Oxford University Press.

Foureau, Fernand. 1902. *D'Alger au Congo par le Tchad*. Paris: Masson et Cie.

Frankfort, Henri. 1960. *Before Philosophy*. Baltimore: Penguin.

Fraser, Douglas, ed. 1966. *Many Faces of Primitive Art*. Englewood Cliffs, N.J.: Prentice-Hall.

———. 1974. *African Art as Philosophy*. New York: Interbook.

Freeman, Richard A. 1898. *Travels and Life in Ashanti and Jaman*. Westminster: Constable; New York: Stokes.

Freeman, Thomas B. 1968. *Journal of Various Visits to the Kingdoms of Ashanti, Aku and Dahomi*. Orig. publ. 1844. Reprint London: Frank Cass.

Frobenius, Leo. 1923. *Das unbekannte Afrika, Aufhellung der Schicksale eines Erdteils*. Munich: Oskar Beck.

Froelich, J. C. 1949. "Les Sociétés d'initiation chez les Moba et les Gourma du Nord-Togo." *Journal de la Société des Africanistes* 19: 99–141.

———. 1962. *Les Musulmans d'Afrique Noir*. Paris: Editions de l'Orante.

Froger, François. 1698. *Relation d'un voyage fait en 1695, 1696 et 1697 aux côtes d'Afrique. . . .* Paris: M. Brunet.

Fromentin, Eugène. 1857. *Une Eté dans la Sahara*. Paris: Lévy.

———. 1859. *Une Année dans le Sahel*. Paris: Lévy.

Fynn, J. K. 1971. *Asante and Its Neighbors, 1700–1807*. Evanston, Ill.: Northwestern University Press.

Gabus, Jean. 1955, 1958. *Au Sahara: arts et symboles*. 2 vols. Neuchâtel: Editions de la Baconnière.

———. N.d. *Guide du Musée d'ethnographie de Neuchâtel*. Neuchâtel: Musée d'Ethnographie.

Gaden, Henri. 1931. *Proverbes et maximes Peuls et Toucouleurs*. Travaux et Mémoires de l'Institut d'Ethnologie XVI. Paris: Institut d'Ethnologie.

Gallay-Jorelle, Suzanne. 1961–1962. "Les Tissages Ras de Djebala." *Cahiers des Arts et Techniques d'Afrique du Nord* 6: 103–115.

Gallieni, Le commandant. 1885. *Voyage au Soudan français: 1879–1881.* Paris: Librairie Hachette.

Gallieni, Le lieutenant-colonel. 1891. *Deux Campagnes au Soudan français: 1886–1888.* Paris: Librairie Hachette.

Gallotti, Jean. 1925. *Moorish Houses and Gardens of Morocco.* 2 vols. New York: William Helburn.

Gardi, René. 1970. *African Crafts and Craftsmen,* trans. Sigrid MacRae. New York: Reinhold Van Nostrand.

———. 1974. *Indigenous African Architecture.* New York: Reinhold Van Nostrand.

Gideon, Siegfried. 1964. *The Eternal Present: The Beginnings of Architecture.* New York: Pantheon.

Glück, Julius. 1956. "Afrikanische Architektur." *Tribus,* n.s. 6: 65–82.

Göbel, Peter. 1970. "Gelbschmiedearbeiten der Nupe im Museum für Völkerkunde zu Leipzig." *Jahrbuch des Museums für Völkerkunde zu Leipzig* 27: 266–319.

———. 1973. "Bemerkungen zu den 'Buchdeckeln' der Nupe." *Jahrbuch des Museums für Völkerkunde zu Leipzig* 29: 191–227.

Goichon, A.-M. 1927, 1931. *La Vie feminine au Mzab.* 2 vols. Paris: Paul Geuthner.

Goldwater, Robert. 1960. *Bambara Sculpture from the Western Sudan.* New York: Museum of Primitive Art.

Golvin, Lucien. 1950. "Le 'Métier à la tire' des fabricants de brocarts de Fès." *Hespéris* 37, 1–2: 21–52.

———. 1950–1953. *Les Arts populaires en Algérie.* 4 vols. Alger: Gouvernement général de l'Algérie.

———. 1957. *Aspects de l'artisanat en Afrique du Nord.* Publications de l'Institut des Hautes Etudes de Tunis, Section des Lettres II. Paris: Presses Universitaires de France.

———. 1970. *Essai sur l'architecture religieuse musulmane.* Vol. 1: *Généralités.* Paris: Klincksieck.

Gombrich, E. H., Julian Hochberg, and Max Black. 1973. *Art, Perception and Reality.* Baltimore and London: Johns Hopkins University Press.

Goodchild, R. G. 1954. "Oasis Forts of Legio III Augusta on the Routes to the Fezzan." *Papers of the British School at Rome* 22: 56–68.

Goody, Jack. 1962. *Death, Property and the Ancestors.* London: Tavistock.

———. 1967. *The Social Organization of the LoWiili.* 2nd ed. London: Oxford University Press.

———, ed. 1968. *Literacy in Traditional Societies.* Cambridge, England: Cambridge University Press.

———. 1971a. "The Impact of Islamic Writing on the Oral Cultures of West Africa." *Cahiers d'Etudes Africaines* 11, 3: 455–466.

———. 1971b. *Technology, Tradition and the State in Africa.* London: Oxford University Press.

———. 1977. *The Domestication of the Savage Mind.* Cambridge, England: Cambridge University Press.

Gourou, Pierre. 1970. *L'Afrique.* Paris: Librairie Hachette.

Gouvernement Général de l'Afrique Française. Direction des Travaux Publics No. 359 TP DG/ST. 1945. "Dossier documentaire sur les voûtes haoussas." Documentation IFAN XII/6, Dakar.

Grant, James. 1873–1875. *British Battles on Land and Sea.* 3 vols. London: Cassell, Petter, Galpin and Co.

Gray, William. 1825. *Travels in Western Africa in the years 1818, 19, 20 and 21.* . . . London: John Murray.

Griaule, Marcel. 1966. *Dieu d'Eau: entretiens avec Ogotomeli.* Paris: Fayard.

Griaule, Marcel, and Germaine Dieterlen. 1951. "Signes graphiques soudanais." *L'Homme* 3: 1–85.

———. 1965a. "The Dogon." In *African Worlds,* ed. Daryll Forde. London: Oxford University Press.

———. 1965b. *Le Renard pâle.* Vol. 1: *Le Mythe cosmogonique.* Paris: Institut d'Ethnologie.

Grunebaum, G. E. von. 1964. *Islam: Essays in the Nature and Growth of a Cultural Tradition.* London: Routledge and Kegan Paul.

Gsell, S. 1913–1928. *Histoire ancienne de l'Afrique du Nord.* 8 vols. Paris: Hachette et Cie.

Guebhard, P. 1911. "Notes sur la religion, les mœurs et coutumes des Bobo." *Revue d'Ethnographie et de Sociologie* 2: 125–145.

Gutkind, E. A. 1953. "How Other Peoples Dwell and Build—Indigenous Houses of Africa." *Architectural Design* 23: 121–124.

Hallowell, Alfred Irving. 1974. *Culture and Experience.* Philadelphia: University of Pennsylvania Press.

Hamdun, Saïd, and Noel King, trans. 1975. *Ibn Battuta in Black Africa.* London: Rex Collings.

Hammond, Peter. 1966. *Yatenga: Technology in the Culture of a West African Kingdom.* New York: Free Press.

Hance, William A. 1975. *The Geography of Modern Africa.* Orig. publ. 1964. 2nd ed. New York: Columbia University Press.

Harley, George W. 1941. *Native African Medicine.* Cambridge, Mass.: Harvard University Press.

Haselberger, Herta. 1962. "Wandmalereien und plasticher Bauschmuck in Guinea." *Jahrbuch der Museum für Völkerkunde* 19: 138–166.

———. 1964. *Bautraditionen der Westafrikanischen Negerkulturen.* Vienna: Verlag Herder.

———. 1965. "Bemerkungen zum Kunsthandwerk im Podo (Republic Mali)." *Baessler-Archiv* n.s. 13: 433–499.

———. 1966. "Architekturskizzen aus der Republik Mali Ergebnisse der DIAFE 1907–1909 des Frobenius Institut." *International Archives of Ethnography* 50, 1: 244–280.

————. 1969. "Bemerkungen zum Kunsthandwerk in der Republik Haute Volta." *Zeitschrift für Ethnologie* (Braunschweig) 94, 2: 171–246.

Haynes, D. E. L. 1959. *The Pre-Islamic Antiquities of Tripolitania.* London: Trinity Press.

Heathcote, David. 1972. "Hausa Embroidered Dress." *African Arts* 5, 2: 12–19, 82.

————. 1974. "A Hausa Charm Gown." *Man* n.s. 9, 4: 620–624.

————. 1976. *The Arts of the Hausa.* London: World of Islam Festival Publishing Co.

Herber, J. 1950. "Influence de la bijouterie soudanaise sur la bijouterie marocaine." *Hespéris* 37, 1–2: 5–10.

Himmelheber, H. 1960. *Negerkunst und Negerkünstler.* Braunschweig: Klinkhardt and Biermann.

Hirschberg, Walter. 1962. *Schwarzafrika.* Graz: Akademische Druk-U. Verlagsanstalt.

Hiskett, Mervyn, trans. 1963. *Tazyīn Al-Waraqāt*, by Abdullah ibn Muhammad. Ibadan: Ibadan University Press.

————. 1973. *The Sword of Truth: The Life and Times of Shehu Usuman Dan Fodio.* New York: Oxford University Press.

Hodge, Carleton T., ed. 1971. *Papers on the Manding.* Bloomington: Indiana University Press.

Hodgson, Lady. 1901. *The Siege of Kumasi.* London: C. Arthur Pearson.

Hogben, S. J. 1967. *An Introduction to the History of the Islamic States of Northern Nigeria.* Ibadan: Oxford University Press.

Holas, B. 1957. *Les Senoufo.* Paris: Presses Universitaires de France.

————. 1960. *Cultures matérielles de la Côte d'Ivoire.* Paris: Presses Universitaires de France.

————. 1968. "L'Imagerie rituelle en Afrique Noire." *Bulletin IFAN* 30, B, 2: 586–609.

Hopen, E. Edward. 1958. *The Pastoral Fulbe Family in Gwandu.* London: Oxford University Press.

Hulot, Baron. 1900. "Rapport sur les progrès de la géographie en 1899." *La Géographie* 1, 1: 195–206.

Hunwick, J. O. 1966. "Religion and State in the Songhay Empire, 1464–1591." In *Islam in Tropical Africa*, ed. I. M. Lewis. London: Oxford University Press.

————. 1972. "An Andalusian in Mali: A Contribution to the Biography of Abu Ishaq al-Sahili, c. 1290–1346." Paper read to the Conference on Manding Studies, S.O.A.S., London.

————. 1973. "The Mid-Fourteenth-Century Capital of Mali." *Journal of African History* 14, 2: 195–206.

Hyland, A. D. C., ed. 1975. *Traditional Forms of Architecture in Ghana.* Kumasi: University of Science and Technology.

Ibn Batouteh. 1874–1879. *Voyages*, trans. C. Defrémery and B. R. Sanguinetti. 4 vols. Paris: Imprimerie Nationale.

————. Ibn Battūta. 1929. *Travels in Asia and Africa*, trans. H. A. R. Gibb. London: R. M. MacBride.

————. 1966. *Textes et documents relatifs à l'histoire de l'Afrique*, annot. and trans. Raymond Mauny et al. Faculté des Lettres et Sciences Humains, Publications de la Section d'Histoire No. 9. Dakar: University of Dakar.

Ibn Khaldûn. 1927. *Histoire des Berberes*, trans. Baron de Slane. Paris: Paul Geuthner.

————. 1967. *The Muqaddimah: An Introduction to History*, trans. Franz Rosenthal. 3 vols. Orig. publ. 1958. 2nd ed. Princeton: Princeton University Press.

Imperato, Pascal J. 1973. "Wool Blankets of the Peul of Mali." *African Arts* 6, 3: 40–47.

————. 1976. "Kereka Blankets of the Peul." *African Arts* 9, 3: 56–59.

Innocent, C. F. 1916. *The Development of English Building Construction.* Cambridge, England: Cambridge University Press.

Italiaander, Rolf. 1956. *Nordafrika.* Munich: Hans Reich Verlag.

Jackson, James G. 1968. *An Account of the Empire of Morocco.* Orig. publ. 1809. London: Frank Cass.

Jackson, Michael. 1977. *The Kuranko.* London: C. Hurst.

Jacques-Meunié, Dj. 1951a. *Greniers-citadelles au Maroc.* 2 vols. Rabat: Publications de l'Institut des Hautes-Etudes Marocaines 52.

————. 1951b. *Sites et Forteresses de l'Atlas.* Paris: Arts et Métiers Graphiques.

————. 1961. *Cités anciennes de Mauritanie.* Paris: Klincksieck.

————. 1962. *Architectures et habitats du Dades.* Paris: Klincksieck.

Jannequin, Claude. 1643. *Voyage de Lybie au Royaume de Sénéga, le long du Niger.* Paris: C. Rouillard.

Johnston, H. A. S. 1967. *The Fulani Empire of Sokoto.* London: Oxford University Press.

Johnston, Keith. 1879. "General Map of Africa." Edinburgh and London: W. and A. K. Johnston.

Jouin, Jeanne. 1932. "Thèmes décoratifs des broderies marocaines." *Hespéris* 15, 1: 11–30.

Kâti, Mahmoûd Kâti ben El-Hâdj El-Mataouakkel. 1964. *Tarikh El-Fettâch*, trans. O. Houdas and M. Delafosse. Orig. publ. 1913–1914. Reprint Paris: Adrien-Maisonneuve.

Khalīl ibn Ishāq, al-Jundi. 1848–1852. *Précis de jurisprudence musulmane . . . selon le rite mâlékite, par Khalîl ibn-Ishâk*, trans. M. Perron. 5 vols. Paris: Imprimerie Nationale.

————. 1956. *Abrégé de la loi musulmane selon le rite de l'imâm Mâlek, Le Ritual.* Alger: En Nahdha.

Kimble, George H. T. 1938. *Geography in the Middle Ages.* London: Methuen.

Kirk-Greene, A. H. M. 1958. *Adamawa Past and Present.* London: Oxford University Press.

———. 1963. *Decorated Houses in a Northern City*. Kaduna: Baraka Press.

Kruger, Christoph, et al. 1967. *Sahara*. Vienna and Munich: Anton Schroll Verlag.

Kunst, Hans-Joachim. 1967. *The African in European Art*. Bad Godesberg: Inter Nationes.

Kyerematen, A. A. Y. 1964. *Panoply of Ghana*. London: Longmans, Green.

Labouret, Henri. 1931. "Afrique occidentale et équatoriale." In A. Bernard et al., *L'Habitation indigène dans les possessions françaises*. Paris: Société d'Editions Géographiques, Maritimes et Coloniales.

———. 1955. *La Langue des Peuls ou Foulbé*. IFAN Mémoire 41. Dakar: IFAN.

Lajoux, Jean-Dominique. 1962. *Merveilles du Tassili n'Ajjer*. Paris: Editions du Chêne.

Lamb, Venice. 1975. *West African Weaving*. London: Gerald Duckworth.

Lane, Edward William. 1960. *An Account of the Manners and Customs of the Modern Egyptians*, ed. E. S. Poole. 5th ed. London: John Murray.

Langer, Susanne. 1953. *Feeling and Form*. New York: Charles Scribner's Sons.

Laoust, E. 1930, 1932, 1934. "L'Habitation chez les transhumants du Maroc Central." *Hespéris* 10, 2: 151–253; 14, 2: 115–218; 18, 2: 109–196.

Last, Murray. 1967. *The Sokoto Caliphate*. New York: Humanities Press.

Leach, Edmund. 1974. *Claude Lévi-Strauss*. New York: Viking Press.

Lebel, Roland. 1952. *Les Etablissements français d'Outre-Mer et leur reflet dans la littérature française*. Paris: Emile Larose.

Lebeuf, Annie, and Jean-Paul Lebeuf. 1973. "Symbolic Monuments of the Logone-Birni Royal Palace (Northern Cameroons)." In *French Perspectives in African Studies*, ed. Pierre Alexandre. London: Oxford University Press.

Lebeuf, Jean-Paul. 1953. "Labrets et greniers des Fali (Nord Cameroun)." *Bulletin IFAN* 15, 3: 1321–1328.

———. 1961. *L'Habitation des Fali*. Paris: Librairie Hachette.

———. 1967. "L'Architecture africaine traditionelle." In *Colloque, 1er festival mondial des arts nègres, Dakar*. Paris: Présence Africaine.

Le Corbusier. 1927. *Towards a New Architecture*. New York: Holt, Rinehart and Winston.

Lee, Dorothy. 1960. "Lineal and Nonlineal Codifications of Reality." In *Explorations in Communication*, ed. Edmund Carpenter and Marshall McCluhan. Boston: Beacon Press.

Leiris, Michel. 1933. "Faîtes de case des rives du Bani." *Minotaure* 2: 18–19.

Lem, F.-H. 1949. *Sudanese Sculpture*. Paris: Arts et Métiers Graphiques.

Le Maire, Sieur Jacques J. 1695. *Les Voyages du sieur Le Maire aux Isles Canaries, Cap-Verd, Sénégal, et Gambie*. Paris: Chez J. Collombat.

Lévi-Strauss, Claude. 1966. *The Savage Mind*. Chicago: University of Chicago Press.

Levtzion, Nehemia. 1965. "Early Nineteenth Century Arabic Manuscripts from Kumasi." *Transactions of the Historical Society of Ghana* 8: 99–119.

———. 1968. *Muslims and Chiefs in West Africa*. Oxford: Clarendon Press.

———. 1971. "A Seventeenth Century Chronicle by Ibn al-Mukhtār: A Critical Study of the Tarīkh al-Fattāsh." *Bulletin of the School of Oriental and African Studies* 34, 3: 571–593.

———. 1973. *Ancient Ghana and Mali*. London: Methuen.

———. 1979. "Patterns of Islamization in West Africa." In *Conversion to Islam*, ed. Nehemia Levtzion. New York: Holmes and Meier.

Lewcock, Ronald. 1978. "Architects, Craftsmen and Builders: Materials and Techniques." In *Architecture in the Islamic World*, ed. George Michell. New York: William Morrow.

Lewicki, Tadeusz. 1960. "Quelques Extraits inédits relatifs aux voyages des commerçants et des missionaires Ibadits nord-africains au pays du Soudan occidental et central au moyen âge." *Folia Orientalia* 2, 1–2: 1–27.

———. 1961. "Les Historiens, biographes et traditionnistes ibadites-wahabites de l'Afrique Nord du VIIIe au XVIe siècle." *Folia Orientalia* 3, 1–2: 1–134.

———. 1962. "L'Etat nord-africain de Tahert et ses relations avec le Soudan occidental à la fin du VIIIe et au IXe siècle." *Cahiers d'Etudes Africaines* 2, 4: 513–535.

Lhote, Henri. 1944. *Les Touaregs du Hoggar (Ahaggar)*. Paris: Payot.

———. 1947. *Comment campent les Touregs*. Paris: J. Susse.

———. 1958. *A la découverte des fresques du Tassili*. Grenoble: Arthaud.

Ligers, Z. 1967–1969. *Les Sorko (Bozo): maîtres du Niger*. 4 vols. Paris: Librairie des Cinq Continents.

Lombard, J. 1957. "Aperçu sur la technologie et l'artisanat Bariba." *Etudes Dahoméennes* 18: 5–50.

Low, Victor. 1972. *Three Nigerian Emirates: A Study in Oral History*. Evanston, Ill.: Northwestern University Press.

Loyer, Godefroy. 1714. *Relation du voyage du Royaume d'Issyny, Côte d'Or, païs de Guinée, en Afrique*. Paris: A. Seneuze.

McIntosh, R. J. 1974. "Archaeology and Mud-Wall Decay in a West African Village." *World Archaeology* 6: 154–171.

McNaughton, Patrick R. 1977. "The Bamana Blacksmiths: A Study of Sculptors and Their Art." Ph.D. dissertation, Yale University.

Mage, M. E. 1868a. *Voyage dans le Soudan occidental (Sénégambie-Niger) 1863–1866*. Paris: Librairie Hachette.

———. 1868b. "Voyage dans le Soudan occidental (1863–1866)." *Le Tour du Monde* 17, 1: 1–112.

Marçais, George. 1927. *Manuel d'art musulman: L'architecture*. 2 vols. Paris: Editions Auguste Picard.

———. 1954. *L'Architecture musulmane d'Occident*. Paris: Arts et Métiers Graphiques.

———. 1957. "L'Urbanisme musulman." In *Mélanges d'histoire et d'archéologie de l'Occident musulman*, 2 vols. Rabat: Imprimerie Officielle.

———. 1962. *L'Art musulman*. Paris: Presses Universitaires de France.

Marcy, G. 1937. "Déchiffrement des inscriptions 'Tifinagh.' " *Hespéris* 24, 1–2: 89–118.

Marles, Eric F. 1967. *Mosques in Ghana*. University of Ghana, Institute of African Studies, Field Report 1. Legon: University of Ghana.

Marti, Montserrat P. 1964. "Les Calendriers Dahoméens." *Objets et Mondes* 4, 1: 29–38.

Martin, A. G. P. 1908. *Les Oasis sahariennes (Gourara-Touat-Tidikelt)*. Paris: Challamel.

Marty, Paul. 1916–1918, 1918–1919. "L'Islam en Guinée." *Revue du Monde Musulman* 34: 69–333; 36: 160–227.

———. 1920–1921. *Etudes sur l'Islam et les tribus du Soudan*. 4 vols. Paris: Editions Ernest Leroux.

———. 1922. *Etudes sur l'Islam en Côte d'Ivoire*. Paris: Editions Ernest Leroux.

———. 1926. *Etudes sur l'Islam au Dahomey*. Paris: Editions Ernest Leroux.

Mauny, Raymond. 1950. "La Tour et la mosquée de l'Askia Mohammed à Gao." *Notes Africaines* 47: 66–67.

———. 1951. "Notes d'archéologie au sujet de Gao." *Bulletin IFAN* 13: 837–852.

———. 1952. "Notes d'archéologie sur Tombouctou." *Bulletin IFAN* 14: 899–918.

———. 1954. *Gravures, peintures et inscriptions rupestres de l'Ouest africain*. Dakar: IFAN.

———. 1961. *Tableau géographique de l'Ouest africain au moyen âge*. Mémoires IFAN 61. Dakar: IFAN.

———. 1970. *Les Siècles obscurs de l'Afrique Noire*. Paris: Fayard.

Mayer, L. A. 1956. *Islamic Architects and Their Works*. Geneva: Albert Kundig.

Mbiti, John S. 1970. *African Religions and Philosophies*. Garden City, N.Y.: Doubleday.

Meillassoux, Claude. 1966. "Plans d'anciennes fortifications (tata) en pays Malinké." *Journal de la Société des Africanistes* 36, 1: 29–43.

———. 1972. "L'Itinéraire d'Ibn Battuta de Walata à Malli." *Journal of African History* 13, 3: 389–395.

Méniaud, Jacques. 1912. *Haut-Sénégal-Niger (Soudan français)*. Géographie Economique. Series 2, 2 vols. Paris: Emile Larose.

———. 1931. *Les Pionniers du Soudan*. Paris: Société des Publications Modernes.

———. 1935. *Sikasso*. Paris: F. Bouchy.

Mercier, M. 1922. *La Civilisation urbaine au Mzab*. Alger: Emile Pfister.

Mercier, Paul. 1954. "L'Habitation à étage dans l'Atakora." *Etudes Dahoméenes* 11: 30–78.

———. 1962. *Connaissance de l'Afrique: Civilisations du Bénin*. Paris: Présence Africaine.

Meunié, Jacques and Charles Allain. 1956. "Quelques gravures et monuments funéraires de l'extrême sud-est marocain." *Hespéris* 42: 51–85.

Meyerowitz, Eva L. R. 1951. *The Sacred State of the Akan*. London: Faber and Faber.

———. 1958. *The Akan of Ghana*. London: Faber and Faber.

Michell, George, ed. 1978. *Architecture of the Islamic World*. New York: William Morrow.

Migeon, Gaston. 1927. *Manuel d'art musulman*. 2 vols. Paris: Editions Auguste Picard.

Miner, Horace. 1965. *The Primitive City of Timbuctoo*. New York: Doubleday.

Ministère de la Marine et des Colonies. 1884. *La France dans l'Afrique occidentale, 1879–1883*. 2 vols. Paris: Challomel Aîné.

Mollien, G. T. 1820a. *Travels in the Interior of Africa*, ed. and trans. T. E. Bowdich. London: H. Colburn.

———. 1820b. *Voyage dans l'intérieur de l'Afrique aux sources du Sénégal et de la Gambie, fait en 1818, par ordre du gouvernement français*. Paris: Courcier.

Monod, Théodore. 1946. *L'Hippotame et le philosophe*. Paris: René Julliard.

———. 1947. "Sur quelques détails d'architecture africaine." *Acta Tropica* 4, 4: 342–345.

———. 1948. "Sur quelques constructions anciennes du Sahara occidental." *Bulletin de la Société de Géographie et d'Archéologie de la Province d'Oran* 71: 1–30.

Montagne, Robert. 1930. *Villages et kasbas Berbères*. Paris: Librairie Félix Alcan.

Monteil, Charles. 1903. *Monographie de Djénné*. Tulle: Jean Mazeyrie.

———. 1924. *Les Bambara du Ségou et du Kaarta*. Paris: Emile Larose.

———. 1932. *Une Cité soudanaise: Djenné*. Paris: Société d'Editions Géographiques, Maritimes et Coloniales.

———. 1953. "La Légende du Ouagadou et l'origine des Soninké." *Mélanges ethnologiques*. Mémoire IFAN 23. Dakar: IFAN.

Monteil, Parfait-L. 1894(?). *De Saint-Louis à Tripoli par le lac Tchad*. Paris: Félix Alcan.

Monteil, Vincent. 1964. *L'Islam Noir*. Paris: Editions du Seuil.

Morton-Williams, Peter. 1968. "The Fulani Penetration into Nupe and Yoruba in the Nineteenth Century." In *History and Social Anthropology*, ed. I. M. Lewis. ASA Monograph 7. London: Tavistock.

Moughtin, J. C. 1964. "The Traditional Settlements of the Hausa People." *Town Planning Review* 35, 1: 21–34.

———. 1965. "Traditional Architecture of the Hausa People." M.A. thesis, University of Liverpool.

———. 1972. "The Friday Mosque, Zaria City." *Savannah* 1, 2: 143–163.

Müller, Wilhelm J. 1676. *Die Africanische auf der Guineischen Gold-cust gelegene Landschafft Fetu*. Hamburg: Zacharias Hartel.

Nachtigall, Horst. 1966. "Zelt und Haus bei den Beni Mguild-Berbern (Marokko)." *Baessler-Archiv* n.s. 14: 269–329.

Nadel, S. F. 1965. *A Black Byzantium*. Orig. publ. 1942. London: Oxford University Press.

———. 1970. *Nupe Religion*. New York: Schocken Books.

Nasr, Seyyed Hassein. 1964. *Science and Civilization in Islam*. Cambridge, Mass.: Belknap Press.

———. 1978. *An Introduction to Islamic Cosmological Doctrines*. Orig. publ. 1964. Boulder: Shambala.

Niane, D. T. 1965. *Sundiata, an Epic of Old Mali*, trans. G. D. Pickett. London: Longmans.

Nicolaisen, Johannes. 1963. *Ecology and Culture of the Pastoral Tuareg*. Copenhagen: National Museum.

Nicolas, Francis. 1938. "Les Industries de protection chez le Tuareg de l'Azawagh." *Hespéris* 25, 1: 43–84.

———. 1950. *Tamesna*. Paris: Imprimerie Nationale.

Nicolas, Guy. 1966. "Essai sur les structures fondamentales de l'espace dans la cosmologie Hausa." *Journal de la Société des Africanistes* 36, 1: 65–108.

Norberg-Schulz, Christian. 1971. *Existence, Space and Architecture*. New York: Praeger.

Norris, H. T. 1975. *The Tuaregs*. Warminster: Aris and Phillips.

Norwich, John Julius. 1968. *Sahara*. London: Longmans, Green.

Nwabara, Samuel N. 1963. "The Fulani Conquest and Rule of the Hausa Kingdom of Northern Nigeria (1804–1900)." *Journal de la Société des Africanistes* 33, 2: 231–241.

Norberg-Schulz, Christian. 1971. *Existence, Space and Architecture*. New York: Praeger.

Norris, H. T. 1975. *The Tuaregs*, Warminster: Aris and Phillips.

Norwich, John Julius. 1968. *Sahara*. London: Longmans, Green.

Nwabara, Samuel N. 1963. "The Fulani Conquest and Rule of the Hausa Kingdom of Northern Nigeria (1804–1900)." *Journal de la Société des Africanistes* 33, 2: 231–241.

Ofori, Patrick E. 1977. *Islam in Africa South of the Sahara*. Nendeln: KTO Press.

Oliver, Paul, ed. 1971. *Shelter in Africa*. New York: Praeger.

Oliver de Sardan, Jean-Pierre. 1969. *Système des relations économiques et sociales chez les Wogo (Niger)*. Paris: Institut d'Ethnologie.

Oloruntimehin, B. O. 1972. *The Segu Tukolor Empire*. New York: Humanities Press.

Ottenberg, Simon, and Phoebe Ottenberg. 1960. *Cultures and Societies of Africa*. New York: Random House.

Pacheco Pereira, Duarte. 1937. *Esmeraldo de situ orbis*, ed. and trans. G. H. T. Kimble. London: Hakluyt Society.

Pâques, Viviana. 1956. "Les 'Samake.'" *Bulletin IFAN* 18, B, 3–4: 369–390.

———. 1964. *L'Arbre cosmique dans la pensée populaire et dans la vie quotidienne du nord-ouest africain*. Paris: Institut d'Ethnologie.

Paris, André. 1925. *Documents d'architecture Berbere sud de Marrakech*. Collection Hespéris 2. Paris: Emile Larose.

Paris Exposition Reproduced. 1900. New York: R. S. Peale.

Park, Mungo. 1799. *Travels in the Interior Districts of Africa*. London: C. Nicol.

Parville, Henri de. 1890. *L'Exposition Universelle*. Paris: J. Rothschild.

Le Pavillon du Sénégal-Soudan à l'Exposition Universelle de 1900. 1901. Paris: Alcan-Lévy.

Péfontan, Le capitaine. 1926. "Les Armas." *Bulletin du Comité d'Etudes Historiques et Scientifiques de l'A.O.F.* 9: 153–179.

Perani, Judith. 1979. "Nupe Costume Crafts." *African Arts* 12, 3: 53–57.

Perignon, A. 1901. *Haut-Sénégal et Moyen-Niger*. Paris: J. André.

Peroz, E. 1890. "Le Tactique dans le Soudan." *Revue Maritime et Coloniale* 107 (Oct.): 79–129; (Nov.): 235–283; (Dec.): 364–453.

Person, Yves. 1964. "En quête d'une chronologie ivorienne." In *The Historian in Tropical Africa*, ed. J. Vansina, R. Mauny, and L. V. Thomas. London: Oxford University Press.

———. 1968–1970. *Samori: une révolution Dyula*. 2 vols. Mémoires IFAN 80. Dakar: IFAN.

Petonnet, Colette. 1972. "Espace, distance et dimension dans une société musulmane à propos du bidonville marocain de Douar Doum à Rabat." *L'Homme* 12, 2: 47–84.

Picton, John, and John Mack. 1979. *African Textiles*. London: British Museum Publications.

Piétri, Camille. 1885. *Les Français au Niger*. Paris: Librairie Hachette.

Polhemus, Ted, ed. 1978. *The Body Reader: Social Aspects of the Human Body*. New York: Pantheon.

Posnansky, Merrick. 1973. "Aspects of Early West African Trade." *World Archaeology* 5: 149–162.

Pougade, Jean. 1948. *Les Cases décorées d'un chef du Fouta-Djiallo*. Paris: Gauthier-Villars.

Préchaur-Canonge, Thérèse. 1962. *La Vie rurale en Afrique romaine d'après les mosaïques*. Paris: Presses Universi-taires de France.

Prost, R. P. 1954. "Notes sur les Songhay." *Bulletin IFAN* 16, B, 1: 167–213.

Prussin, Labelle. 1968. "The Architecture of Islam in West Africa." *African Arts* 1, 2: 32–35, 70–74.

———. 1969. *Architecture in Northern Ghana*. Berkeley and Los Angeles: University of California Press.

———. 1970a. "Sudanese Architecture and the Manding." *African Arts* 3, 4: 12–19, 64–67.

———. 1970b. "Contribution à l'étude du cadre historique de la technologie de la construction dans l'Ouest africain." *Journal de la Société des Africanistes* 40, 2: 175–178.

———. 1972. "West African Mud Granaries." *Paideuma* 18: 144–169.

———. 1973. "The Architecture of Djenné: African Synthesis and Transformation." Ph.D. dissertation, Yale University.

———. 1976. "Fulani-Hausa Architecture: Genesis of a Style." *African Arts* 9, 3: 8–19, 97–98.

———. 1980. "Traditional Asante Architecture." *African Arts* 13, 2: 57–65, 79–82, 85–87.

———. 1981. "Building Technologies in the West African Savannah." In *Le Sol, la parole et l'écrit, mélanges en hommage à Raymond Mauny*. Paris: Société Française d'Histoire d'Outre-Mer.

Prussin, Labelle, and David Lee. 1973. "Architecture in Africa: An Annotated Bibliography." *Africana Library Journal* 4, 3: 2–32.

Quimby, Lucy. 1972. "Transformations of Belief: Islam among the Dyula of Kongbougou from 1880 to 1970." Ph.D. dissertation, University of Wisconsin.

Raffenel, Anne. 1856. *Nouveau Voyage dans le pays des Nègres*. 2 vols. Paris: Napoléon Chaix.

Rattray, Robert. 1923. *Ashanti*. Oxford: Clarendon Press.

———. 1927. *Religion and Art in Ashanti*. London: Oxford University Press.

———. 1929. *Ashanti Law and Constitution*. Oxford: Clarendon Press.

———. 1930. *Akan-Ashanti Folk-Tales*. Oxford: Clarendon Press.

———. 1932. *The Tribes of the Ashanti Hinterland*. 2 vols. Oxford: Clarendon Press.

Read, Herbert. 1965. *The Origins of Form in Art*. New York: Horizon Press.

Réclus, Elisée. 1876–1894. *The Earth and Its Inhabitants*. Vols. 10–12, ed. A. H. Keane. New York: D. Appleton.

———. 1887. *Nouvelle géographie universelle*. Vol. 12: *L'Afrique occidentale*. Paris: Librairie Hachette.

Renaud, H. P.-J. 1938. "Ibn al-Banna de Marrakesh." *Hespéris* 25, 1: 13–42.

Rennell Rodd, James Francis. 1926. *People of the Veil*. London: Macmillan.

Reygasse, Maurice. 1950. *Monuments funéraires préislamiques de l'Afrique du Nord*. Paris: Arts et Métiers Graphiques.

Ricard, Prosper. 1924a. "Les Métiers manuels à Fès." *Hespéris* 4: 205–224.

———. 1924b. *Pour comprendre l'art musulman*. Paris: Librairie Hachette.

Riesman, Paul. 1977. *Freedom in Fulani Social Life*. Chicago: University of Chicago Press.

Robert, Denise, Serge Robert, and Jean Devisse. 1970. *Tegdaoust I*. Paris: Arts et Métiers Graphiques.

Robinson, Charles H. 1897. *Hausaland or Fifteen Hundred Miles through the Central Sudan*. London: Sampson Low, Marston.

———. 1913. *Dictionary of the Hausa Language*. 3rd ed., 2 vols. Cambridge, England: Cambridge University Press.

Roche, Manuelle. 1970. *Le M'Zab*. Bellegarde: Arthaud.

Rognon, P. 1962. "La Confédération des nomades Kel Ahaggar (Sahara Central)." *Annales de Géographie* 71, 388: 604–619.

Rosenthal, Franz. 1971. *Four Essays on Art and Literature in Islam*. Leiden: E. J. Brill.

Rouch, Jean. 1953. *Contribution à l'histoire des Songhay*. Mémoires IFAN 29. Dakar: IFAN.

———. 1960. *La Religion et la magie Songhay*. Paris: Presses Universitaires de France.

Russell, A. D., and A. Surrawardy. N.d. *A Manual of the Law of Marriage from the Mukhtasar of the Sidi Khalil*. London: Kegan Paul.

Rutter, Andrew F. 1971. "Ashanti Vernacular Architecture." In *Shelter in Africa*, ed. Paul Oliver. New York: Praeger.

Ruxton, Upton F. H. 1916. *Maliki Law*. London: Luzac.

Rykwert, Joseph. 1969. "The Sitting Position—A Question of Method." In *Meaning in Architecture*, ed. Charles Jencks and George Baird. New York: Braziller.

St. Croix, F. W. de. 1972. *The Fulani of Northern Nigeria*. Orig. publ. 1945. New ed. Westmead: Gregg International.

Saint-Martin, Yves-J. 1970. *L'Empire toucouleur 1848–1897*. Paris: Le Livre Africain.

Salifou, André. 1971. *Le Damagaram ou sultanat de Zinder au XIXᵉ siècle*. Etudes Nigériennes 27. Niamey: CNRSH.

Sauvaget, J. 1950. "Les Epitaphes royales de Gao." *Bulletin IFAN* 12: 418–440.

Savary, J.-P. 1966. *Monuments en pierres sèches du Fadnoun (Tassili n'Ajjer)*. Mémoires du Centre de Recherches Anthropologiques Préhistoriques et Ethnographiques 6. Paris: Arts et Métiers Graphiques.

Scarin, Emilio. 1934. *Le Oasi del Fezzan*. 2 vols. Bologna: Nicola Zanichelli.

Schacht, Joseph. 1954. "Sur la diffusion des formes d'architecture religieuse musulmane à travers le Sahara." *Travaux de l'Institut de Recherches Sahariennes* 11, 1: 11–27.

Schimmel, Annemarie. 1970. *Islamic Calligraphy*. Leiden: E. J. Brill.

Schwerdtfeger, Friedrich. 1971. "Housing in Zaria." In *Shelter in Africa*, ed. Paul Oliver. New York: Praeger.

Sebag, Paul. 1965. *The Great Mosque of Kairouan*. New York: Macmillan.

Shepard, Paul. 1971. *Man in the Landscape*. New York: Knopf.

Shinnie, P. L. 1967. *Meroe: A Civilization of the Sudan*. London: Thames and Hudson.

Sieber, Roy. 1972. *African Textiles and Decorative Arts*. New York: Museum of Modern Art.

Skertchly, J. Alfred. 1874. *Dahomey As It Is*. London: Chapman and Hall.

Smith, E. Baldwin. 1950. *The Dome: A Study in the History of Ideas*. Princeton: Princeton University Press.

Smith, Mary. 1954. *Baba of Karo*. London: Faber and Faber.

Smith, Michael G. 1964. "The Beginnings of Hausa Society, A.D. 1000–1500." In *The Historian in Tropical Africa*, ed. J. Vansina et al. London: Oxford University Press.

Smith, R. H. T. 1971. "West African Market-Places: Temporal Periodicity and Locational Spacing." In *The Development of Indigenous Trade and Markets in West Africa*, ed. C. Meillassoux. London: Oxford University Press.

Snowden, Frank M. 1970. *Blacks in Antiquity*. Cambridge, Mass.: Belknap Press.

Sow, Alfa Ibrahim. 1967. "La Foi, la loi, la voie: œuvre classique peule du début du XIXᵉ siècle." Mimeo. Bordeaux.

Stamp, Sir L. Dudley, and W. T. W. Morgan. 1972. *Africa: A Study in Tropical Development*. 3rd ed. New York: Wiley and Sons.

Stanley, Sir Henry M. 1971. *Coomassie and Magdala: The Story of Two British Campaigns in Africa*. Orig. publ. 1874. New York: Harper and Bros.

Stenning, Derrick. 1964. *Savannah Nomads*. London: Oxford University Press.

Stevens, Phyllis Ferguson. 1968. *Aspects of Muslim Architecture in the Dyula Region of the Western Sudan*. Legon: University of Ghana.

Sultan, A. A. 1980. "Notes on the Divine Proportions in Islamic Architecture." *Process Architecture* 15: 152–162.

Swithenbank, Michael. 1969. *Ashanti Fetish Houses*. Accra: Ghana Universities Press.

Tauxier, Louis. 1921. *Le Noir de Bondoukou*. Paris: Leroux.

———. 1927. *La Religion Bambara*. Paris: Paul Geuthner.

———. 1932. *Religion, mœurs et coutumes des Agnis de la Côte d'Ivoire*. Paris: Paul Geuthner.

———. 1937. *Mœurs et histoire des Peuls*. Paris: Payot.

Taylor, F. W. 1932. *A Fulani-Hausa Dictionary*. Oxford: Clarendon Press.

Taylor, F. W., and A. G. G. Webb, trans. 1932. *Labarun Al'Adun Hausawa Da Zantatukunsu*. London: Oxford University Press.

Tedzkiret en Nisian. 1966. Trans. O. Houdas, 1901. Reprint Paris: Adrien-Maisonneuve.

Tellier, Gaston. 1898. *Autour de Kita: étude soudanaise*. Paris and Limoges: H. Charles-Lavauzelle.

Terrasse, Henri. 1938. *Kasbas Berbères de l'Atlas et des oasis*. Paris: Editions de France.

Terrasse, Henri, and J. Hainaut. 1925. *Les Arts décoratifs au Maroc*. Paris: Henri Laurens.

Thiel, Philip. 1970. "Notes on the Description, Scaling, Notation and Scoring of Some Perceptual and Cognitive Attributes of the Physical Environment." In *Environmental Psychology*, ed. Harold M. Proshansky, William H. Ittelson, and Leanne G. Rivlin. New York: Holt, Rinehart and Winston.

Thomas, Benjamin E. 1965. "The Location and Nature of West African Cities." In *Urbanization and Migration in West Africa*, ed. Hilda Kuper. Berkeley and Los Angeles: University of California Press.

Thomas, Louis-Vincent, and René Luneau. *Les Religions d'Afrique noire*. Paris: Fayard.

Thomassey, Paul, and Raymond Mauny. 1951. "Campagne de fouilles à Koumbi Saleh." *Bulletin IFAN* 13, 2: 437–462.

———. 1956. "Campagne de fouilles de 1950 à Koumbi Saleh (Ghana?)." *Bulletin IFAN* 18, B, 1–2: 117–140.

Thompson, D'Arcy Wentworth. 1966. *On Growth and Form*. Abridged edition, ed. John Tyler Bonner. Cambridge, England: Cambridge University Press.

Tremearne, A. J. N. 1910. "Hausa Houses." *Man* 10, 99: 177–180.

———. 1970. *Hausa Superstitions and Customs*. Orig. publ. 1912. Reprint London: Frank Cass.

Triaud, Jean-Louis. 1973. *Islam et sociétés soudanaises au moyen âge*. Recherches Voltaïques 16. Paris and Ouagadougou: CNRS-CVRS.

Trimingham, J. Spencer. 1959. *Islam in West Africa*. Oxford: Clarendon Press.

———. 1962. *The History of Islam in West Africa*. Oxford: Oxford University Press.

———. 1966. "The Phases of Islamic Expansion and Islamic Culture Zones in Africa." In *Islam in Tropical Africa*, ed. I. M. Lewis. London: Oxford University Press.

Trowell, Margaret. 1960. *African Design*. London: Faber and Faber.

Turner, Victor. 1974. *Dramas, Fields and Metaphors*. Ithaca, N.Y.: Cornell University Press.

Turudi, Abdullah ibn Muhammad al-. 1963. *Tazyin al-Waraqat*. Ed. and trans. M. Hiskett. Ibadan: Ibadan University Press.

Urvoy, Y. 1934. "Chroniques Agadès." *Journal de la Société des Africanistes* 4: 145–177.

Vansina, Jan. 1965. *Oral Tradition: A Study in Historical Methodology*. Chicago: Aldine.

Verne, Jules. 1863. *Cinq Semaines en ballon: voyages de découvertes en Afrique*. Paris: J. Hetzel.

———. 1919. *L'Etonnante Aventure de la mission Barsac*. Paris: Librairie Hachette.

Vieillard, G. 1940. "Notes sur les Peuls du Fouta Djallon." *Bulletin IFAN* 2, 1–2: 87–210.

Viollet-le-Duc, Eugène-E. 1863–1872. *Entretiens sur l'architecture*. 2 vols. Paris: A. Morel et Cie.

———. 1876. *The Habitations of Man in All Ages*, trans. Benj. Bucknall. Boston: J. R. Osgood.

———. 1895. *Rational Building*, trans. G. Huss. New York: Macmillan.

Viré, Marie-Madeleine. 1958. "Notes sur trois épigraphes royales de Gao." *Bulletin IFAN* 20, B, 3–4: 368–376.

———. 1959. "Stèles funéraires musulmanes soudano-sahariennes." *Bulletin IFAN* 21, B, 3–4: 459–600.

Vitruvius, Pollio. 1914. *The Ten Books on Architecture*, trans. Morris Hickey Morgan. Cambridge; Mass.: Harvard University Press.

Waldman, M. R. 1966. "A Note on the Ethnic Interpretation of the Fulani Jihad." *Africa* 36, 3: 286–291.

Waterlot, Em.-G. 1926. *Les Bas-reliefs des bâtiments royaux d'Abomey (Dahomey)*. Travaux et Mémoires de l'Institut d'Ethnologie 1. Paris: Institut d'Ethnologie.

Welch, Anthony. 1979. *Calligraphy in the Arts of the Muslim World*. Austin: University of Texas Press.

Westermarck, Edward. 1926. *Ritual and Belief in Morocco*. 2 vols. London: Macmillan.

———. 1930. *Wit and Wisdom in Morocco*. London: G. Routledge & Sons.

———. 1933. *Pagan Survivals in Mohammedan Civilisation*. London: Macmillan.

Wilks, Ivor. 1961a. "The Northern Factor in Ashanti History: Begho and the Mande." *Journal of African History* 2, 1: 25–34.

———. 1961b. "A Medieval Trade Route from the Niger to the Gulf of Guinea." *Journal of African History* 3, 2: 337–341.

———. 1968. "The Transmission of Islamic Learning in the Western Sudan." In *Literacy in Traditional Society*, ed. Jack Goody. Cambridge, England: Cambridge University Press.

———. 1975. *Asante in the Nineteenth Century*. Cambridge, England: Cambridge University Press.

Willett, Frank. 1971. *African Art*. New York: Praeger.

Wolf, Eric. 1951. "The Social Organization of Mecca and the Origins of Islam." *Southwestern Journal of Anthropology* 7: 329–356.

Yūsuf Kamāl. 1926–1951. *Monumenta cartographica Africae et Aegypti*. 5 vols. Cairo: n.p.

Zahan, Dominique. 1950. "L'Habitation Mossi." *Bulletin IFAN* 12, 1: 223–229.

———. 1970. *Religion, spiritualité et pensée africaines*. Paris: Payot.

———. 1973. "Towards a History of the Yatenga Mossi." In *French Perspectives in African Studies*, ed. Pierre Alexandre. London: Oxford University Press.

———. 1974. *The Bambara*. Iconography of Religions, Section VII: Africa, II. Leiden: E. J. Brill.

Zaslavsky, Claudia. 1973. *Africa Counts*. Boston: Prindle, Weber and Schmidt.

Zeltner, F. de. 1914. "Les Touareg du sud." *Journal of the Royal Anthropological Institute* 44: 351–375.

Zevi, Brun. 1957. *Architecture as Space*. Rev. ed. 1974. New York: Horizon.

Zola, Emile. 1899. *Fécondité*. Paris: Charpentier.

Zwernemann, J. 1961. "Les Notions du dieu-ciel chez quelques tribus voltaïques." *Bulletin IFAN* 23, B, 1–2: 243–272.

ILLUSTRATION SOURCES AND
OBJECT CREDITS

Objects

Afrika Museum, Berg-en-Dal, The Netherlands: 4.6a, b.
American Museum of Natural History, New York: 7.25, 8.8.
David Ames: Plate 6 (Nigerian caps).
Basel Mission, Switzerland: 4.3, 4.4a.
Bibliothèque de l'Institut de France, Paris: 1.2.
Bibliothèque Nationale, Paris: 1.1, 1.15.
Philip Demonsablon, Paris: 4.12i.
The Detroit Institute of Arts, Detroit: 8.18.
M. H. De Young Museum, San Francisco: 4.7a.
Freetown Museum, Sierra Leone: 4.6c, 4.9a, b.
Metropolitan Museum of Art, New York: 4.15b, 5.28a, 5.30a, 8.12.

Musée de l'Homme, Paris: 3.26, 4.4b, 4.8b, c, 4.10a, c, 4.12d, f, 4.13b, 4.14a, b, 4.16c, 5.23b, 5.31a, 6.30a, 7.22b, 7.35.
Musée des Arts Africains et Océaniens, Paris: 8.18.
Museum of Cultural History, UCLA, Los Angeles: 4.12a.
Museum of Mankind, London: 4.12b, c, h, 4.14c, 8.10a, 8.13a, b, d.
Simon Ottenberg: 4.10d, 4.16a, b.
Carl Schlettwein, Basel: Frontispiece.
Seattle Art Museum, Seattle, Katherine C. White Collection: 4.11, 4.12j, 4.13c, d, 4.15c, 8.3.
Yale University Map Collection, New Haven: 1.6.

Original Photographs

Basel Mission, Switzerland: 8.4, 8.7a, 8.19, 8.21.
Roger Bedaux: 2.14a.
Lt. Bluzet, courtesy Professor Th. Monod, Paris: 6.35b.
Herbert M. Cole: 3.2a, b, 3.3a.
Documentation Française, Paris: 5.17b, 6.6a, 6.16b, 7.36a.
Rory Fonseca: 7.2, 7.12, 7.13a, 7.27a, b.
Eliot Elisofon Archives, National Museum of African Art, Washington, D.C.: Plate 12.
Frobenius Institut, Frankfurt-am-Main: 5.33c.
Jean Gabus: 5.37a.
René Gardi: 3.6b, 3.7a, 3.17, 3.24a, 8.7b.
Ghana Information Services: 8.2, 8.14.

IFAN, Dakar, Photothèque: 5.7a, 5.27, 5.32b, 5.36a, b, 6.14.
Paul Macapia: 4.11a, 4.12j, 4.13c, d, 4.15c, 8.3.
Andre Martin: 7.5a.
Raymond Mauny: 2.15, 5.5b, 5.12a.
Musée de l'Homme, Photothèque, Paris: 3.9a, 5.17a, 6.11a, 6.16a, 6.18d, 7.20b, 7.26a.
National Geographic: Georg Gerster, 6.1b, 6.8; Robert Moore, 5.15e.
C. Pelos and J.-L. Bourgeois: 5.19a.
Gerd Pinsker: Frontispiece.
Doron Ross: 8.10a.

293

Marli Shamir: 2.3, 2.7, 2.9, 2.11, 2.12, 2.14c, d, e, 2.16, 3.1a, b, 3.8, 3.11a, b, 3.12b, 3.19, 3.21, 5.8, 5.15b, 5.28b (dust jacket), 5.33a, e, 6.25, 6.27, 6.28a, 6.29d, 6.30b, 6.31, 6.32, 6.33b, 6.35c, 6.36a, 6.37, 6.39, 6.41b, 6.42, 6.43, 7.33b, Endpiece, Plate 11.

Roy Sieber: 6.21a, 8.9.
Harmit Singh: Plate 15.
Karl Striedter: 6.36c.
Paul Toucet: 3.4a, b.
Clara Zaslavsky: 7.11b.

Original Drawings

Douglas Briant: 2.17, 3.14a, 3.16a, c, 3.23b, 4.1b, 4.2d, e, 4.11b, c, 5.21, 5.25b, 5.29b, 5.30b.
Barbara Paxton: 4.7b.

Mamoun Sakkal: 5.2d, 5.4a, c, 5.5a, 5.15c, 5.29a, c, 5.32a, 5.33d, 5.34b, 6.28b, 7.13b, 7.18, 7.31b, c, 7.32, 7.34c, 8.17.

INDEX

Note: Page numbers in **boldface** refer to illustrations.

Designer: Sandy Drooker
Composition: Wilsted & Taylor
Text: 10/12 Sabon
Display: Sabon
Printer: Malloy Lithographing
Binder: John H. Dekker and Sons